The Complete Guide to Game Audio

"Aaron Marks' The Complete Guide to Game Audio *should be compulsory reading for anyone considering a career in game audio."*

Greg O'Connor-Read, Founder & Editor, Music4Games

"Aaron's book is recommended reading in my USC and UCLA Composing Music for Video Games courses. It is a well-rounded presentation of what we video game composers do every day. Anyone wanting to know more about this great industry should start here!"

Lennie Moore, Composer, Outcast, Dragonshard, War of the Ring, Dirty Harry

"Aaron knows his stuff!"

George Sanger, The Fatman–Game Audio Legend

"Let the fat lady sing! Aaron has created the definitive resource for all things game audio. Bravo, Aaron!"

Chris Rickwood, Composer, Rickwood Music LLC

"Aaron Marks *the spot. An informative, educated, thorough look at the game audio industry, and provides valuable insight into the production process of many of the top working professionals.* The Complete Guide to Game Audio *continues to be one of the best resources for game audio engineers and composers."*

Keith Arem, Creative Director, PCB Productions

"Seven years ago, Aaron Marks redefined how to learn the art, science and business of making world-class game soundtracks with the release of 'The Complete Guide to Game Audio.' His groundbreaking contribution to game audio continues in this, the second edition of his seminal work!"

Todd M. Fay, Professional/Personal Coach (*www.toddmfay.com*) & President of DemoNinja (*www.demoninja.com*)

"This book has changed my life! To understand the game audio business, creativity and the people who are involved in this industry, Aaron Marks has put together the perfect easy-to-read manual. If you are reliable, talented, and excited about how to pursue a path into game audio, then this is THE BOOK for you. I read it, loved it, read it again, and ultimately followed Aaron's advice. Now I owe him my life…and so can you. Buy, immerse yourself, and tell everyone you know about this book!"

Watson Wu, Composer/Sound Designer/President, WOOTONES, LLC (a media & publishing company)

"Aaron Marks' book is THE most insightful look into the world of sound for the multi-billion dollar video game and interactive media industry. It is a resource as valuable to game producers and developers as it is to those looking to venture into the field as sound artists and composers. Bravo Mr. Marks!"

Jon Holland, Game Composer and Recording Artist

The Complete Guide to Game Audio

For Composers, Musicians, Sound Designers, and Game Developers

Aaron Marks

Second Edition

AMSTERDAM • BOSTON • HEIDELBERG • LONDON
NEW YORK • OXFORD • PARIS • SAN DIEGO
SAN FRANCISCO • SINGAPORE • SYDNEY • TOKYO

Focal Press is an imprint of Elsevier

Focal Press is an imprint of Elsevier
30 Corporate Drive, Suite 400, Burlington, MA 01803, USA
Linacre House, Jordan Hill, Oxford OX2 8DP, UK

Recognizing the importance of preserving what has been written, Elsevier prints its books on acid-free paper whenever possible.

Library of Congress Cataloging-in-Publication Data
Application Submitted

2008028495

British Library Cataloguing-in-Publication Data
A catalogue record for this book is available from the British Library.

ISBN: 978-0-240-81074-4

For information on all Focal Press publications
visit our website at www.elsevierdirect.com

08 09 10 11 12 13 5 4 3 2 1

Printed in the United States of America

DEDICATION

To the two most wonderful people in the world, my wife, Cynthia, and
my daughter, Kristina. Without their love and support this book would not have
been possible.

While planning for this second edition, the game audio world lost two
incredibly talented and selfless artists. I also dedicate this effort to the memories of Ingo
Nugel and Simon Castles—both true friends and beloved colleagues who are truly missed.

CONTENTS

Chapter Three Getting Organized and Ready for Business

Chapter Four Finding and Getting the Jobs 95

Chapter Five The Bidding Process 127

Chapter Seven Setting the Stage 199

Chapter Eight Creating Music for Games 227

Chapter Nine Creating Sound Effects for Games

Chapter Ten Blending the Total Soundscape

FOREWORD

By Keith Arem

For the past 15 years, I've had the privilege to be involved in one of the most fascinating and dynamic professions around. Composing, creating, and producing sound for video games is a challenging entertainment career—every bit as exciting as, if not more exciting than, working in the film or television industry. The games industry is a diverse and changing world, and this book can be your passport to a rewarding and fruitful profession.

The Industry Then

People often ask me how I got started in the games industry. Being a game composer, voice director or sound designer isn't the most well-known profession—so how does someone actually get started? Well, the first rule of thumb is…you have to love games!

Defender, Tempest, Berserk, Asteroids, Choplifter, Battle Zone, Phoenix, Sinistar, Dragon's Lair, Spy Hunter—those were the glorious programs that shaped my early childhood growing up. Sure my education revolved around math, social studies, English, and all the usual school requirements—but video games influenced me in ways that no class ever did. Video games opened my eyes to new worlds, new ideas, and especially new sounds.

As a child, I remember seeing *Tron* in the theater and thinking how amazing it would be to live in a universe of video games. My wish was soon answered when my father brought home an Apple computer for the family. I quickly realized that this new machine was much better equipped as a home game machine than a mere family word processor.

As I got older, I became involved in synthesizers and playing in bands—and discovered I could combine my love of computers with my love of music. Throughout high school, much to my parent's dismay, I would drag our family computer to my local band gigs and sequence live on stage. After high school, I went on to earn a Bachelor's degree in Audio Engineering and Electronic Music Synthesis—which perfectly integrated my passion for computers with music and recording. I was offered my first record deal my freshman year of school, and I signed a recording contract with my band Contagion on Capitol Records during my senior year of college.

Even on tour, I couldn't escape my passion for games. One of my fondest memories from our first North American tour was playing *Street Fighter* in the back of the tour bus between cities. One concert, we even hooked our Nintendo to the other band's video projection wall and played a match during their concert performance.

When I returned from the tour, I decided to make my introduction into the game industry by approaching a local developer in Los Angeles. After quickly learning the ropes with early console development, I was approached by Virgin Interactive to become their

in-house staff composer. Within a year, I was promoted to their Director of Audio and began supervising all music and sound for Virgin's internal and external titles. Directing audio for one of the largest game publishers in the United States and Europe gave me a fantastic firsthand education, and a wonderful working experience in one of the fastest growing industries of its time. After several years as an internal director, I decided it was finally time to establish PCB Productions—to focus on high-end game audio. Since starting my own facility, I have had the great opportunity to work with some of the industry's finest developers and publishers. Over the past several years, I have been fortunate to be part of many successful franchises, including *Call of Duty* series, *Tony Hawk Pro Skater* series, *Ridge Racer* series, *Prince of Persia* series, *Ghost Recon* series, *Spiderman* series, *X-Men* series, *Iron Man*, *Star Wars*, and many, many others.

The Industry Now

The games industry can be a very exciting and dynamic place for musicians and sound designers. Through sound and music, a game can completely immerse a player in another universe or reality. The creative freedom to manipulate moods and environments is limited only by the technical capabilities of the machine and a musician's imagination.

While being creatively liberating, interactive game audio can also be technically demanding. Scoring and designing audio for games can often be much more challenging than motion pictures. This is due to the simple fact that games are, by nature, nonlinear. An example of this can be simply demonstrated by a car passing the camera. In a film or television program, where the picture is established and consistent, the image of the car pass-by is a linear time-established scene that can be scored, synchronized, recorded, and mixed by a sound designer or musician. By contrast, in a 3D game environment there can be hundreds of variables that determine how and where the car exists within a 3D space. Because a player can view the car from a multitude of angles, the sound must be capable of being manipulated to match the image from any viewpoint. A simple car sound may need to be looped, layered, panned, pitch-shifted, down-sampled, and format converted—just to accommodate a simple car-pass sound.

One other obvious difference from films is that an audio designer typically doesn't always have the control to "mix" the sounds in-game because most titles require sounds to be individually manipulated and programmed within the code. In a game environment, there may be hundreds of pieces of dialog, music, ambience, and Foley sound effects—each with its own volume, pitch, and positioning within the 3D environment. It is generally up to the sound engine and programmer's code to determine how these will be mixed real-time in the game. (It's no wonder that even the most amazing sound effect or piece of music can be utterly annoying if it is played incorrectly or too repetitively in a game!) It's important for audio designers to learn as much about how their sounds will be *implemented*, as they do about how their sounds should be *created*. Having a strong understanding of game mechanics, programming techniques, and platform limitations will make your life much easier.

Until recently, software sound design had not been recognized as a well-regarded well-paid industry profession—mainly due to the poor fidelity of most consoles. In the past, PC speakers and console systems had limited audio quality and kept the resolution of sound to a minimum. In recent years, there has been a strong effort to enhance sound

for games—and next-generation systems and speakers have made great strides to address memory and bandwidth for audio. Dolby encoding, Blu-ray DVD, surround sound speakers, and increased memory have given sound professionals a new field to play on.

One fascinating aspect of the games industry is that the technology changes continuously. With every new technological development, enhanced software package or hardware device, each new game title strives to out-perform the previous one. As technology improves by leaps and bounds each year, every game title attempts to implement new ways of making games faster, bigger, and louder than before. For an audio professional, this means constantly adapting to new recording techniques and establishing new compositional methods to keep up with an ever-evolving industry.

Because the games industry is a "hit-driven" business, many titles these days are based on established properties or major motion picture properties—allowing game players to interact with worlds and characters originally only on the silver screen. Nowadays, almost every box office hit spawns multiple interactive games based on its property. This is also true for well-known superheroes, comic books, sports teams, racing cars...you name it. For a game audio engineer and composer, this often means working on prestigious titles— sometimes working with star talent and being involved with big Hollywood productions.

Another interesting observation about the games industry is the youthful age of its creators. In most companies, the average age of game development teams ranges from 20 to 40. This is not an industry of children, but rather a generation of people who grew up playing games and chose to deviate from a "normal" career route. Until recently, a career in the games industry was seen as a low-wage job for kids. However, in recent years the games industry has yielded higher profits than the music and film industries combined. Because most musicians and audio designers already know the struggles of justifying their careers, the game environment is a great place to fit in...and never have to wear a tie.

Given the relative youth of our industry, the game community is unfortunately void of experienced, well-rounded role models. As I forged my way through the industry, there were not many well-known game audio professionals who stood as an example of how to make a career in games. Sure, Bill Gates was an inspiration for computer entrepreneurs everywhere, but there weren't many game audio professionals who led the way for future generations.

The Complete Guide to Game Audio, Second Edition serves as that role model for game audio and is a great resource for anyone looking to enter this fascinating industry. New and old engineers alike will find this book as a strong reference tool to understand the interactive arena and how to survive in it. This definitely would have been useful when I was getting started.

Good luck with your future projects, and I look forward to playing one of your games soon!

Keith Arem

PCB Productions

ABOUT THE AUTHOR

Music had always been a part of Aaron Marks' life. But it wasn't until 1995, when his overgrown hobby became On Your Mark Music Productions, that he began selling it to the world. He began with the local radio and television scene, composing jingles and scoring public service announcements—with eventual sights on Hollywood. Instead, he fell headfirst into the games industry, where his sound design and voice-over talents also exploded—leading him to music, sound design, and voice-over credits on over 100 game titles for the Xbox and Xbox 360, PlayStation 2 and 3, Wii, Dreamcast, CD/DVD-ROM, touch-screen arcade games, Class II video slot machines, Class III mechanical and video slot machines, coin-op/arcade games, online and terminal-based video casino games, and numerous multimedia projects.

In addition to *The Complete Guide to Game Audio*, Aaron is the lead author of *Game Audio Development* and has written for *Game Developer Magazine, Gamasutra.com, Music4Games.net,* and the Society of Composers and Lyricists. He has authored an accredited college course on Game Audio for the Art Institute Online, is a member of the AES Technical Committee for Games, was on the launch committee for the Game Audio Network Guild (GANG), and is the owner of On Your Mark Music Productions—where he continues his pursuit of the ultimate soundscape, creating music and sound for a multitude of projects.

Author's Selected Gameography	
Colin McRae's DIRT	Codemasters: Voice-over direction and performances, recording and editing for this multi-platform, rally car, race game.
The Settlers II–10th Anniversary	UbiSoft/ Funatics: Original musical score for this updated remake of the highly popular strategy game. Musical performances in association with Nugel Bros. Music.
Stack Attack	Microsoft/Machine: Music and sound effects for this Xbox 360 Live Arcade game.
King's Crown, Smokin' 7s, Money Bunny, Piggy Banks, Oki Oil, American 7s, Mr. Money Man, Mrs. Money Man, Wheel of Riches, Super Wheel of Riches, Lucky Leprechaun, Captain Cash, Vegas Acers, and *Stealin' Sheep* video slots; *Kangaroo* and *Super Kangaroo Keno, Royal Poker* video poker	Beyer Productions (developer): Audio director, music, sound effects, and voice overs for these terminal-based video casino games.

ESPN MSL Extra Time	Konami Computer Entertainment of America: Music cues and sound bank programming for this PlayStation 2 soccer title.
I, of the Enemy and *I, of the Enemy – Ril Cerat*	Enemy Technology (developer): Musical score, sound effects, and narratives for these multiplayer space strategy games.
Feet of Fury	Cryptic Allusion (developer): Original dance tracks for this dance game with emphasis on player-versus-player combat on the Dreamcast.
Bloxx, Shanghai Express, Palm Reader, Zillionaire, LoveOMeter, Mezmerized, Kubis, Slide 'Em	uWink, Inc.: Sound effects and music cues for these touch-screen arcade games.
Online casino/arcade game sound effects and music	*Flipside.com, VirtualVegas.com, PrizeCentral.com, iWin.com*: More than 70 individual Java-based games for these web sites.
The Many Faces of Go Deluxe	Smart Games: Sound effects for this CD-ROM strategy game.
Hardwood Solitaire II	Silvercreek Entertainment (developer): Sound effects.
Hardwood Hearts	Silvercreek Entertainment (developer): Sound effects. Finalist at 2nd Annual IGF held at GDC.
Fallen Heroes	A&B Entertainment (developer), ionos, inc (publisher): Sound effects and character narratives for this CD-ROM title.
SC3	A&B Entertainment (developer), ionos, inc (publisher): Musical score, sound effects, and character narratives for this CD-ROM title.

ACKNOWLEDGMENTS

It would have been nearly impossible to write a book of this scope without the help and inspiration of many remarkable people. I'd like to give special thanks and recognition to the many individuals and teams who helped keep my facts straight and the proverbial nose to the grindstone. A heartfelt thank-you to:

My family (all of the Marks', Sartor's, Van Cleave's, Posey's, and Rodgers'), Watson Wu, Alexander Brandon, Todd Fay, Laura Lewin, Chris Simpson, Mark Scholl, Mark Temple, Ingo Nugel, Henning Nugel, Will Davis, Keith Arem, George Sanger, Nathan Madsen, Jon Holland, Jamie Lendino, Brian Tuey, Ron Jones, Tim Larkin, Eric Doggett, Greg O'Conner Read, Christos Panayides, Jon Jones, Kristoffer Larson, Pete Bernard, Tommy Tallarico, Joey Kuras, Chance Thomas, Darryl Duncan, Chris Rickwood, John Griffin, Lori Solomon, Scott Selfon, Brian Schmidt, Michael Henry, Kurt Kellenberger, Rodney Gates, Tom Salta, Richard Jacques, Lennie Moore, Mike Brassell, Adam DiTroia, Fernando Arce, Tom Graczkowski, Matt Piersall, Dave Chan, and Dan Woods.

Thanks also to:

Dolby Labs, Obsidian, Machine, Elsevier/Focal Press, Music4Games, *Game Developer Magazine*, Gamasutra, NFG, SoCal TRACON, and the game companies who have given me the chance to not only prove myself but to gain the wisdom to teach others.

And to all of the many others not listed, your contributions were all very much appreciated! Thank you!

CHAPTER ONE

An Introduction to Game Audio

Insert Quarter Here

Any worthwhile journey always begins with that first step, followed by another and then another. Regardless of whether you are already many miles down the road or are just about to take that first stride, this book is designed with you in mind. Working in the multi-billion-dollar game industry as an audio content provider is a challenging and rewarding avenue—best traveled with a useful guidebook in hand. My thanks to you for bringing this particular one along.

There are as many reasons as there are individuals for wanting to work in video games. Doing something you enjoy, creating games which millions will experience, or getting a paycheck for it, are all undoubtedly given the most often. Another, perhaps more enticing reason, is the mystique and prestige associated with it. Most of the world is practically computer illiterate, and those of us who can get inside "the box" and make it do these incredible things hold a measure of prominence in our society. We like to be that kind of person.

There are countless job descriptions within the industry: programmer, artist, animator, game designer, producer, and so on. But the ones which probably drew you to pick up this book are titles such as game composer, musician, sound designer, or audio content provider. These are the jobs which will bring us the kind of satisfaction we crave, creating music and getting paid to do it. It will also give us another way to get our music "out there" and maybe even be considered for a Grammy Award in the process. It will give us some needed recognition and acceptance from our family and friends who thought being a musician was a waste of time, and might even serve as a stepping stone to another career—such as film, if you wish. There are endless possibilities to meet your personal and professional goals as a game composer and sound designer. And it's not such a bad career, either.

Music had always seemed to be a part of my life, and like everyone else, I had big dreams. I just didn't have a clue as to the "what" or "how" part of it, though. I did know how to spend money, and as my abilities and interests grew, so did the number of instruments and recording gear in my inventory. So much, in fact, my wife became concerned with the excessive outflow. The foot was brought down with a resounding thud and a new challenge was posed. I could not buy any more "gear" unless I made money with what I had, and after that, this little hobby of mine was to remain self-sufficient.

Originally, local television and radio seemed to hold some promise but as I jumped into that chaos with both feet, I quickly realized the competition was fierce and I was

mere plankton in an ocean populated by whales. Out of necessity, my strategy widened and diversification became fundamental. I looked into composing for music libraries, local video production companies, and multimedia. I had to have more gear, after all.

I soon learned just how these other businesses worked. They all wanted grand, original orchestral scores, à la John Williams, but only wanted to pay $200 for them. Considering the amount of time and effort you need to pursue this course, there is no way to see any return on the investment and it became painfully obvious, that even though I was still overwhelmed by the urge to sell my music to someone, this was not the way to go about it.

I didn't naturally move to video games, though. I was still playing the original Nintendo at this point and didn't consider the noise I was hearing to be music. And I'm sure nobody was making any money for those minimal compositions either.

The constant pursuit of more gear is great motivation for selling your music to the game industry. (Photo courtesy of AMC Studios.)

But when scoring for video games did finally run up and slap me across the face, I realized my perceptions of this strange new world were woefully distorted. The gaming world has advanced far beyond what I had imagined and the music has become utterly fantastic! And to top it off, I discovered some game composers were making $50,000-plus per game for just a month or so of work. Now I was interested!

Thus began an incredible journey, making money selling my brand of noise, realizing my goals and dreams, taking my "hobby" to a successful business, and, most importantly, bringing peace and harmony to the home front. But, because I knew absolutely nothing about the business, it took a couple of years to struggle into it, learn the ropes, and find my niche before I began to realize success.

That, in a nutshell, is the purpose of this book—to educate you, to help you decide if this industry is right for you, and then give you the knowledge to take on the gaming world by storm. My experiences have given me a certain view of this unique industry

and this is what I intend to share with you. If I can provide you the assistance to hit the ground running and save a couple years in the process, my objectives have been fulfilled. So, sit down, hang on, and enjoy the ride.

The Bleeps and Bloops of Yesteryear

In 1971, video games made their grand public appearance with the game *Computer Space*. Although this game isn't as well remembered as some, society took to this new form of entertainment—plunking down stacks of quarters at a time. A year later, Atari's *Pong* took its place in history. This console game was uncomplicated by today's standards, the few sounds it played were simple, single-tone electronically generated bleeps. Atari's home entertainment offering in 1975 brought *Pong* into our homes, but it wasn't until 1977 that the Atari 2600 game system brought the first (although slight) improvement in game sound.

As the thirst for these games grew, so did the technology and the search for more stimulation was set into high gear. Various methods and audio processors were applied to aurally satisfy the game player and keep them coming back. In 1979, Mattel presented their Intellivision system—offering a sound generator capable of three-part harmony. Atari answered back in 1982 with their 5200 platform and a dedicated audio processor called Pokey. The Pokey chip used four separate channels which controlled the pitch, volume, and distortion values of each—allowing a four-piece virtual band to perform for the first time.

From here on out, each new game system introduced had more audio resources to draw from. The original Nintendo Entertainment System (NES) in 1985 used five channels of monophonic sound. 1986 brought Sega's introduction into the ring with monophonic sound generators using four octaves each. By 1989, the NEC Turbo Grafx brought six voices with stereo output—and the Sega Genesis brought 10 voices. Both incorporated a later add-on which allowed for CD-quality audio and at last we were getting to enjoy some music and sound the way it was meant to be heard. Audio processors continued to improve, adapting synthesizer chips, 16-bit processors, more voices, more memory, better compression and decompression algorithms, and even internal effects processors.

But far away from the consoles and dedicated gaming platform market, the personal computer was beginning to show its potential. Initially, the sound quality was no better than the early console games: the generated bleeps played back through an even more horrendous-sounding internal speaker. Memory space was always an issue and the considerations for audio were last on a very long list of priorities. As a response to the almost hopeless situation, separate sound cards were developed with small synthesizer chips which allowed for very small message files (encoded with triggers similar to the roll on a player piano) which told the device what sounds to play and when to play them. The sound bank consisted of 128 sounds with the capability to play a total of 16 notes at a time and this use of the MIDI (Musical Instrument Digital Interface) standard gave us some hope. The tinny, cheesy sounds early cards produced were a far cry from the real thing but at least the compositions were becoming better and more complex and musicians were replacing programmers at an increasing rate.

The computer sound file, such as today's *.wav* and *.aif* files, utilized a compression algorithm which enabled real recorded sounds to be played back initially in the *.voc* format. This gave a musician the ability to track music in a studio using traditional recording methods and to then convert to the required sound file format. The sound quality

wasn't much better than the MIDI music being expelled; initial sample rates of 11 kHz, 8-bit, mono were hardly even AM radio quality but at least the composer wasn't restricted to the sound palette which came with the hardware. Sound designers benefited as well, enabling their creativity to literally explode. The stage was set, ready for the next level and beyond.

Tools of the Trade

Lennie Moore—composer

I'm a 10-year veteran composer for video games, not to mention 20 years in film and television. My clients usually hire me because of my expertise in using live musicians, whether it be a large orchestra or a jazz ensemble. The most important pieces of gear to me are the following:

- Favorite pencils: Staedtler Mars Lumograph 2B (Art No. 100-2B A6)
- Favorite erasers: Staedtler Mars plastic combi (Art No. 526 508)
- Current electric pencil sharpener: Royal Power Point
- Favorite sketch pads: custom Judy Green Music PS-1556

I'm also extremely computer savvy. I build my own custom PCs and have a mastery with most of the current music creation software on the market. I am in the process of mastering third-party game audio middleware engines such as FMOD and Wwise, as I feel this helps me in my communications with my clients regarding music implementation into video games.

Computer: Computer 1 (sequencing host): Intel Core2 Duo E6750 2.66-GHz cpu, Intel D925XCVL-K mobo, 3-GB DDR2 PC4300 RAM, 80-GB WD Caviar SE 7,200-rpm ATA HDD, (2) 250-GB WD Caviar SE 7200-rpm SATA HDD in RAID0 for archiving protection, (2) 500-GB WD SATA HDD, Sony DVD + RW/DVD + R/CD-R/CD-RW, gigabit LAN, 128-MB MSI 128-MBPCX 6600 video card, RME Fireface 800, Windows XP Pro, Emagic Unitor8 MIDI interface, Cubase 4, MIDIoverLAN. Computers 2–5 (Gigastudio hosts): (4) Intel P4 540 3.2-GHz, Intel D925XCVL-K mobo, 2-GB DDR2 PC4300 RAM, 80-GB WD Caviar SE 7,200-rpm ATA HDD, (2) 250-GB WD Caviar SE 7200-rpm SATA HDD in RAID1 for libraries, Sony DVD + RW/DVD + R/CD-R/CD-RW, gigabit LAN, 128-MB MSI 128-MBPCX 6600 video card, RME HDSP9652, Windows XP Pro, MIDIoverLAN.

Music creation: Cubase 4, Ableton Live.

Samplers: Gigastudio.

Audio editing: Sound Forge, SawPro.

Music notation: Finale.

Audio engine middleware: FMOD, Wwise.

Monitor system: 5.1 surround system of five Dynaudio BM5-As and a BM9S subwoofer.

Mixdown: I bypass any mixing boards and mix everything in Cubase. I run the audio directly out of my RME Fireface 800 to the surround speakers, which are self-powered.

Sound modules/VST instruments: Spectrasonics Omnisphere, Atmosphere, Trilogy, Stylus RMX, First Call Horns, Arturia MiniMoog V.

Outboard gear/plug-in effects: Nomad Factory Integral Bundle, Waves IR1 Convolution Reverb, Wave Arts Power Suite 5, PSP Audioware MixPack.

Keyboards: Studiologic SL-990.

Other instruments: Roland S-770 (I just can't get rid of this great old-school sampler!), Carvin six-string electric bass (my other wife).

Microphones: Sennheiser 414 (plus I rent whatever I need).

Sound libraries: I have a lot of custom sampled library material, Back Beat, Bass Legends, Bizarre Guitar, Dan Dean Woodwinds, Brass, and Gigabass, Distorted Reality 1 & 2, Burning Grooves, Han Zimmer Guitars 1 & 2, Liquid Grooves, Metamorphosis, Peter Erskine Living Drums, Project SAM Brass, Project SAM True Strike Percussion 1 & 2, Quantum Leap Brass, Retro Funk, Roland Orchestral Family (my own custom Giga conversions), Scarbee Basses & RSP 73 Rhodes, Siedlaczek Advanced Orchestra, Sonic Implants Strings, Steve Stevens Guitars, Symphony of Voices, Ultimate Orchestral Percussion, Vocal Planet, and Will Lee Bass.

Where Sound Is Now

Today, game audio has evolved into an art form all its own. Game music quality, the release of standalone game music CDs and their potential for a Grammy Award have at last put us on par with the television and film industries. Hollywood-quality sound effects and celebrity voice-overs are commonplace and help create an incredible, almost movie-like experience. Who would have thought this even possible 30 years ago? Game audio has made a quantum leap forward, and we not only have the talents of many veteran game composers and sound designers to thank, but the game industry for its continued support and the technological advancements of audio hardware.

While 22 kHz, 8- or 16-bit sounds are still in use for some applications, 44.1 kHz, 16-bit, stereo (CD-quality audio) is the standard audio property of today's audio content—with some game consoles even capable of playing sample rates of 48 kHz. Larger storage space, higher-capacity memory, and faster processors continue to develop—which make the increase in audio file sizes possible. Higher sample rates and resolutions equate to better-sounding audio and CD quality takes up a large amount of space.

In the not so distant past, stereo playback was considered the ultimate. Today, however, this is merely the minimum standard used in games. Surround sound has quickly become the missing immersive dimension players have been looking for and it is almost unheard of to have a major game title released without it. With gameplay becoming increasingly more complex, surround sound allows the player to make use of their sense of hearing for directional cues and to really put them in the game. 5.1 and 7.1 playback systems are in more than 120 million homes, thanks to the efforts of companies such as Dolby and DTS and because of the popularity of the home theater; and game developers have taken this phenomenon and run with it to create incredibly engaging experiences.

Imagine being fully engulfed by sound. Walking down a dark corridor in a first-person shooter, hearing your footsteps below you, environmental sounds coming from air ducts and doorways, suddenly you hear a noise behind and to your left, you turn to be confronted by a ghastly beast wanting you for lunch. You fire your weapon, the sound reverberating all around you, shell casings tinkling on the floor, and the creature falls to the ground with a thud. That is some serious entertainment! The name of the game is total immersion and you as a composer or sound designer can expect to set that stage.

Adaptive audio is the latest concept to see industry-wide support and increased usage in games. In an effort to better follow the unpredictable and ever-changing on-screen action, music and sound which can "adapt" to what the player is experiencing is being integrated into gaming and quickly establishing itself as a new standard. With film, all music and sound effects are post-production elements placed after the visual elements have been created. As a movie plays, the linear soundtrack follows along—setting the appropriate mood for each scene, building tension, or tugging at your heartstrings. However, most video games aren't predictable in that sense and a music score can seldom anticipate what will happen next to a player. Audio presentation methods have been developed over the last few years to interact with what the player is experiencing; whether they are casually exploring a game level or locked in heated battle with an opponent, the music and sounds will change accordingly. Interactive and adaptive audio tools enable a developer to have more control over the mood and the game player's experience, often leading to spectacular results.

A studio at Dolby Labs in San Francisco, where surround sound equipment and techniques are designed and tested.

A score created with a live orchestra can really give the total "movie-like" experience to a game title and today's large game budgets and skilled composers make this form of music much more common. While an orchestral score is not always the right choice for a game project, most triple-A action titles tout this type of music as a main selling feature, ultimately giving the players a better experience for their money. The chances are very good you will eventually lend your talents to one of these massive undertakings as you make your way to the top of the field.

The previously popular MIDI music standard has had its ups and downs and has come close to falling by the wayside as the public expressed its disappointment with it. Internal instruments gradually became better as sound card manufacturers included high-grade synthesizer chips but because this quality differed greatly among manufacturers, what sounded good on one card sounded like a train wreck on another. This lack of consistency, while leading the decline in its usage, has actually fostered other viable solutions for the format and we are currently seeing a resurgence in MIDI use.

Down-Loadable Sounds (DLS) and new audio features have kept MIDI as a practical format offering advantages of its own. Because these "sound fonts" can be loaded as needed into the internal memory and triggered by standard sequenced data, the instrument quality is always consistent no matter what system or sound card the player has. An added advantage is an almost infinite palette of instruments can be loaded, even new samples for each game level, as a way to keep the player immersed and entertained. Allowing composers and sound designers to pick and choose their own sounds, instead of being stuck with whatever the sound card manufacturer has installed, increases the creative quality while keeping file sizes small and giving more flexibility to the developer. Cell phones and handheld consoles, such as the Nintendo DS and Sony PSP, take full advantage of sound fonts to keep music engaging and interesting.

Overall, the general trend shows a continued movement toward improved sound quality. Arcade games have better customized speaker arrangements, subwoofers, and more powerful playback devices. Home gaming consoles have stereo, surround and digital outputs, and additional sound controls built in. PCs include upgraded audio hardware as standard and can stream quality audio straight from the disk. Game developers consistently understand the impact of superior music compositions and film quality sound effects, and their increase of sound budgets allows them to hire veteran audio professionals to make this happen. Composers and sound designers are even brought in earlier in the development cycle, as part of the design team, instead of as an afterthought during the final phases of production as in the early years. Eventually, video games will be interactive movies where the psychological effects of music and sound will be dominant.

The new frontiers for games today are the World Wide Web and cell phones. Games played either over or on the Internet have enjoyed a tremendous boost with the spread of broadband access. Previously, dial-up and slow modem connections restricted audio to small file sizes and MIDI music—using audio properties as low as 8 kHz, 8-bit, mono, and unflattering compression. Now, with faster connections and high-quality compression schemes, Java, Shockwave Flash and online games are enjoying respectable audio. These advances have crossed over to cell phone games as well, making what was once a limited audio experience a little more exciting. There are definitely many more technological improvements which will be made over the next few years, and if history is any indication, game audio quality will follow the same path.

Composer at Work

Keith Arem

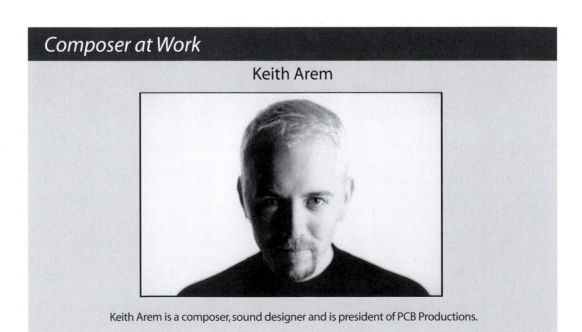

Keith Arem is a composer, sound designer and is president of PCB Productions.

Describe your thought process for scoring/creating sound effects.

I initially try to envision the entire sound field and consider other elements that will be combined into the scene. If there is an enormous explosion sequence, the score needs to accentuate the action but also needs to allow the dialog and sound design to breathe and then come in to do its job. For sound design, I concentrate on organic elements that will blend together and try to make a cohesive sound. I try to consider the sound field from a visual perspective—panning and separation for left to right, top to bottom and depth and ambience for front to back. For creatures or dialog effects, I try to create an organic sound that sounds cohesive and believable, even if the sound is completely unnatural.

Are there any particular secrets to your creativity?

Speed and perspective. I tend to work very fast, focus on the immediate content, then step back and evaluate it. Usually I find that my best ideas come quickly and if I spend too much time on one element it distracts from the rest of the project. I also build my studios to minimize setup, so I can focus on the creativity and not waste energy on templates, wiring or finding assets. That way I can concentrate on the creative elements at hand and not be distracted by technical concerns during a session.

When do you find you are most creative?

My best ideas come just before I wake up in the morning, but my best work is always at night. I've always found it's difficult to structure creativity in a nine-to-five environment, so I designed my facility so I could work day or night and not disrupt the workflow for our clients.

Any specific "lessons learned" on a project which could be shared?

Managing expectations is one of the best things to do with a client. Often clients come in with preconceived ideas of how things should sound or be done, based on their previous experience. Often clients have a concept for a sound element, but no tangible example they can point to. They sometimes have an idea in their head that doesn't always translate to the real world: "I want it to sound sort of like that scene in the Matrix, but maybe using a Tuba underwater." I always want our clients to be happy with our work, but it's most important that they first understand what is feasible or sonically possible.

Do you have any interesting sound design creation techniques which resulted in something notable?

I've found that some of the best sounds come from the most unexpected places. When my wife was pregnant, being a true audio geek, I recorded the sounds of my daughter's heartbeat through a stethoscope. Years later, when I was creating the trailer for *Dead Speed*, I was searching for the right elements to design a viral mutation through an electron microscope. I was very proud to find that my daughter's heartbeat worked perfectly.

Where Sound Is Going

The future holds some incredible offerings for game audio. It's a given that computer processors will continue to get faster, memory will become plentiful and cheap, and as the hardware side of things improves, the gaming experience will follow close in trail. And it's only obvious, too, game audio will be right there to take advantage of it. The DVD format has essentially replaced the CD, and the Blu-ray Disc (already in use on the PlayStation 3) is well on its way to replacing the standard DVD. These give an incredible increase in storage space, allowing all audio to be at least 44.1 kHz, 16-bit, stereo.

As audio properties predictably reach for a higher standard (such as 96 kHz, 24-bit, surround), Blu-ray and the next format generations will allow plenty of room to accommodate it. The sound quality will be right in the "audiophile" range, which in turn, will drive the need for better recording methods and equipment, extremely talented composers and sound designers, and accompanying elevated audio budgets. The only real flaw in this theory is the general acceptance of reduced-quality, compressed audio files, such as mp3s, which are quite prevalent in many sources of personal entertainment. Although this might lead you to believe that audio quality isn't a big concern to the masses, you can feel encouraged even these less than desirable formats are being improved upon—sounding better with each new update. And if they are used at higher settings, in the range of 196 to 256 kbit/sec, the quality is almost indistinguishable from uncompressed digital audio files.

Surround sound usage will become even more widely used by developers, encouraged by consumer surround equipment becoming cheaper and more abundant. But, as new formats such as 7.1 and 9.1 gain momentum, these will be incorporated enthusiastically into games for an even more incredible experience. Immersion isn't just a buzz word in the industry, it's a reality which is being wholeheartedly pursued with the help of even more enveloping surround formats. Current 5.1 or Dolby ProLogic II, as incredible as they are, will eventually be formats of the past.

Looking back even five years from now, interactive and adaptive audio will be seen as barely in their infancy. The potential of these concepts is so incredible and has the ability to single-handedly drive the audio creation and implementation processes far beyond anything we can imagine. The future looks very promising for alleviating repetition and creating a more engaging experience for the player, as audio elements change more effectively to match the action. To keep pace with the demand for the increase of required audio assets, we may see the trend of larger audio teams (both in-house and third-party contractors) and longer and more involved production schedules. More powerful audio creation and middleware tools will be developed to aid in the increasingly complex task and scripting (performed by the composer, sound designer, or newly designated audio scripting specialist) will be the standard method of implementing the vision of the audio experts. Regardless of the work involved, the end results will still be the main focus and interactive sound could quite possibly be the entire future of game audio.

The ever-increasing complexities of audio creation and implementation have begun an interesting trend in the manpower required to accomplish the job. What was once handled by a single, accomplished individual is leaning toward a more specialized compartmentalization of skills and in the near future, it will be almost impossible for any one person to effectively manage even a medium-sized project. In-house audio departments, especially for large development houses, will require a full staff of composers, sound designers,

voice-over directors, audio editors, engineers, and mixers, to name just a few, in order to concentrate on the many small details. To stay competitive, independent game audio studios will also have to staff appropriately or establish alliances with other independents to meet the demands and maintain a high quality. The landscape is definitely changing, and the good news is there will be many more job opportunities and career possibilities.

The future of game music will require a higher caliber of composer as live orchestras, live musicians, and large audio production budgets become even more prevalent. This isn't to say that film composers, although experienced at orchestral scores, will have any distinct advantage. Interactive scores can be highly complex and game composers will also need the ability to write in multiple layers to enable the music to follow the always unpredictable, on-screen action. Game music is expanding in every direction and will make film scoring seem easy by comparison as the task becomes even more technical.

In a completely different musical direction, the power of the current next-generation consoles has exposed another interesting possibility to developers. For a variety of reasons—such as restrictive budgets, console capabilities, or needs of the game—pre-recorded music is not always the best solution and developers have begun to look toward the bulletproof MIDI format as the answer to audio interactivity. Audio files, even in compressed formats, can take up valuable storage space and processor capacity. As a way around these limitations and to enable a nearly unlimited amount of music, instrument samples can be loaded into memory and triggered via MIDI messages. While this initially seems like a giant step back to the ancient days of "chip music," the quality of instrument samples, in-game effects processing, and skillful composers who live and breathe MIDI have made this a viable format once again. Interactivity is the wave of the future and new applications of old tools such as MIDI will help make that happen.

On the sound effects horizon, the crusade to alleviate repetitive sounds will continue with some very exciting possibilities. Efforts are underway which address this particular weakness, some focusing on processing pre-recorded audio while others consider actually generating sound effects in real time as they are needed. Each concept approaches the subject from a slightly different angle but with the same result in mind.

Pre-recorded sounds can be manipulated quite easily as the power of audio engines and high-quality effects processing are integrated more effectively into the chain. As an example, multiple machine gun shots would be incredibly boring if the same single-shot sound were triggered over and over again. With this process, each shot will be randomly manipulated in pitch, volume, and equalization—and the timing of each successive shot will vary slightly for realism. The power of this method is clear since only one shot sound is needed, instead of having to create dozens of variations, saving production time all the way down the line. The same can be applied to any repetitive sound. This technique has already experienced great success in many games but the unlimited future refinements are what is creating the most excitement.

Another promising possibility for sound effects hinges on the work being done toward their generation in real time and on the fly. Unlike pre-recorded sound effects which have been created and integrated into the game prior to their playback, generated sounds don't physically exist until the sound generation engine creates them. These types of sounds require no previous efforts by a sound designer, they don't need to record them, edit them, mix them, or even deliver them to the developer for integration. Not only does this save the time and effort to complete them, but saves storage space and offers unlimited variations of sounds—guaranteeing the player will never hear the same sound twice – ever.

On top of a fresh generation of sound, this technique will also allow for every conceivable physical environment and acoustical modeling possibility. Using our machine gun shot example, each shot will obviously have a slightly different sound generated by the audio engine to start, but the variables of what environment the shot is being fired in, the reflective surfaces which will affect that sound, and the types of surfaces the bullets are impacting and ricocheting off of will be unlimited. The bad news is that this has the potential to negatively affect the job of the game sound designer as developers eventually move toward in-game sound generation. The good news is that our jobs are still safe for many more years as this technology matures into something worthwhile. It will more than likely begin its run on handheld platforms where storage and processors are more limited in an effort to make these portable gaming systems more viable.

Real-time audio mixing within the game environment is another forthcoming technique which is also gaining momentum. Developers currently have the option to mix the levels of each of their audio elements manually, where each sound or music cue has an established preset volume in code, or they can also dynamically adjust the music and sound effects through the use of scripting. A large portion of today's game titles can create a fulfilling soundscape using either of these current methods but the growing complexities of future games will demand more efficient and effective techniques. Sound volume, panning, occlusion and obstruction, simulated acoustic modeling, and environmental physics are just some of the parameters which will be manipulated in real time as the player interacts with the virtual world. Although most of these considerations will be subtle, the effect on the added realism and believability will be immense.

Chances of Finding Work

With the current and future states of game audio, you can imagine the need for skilled audio craftsmen to provide that content. But, what are your chances? With the thousands of game companies worldwide and the unending flow of the production pipeline, your chances are actually pretty good. We are in an exciting time in this industry, with continually evolving technology making the entire game experience incredibly realistic and the public constantly hungry for more. Together they feed the development of bigger and better games—and audio will play a vital role in that total experience.

The last show of hands suggested an estimated 100,000 game developers (with 48,000 working in North America alone) and more than 1,000 official game development companies operating within the industry. Consider the number of "garage" or student developers and their individual game projects which could easily add another couple of thousand to the list. These figures allude to the number of games in production but we can only really imagine the actual number of commercial, showcase, or student game ventures in the works.

To get the big picture, do a search of the Internet looking for key terms such as *video games, video game development* or *game developer* for a nearly endless list of games and the companies who make them. Back when the Electronic Entertainment Expo (E3) was *the* video-game-related event of the year, it was easy to witness firsthand the immenseness of the industry by wandering the never-ending show floor. But, until E3 returns to its former glory, old-fashioned sleuthing will reveal an interesting perspective. Walk into any major computer software retailer and gander at the row upon row of game boxes on

display. Head off to your local arcade and take in all the coin-op game consoles vying for your attention. Do another search of the Internet for online, Shockwave Flash, or Java games. You'll never find them all! Are you getting the picture yet? The games industry is *huge* and there is always work for those of us who are good enough, persistent enough, and lucky enough to be in the right place at the right time.

Tools of the Trade

Mike Brassell—composer and voice-over artist

I am a mid-level game composer and do work with mid-sized developers and online companies. I love gear like anyone else, but have certainly learned how to streamline the studio and move the clunky machinery out of the way for the soft-synths and streaming samples. Still love to mix through the ol' analog mixer, though; there's something about that warmth. Rockin' the 88-key weighted controller with enough assignable knobs and faders to make me feel somewhat qualified to land a shuttle or at least be yeoman status aboard the *Enterprise*!

Computer: Mac G5 Quad Core for my DAW, Monster PC with AMD Athlon chip set, tons of RAM, and lots of gigage for my samples.

Mixdown: ProTools/Logic for my sequencers, Behringer Eurodesk MX 9000.

Monitors: 8812 Linear Phase Studio Monitors.

Sound modules/VST instruments: Waves Diamond Bundle; Spectrasonics RMX, Trilogy, Atmosphere, Symphony of Voices and Vocal Planet; EastWestQuantumLeap Gold Pro XP, RA, Colossus, Choirs and StormDrum; Native Instruments Kontakt 2 and Vokator; Vienna Symphonic Library Opus 1 and Epic Horns; Vienna Instruments Special Edition and SE Plus; Kirk Hunter Orchestra; Sonic Implants Strings; Roland XV-5050; Kurzweil PC2R; Roland V-50; Ensoniq MR-76.

Other instruments: Scarbee Slap Bass.

Sound libraries: SFX Kit by Tommy Tallarico Studios; Sound FX 1, 2, & 3 from Digital Juice; and others.

The Rewards

Providing audio for games can be a unique challenge and sometimes a job well done can be the ultimate reward. But satisfaction alone cannot put food on your table or buy any of the new gear you have to have. While the money can be quite good, and often is, there are other enticements which make composing for games a worthwhile endeavor.

We've all heard the statement that the perfect job is being able to take what you love doing and make a living at it. I couldn't agree more. The one constant throughout my life has always been music and to me, it makes perfect sense to pursue it as a career. There is no greater reward than taking your passion and getting someone to pay you to do it.

Tim Larkin—in-house composer and sound designer for Cyan Worlds in Spokane, Washington—is a perfect example. He has worked on a long list of game projects such as *Half-Life 2* (Episodes 1 and 2), *Portal*, *LAIR*, *Left for Dead*, *Splinter Cell 4*, *Middle Earth*, *The Incredibles*, *Pariah*, *Lord of the Rings*, *Robota*, *Prince of Persia*, *Where in the World Is Carmen San Diego?* and, of course, on Cyan projects, such as *Myst*, *Riven*, *Uru: Ages Beyond Myst*, *Myst V: End of Ages*, and *Myst Online/URU Live*. He has some serious formal music training and experience and can write his own ticket in the game world or in any other creative endeavor for that matter (such as sound designer on the Academy Award–winning animated short *The ChubbChubbs*).

But, instead, he enjoys his in-house position and the steady paycheck and benefits it brings. As an alternative to constantly marketing and concerning over where the next

Tim Larkin.

job is coming from, Tim prefers the comfort and security—which in turn allows him to focus more on his craft. "Working in-house as a composer and sound designer, I enjoy the interaction with a creative team and am ultimately more focused on the creation of the art," says Tim. His particular reward is having steady work and doing something he loves.

Believe it or not, there are actually people who aren't in this business specifically for the money. They can pursue their passion of music in a creative and supportive setting and earn a good living in the process. It might seem crazy now, but a few years as a contractor might just change your mind about in-house work. Don't thumb your nose just yet.

Fame

In Japan, game score composers enjoy "rock star" status among their appreciative fans. Rabid admirers flock in mass to see appearances of their favorite video game stars, continuing to drive a whole other aspect to the audio side of the industry. Sales of video game soundtracks continue to top the charts there as well, giving more avenues to pursue.

The fame and glory of being a recording artist is quite well known to us in the United States and game score composers and musicians are standing poised to take advantage of this type of notoriety. We don't share the spotlight with "name brand" artists and we don't have hordes of screaming fans following our every move, but we do have a sort of recognition that feeds our egos and drives us to do more and to do it better. Eventually, as the popularity of game soundtracks grows and more of the public becomes aware of our existence and fans bases develop, the fame that many seek, will be at hand.

Have you ever seen "music by Bobby Prince, composer for *Doom*" on a box cover? Talk about fame! Everyone in the industry knows who Bobby Prince is and the entire industry is benefiting from it by using it as a selling point. Not only that, but Bobby's stock goes up as more game companies just "gotta have him." He's done other games, such as *Wolfenstein 3D*, *Duke Nukem 3D*, *DemonStar*, and *Axis and Allies* among others, and while he rides his string of hits, his fame continues. I'll take luck over skill any day and Bobby just may have been in the right place at the right time getting involved in a hit game like *Doom*. The music was pretty darn good, too.

And how about George Sanger, aka The Fatman? Having spent many years in Texas, I can appreciate the grand Texas-style way of doing things and George has it down cold. He's done a stable full of games like *The 7th Guest*, *The 11th Hour*, *Wing Commander*, *Might and Magic III*, *Total Recall*, *Star Trek III*, *NASCAR Racing*, *Putt Putt Saves the Zoo*, *ATF*, and more than 250 other games since 1983, and brings his own panache and flair to the gaming industry—he and his "Team Fat" having composed some truly innovative and absolutely memorable game scores. I'm sure every kid in America has heard his music and could sing along with some of the themes. Not only does his ten–gallon hat and his grandiose compositions make him stand out, but his book *The Fat Man on Game Audio: Tasty Morsels of Sonic Goodness*, past magazine

columns and his efforts in joining the gaming forces at his yearly Project B-B-Q make him hard to ignore. Everyone knows who The Fatman (*www.fatman.com*) is, and that's not such bad notoriety.

George "The Fatman" Sanger, a game audio legend.

And what about Marty O'Donnell? Ever heard of him? You bet anyone who owns an Xbox and has played any of the Halo titles is a fan. This guy came from the world of TV jingles, his most notable one being the Flintstones Chewable Vitamins commercials (i.e., "We are Flintstone kids, 10 million strong, and growing"). He has created audio for the *Myth* series and *Riven* and because of it, has become one of the most recognizable names in game audio today.

There are varied degrees of "famous," and depending on what you may be seeking, you will definitely find it in the gaming world. Whether it is a sort of notoriety within the industry for your work ethic and superior audio product, nationwide fame as a game score composer playing your music to thousands of screaming fans, releasing a hit soundtrack CD, or just being known by the kids on your block as the person who does those cool tunes for video games, they are all worthwhile places to be and have their own separate and distinct rewards. Not only is it great to be recognized by your peers in the industry but it's hard to beat that warm and fuzzy feeling having touched a young teenager's life and inspiring him or her to learn music. It's all right here, ready and waiting.

Composer at Work

Jamie Lendino

Jamie Lendino is a composer and sound designer for Sound for Games Interactive. (Photo by *Schedivypictures.com*.)

Describe your thought process for scoring and creating sound effects.

It's different for every game. I work on a wide variety of platforms and it often depends on external factors such as available memory, how much sound and music can be digital, and so on. It also depends on what visual assets are ready, what stage the build is in, and how developed the sound design document is. The client can decide the workflow as well; they might need certain tracks quickly or they may need sound effects first.

Once all that's established, I'll sift through my tool set until I come up with some core sounds and instruments, which define the sonic landscape and give it some consistency. After that, I'll begin to develop themes, usually by working directly in one of the sequencers with the record button pressed at all times. I'll also try and narrow the material down fairly early in the process. If I record three hours of noodling, it's not going to do me much good if I can't remember where the good parts are! I'll alternate between jam sessions like this and more laborious crafting where I hack away at what's there until I have something I'm happy with.

Are there any particular secrets to your creativity?

Coffee. Aside from that, I learned to keep composing no matter what—even if I didn't like what I was hearing. No one said I had to play that particular track for anyone. But in finishing one track and moving on to the next one, you learn to work the muscle, and over time you get better and better at it. It's an ongoing process.

(Continued)

Also, I'm a voracious "media consumer," as disgusting as that sounds. I listen to lots of music, play games, read fiction, and watch movies in as many genres as possible. I also take little creative "holidays" where I don't do any composing or sound design in order to recharge the batteries. It's amazing what a fresh perspective can bring the next morning.

When do you find you are most creative?

I'm most creative in the early mornings. When I was first getting started, I would get up early, work for a few hours, and then go to a "regular" job, squeezing in as many vacation days, sick days, nights, and weekends as possible to work on games. But now that I've been freelance full time for four years, I still prefer the early mornings, much to the detriment of my social life. Hey, it's a living.

Any specific "lessons learned" on a project you could be share?

A lot of it is hard work and communication: working together with teammates, resolving issues, doing your absolute best to please clients, delivering on time and on budget, and always following through on your promises. Looking back over the years, I can think of a handful of projects that could have fallen apart, either due to a new team lead being put in halfway through, a publisher overruling a developer's audio preferences even after they were "accepted," or having the audio spec change several times during development.

The answer in all these cases is to go with the flow. By and large, game developers aren't trying to screw you or make you work for no reason. Games are very complex projects and it's easy for team members to fall out of sync as design documents evolve and improve. This is especially true when working freelance, since I'm not physically in the office with the rest of the team all day.

Do you have any negotiation tips that work well for you?

Aaron lays out the right negotiation methods; I learned it all from him! A couple of tips: when first starting out, you don't need a 20-page contract. You want to protect yourself, of course, but without scaring off potential clients who are likely inexperienced as well and operating on a shoestring budget.

However, there's one very important line to add to any contract: "ancillary use of sound or music outside of the game will be negotiated at a later date." This way no matter what the contract covers, it's only for the specific game in question. Once you're working with established developers and publishers, then you can move on to more complex agreements. But you never want to give away the farm, even early on.

Have you ever had any development issues negatively influence your workflow?

On a recent title I had to "put my foot down," so to speak. My client was great, so it wasn't a personality issue or anything like that. What was happening was that the publisher was requesting changes, but then taking forever to approve the results.

The developer, meanwhile, didn't want to keep the publisher waiting for new deliverables. After all, the publisher was the one funding the whole project!

So at one point, the developer asked me to continue composing tracks along the same vein as a track *in a new style that wasn't yet approved,* and on a rush schedule. The idea was to keep the production line flowing, but potentially at my expense.

So I asked, as nicely and diplomatically as possible, if we could please ping the publisher again and ask them to listen to the first track and approve it before I keep going. The last thing I wanted to do was spend several days working hard on new music, only to find out that the publisher changed their mind on the style and didn't get around to telling us. I created a bit of a standoff, but in the end they approved it and I continued working—with much less stress! Sometimes it helps to work with the publisher directly, but it can be a touchy thing depending on who hired you. Communication, again, is key.

Do you have any interesting sound design creation techniques that affect the type of sounds you create?

I find sound design to be tremendous fun—much more than I ever thought it would be when I first got into this business. Early on, I attended a great talk by Scott Gershin at the '99 GDC about how to really listen to your environment and think carefully about the sounds that everything makes. You train your ear that way. Then, when you're recording new sounds or even browsing a library you can investigate things you never would have thought. That gives you ammunition for creating new pieces of audio or new layers that can contribute to original sounds. There's much more to creating, say, a kick drum than digging through the "kick drum effects" folder. Think of door slams, footfalls, basketballs bouncing on wood floors, closing the refrigerator door—add some EQ and you get an entirely different sound.

What advice can you give when working with a developer who has ensured a good working relationship and a good final product?

I've been lucky, so I'm probably due for a disaster soon. I can say this: treat every situation, even a seemingly intractable one, as a problem that you can help the client solve. Of course, if you created the problem then that's different. But so much of this is the human element, and being willing to go beyond the call of duty—the extra mile—help, I'm drowning in clichés!

How did you find your way into the games industry?

I was one of the first nuts with a Roland MT-32 and a Sound Blaster 1.0 in high school and college, playing all of those old *Sierra, Origin, Looking Glass,* and *LucasArts* games. Some of those even had early attempts at adaptive audio. Later, in 1998, I gave a presentation about game audio at an academic computer music

(Continued)

conference. Shortly thereafter, I decided I wanted to do it for a living and essentially blabbed about it to anyone who would listen—enough that I eventually found myself on a couple of independent game projects as the "audio guy."

I also went to the 1999 Game Developer's Conference in San Jose, even before I had any official finished game credits. That was a life-changing experience. I met all my heroes, including George Sanger (*Wing Commander, Loom, 7th Guest*), Pete McConnell (*Grim Fandango*), and Bobby Prince (*Doom, Doom 2*)! I've attended several times since then.

After that, it was just a matter of putting my nose to the grindstone and promoting myself. When a game I had worked on was released, I'd have another official credit—but the phone wouldn't just start ringing on its own. It always took a lot of promotion. But finally, I ended up with some regular clients who I love working with. This story, by the way, is completely unique—everyone ends up on a different path. For example, I know someone who landed a huge audio contract with a top publisher as only his second game. If you can do that, more power to you!

Fortune

Making a living doing what you love and the corresponding notoriety are enough reward for some, but let's face it, one of the real reasons composers and musicians become involved with the gaming world is the potential to earn their fortune. The movers, shakers, and deal makers are the ones making things happen in this occupation and their business tenacity has made them financially well off.

When game music began and the programmers were slowly being replaced by composers, the miniscule income was almost hardly worth it. But as game budgets skyrocket into the millions of dollars, the composer also collects her or his share by creating some extremely appropriate, thought-provoking, and well-crafted music—with professional musicians and the occasional symphony orchestra to boot. There are very busy composers out there who earn $50,000 to $60,000 for an hour or hour and a half's worth of music per game and some of them do up to 30 games a year! Do the math, there is some serious cash potential. And that isn't even the end of it.

Consider earnings from royalties, soundtrack releases, fees for the same music on different game platforms (sku's) and money from licensing in commercials, television shows, and movies (ancillary rights) and you can see the sky is wide open. If you've negotiated a good deal and signed a contract with a big developer, the potential to have income from simultaneous sources, all from the same music score can really make a difference.

There are several game composers which fortune has indeed smiled upon. They all possess similar traits and have made games very exciting with their musical offerings. Their deal-making skills, reputation for providing quality, on-schedule audio, and stature within the industry have all contributed to their continued success.

Tommy Tallarico has lived one of my favorite game audio success stories. His tenaciousness and drive has taken him from working two full-time jobs, 16 hours a day and literally living on the beach when he first moved to California in 1991 to a highly respected businessman and philanthropist living in a bazillion-room estate with a Ferrari, among

many others, parked in his garage. His deal-making skills and excitement for what he does is legendary, and composing music for more than 250 games and eight game soundtrack releases to date has secured his place at the top.

He has won over 35 industry awards for his work; has hosted weekly TV shows such as *Electric Playground*, *Judgment Day*, and *Championship Gaming Series*; is quite prevalent on many other game-related broadcasts; is the co-owner of the Video Games Live franchise; was the main personality behind the formation of the Game Audio Network Guild (G.A.N.G.); and is a leader in many other quests, including game audio's inclusion in the Grammy Awards. His amazing journey is something we can all draw something from. Later in this book, I'll be sharing with you much of Tommy's deal-making prowess, sample contracts, and ideas that have made him so successful. Stay tuned.

Tommy Tallarico is one of the most recognized and most influential champions of game audio.

Let's Go Get 'Em

Creating audio for games is an incredible ride and if you stick with it long enough and have your act together, you'll eventually have something to show off to all of your friends. Who knows, you may even win a Grammy to adorn your mantel. Speaking of Grammy's, Appendix B goes into detail about this coveted award and what we need to do as game composers to make it a reality; it's not as easy as simply showing up to the party, you know. Game audio definitely has much to offer, so, if you're ready, let's get into what this corner of the multi-billion-dollar games industry is all about.

Tools of the Trade

Richard Jacques—composer

(Photography by Matt Eaton.)

Quite simply, I demand the highest quality of equipment, since I work with the highest quality of developers on triple-A projects across many continents with many different publishers, so I always demand the most from my equipment and continually invest in new technology.

Computer: Mac Pro 8 Core x 5 (1 x main rig for Logic Studio, 4 x slave computers for running Kontakt, virtual instruments, and sample library playback), Mac G5 Quad Core (for running Pro Tools HD), Carillon Custom Audio PC's x 2 (for running Gigastudio), Mac Powerbook G4 (for office applications and ProTools LE 7.3), Mac G4 (for running AkSys network and librarian/editing software for Akai samplers).

Multi-track system: Pro Tools HD 7.4, Logic Studio 8, Pro Tools LE 7.3.

Monitor system: Dynaudio Air 6 (5.1 system), Dynaudio M2, Dynaudio M1.5, Dynaudio BM5, Tannoy PPM 6.5 II, Yamaha NS10.

Mixdown: Pro Tools HD 7.4, Mackie HUI, Novation Remote SL Zero.

Sound modules/VST instruments: East West / Quantam Leap Symphonic Orchestra Platinum Pro XP, East West / Quantam Leap Symphonic Choirs, Vienna Symphonic Library, Sonic Implants Symphonic Orchestra, Stylus RMX, Atmosphere, Trilogy, Colossus, Arturia Moog Modular, BFD, Broadway Big Band, Ethno World (1, 2, and 3), Albino, Blue.

Outboard gear/plug-in effects: SSL bundle, Waves 360 bundle, Altiverb, Reverb One, TrueVerb, Sound Toys, Antares Vocal bundle, Drawmer, MacDSP Channel Strip, Ozone, T-Racks EQ, Lexicon PCM 90, TC 6000, Vac Rac, Purple Audio MC76 x 2, Distressor x 2, DBX Subharmonic Synthesisers x 2, TC Finalizer.

Keyboards: Roland RD700, Roland XP80, Yamaha Silent Upright piano.

Other instruments: Conn 8H trombone, Yamaha 12-string guitar, semi-acoustic guitar, Yamaha RGX electric guitar, CP 5-string bass, assorted world percussion, Akai S6000 x 8, Akai S5000 x 4, Akai S3200 x 2, Akai S3000 XL x 2, Akai EWI, Studio Electronics SE1, Access Virus, Novation Supernova II, Hammond XM1, Oberheim Matrix 1000.

Microphones: AKG C12 VR, AKG C3000 x 2, AKG C1000, Sure SM57.

Additional relevant hardware/software: Bias Peak, a nice pair of bongos.

Remote recording gear: Tascam portable DAT.

Sound libraries: Various Gigastudio libraries, various custom sample libraries (orchestral, choir, drums).

Essential Skill Sets and Tools

Important Skills

Now that you have been properly motivated to consider the game world as a place to sell your music and that burning flame inside you has been turned up a notch, let's check out the important skills and equipment you will need to work and thrive in this industry. I think it is probably safe to assume most of you have either done some composing or play a musical instrument (or two) and you might even have much of the equipment already. If not, I welcome you into our world and applaud you for doing your homework.

The practicing one-man band seems to be the working method of choice for most game composers. By not having to rely on anyone else, the process becomes streamlined and more gets done. You can stay focused for longer periods of time and compose some compelling scores without interruption. Unless I'm using a specific musician for his or her sound or for something I am not capable of doing, I never have to wait for anyone to show up—because I am already there! It's a great way to work, lets you work when you are at your most creative and saves a lot of downtime waiting for someone to show.

There are also many music "teams" within audio production houses, who have specific duties and skill sets which all compliment a project. Even in that atmosphere, it is advantageous to everyone if you are familiar with the other functions of a production.

Attitude

Attitude plays a big part in this business and is the one thing which can set you apart or destroy your chances altogether. The very first game job I got, I found out later, was because of my attitude. I had absolutely no experience composing for games or doing sound design, and while it initially factored into the developer's decision, my confidence and positive attitude are what got me the gig. Since it seemed to work the first time, it has become a permanent part of my sales pitch and how I do business.

Your passion and drive will certainly be enough to get you started, but no matter how much you already know or think you know, there will always be more to learn along the way. Always remain receptive to new ideas and concepts. Technology improvements are rapid and by staying up with all the latest, you place yourself in a good position to take advantage of them. It's always nice to say, "Yeah, I'm familiar with that," rather than having to show your ignorance. Sometimes it can mean winning or losing a contract.

Tools of the Trade

Alexander Brandon—audio director of Obsidian Entertainment

I don't consider myself someone who needs Pro Tools and a quarter million bucks to make effective audio—not unless I'm into a full-fledged multi-project (as in 10-plus projects at once). So I would say that you can get a lot of bang for the buck for not as much money as you'd think. A studio integration specialist I'm working with says you can get a great Neve pre-amp for five hundred dollars or so. That's a far cry from the hundred thousand and up you'd need to spend on a full Neve console. And look at Native Instruments. Get everything they make for about a grand. Times are different for sure. No need to break the bank to get great results.

Computer: Dual-core PC running Windows XP, 4 GB RAM, 750 GB HD.

Multi-track system: Nuendo.

Monitor system: Genelec Espresso 5.1.

Mixdown: Sound Forge 9.

Sound modules/VST instruments: Waves Gold, GRM Tools, NI Komplete 5, Stormdrum, SD2, Vienna, Quantum Leap Brass, Antares Auto Tune, AVOX.

Outboard gear/plug-in effects: Muse Receptor.

Keyboards: At the moment an Axiom 25 by M-Audio, but soon to be CME 88 key.

> *Other instruments:* Acoustic guitar (JBPlayer), Electric guitar (Ibanez Jem).
>
> *Microphones:* AT4040.
>
> *Sound libraries:* Too many to name. Just about all of them.

Business Sense

As the one-man show, you can expect to wear many hats—playing the roles of composer, musician, engineer, producer, technician, sound designer, voice talent, salesman, marketing director, secretary, accountant, janitor—hey, wait a minute! Where did all the music stuff go? Unfortunately, composing music and sound design comes into play less than 25% of the time and maybe only around 5% if you are just starting out. You have to remember you are in business and you are selling a product.

All of the rules, strategies, and abilities come into play here. Being successful means being business savvy and remaining focused on your "product." Until you've attained success and can hire a staff of assistants to provide for your business needs, you won't be able to just sit at your piano and write. Then again, who wants to do that all of the time anyway? A little hard work and dedication on your own behalf makes your efforts even that much more rewarding. Take some time and study how a business works and you'll be miles ahead of anyone who fuddles through it blindly.

Marketing

Another critical skill, absolutely unrelated to creating audio, is the ability to market yourself. I rate this second in importance behind the administrative side of business for good reason. It doesn't matter one iota if you were a child prodigy, mastered every instrument before you were eight years old and have the abilities of a world-class composer if no one knows you exist. You can't just open the doors to your business, expect customers to flood into your studio, and the phone to ring off the hook, unless you've spent some quality time beforehand making sure the right people are aware of your existence. And if they know about you, make sure you properly entice them to buy your product. All of this is part of marketing.

Marketing is as old as business itself, the more you know and use, the more work you will have. You will find yourself spending a good majority of your time planning and implementing ways to get customers in the door, constantly changing strategies, and ideas as you go—searching for the most effective method that brings in the most money for the effort. And you thought you were going to spend all of your time composing and creating sound effects. Well, sorry to burst the bubble, but this too can be an exciting challenge. There are very successful people who specialize in marketing as a career and it may initially seem overwhelming to you. But once you get the hang of it, it becomes second nature and lots of fun.

Later in the book I'll spend more time on this subject with some very basic marketing concepts and strategies geared toward your efforts in the game world. If you can't wait, go ahead and flip to Chapter 4. I'll wait here. But come back soon, I'm going to start talking about music stuff now.

Music Skills

The key piece to this puzzle is your skills as a composer, musician, engineer, producer, and technician—which is probably what you've been waiting to hear. These days, most music is done in the composer's home or project studio—forcing us into the "jack of all trades" role. It is paramount you are familiar, if not an expert, at all of these tasks. Keeping the creative process unhindered and free flowing is fundamental to composing. Nothing ruins your creativity faster than having to stop to troubleshoot or look something up in a manual. The more you know now, the better.

Guitar virtuoso Jon Jones laying guitar tracks for Konami's *ESPN MSL Extra Time* game.

Musicianship

Your musicianship should be well practiced and solid as a rock. Sequencers and multi-track recording software can enhance these abilities and fix mistakes—but trust me, building upon a solid foundation will save you much headache in the end.

I also recommend that no matter what your main instrument is, become proficient on the keyboard. The MIDI keyboard, next to the computer, is essential equipment which has the ability to access all other MIDI instruments and software in your arsenal. It is a focal

point by which you can control other keyboards, sound modules, samplers, electronic drums, virtual instruments, and even start and stop your computer recording software. This workhorse is in constant use and a must to have mastered.

The keyboard, as a musical instrument, can be highly expressive—with nearly unlimited sounds you can play from it. Musically speaking, this knowledge and power is inspiring—but too much of one direction can become stale and characterless.

If you are already a keyboardist, pick up the drums or guitar, anything other than the keys, and learn to play. It will open up another world, giving you better understanding of how music works and give you another instrument on which to compose. Styles can vary widely when composing on piano for one tune and guitar for another. Your outlook will always be fresh and the music will reflect positively.

Another advantage will be self-sufficiency. Although I enjoy composing and playing with other musicians, it saves time not having to wait a week for a player to show— enabling me to get my work done quickly. The clock is running and busy production schedules are not always flexible enough to accommodate. Most composers in the game industry are multi-instrumentalists, having become so out of necessity.

Creativity and Compositional Skills

Never written a song? Then this might not be the business for you. Game music is designed to create a specific mood and audio "feel" to the accompanying virtual world and it is something you should be able to pinpoint exactly within the first couple of tries. While you may be strongest in one particular style of music, consider studying and composing in a variety of others as well. All games are not simply techno or other upbeat rhythmic compositions only there as background clutter. They serve a specific purpose and are skillfully mastered to absorb the player fully into the experience.

You might be lucky enough to find work composing in "your" style, but I prefer to diversify and have more potential jobs available. Orchestral is the current trend, but techno, rock, pop, urban, dance, sports, hillbilly, children's, religious, and so on are other styles—just as legitimate and paying just as well. There are even games which may include music in many of those styles on the same project. You want a developer or publisher to rely solely on you for their musical needs and not seek out anyone else. One-stop shopping is convenient for them, good business sense for you.

Practice composing short pieces in various styles as a creative drill. This will increase your repertoire while simultaneously adding more variety to your demo reel. Early in Brian Tuey's (currently a sound designer and audio programmer at Treyarch) game audio career, he consciously chose to push his creative envelope by trying previously undiscovered approaches to his music making. He happily admits this technique helped his creativity and broadened his musical horizons by exploring other avenues he hadn't previously considered. Try composing "Egyptian surf music" or "heavy metal monk chants" and see where it leads you. It's really not as far off as you think. Sometimes developers can have some crazy ideas and your creativity will be appreciated.

Writing for games is not like writing for your own album release. You will not have the luxury of time, composing and recording only when the "mood" strikes you. Like any other fast-paced adventure such as writing for commercials, weekly TV shows, and

film, you must be able to turn your creativity on like a faucet. It must be an immediate action, ready to go at a moment's notice. If you wait for the elusive muse to appear, the rapidly approaching deadline will be gone and you'll be left looking foolish. You do not want to be the one person the project is waiting on. Time is money and any delay could mean wasted funds for the developer and publisher—who are all counting on you. If you are used to composing only when you feel like it, fight the urge, write when you don't want to, pretend you have a looming deadline, and just do it. As you progress through this business, you'll discover it gets easier turning on the switch. The problem comes with turning it off and knowing when to say a piece is done. The curse of being a perfectionist, I guess.

Engineering Skills

Know the equipment and software you are working with inside and out! Study the manuals, try new techniques in your spare time and know their strengths and weaknesses. Waiting until you are recording a project is too late to figure out how to use your gear. Losing a sound in the maze of electronics can lead to some extensive delays and may tamper with your mindset at the most inopportune time.

Be well practiced at your engineering skills. Know how to get the best sound from your instruments and have the EQ (equalizer) and effects processor settings memorized. Standardize and streamline the process, if you can, by leaving the same instruments plugged into the same channels on your mixer and fight the urge to change it. It will save you significant time during a session to be to able to grab the right knob or fader without having to think about it.

Engineers should be very familiar with their gear, in order to keep the creativity moving in a forward direction.

The marketing departments in every equipment and software manufacturer are hard at work enticing you to buy their latest and greatest products. If you are a recording facility and have rich, demanding clients who love to spend money, you have a legitimate need to buy the newest gear. But if you are a project studio existing only to record your music, you might not. My general philosophy is to buy only the gear that will make me more competitive and profitable, not buy gear because I've got to have it. By staying solidly on the trailing edge of technology, I don't have to constantly relearn new equipment and software, instead, I keep and maintain what works for my composing and recording methods. It's not that I refuse to upgrade, because I do from time to time, I just don't do it unless it satisfies both of my requirements. By staying with familiar gear that works longer, I'm able to work without having to think about the technical issues and disrupting the creative process.

Early in my game career, I had a project with a new game company requiring me to add sound effects to their cinematics (in-game movies). The game was still in development and they were trying to add an audio personality to these cut scenes and have something to show their investors at the same time. Unfortunately, the software they were using was completely new and the learning curve for me was steeper than normal. What would have been a two- or three-day sound design project became a five-day undertaking because they also required me to add sounds to the cinematics myself.

After day 2, I called the company who developed this "tool" and discovered I could not layer sounds on various tracks as it advertised but had to do a composite on a single track instead. No problem, except there was no reference to synchronize to and a stopwatch was unreliable when the animations bogged down or skipped frames. A trusty calculator and a lot of trial and error finally did the trick, but not after a couple of days added to the production cycle and much grumbling. A new program without all of the bugs fixed and no one available who had any experience with it brought a normally speedy sound design process down to near gridlock—a great lesson when introducing something new into your process. Beware.

Familiarity with your equipment will make your job easier and I cannot stress its importance enough. Consider audio engineering courses at your local college, volunteering yourself and studio to record demos for local bands, or remixing your old tunes—all in the name of keeping your ears open and staying on top of your game. A skill without practice becomes a hindrance. Suddenly, I'm a philosopher.

Producer Skills

As the proverbial one-man band, you are also acting as the producer. When producing other band projects, it's easier to remain more objective to the overall project because you are not emotionally attached to the music as a musician would be. In this case, you would have the luxury of focusing on the overall picture—keeping it on track, motivating and evoking heartfelt performances from the musicians and sheltering them from any outside influences which might disrupt their creativity. It is indeed a job in itself.

When producing your own music, the line becomes blurred and may not always be the best situation unless you can take a step back and maintain your objectivity. This is almost an acquired skill, obtained slowly and painfully through your years of experience— but it is something you should strive for in your quest.

You cannot fall in love with your music as the artistic endeavor "creation" can be. Because this is a work-for-hire situation, you have been commissioned to write a score which will enhance the overall game project and that must always be your first priority. You are creating for the project, not for yourself. If a producer asks you to take out a passage of the music and it happens to be your favorite part, you must be able to detach yourself, as a producer would, and make the change. Remember, none of this is personal—as you might sometimes feel. It is all strictly business and it demands objectivity from everyone involved.

Another producer function which must be considered is the knowledge of how the music and/or sound effects will interact in the soundscape. During the development process, there are particular questions to ask—designed to gain an overall understanding of what sonic activities are present in a game. If separate narration is to play over particular music, that should be considered and the final mix of the music should have a "hole" in that frequency range to accommodate the voice-over. Otherwise, the programmer may decrease the music volume to compensate—which may degrade the entire audio moment. The same thing applies to sound effects. If there are heavy explosions in the lower frequency range, then the music should have less bass end so the most important sounds are heard. It can be a lot to consider but an on-the-ball producer can make all the difference. If you intend to release the game's music as a CD soundtrack, the music will have to stand on its own. You'll probably need two entirely different mixes to make this happen.

Technical Knowledge

Another skill set which goes hand in hand with the musical and engineering skills is solid "technical" abilities. You can fudge on this and get away with hiring outside help but you'll be increasing overhead and traveling further away from your goal of being self-contained. You've probably been picking up more than you think, repairing and troubleshooting your way to successful recording sessions.

Basic skills like tracking down a faulty patch cord and being able to solder it back together, being able to successfully splice together a complicated MIDI setup and having it work, being able to understand and synchronize difference pieces of equipment, integrating your computer into the recording process by yourself, are assets that will save you time and money. There is a myriad of complicated, specialized equipment which needs to somehow all work together and if you can make it happen with only minor assistance, you have already mastered this.

Computer Knowledge

In this day and age, it is nearly impossible to compose music and design sound effects for video games without having a computer. Plus, how do you expect to know what is going on without playing a game or two yourself? The first word in "computer games" is *computer*. Know thy computer!

A developer is considering you as the sound contractor on a big game project and, after the nondisclosure agreement is signed, sends you a beta version of the game to load on your computer for a look-see. What do you think your chances are going to be if you can't get the program to work on your machine? Sometimes, it takes a bit of finessing and coaxing to get a game to work—and if you can't do it, the developer sure won't have the time to

either. This is a severe case and highly simplified, of course, but the truth is, the developer is already extremely busy with their task of getting a game to market and prefers to deal with the path of least resistance. I've been told by several developers they would never consider hiring anyone unless that individual possessed solid computer skills. Computer literacy is a good thing and will keep you from being knocked out of the competition.

Today's music making has become centered almost entirely around the computer as well. Sequencing programs, multi-track recording programs, sound editing programs, virtual instruments, effects processing plug-ins, notation software, accompaniment software, samplers, and the like, are studio mainstays and you've got to know how to make them all work correctly. If you can install a sound card, MIDI, or digital recording interfaces on your own, that can be a big plus. No one knows your system better than you, unless you have a trusted computer guru readily available to serve your needs. On-the-spot troubleshooting can save the day.

Much of the sound design process is done on a computer. Initial recordings, the editing process, conversions to the final playback format are all completed inside this machine. It definitely pays to be knowledgeable and unafraid in this frontier. The more you know and understand about it, the better off you will be.

Composer at Work

Fernando Arce

Fernando Arce is the composer and owner of DamselFly Music.

Describe your process for creating audio for games.

I try to ask questions. I think a lot of pain can be avoided this way. I'm slowly learning that not assuming anything is the best way to go. You'd be amazed what different results you can get from creative people when creating, let's say, something moody or uplifting. They mean different things to different people. Asking for specifics from your client is the best way to clear the fog and get on the same page.

Are there any particular secrets to your creativity?

Other than keeping your eyes and ears open and taking everything in around you? Not really. I think everything you put inside will come out somehow when the time comes. Turning off the phone and coffee are a big help as well, though.

(Continued)

When do you find you are most creative?

At night, with no one around me. I live in San Francisco and my window faces a busy street. It's hard to get into it during the daytime; too much going on.

Any specific "lessons learned" on a project you could share?

Yeah, always cover yourself and the person you're working for by having contracts and paperwork. Although it's nice to think you can do away with these with people you have a good working relationship, it's really to protect both of you. Clarity is a beautiful thing.

Do you have any negotiation techniques or stories others could learn from?

Be honest, straightforward, kind, listen more, and speak less. I think it sounds overly basic but it applies to all aspects of life, I think.

How did you find your way into the games industry?

Thanks to your first book, silly!

Sound Design

Another important skill which will serve you well in the gaming industry is sound design. You may not know it yet, but as a musician you already have the foundation for this and all it takes is some fine tuning to make it another profitable part of your business.

Consider the creation of a sound effect to be like a mini musical composition. You first choose the "sounds" which will work best toward your end goal. You cut, paste, layer, EQ, pan, fade, add some effects processing, do a final mix—and, voilà, instant sound effect. Suddenly, you realize you build a musical piece the same way. Well, it's practically the same—except the choice of instrumentation is slightly different and instead of the final mix being minutes, it's seconds long.

Think about this, too. For those of you who create your own keyboard patches or samples, these are the same skills sound designers use on a daily basis. They don't always use every-day sounds or sound effects libraries; they will also use keyboards and tone generators and manipulate them to create the effect they are looking for. It's the same thing you do when you develop your own original keyboard patches. You're a sound designer, too! Keep that in mind.

"Diversify and thrive" is a business axiom which applies well to game audio folks. You don't have to create music for just video games, but always keep your options open—and also consider jobs composing for multimedia, video, radio, TV, and film. You have a valued skill, don't waste it on one medium. The same goes with your sound design talents. By becoming proficient as a sound designer, you've just doubled the amount of jobs you can do in games. Game developers almost expect a composer to double as the sound designer as well or to at least have someone on their team who acts in that capacity. They see it this way: you have a tape recorder and a microphone so you must be able to do sound effects, too. Ridiculous, I know, but that is the misconception the wise have capitalized on. There is no reason you can't also.

Another great reason to have "sound designer" on your resume is to make yourself and your audio production house a developer's or other client's one-stop shop. The game development process is already complex enough and the fewer people producers have to explain their vision to, the better. They would much rather hire one person, saving them the entire process of dealing with an extra body and keeping things simple. They know anytime "anything audio" is needed they can call you. By making yourself and your company look that much more attractive, you have opened up the world of possibilities—whether you prefer to work as a contractor or a full-service in-house audio authority.

Voice-overs

As the person with the tape recorder and microphone, you've just been assigned yet another task for your already overflowing capabilities. Did you know you can also be expected to not only be able to audition and hire character actors and voice-over talent but direct and record them, too? You've already got your finger on the pulse of the musician world, why not voice talent? But all I wanted to be was a game score composer, you say. Sure, but you'd be giving up another opportunity to make some money and giving the developer a reason to look for someone else to take care of them. You already possess the skills needed to make great recordings and you can probably already motivate your artists into some dazzling performances. With a little bit of patience and practice you can develop an expert approach to this line of work.

Needed a hot guitarist for a recent project of yours? Where did you go to find them? Did you try word of mouth, the newspaper, a talent agency? Where would you go for voice talent? How about the same places? For voice talent, you could even try your local radio and television stations for the people who do all the commercial voice-overs. Jon St. John, radio and voice-over personality in San Diego, California was also the voice of Duke Nukem and many other voices in *Half Life – Opposing Forces, Evil Dead, Twisted Metal 4, The Sonic the Hedgehog* game series, *NASCAR Racing 4, NBA Shootout, Ken Griffey Jr. Baseball,* and others. Voice acting is what he does and he does it very well. Just because they hold a certain celebrity status on TV or radio, there is no reason to be intimidated by them. They are normal people looking for work, so introduce yourself and make them part of your network. You'll never know when they could come in handy.

Talent agencies are another great source and are not as complex as you might think. You let them know your criteria and they arrange auditions for you. After sifting through audio and video demos or even sitting patiently while they perform for you in person, it's fairly easy to pick your favorite and set up a recording session. And, with fees ranging between $250 to $2,500 per session for standard voice talent (which you already included in your contract for the job, so it isn't coming out of your pocket), there is really no reason not to bring in the experience of a seasoned actor to maintain a high quality. We are in the profession of hiring talent on occasion, so learn to use this resource.

The point here is, you have probably been through all of this with musicians before so you already have the knowledge to make it happen. While this particular skill won't make or break your game scoring career, it will make you much more attractive to your clients.

Many game composers and sound designers act as their own voice talent. It goes back to what I mentioned earlier about becoming self-sufficient by learning several instruments. When a deadline is looming and you have to wait for your talent to appear, this type of stress can easily disappear by becoming your own readily available voice actor.

As a creative entity in music, your mind is already geared towards performance and I'd be willing to bet you have plenty of those "funny voices" in your repertoire which you could take advantage of. And with creative use of EQ, effects, and some pitch shift, you can make a man sound like a woman and vice versa. I've been a pesky gremlin, goblin, seductive woman Russian agent, barrel-chested gladiator, southern steamboat captain, race track announcer, card dealer, lispy fashion designer, fighter pilot, air traffic controller, cowboy, game show host, king, queen, geek, orc, elf, dog, cat, parrot, frog, rabbit, fish, and an assortment of cartoon characters. I took a little of my high-school drama days, my impatience and a microphone, and added another sideline to the job that, frankly, I'm having an awful lot of fun with. I got into this industry to do music but have remained open to all the possibilities. Our type of creativity can pay off in many ways.

Industry Knowledge

The only thing left on this long list of essential skills which will make you competitive in this foreign land is knowledge of the gaming industry itself and how it works. It is a world unto itself and far from your comfort zone as a musician. If you already possess some solid business sense, you are another step ahead of the crowd—but knowing when and where to strike in games is the secret. Do research. Talk to any friends or acquaintances who are in the industry, find out how their companies work, who to talk with to get the jobs, and most importantly, how they do what they do. Talk to other game composers, sound designers, and voice talent. These people have plenty of knowledge and are willing to share much of it. Don't expect them to give you names and phone numbers of their clients, they have fought hard themselves for them, but they will gladly discuss the process and the technicalities. Most are very open and friendly.

Be a sponge. Absorb everything. Stay alert for any information about the games business. Subscribe to a few magazines (such as *PC Gamer, Games for Windows, Game Informer Magazine*, or *GamePro Magazine*) for the consumer side. Try *Game Developer Magazine* for the "how-to" down-and-dirty technical side and *Games Industry* webzine (*www.gamesindustry.biz*) for the business side of game making. Try the Web. There are many, many sites available free of charge which are full of great information. Gamasutra (*www.gamasutra.com*) is a great resource for industry information and job leads, for example. We'll talk about more of these in Chapter 4.

Every time you walk into a retail outlet, check out the video game isles; pick up boxes and look at the companies who are making these products. Buy a few. Don't be shy. They're a tax write-off for your business now. You can't expect to do audio for games if you aren't familiar with the major titles, what technology is being used, and what types of sounds they are making, now can you? Rent games from your local video stores. No one said this was going to be all work now, did they? After all, this is the games business. We do have fun on occasion.

The point of all of this is to be educated about the industry in which you work. It is in constant motion as smaller companies are taken over by larger ones, companies disappear one week and spring up somewhere else under a new name the next. A producer you worked with on one project may have jumped ship to another company or even started his own. By keeping your finger on the pulse you can guarantee your survival and flourish. Evolution is constant. Education is paramount. Know your business.

Tools of the Trade

Eric Doggett

Eric Doggett is a composer, sound designer, and co-owner of MoonDog Media.

We currently handle small- to medium-sized projects, creating both music and sound assets. With two studio environments, we've worked hard to have a consistent software set between multiple machines. We've also focused on downsizing our gear to what we need to get the job done well.

Computer: Mac Pro Towers.

Software: Logic 8.

Monitor system: KRK/Alesis.

Sound modules/VST instruments: All the great Logic instrument plug-ins.

Keyboards: Korg Tritons.

Other instruments: Guitars (Gibson, Les Paul, Yamaha).

Microphones: Shure, Audio Technica.

Additional relevant hardware/software: Focusrite Voicemaster Pro pre-amp, MOTU interfaces, multiple computers for instrument sections.

Sound libraries: A lot of East West libraries, Spectrasonics, Guitar Rig, Garritan, Drumkits from Hell.

Tools for Your Business

Musical arsenals vary greatly with each composer. Some prefer a minimalist approach, to keep technology from interfering with the process and let them create truly unencumbered art. Others have to possess all of the latest and greatest gadgets and gizmos, computer wizardry and plug-in noise-making boxes—preferring to let technology drive the creative course. Both extremes produce appropriate game scores which serve the virtual experience quite well. Most of us, however, are somewhere in the middle. The trick is finding what works best for you and whether you will do it leading the pack, using up-to-the-minute hardware on the leading edge, or working comfortably with the tried and true on the trailing edge. There are advantages and disadvantages to each.

By purchasing equipment and software the second it hits the store shelves, you are always guaranteed to have the newest possible technologies at your disposal. With the highest sample and bit rates at your command, your music has the potential to be pristine and an example of sonic perfection. And based on your equipment inventory, you are also more likely to be able to handle jobs that utilize these technologies. Since most of us usually wait until a job requires a specific piece of gear before we incur the expense, by already having it and being familiar with it, you may have the advantage. But don't let this belief be the influential force in your business.

There is always something newer and better on the market. By the time you've purchased what you thought was the best piece of equipment, something else is introduced just a little leaner and meaner. You will quickly go broke racking up tremendous debt in a hurry with this mindset.

Another disadvantage that becomes quite frustrating, you may buy this great "gotta have" piece of gear, get it back to the studio, and realize it won't interface with your existing setup. Back to the store you go, only to find no one has developed, or even thought of yet, the cable, box, or driver which you need to make it work. Or maybe you get lucky. But then you get it back, plug it in, and discover some horrendous software bug has stopped you cold. Give the manufacturer a couple months to develop a patch, box it back up, and send it to the factory for them to fix it there. Think I'm being a bit extreme? Not at all. It's happened to me and many others I've met in my travels.

The trailing edge of technology is not a bad place to be with most equipment. The manufacturers have had plenty of time to work the kinks out and receive plenty of input from consumers about which features they feel are useful. By the time the next version does appear, you are working with technology that has been on the market for a time and upgraded with some very convenient features. Not a bad trade-off for some patience and disciplined spending.

What about the constant learning curve involved with the continuous flow of new equipment through your doors? It would be much different if you were running a full-blown recording studio but as the sole composer and business proprietor, no one has that kind of time to spend learning and relearning. As your studio setup becomes second nature, very little effort is needed to record or find the sound you're looking for with familiar parts at your fingertips. Streamlining your composing and recording process will keep you efficient and running smoothly as you work to move your product out the door.

Now, why have I been pushing this line of reasoning? Let me tell you. I want you to keep these points in mind as we go through the list of absolutely essential equipment

you need. I will cover the basics, bare bones setup, the nice-to-have gear and what established game composers are using themselves to do the job. You can get this venture off the ground with very little, but as money starts coming in, it will be very tempting to spend it on toys which will do nothing for your bottom line or your success. My advice: Buy only what will make you competitive and only what will make you money. Trust me on this. It's easy to get carried away.

Assuming most of you own an instrument or two and have some type of medium to capture them onto, believe it or not, you could almost get by with this as is. If you have the ability to get music to a developer in a polished form, you are in the game. But most developers don't have the time or the expertise to convert your audio to their required final format. It's up to you and probably best that way. You are the ears of a development team and most likely have a few more years of experience in the audio arena than they do. You know what the music is supposed to sound like and what noise was designed into it. By delivering material in its final format, you can almost relax—knowing the audio is sounding its best.

Computer

A typical computer audio workstation.

If you don't have a computer, get one. You will need it for many tasks and these days it is an indispensable part of every studio. As the brain of your operation, it not only accomplishes your administrative tasks like word processing, e-mail, Internet access, and accounting but is used extensively in the creative music making and sound design process. MIDI sequencing, sound editing, multi-track recording, mastering, and CD duplication are all vital activities which center around this appliance. You cannot get by without it.

The software you purchase will ultimately drive the minimum requirements of the computer you use. For MIDI sequencing or basic sound editing programs, any computer built within the last five years or so is adequate. If you have one in a closet somewhere, pull it out, dust it off, and put it back to work. But if you want to spare some frustration and a lot of finger tapping while files process, I recommend starting off with the best machine you can initially afford—something with the fastest processor, the most RAM, and the largest

hard drive you can get your hands on. Audio files tend to be large and gobble up storage space and processor speed at an incredible rate. Make sure you have a reliable archive system to save to. A DVD-R or external drive will work well, but since you'll have the tendency to be burning audio discs anyway, a DVD-R will cover both for the time being. Regardless of what you buy to do the work, make sure it is a system that will carry you for at least a couple of years. Upgrading computer systems is a lifetime process, so at some point you need to just stop the cycle and do the job until you absolutely need to make another purchase. Drive that baby 'til it won't go no more.

An extremely fast Internet connection is something else you should consider when piecing together your studio computer. A dial-up modem is nowhere close to being viable anymore, so consider a T1 line, DSL, or cable modem as essential. One of the great things about our jobs is that we don't have to actually be on site at the developer's office. As long as the final audio work is presented in the correct format, that's pretty much all they care about. Delivery is mostly through the Internet and when files sizes are 11 MB per minute of audio it's not uncommon to send off files of 100 MB or more. I still vividly remember the pain of staying up all night to send a measly 10 MB file from a 14.4 k modem several years ago. I went out the next day and bought the fastest connection I could find, never once regretting the decision. I now regularly inquire to my Internet service provider every six months or so about any available speed upgrades. I was surprised to find out I could double my already blazing speed by spending an additional $6 a month. Sign me up!

A Word About Hard Drives

Recording music in real time to a hard drive can tax any system. One way to ensure flawless recording is to have a high-speed drive or one rated for A/V use. Look for rotation speeds of 7,200 rpm or more. I did have some luck with a 5,400-rpm drive but never felt totally comfortable using it for audio data. Stay away from bargain brands, look for reliable product names which have a proven track record. Don't skimp on the quality of this type of storage medium. It will be getting plenty of hard work in its life and a catastrophic failure will shut you down. Seagate, Maxtor, Fujitsu and Western Digital are solid bets. Dedicated hard drive storage systems are also available—such as Glyph Technology's rack-mounted units which are designed specifically for audio use. An even better bet.

Currently, the fastest bus speeds these days are SATA 3 GB/sec and 15,000-rpm spindle speeds. Fiber optic can go even faster, upwards to 4 GB/sec, but expect to pay for the privilege. If you're so inclined, consider the Western Digital VelociRaptor or the Seagate Cheetah for some serious speed.

Interfaces

Having a computer is almost worthless without the appropriate interfaces to connect your gear. You could compose and do sound effects completely on a computer. Using loop, notation, or sequencing programs which play software-based synthesizers, virtual

instruments, and samplers, you could make some great video game audio. There are a few composers who do but many like to have this as just another option. Interfaces with your electronic instruments and recording gear will greatly expand your possibilities.

You will need a good sound card—one which sounds good without adding noise with all of the plugs you need to get audio in and out of your computer easily and cleanly. Nowadays, it is possible to find a decent sound card which not only has analog audio inputs and outputs but digital as well. I recommend having one with the digital input/output (I/O) option, which you can route sound to and from your digital mixing board, digital recorder, or instruments which also comes equipped with the appropriate connections. By keeping sound in the digital domain, you are avoiding any unwanted discoloration from needless conversions back and forth from analog to digital storage—maintaining audio as you originally intended. Higher-end professional cards are common and plentiful, a little research will help you find just the right one for your needs. If you don't have the cash now, start with a good consumer-grade card and then upgrade as you can. This device is one of the most important computer accessories for our business and having a good one is paramount.

Some type of MIDI interface or appropriate USB connection is also required between your computer and external electronic devices. Selected sound cards have MIDI capabilities but only on a limited basis—and usually with only one MIDI input and one MIDI output giving you 16 channels of information. As a basic setup, this is workable but for your eventual growth, a further investment will secure a separate MIDI card with two in and outs, for 32 channels, or consider a high-powered audio interface with this capability included. M-Audio makes some pretty good interfaces for the PC and MAC with 1 x 1, 2 x 2, and 4 x 4 options. RME products are a nice step up and have a rock solid track record that rivals the Digidesign interface lineup. This can seriously increase your MIDI capability and overall system control and performance. There are also multiuse interfaces with included internal sound cards which allow for both full audio and MIDI capabilities.

Software

With a solid computer system ready to go, let's talk about the software which will help us put together our audio product. I don't currently endorse any particular software but am extremely familiar with the programs in use at my facility so I might occasionally lean in that direction. This is *your* bread and butter, so in the end you'll need to decide on the combination which works best for your needs.

Sequencers

Sequencing software is a must when dealing with instruments using the MIDI standard. Every professional keyboard, sampler, sound module, and electronic drum kit utilizes this interface—along with many types of outboard gear, like sound effects, and guitar processors. By having an appropriate MIDI interface between your computer and gear, you will be able to act as the one-man show—having control over your entire setup with the touch of a button.

Several sequencing programs are available, some simple and others incredibly advanced, integrating multi-track audio options and plug-ins. If you aren't familiar, I suggest starting out with simple (and inexpensive) then build up as you become proficient. Cakewalk, Steinberg Cubase, Mark of the Unicorn (MOTU) Digital Performer, and Apple

Logic are mainstream products with good track records and many years of experience behind them. The one you choose depends on you, though. You'll find that over the years you will gravitate toward software you are comfortable with regardless of what other people may say and for me it was, and still is, Cakewalk (now SONAR). As my needs grew, so did the complexity and features of the software—and I've not had a reason to go elsewhere. That ol' comfortable shoe still fits. I'm pretty sure if I'd started out with any other program I'd be saying the same thing about them, too. It's hard to go wrong, as long as it helps you in your creation process.

Multi-track

Music constructed using several instruments and sounds is recorded onto some form of multi-track system, whether it is a tape- or software-based medium. By recording each instrument to its own track, more total control is afforded during mixdown phases. Although it is certainly plausible to record using "virtual" MIDI tracks, there are many occasions when addition of non-MIDI instruments, such as guitar, live drums, and vocals, helps break up the mechanical feel of the music and humanize it. When creating sound effects, though, software-based multi-track systems allow the best all-around options.

Multi-track software is not absolutely essential if you have the capability of a multi-track tape machine, but it still comes in very useful for music and sound design. Pro Tools is a favorite for some, but there is also an equal number who dislike it with equal fervor. Steinberg's Nuendo, Cakewalk's SONAR, and Sony's Vegas Video are other solid programs which fulfill the multi-track mission. Again, it comes down to personal preference and budget. You can get by without it, so don't beat yourself up if the budget doesn't allow for it yet. It is, however, something to keep in the back of your mind.

Steinberg's multi-track audio and MIDI powerhouse, Nuendo.

Nuendo and SONAR are two powerful programs at different ends of the price spectrum. Nuendo is Steinberg's high-priced no-holds-barred software version of the professional Digital Audio Workstation (DAW). Its strengths are with combined multi-track audio and MIDI production, automated and surround mixing, use of internal virtual instruments, and a very neat little feature which lets you undo any edit at any time during the production even if it was 100 edits ago. This is a very professional-looking program, reminiscent of a large studio mixing console with more plug-in processor support than you can shake a stick at—a great program if you want to spend the money.

If you still want the power of combined audio and MIDI production without the large expense, try Cakewalk's SONAR. This incredible program takes its expertise in MIDI production to an entirely new level, adding unlimited audio tracks, internal virtual instruments, and Downloadable Sounds (DLS), advanced loop production tools, real-time effects plug-ins, and tons of extras. This program has quite a bit to offer. Vegas Video is strictly a digital audio production tool, so if you require MIDI support, one of these programs will do you well.

Cakewalk's powerful MIDI and audio production application, SONAR.

Very early in my game career, I had been doing sound design with a no-frills audio editing program. I would layer, cut, paste, and expend much time in trial and error—forging new sounds in the stereo and mono realm. I was quite happy until I met a fellow sound designer who was using Pro Tools. My jaw hit the floor when he showed me the awesome capabilities of creating sound effects in a multi-track atmosphere. Instead of the old hope-and-pray method, this was indeed nirvana.

By having each layer of sound on a different track, you have complete control—and as the layers become thicker, you can still go back and tweak by individually equalizing, panning, fading, and processing them to your heart's content. And the best part is these programs are nondestructive, leaving the original sounds untouched. Only during playback

and final rendering do the plug-in effects assist to produce the end product. Since then, I haven't looked back and do all of my sound effects creation in multi-track. After they are rendered, I polish them up in my audio editing program for their final stop before delivery.

Sound Editors

Sound files cannot be manipulated in the computer domain without a strong audio editing program. If you don't have anything else, make sure you definitely have one of these. In fact, I'd say it is virtually impossible to work in the games industry without one. Once music is created, it has to be translated into an acceptable computer format for playback within a game—and this type of software has that ability. It can also ensure it sounds its best with EQ, volume, compression, effects, and many other features. Also, by supplementing what you hear, this visual method will show any dead space before or after the sound, any peaks which may distort and the overall loudness of the sound. This can come in handy when trying to keep file sizes down. Silence takes up the same amount of space as noise, plus, when you see a sound as a solid square block of color, you may reconsider the mix with more dynamics.

One of the more popular sound editing programs is Sony's Sound Forge. Others you might also consider are Adobe Audition, Steinberg's Wavelab, Goldwave, or Audacity. Having a good main editing program will make life easier for you in the end, so don't scrimp if you can help it. Also consider having several of these programs available, to keep your ideas fresh and to take advantage of each program's better features. I initially didn't consider the shareware version of Goldwave to be worth my time until another sound designer mentioned it had a great Doppler effect. Now I use it exclusively for that one effect. You just never know.

Adobe's capable audio editing software, Audition.

Mastering

Mastering software is mainly designed with CD production in mind and if you plan on releasing any of your game soundtracks, this will come in handy. When producing music for games, though, this type of software, while not used exclusively in the creative process, has a few features which are practical. Before I submit music in its final format, I'll run it all through my mastering software—ensuring consistent volume levels, adding cross-fades to those cues which will run together and add any last compression or final touches.

I'm mainly concerned with the overall picture, making sure the music sounds like it came from the same place, written for the same game, and that they work well together. Video games can jump around from menu screens to action to cinematics to credits fairly rapidly, so the music for each can be heard by the player close together. I want to make sure they are all of equal volume and sound quality, none sticking out and calling attention to itself. The music should be there to enhance the game, not take it over. Programs available include Sony's CD Architect, Wavelab, Steinberg Mastering Edition, and T-Racks 24.

IK Multimedia Production's analog mastering software, T-Racks 24.

Plug-ins

You can never have enough effect processors in your hardware arsenal and you can never have enough effect plug-ins for your software setup. The manipulation of sound is what keeps things interesting to our ears and there are literally hundreds of plug-ins which add their own brand of flavoring to the mix. Many of the previously mentioned programs come with several plug-ins pre-loaded, giving you the option to add reverb, chorus, flange, or other effects to your sounds. The problem with these included effects is that everyone else has them, too. By adding other plug-ins, you guarantee a distinct sound to your mixes that are fresh and stand out from the sonic crowd.

Of course, the manufacturers of these add-ons know this and have priced them accordingly. So, to keep you out of the poor house, only buy what you really need and what will make you competitive. I know, I've said it before. You can find these in any music catalog that sells software, music stores, and at your online retailers.

Loop Software

Other nice-to-have programs which help computer game score writing are those which utilize loop libraries. Originally, I wasn't too keen on them—thinking they could eventually replace composers with programmers and save a buck or two. But then I heard the so-called "music" these non-musicians were coming up with and I relaxed. The musicianship of these prerecorded tracks is usually good, but the arrangements are what gives away the amateurish production. There is much a true musician can do with these tools to make them sound great.

The Sony ACID series, with an abundance of loop libraries in varied styles, can turn some wicked grooves on its own. It can also set your creative wheels in motion, giving you some great ideas to pursue when you may be feeling less than inspired. Steinberg's ReCycle and Cakewalk's SONAR are useful programs as well, establishing grooves and processing loops by matching tempos to keep everything in sync.

Sony's loop-based production tool, ACID Pro.

The only real downfall to composing in this manner is that occasionally you will hear bits and pieces of different games using the exact same loop. To remedy this, try using loop libraries as audio seasoning to add some texture and interest to your tracks or make sure you don't always use the preset key and tempo values of the program. Go out of your way to ensure uniqueness. I'll also use a drum track or prebuilt groove as the basic track, which I add to with my own blend of sound.

Sound Modules, Keyboards, and Virtual Instruments

Computer? Check. MIDI and audio interface? Check. Software? Check. How about instruments? Yeah, that's probably something you'll need. If you had only a single instrument, I suggest a decent keyboard with a good variety of sounds—including percussion and a MIDI port on the backside. That's really all you need. Later, when we get into the actual composing process, it will make more sense but know it is completely possible to do it all from one good keyboard. You only use a few patches per song, maybe 10 or so at the most, and a keyboard with 256 patches will have plenty of sounds at your disposal. As a basic setup, this will work nicely.

Do I recommend having only one keyboard? Most certainly not! Have as many sound modules, samplers, virtual instruments, keyboards, and electronic noise-making devices that you can to keep yourself inspired and to keep your music fresh. By having an infinite amount of sounds at your beck and call, you can be more versatile and have a better chance of finding the perfect sounds for each project. This increases your chances of obtaining a variety of jobs, the limiting factor being only your creativity—not your sounds.

A well-equipped keyboard station is essential when composing for video games.

I once received some very good advice from TV theme great Mike Post. After listening to a demo of mine, I asked him what I could do to make my music better. He said the most immediate, positive effect I could have was to increase the number of sounds available to me. By doing so, I could remain in love with the composing process—always having a new, exciting aural experience awaiting me with a push of a button. He mentioned that feeling you have, when you bring home a new sound module or keyboard, when you first turn it on and that creative rush that lasts until you look at the clock again 10 hours later. You can be proficient at composing but to really stand out, the inspiration and emotion that filters through is the key to it all. I totally agree. By making your new purchases slowly and wisely, this can be a feeling that lasts for years.

I highly recommend a good keyboard which you can use as a master controller for the various sound modules, virtual instruments, and samplers you'll eventually be buying. Try something with a full 88-key compliment so you have plenty of room to split sounds and have the full range available from top to bottom. Once you have a good keyboard, you can save money by acquiring virtual instruments or rack-mountable sound modules—which are usually cheaper versions of an existing keyboard. Make sure these modules are expandable and have plenty of room to grow with additional sounds and memory. The end goal is to buy the most sounds for the least amount of cash outlay—a relatively simple concept in theory, of course.

Other Instruments

Because we are creating for computer games, it isn't necessary to just use computer and electronic devices. In addition to your keyboards, sound modules, and computer, good old-fashioned analog musical instruments, which can be played live with your MIDI-controlled virtual tracks, are a superb supplement. They can add an entirely new dimension to your music and also keep it from sounding mechanical and boring. Guitars, drums, vocals, various percussions, brass, and so on are all perfect to add that extra flare. Even though we are creating music to play behind a game, it doesn't mean it can't be good music. By using all of the tools available to you, the listener will always be surprised by new sounds they hear—enhancing their overall gaming experience.

If you don't play another instrument, take some time to learn the basics or have musicians who do in your talent pool for those projects needing extra zing. By doing so, you will have increased your musical options and kept yourself competitive in the market. Remember earlier I mentioned most game composers are multi-instrumentalists or can fake it really well.

Remote Recording

Other nice-to-have equipment will serve your sound design career and add some extra spice to your musical creations. During various sound design gigs, you may be tasked with either FOLEY work or creating original sound effects. Prerecorded sound effects libraries are easy to reach for, but say you're looking for a fresh sound which hasn't been heard in the last wave of games. You have the alternative of dragging items into your studio to record, but after you've made a mess a few times, you'll think twice. The option is to have a portable flash, DAT (digital audio tape) or MiniDisc recorder, and a good microphone which you can haul out to the field in search of unique sounds. Why be restricted to what you can drag into your studio or by the length of your microphone cable? A decent portable rig will open the world of sound effects and give you a nice competitive edge in the process.

The term "Foley" is named after Jack Foley, one of the earliest and best-known Hollywood practitioners of the art of recording.

M-Audio's MicroTrack, Zoom's H4, Sony's PCM series, Edirol's R09, Fostex's FR-2, and Marantz's PMD660 are examples of solid transportable units with great sound and features. Music stores, music catalogs, and online retailers have great selections available with a variety of feature sets and in a wide price range. If you intend to do any practical field recording, portability and convenience will be important—even beyond that of a laptop's mobile recording capabilities.

Sound Effects Libraries

What good sound designer doesn't have an extensive sound effects library? Practically none. Most game sound designers who have been around for a few years either own or have use of practically every sound effects library ever made. Why? In their quest to maintain freshness and added creativity to their sounds, they have scoured the modern world for these prerecorded easy-to-use time-saving audio wonders. Television and film have used these resources practically since recordings were first made; it's only logical the billion-dollar game industry does the same. Cinema quality and the extra bang for the buck keep the game-buying public happy.

Initially, it is possible to do sound design work without a sound effects library. I got away with it for a few years, creating effects either from scratch or by manipulating sounds collected with my microphone. It was a great learning experience, delving into the sonic world and learning how sounds are perceived by the human ear and how to create sounds from practically nothing. It probably would have been much easier to take classes on the fundamentals of sound and would have taken less time, but by discovering concepts yourself, their lessons tend to remain with you much longer.

Eventually, as you remain in this business, projects will require more than what you can create from scratch. Unless you've got friends in the Marines who let you record streaking low-level fighter jets, firing weapons, and explosions, you need an alternate method. The next step would be to comb the Internet and its offerings. There are many sound hobbyists who post recordings on their web sites for public use. This approach can get you out of a jam but can also get you into one. Unless you know for sure, there is no telling where these sounds originated and possible copyright violations could arise. A developer is usually not too happy being party to a lawsuit for sounds you don't own or have licensed to you. Most contracts, which you sign with them, have a paragraph which clears them of any wrongdoing and puts all of the responsibility on the sound contractor to not violate any such copyright laws. It could end up being very expensive for you. Does it ever happen? Rarely, but I wouldn't want to be the one out of a thousand who ends up in court.

The solution: sound effects libraries. They are abundant and cover sounds from almost everything which makes noise on the globe. By purchasing these libraries, while not actually obtaining "ownership" of the sounds, you are granted a license to use them in your work. It doesn't get much better than that, nice and legal-like.

The two prevalent sound effects library providers are Sound Ideas and The Hollywood Edge. I recommend asking for their demo discs or perusing their online samples to get an idea of the sound quality and types of effects available. Whether you purchase now or not, knowing what sounds are actually available and where to find them when you do need them will save a lot of frustration later.

Sound Ideas (*www.sound-ideas.com*)
105 West Beaver Creek Rd., Suite 4
Richmond Hill, Ontario, Canada L4B 1C6
800-387-3030 USA
800-665-3000 Canada
info@sound-ideas.com

The Hollywood Edge (*www.hollywoodedge.com*)
7080 Hollywood Blvd., Suite 519
Hollywood, CA 90028
800-292-3577
info@hollywoodedge.com

There are also many online retailers who allow direct download and individual licensing for single sounds. This is great when you need just one or two sounds and don't want to buy an entire library series. Search *sound effects* on any search engine and you'll see what I mean. The following are a few of the more popular sources.

- Sound Dogs (*www.sounddogs.com*)
- Shockwave-Sound.com (*www.shockwave-sound.com*)
- Serafine SFX Collection (*www.frankserafine.com*)
- PowerFX (*www.powerfx.com*)
- Sonomic (*www.sonomic.com*)
- Sound-Effects-Library (*www.sound-effects-library.com*)
- Sound America (soundamerica.com)

Development Systems

At the end of our list of tools for the discriminating game composer and sound designer is the game console development system. This is specialized equipment which allows you the ability to test and deliver final work in the proper format when working on Nintendo 64 and GameCube, PlayStation 1 and 2, Sega Dreamcast, and Game Boy projects, as examples. These systems must be licensed to you (at a price, I might add), but it is almost a necessary evil if you intend to work on these particular consoles. It is possible to outsource this conversion work to others who are already licensed and trained or to work out an arrangement with the developer if needed, saving you time having to learn the development system.

Now, at this point in time, you happen to be quite lucky. With the introduction of the next-generation game consoles (Sony PlayStation 3, Nintendo Wii, and Microsoft Xbox 360), the need for a standalone development system is almost a thing of the past. To create audio content these days, you almost don't even need anything beyond what you may already have in your arsenal. There are platform-specific tools you can use, mainly software programs, which will increase your options, such as XACT for the Xbox and SCREAM for the PlayStation. These are available though the respective manufacturers and are recommended if you become involved with a project on any of these platforms.

Chapter 11 discusses many specifics about each type of game console and their respective audio production and implementation needs. It is another personal choice whether

to add these tools to your lineup. They will require extra time to understand, but on the other hand, you can still work and do well without them. In the end, though, it is not an absolute necessity to have a development system to be able to do work on a project but there are distinct advantages to having one to implement and test your own sounds before delivering them to the developer.

Tools of the Trade

Mark Scholl—composer and sound designer for International Game Technology (IGT) and owner of Screaming Tigers Music

The equipment is, of course, extremely important at this stage in composition. We now have the ability to create just about any style of music on our own with a fair degree of realism within our studios. It is amazing what is available to us today compared to even just ten years ago. I am having a great time with the realism I can now get with these sample libraries. There are definitely some very forward-thinking problem-solving companies out there, for example, the Vienna Symphony legato feature is tremendous!

Now, as incredible as all of this modern gear is that pretty much anyone can buy these days, it ultimately comes down to the reality that a composer still needs to have the natural creative artistic ability and a practical real-world knowledge about music to really stand out. And, of course, you still have to be personable and be able to interact well with all types of people; your gear won't do that for you. I have found that ninety-nine percent of the people you will work with who are not musicians or composers won't ever say something like, "Gee, is that the East West Gold XP or the Vienna Special Edition contrabassoon sample playing unison with the arco bass section? The sample is really nice, but wouldn't he have needed to have taken a breath about two bars earlier?"

(Continued)

Computer: Mac G5 Quad Core 2.5 GHz.

Software: Digital Performer 5.1.

Monitor system: Event 20/20 bi-amp plus subwoofer.

Mixdown: Within Digital Performer.

Sound modules/VST instruments: Native Instruments Komplete, East West Orchestral Gold XP, VSL Vienna Symphony Special Edition, Atmosphere, Trilogy, Stylus RMX 1.5, Chris Hein Horns, Chris Hein Guitars, Garritan Jazz, MOTU Ethno, Quantum Leap RA, Stormdrum, Symphonic Choirs, Synthogy Ivory.

Outboard gear/plug-in effects: Avalon 737 Tube Pre-amp, Yamaha OV1 mixer, MOTU 828 MKII.

Keyboards: Fatar Studio Logic 88 note-weighted controller.

Other instruments: 5 acoustic drum kits for various styles and 13 different sizes of snare drums for a total of 35 acoustic drums, 32 Sabian cymbals (Sabian endorser), tons of hand percussion and hand drums, several Dejembe's/congas, and so on.

Microphones: AKG C4000 B Condenser, Sennheiser 421 Dynamic, AKG D112 Kick mic, (2) AKG 535 condenser mics, Shure SM57, Cad Pac drum mics.

Remote recording gear: Mac G4 1-GHz powerbook.

Sound libraries: Distorted Reality, Han Zimmer Guitars, Symphony of Voices, Quantum Leap Brass.

Preparing Your Studio for Surround Sound

As I alluded to earlier, 3D audio is a powerful and popular feature of video games. With DVD players and home theaters in many households, surround sound is the new audio standard and everyone expects to hear it. Whether you do surround for games, your own music projects or for other media, you will eventually need to have the setup to make it happen. This section will explain what you need and provides the basics to set it up for a variety of studio configurations.

Equipment and Placement

Obviously, the first thing you will require is the proper tools for this grand application. Software-based studio setups can make use of internal surround encoding and decoding script, most of the time as a plug-in to whatever multi-track program you are using. For those who don't have the ability to do it in software or have a tape and mixing console based system, separate devices are necessary.

Dolby Labs, which has a strong relationship with game creators, manufactures specific equipment for just this purpose, the Model SEU4 Surround Encoding Unit and the Model SDU4 Surround Decoding Unit. While it isn't entirely necessary to have the decoding unit, Dolby recommends that playback is heard through it while mixing in order to hear any subtle changes the surround matrix may create. The SEU4 Encoder receives four input signals (left, right, center, and surround) from the audio console and matrix encodes them into two output signals—the Left Total (Lt) and Right Total (Rt) signals. These signals are treated as any stereo signal would be for transmission and recording. The SDU4 Decoder then decodes this two-channel signal into four output signals using Dolby Surround Pro Logic II decoding technology. The unit also provides switchable stereo and monophonic monitoring modes for evaluating mix compatibility. A ganged master fader allows all four monitor output channels to be varied together, allowing variations in listening level while maintaining playback balance and calibration.

Consumer Dolby Surround Pro Logic II decoders, as found in various stereo and home theater receivers, operate identically to the SDU4 and could be used in a pinch or temporarily instead of purchasing the professional unit. However, these consumer decks include circuitry to auto balance and correct left and right channel errors and may pose a problem when mixing because this feature hides the very problem you would be checking for.

Dolby Digital 5.1 is also another option which runs congruent to the Pro Logic II surround arrangement. This technology uses five discrete channels of audio and a Low-Frequency Enhancement (LFE) channel (the .1) for greater separation. The encoding and decoding process requires different hardware, two-channel rear surround playback, an LFE device, and a bass management system. The Dolby DP569 Encoding and DP564 Decoding units are appropriate hardware for this application; bass management systems are manufactured by various other companies and are available separately. Bass management redirects bass frequencies intended for the five main speakers and routes it to the subwoofer, recommended since most speakers do not extend to extremely low frequencies. All consumer Dolby Digital receivers have bass management, which is highly recommended for studios as well.

A speaker system that includes a left, right, center, two surrounds, and subwoofer, is necessary for proper playback in a studio environment. Most everyone already has a left and right pair of speakers, so an addition of only four would be required.

A center speaker can be added to your existing pair, but be sure the addition matches either the acoustic characteristics of the other two for consistency or you could install three identical near-field monitors designed just for this purpose. It isn't necessary all speakers be the same size. Large left and right speakers and a smaller center speaker from the same line are acceptable. If possible, the center speaker should have the same high- and mid-frequency drivers as the left and right speakers. When placing the front line of speakers, all of them should be equidistant from the mixing position—and the left and right speakers should be as far apart as the engineer's head is from the center speaker. This will provide optimum coverage and keep the listener in the sweet spot.

The two surround speakers can be smaller bookshelf-type speakers. The actual frequency response of the surround channel is 100 Hz to 7 kHz, so larger speakers for bass reproduction and extended range tweeters for ultra-high frequencies are not necessary. It is important to choose surround speakers that sound similar to the front

speakers throughout this range, a smaller speaker from the same product line usually works best. The surround speakers should be placed on the side walls approximately 2 feet behind and at least 2 feet above the engineer's seating position. They should point to a spot 2 feet above the engineer's head for maximum effect. It is not recommended that surround speakers be pointed directly at or below the listener's seating position. For a Dolby Digital setup, the rear speakers should be placed 110 degrees from center.

If all three speakers in the front are identical, the power amps for each should be rated equally. If the center speaker is smaller and center channel bass is being redirected to the left and right channels, the power rating of the center amp should be at least 75% of the left and right amps. The total power provided for the surround channel should not be less than that of either the left or right channels. The preferred method is for each surround speaker to have a separate amp at least 50% of the power of the left and right amps. If one amp is used for the surrounds, it should be rated the same as the left and right. There are also many active monitor systems available which have amplifiers built into the speaker cabinet which would serve this purpose well.

Your audio console's flexibility will greatly affect surround mixing capability. While it is possible to create a surround mix on a console with as little as a stereo bus and one auxiliary send, the ability to do complex mix moves will be nonexistent. A console, or software, with film-style panning allows the greatest flexibility for desired sound placement. The exact need for a particular application will depend on the complexity of the mix. Be sure, when deciding to purchase new equipment, to think about future needs and not just what's in store for a current project.

Studio Setup

We all know there are as many methods of audio creation as there are creators, which supports the idea that the studio setups of each of these will be different. Budgets, locations, and accessibility of equipment dictates that no two setups will be alike and integrating surround equipment into them can sometimes prove to be a challenge. New mixing consoles provide the luxury of discrete surround channels, designed for this new day and age. Older model consoles can still perform the task but require a little finesse to make this addition.

On all consoles, left and right outputs are standard—and these will connect to the surround encoder's left and right channels exclusively. Older consoles can utilize either the auxiliary send busses or another left and right channel output in order to connect the center and surround channels to the mix. Using the aux bus will be most limiting when panning a signal but it will work fine for simple music mixes. Using another left and right output source would be the better option if available, although still not quite as flexible as a film-style setup with individual outputs dedicated specifically to the four channels.

Once the issue of console channel outputs has been resolved, these discrete signals will be routed to the encoding unit. From there, the encoders Lt and Rt outputs can be recorded as a two-channel encoded mix. Playback and monitoring is accomplished when the two encoded channels are returned to the decoding units Lt and Rt inputs and further routed to the surround speaker system as four separate signals.

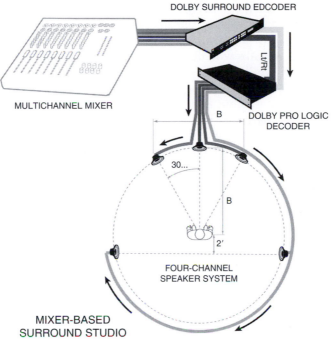

DOLBY SURROUND EDCODER

MULTICHANNEL MIXER

Lt/Rt

**DOLBY PRO LOGIC
DECODER**

B

30...

B

2'

**FOUR-CHANNEL
SPEAKER SYSTEM**

**MIXER-BASED
SURROUND STUDIO**

A mixer-based Dolby Pro Logic Surround studio setup.

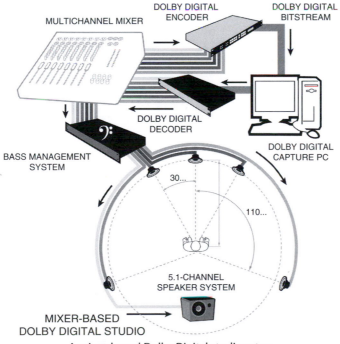

**DOLBY DIGITAL
ENCODER**

**DOLBY DIGITAL
BITSTREAM**

MULTICHANNEL MIXER

**DOLBY DIGITAL
DECODER**

**DOLBY DIGITAL
CAPTURE PC**

**BASS MANAGEMENT
SYSTEM**

30...

110...

**5.1-CHANNEL
SPEAKER SYSTEM**

**MIXER-BASED
DOLBY DIGITAL STUDIO**

A mixer-based Dolby Digital studio setup.

Computer-based multi-track recording systems can also produce and record surround material with minimal requirements, the latest crop of applications having surround encoding capability actually built in. Starting with digital audio software with multi-channel capability, the signals will flow to a multi-channel output soundcard. From there, the four channels would move to the encoding unit, to the decoding unit, and out to the amplifier/speakers. For programs which utilize software surround encoding and decoding, the output from the multi-channel soundcard can go directly to the speaker system or will bypass the decoding circuitry of the consumer amplifier which may be connected. Computer-based recording using Dolby Digital technology would also require a bass management system to be connected between the sound card and speaker setup.

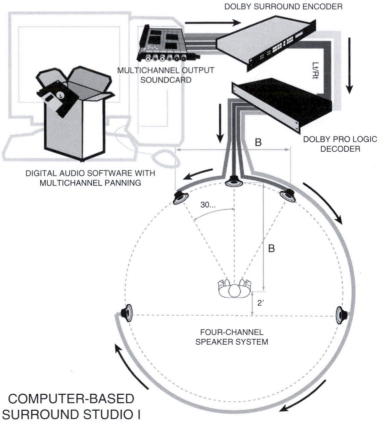

COMPUTER-BASED SURROUND STUDIO I

A computer-based Dolby Pro Logic surround studio setup utilizing outboard encoding and decoding units.

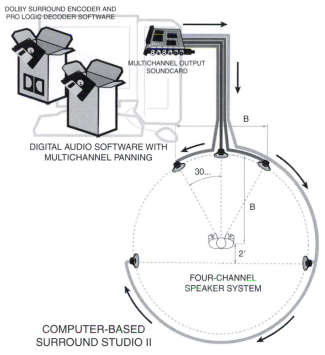

A computer-based Dolby Pro Logic surround studio setup utilizing internal encoding and decoding software.

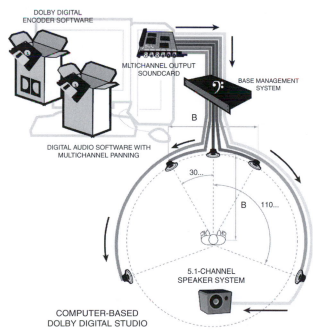

A computer-based Dolby Digital studio setup utilizing internal encoding and decoding software and an external bass management unit.

Surround Tips

Dolby Pro Logic II decoding relies on amplitude and phase differences between the two channels of an Lt/Rt signal to extract the four channels. As a result, there are certain things to keep in mind when mixing in Dolby Surround.

- Only one signal can be steered at a time by a Pro Logic decoder and this must be the dominant signal. The rest of the mix is distributed equally among the remaining speakers.
- The surround channel rolls off at frequencies above 7 kHz, so you may notice this limited high-end frequency response of the surround channel in certain situations.

When mixing with four channels, the following are some general guidelines recommended for obtaining good results.

- If you want to hear exactly what your audience will hear, it is best to monitor and play back through a decoder.
- Track and pan the sound of all important objects continually as they move.
- Although the dominant signal is the only sound being steered by the decoder at any one time, it is still okay to pan multiple signals in different directions. When a signal is no longer dominant, the decoder finds the next dominant one to steer. Therefore, it's important that all signals are positioned properly even when they are not dominant.
- Unless there is a specific reason not to do so, include the center channel when panning from left to right.
- There should be no essential information in the LFE channel. This should only be used for bass enhancement.
- The best way to understand how Dolby Surround works is to use it. Practice creating different types of mixes. Listen to games and movies in Dolby Surround to gain a greater sense of the possibilities of the medium; you can learn many tricks from careful listening.

Dolby Support

Dolby Laboratories has been very active in gaming in recent years, so much in fact they established a game development relations branch to support game developers and audio content providers. They have extended their hand to the community and are available for questions and advice at *games@dolby.com*. Just be sure to let them know I sent you.

Other Composer Setups

We've spent some time discussing recommended equipment needed to work in the game industry as an audio content provider. You're probably thinking it's all well and good, but what do the other guys who are doing this every day really use? Be sure to keep an eye open throughout the book for various composer setups and gear lists that answer this very question. Examine their audio tools, find the trends, and discover what everyone else is using to do today's great game audio.

Sound Designer at Work

Christos Panayides

Christos Panayides is a sound recordist, sound designer, voice-over artist, and president of CP Audio Services.

Describe your thought process for creating sound effects.

Every sound is special, so I don't need to put that much effort when creating it. The idea is to translate the picture into sound. I record sound effects every day and every time I listen to something, various pictures come to my mind. But when I have to create something very specific, I try to give the audience the sensation of where they are even with having their eyes shut. When creating customized sound effects, I always think what I would like to listen to when seeing a specific picture, the direction, the duration, and the time.

Are there any particular secrets to your creativity?

There is one secret, feeling and sensation—from where, how long, and when. After many years producing sound effects, I have learned to trust what I hear even if it seems really bad or odd to be recorded and played because there is always an empty place waiting for its sound effect.

When do you find you are most creative?

I can be creative all day long because thousands of pictures pass through my mind when I am in studio or in my car driving to my recording session. I always keep in mind what I am going to record; for example, if I am going to record waves, splashes, water seaside view, et cetera. I create a list in my mind with different shots that could include the sounds I am recording; that is, a very close splash, a splash from distance, et cetera.

(Continued)

Of course, we are not always in the mood of creating something, but even in my bad moments there is always an idea for creating something—either melancholic or happy—to lift me up. Because for every moment there is the suitable sound.

Any specific "lessons learned" on a project that could be shared?

Yes, a few years ago when I went to record wind sound effects for the very first time, I had taken all the necessary equipment for the recording with me—but I hadn't thought that the microphone would be that sensitive to the wind. As a result, I had traveled three hundred kilometers for these sounds and they all had serious problems. A few months later, when I had finally studied more carefully how to record "wind," I went back to record equipped with a windscreen and windshield and I made one of my best recordings containing ninety-nine "wind" tracks.

I would also like to share my techniques when recording sound effects. When you record in a studio, remember that all sounds need to sound natural! When you record outdoors, the first thing you need to do is to walk around the area and check for challenges which will interfere with your recording so you can bring the right equipment to eliminate them. Also keep in mind that every day is unique and that when you return to a location for recording the weather, conditions might have changed and you might need something you originally had not planned on. So, always think ahead and you will never miss something when recording outdoors.

Here are my equipment suggestions for outdoor recordings.

- Recording machine, two channels L/R
- Two microphones with their necessary accessories like a foam windscreen, windshield, and suspension
- A boom
- Cables in various lengths, but always of the same material and of the same resistance
- Lots of batteries, if your recording machine operates with batteries
- A notebook for writing down your thoughts and any other particulars of the recording session

Do you have any interesting sound design creation stories?

During an in-house session one summer, we were getting ready to record some artificial rain sound effects using rice, metallic plates for creating thunder, et cetera, and after three hours of preparations, it suddenly started to rain! So, we went outside and recorded the real thing instead!

How did you find your way into the games industry?

In my career in television and films here in Cyprus, I had the chance to do a small part of a game—which actually was the reason that made me want to get involved even deeper in the games industry. Aaron Marks was the person who really inspired and motivated me to get involved in this industry and now, I really want to make my mark on the world of games! Thank you, Aaron Marks.

CHAPTER THREE

Getting Organized and Ready for Business

Understanding the Business of Game Composing

It's getting close to decision time. You have the music and sound design aptitude, a great attitude, and the total willingness to make this a successful venture. But, do you really want to? Is the games industry the right place to sell your music? Do you even want to work that hard?

Truthfully, not everyone can do the job. You might be able to compose some fantastic music, but your business ability or lack thereof will stand in the way. Historically, musicians are not well respected by the establishment as business minded. Management types do not fully understand "creative" people and tend to stereotype them into neat categories which suit their purposes. We, on the other hand, know better. Just because we may come across sometimes as "free-spirited," it doesn't mean we don't have our act together and aren't capable of comprehending the complexities of the business world. Regardless of the trade you are in, your "product" is almost worthless unless you can sell it. Keep that in the back of your mind.

To do this type of work, you must be creative and be able to craft an original "mood" to enhance the game you are writing for. You must remain detached and objective when asked to rewrite passages or redo any work. You must have a great attitude and always come across in a positive and professional manner despite any instinctive urges to thin the obnoxious producer gene pool. And to be successful, you must have it in your mind you are in this for the long haul. By dedicating your efforts and focusing on your personal and professional goals, you will outlast anyone who thought they could get their music on a major game title within a month of opening their doors for business. It can be frustrating at first, but rewards come to those whose calculated patience remains intact.

Expectations

A lot is expected from a game composer. Because the audio provider is often an aloof character seldom understood by a producer, they usually end up working alone—providing a third of the game experience literally by themselves. Because we can work off-site and at odd hours, the mystery of our creations are nervously awaited for examination—usually in their entirety near the deadline with little chance for reworks. No pressure there.

I spent about five days working tediously on a piece of music for a medieval-themed game project. The artwork presented was dark and ominous, with evil dripping from every scene. The producer let me take it all in. I mentioned the previous adjectives, heads nodded, and it felt like we were all on the same page. Five days later, I submitted completed music—excited by what I felt was a direct hit. Later in the day, I got a call. "Hey, we got your music. Great stuff. But, ah, we all talked about it and decided it was too dark and too ominous for our purposes. We decided we want to try something more whimsical and cartoonish instead." Aaaggghh!! So, with two days until the deadline, it was back to the drawing board and music for a whimsical medieval cartoon emerged instead.

Crazy? Yes, but you occasionally have to change gears and run off in an entirely new direction. As a game's personality slowly matures and the producer's vision takes shape, original ideas for music may not fit when played within the context of the game. If your first submission doesn't fit, carefully crafted after digestion of all the right adjectives describing the game, the content provider is still expected to magically throw another masterpiece together to match the new ideas. That's what we do. We pull sound from thin air and make glorious music out of it. It's a puzzle to most people how we do it. Producers tend to forget that each one of these little tunes we just "threw together" is actually a child we gave birth to, nurtured, watched grow, and then sent on its way out into the cold world. But for those children who do come back, we can put them on our demo reel or save them for the next dark, ominous, and evil game.

Composer at Work

Tom Salta—composer

Describe your thought process for scoring.

Music's role in a game is to support the gameplay and the producer's vision. The first thing I do when working on a game project is get as much info as I can about the game and try to understand the team's inspirations for the project.

In the case of *Red Steel*, which was very unique and based in Japan, I did a lot of research into Japanese music—both traditional and modern. I contacted the Japanese Embassy in New York and got in touch with several musicians, who proved invaluable for the project in teaching me what Japanese music and culture is all about.

Are there any particular secrets to your creativity?

Yes, but it's a secret.

When do you find you are most creative?

It gets different when you have a family and kids. Normally, late evening and night is a typical time for creativity for many musicians. In my case, I've been able to adapt and be creative any time I need to. But I find that routines are particularly helpful. I try to get much of the "heavy lifting" done in the earlier part of the day and leave the routine stuff for the evenings.

Any specific "lessons learned" on a project that you could share?

I think I've learned that pushing too hard and stressing out slows me down. Even in the craziest schedules, when I'm juggling several projects, I find I'm much more efficient and productive when I remove the stress and go with the flow.

Do you have any negotiation techniques others could learn from?

My technique for negotiations is fairness and honesty. It's important to respect the value of your time and work, but you're never going to get top dollar on every project. It's very helpful, however, to have a good agent who knows the business when it comes to negotiations.

Any interesting audio creation techniques which resulted in something memorable to you?

Even when you're composing music, don't be scared to break out the microphone and record your own sound effects. To accomplish the Indoor Amusement Park level in *Red Steel*, where you are being hunted down by gunmen in pink tutus and Godzilla costumes, we wanted to create the mood of a very eerie and disturbing amusement park that was falling apart. In addition to the warped carousel theme, I recorded various metallic and rusty items from my garage—including my son's dirty training wheels.

(Continued)

How did you happen to find your way into the games industry?

After a fifteen-year career in the music industry, working on some pretty notable projects, I fully anticipated just how hard it would be to reestablish myself in a new part of the industry. I did a lot of research, found out who represented the best composers in the game industry, and started sending my reel around. I also attended as many industry events as I could.

At the same time, I recorded my first solo album under the artist name Atlas Plug. I felt licensing this kind of high-octane electronica would be a great way to introduce one side of my musical personality to the game industry, as well as for TV and films. This was very helpful for projects like *Need for Speed Underground 2*, for example, but it was an expected uphill battle to prove myself in the orchestral world. It took several years, but I think I've proven I'm just as comfortable with the orchestral genre and especially blending the two together.

Reasonable Costs

Something else to chew on before diving head first into this venture is the costs involved and the return on your investment. Professional music equipment and software is expensive. It is built to be rugged and hold up under constant use—more so than occasional use of consumer gear. Manufacturers know you are willing to pay a bit more for pro equipment and increase profit margins accordingly. Because this gear costs a little bit more, your income will need to be able to meet the demand.

Initially, you probably won't be making fistfuls of dollars and you will have to weigh the expenses of doing business with the potential of income to be generated—and then decide what works best for you. I'm guessing if you bought this book, you have already made a sizeable initial investment in your equipment and are looking to capitalize on it now, so you probably aren't planning on acquiring much more expensive gear in the near future. If you are making payments or are using this as a sole source of income, it might add some extra impact to my next statement:

Never give away any of your music or sound effects for free.

In the beginning, it is very tempting to do just that, in order to add a project to your resume. But what it does instead, is let a game developer take advantage of you and cheapen our profession. At the very least, make sure your expenses are covered. While the rush of creating music for your first game can invigorate your soul, it will be short-lived when you have to sell some of your equipment to pay the rent. It's just not worth doing it for free. Your talent adds value to a product they will sell and make a lot of money from. Make sure to receive your fair share as an integral part of the team who put it together.

We'll cover how to determine your pricing structure to be in line with the game industry later in the chapter. Right now, you should be formulating your considerations: how to make a reasonable profit against the cost of doing business within your plans and if

the income you make will be enough to reach these goals. By analyzing beforehand, you can see the numbers in black and white and decide whether it is even worth going into business prior to wasting a lot of time, money, and effort. I'm not trying to talk you out of pursuing this type of career, don't get me wrong; I'm giving you a cold dose of reality to make sure this is a balanced presentation. The reality of business is that sometimes it makes better financial sense to not go into business. Perhaps composing and sound designing as a part-time gig to supplement other income makes better sense.

Whatever you do at this point, though, be sure to read the rest of the book for the full story before coming to any conclusions. This would just be one of the many factors in any final decision. While it did cost money in the beginning, my passion for music and many other enticements the gaming industry has to offer was enough to see me through.

Flavor of the Month

While we are on the subject of reality, let's get another dose. Your music will not be perfect for every job. Even if you are well versed in various techniques and can compose jazz, acid rock, and classical expertly, your music will not be perfect for every job. *Even* if a game cries out for your strongest style and there is no doubt that you could nail it, your music will not be perfect for every job. Instead of getting into a one-sided philosophical discussion about this phenomenon, let's just agree on this, OK?

We call it "flavor of the month." Even after you've composed for 100 games, your "flavor" may not be what they are looking for and you won't get the job because they like someone else's "flavor" better that month. It's sort of like a "fad," the unexplainable force which shifts the focus onto someone else for awhile. Your "flavor" is made up of your personal composing and recording style, like recording artists who maintain their "sound" from album to album. They have their own sound regardless of what they do because of who they are. Not much you can do about that.

The rest of the "flavor" comes from your instruments, your mixing board and recording equipment, your sample and loop libraries, your software, and from the room you record in. They all contribute to the particular sound which people will associate with you. You can change that, though. Keep your sounds fresh, trade in your old gear regularly, and try different recording techniques—anything to be different than before. Then again, maybe it's your "sound" which makes you money. A paradox only you can solve.

Composing versus Sound Design

As you prepare for business, you want to set yourself up to be successful. In our case, we sell our "sounds"—whether it's music or sound effects. About now, you should be deciding on what you have to offer the gaming world—what "products" you have to sell, and whether you can sustain your enterprise with what you have. If you've decided to deal strictly with music, then so be it. Get your music together and get out there and sell it. Make your success. If you've decided sound design is more your bag, then get your sounds together and go for it. Take your product and hit the market running.

The main question you should be asking yourself is, "Can I make the kind of money I need *and* stay busy in the games industry with the product I am offering?" If you are

only selling one product, chances are you are not going to stay as busy as you'd probably like. Well, not at first anyway. With that in mind, you can initially plan to supplement another source of income with this venture until business picks up and you've reached a livable income level.

I mentioned in Chapter 2 that using your audio talents and recording equipment in another form of audio work will increase your income and chances of success. There is plenty of work for composers who go out and search in other arenas, but for those of you who like what you see in the games industry, you should keep within the perimeter and reach into every facet of it. Like I've said, the advantages of making your audio house the only source for a game developer are endless. And as your reputation grows within this tight-knit group, more work will follow naturally so you can spend more time creating and less time pounding the pavement. This means being composer, musician, sound designer, voice talent, engineer, producer, and all-around audio pro.

It can be done selling a single product. You can be successful and meet your personal and professional goals. There are many who have, and more who will. But you need to sit down, take a hard look at what you want to accomplish, and then make the decision.

Composer at Work

Watson Wu

Watson Wu is a composer, sound designer, and president of WooTones LLC.

Describe your thought process for creating music and sound effects for games.

My thought process always starts with questions like "Who are the gamers?" "How loud can I go with this?" "Is the audio for the background, foreground, or a mix of both?" "How many different people would I have to please in order to complete the milestones?"

To not waste time and effort along with the reminder to improve the audio quality, I have to often question myself and my team. Am I really creating the effective elements?

Are there any particular secrets to your creativity?

The first part of my creativity is from learning disciplined scoring as well as improvisation. I have always liked how Beethoven can go on forever improvising variations from a single theme. Humming melodies and harmonies is part of my secret. Once I like what I hummed, I search and play with particular sound banks until I am satisfied with the music. For part two, I do loads of listening through gameplay, movies, and mini-series, like the hit TV show *24*, for example. With mini-series shows, over time you can hear variations of the same theme that may sound better and better. I often compare video games with mini-series TV shows.

For sound design, I record my own sources as well as create sounds from scratch using synthesis-based programs. Professional systems, software, and loads of plug-ins are extremely helpful and make great secret weapons.

When do you find you are most creative?

The motivation, or the fear of a fast-approaching deadline, sometimes sparks my creativity. During my early years, some of my best sounds were created late at night. Recently, it has been both late evenings as well as early mornings. Learning to improvise has been very helpful with my music.

For sound design I always have a Microtrack charged and ready in my car. I just love to collect my own recordings. Over time, and many professionals can agree to this, the creativity process can be turned on and off like a switch—especially during crunch modes.

Any great lessons you've learned over the years working on game sound?

Having good-sounding and reliable equipment has been a lesson well learned. Sometimes you do have to sacrifice money in order to make more money. Recording with cheap microphones, mixers, recorders, and software does not pay. Your audience will hear it and sooner or later, you will be labeled as an amateur. This, however, does not mean you have to buy the most expensive gear.

Do you have any advice to help with the negotiation process?

Listen to good negotiation audio books from Roger Dawson and others like him. Practice the lessons out in the public so you can be comfortable when dealing with developers and top publishers. Get to the point where negotiations become fun!

(Continued)

What advice can you give when working with a developer to ensure you are able to make great sounds?

There are many companies who are reasonable, as well as unreasonable, to work for. Read daily game industry news and converse with friends so you know which companies to avoid. Sometimes the high-paying jobs are too difficult for anyone to take. When a developer/publisher provides me with an asset list of music and/or sound design, I usually will have to speak to them to clear up what exactly is involved. I have worked on many projects where both parties were on separate pages. From these experiences, I always push for the companies to provide me with real examples. "How many variations of foot steps can the many kinds of giants make?" "Does it need to sound like a T-Rex from *Jurassic Park* or the walking trees from *The Lord of the Rings?*" Some of the replies I have received sound like this: "It's too harsh." "Now it's too soft." "Can you make it sound bigger?" "Now it sounds too light." "Can you make it sound happy?" This list will go on and on, so we all need precise examples.

For music, as well, always ask for real examples. Hopefully, the contact person you deal with has a music background. When someone complains about a particular percussion sound during the drum breakdown section, which sound is it? Is it the tom or the snare? To be specific, be prepared to send in multi-tracks for them to click through.

Do you have any music creation techniques that resulted in something interesting?

Instead of relying on library sounds, I have often sampled my own instruments. There are many times I created great-sounding percussions as well as sound effects through layering, pitching, doubling, as well as applying loads of plug-ins. An electronica piece of music I wrote contained massive amounts of bouncing basketballs, smacking trash cans, and various wood and metal objects. Experimenting is gold!

Any surprising endings to a project that you weren't expecting?

Awhile ago, I acquired a project to create strange as well as dramatic original music. It was Hasbro's *Trivial Pursuit* DVD edition, which ended up winning the International Toy Show Innovation Award in the Trend Category held in Nurnberg, Germany. Sometimes you go with your gut feeling and take on odd jobs.

How did you find your way into the games industry?

I have always loved video games. When I was young, my father owned an arcade and for many hours I would play Pac-man and pinball machines. After college, I read in a music technology magazine of how a small group of composers were making a career in video games. This of course sparked an interest to further study this industry. I also accidentally saw the first edition of Aaron Marks' book. After the enjoyable reading, I attended both E3 as well as the Game Developers Conference. It was at these events where I acquired various contacts, by meeting and networking with the many professionals there.

In-house Audio versus Independent Contractor

You've decided to compose music, create sound effects, or both for video games. Your next choice is to determine the method you will use to accomplish the task, either as an in-house sound person, working directly for a game developer as an employee on their premises, or as an independent contractor. Both have distinct advantages and also carry their own baggage. There are no particular rules governing the decision. You can bounce around and do it whatever way suits you, gaining experience and exposure from various projects and the many ways of doing business.

Initially, you may face a roadblock or two chasing either avenue. A game developer may not even consider you for an in-house position unless you have certain experience in the industry and perhaps a game or two under your belt. In a case like this, maybe you can get your foot in the door by applying for another position—say, game tester or as an assistant to the audio department. Do a good job and keep your eyes open for composing and sound design opportunities. Once the company knows you, trusts you, and sees how valuable you can be as an audio resource, you may naturally migrate into the job you were eyeing.

Tommy Tallarico started out as a play tester at Virgin Interactive and ended up as their audio director until branching out on his own. Joey Kuras started play testing, then designing game levels and some composing—and is now a sound designer at Tommy Tallarico Studios. Brian Tuey, having done music for a couple of games as an independent, was hired on at Gigawatt as a game tester to learn more about the inner workings of video games. As expected, they started to ask for his assistance in a few audio matters and he quickly moved into their audio department—then became audio director at Luxoflux and is now enjoying his position at Treyarch. Rodney Gates, of HighMoon Studios, set his sights on game audio, put together a killer demo, and mailed it to practically everyone. His talent and passion won him a job, which he feels lucky to have and is enjoying to this day.

In-house Composing

Working in-house as a composer or sound designer is not a bad way to make a living. Jamey Scott enjoyed his time at Presto Studios. Tim Larkin at Cyan enjoys the innovative environment working with the company's other creative minds—constantly energized by the surrounding forces. Alex Brandon has been working in-house for eight years, and while the industry can be volatile, he says nothing beats working face to face with developers.

Working directly for a game developer gives you more time to concentrate on the job at hand, enabling you to give it your best on a daily basis. You receive a steady paycheck, always confident of how much and when it will arrive. This security goes a long way in keeping the support of your family—relieving the pressure they may have put on you for previously "wasting your time." Additional benefits, such as health coverage and paid vacations, can be other carrots dangling in front of you.

Relentlessly looking for work can drain the heartiest of souls. By working in-house, all of your creative efforts can be focused on your music and sound creations. Often, while working as an independent in the middle of one project, you will be spending your prime

time looking for the next. Your mind can be more relaxed and focused on music writing without the added headache of searching for more work. As the in-house employee, the company will take care of it for you. Many in-house composers can attest to the positive effects this has had on their music. This is especially true for artists who don't care too much for the business side of the industry.

If you enjoy working in an extremely creative and nurturing atmosphere as an essential member of a team, then an in-house position is definitely for you. There is just something about being among other imaginative types, living within the game you are creating, watching it grow and receiving instant feedback on your role. Communication between other project members is critical and physically being there keeps the lines open—whether you overhear someone talking in the hall or if they come to you directly. There always seems to be a bit of a barrier between a game developer and an independent contractor—even a slight level of mistrust. You feel immersed in the process instead of feeling like an outsider.

Working around other artists, craftsmen, and tunesmiths helps create a mysterious aura—an unexplainable atmosphere which primes the juices and keeps you at your best. If you find you are not capable of self-motivation or sometimes need that an extra kick in the pants, an in-house gig will give you the charge to produce some truly inspired music which might have been difficult when working in isolation. My best work always comes from being around and working with other creative forces directly. There's just something about keeping trusted associates nearby to keep your audio mission on track.

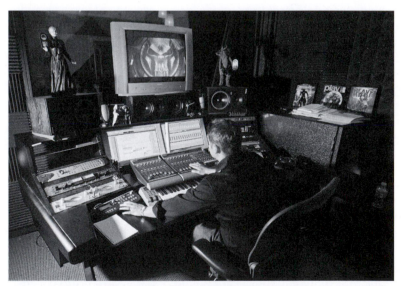

HighMoon Studios in Carlsbad, California, has a well-equipped audio department. Former audio director Gene Semel is seen here mixing audio for their hit project *Darkwatch*.

In-house Equipment

Game companies have various policies regarding equipment purchases. Knowing your previous experience with audio has more than likely brought with it a gear list to

match, some leave it up to the composer to equip their studios with their own funds. The company's advantage: they don't have the expense of endless equipment purchases. Your advantage: you can take it all with you if you leave and you have complete control over what is bought. They know music and recording gear is expensive—far more so than, say, a computer and a graphics card they'd need to buy for an artist or programmer. Most of the time they will supply a computer without hesitation. The rest is up to you.

Large game companies may have another view. If the number of games in production warrants it, they'd rather equip their own studio to match their quality and compatibility requirements. Electronic Arts is a prime example. They have a large state-of-the-art studio complex in-house to use exclusively for their myriad of game projects. By equipping their studios with high-end gear, their sound is completely under their control. The company's advantage: they own all the equipment, which stays as people move on. Your advantage: you get to play with top-notch gear you didn't pay for and gain some valuable experience you normally couldn't have afforded.

There are also game companies which fall in the middle of the previous extremes. Occasionally, developers may require their audio department to have specialized equipment for which they foot the bill. In other instances, they may have specific sound libraries in mind for a project, either sound effects or samples, and unless you want to buy them for your own collection, they will pay. Generosity is dependent on budgets, but an occasional bonus in the form of an extra piece of gear is not entirely unheard of. Your relationship with the developer will determine the amount of money thrown your way for purchases in this environment.

Expect the unexpected when working in-house. If it makes noise in a game, you will do it. The purpose of having an audio department is to keep the company from outsourcing any of its work. The last thing they want to do is pay a contractor to do voice-overs or sound effects when they are already paying you to occupy space. Larger game companies may have several working in audio, all with particular specialties. It may not be as critical for a composer to also do sound design. But for other game companies—where the audio department is made up of a single entity—they will more than likely have to be a jack of all trades. For those of you who are self-sufficient, or like to work alone, this is a job where you can thrive. Others, with expertise in one area, may find getting an in-house audio job difficult.

You may also be expected to know or learn how to implement sound in a game as well as writing actual programming code to make your sounds work. You may have to port to other game platforms and be familiar and licensed with any proprietary development systems. A lot of technical work may await you, so it's important to know what you might be getting into when shopping for a company. If you have this kind of wisdom, you will be extremely marketable. If you learn, it can contribute to your job security.

One serious disadvantage to working in-house is that your position and/or the company could disappear at any moment. This is not to say every game company is inherently unstable, but there are many who struggle to make monthly payroll. Instead of paying an in-house composer $60,000 a year to work on scattered projects, it might be beneficial for them to hire contractors at a lower rate as each project warrants.

In this volatile industry of takeovers and buyouts, your game team runs the chance of being disbanded by new owners—especially if they already have duplicate positions

staffed elsewhere. Most of the time, company acquisitions are a chance to buy the rights to intellectual property, game engines, licenses, AI (artificial intelligence), game titles, development tools, and so on and to make the previous owners some money. Their concern is not really the employees. Every so often, a successful team may survive intact, but it is indeed a rarity.

Independent Contractors

For those of you who enjoy the open road, life as an independent contractor is for you. There is so much more to this business than just composing music or designing sound effects. Little triumphs and exciting moments along the way make you feel like the king of the world—winning that first big contract, negotiating a sweet deal, having developers call you on a project instead of you calling them, or having your peers accept you and invite you in on a project—all contribute to the personal triumph you'll feel. It's not always about the music you create. There is that little something extra which motivates us as well.

The advantages are many for those who opt to give up the security of an in-house job. The freedom of running your own business your way and calling all the shots is a serious enticement. How about picking and choosing which projects you work on? Or unlimited income potential? Hey, hey! Now we are talking!

Working in-house is strictly a work-for-hire arrangement. The game developer pays you a salary and in turn, everything you produce as partial or finished work belongs to them. They own all the rights and are free to do whatever they want with your creations. It's painful sometimes watching your work used in a movie or commercial, knowing you'll never see another dime from it. As an independent, you are free to negotiate whatever kind of deal makes you happy. You can license the music to them to use for their project, but save the rights to everything else. Music soundtrack releases, use in movies, licenses for other game platforms—they all add up to some substantial income for you. Consider having several projects with the same type of deal simultaneously. Your income becomes almost boundless. There are also game royalty deals or bonuses you can negotiate. If a game becomes a hit, you are also rewarded for your hard work and vital contributions to the project with regular payment. Not such a bad arrangement.

Independents have the freedom to work if and when the mood strikes. But if you do not have self-discipline, you'll end up taking a long self-inflicted vacation instead. And it is certainly much easier to schedule in time with the family or other obligations. It's nice to have that sort of independence.

It's also sweet to have the liberty to pick and choose which contracts to pursue. In-house composers work on whatever is thrown their way. Occasionally, there may be a project presented to you beyond your abilities or you may not feel comfortable with the company—sensing you'll end up working hard for a game which will never be released. Companies that don't quite have their act together will end up driving you crazy, asking for the impossible, and cost you time and money. Initially, you'll want to take every job that comes your way, but sooner or later your guts will tell you when it's time to pass this headache off on someone else and let your competitor pull their hair out over it instead. You can also consider exposure, money, or the good old "fun factor" when choosing games to work on.

Jon Holland often uses his location for inspiration when creating epic scores. His long-awaited solo album is nearing completion and he hopes to place some of the tracks in future games.

In-house composers, as the name implies, work on the game developer's premises. They get up in the morning and fight traffic to get to their windowless studio, which was formerly a broom closet. If they are lucky enough to have a window, it usually overlooks a parking lot full of cars or the nearby freeway. So, another big plus for the independent is working wherever you want—letting issues such a convenience and the view guide your productivity and inspiration. Chance Thomas has a stunning location near Yosemite National Forest which has served him quite well. His studio has two large glass walls: one overlooking a two-story glass atrium and the other opening to the surrounding forested acreage and five huge windows offering inspiring views of nearby Thornberry Ridge and Deadwood Mountain. There is a handcrafted spiral oak staircase leading up to the studio entrance and a walk-out redwood deck just outside the control room. The studio is decorated with Haitian art, pictures of St. John and St. Bart, photos of his family and a handful of awards, plaques, and little golden statuettes. Jon Holland enjoyed his personal Yosemite view overlooking forests of 100-year-old pines during his time there as well. These guys have made great use of what inspires them.

Most composers tend to work at home in their project studios—foregoing regular office hours and the commute, preferring to work where they are comfortable and close to the other important things in life. Some have nearby studios and composing space, which allow them to get away from any distractions, close the doors, and come out when they are through. An office building isn't always the best place for your finest work.

"All work and no play makes Jack a dull boy." If Jack played music constantly and never took a break from it, Jack would become boring and his music lifeless. As an independent contractor, this can never happen to you. Your business forces you to do other

things that help keep your musical perspective fresh. I usually find that after a week or two of working the phones, negotiating deals, and being caught up in the administrative chores that when it's time to do music, I'm chomping at the bit, ready to roll. I'm excited about the music and go into it with a better attitude than say, walking into the studio for the fifth straight week to rework the same "piece from hell" that I can't seem to get right. In a case like that, I end up walking away from it for a week anyway and nailing it by the second day back. The change of pace running your own business is a healthy side effect. The time away from the music will only make it better.

The only serious disadvantage to being out on your own is the eternal question: Where will my next project come from? There is uncertainty in this business. A lot, as a matter of fact, for the independent contractor. One day you'll have several contracts lined up, your production schedule overflowing for the next couple of months, then suddenly, you'll be scratching your head wondering where the next check is going to come from. Everyone has experienced it at some point in their career, it's an inevitability. Make sure you plan accordingly and budget your income for any dry spells.

There are other ways around the empty bank account syndrome. Look for on-going contracts, i.e., open-ended agreements that carry with them several yearly projects. Always consider negotiating royalty agreements where payments are made on a quarterly basis, spreading out your receivables to compensate during downtime. At first, consider composing as a side job and relying on a full-time job for living expenses. The extra income can be put in the bank to support yourself when you make the big break. Stay one step ahead and you'll be fine.

Tools of the Trade

Tim Rideout—recording artist and music producer

I'm actually a wannabe—a frustrated game composer. I've worked on the sidelines and pitched for many a project, but still haven't landed the big fish yet. But that's fine. It's about the people and the network. It will come eventually, and in the meantime I'm extremely happy composing for multiple media and "researching" gaming platforms.

Computer: A beige one.

Monitor system: Old set of Rogers speakers from the BBC.

Outboard gear/plug-in effects: A cool little KORG Kaossilator.

Keyboards: Steinway "Ebonite" circa 1897.

Other instruments: Drums, Flying Disco Wok (a Swiss-made "häng"), insecticide drum, darbuka, wooden frogs, Korg KP3 Kaoss Pad, more cowbell.

Microphones: Beat-up SM-58, APEX somethin-somethin.

Additional relevant hardware/software: Fridge to keep Canadian beer extra cold.

Audio Demo Reel

Unless you are an established game music composer or sound designer in the industry, chances are, you will need a professional representation of your audio skills to get your name out there and to win the job. Your previous work or current audio samples can be neatly packaged into a *demo reel* and sent directly to the powers that be—giving them a chance to listen to your breathtaking work.

Demos come in all shapes and sizes and everyone seems to have their own philosophy as to what makes them effective. However, in all of those varied opinions, no one will argue the need for one. They are truly valuable tools in the quest for the perfect audio for a project. After talking with several game and multimedia producers, developers, and other sound artists, many points seemed to continually stand out. Consider the mystery revealed.

Putting Your Demo Together: The First Step

The highest priority when considering your demo is quality. Without a doubt, the first thing a producer will notice is how it *sounds*. Cut corners where you have to. Trim out the fancy labeling, stationary, packaging, and the full-color brochures, but never, ever skimp when it comes to the caliber of your sound. Use high-grade instrumentation, studio equipment, and recording medium. Think quality all the way down the line. Do what you have to; just make your audio sound great. Remember, if it doesn't sound "professional" in a demo that you've had months to work on, how will they believe that you'll sound good when dealing with a rushed two-week project deadline?

Your mix should contain that pro quality on a variety of playback systems. There is no way of telling what system your demo will be listened to on. If you are extremely lucky, their audio department will play it on studio equipment similar to yours—but the majority of the time, it will be listened to either in the car or on a PC. If you have ensured, through a careful mixdown process, that your music sounds equally good on your studio monitors as it does on your iPod, then you've covered all of the bases. Before I am completely satisfied with a final mix, I will critically listen in my car, on my home stereo, on my MP3 player, and on my daughter's boom box. It passes the test only then.

Demo Content

There are very few unbreakable rules, but this is one.

Put your absolute best work in the first two minutes of your demo. Always.

Media buyers are busy people and usually wade through stacks and stacks of demo reels. Chances are they won't have the time to listen past the first couple of tracks. Always lead with your strongest piece and style. A great song that takes too long to get to the point has no place here. Feature your personal flavor. Show your originality, versatility, and compositional and sound design skills.

Ensure each track has impact and gives a continued strong impression. If you lead with shorter pieces, be sure to include longer tracks to show consistency and to let them know you can hold a listener's attention throughout. If one style is your specialty, that is certainly okay—but keep in mind that it may also limit your clients. Show plenty of versatility on your reel. Here is some advice gleaned through "pet peeves" producers have eagerly shared.

- Do not repeat works to make your reel longer.
- Do not place work in chronological order from the beginning of your efforts. They urge you to get right to the point and show what you can do in the present with little wasted time.

How Long Is Yours?

Did you know that 40% of media buyers only spend between two and five minutes listening to a demo? Another 40% only spend six to 10 minutes. The average preferred length of a reel is only seven minutes. That is not much time to present all the work you've done over the years, but it is more than enough to interest a producer. By leaving them wanting more, it builds interest and gives you another chance to present more music and have your name in front of a prospective client one more time.

Keep the length of your demo in check. An hour of music is probably a bit much. It's completely understandable to be proud of your work, but unless you're showcasing all of the mega hits you've worked on throughout your career on purpose, it's doubtful a busy producer will ever hear it. Conversely, it could also give them a chance to discover your flaws—which is something you definitely don't want.

Demo Chic: Types of Demos

There are as many ways to present your work as there are composers and sound design-ers. Your creativity can be let loose to make your creations stand out. There are no hard and fast rules; again, just make it sound great.

I've heard demos which use music, sound effects, and narration like a radio commercial to present an audio product. Most producers I spoke with, however, agreed that it distracted them from getting to hear the music or effects and the quality of the tracks. They prefer to hear music either presented as a montage or as numerous short (1:00 to 1:30) selections in rapid succession. Five full-length pieces of various styles are also acceptable.

The demo montage makes the strongest impact. Five to seven minutes worth of music, fading from one selection to the next, blended together to almost sound like one song of different styles will definitely keep them listening. Include only the best sections of your work, taking them on a musical expedition full of surprising twists and turns. It's unbeatable. I normally include two montages: one with a harder edge, full of intensity, and a softer, more emotional montage. Because the montage does not show your musical thought process or prove you can hold a listener's attention with a single song idea, I also include a few longer tracks, i.e., songs done in their entirety, just in case they are curious and wish to put me to that test.

Minute to minute-and-a-half selections are another surefire way of presenting your pieces. With only seven minutes on stage, you have to make it fast—and this is a great way to show off your musical dexterity. The one thing I've noticed when listening to these types of demos is my urge to hear more! And because I can't immediately hear more of a track, I end up playing the entire tape/CD over again! It's a trick that has been used in pop music for many years. By keeping a song short, it is requested again and again in order to satisfy the hungry radio listener—invariably making it the number one requested song of the week. Chart-toppers are usually just good songs marketed wisely. If your demo is of this style, be sure to include a few longer pieces, too. A demo with five complete selections of music also works well. Pick the current popular game music styles, such as:

- Orchestral
- Alternative/rock
- Ambient
- Sports
- Playful/quirky

A spread like this will cover the bases nicely. Make sure each selection is 100% perfect—something you would be proud to put your name on. This is no place for half-finished pieces or excuses. They should all be polished and ready.

A sound effects demo can equally stand out. I don't recommend just playing a sound effect, then playing another. It's boring and shows a lack of imagination. Remember, you want to impress the producer and make it impossible for them to look anywhere else.

If you choose to put sound effects tracks on your web site or CD, may I suggest creat-ing a "scene." Forge an action-packed audio journey using your original effects and Foley sounds to create the excitement. It doesn't have to be long or totally outrageous; it only

needs to favorably show your sound design and production skills. Producers are most concerned that you have the knowledge and ability to do good sound effects before they hire you. Check out the companion DVD for a wide range of audio examples and demos from myself and others in the biz. You'll see what I mean.

Another way to present your sound design achievements could be on DVD or as a computer movie file (*.avi*, *.mpg*, *.mov*, and so on). If you've done audio for any multimedia presentations or game intro sequences, for example, these would be a great stage to show your efforts. Nothing quite has the force as project-specific sounds created for moving picture.

Narrations are another breed. If you want to advertise your ability to record superb voice-overs, consider adding a track of narration—on its own or between audio tracks. I don't recommend sticking a microphone in front of your face and talking about whatever comes to mind. Experienced vocal talent, and perhaps even yourself, should perform from a well-crafted script. You can talk about the music and sound effects included on your demo, either adding an intimate touch or raising the excitement level. Or, you can include examples of a previous narrative project. Make sure you've added some subtle sound effects or musical bed behind the speaker to give it continuity and keep it interesting.

The Presentation

Demo reels are very personal things—a part of ourselves and a part of our professional image. We want to look qualified but stand out at the same time and draw attention. From the look of the packaging to the impact of the tracks, it all fuses together to convince our prospects we are the best person for the job. First impressions can go a long way.

Think ahead of time about the impression you are trying to make and then make it a good one. Because this is not retail sales, graphics and expensive packaging are not mandatory. Make the demo sound fantastic and look pro. From the moment the package arrives on a producer's desk, you are making an impression. Bright packaging will certainly get you noticed, but then again it may backfire. While musicians are expected to be a little outlandish, a company seeking outside media will more than likely be playing conservatively.

Decide what market you are trying to make it in and customize the tracks on your demo reel appropriately. I try to decipher what sort of music or sound effects a client may be looking for, then I search my existing material for something similar. A producer looking for music to a game marketed to the eight- to twelve-year-old girl is probably not interested in hearing heavy metal, and I don't send it. A custom demo reel for each prospect can help you zero in on their target.

Include your contact information on everything—from the demo to all of the other envelope stuffers. Materials get separated and you'd hate for someone to discover the perfect piece of music for their project without any idea who sent it. Affix your copyright information to the CD or embedded with an MP3 as well. Other items to consider including in a demo package:

- A cue sheet. Name each track and explain what they are listening to as well as whether the piece has appeared in a previous body of work, what it was used for, and any production notes used to explain your motivation for composing the piece.

- A resume of any past work.

- Promotional materials, brochures, and press clippings.
- Business card.

What Format Is Best?

CDs are definitely at the top of the demo reel heap. Whether you burn them individually on your CD writer or have your demo professionally duplicated, they are an effective way to present your musical mastery. They have the best sound quality plus allow a listener to quickly scan through material, saving them valuable time. The disadvantage to you, of course, is they might use that feature and miss the best parts of your music.

Another potential problem, you can't control what kind of CD player they use and where they use it. They could listen through their PC, boom box, home stereo, or car with a variety of sound quality differences— another reason to mix for any possibility. My preference is to have them listen in their car so I have a captive audience with nothing to really distract them, and I often encourage that. Besides, music just sounds better when the scenery is moving. For the do-it-yourselfers, there are several CD labeler kits out there which are better looking than a smeared Sharpie pen any day—so be sure to use a good one.

If a developer is auditioning several potential composers or sound designers, they will typically listen to them at the same time—often with several other team members in attendance. Because they don't want to have to switch back and forth between different formats and players, and like to use the same one to get a standardized comparison, I make it a point to ask what type of demo the media buyer prefers. While CDs are the most requested, they can ask for anything from downloadable MP3 files to DVDs.

MP3 files, and other compressed formats like *.ogg* or *.wma*, are a popular demo format as well. Obviously, their unique advantage is immediate delivery and easy posting to your web site. Their file size and good sound quality are an excellent way to strike as the prospective client is giving your talents consideration. They must be interested or they wouldn't be there, right? This could provide immediate feedback and possibly close the sale for you. This format would also work well if a client asks you to send a demo as an e-mail attachment. You are already making points by giving them what they want.

The smaller file size of compressed audio comes at a price, though. While compression schemes are getting better with each new generation, they still can't beat the sound quality of a comparable uncompressed audio file like you would find on a CD. And, because the purpose of a demo is to not only show your skills as a composer or sound designer but to showcase your production values as well, pristine audio is incredibly important. Sending an MP3 demo is good, but be sure to follow up with a CD version as soon as possible to ensure an accurate first impression. Higher bit rates, above 128 kb/sec, sound best—especially when showcasing your work to a potential client.

DVD demos are gaining in popularity and are almost a guarantee the media buyer will listen or view it on a good display and playback system—which is *exactly* what you want! In the mind of a potential client, a DVD in their hand means they are in for an experience. Having watched hundreds of blockbuster movies in the past, this reinforcement gives the DVD demo a psychological advantage right from the start—which you can really take advantage of. If you have past work to showcase, such as cinematics or in-game footage, film, television, video, or theater work, this is an excellent format to really grab their attention. Hearing music and sound effects is one thing, but hearing it within the context of the project it was created for is priceless.

While DVDs can give your work another possibility to really shine and be unique, it can also backfire if your menu and visuals don't look professional. If you have the resources and the ability to create a good-looking interactive DVD, it can really pay off—but will have the complete opposite effect if it's not. The idea is to showcase your music and sound design favorably, and if your talents in the visual arena don't quite cut it, consider hiring a professional to help out or keep to the tried and true compact disc. Finally, be sure to check with a potential client's ability to play DVD-Rs or have them professionally duplicated on a yearly basis to avoid this potential deal breaker. If they can't play it or have to waste time looking for something to play it on, you might as well have not sent it at all.

Once in a blue moon, a developer will ask for a cassette demo. Yeah, I know, it seems out of place in this day and age—but keeping with the "full service" mindset, I maintain a working cassette recorder just in case. Some developers have older classic cars with a cassette deck in the dash and love driving them. Why not provide the soundtrack to the times when they are most content? Cassettes are still a convenient option and because they are not as easy to skip tracks on, they tend to make people listen longer. This is a great argument for putting your best work up front. Always use quality tape and be sure to label it appropriately with your contact information. When I send a tape, it is normally a 15-minute cassette—which allows me to put a 7-minute montage on side A and two complete tracks on side B. As part of the image thing, I use labels I can run through my printer instead of anything handwritten.

Delivery

So, now you've created a demo reel to be proud of. Staring adoringly at it on your desk, though, won't get you very far. You have to get it to your prospect and in one piece. The best way is to hand deliver it and perhaps introduce yourself to some key players at the same time. Sadly, most of us can't afford a road trip every time a request comes in so we have to rely on someone else to make the delivery for us. A couple of tips to consider:

- Always ship your CD or DVD in a protective case and use padded envelopes or specialty shipping boxes. Too many demos have arrived smashed and unplayable. The media buyer probably won't have the time to call you to request another and instead will listen to the ones they've received from other potential composers.

- Don't waste your money sending your demo UPS, FedEx, certified, or anything more expensive than first-class mail unless specifically asked to do so. While you may feel the urgency to send out your reel, believe me, there is none on the receiving end. Save yourself the money.

Follow-ups

You've sent out your demo reel, now what? You start pestering the producer, right? Wrong. The last thing a busy producer wants to do is be hounded. If they got in contact with you for your reel, they know it is coming and they probably already have time set aside time in their schedules to review all submissions. And until that time, you probably won't hear a peep. It's taken months before I've gotten any word back sometimes. Just be patient.

It is okay for you to check in with them after a couple weeks to ensure they received the package in one piece. This shows your professionalism and concern for delivering the product to them. But, do not badger them as to whether or not they have listened to it yet. Believe me, if they are interested, they will call. Occasionally, some will send a "no thank you" letter and even return your material. Don't be offended if your hard work comes back. They know sending demos can be costly and they are giving you the chance to reuse it again. I think it's a fine gesture.

I have developed a simple tracking method I use religiously. I log the date and the company I sent the demo to. After 10 days, I proceed with my follow-up—either a phone call or e-mail. I now know they received my package and I relax. If they call me, I check another box. If they hire me, I check another box. But I never, ever ask them if they've listened to it. I've only done it once and now it seems to be the running joke. Every time I call, he takes mine from the bottom of the pile and puts it right on the top. (I've even been there once to see him do this.) It is soon buried under other arriving packages and sits there until I call a month later and we repeat the process. One of these days he'll actually have the time to listen to it and I know I'll get the gig.

Some Final Demo Reel Thoughts

Never make apologies for your demo. If you feel the need to apologize for the lack of quality or the lack of substance, you are not ready to send it out. No one wants to hire someone who appears insecure. Insecurity means inexperienced, which in turn tells the producer he will be spending a lot of time holding your hand throughout the project. Be confident about what you can accomplish. They are more willing to educate you in the ways of the gaming industry if your self-assuredness shines through and they know you can indeed create fantastic sound. And if you need some unbiased ears to give your demo listen beforehand, company's such as DemoNinja (*www.demoninja.com*) offer expert reviews to ensure you're sending out demos that shine. You can learn more about these folks under the *audio_demos* folder on the companion DVD.

Keep your demo reel up to date. As you add clients, you will have new music to add. If you don't like the customizing idea, be sure to at least produce a new demo every year. Keep it fresh and exciting. Send it to all of your previous clients and prospects.

Sending unsolicited demos has got to be one of the hotter topics in the industry and there still is no definitive answer. If you have the money and the time, you can beat the odds by shot-gunning demos to every game company and multimedia house on the planet. You are bound to pick up a job or two that way. But what good is it to send it to someone who didn't want it, didn't ask you for it, and lets it sit unopened in a box with hundreds of other packages? I would much rather have the extra momentum of having it requested from someone who is sincerely interested. In my opinion, your time and money are better spent being selective rather than chasing probability.

Like everything else in business and the game industry, timing is everything and sometimes it's *who* you know not *what* you know. But by having a professional-looking and professional-sounding demo reel in your possession, you are equipping yourself for success and ready to beat the odds. Someday, who knows, with many successful titles under your belt and a name recognized by millions, you won't even need to look for work. It will find you. Imagine that!

Sound Designer at Work

Brian Tuey—sound designer and audio programmer for Treyarch

Describe your thought process for creating sound effects.

As a sound designer in games, I have to work on an enormous variety of things, each of which may require completely different thought processes—incidentally, one of my favorite things about game audio. If I'm working on the ambient sound for a level, I like to play through it several times without any game scripting going on. What does this place sound like when there is no one here? How can I implement audio that is sufficiently organic for a specific location? How do I want the player to feel here?

If I'm working on creating a new weapon sound, I first take some time to do some research on it, provided I can't fire one myself. How fast does this thing shoot? What did/do people who fired this weapon in the past think about it? Was its quality poor? Are there any definitive characteristics that should be represented in the game, like the "shing!" you hear when an M1 Garand is completely out of bullets or the rattles you may hear in a Thompson?

The main differences between the two examples are that environmental audio is completely subjective, while making weapons is all about the mechanics of the weapon itself. Organic versus mechanical. The relevant questions you ask change depending on what you are working on.

Are there any particular secrets to your creativity?

I like to keep game assets really organized, for one. Knowing exactly where everything is and what is using it is something that keeps stress levels down and productivity up. When you are dealing with games that have enormous amounts of sound assets, you better keep everything straight. The more variations and work folders you have in your asset directory the less time you'll end up having for being creative because you'll be wasting time trying to remember which version you are using.

In fact, time management may be the most crucial aspect of creativity for me. You have more free time to experiment, think, and design; that is, if you don't spend much time trying to find things or trying to figure out why some old sound asset is playing.

When do you find you are most creative?

When the deadline is at its closest! Honestly, I usually find myself getting most of my work done late at night. I'm not sure why, but something about the late-night hours and audio just really go well together for me. Maybe it has something to do with writing so much music after school and work over the years.

Any specific "lessons learned" on a project that could be shared?

Plan, plan, plan—even if things change. You can't produce great audio in a game by yourself. You have to have buy-in from everyone on the team. If you don't have a

plan of your own, you'll never know what you need to ask from designers, artists, or programmers.

Early in my career I tried working only from producer/designer-made asset lists. This will ultimately get audio in your game, but not great audio because games that sound great, sound that way because everyone that plays is working together. Game audio is often thought of as a bunch of individual assets. That's not anymore true than an orchestra is all about one instrument. It's about everything coming together in the end and producing an experience that's sonically pleasing.

Do you have any development stories that serve as good lessons learned or something which can be avoidable in future projects?

I wish I could be more specific on this one, but, you know….Watch out for your celebrity stars when getting voice-overs recorded. I was involved with one celebrity actor that was very difficult (read: impossible) to work with. They wouldn't listen to the VO director, complained about the food, and generally acted like they didn't want to be there. In fact, they angered the engineer so much that he left the room. All I ended up with from this person was badly acted dialog that was so clipped it was pretty much unusable. But because of the money we spent, it *had* to go in the game. Try and find out if your A-list stars are going to be easy enough to work with, and if they have a bad reputation, try and get someone else!

Do you have any good advice for working on game sound?

I've learned throughout my career that the equipment you have in the studio really is second fiddle to your determination, and more importantly, the game technology itself. So often people write off the game engine and try to focus only on sound assets. This is a huge mistake. I'd rather have average sound assets with a great implementation scheme than have pristine assets and have them be difficult to put in the game properly.

When looking at expanding your game technology, keep it simple. Several simple subsystems working together is always better than a complicated "uber" system. Simple systems are easier to work with, easier to debug, and because of those two things, always sound better. Much like a game design proposal: if you can't explain what your system does in 10 words or less, it's too complex.

How did you find your way into the games industry?

By lucky, lucky happenstance, and getting connected with the right people. I was actually in the trucking business a lifetime ago. I hated it. I would come home at night and work on lots of side projects, mainly creating games on the Internet with various people that I met online. And when I wasn't designing games, I was producing music of my own or running the boards at a friend's studio—working with local rock and punk bands.

One day I had a realization: Why am I making games all night and loving it and being so miserable during the day? So, I got online, used the games that I had made

(Continued)

(badly, by the way), and got a job as a junior game designer at a long-forgotten company in Hollywood.

I worked as a designer there for four years, learning as much as I could about how everything in game development was done—from designing games, to programming, to modeling and animation, even some of the business side of things. This experience gave me a great foundation to develop my game and audio skills, and allowed me to speak professionally with people from all departments.

Once I left that company I came to Activision (at Luxoflux) and got hired as a game designer for a couple more years. They didn't have a sound department there, so I started working both audio and design pretty much as soon as I started—using my previous audio experience as a stepping-stone into the game audio world.

After putting out a few games there with both game and sound designer credits, I was approached by the studio director—who asked me if I wanted to focus solely on audio and get serious about it. It was a tough decision at the time, having to leave my game design roots behind to focus on sound, but it was the right decision for me. I have since left Luxoflux to go to Treyarch, where I'm able to work on a lot of great projects at a bone fide triple-A quality studio.

Because of my odd background, I have a very good understanding of both the technical and creative aspects of making games. I feel very lucky and blessed to be in this industry!

Determining Your Costs

The final stop before we fling open our doors is to work out our fees for services rendered. However, we can't do that until we've determined what it costs for us to operate. It's an on-going process once you're working, but starting out you need a point of reference. Unfortunately, it's not as simple as finding out what everyone else is charging and doing the same. Until you've been around long enough to demand the higher fees, consider determining what you need to live on and what your business operating costs will be and go from there. Pad in a decent profit and you are in business.

How does the musician/sound designer compute his operating costs to make a competitive bid? It is not as simple as saying, "Hey, I want to make five hundred an hour!" Initially, decide on your needs for the project—whether it is purely for recognition sake, a resume project, or just to cover the cost of overhead. We then calculate in many different factors to cover the expense of creation and consider each of them accordingly. For the final numbers, the fees will generally be lumped together. Separate fees are developed for cases when this is not feasible.

Types of Fees

First off, we need to determine what our cost is to do business. In our line of work, several different billable talents are present—which all have value. Until you resolve what the actual costs are, you may be losing money without ever knowing it. This is an important step.

Creative Fees

Creative fees are for the actual creation, composing, recording and arranging of the music, and sound effects. It is based on the time it takes to create a minute of music or a single sound effect and whether or not the work will be licensed for single use or will be bought out. For most games, the buy-out option is standard—but sounds or music used on web sites or in Java applications may be licensed for exclusive use for a period of time. The licensing option is often cheaper, the creator retains the ownership rights, and the sound can be used again after the contract period has expired.

This fee is the most difficult to uncover and is generally based on what the market will bear. It can be added to your total fee structure or can be substituted with your hourly wage. As your name grows, you will be able to charge more—your creative fee increasing exponentially. If you are John Williams, your creative fees might start at $250,000 and move up from there. Johnny Game Composer might be able to command $10,000. The value of your stock is entirely dependent on how valuable or in demand you are for a game project. If they just "gotta have" you, they are willing to pay more for the privilege.

Chance Thomas, seen here in his element, can command a higher price than most for an original game score.

The best part about this fee is that there are no costs involved—nothing to buy and no expenses to cover! Consider it everything you've done in the past—the culmination of your hard work, studying and music lessons all rolled up into one. It's the investment you've already made that determines your talent's worth. All of this will factor in the negotiations and how much you can make. Think about how it will impact your price and whether or not the product will be sold outright or only licensed for use within one particular application.

If all the rights to your music are sold, the price should be at least four times more than licensed work.

Studio Fees

Renting an outside studio can be expensive, especially when a full orchestra or live band is involved. Studio fees cover that. It is also intended for the composer/sound designer to be able to cover the actual costs, maintenance, and general operation of their personal studio. Equipment payments, insurance, utilities, and general maintenance requirements are factored together to arrive at an hourly rate. Most sound creators, however, work out of their homes and are able to keep the cost down.

This fee is the actual cost to use an outside studio or what you would charge someone to use your project studio if you were to rent it out. It's easy to determine when dealing with another studio, but how would you figure out the value of your facility?

- Are you making payments on any equipment?
- Does your electricity bill go up noticeably whenever you power up?
- How much do you spend to have equipment serviced or repaired?
- Are you paying extra for another phone line, insurance, or Internet access?

Add that up and divide by the number of hours in a standard work month (160) and you'll have a rough estimate of what you need to cover your costs. Figure in an appropriate profit margin of 25% to 30% and there you go. Check prices at other local studios for their hourly rates to see how you compare. The advantage you have is that your overhead is far lower than a professional recording studio and that savings can be passed on to your client.

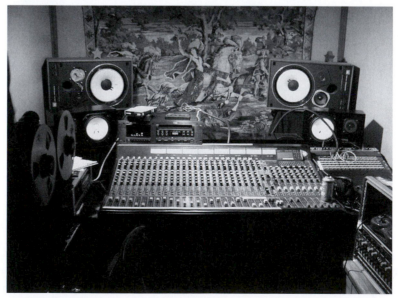

This studio, owned by the San Diego–based musician and studio designer Steve Tanner, is occasionally rented for live sessions to game composers. Because I can't do live drums at my home-based studio, this fee is written into the studio fee to cover the expense.

Here's an example of a typical cost analysis for a basic project studio setup.

Monthly equipment payments:	$1,000
Electricity:	$50
Maintenance:	$50
Phone:	$45
Internet:	$60
Insurance:	$30
Total:	$1,235 per month

Divide this total by the number of billable hours per month. This is based on a standard 40-hour workweek, although you can work 16 hours a day very easily.

$1,235 divided by 160 hours = $7.71 an hour
Or another way to think about it: $61.68 per day

If you were working 40 hours a week, five days a week, making money on billable contracts, this would be what you need to charge just to cover your studio costs. Not everyone works that many hours on projects—so it will vary, obviously, for less studio time. I just want you to start thinking along those lines.

As you determine the fees to charge for your studio usage, be aware of this. By working out of your house, using your own project studio, you can substantially affect the costs of studio time by keeping it lower than any professional studio. Because your overhead is lower, you can price your services competitively and pass along the savings to your clients. As you start out, an enticement to the smaller game developers will be your lower costs—their hope to get some pretty decent music for much lower than the big boys, which is a perfect place to start as you build your resume.

Consider a price range between $15 and $30 an hour for studio time—our example working both one week and two weeks out of the month. We want to play conservatively and make sure we recoup our costs. If you work one week out of the month on an audio contract starting out, you are doing pretty good. Add 30% as your profit margin and the figures change to $20 to $40 an hour.

Talent Fees

The actual performances by musicians and voice talent are included in talent fees. Some music composers may charge to play instruments on the tracks, others will include their part in the creative fee. Figures will vary based on the caliber of talent requested and outside talent; therefore, virtuosos or famous players will increase this price accordingly.

As you build your local talent pool, establish what their per-hour or per-session fees are and do the appropriate math. It will vary by area, as major cities and music hubs demand higher rates than those in out-of-the-way places. A reasonable per-session

rate would be between $250 and $500 for mid-level performers in major cities where talent is in demand. Less prevalent talent can charge between $50 and $200 per session.

If you choose to charge for your own musicianship or voice talents, select an appropriate figure which will keep you competitive. Again, because you are the creative entity and a one-man show, you can get away with smaller fees to get the business. Many times, I've been told I was hired because the big guys were just too expensive. Find your niche and price accordingly.

Media and Material Costs

Recordable CDs and DVDs, digital or analog recording tape, shipping, and any other costs incurred while recording and delivering the final product are covered in this fee. Any material you use in the creation process needs to be discovered to figure your out-of-pocket expenses—everything from your recording medium to the stamps you put on the envelope. If you had to buy it for use on the project, you need to know the cost and ensure it is covered in the fees. Leaving this out will chip away at your profit margin. A 100% markup is not uncommon for CDs and DVDs when figuring them into a bid package.

Hourly Wages

The hourly wage is a unique formula calculated using the sound creator's salary requirements based on the available billing hours for the year, the cost of healthcare and other benefits, vacations, holidays, and retirement. Because we don't work for a regular "company," this fee is our actual wage.

After vacations (you'd like to take), sick time, and the hours of administrative duties running your business are factored, roughly 1,000 hours per year are available to bill for your creative work. If you want to make $30,000 a year, you'll need to charge roughly $30 an hour. After taxes and company benefits such as healthcare, you'll charge 30% more or roughly $40 an hour to clear that same amount. This is a fairly close example of what you may find others charging. Insert your own figures to see what you should charge.

The Kicker

Also known as the "fudge factor" or "margin of error," this is an additional fee to cover any unexpected problems or minor adjustments to the project. Because the game development process is a continuously evolving one, additions are commonplace and this fee allows them to be included without having to renegotiate the entire project. Reactions to the kicker are varied, but time saved from having to renegotiate a contract is priceless and it is always more palatable to charge less rather than to charge more. If the project happens to expand far outside the original borders, renegotiations will be necessary. Fifteen percent is generally a good figure to use.

Rate Calculation

An established composer can charge $1,500 upward to $2,000-plus per finished minute of music. Established sound designers can charge between $150 and $200 per sound effect or hourly at a rate of $175 to $250 an hour. While they may be making more money than

when they first started out, and deservedly so, their cost of doing business and overhead have also increased. As you gain experience, you'll find that more expensive recording gear and software will help push your music another step further. As you leave behind the $3,000 analog mixing console for a $10,000 digital one, your payments increase to match. There really is no ceiling.

To calculate our rate, we need to have a good idea of the length of time it takes to do what we do. While you are putting together your demo reel, keep track of how long it takes to compose, record, and mix down one minute of music. Average this out over the course of the production and you have a good idea. Experienced composers, working from scratch, can do two to three minutes a day. Those using loops and programs such as Sonic Foundry's ACID can do considerably more. When I started in radio and TV commercials, my general rule of thumb was that 30 seconds of music took four hours—start to finish. Today, I'm up to about one minute in a four hour period.

Sound designers need to do the same. While working on various original sound effects, keep track of the time it takes to do one sound effect. My working model is an average of two hours per original sound effect. That doesn't mean that it takes that long to get one sound recorded. After many attempts and ideas for a sound are created, the final incarnation of the effect will have taken roughly two hours. Sometimes sound effects happen immediately and you are done. Other times, it's like pulling teeth—with two days passing before one materializes. We're looking for the *average* of the process to determine what our costs are.

Using our previous examples, we can finally conclude what our rates should be. I will be using the "4 hours per finished minute of music" and "2 hours per sound effect" models in the calculation with no outside musicians or voice talent.

Hourly wage and/or creative fee:	$30.00
Studio fee:	$7.71
Total cost:	$37.71 per hour

Then multiply by the number of hours to complete using your working model:

1 finished minute of music: 4 × $37.71 = $150.84
1 sound effect: 2 × $37.71 = $75.42

Figure in the 15% fudge factor:

1 minute of music: $150.84 × 15% = $173.47
1 sound effect: $75.42 × 15% = $86.73

Add in the material fee for the project:

1 minute of music: $173.47 + $15 = $188.47
1 sound effect: $86.73 + $5 = $91.73

In this example, recouping our costs and covering our minimum salary requirements, we've determined the cost of one finished minute of music to be $188.47. If we lowered our salary or were able to complete more music in less time, the price would go down

further—what you make on a job being your bargaining room. First out, you will probably only be able to charge $250 to $300 per finished minute of music—which, coincidentally, is a 30% profit margin added to our cost.

It's a fair price for someone with average musical and no game experience. And when you factor in the number of minutes in a game, say, 45 minutes to an hour, that would be $11,250 to $15,000 for a project using your own instrumentation and no outside talent. That's not a bad start, considering this doesn't even include royalties, bonuses, and any soundtrack album releases you might negotiate.

Sound design is another animal. If you are offering it as another service of your business, it takes your time away from doing other creative activities so your costs will be the same as above. If you are only doing sound design, your overhead will be much less—the only equipment needed being a computer, sound library, and remote recording gear at most. Looking at the previous example and offering this as another benefit of our business, our cost on a single sound effect is $91.73. Adding a 30% profit margin, $119.25 would be our fee.

Can you get that much in the games industry? Not at first. Sound-effects-only projects tend to be paid on a lower scale—the games market not tolerating the same pricing structure as music. The big boys can command about $15,000 per game project doing sound effects only, but this is after a few years under their belts. New sound designers in the games business can expect a rate of $25 per hour or even $25 per sound effect. It varies greatly with the deals you work out. If you're doing the music on a project as well, you'll be able to make up your costs on the sound effects by charging a comfortable overall fee for the project.

I have yet to make the same amount on any project; sometimes it's at an hourly rate, other times it's per sound effect. When I started doing sound design several years ago, I started at $25 per sound effect. As my skills increased, I changed to $25 an hour. Later, it changed to $50 per sound effect and then $50 an hour. These days, I charge either $75 to $100 per sound effect or $75 to $100 an hour—depending on the situation.

Producers have many different ways of choosing sound effects and some will have you tweak and redo sounds to death to get them just right. My train of thought is usually this: say a small project requires five specific sound effects. If I send 15 sound effects to a producer I have crafted using their specifications and he chooses to use five of those, I charge per sound effect. They trusted my talent, were happy with my judgment and accepted my first pass. If that same producer would have chosen five sounds but had me rework them several times or wanted different sounds, I would charge by the hour. Obviously, we weren't communicating or I would have gotten them right the first time. They can be extremely picky and have the tendency to micro-manage every aspect of a project, and that's okay, too. It's *their* vision for the production; I can respect that and will give them exactly what they want. But, because my time has value, for projects which work this way, an hourly rate is more appropriate—keeping me from losing money and wasting time.

Organization Is Key

At this point, we should be fairly well organized. We know what we plan to do and how we plan to do it—either as in-house or as an independent contractor. We have examples of our work on a great-sounding demo reel and know how to send them out. We've also figured out what we want to charge for our services and have the basis to judge our initial income potential. Time to reel in the business!

Tools of the Trade

David Chan

David Chan is a sound designer, audio producer, and owner of Giant Sandbox Productions.

I consider myself a professional game sound designer. I enjoy working both in-house and as an external contractor. Even when I was working in-house I made sure that I kept a decent rig going at home as well, which helped me when I transitioned to working as a contractor. I generally stay away from external gear and tend to rely more on software to do my recording and processing. I tend to use a few different programs and plug-ins as I haven't found any application that does everything the way I like.

Computer: I build my own PCs because that way I can choose every component myself. Currently, a dual-core Athlon 5200+ system with 2 GB of RAM and two system drives—one for OS and programs and the other for swapfile and work. Various external Firewire drives for each project and backups.

Software: Windows XP stripped of any unnecessary software. I use Sound Forge as my primary single-track editor.

Multi-track system: I use Pro Tools LE, Sony Vegas, and Adobe Audition.

Monitor system: Currently, KRK VXT-6, but will be moving to a 5.1 system because the demand for mixing 5.1 cut scenes has increased.

Mixdown: Mostly mix in the computer, but I sometimes use my CM Labs Motormix when I need to do tricky fader moves.

Sound modules/VST instruments: Tons, but off the top of my head my favorites are Komplete 4, Emulator X, Xtreme FX, and Ultra Focus.

(Continued)

Outboard gear/plug-in effects: Outboard gear is limited to my 002 Rack, Emu 1820M, CM Labs Motormix.

Keyboards: M-Audio Axiom.

Microphones: Various Audio Technica and Shure mics.

Additional relevant hardware/software: Tritton AX360 Dolby certified 5.1 headphones.

Remote recording gear: I use my Zoom H4 for remote recording.

Sound libraries: General 6000, L2, 8000 Sci-fi, and others.

CHAPTER FOUR

Finding and Getting the Jobs

It's official. You are ready to tackle some challenges and make some money. Unlock the front door, put out your "open for business" shingle, turn on the lights, and prepare yourself for the onslaught of customers who have been patiently waiting for this moment. The phone starts ringing off the hook. Life is good. Not! Unfortunately, you're going to have to be a bit more proactive than that and get a little dirt under your fingernails first.

Marketing

Drumming up business and getting the customers through your doors with wads of cash in hand will take some considerable effort. For most of us, playing the role of marketing director and salesman is as unnatural as brushing your teeth with your other hand. The best part, though, is after a bit of practice and patience, it can be yet another act we do without even being cognizant of it. After awhile, you'll be throwing a dash of "marketing" in with everything you do. It's not difficult really. Don't let the fact that there are college degrees in marketing, huge companies which do nothing but marketing, and individuals who spend their every waking hour as marketing experts intimidate you one bit. We can use some of their tricks and hard-won secrets to our advantage.

Tell Everyone

The very first thing you need to take care of is to tell everyone what you do. I mean *everyone*! Don't be shy and play coy little games. Don't consider it bragging or showing off, and while it might not feel like it, it's actually "marketing." Tell your mother, father, brothers, sisters, grandparents, uncles, aunts, cousins, friends, co-workers, and neighbors as a start and see what happens.

Whether you know it now or not, somewhere within that small group, somebody knows someone who has a friend whose brother's cousin's girlfriend went to school with a guy who is a programmer at a game company. That guy can be your foot in the door! But, you'll never meet him unless everyone knows you are trying to do audio for video games—so tell everyone! I'm not kidding about the kind of connections you can make by being open about your new endeavor. Let me share some of my marketing success stories.

Tools of the Trade

Adam DiTroia—composer and sound designer

I would call myself a mid-level composer/sound designer. I've worked on several projects for the PC, DS, and others. But I've yet to work on a next-gen console title or triple-A PC title. While I'm constantly after that result, I absolutely love working on just about anything! I'm just glad to have the opportunity to do what I love and make a living at it—you can't ask for much more than that. I would, however, *love* the opportunity to work with a live orchestra and choir! But I'm not going to beg!

Computer: AMD Phenom Quad core 2.3 GHz with 3 gigs of ram, two 500 GHz 7, 200-rpm hard drives, Firewire card, et cetera.

Software: Because this book isn't completely about me, I'll make a short list. Cakewalk Sonar 7.2 Producer edition, Cakewalk Project 5 Version 2.5, Sony Vegas 8, Sony Soundforge 9, Ik Multimedia's Philharmonik, Sonic Synth 2, Sampletank 2, and Amplitube 2, Cakewalk Dimension Pro, and Rapture (*love* them!).

Monitor system: Right now I'm using a pair of Behringers, but I'm going to be upgrading the ones I'm using very soon. Not sure to what yet actually… suggestions?

Mixdown: Sonar 7, Vegas 8, Sound Forge 9, mostly.

VST/DXIs: East West/Quantum Leap Symphonic Orchestra Silver edition, Z3ta, Session Drummer 2, a bunch of the M-Audio Prosession libraries, a bunch of Acid loop libraries.

Keyboards: Currently my main controller is an M-Audio keystation 88ES. That too will be changing very soon. I also use an old Ensoniq SQ-2 sometimes. I like the feel of the keys for programming drums, percussion, et cetera.

Other instruments: I have a Schecter electric guitar that I absolutely love! I have a wooden flute that I attempt to play. I just finished my new studio and plan to fill it with percussion from around the world (Taiko, Djembe, Congas, Bongos, et cetera).

Remote recording gear: Right now I'm using a Zoom H4 but I'm looking into another option.

Sound libraries: Sony pictures sound effects collection (volumes 1 through 10), a large collection of custom sound effects, many. For sound effects, I use Sony pictures collection and USB's Xtreme fxs mostly. But I love to field record and create my own.

Tale #1

After about six months into my business venture, I decided to take a couple of weeks off and serve my country as I do from time to time as a military reservist. I received a phone call from an individual who was gathering information about doing the same. During the course of our conversation, I asked him what he did for a living.

"Oh, I'm the president of a software development company here in town."

"No kidding!" I said, "Do you ever do any games?"

"Yeah, we do contract work for other game companies, mostly programming, but we are gearing up for one of our own game projects."

"Sounds like fun. Do you foresee needing any music for your game?" I queried.

"As a matter of fact, we just let our sound guy go; he just wasn't working out."

"What a shame. Well, you know, I do music. I just happen to run a music production company, maybe we ought to get together."

As it turned out, we lived two blocks from each other and met the next day at my studio. After playing some cuts from my demo reel, I was shaking hands with the president and vice president of this company—signing on for their first game. Not bad considering that all I did was tell him what I do. It turned out to be my first game project and led the way to many more. And the best part is, I've done three games for these guys!

Tale #2

One evening I received a phone call at the house. My wife handed over the telephone and said it was someone named Mike Post. I chuckled and proceeded to give my friend a hard time. He always calls up as someone "famous," and I smiled at his originality at this one. Well, it turned out it wasn't the friend that I thought and the voice was indeed *the* Mike Post! Surprise, surprise! He'd always been sort of a TV theme composer idol of mine, my favorites being *Quantum Leap*, *Magnum PI*, and the *A Team*. It was quite a treat. After my adrenaline rush returned to a more controllable level, I asked him what prompted the call. After all, it isn't every day I get phone calls out of the blue from real-life famous people.

The story: a guy I'd met at the local airport asked me to send a demo. He really enjoyed music, shared the passion, and wanted to hear what I was up to. In his garage at home, he was listening to my music when a friend walked in. Liking what he heard, he borrowed the tape to let another friend of his give a listen. He mailed it to a golfing buddy of his who "plays music in Hollywood." Turns out this golfing buddy was Mike Post! So now, Mike was telling me that he never listens to demos sent to him because if he never hears them, he can't be sued for stealing ideas (or something similar). But at his friend's insistence, he listened to mine and was calling to talk about my future. This story did not land me a game audio job per se, but shows what can happen when you tell everyone what you do! Get the word out and see what happens. Now, keep reading.

Tale #3

It started with, "Do you know anyone with a microphone?" and ended up with me voicing the daily News, Lifestyles, Health, and Comedy features on the Sprint Mobile Network! It's one of those "friend of a friend" stories that always happens to someone else, this time I really found out what telling everyone could lead to!

A friend of mine, who works for the government, was talking with a friend of his who had recently started up an audio outsourcing business. They were planning to do all sorts of audio and news segments for national radio stations and the cellular market but didn't know where to find the people to "voice" the spots. To keep their initial costs low, they were considering doing the recordings themselves and casually asked my friend if he knew anyone with a microphone. He said it took him all of about two seconds to think of my little hobby and set the wheels, to what has been an incredible ride, in motion. So, five days a week, I print out a dozen scripts and flap my gums at a microphone—all so people don't have to read the tiny little text on their cell-phone screens.

What started out as a casual remark has really turned into an interesting sideline for me—one that is expanding exponentially as negotiations with every major cellular carrier in the US continues. After 10 years in the games business, "tell everyone" is still proving to be a valuable strategy. I highly recommend it! Oh, and I took care of my friend, don't you worry.

Look Professional

While we are out there beating the bushes, things are going to start happening fast and furious. Bid requests, information requests, demo requests, and our pricing structures are going to be sent out to prospective customers as fast as they hit your desk. What you send out and how it looks is going to have a big impact on whether you get called for the next step. I am a firm believer in first impressions.

What you put inside that envelope can make all the difference. If you handwrite a bid on a scrap piece of paper, you're telling them you are an amateur, that your music product will probably be amateur as well and that you don't care about little details. On the other hand, if you send an information packet in an expensive binder with high-gloss paper, color laser printing, and gilded edging, you're telling them you are way out of their league and they probably couldn't afford you. You want to give an impression that you can do the job within their budget in a professional, reliable manner.

GameBeat Studios' eye-catching logo.

Christos Panayides' CP Audio Services.

There's no doubt what "The Fatman" does by looking at his logo.

The key is to look professional in every respect. You don't need to spend a lot of money and go overboard. You just want to make your prospective clients feel confident you have your act together, know what you are doing, and won't waste their time or money.

Design a Cool Logo

Work a logo up yourself or find a graphic artist if you don't have the ability. I'm sure a graphic arts student would love a "real-world" project to put in their portfolio and would work cheaply. The idea is to have something eye-catching and something professional. Put it on your web site, business cards, stationery, and envelopes. Put it on your demo reel and make bumper stickers, hats, and T-shirts, if you like. Have a recognizable symbol that everyone will associate with you and your quality work. Later, we'll talk about negotiating deals where your logo can appear on the game box cover and splash screen during the opening sequence of a game. You'll definitely need something to show the world by then.

Keith Arem's company, PCB Productions, and its simple yet effective logo.

The Nugel Bros.' revealing logo.

Tim Rideout takes the guesswork out of what his business does.

Business Supplies

Stationery, envelopes, mailing labels, business cards, and CD labels should all be acquired. You can have them designed by a print shop for fairly reasonable prices. If not, try spending a little time at your computer formatting various templates which include your logo and contact information. The only thing I don't recommend skimping on is business cards. Pay the $25 to $30 and have 500 cards printed. You'll be passing many of these out and they will be the first impression people get of your company. Cards with perforated edges and dot matrix printing convey a sense that this person won't be around for long.

Web Sites

Potential clients are out there waiting, but they may be a little shy. They have your card, but don't feel like getting into a long drawn-out conversation to find out what they need to know. Instead, they may turn to your web site. Web sites are easy to set up and maintain and the minor server space cost per month makes them a great marketing tool. So, set one up and pack it full of information.

Make it look professional. This is another great place for that new logo of yours. Explain what you do, how you do it, previous projects, maybe a biography about how you got where you are, any press clippings, some downloadable music and sound effects samples and, of course, contact information. Don't go overboard with the audio samples—just a few short pieces to build their interest and get them to request your demo reel. MP3 or Real Audio formats work well for small file sizes. Your reel will still sound the best, so make sure you have an e-mail available for their orders.

Be sure to keep your web site updated. As you finish projects, get them on there. Be proud, and show prospects that others found you suitable for their projects and that they will, too.

A Note on Embedded Audio
Don't use embedded audio on your web site. If you use it within the context of an Adobe® Flash® presentation, that's different and perfectly acceptable. The audio I'm talking about is the MIDI music or digital audio files which play in the background while someone browses your site. Not only will it feel like you are pushing your audio on them, there may be some technical issues as well.

First off, not everyone has the plug-ins on their browser which play back the type of audio you embed. Secondly, even if they did, there is no guarantee of the quality which spits out the other end. I know, we do audio. We want people to hear it and why not have it on our web sites? I'd much rather have nothing than have something that could lock up someone's browser or just sound horrible. MIDI music is very prone to sounding like garbage. It sounds great on the computer it was composed on, but the various sound cards out there almost guarantee it won't sound the same on someone else's. Don't use embedded audio and save yourself some embarrassment and some business. Stick to downloadable audio samples and you can't go wrong.

Industry Presence

If you plan on working in the video game industry for very long, you'll need to develop a presence. Some call it a "buzz" or "hype." Whatever you call it, it will build momentum toward your goal as a musician and will keep your name on everyone's lips. The day I got an e-mail from one of the industry's top game composers asking me who I was and "how come I've never heard of you before?," I knew I was doing something right.

Tommy Tallarico has a solid industry presence. His unbridled excitement about video games has gotten his name on more than 250 game titles; brought him a regular guest speaker gig at industry functions on all things audio; has gotten his face on weekly television as the host of *Electric Playground*, *Judgment Day*, and *Championship Gaming Series*; and has him as a consultant to many, many audio-related companies including DTS. Practically everyone knows Tommy Tallarico. This skilled showman made it his quest to become recognized, to have a presence.

Another example of presence is George "The Fatman" Sanger. He's done well over 250 games as well, but most people know him as the guy who runs around in glittery "Nudie" cowboy outfits. That's his shtick and it works very well for him. He also acts as a consultant to many companies and goes one step further by awarding his "Fat Labs Certified" seal to game hardware which meets his demanding standards of audio excellence. Now that's presence.

There are many other lesser-known game composers and sound designers who have a presence—albeit at a lower, more subtle, volume. Look through any computer music or recording magazine for their interviews. Look at advertisements with their endorsements. Look for their by-lines. They are everywhere, carving out their particular niche in the industry. There are plenty more to fill. The idea is to have your name out there, seen by your peers and prospective clients. They will definitely think you are doing something right if you are getting all this exposure, even if you are the one creating it all. It's nice having someone recognize your name even if they can't remember why. It gets your foot another step inside that door.

The author's music production company logo.

Tom Graczkowski's TDimension Studios logo makes an obvious statement.

Tom Salta's company logo.

**WATSON WU
STUDIOS**

Watson Wu's logo has given him celebrity-like status in the industry with his highly recognizable profile.

Tools of the Trade

Darryl Duncan

Darryl Duncan is a composer, sound designer, and president of GameBeat Studios.

My vision for GameBeat Studios from the start was to be a full-service music production and sound design company. I wanted to service all levels of game developers and publishers as well as the needs of the digital media world as a whole. I have always believed that one must have all the tools necessary to compete in the industry, so I invested heavily in the state-of-the-art equipment that I felt was needed for me to be competitive and maintain a fairly large arsenal of the hardware and software tools in my studio.

The following is a partial list of the gear I use the most frequently. It actually represents only about a third of the gear in the entire GameBeat Studios arsenal.

Computer: Apple Mac G5 dual 2.0, with four 500 GB audio drives.

Software: Pro Tools HD3/TDM system, Magma Expansion Chassis.

Monitor system: KRK V8 powered monitors with sub.

Mixdown: Pro Tools.

Sound modules/VST instruments: All of Native Instruments Soft Synths, Yamaha Motif ES7, Roland XV series, Korg Triton racks, Digidesign Air instruments-Hybrid, Strike & Expand, BFD2.

Outboard gear/plug-in effects: Waves Diamond plug-in collection pack plus tons of other effect plugs too numerous to mention.

Microphones: Neumann M149, TLM 127, AKG 414, Blue Baby Bottle.

Remote recording gear: Marantz PMD660 solid state stereo field recorder.

Sound libraries: Sound Ideas and Universal libraries, more than 400 CDs.

Basic Marketing Tools

How you develop your presence is completely up to you. There are no rules to follow; creativity is your winning bet. Nothing beats your music on a hit game, though, followed up with a lot of industry press. You can ride the wave into several more games and keep the momentum. Most of us, though, aren't going to have the fortune of a blockbuster project the first time out. It's going to take some creative magic of our own to turn on the hype machine. But there are some basic marketing tools to add to your regimen to help make things happen.

Direct Marketing

Build a list of developer and publisher addresses and points of contact. Addresses can be found on the backs of game boxes and from their web sites. Important connections are producers, creative directors, and audio directors—but at a minimum, have the human

resources departments dialed in. Put together an information package—an introduction to you and your services—and start sending them out. Unless those in the industry know you exist, you are not going to get the gig. Tell them who you are, what you do, and how your services will make their lives easier.

Some say that sending out *anything* to a human resources department is a grand waste of time. I agree to a point, but I've gotten calls from companies who say they received my name from their HR office and want me to submit a bid. Most of them keep your information on file from six months to a year and forward it to producers when requested. Hey, you have to start somewhere.

Telephone Marketing

Pick up the phone and start calling around. Ask for the audio department or the person in the company in charge of buying outside content. The smaller the company, the better. Large companies tend to have roadblocks in place which can rarely be negotiated. The switchboard operators and receptionists are highly skilled at sensing salespeople and are usually under strict orders to stop them cold. If you run into this situation, explain that you are a game composer or sound designer and you wanted to let them know of your availability.

Knowing you're not an office supply guy with extra reams of paper or toner to unload helps break the ice. Unless you are the twentieth composer to call that morning, you might get forwarded to a contact within the company. At worst, they'll patch you through to the dreaded Human Resources department.

Tommy Tallarico Studios' logo says it all. It capitalizes on his name recognition and his music services.

Another trick is to ask the name of the person who buys audio, say thank you, and call back a couple of days later asking specifically for them. If you get through, great! If not, ask for voice mail and speak your introduction. You can also ask for the person's e-mail and try an introduction that way. Don't be surprised if you don't hear from anyone right away, if at all. They may not need you for their current project, but might keep your name handy to bid on the next. Play the odds. Do this enough times and you'll succeed. Again, at worst, you've made your introductions, they know you exist, and all you have to worry about is following up every few months to keep your name fresh.

This method can be a little costly, especially if you end up making long-distance calls. There is nothing written that says you have to call everyone the first week. Spread it out over several months—breaking up the cost into more manageable chunks or consider subscribing to a unlimited long-distance calling plan.

Internet and E-mail Marketing

This is by far the most bang for your buck and the easiest way to scope in on the people who make decisions. Case in point: For every 100 letters I mailed the old-fashioned way, I got roughly 10 responses. Seven were "We'll keep your information on file" letters and three were requests for a demo. If I was lucky, I'd have one bid request out of that whole effort, but it was a lot of work for little reward mostly. Rarely did it lead to a job.

When I began e-mailing my introductions, the most astonishing thing happened. Out of 100 e-mails I sent, 25 responded. Twelve to 15 of those requested a demo. Three to five of those requested a bid submission or speculative demo for a project. And out of 100 e-mails sent out, I ended up getting at least one if not two jobs. It was the exact same letter I had snail-mailed, but my targeting strategy was much more focused. Ah, success!

This particular method is fairly time consuming, but indeed a gift from the gods. Start building your e-mail address book with every contact you make. Visit developer web sites and dig around for the right person. Send them an introduction. Personalize it as much as possible. You could save a lot of time by adding everyone to the same "to:" line, but this will come across as impersonal when the recipients see they were just part of another mass e-mail. Try sending to one person at a time (or using a program which does this); put their name at the top of your letter and their company name somewhere in the text. Even if they are smart enough to see through your ploy, they will still appreciate the extra effort and perhaps you'll score a point. Make your letter succinct, to the point and leave the impression you mean business. Always invite them to follow up, request a demo; or call just to say hi.

Print Advertisements

Print advertisements can include a classified ad, a corner spot in a company newsletter, or a full-blown page ad in a national publication. It's undoubtedly the most expensive part of a marketing plan and not something to take lightly. A well-designed ad, strategically placed, can build your name recognition and get you a project or two. It will tell prospects you must be doing well to afford such exposure and will make them curious. Obviously, you must be successful to pay for such an attractive ad.

On the other hand, if your ad doesn't look professional or is buried deep within pages of other ads, you might as well just walk over to the toilet, throw in your money, and flush. I've had a few composers tell me they tried print ads and all were disappointed with the results. They also only ran their ad once. To gain exposure through print advertisement, you must continually bombard your target audience using multiple shots across their bow. Try running an ad every other month, several places in the same magazine or in multiple magazines in the same month. It will eventually bring some business in your door. Even those cheesy late-night commercials on TV run more than once. You'll usually see the same one over and over for a couple of weeks before it sticks in your mind. The same principle can be applied to print.

I don't recommend television or radio ads. They cost serious cash and don't necessarily focus on the business you cater to. Unless you could buy some time on a closed-circuit company broadcast, you are better off spending your money elsewhere. This type of broadcast media is ineffective for our purposes. I don't know of anyone who has ever used it.

Press Coverage

One medium I know everyone uses is the press. Nothing like having them do a little work for us for a change. Press coverage equals free advertising. You can issue a press release to your local newspapers and television stations highlighting a recent milestone or to give them ideas for a special interest piece: "Local Composer Signed to Score Myst VIII," "Area Music Production House to Offer Sound Design," "Local Musician Creates Music for Video Games." For your local market, it will give you a much-needed push to help establish yourself. And, if you plan it correctly, you can either saturate for some serious immediate coverage or draw it out over a period of time for continued lower-key publicity.

Large city newspapers are very effective, as is mention in a game development magazine or web site. It gives solid exposure within your immediate market and continues with our motto: *Tell everyone what you do*. Small "news bites," mentions, or quotes supporting related industry articles and interviews are great ways to get your name to the point of recognition with your potential clientele. You can build alliances with journalists, giving them leads on interesting stories and making yourself available as an expert when they need to verify facts. It's all part of the well-oiled marketing machine. Consider using it.

Write Relevant Industry Articles and Books

Are you technically astute and have a way with words? Like to write? Consider sharing your knowledge and expertise with the rest of the gaming industry in the form of magazine or "webzine" articles or a book as another form of marketing. Your by-line is a powerful way to garnish some industry attention and start building a name for yourself. If you luck into a regular writing gig, you'll find folks start to look at you as an expert. It lends much credibility to your resume and keeps your name alive in a world where you are only as good as your last project.

The Game Developers Conference, previously held in San José, now takes place yearly in San Francisco, California.

Presence at Industry Events

It's a great idea to be seen at industry events and trade shows. Everyone will see how seriously you take the game industry and that you are very much a part of it. With a high concentration of the *actual people* who make games, chances are very good that you will make valuable contacts which will last for many years. It's an opportunity for everyone to put a face with a name and will make you stand out when they start thinking of audio for their next project. While your music and sound effects in a game is your number 1 marketing tool, your personal attention and commitment in showing interest and being among your fellow game creationists at these functions runs a very close second. Get out there and press the flesh. Be seen.

Industry Events Worthy of Your Attendance			
Game Developers Conference (GDC)	An industry insiders' event and gathering of game developers from around the world—showcasing the latest game development tools and hundreds of educational forums and discussion groups.	*www.gdconf.com*	Feb.

GDC Austin	A smaller but eclectic gathering of game developers that is perfect for those who can't trek to GDC in California or who just can't get enough.	*www.austingdc.net*	Sept.
Special Interest Group on Computer Graphics (SIGGRAPH)	Their annual international conference and exhibition focuses on computer graphics, animation, and other interactive techniques. A gathering of artists from around the globe. A very interesting look at how they do what they do.	*www.siggraph.org*	July
Project Bar-B-Q	An intense conference designed to influence music hardware and software over the following five years.	*www.projectbarbq.com*	Oct.
Audio Engineering Society (AES) Convention	A gathering of audio professionals devoted exclusively to audio technology. Includes a game audio technical committee.	*ww.aes.org*	Varies
E For All	A chance to get your hands on all the latest games, participate in game tournaments and network with game makers.	*www.eforallexpo.com*	Oct.
ComicCon	A focus mainly on comics and anime, but games and game makers are also well represented. A great place to network and enjoy unbridled creativity.	*www.comic-con.org*	July
Electronic Entertainment Expo (E3) Media and Business Summit	Reduced in stature from its previous glory, this gathering focuses on marketing and sales support of games.	*www.e3expo.com*	July

Word of Mouth

Another effective marketing tool is word of mouth. By amassing an army to spread the word on your behalf, you've affected a marketing machine which only gets bigger and more effective over time. Beginning efforts with your family and friends will stir up some interest. But, the best way to do this is through previous clients.

People and companies you've done business with in the past carry tremendous weight. If you've worked around the industry for awhile, your reputation will usually precede you no matter what you do to the contrary. Game developers talk. If you were hard to work with, overpriced, produced lousy music, or never delivered on time, that information will spread throughout your market faster than you could ever comprehend. You might as well pack up and move out. It is extremely important to work hard, be honest, deliver superior goods on time, and always go above and beyond what is asked of you. Always. If you do a good job at a fair price, people will remember. When producers get together, you never know when the subject of audio will come up. If I work with someone, I want them telling all their peers what a great job I did.

Use every meeting with potential clients as a chance to market yourself and your wares. Leave them with a positive impression and encourage them to pass on your name to others. Timing is often the key. If they can't use you now, maybe they know of someone who does or will remember you for later.

Other Resources for Marketing Success

There are many titles on bookstore shelves which cover the issues of marketing. None are geared specifically toward the game industry, but they are relevant just the same. Business is business and products are products no matter what line of work you are in. The following books will help you get your audio "product" in the face of the games business.

Money Making Marketing: Finding the People Who Need What You're Selling and Making Sure They Buy It	Dr. Jeffery Lant
Guerrilla Marketing, Guerrilla Marketing Attack, Guerilla Marketing Weapons, Guerilla Marketing Excellence, and several others	Jay Conrad Levinson
The Complete Idiot's Guide to Cold Calling	Keith Rosen
Cashtracks: How to Make Money Scoring Soundtracks and Jingles	Jeffery P. Fischer

Where to Look for Clients

If you were a game company, where would you be? That's the question you need to ask yourself when you set out to gather information on prospective clients. And, actually, it's not as hard as you might imagine. Game developers are a fairly visible lot if you poke your nose in the right places. They are all over the planet and every game needs someone to do the music and sound effects. The trick is matching your services to their needs. You need to establish "who" they are and "what" their needs are first.

Internet

The Web is the ultimate source for information on computer games and the developers who make them. It is a veritable gold mine which can, literally, make you rich. Practically every game developer and game publisher has a presence on the Web and it's a great place

to start. You can either search for every game company yourself or use game development resource sites which have pages of game company listings, links to their web sites, and contact information. Many game developers also post job openings on their sites, which can lead to solid contacts.

At the time of publication, the following web sites cater to game developers and either include job openings or game developer listings for further exploration. Many also serve as a general forum for development topics and the latest news.

Selected Game Developer Web Site Listings and Job Research	
Gamasutra	*www.gamasutra.com*
GameDev.Net	*www.gamedev.net*
Music4Games	*www.music4games.net*
Gamespot	*www.gamespot.com*
David Perry's Game Industry Map	*www.gameindustrymap.com*
IGN	*www.ign.com*
GameSpy	*www.gamespy.com*
Game Jobs	*www.gamejobs.com*

Industry Magazines and Books

Hit your local newsstands or the Internet for these monthly publications which cover a wide spectrum—from technical issues, to the big business side of things, to strategy and gameplay. Every one of these magazines is packed with game companies, either in the form of "help wanted" ads or Internet addresses. These will help define who the developers are and give you an idea of the type of games they produce, rounding out your research files. It is important to determine which companies license game engines, create graphics, or contract out programming services. These are specialized companies who, more than likely, won't require audio and thus you won't need to waste time with them. Concentrate your efforts on the companies who make the end product.

A Great Industry Source Book	
Game Developer's Marketplace: The Definitive Guide to Making It Big in the Interactive Game Industry	Ben Sawyer, Tor Berg, and Alex Dunne

Telephone Books

Don't overlook the obvious. If your market is a good-sized metropolis, the odds are decent that a game or software company is close by. Pick up the yellow pages or the business

section of the white pages and look! Look under *Computer Software Publishers and Developers, Computer Multimedia, Software*, and the like for some leads and then pick up the phone. If they don't use audio in their work, perhaps they know of someone who does. Be sure to ask. Make every call count—letting people know your availability or initiating a lead to someone else. Get names, numbers, and e-mail addresses of the decision makers and follow up with information packages and demos. A phone call may be all it takes to get the ball rolling.

Store Shelves

Take a trip to the local software retailer with pen and paper in hand. Pick up game boxes, look on the back, and find the names of the developers and publishers who are making them. It may seem painfully apparent, but it's a great way to add names to the list when starting from scratch. After awhile, you'll start to notice the trends and the leaders—a particular publisher who has his or her hands in many games and the ones who seem to dominate the market.

This is valuable information which will keep you up-to-date on the latest types of games out there and what types of music they might be looking for. An abundance of racing games equals high-energy techno or rock music. Medieval games use heavily orchestrated music. The trip to the store can be an important fact-finding tour. It's something you'll do on a regular basis even after you've been composing for a while to remain current on things.

Keep in mind when browsing through the retail aisles, that it is usually the major game companies that can command shelf space. Retailers are only interested in moving product and aren't interested in having an obscure game take up space for the one or two individuals who might buy it. High-volume games are the money makers. Take a look in several different retail outlets and smaller software and "game-only" stores for a broader offering.

Game Developer Headhunters

While hot in pursuit of clients or an in-house job, you might also consider contacting companies who have made a living out of filling vacancies at software and game development firms. These people are extremely connected to the business, earning wages by matching talent to the job and usually having all the latest gossip about what might be happening inside the companies' walls. They normally cater to programming and graphic artist positions but may keep an eye out on your behalf if you ask nicely. They literally live and die by the effectiveness of their networks and are always anxious for any leads.

I once offered a small upstart game company to a headhunter (I asked permission first, of course), mentioning they were looking for an artist. In turn, I was rewarded with several names and numbers of local game producers. They understood my needs and were able to share solid contacts. Because you are out there every day looking for your prize,

circulating some of that golden information with the right people could open some doors. Of course, always ask permission from the company before you unleash a headhunter on them—and never share privileged information or articles covered by a nondisclosure agreement. You can find these companies after a brief Internet search or in a phone book under *Employment Services* or *Recruitment*. Digital Artist Management, Game Recruiter, and Mary-Margaret are popular ones specializing in the games industry.

Networking

Starting from day 1, every person you come across has the potential to lead to a paying contract—whether they are a programmer, play tester, artist, producer, receptionist, or even the janitor. Other game composers and sound designers, although considered as competition, can be part of your network and lead to some work as well. By cultivating continued friendly relationships you'll be privy to information on jobs and companies those on the "outside" do not have.

Word of a game developer adding bodies could mean they are staffing a new project, hearing that a developer and a sound contractor are at odds, or knowing an in-house composer is preparing to make a leap into film scoring can all put you in the perfect opportune place. There is even the possibility for some subcontracting or overflow work being tossed your way from other composers. We all have to take vacations some time and are in a perfect spot to cover for our peers on short-term projects. Keep your eyes and ears open and make yourself available. The last place I ever expected to get a job from was my competition, but it's happened enough now that I'll believe anything.

Nextdoor Neighbors

It may seem like scraping the bottom of the barrel, but I'm guessing, unless you live far from civilization, within a block of your humble domicile, you can find some audio work. There are so many jobs which deal with computers, software, and games out there that several of your neighbors might work in the industry or have close connections to those who do. In my own little block of suburbia, I've

- Scored and designed sound effects for one CD-ROM game
- Created sound effects for two web sites and music for one Flash presentation
- Edited music for several ice skating competitions
- Engineered the final mixdown on three CD projects
- Mastered and duplicated an album for a band from Mexico City
- Recorded and edited narration for a massive multimedia presentation

All of these came through contact with just my neighbors! Imagine what I could accomplish if I went out two blocks! Word spreads quickly when people know there is a recording studio in the neighborhood. You'll be their first stop, since the sense of community will make your services that much more attractive. You live in their neighborhood, so you must be okay.

You might get the occasional off-the-wall request from time to time—a housewife wanting to sing and record her favorite song as an anniversary present, a teenager wanting to get a recording of his guitar prowess as a demo or some music "without the vocals" for the elementary school talent show. But that's what makes it fun. Perhaps the money comes after the husband hears the CD and wants to hire you for a corporate training video he's in charge of filming or when the teenager gets hired by a well-funded band and they want you to produce their next blockbuster album. Or when a parent in the audience at the talent show happens to be producing a video game and wants you to do the score! You just never know. Never discount the contacts you can make in your neighborhood.

Sound Designer at Work

Rodney Gates

Rodney Gates is a lead sound designer at HighMoon Studios.

Describe your thought process for creating sound effects.

I create each sound with a similar approach. After reviewing what it is I'm designing for and hearing what I want it to do in my head, I break it down into syllables that will realize the sound and begin the design process using suitable elements and/or processing in a DAW like Pro Tools or Nuendo.

When it's complete, I decide how best to divide the final sound so that the game engine can play it back correctly, and with some variability (for each sound, you really need to design it several times, to combat repeated playback). These divisions can simply be frequency based, or sometimes the particular thing the sound

(Continued)

is designed for dictates how it should be split up (a physics-based exploding prop, for instance, would require different parts to be triggered at certain stages of it's destruction).

Finally, I use some in-engine playback parameters such as random pitch and delays throughout for additional randomness, depending on the nature of the sound and its timing constraints.

Are there any secret techniques you regularly employ?

Well, it's not really a secret, but it's certainly effective: dropping a dry-fire pin click just before a gunshot really makes the sound pop. Also, when I'm recording loud sources such as firearms (or smashing televisions in the back of a retail electronics store), I am not timid with the level. I use analog-stage limiters to my advantage to get awesome Hollywood-sized recordings right off the bat, at least for some of the channels I'm recording. There are far too many recordings of "popcorn" guns or impacts out there and that's not what we're after.

When do you find you are most creative?

When it's due by the end of the day! No, really, as game development is generally a gradual process you usually have the time early on to get a feel for an environment, weapon, or creature and experiment with some ideas before they're necessarily ready to go into the game.

Conceptual artwork really helps in this regard. You can feel the mood of the upcoming locales or functionality of a particular item well before it's realized by an environmental artist, modeler, or prop artist. For me, thinking of the initial ways in which to realize the audio at this stage can be a really creative time—more so than say a "time of day."

Do you have any advice for the audio implementation side of things?

On the programming end, whenever possible, try not to reinvent the audio wheel. As consoles change and technology brings the new game experiences to even greater heights, the tools we use inevitably change as well. However, having to start from complete scratch again is a waste, unless the tools were bad to start with. Right now I have the ability to work on a second project using the same excellent toolset from the first project that will only be optimized and improved over the next development cycle, which is awesome.

Another important fact is to be sure the tools you are using are compatible with the many consoles out there, or you will be designing your audio several times over. That is truly a pain to maintain and inevitably results in different-sounding games from platform to platform due to restrictions with each tool and/or severe memory differentiation.

How did you find your way into the games industry?

Well, funny you should ask, Aaron! I remember pestering a certain author of a certain game audio book not so long ago with demo submission ideas, and thanks to your input, it somehow was a hit with someone in particular.

Paul Lackey, the head of then Sammy Studios' audio department, e-mailed me one day a few weeks after I had mailed out several submission envelopes. Now, I almost didn't even send one to "Sammy" Studios because I thought the name sounded ridiculous—but luckily for me I did.

Within a relatively short time (which feels like an eternity when you're outside trying to get in), I was off for an interview and got the gig. Turns out I was the only one being interviewed, so fortunately for me, I didn't blow it! I never heard back from any of the other studios, which was what I expected—so who knows how long I could have been mailing demos out.

It was an awesome opportunity for me, more so as I learned later—being able to skip over QA or not having to start as an intern and I won't ever forget it. These days I look for that same kind of ambition in people really trying to get into the field of sound design for games and see what I can do to help make that a reality.

Finding Your Niche

Creating music and sound effects for video games is like any other business practice. Much time is spent studying the layout, determining client needs, and developing a strategy to get your product in their door. If you have grand intentions, the focus will only be on the largest game publishers and the big moneymaking game titles. If you are being more realistic, smaller developers, upstarts, and multimedia companies would be the better place to start. Either way, the direction your business is geared toward has to fit in with and deliver the product no one else could do previously. In other words, you need to find your place in life—your niche.

Looking back, it took four years to find mine. Original plans for local TV and radio support gave way to a couple of small game developers. Those led to a couple of upstart companies who were keeping an eye on their cash outlay. Since I already had another full-time job paying the bills, I could keep my costs low and appeal to their budget. For about two years, most of the projects I did were for small upstart companies. That was my niche. As my experience grew, my efforts leaned toward the medium-size companies. Lately, as the medium-size developers are getting larger or swallowed up by the big fish, I've stumbled upon good fortune and a new niche. My low fees used to be where I drew the most attraction. Now it seems to be my "style" and work ethic. I'm still in search of the "highest paid game composer" niche, though. Hope to see you there someday.

Stay Educated

Information is the key to finding your place in the game industry. Games are a multi-billion-dollar a year affair and there are tons of data available to those who want it. Keep your eyes and ears open. Read, investigate, research, talk to other industry players, stay educated. The more you know about what is going on around this business, the better. It may seem a bit like what investors continually do; that is, following the trends or trying to stay one step ahead of them. You are out to do the same thing, but investing your talent and time instead. It can pay off equally as well. By following the ebb and tide of the gaming industry, your niche will be whatever you make it.

Example: gaming platforms come and go. Suppose you decide it's time to become licensed for the Nintendo GameCube system. You go through the process, pay your money, and add it to your company's services. You're all set. Funny thing, though, Nintendo's *new* platform is released and developers stop producing GameCube titles and begin work on the new Wii titles. Now where does that put you? That's what I'm talking about when I say "stay informed."

Start Small

For the composers and sound designers who are ready to cut their teeth and learn something about the industry, my advice is: Start small and work up. Unless you happen to luck into a hit game out of the chute, no one from the larger game companies will ever consider you unless your experience can guarantee them a trouble-free production cycle. It helps to have a project or two on the resume.

As mentioned previously, your initial focus should be on small game developers, small web design firms, and small software companies. Look for production teams which consist of one to five members only; the smaller the better. Look for the guy working out of his spare bedroom trying to be the programmer, artist, designer, producer, et al. He's the one who is so overwhelmed, he'd be happy to place some of the burden on you and would tolerate your inexperience for the relief it brings. He may be able to teach you more than you could learn on your own, proving invaluable in your career to come. Obviously, the small developer will be working to keep costs down and you should be able to offer savings for the chance to put a project on your resume. Don't work for free, of course, but work out an amicable agreement where you take less on the front side out of the production budget and more on the back side out of the product's returns.

The initial niche you can fill is lower costs. What you lack in experience, you more than make up for with savings to them. Their willingness to spend more time holding your hand through the process indicates their need to save some cash. If you were to charge full price for your services up front, the likelihood that the game would ever see the light of day is slim. And, as your first game project, you may have some income but won't have a product on the market to show for it—leaving you basically right where you started. The key is to use this as a steppingstone to the next level, which will naturally bring in more income as you progress.

Therefore, use this first game with the small developer as a learning experience. Learn your craft, make mistakes when it isn't as critical. These small developers will tolerate

your learning curve for the chance to make their game a reality. It makes better sense to have someone concentrate on making the audio content perfect rather than an overworked programmer adding in bland stock sound effects between naps.

After you've had experience with a couple of smaller projects like these, you'll be ready to start approaching the medium-size developers. It's an extremely fluid venture—moving from one role to the next, defining your place among the other developers of games.

Start Locally

By now, your list of prospective clients is sure to include several companies which are fairly local. These need to be your first targets, so get out there and show your face. If you do it right, every local game and multimedia house will know you are available to help on their projects. Eventually, you'll be expanding your scope until full global coverage is attained. Most of the time it is not necessary to meet with clients face to face, nor is it cost effective.

Game producers understand that while they may be in San Francisco, their perfect person for the audio job could live in Florida or Germany or New Zealand. With the advent of broadband Internet connections and overnight package delivery, audio delivery is not a concern. But your experience level is. Until you've put your name on a couple of game projects, expect a developer to keep a tight rein. And they cannot do that unless you are local. So, for the first couple of projects, expect a bit more face time with the producers until they know you can handle the job. With experience, expand out of your local area.

Getting the Break

The first question any developer or publisher will ask is: "What games have you worked on?" Your answer will determine what happens next. Whatever you do, don't succumb to the urge to fib—thinking you'll get away with it. The first time you do, your credibility will be shot full of holes. Everyone knows everyone in the game industry. While it is actually quite large, enough people move from company to company that at some point, everyone used to work together. A quick phone call to the producer who did the game you claim you worked on will not corroborate your story.

So what do you say? Before I got my first game gig, I didn't have a clue either. It actually took a couple months to figure it out. When someone asks what games you've worked on, and assuming you actually have none to your credit, your answer will be "None." Then when they've cast you aside and looked away, hit them over the head with: "But I've been composing music for the last 10 years, play keys, guitar, bass, and drums. I've also engineered and produced three local band CD releases, one of which is the band I actively play in."

"I've done local radio and television spots and just recently completed a five-minute public service announcement which won a regional award for the score." Et cetera, et cetera. "While I've never actually worked on a video game, I am expert on all things musical and can, without a doubt, compose the perfect music for your game. Here is my demo reel, which highlights the various styles I am proficient in—including one which I think will suit this game quite well. If you'd just give me a shot, I will give this project my full attention and strive to exceed your expectations. So, what do you think?"

See where I'm going with this? No, you haven't worked on a video game—but, yes, you are an experienced composer and can do the job. What you are looking for is that first break. Once you get it, you must, at all costs, give them your complete and undivided attention. Kiss their butts, if you will.

You want to ensure they never find a moment to regret hiring you. Make the music great, beat their deadlines, go all out to make the audio shine, and above all, exceed their expectations. Always do more than asked.

Your work on the first game will set the tone for the next and give you a reference who will enjoy bragging about how great you are. There's no better advertisement than that!

Composer at Work

Chris Rickwood

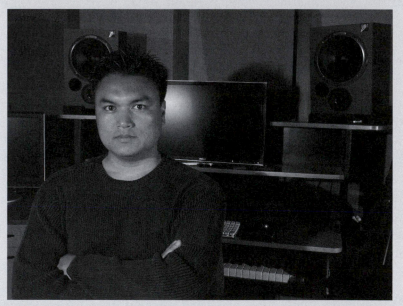

Chris Rickwood is a composer, sound designer, and owner of Rickwood Music for Interactive Media (www.rickwoodmusic.com).

Describe your thought process for composing.

My formula is pretty simple. Idea plus some kind of intervention by God and the universe plus editing equals finished cue. I'm fortunate that I get requests for a large variety of styles, from bluegrass to orchestral to ambient to heroic. At the same time, it scares the hell out of me to have to dive in to the unknown for each and every

project. So when the call comes in and I settle down to start sketching, my first thought is almost always *How the hell am I going to pull this off?* But after my brief moment of low self-confidence and an hour of so of procrastinating by surfing the Web/installing Facebook apps/walking the dog, I dig in and fire up the sequencer.

The first thing I try to nail down is the tempo. Matching the pacing of the game to the tempo of the music is critical in my opinion. I don't mean things have to be exactly in sync, but there is usually a groove already present in the animation that should not be ignored. So, I spend quite a bit of time with just a metronome and the action on screen. By the time I have the tempo right, I usually have a few melodic or rhythmic ideas in my head that I try to lay down as fast as possible. The key here is to take off the editor hat and put on the creative hat. It usually takes a lot of prying to get the editor hat off and it's best to lock it up in the closet and bury the key to make sure it stays off.

Now the artistry fades in and broadstrokes on the canvas is what works best for me. I'll create a four-bar ostinato and loop it to the end of the cue (luckily with Logic, you just press L). Over the ostinato, I'll sing or play an eight-bar melody. Then I'll sing another melody directly after that. Then I'll layer some counter-melodies, or I'll layer in some pads or a tuba accompaniment or a cuica solo. After a while I will have a ton of material that I can then arrange, edit, chop up, or delete. That's when I frantically dig up that key to the closet where I locked up my editor hat.

So now I have this huge block of audio clay that I can chisel away into a final cue. Luckily we have the power of sequencers that allow us to easily move things around and experiment. I'll edit the cue to a pretty solid arrangement, add some detail, check to make sure I didn't break too many theory rules and double check that the cue still matches the action. That's what I do until I think the arrangement is good enough or the deadline hits. I can usually tell that I'm done with a cue when I'm listening to the cue over and over again and not making any real changes.

That's how creation works for me. At the end of the process I am almost always surprised with the results.

Are there any particular secrets to your creativity?

I don't think there are any real secrets to being creative. I think you have to have confidence in your abilities. Once, there was a project where I had to mimic the work of Scott Bradley—the composer of the old Tom and Jerry cartoons. As you may recall, he has a very recognizable orchestral sound that almost always matched the picture perfectly. I wasn't really sure if I could pull off the style, so I asked the advice of one of my friends who is pretty fluent in the language of animation scoring. His only advise was, "Chris, don't be afraid of it." At the end of the day you just have to stop fearing the assignment and do it. That really stuck with me. Creativity in music is really just a series of choices. Should a piece go fast or slow? Should it be loud

(Continued)

here or soft? Should the melody go up by step or leap? Should the music resolve here or be deceptive? The more confidence you have in making those choices, the easier it is to let the ideas flow.

When do you find you are most creative?

Contrary to a lot of "artists," I am a morning person and find that the hours between six to eleven a.m. are my most productive. Around two in the afternoon I am pretty much useless and will do just about anything to avoid doing any kind of real work. I also find that I am the most creative when I am under some kind of pressure. To boost my productivity, I will create daily deadlines of what I want to accomplish and try to stick to them as much as possible. Sometimes I get really granular and say, "I'm going to sketch this thing out in fifteen minutes...go!" It really helps get over that hump of getting things started.

Any specific "lessons learned" you could share?

The best lesson I've learned so far is to listen. I listen to the sounds around me. I listen when the audio director is explaining the style, mood, and story of the game. I listen to stories of people who have already done what I'm trying to accomplish. I listen when my kids tell me I'm working too much.

Do you have any negotiation techniques others could learn from?

The only advice I can give is to know what you are worth and expect to get what you are worth.

Do you have any development stories which serve as a good lesson learned, maybe something you'll keep an eye out for in future projects?

Double check, no...*triple* check your numbers. I once had a project where the assets were specified in great detail in an Excel spreadsheet. Everything looked fine on the spreadsheet and in the contract, so we signed it and started production. I carefully mapped out the schedule to make sure all of the deadlines were hit and even padded it by adding an extra week for each milestone. The project went great and we hit the first milestone with relative ease. I then went to the spreadsheet to check off everything we had done and noticed that something didn't add up correctly. After checking off the assets we delivered, there were about a hundred more sound effects left to create than I thought we should have. After banging my head up against the wall for a few hours, I discovered that the formula that added up the number of assets left out two rows of the Excel sheet! So even though the contract and the total on the Excel sheet seemed correct, it actually left out a whole group of sound effects.

This error completely screwed up the time budget and the financial budget. Unfortunately, the developer wasn't very cooperative about any of it and didn't allow more time or money for the clerical mistake that they made. And even though the contract was in my favor, I felt I needed to provide them with the complete list of assets. Lesson learned.

Do you have any interesting music creation techniques which resulted in a notable piece of music?

For a horror film I scored, the director recorded an entire music commentary track for the film that outlined exactly where cues should start and end. In the commentary, he actually sang what he thought he wanted the score to sound like. So, I took his track, imported it into Kontakt, and created instruments from his commentary track. As a result, many of the cues ended up being these ambient textures created from the director's singing.

I actually use this technique now where I will sing what's in my head into Logic as fast as I can just to get the cue down as quickly as possible. I'll record all the parts, including percussion, just using my voice. It sounds awful! But once I'm done, I have a complete sketch of the cue with all of the structure, arrangement, and tempos all worked out. From there, it is just a matter of transforming the sketch into the final product.

How did you find your way into the games industry?

I always thought music for games would be fun to do. My schooling is in music and I have a Masters degree hanging on my wall that proves that I am "qualified" to write music for a living (okay, it's not really hanging on the wall and it doesn't really qualify me for anything). Anyway, back when I was in graduate school in the mid nineties, I read an article in one of the trade rags that highlighted the game audio industry. It looked exciting and cutting edge and *nobody* wanted to do it! Where do I sign up? Coincidentally, at the end of the article it gave the names and addresses of the audio directors at some of the biggest game studios with the specific instructions to mail in your demo. Seizing the opportunity, I slapped together a cassette tape and floppy disk of MIDI tracks (yeah, I was bleeding edge) and mailed them to all of the addresses.

I actually got a couple of calls back but specifically remember the call from Tommy Tallarico. He basically told me that my writing was great but the production sucked. It was true, but I was a poor student at the time and didn't know the first thing about music production. But at least the door was cracked. A couple of years later, I read that Tommy was doing the music for *Evil Dead* and would be using a live orchestra and choir! This was perfect for me. First, I was a huge *Evil Dead* fan so I was instantly excited about the project. Second, since they would be using live players production skills were not that important. So, I picked up the phone and asked Tommy if I could write a few cues for him. Luckily, he agreed and let me submit a few tracks which ended up getting used in the game. Sweet, my first real credit, my entry fee into the industry!

Networking Basics

As I've discussed earlier, the ability to network goes hand in hand with your marketing crusade—to connect with others in your profession with whom you can trade favors, gossip, rumors, hunches, and maybe a job lead or two. You can trade techniques, equipment recommendations, stories, studio time, or just friendly advice with someone who has been

out there making it happen and is eager and excited to share their wealth of knowledge. I'm not talking about going out and making a nuisance of yourself, pestering hardworking individuals with a barrage of questions that could take a book to answer. Come to think of it, that's pretty much how I started on this project—but I digress. The point is, your goal is to become a respected member of the industry whom your peers can associate with in a friendly, professional manner. This is no place for a starstruck fan to stalk their favorite game composer.

Your network should have value. For the games business, the obvious choices are producers, artists, programmers, composers, and sound designers. But, also consider contacts further out on the fringe. Try contract lawyers, accountants, other businessmen, and entrepreneurs. Other working musicians, engineers, and producers in the music industry are equally important—as are sound designers and composers who work in television and film. You can learn a lot from others who specialize in these fields and additionally, as part of your network, they can answer any question you may have, any problem that arises, with a quick phone call or e-mail. Alliances with journalists, TV reporters, and editors will also expand your public relations possibilities. Networks can be practically endless. It will take a few years to build, but before you know it, you'll be a part of others' networks as well.

The ultimate goal of your network is to make it yet another way to stay connected to your livelihood. Networking goes hand in hand with our marketing efforts and will pay off in the end, with income or lifelong friendships.

Industry Functions

Not only will your appearances at GDC, SIGGRAPH, or ComicCon keep your face in front of past and future clients, it is also another way to stay in touch with your networking buddies. I've witnessed several happy reunions that result from people literally bumping into each other on a crowded expo floor. In our busy lives, we can sometimes let correspondence go—but these shows are a perfect way to stay in touch. Everyone is out of their studios and offices with an open agenda. It's a great time to catch a few uninterrupted minutes, say hi, and see how everything is going.

Make Yourself Available, Make Yourself Known

Building a solid network is almost as complicated as marketing yourself to prospective clients, but the same basic principles apply. Review the basic marketing steps posed earlier in the chapter but insert *composer* and *sound designer* everywhere you see *prospective client*. Same idea, but with a different purpose. Obviously, others need to know you exist and accept you as a peer. Beyond that, you need to make sure you are available to meet with them on their turf as the opportunities present themselves. I'm always curious how other game audio folks do what they do and anxious to see their setups in person. It's easy to get submerged in other tasks, but I always try to schedule time to spend an afternoon with peers. You will learn a lot just seeing how the other half lives, what their working spaces look like, and listening to their ideas and visions. You have to make time. It's that important.

As your network gains in stature, consider hosting get-togethers with as many people as you can cram into your domicile at one time. Nothing fancy, just pick a convenient time and

start inviting. The idea is to get people together of like minds and interests and watch what happens. I've been to a few, dropping whatever I was up to at the time for the chance to mingle with some really neat people. Most others will do the same, thanking you several times for the chance to socialize and exchange ideas with their peers. Don't forget to invite me.

Game developers, producers, programmers, artists, and audio folks out of their caves and into the light at the yearly Game Developers Conference.

Tools of the Trade

Henning Nugel

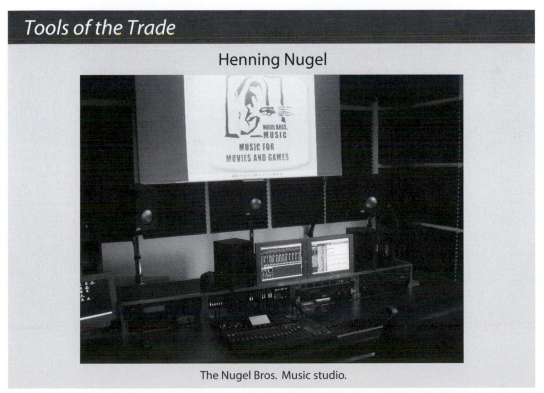

The Nugel Bros. Music studio.

(Continued)

The studio is geared toward professional composition and production of music for different media, mostly games and commercials with the option of recording up to three instruments or voices in this room simultaneously. Ensemble recordings take place in rented locations fitting the purpose. The room itself is acoustically fine tuned with Auralex absorbers, diffusers, and bass traps. Also included is a wall-mounted LG AN110B HD projector, which is used for screening film material or stills in sync to the music.

Computers: Four PCs synced with FX-Teleport and system link; one additional PC as game-testing and Internet machine.

Software: Nuendo4, Cubase4, Wavelab6.

Monitor system: Blue Sky System One 5.1, B&W DM310 with Rotel amp, FAR near fields, AKG K-271, and Beyerdynamic DT-770 pro headphones.

Mixdown: Tascam DM24, RME Fireface 800, RME Hammerfall 9652, Steinberg Midex8.

Sound modules/VST instruments: Lots of East/West stuff (orchestra XP, Rare Instruments, Vota, Stormdrum a.o.), Spectrasonics stuff (Trilogy, RMX with different libs), lots of drum and percussion libs (Stormdrum, Project Sam True Strike2, Artist drums).

Outboard gear/plug-in effects: Line6 POD2, Mesa Boogie MarkIV amp, Melodyne, Wizooverb 2/5, Waves plug-ins, Halion3, Kontakt2, Dolby 5.1 plug-in, Steinberg surround edition.

Keyboards: CME UF8, digital piano Technics SX-PX 71, Roland XP-30, Korg 01/RW Wavestation, Alesis DM-Pro drum unit.

Other instruments: Gibson SG Standard cherry, Charvel custom, Fender Irish bouzouki, Yamaha western and concert guitars, violin, Ralph Sweet wooden pennywhistle, Chieftain low whistle, Irish flute, duduk, shakuhachi, mizmar, Schlagwerk Cajon.

Sound libraries: Lots of Sound Ideas, Hollywood Edge, and self-recorded stuff.

CHAPTER FIVE

The Bidding Process

How Much Do You Charge?

Game sound designers and music composers are constantly bombarded by this question. Our first instinct is to answer back, "How much do you have?" or my personal favorite, "For projects I know nothing about, my standard fee is one million dollars." Though we never actually say it out loud, underneath our happy-go-lucky artistic exterior, the businessperson inside is thinking it. A list of questions and pertinent details immediately comes to mind to make a competitive quote.

So we estimate a figure. Based on what? We're not sure, but the question was asked and we aim to please. Then one of two things happens. We get the contract or we don't. And if you're just throwing around price quotes with no idea of what you are bidding on, it's usually the latter. The producer or media buyer is asking a sensible question—doing their best to obtain the finest media for the project and keep it within budget, but it is not always an easy task. Unfortunately, leaving out the particulars will cost them more time, more money, and many more headaches. You should take it upon yourself to solve this potential predicament.

Effective communication between producers and sound artists from the earliest stages can bring invaluable teamwork and the exchange of ideas. Producers who have a solid idea of the information needed by sound creators, our thought process and the guidelines we follow to deliver the perfect quote are effective asset managers who cultivate success. Sound artists utilizing standardized guidelines to determine their fees, options for payment, and winning bid procedures would bring it home.

Let's Play Twenty Questions

- "We are constructing a large multiplayer strategy game and in need of soundtrack help. I can't say much beyond that. What are your prices?"
- "Take a look at the game on our web site. We are rethinking the sound effects. Quote us a price and remember, we don't have a money tree, more like a money weed."
- "Can you duplicate sounds? We have copyrighted sound that we need changed slightly, but not much. Let us know a cost."
- "Can you give me an idea of the costs of SFX?"
- "Please send a demo and tell us how much you charge."

These are *actual* quotes from inquiries I've received over the years. The questions are well-founded, just slightly vague on pertinent details, so nebulous in fact that I have to fire off a barrage of questions in return, such as:

- "A full orchestral or single-note MIDI score?"
- "*Star Wars*–quality sound effects or humble everyday sounds?"
- "Next-gen console or cell phone?"

Suddenly the fog begins to clear. The sound guy isn't making this stuff up and actually has some solid points.

Composer at Work

Jon Holland

Jon Holland is a composer and owner of Xyxu Studios.

How do you go about scoring for a project?

I like producers to give me specific examples of music. I need names of songs or pieces of music that are close to the direction they want to go, that way I know where the producer is coming from. If he tells me he wants Vangelis or Hans Zimmer and then he ends up playing me some acid jazz, we might have a problem. I save a lot of time by finding out exactly what piece of music influenced that producer in the first place. If it is a cross between John Tesh and Korn, you may have to nail them down a little more specifically to what it is about John Tesh

that turns them on. What is it about Korn? When you start compartmentalizing, it gets you into the zone quicker. Sometimes I may have to redo a demo, but it's rare—especially if I ask enough questions before I start. Most of the time it just takes the right interrogation methods on my part to pinpoint exactly what they are talking about musically.

It is hard for me to look at storyboards and have somebody explain to me what a game is about. It's better than nothing, definitely, but I like to see animations that are far enough along where I can see what the environments look like. It doesn't have to be completed art by any means. I immediately start getting ideas when I see animations. You can explain to me for three days something that I will see in an animation in fifteen seconds.

During the scoring process, when do you seem to be your most creative?

Ironically, stringent deadlines tend to do wonders for the imagination, however, some can be downright ridiculous. After viewing animation loops and reading a few notes I can get crackin'. Fortunately, ninety-five percent of my music themes come to me within the first hundred and twenty seconds of composing. Unfortunately, tight deadlines have a way of reducing options and experimentation—but in the end the producers get something that they're happy with. I play it safe with situations like that because there is little, if any, time for redos. By the same token, when I have a harsh deadline I usually get into a groove—working from one piece of music to the next quickly. Detail in my music arrangements is usually where I have to censor myself. Usually the more time I have the more intricate the arrangement will be. I've been called a perfectionist, but I really know when there is enough info on a piece to keep the listener interested and when there isn't.

How should other composers go about getting into this business?

Most of my work comes from word of mouth, but there are no rules. To me music is all about flavor. I have a style that I compose in, and fortunately my clients seem to like that flavor. Whether I'm writing drama, racing, or sports music it will always have my flavor stamped on it. But in reality it is not going to be the flavor that answers every producer's needs. Maybe a producer will want bluegrass music for their game. Well, that may be your shot because I don't write that kind of stuff and maybe you do.

Details, Details, Details

From the beginning, the more information provided the better. Having all of the details up front can streamline the process and cut costs for the developer instead of going back and forth with questions and answers. Not only can we anticipate potential problems but solve them well before they get out of control. If the project calls for a score, sound effects, and narration, it's a great idea the sound creator knows about it! As a full-service production facility with experience directing various musical and voice talent, you could handle the project for less than three different audio contractors. Then again, maybe not. My preference is to have these out in the open first.

I am also fond of the "6 Ps" (Prior Planning Prevents Piss Poor Performance) when running my production company. Deadlines are manageable when you can plan ahead. An established set of reasonable milestones is a must. Just as the developer has planned ahead, so must the sound artist. We map out our production schedule based on theirs and budget our logistics accordingly. The game developer has a hard time getting artists and programmers together on a project, so likewise they need to understand our plight of getting a bunch of musicians to show up on time and ready to play. We need time to plan and time for the unforeseen. Fickle musicians and their unpredictable gear doth not a successful project make! For the busier sound folks, we may have other concurrent projects and need to determine if there is time in our production schedules to take on another.

Asking the Right Questions

Exactly what does the organized musician or sound designer need to determine if they can perform the service and produce a competitive bid? This list of questions should definitely have answers prior to the final submission.

What platform is the project intended for?

Game platforms each have their own idiosyncrasies and ways they manage sound programming and reproduction. Different equipment may be needed to produce these sounds such as a development system. You may have to rent or buy additional equipment or hire a subcontractor because of your lack of expertise in a certain area and this will factor into the projected costs. If you cannot develop for a particular platform, be ready to hire additional help to convert formats. Check with the developer, too. They may know of someone who specializes in this type of work and save you some time. Remember, this is a team effort.

Are you bidding the project or just one song or sound effect?

Composers and sound designers normally charge less for working the entire project than for creating individual music tracks and sound effects. It makes sense that once the factory is tooled and the "sound palette" is chosen, creating music and effects in the same vein takes less setup and production time. There are also those times when only a musical piece or sound effect or two are needed and we should have pricing structures available for those instances.

How much music is needed? Number of tracks? Lengths? Styles? Format?

Obviously, the more music needed, the more it will cost. A song's length also determines the fee. Because most composers normally charge per "finished minute," it only makes sense that a three-minute song would cost more than a one-minute one. To plan production time, use your working model.

Four hours to compose from scratch, record tracks and mixdown for each 30 seconds of music is pretty typical.

Composing and recording in several *different* styles could change the price, too. Some composers are capable of many styles; some are only great at one. If a developer only has one genre of music in mind, it should work out well. But if country, jazz, rock, and classical are all needed for the same project, it could cost a little more. Calling in other musicians to lend their talent costs money and should be written into the bid.

The format of the tangible, deliverable medium—such as CD, DVD, compressed formats like *.mp3* or *.ogg* resolution, or even digital audio tape [DAT]—should be revealed here to ensure you have the required equipment. For digital files, the sample rate in kHz, 16- or 8-bit, and stereo versus mono are all extremely important to know about in advance. Early in my game career, I found out my old computer's processor could not handle recording files using the 44.1 kHz sample rate and forced an upgrade. Not that I mind upgrading, I just *really* hate surprises! Plan on recording everything in the highest possible sample rate regardless of the final format requirements and converting down—your only limitations being your storage medium and processing power.

Are sound effects needed? How many? What specific sounds? Recognizable or original creations? Actions to accompany? Critical timing points for animations or character movement? Type of device used for playback? Format?

If you get the call for music, find out if they also need sound effects for the project and offer your services. The probability is high that you are also equipped to handle sound effects, right? The equipment used in a recording studio and methods used to record sound are the same for both specialties. The minor difference is the programs you may use. Combining these tasks with one content provider is less expensive for the developer in the long run, plus it is one less person for them to meet with.

Attention to detail regarding sound effects at the outset can help the process considerably. It shows the developer has looked at their sound needs and assessed requirements early in the project. Although the precise sounds may not be planned, ideas for weapons, environmental, and administrative functions may have formed and an idea of the number should be passed on to the sound designer. Using a personal working model, the designer can calculate how long their production cycle would be.

A general rule is one original sound effect requires two hours of time to create.

The more sounds, the more it will cost, but complexity can also raise the price. Standard or recognizable sounds from natural or man-made occurrences are usually "no-brainers." While effects libraries already in existence can provide some sounds, they may need manipulation to match character movement or an action. Other processing may be needed to adjust volume, equalization, or length. But generally these are considered elementary.

The sounds which will be the most valued are the "*Star Wars*"–quality original creations—fresh, wildly fantastic sounds which take your breath away. Completely original, highly creative effects cost more. For the developer, finding the right person with the patience, know-how, and the shared vision may take a little digging—but I don't know of too many sound designers who won't at least give it a shot. We do, after all, crave a good challenge.

I never thought the type of playback device mattered until a company approached me to do some sound effects. I received a list of effects and the format to save them in, pretty cut and dry. I proceeded to create some really killer sounds, smitten with myself and convinced I had indeed pulled off an impossible feat—ready to shatter the most powerful subwoofer in existence. Turns out, they would never even see a speaker system; they were sounds intended to be burned onto a chip for playback on a T-shirt! Gasp! So now, as you can imagine, I *always* ask what the playback device will be. That way, I can design them specifically for the audio characteristics of the device. Lesson learned.

Any dialog needed? Do you need to hire voice talent? Will there be background sounds to accompany narrations? Do you have rewrite authority of scripts?

Dialog fits into the sound recording category and generally, anyone capable of music recording can also record narration. That's how a developer looks at it. As with sound effects and music, packaging this task together will normally yield a lower cost from the sound contractor while also making it one-stop shopping. If they already have narratives recorded, you can usually provide the service of transferring them to digital files if needed, maximizing the sound, cutting them to length, and adding any additional background or Foley sounds.

If narratives are to be recorded, you will need to know if you will be providing the voice talent and budget accordingly. Many sound guys have access to local talent or use talent agencies to find just the right personality. Auditions are usually free, paying only when the talent has performed the work—which surprisingly enough, for a four-hour session, starts between $250 and $350 for non-union to $768 for union-affiliated actors. This is well worth the price for professional voice talent. A developer may ask if you have any experience directing narrative sessions—a good question. After dealing with musicians, though, you are probably fairly adept at coaxing great performances from practically anyone.

Rewrite authority for a script is a big plus and can be a money saver when the clock is ticking. Knowing this will determine how large the "fudge factor" will be. I once had voice talent who could not say, "… live to tell their tales." No matter how many times we tried, this tongue twister never came close to resembling the script. A quick rewrite got us back on track instantly. Had we been required to track down the producer for permission, it may have taken longer—or worse, the talent may have had to return later, costing me the price of another session.

Timeframe needed?

If they need it tomorrow, it will cost more. If they need a half hour of music in a week, it will also cost more. The more projects put on hold and any severe lack of sleep, the price jumps up accordingly. But, if we have been able to plan ahead and are afforded the time to schedule around other commitments, standard rates will apply. Rush jobs in any industry can be costly.

Delivery method?

The beauty of the Internet is the immediate mass distribution of digital data. Attaching a sound file to an e-mail or posting to an FTP site is the method of choice and assuming we have access, it is also the cheapest. Costs begin to rise as the delivery method changes. If the developer requires shipment on removable media such as CDs or DVDs, there will be a cost involved. It'll only be a few dollars for a one-time shipment of the final deliverables but if several milestones over a period of time are expected to be over-nighted, then this can start to add up. Understanding the costs you can incur on a project will allow you to cover it in your bid submission later on.

Is a speculative demo needed?

An established development company typically draws upon many musical/sound design resources at once, having them create specific music and sounds for a project from their guidelines and then choosing the best one. If the developer lets you know ahead of time that they require a speculative demo, it will save a lot of frustration for everyone—allowing you to schedule it in with your other projects. But normally, a composer's suitability

can be easily determined from a previously submitted demo reel. But be ready, just in case. Some developers will pay a reduced rate for your time; others consider it your investment to win the job. Be sure to check.

What is the production budget?

The production budget can be a touchy subject. If they already have numbers in mind for the sound budget, request at least a ballpark estimate. This will disclose the budget to be met and how serious the project is (i.e., whether it is a veteran development team or newcomer to the industry operating on a shoestring budget). For the small developer, you can offer budget solutions dependent on the information and ask for payment up front, at milestones, royalties, lease, or even barter agreements. We are part of the development team and do not want to doom a project before it even has a chance. Flexibility is a practice of many sound professionals. As long as the compensation is worthy of your efforts, there is nothing to lose.

Who will publish? What method of distribution?

This question is especially reasonable if the possibility of royalty payments surfaces in the negotiations. A game which will be self-published by a new inexperienced developer and distributed by word of mouth does not exactly scream success. A well-established veteran development team, on the other hand, who is using a giant publishing and distribution company and an onslaught of marketing ultimately has a better chance. Everything is negotiable and it pays to have all of the facts in the beginning to help make an informed decision.

Payment method?

If a developer already has a standard method of payment, find out and determine if it is acceptable for your needs. No one has a problem dealing with cash; some up front, some after acceptance of the first pass, and the rest upon final approval. It is the standard for most companies. Find out their standard terms for payment as well. "Net 30" is the bare minimum to ensure you get paid in a timely manner, but some have different methods—which might make a difference when reviewing a prospective project. The last thing you need is to find out their standard term for payment is six months after the game has shipped.

But if there are other methods in mind, royalties on the backside or a salary or hourly wage, for example, some discussion may be warranted. Would you want to shoulder the risk? You might consider the gamble, if you are willing to help keep your production costs down on the front side for a much larger piece of the pie on the end. It might be well worth your time. You never know when that game will become a smash hit.

Target market?

Who do they expect to buy the game? A classically trained pianist may not have the ability to write music for a game targeted to the teenage male. A heavy metal guitarist may not be exactly right for the three- to eight-year-old female market. As the composer, it is our responsibility to let them know if we can in fact handle the scope of the job—and providing this little detail up front can save a lot of time.

Who has final authority to accept your work?

This is an important point which needs to be nailed down early; the answer will factor heavily into your bid submission. A producer may stand up and proclaim, "It is I who has

final authority!" That would be a perfect scenario and you wouldn't need to worry about all those other little fingers in your business as much. You could charge on a "per project" or "per sound effect" basis and feel confident you wouldn't lose money. But if the answer is "the entire team," well, you've got your work cut out and my guess is you'll be spending some considerable time doing reworks. Achieving consensus would be nearly impossible. An hourly wage might be more appropriate to ensure all of that extra time is accounted for and you have something to show for your efforts. Or, you could add 5% to 10% more into your margin of error to cover what looks to be a severe headache in the making.

Knowing a game's prospective audience will allow you to honestly assess whether you are able to do the job.

This will eventually need to be worked out anyway, no later than the contract negotiations to be safe, and will serve as the last step before any milestone or final payments. When the designated individual accepts your work, ensure a check in your name is being processed. Occasionally, some will try to wait until the game is finished or released before parting with their funds. By having it in the contract, they can be held to their side of the bargain.

Tools of the Trade

George "The Fatman" Sanger

The game audio legend's laboratory.

If you play an instrument and it makes great sound after great sound after great sound, buy it. If you play it and think, *I could make some great sounds if I spent some time with this*, then don't. Go out and get what nurtures your belly laughs. Or better yet, dream about it and do what you think it takes to get that thing.

I recently heard a recording made on a MOOG Voyager, the tones made me grin and squinch my eyes and it felt like the music was licking my eardrum. So I'm getting one. People say, "If you're serious, you should get Pro Tools." That's not a good reason. They don't know who you are, do they? Oh, and another thing: Make your own instruments and fix broken ones. It'll make your music deep.

Philosophy on gear: This used to be a very complicated question, not so much anymore. I'm trying out a new answer. If you have an Open Labs MIKO, a mic, a pair of headphones, and a power cable, you will have all the hardware and software you need to do what I do for a living. If you can't do it with that, then don't blame the equipment, because the problem lies elsewhere.

Pre-Production Made Simple

With the previous list in mind, the producer or media buyer can easily increase the chances of a trouble-free bidding process by answering as many of the questions as possible. Make sure you've got them answered to your liking before making your final calculations. Any surprises could change the parameters of the bid, causing a devaluation of services.

Even before the project is put out for bid, the media buyer can do their homework. Investigating various sound production companies beforehand is a good idea to help stay ahead of the game. Web search engines, developer resource web sites, and the numerous unsolicited e-mails, inquiries, and resumes can be (finally) taken advantage of. They should request your current demo reel, references, and past work samples. Do your part to encourage them. They'll be thankful when the time comes.

Developers should plan as far ahead of the bidding process as possible, gathering any preliminary work, design documents, artwork, character biographies, storyboards, and lists of other comparable games on the market and have them handy to show the sound artist. I always appreciate getting these extra details at the bidding process. It is a classy gesture—one which will strengthen the new relationship immediately. The more you know, the more likely you will get your part right the first time.

Good developers keep the sound guy informed. Details and ideas change fast and furiously during the development of any title and the timeframe while waiting to receive bid replies is no different. Any major specification changes should be immediately forwarded to the prospective audio providers to ensure accuracy on your part. Platform changes, surround sound, or interactive music scores come to mind as important examples. Timely feedback on rejections, accepted submissions, and words of encouragement are always nice, too. Be on the lookout for any information between the lines. Sometimes a developer may swear they gave out certain information, but in reality, it was never said directly. ESP is a good thing if you've got it. Asking lots of questions is your next best bet.

Contract Payment Options

During negotiations, the single most recurrent topic is the payment option. Cash flow is important to both parties. You, the contractor, endeavor to receive payment in your favor—whereas the developer strives to keep their money as long as possible. It is a standard practice throughout the business world and not confined to the gaming industry but frustrating nonetheless. There are a few options to ease the pain on both sides of the fence and to help make the bid more attractive. Consider offering some of these options to ease the financial pinch a developer may be feeling. Remember, you're the problem solver and there is no reason you can't take that beyond just doing music and sound.

Salary or hourly wage

The easiest scenario, by far, is to be brought in as part of the development team and accept either a salary or hourly wage as consistent work is produced. No squabbling or haggling as terms of the contract are changed and giving the sound creator a sense of project ownership are highlights of this particular option. This situation is best for larger or well-funded developers but totally unrealistic if no development money is available.

Payment according to milestones

Given a hard list of required audio content, set milestones and have the developer schedule payments according to them. The downside is that this will force them to plan ahead and have exact specifications nailed down. The plus side is that it motivates you, the sound artist, to meet them. (I'm always more focused when I have a deadline to work toward myself.) If they don't wish to be tied, payment terms of half up front, the other half upon completion or variations in between, are also feasible. Payment according to milestones, however, is the standard practice.

Good faith, barter arrangement and small royalties

This example has wide-open possibilities. By starting with a small "good faith" payment, the developer is showing commitment to the project and to the sound artist. Because cash may be a problem, barter arrangements of some type are workable depending on each other's needs and offerings. Trades of computer equipment, web space hosting or site design, or graphics such as logos are all practical. A royalties option on the backside would round out the final payment for services. This option is great for the newer cash-starved developer and for the sound creator who is part-time or has other income.

Straight royalties

By not taking *any* payment during the development process, the sound artist would be entitled to a larger portion on the backside. A generous royalties schedule would be established to pay the content provider after the title is released. While this is indeed the best-case scenario for a developer, because the sound creator is assuming the risk, it can be the worst for you. Newer composers and sound designers may elect this option as a way to become established and for the steady cash flow as they work on other titles. Wiser ones will consider it if the game has hit potential.

Variations of the above

In the free marketplace of our society, creativity is not always confined to art. Utilizing any or all of the previous examples, an agreeable compensation schedule can be established meeting the needs of both parties. All one has to do is ask.

Composer at Work

Tim Larkin

Tim Larkin is a composer, sound designer, and audio director at Cyan Worlds.

Describe your thought process for scoring/creating sound effects.

I'm very visual with most things in my life. So when it comes to scoring or sound, I really get inspired by what I see. That can be anything from concept art to the final animation or environment. Generally, when I start composing music for an area, I definitely need to see the surroundings and the atmosphere first. Based on that, I can usually start hearing textures and feel right away.

Are there any particular secrets to your creativity?

There are no secrets to being creative in my mind. Sometimes it hits and sometimes it doesn't. Those are the times that persistence sparks the creativity. Occasionally, I get lucky, sit down, and it just happens in one sitting. Those are good days.

When do you find you are most creative?

I have to be in the zone, I guess. It's when I'm really set up and ready to work that the juices flow. I find that having my surroundings organized and feeling comfortable where I'm working is important, too. I'm definitely not as creative when the sun is shining and the river is in need of a few casts from a fly rod.

Any specific "lessons learned" on a project that could be shared?

I think there are things to be learned from every project. I usually learn how to overcome some type of roadblock or hurdle as to sound implementation from each

instance. There's always a different perspective gained from a different project, and figuring out how to manage each is the most valuable experience to come out of them.

Do you have any negotiation techniques others could learn from?

Keep what you can. It's amazing how much you can start to redistribute your library over time, so always keep that in mind. Oftentimes, publishers want total ownership, then put the music on the shelf after the game, never to be heard again. Take the initiative to do something with that music and make sure you work a split with them.

Do you have any interesting sound-gathering stories?

I generally take a MicroTrack with me everywhere I go and as a result have captured some great sounds that I wouldn't normally get. One time my truck was squeaking quite a bit so I had my wife steer it slowly down the road with me recording underneath, and almost got run over! Thankfully, I still have all my limbs intact to record another day. Don't think it was intentional.

How did you find your way into the games industry?

I opened up the phone book and looked under software companies. The first one was under B for Broderbund. So, I called them up and they hired me. The rest is history—as easy as letting your fingers do the walking.

Speculative Demos

We touched upon speculative demos in Chapter 3, but it's a subject which is important enough to warrant its own discussion. A *speculative demo* is a submission of music done by a prospective composer created specifically for a certain project. It is a way for the developers to see how close you can come to their ideas without actually committing themselves to hiring you. Usually, after deciding upon a few composers, a developer may request this type of demo to help narrow the field.

They should be as specific as possible regarding the type and style of music they seek—giving examples of works in other games or music artists which feed the right mood. If at all possible, it is best if they have only one person (i.e., the producer) give their input at this point. A favorite previous spec demo request of mine included this description: "…mid tempo with breakbeats, dark, abstract hip-hop, not too fast or too slow, gritty and industrial, but not jarring or abrasive." It was fairly obvious the *entire* development team contributed their ideas to the cause! It's a difficult task to please everyone.

So, it is extremely important to receive a concise description for mood of the game. You only have one shot to get it right. Occasionally, and if I have the time, I include at least two similar musical directions for the "judges" to choose between on a spec demo—doubling my chances.

Covering Your Expenses

It is a fair business practice to be covered for the very basic production costs for the speculative demo. As incentive, you can also agree to deduct this fee from your contract after being hired. But, unfortunately, this isn't always the case. Developers want to keep their expenditures down to a minimum and may feel that if you want the job bad enough, you'll do it for free. My argument is: If they've heard my demo, they know my production values and should be able to determine whether I am suitable for the job. While I'm not opposed to doing a speculative demo, I believe my time can be better spent working on *real* projects which pay the full fee.

Normally, you won't be able to charge full price for your spec demo. Any charge should cover "reasonable" production costs—basically your time, any outside talent, and material fees. Your standard creative fee is generally waived. For a 1-minute piece normally sold for $1,000 to $1,500, consider $300 to $400 as the most you can expect for the effort.

The ownership issue can blur the fee structure. If a developer asks for a speculative demo and agrees to cover production fees only, you maintain all rights to the music. Assuming, of course, that you aren't hired for the job, it still leaves you with music to sell to other projects in the future and something to add to your demo reel.

Now, let's say you didn't get the gig but they want to keep the music. What you do here is completely up to you. It's my guess they liked it enough to want to use it in something and I'd be careful. I would charge my full fee, give them all the rights, and call it even. They may counter with, "If you give it to us for the spec price, we'll keep you in mind for the next project." Again, it's totally up to you what you agree to—but there are no guarantees and they probably won't call despite what they say. If they like the composer they hired for this project, that person will more than likely get the next one as well. It's definitely a gamble—trying to look like the nice guy—but the odds are not in your favor and rarely will they call again. Put on your business hat when negotiating points like this and make sure you aren't taken advantage of.

Words of Caution

Music created with the project specifications in mind will give the development team a good idea what audio life to give the project and enables them to adopt the best one. They are basically taking advantage of you—looking for free musical ideas for their project. Developers have been known to contact several composers for ideas even though they've already chosen one in advance. It may turn out to be an exercise in futility. Stay alert.

While asking for a speculative demo is a win-win situation from the developer's standpoint, it can be a waste of time for you. Newer sound folks are usually more than happy to spend a week or two sweating and bleeding over a speculative demo, investing their time and money only to find out they have wasted it. Established composers don't need to expend this effort—having a proven track record to fall back on instead.

You have a clear choice when faced with this request. If they've heard your demo reel, you can sell them on what you've already done. Point out a piece on the demo which may be similar in nature to what you are thinking musically and play up the value of your production quality. If your argument doesn't sell them and they insist, it's time to decide. At first, your temptation will be to jump on every request. If you have nothing else going on at the time, work out the spec fee and go for it. Income is good regardless of where it comes from. But, keep in mind, this will take your efforts away from larger money-making

endeavors such as reeling in the big fish. There is nothing wrong with turning down this type of request, choosing instead to stick with your business plan. Why should you risk wasting your time when there is no guarantee anything will come of it? While it may be a calculated risk, sure things feel a whole lot better.

Tools of the Trade

Jamie Lendino

A portion of Jamie Lendino's studio space at Sound For Games Interactive.

While I have a lot of hardware and software, I prefer to do as much work as possible for a project using a core set of tools. That core set varies from game to game. For example, if I'm working on a cell phone title and the music deliverables are MIDI, I'll restrict myself to general MIDI plug-ins and related mobile dev tools. The last thing I want to do when composing for such small amounts of memory is run off and get used to some stellar-sounding evolving "motion" pad that I can't even license for the handset anyway, much less cram into 40 k!

On the other hand, there are also times when only the best-sounding gear and software will do. Speaking of which, I abandoned the Rick Wakeman/Tony Banks-style wall of hardware synths many years ago in lieu of software's instant recall, versatility, and realism. Hey, if some 30-year-veteran mixing engineer wants to salivate over his one-of-a-kind first-run Teletronix LA-2A with a rusty peak reduction knob, let 'em. I'll take the plug-in version, thanks! It's a heck of a lot lighter.

Computer: Apple 24-inch iMac (Core 2 Duo/Aluminum) w/4 GB RAM, AMD Athlon 64 X2 4800+ homebrew PC w/4 GB RAM and 19-inch Sony LCD, Apple 15-inch MacBook Pro (Core 2 Duo), Sony VAIO 13.3-inch laptop (single core).

(Continued)

Multi-track/mix systems: Steinberg Cubase 4, Cakewalk SONAR 7, Sony Vegas Pro 6.

Monitor system: Mackie HR624 mkII, Event TR5, Sony MDR-7506, AKG 240M (x4).

Sound modules/VST instruments: East West/Quantum Leap Goliath, Ministry of Rock, Gypsy, Voices of Passion, Stormdrum, SD2, Symphonic Orchestra Gold XP Pro, and Symphonic Choirs; EZ Drummer, Absynth 3, Kontakt 3, MOTU Ethno, Reason, Stylus RMX, Atmosphere, SampleTank XL 2.5, Sonic Synth 2, Miroslav Philharmonik, Garritan Personal Orchestra, and various AKAI/Emu sample libraries, CDs and freeware VST synths.

Outboard gear/plug-in effects: Izotope Ozone 3, Sonitus:fx suite, Voxengo Elephant, Voxengo Soniformer, Waves Renaissance, Line6 Pocket Pod, plus Western Digital MyBook Pro and Maxtor OneTouch external hard discs.

Keyboards: M-Audio Ozonic.

Other instruments: Fender Stratocaster, Roland HD1 electronic drum kit.

Microphones: Rode NT-1A, Shure SM57.

Additional relevant hardware/software: Sony Sound Forge 7, Bias Peak, Creative ISACT, BREW emulator, Nokia Music Composer, Cakewalk TTS-1, Virtual Sound Canvas, various MOD trackers, and lots of test cell phones, game systems, emulators, and other gear. Plus a dearly loved homebrew Atari 800 "luggable" with custom internal flash memory (which I wrote about in ExtremeTech magazine!)—along with lots of games to keep me motivated.

Remote recording gear: Numerous portable MP3 player/recorders, plus one of the laptops, an external disc, and a USB audio interface for bigger jobs.

Sound libraries: L2 SFX, Sound Ideas Series 4000 Hollywood, Universal Studios SFX, Sony Pictures Series 1–5, Sound Ideas Science Fiction SFX, Sound Ideas Series 11000 Sports, the SFX Kit, Hollywood Edge (Edge Edition), Hollywood Edge (Historical Series), Animal Trax, plus lots of individual Sound Dogs purchases and original recorded material.

The Bid Submission

Well, here we are—back full circle to the question, "How much do you charge?" This time, however, we are armed with powerful knowledge, motivation, and a list for success. All of the parameters for the game have been laid out and it's time to determine your fee. Obviously, the amount you charge is a big factor in determining whether you get the call or not—so don't take the subject lightly.

After you've set a figure, mull over your interactions with the developer to decide whether they are giving you free artistic rein or will be nonstop thorns in your side and then let that gut feeling be your guide. Let that intuition be the basis for the bid you submit. It's not an exact science, but it will affect your motivation and ultimately the quality of the job you do.

> A wise man once said, if you grumble through an entire project, you are not charging enough.

More than likely, there will be other composers bidding on the project as well. If you can find out who they are, great. It will give you an indication of the price range they warrant and you can strategize over how to win the bid. Don't immediately go for the "cheapest composer angle," underbidding just to get the project. By doing so, developers will expect all composers to work cheaply and devalue our efforts. You'll end up working on their next project for this cut-rate fee, unable to earn more for your efforts—setting a bad precedent which will take you years to recover from. I'm not saying this because other composers (or myself) are afraid to lose a contract to the lowest bidder. I'm throwing it out in hopes you will understand that once you are known as the "cheapest composer in town" that's the only type of projects you'll get.

The Bid

For the final bid submission, there is no magical format to follow which will land the contract. Most bids are submitted via e-mail these days—plain-old boring text explaining how much you would charge for the project and what would be accomplished for the price. Occasional submissions are requested through a more formal letter, but either way, what counts is the facts: your professionalism and their gut feelings.

When you make your submission, ensure the recipient actually received it and find out if there are any questions which need answering before their final selection. A phone call is the best way to follow up, especially if you've never met or spoken before. It will add a personal touch and humanize the dry, impersonal bid. If the chance presents itself, request a visit to offer your bid in person and meet everyone face to face. Although it is highly improbable you'll be able to afford jetting off to meet all prospective clients, there still is something to be said for that kind of commitment and dedication. But remember, it still won't guarantee you the job. For a little extra insight into the bidding process, here is an illustration of a bid request you may encounter and an example response.

Example Bid Request

Dear Game Composer,

We are currently requesting bids for an upcoming game release for the PC. We will be requiring a number of different types of music for the project. The game takes place in space and is in the "combat/strategy" genre. In making our decision, we will first consider quality; second, cost; and third, timeline.

For now, if you could furnish us with the following, we will be able to consider your bid:

- Resume of past game work.
- Sample track or part of a track, either done for this proposal or from your archives, which matches one of the descriptions below.

(Continued)

- Cost per track, with any discounts if we request over a certain number of tracks.
- Completion timeline. The project does not require the final soundtrack for four months, although we would like to have it much sooner if possible.
- The music tracks will play throughout the game. All voice and sound effects will be heard over the tracks. There will be a bit of silence after a track is complete before the next one begins (done similarly in *Command and Conquer*).

Here are a few track descriptions. Pick whichever type you want for your bid sample.

- An action piece in a classical genre (*Star Wars*, "Raiders," etc.)—could be a synth mix.
- Rockin' thrash, industrial-esque perhaps.
- Militaristic techno—hard, driving beat, and a cool sci-fi tune. Nine Inch Nails minus the ear-splitting cacophony or Eurythmics "1984," John Carpenter's "The Thing."

We want to avoid recognizable lyrics, although voice can be cool as an instrument and stay away from "happy, Disney-action themes." I will be going through the bids in two weeks. Please call or e-mail me if you have any questions. You can obtain information about our company from our web site. Thank you.

Sincerely,

Producer X

Example Response

Dear Producer X,

Thank you for the opportunity to be considered for your new space game project. Enclosed is the demo reel and bio you requested. I've included several tracks from my archives in a brief musical montage similar to the styles you described. After I've had a chance to speak with you directly, to get a better feel for the game, I'll be able to hit your target dead center.

Although I do not have any published game titles yet, I am currently under contract with two separate software companies scoring music and designing sound effects. Company A has me contracted for two games: *Space Game 1* and another game yet to be named. One project is expected to be released in two months and another by next spring. Company B has contracted me for one title by summer and an option to continue my contract indefinitely. I'm quickly adding projects to my resume, so please don't be alarmed by my lack of published software titles. I have much experience composing and recording music—having done many local TV and radio commercials, PSAs, and am involved with several album projects. I can do what you hire me for without question.

My rates depend on many of your requirements, but $4,900 would include buyout fees for five 3-minute songs/themes and five 1-minute pieces—20 minutes of music in all, using the instrumentation heard on the demo. Additional music beyond the 20 minutes is $149

per minute. I can offer 60 minutes for $11,900. An individual track per finished minute, and based on your request, would start at $349. The quality and value of my services are guaranteed; if you are not happy with the music I compose for you, you pay nothing.

The timeline is fairly straightforward once approval for the styles and lengths of music are granted. The first piece would take two weeks for composition and recording, each piece after that (1–3 minutes in length) would require no more than one week. Once the factory is tooled, so to speak, and my sound palette is chosen, the music comes fast and furious. A week would also be needed for reworks, if there are any. I say a week to be conservative; five days is usually the norm.

My musical/production/computer experience dates back many years and my local area network is always available to draw upon. My reliability is unquestioned and if you'd like to speak with some of my clients, they would be happy to share their experiences. I believe in the utmost quality of each production and strive for perfection. My in-house digital studio is fully equipped to reach these goals and to allow my creativity and inspiration to get quickly to tape. I have been composing for many years, played guitar and drums in various bands, play piano, and have been actively engineering and producing. I have the knowledge and the chops to provide quality music on time and most certainly within budget.

Please feel free to call if you have further questions or need clarification. Again, thank you for your consideration and I hope to speak with you soon.

Sincerely,

Game Composer

Note that the previous illustration is geared toward the new composer. There is discussion about the lack of resume titles and you'll note the price quote is much lower than what an established game composer might charge. The quote was based on a very low overhead for the composer and that the developer was small and fairly new. This example "sells" the composer's talents a bit more than what is typically needed, so was a little more wordy than normal—something you'll eventually narrow down to "just the facts" in future bids.

An aspect to note in the example: The entire point of this process is for developers to survey various sound contractors, find a fee which will fit their budget and get great audio. They are searching for the most bang for their buck, period. We aren't anywhere close to negotiating royalties, bonuses, or other contract items, so don't use this as a forum for that. You'll note the example didn't even breach those subjects. Once you win the contract and they have rallied around, heralding you as their new audio sage, then contract issues will be considered. If you were to walk in with a long list of contract demands, they would definitely consider the path of least resistance (i.e., your competitor) and leave you standing there with your mouth agape.

There Is Still More

After the bids are submitted and the nail-biting begins, there is still more we can do. Maintain an open line of communication, build rapport, ask questions, and grow to understand each other's needs. The process is by no means over. There are times I have even

been asked to rebid based on new parameters only discovered during our conversations. When it comes down to two bids, developers should talk to both composers. A gut feeling will let them know who is right for the job. After all, you will be working closely together for some time and it is reasonable to assume you should be able to communicate ideas and get along. Don't be afraid to pick up the phone and do a little digging on your behalf.

The bid is, without a doubt, the least favorite part of the game development process but is inevitable. Knowing and sharing the ingredients of a sound bid will make this experience better—setting the mood for the project and establishing a cohesive team that ultimately breeds success.

Composer at Work

Tom Graczkowski

Tom Graczkowski is a composer and owner of TDimension Studios.

Describe how you get started on music for a game project.

Whenever I'm working on a project I try to gather as much information about it as possible. Get myself acquainted with the story; if possible see some images and artwork. Once the information is collected, I'll take some time listening to music, play a few games, and watch movies that fit the genre to get inspired. What's left then is powering up that keyboard and writing something wonderful.

Are there any particular secrets to your creativity?

If there are, then I would certainly like to know them. Truth be told, anything can inspire me and at any time. Sometimes I'll play that great game and my creative juices just start flowing. Other times I might be walking down the street, hear a strange noise, and all of the sudden that triggers a cool melody in my mind. In many cases I simply fool around with some random sounds on my keyboard and that will either inspire me or end up being part of a cool piece. I don't think there ever are secrets to creativity. It just tends to hit you when you least expect it and at times that can be a bit frustrating, especially when working on a tight deadline. But, with some positive thought, great ideas always manifest.

When do you find you are most creative?

It really depends on inspiration which may trigger ideas at any time and I do mean that literally. But, I find that most of my creativity usually happens at night when it's time to catch those much-needed zzz's. As a result, there is always a digital recorder by my bed so when that idea hits, I can hum into it so it's there waiting for me in the morning.

Any specific "lessons learned" on a project which could be shared?

Be absolutely clear on the music your client is envisioning for the project and gather as much information about it as possible. It's a real shame to realize you put your heart and soul into a piece of music that's completely off the mark.

Do you have any negotiation techniques or stories others might learn from?

Know what you deserve and get the pertinent language inserted into your agreement. Here are a few points to watch for when negotiating your contract. Firstly, find out what the budget will be and how many units of the game the developer is expecting to sell. This is known as their "breaking point" and is usually somewhere around a hundred and fifty thousand-plus units. It's a needed piece of information that will help you determine your bonus structure. So, for example if the developer sells the hundred and fifty thousand units you can negotiate for a ten-thousand-dollar bonus and so forth for every additional hundred and fifty thousand units sold in the future.

As you know, video games are usually released across different consoles or SKUs. Make sure that's what the developer is planning and if so, it's only fair that you be compensated extra in addition to your creative fee for your work being reused across multiple platforms now and in the future, forever. In case they put up a wall on this point, you can explain it to them that in the long run it will be cheaper than hiring someone else to do all the work from scratch.

You can also offer to do implementation for other platforms to make sure that everything sounds properly. Always use the "It's for your own benefit" approach in your negotiations. Even if, initially, they're not planning to release the game across different platforms, you should still get that language into your agreement. Reasons being

(*Continued*)

if their game becomes successful they may then choose to port it to other consoles, and because that simple line was not in your contract, you'll be kicking yourself for all that extra money that otherwise you could've made. It's a point that is often overlooked in composer agreements, so take note.

About music ownership, although better, many developers still don't understand the music industry or even care to. Agreements between the composer and developer are "work for hire," which means that the music and/or sound effects you create that are used in their game they will own. But, what about opportunities where your music could be used outside of the game, like a soundtrack or a movie trailer? In case of such opportunities, try for splitting the profits fifty/fifty.

Some points in your agreement, especially things like bonuses, are not easy to come by—and if you're someone who is just entering the industry it may be even harder. But, you should always fight for what you deserve and expect to be treated fairly. On a final note, try to do your negotiations directly with the publisher as opposed to the developer. In many cases, the developer doesn't own the intellectual property and so they may not be able to approve all the things you ask for. So, go straight to the source.

What techniques do you suggest when creating and recording a game score?

A large number of game scores today are orchestral, with certain companies going all out by contracting large orchestras and the best of the best to record them. Next-generation consoles and rising audio budgets have made this possible. Unfortunately, not every developer has a million dollars to spend on game audio. However, on a reasonable budget you can still create an amazing orchestral score thanks to the availability of high-quality samples. It's no longer necessary to hire full orchestras, instead you can hire just a few live players and layer them onto your samples. That small touch of human emotion, a violin player or a horn player, will do wonders to the quality of your music and give the impression to the listener that it's all live.

You may also discuss with your developer hiring an orchestra only for the more predominant parts of the game, like that key cut scene or boss fight. In situations where you have to resort to samples exclusively, think variety. Use multiple libraries for different articulations, but make sure they all sound the same by using EQ and adjusting reverb settings and other effects. Layering the string section from different libraries will also help to enrich the strings' sound.

Also, try adding prerecorded musical effects such as runs or glissandi to your tracks; it will add realism to your music. Unless you already have lots of experience recording with a live orchestra, I strongly encourage you to listen to real recordings as much as possible to get a thorough understanding of the sound and orchestral balance. In addition, it doesn't hurt to read some orchestration books or talking to that friend who plays the violin, et cetera. To conclude, programming with MIDI and samples to create an authentic orchestral sound can be a time-consuming task, but if it's done right and with care the results can be astounding!

CHAPTER SIX

Making the Deals

Dear Game Composer,

Congratulations! You have been chosen among five competing composers and sound designers to score music and create sound effects for Company X's next mega-block-buster smash game! Because you stand well above your peers, the choice was not a difficult one. Your vision is clear, your dedication is evident, and we look forward to working with you on what proves to be a very exciting project. We'll be in touch very shortly to discuss all the pertinent details.

Before we can proceed, however, we will require you to agree to and sign some standard paperwork: a nondisclosure agreement (NDA) and professional services agreement (PSA). You will find these documents enclosed. Please fill them out in their entirety, sign and date in the appropriate places, and return them to us within the next five working days. After we have them in our possession, we can get down to the business at hand.

Again, it is a pleasure to have you on board as part of our team. Should you have any questions, feel free to contact me.

Yours in gaming,

Producer X

You've hit the big time! Your adrenaline is flowing, your hands are shaking. This is a significant moment—one you've worked hard for. Except, when you sit down to examine the pages of "legalese" they need you to sign, the weight of the situation pulls you unwillingly back down to earth—a touch of fear rising from your stomach. What are you going to do?

Your first instinct may be to just sign and initial everywhere, send it back, and get it over with. You want to make music! Wrong! You have to realize this contract is skewed heavily in their favor—their interests fully addressed. That would be the *worst* thing you could do at this point.

Find a decent contract lawyer—preferably one who is familiar with the idiosyncrasies of the games industry. Consult with them before signing any contract and discuss ways to include your interests in it as well. If you absolutely cannot afford the $200, find a trusted advisor you can rely on—someone who is familiar with business contracts and

could recommend an appropriate course of action. Consider, at a minimum, getting advice from a game producer or another composer who has dealt with these types of situations. By doing so, it will protect your interests, give you an insight into the process from day 1 and will let the game developer know you are not just a great composer but also a savvy business person.

Dealing with agreements, contracts, and all the other legal paperwork can be enough to try anyone's patience and make them think twice about this line of work. These basic "formalities," necessary evils most people take rather nonchalantly, are enforceable and binding agreements between two parties which can be used for or against you in a court of law. In the previous example, Company X (knowingly or not) is gently forcing you into their agreement without appropriate time for you to consult your experts and consider each point. If you ever find yourself in this type of position, ask for more time to review the contract and offer any counterproposals if you come across something unreasonable.

Don't get suckered into signing something you haven't read and fully understood. I've found myself sitting in a boardroom full of company executives staring at me, all seemingly waiting for my pen to touch the paper. While the pressure to look like a "team player" was tremendous, I asked for some time to review the documents first. Another time, a producer kept reminding me my first payment was on his desk and would be sent out as soon as I signed the contract—that is, he was dangling the carrot. In another instance, a substantial payment was withheld from a previous contract after the company had been bought out—insisting I sign their *new* agreement first. You will meet with many similar situations in your travels.

Never sign any legal document unless you understand and agree to it 100%. Your livelihood and sanity are at stake.

Understanding Industry Contracts and Terminology

Before you can make the deals that bring success, you must understand and become familiar with the legal contracts you'll see along the way. Some can be extremely simple statements which proclaim, "Upon receipt of payment in full, Company X owns all rights to the following audio files." Other contracts are pages of undecipherable legalese which can take days to read. Regardless of what you may encounter, common sense and a little knowledge will go a long way. Let's take a look at some of the more common terms and "standard" agreements.

Nondisclosure Agreements

Before most companies even let you *see* their operation, they require your signature on an NDA. Basically, it is a document that says anything you see and hear is top-secret and cannot be shared with anyone outside the company. It's a fairly simple concept which takes three pages to say, unfortunately.

The following example is a non-disclosure statement in its simplest form. You will often see these as additions to contracts, instead of a standalone document.

It is understood by the below signed individual that all information obtained while providing service will remain confidential and that he/she will not directly or indirectly disclose to any third party or use for its own benefit, or use for any purpose other than the above mentioned project.

By signing an NDA, you are sworn not to divulge any information about the company's projects. This legal document will make you think twice about talking. The last thing you need is a lawyer standing up in court waving an NDA with your signature on it. Game companies take this very seriously and I recommend keeping a tight lip for your own sake. Everyone working in the industry has signed one of these, so when conversation turns uncomfortably toward the specifics of your new project it is always safe to say "I'm under nondisclosure" and they will understand.

An in-house composer will sign an NDA when first taking a job, but after a few months working with the company, her or his loyalty would never be questioned. As a contractor, game companies have more of a reason to hold you to such agreements. Because you don't "belong" to them and it's hard to keep a close eye on you, they are a bit more paranoid. You have contact with many other game companies who are all competing in the same marketplace and a slip of the tongue could end up costing a company their entire project. With millions at stake, this type of industrial espionage (accidental or not) is highly frowned upon. They would not hesitate to drag your butt into court to recoup their losses.

Consider the following example. Say you worked on a project with Company Y and might have overheard some information about their next ultra-secret game title. Over at Company Z, where you are talking to a producer about doing their next game, what you heard over at the other company casually comes up in conversation. It turns out they have a similar game in the making and based on the information you just provided, they move their timetable up in order to beat Company Y to market. The game is released with great fanfare and is acclaimed as an innovative and trend-setting game. Company Z's stock shoots up and orders for millions of copies of the game flood in from around the globe. Two months later, Company Y releases their game with mediocre reception. It's proclaimed a copycat and dies a miserable death on the store shelves. Company Y can't understand why they failed horribly. Then one of the producers casually mentions to the CEO that you had done the audio on Company Z's game and he remembers how angry you were at not winning the contract for this game. Suddenly, their legal team springs into action and decides you had to have been the one who leaked information about their secret project. Whether you were the one or not, they may have a case against you if you signed their NDA.

I don't mention this to raise fear. I want you to understand that video gaming is a serious business and discretion on your part is necessary. What you learn about a company in the course of conversations should *always* be held in confidence—regardless of whether an NDA was signed. If you get the reputation of being a blabbermouth, companies will stop talking to you. You wouldn't want competitors learning your secrets, especially if you've discovered a niche where you've cornered the market—so be respectful of the game developers whose lifeblood is the success of their product.

Work-for-Hire Agreements

When a song or sound effect is created, these audio entities are owned entirely and exclusively by the creator unless that creator happens to be working under a work-for-hire agreement. This type of contract states, in various manners, that any work created for a specific project is owned by the company that hired you. There's little doubt who owns the work in question. In-house composers and sound designers are always under this type of agreement. They work directly for a game developer, the developer pays them a salary to be on their staff, and thus the company has the rights to everything created on their premises.

There are varying agreements which allow in-house personnel to retain rights to their creations if they are not done for a specific project, but to keep this concept simple, assume if you work in-house, the company owns all of your work. It can be negotiated to use the studio for your *own* projects after hours or to do other freelance work during down time which you would keep all rights to. Some companies are okay with this; others strictly forbid composers to do any outside projects. Be sure to ask if you apply for an in-house position and intend to continue doing outside contracting work.

For the third-party contractor, this type of agreement is left a bit more open to interpretation and negotiation. It is entirely possible, by signing an agreement in the developer's favor, for them to own everything you do for a specific project. This means every scratch music track you produce during the composing and recording process and every sound used to produce the sound effects could potentially belong to them.

For example, I did a sound effect of an old prospector and his mule walking up to a gold mine where the character says, "Well, looky there Betsy, it's the Lucky Nugget!" The sound is a compilation of the character's voice, a mule braying, pots and pans clanging, and a crow squawking. It was created under a work-for-hire agreement. The original agreement stated the developer would own all of the sounds used to create the effect, including the voice characterization done by hired voice talent. I negotiated, instead, that the sound they would own would be the work in its final form and *not* the pieces used to construct it.

My argument was simple. Everything up until the point of completion was an "idea" and it would create problems trying to control ownership of a sound that I don't own the rights to in the first place. Some sounds were taken from licensed sound libraries and some I recorded myself. If they had insisted, I would have explained while it could be done and that I would be willing to sell specific sounds I had recorded, it would severely limit my creativity having to rely solely on my own remote recording abilities and then being able to use the sound only once. Because of the time involved, they could not afford to pay me to go out into the field to record donkeys and crows every time I needed one. Having my own library and other licensed sound libraries at my disposal saves an incredible amount of time and money.

The work-for-hire agreement is not a bad way to proceed if you pay attention to the points of the contract. They are negotiable and it behooves you to ensure your interests are covered. The developer will have to own *something*, there is no getting around that, unless limited licenses are involved—whereas you grant them the full use of music and sounds in the one game on the one platform. Then, licensing issues will come into play if they want to use it on other platforms or sequels to the game. It gets even more complicated, so hang on.

Copyrights

Copyright issues could easily make for an entire book but instead, I will attempt a few highlights in a couple of paragraphs. Copyrights can be complicated and as clear as mud, needing an entire staff of lawyers to understand completely.

In a nutshell, whomever owns the copyright to a piece of work, either music or a sound effect, owns the work in its entirety and is free to use and/or license the work for whatever and to whomever they choose.

For our purposes in the gaming world, the developer or publisher will almost always demand to own the music and sound outright, leaving little room for discussion. By doing so, they can now reuse your music and sound effects in every sequel to the game, on every platform, in every television commercial, in every movie, and even release a soundtrack album—all without you ever seeing another dime.

Now, to sidetrack for a moment, if you end up licensing the audio for every instance mentioned previously, you are set to do very well without lifting another finger. The work is already done, the game companies are just paying you more to use it in the other instances. If they insist on owning the copyrights, it becomes another matter—and in order for you *not* to lose future monies for your efforts, you must charge them a much higher fee for a complete buyout. With development budgets first on their minds, you can offer the same work for less money in a licensing arrangement. If they insist on owning all rights, they will have to understand it will cost them more for you to leave your work and walk away.

An argument, using the previous story about the old prospector, could also relate to copyright issues. Who owns the voice characterization? In this case, the voice talent does. The only portion the game company owns is the line he spoke embedded in the complete sound effect. This "sound" is just another one of the layers of sounds which make up the entire effect in its final form. They don't own the character. Now, if they were making a game called *The Zany Adventures of Mr. Prospector and His Mule, Betsy*, the vocal characterization rights could be transferred to the game company. When a character is created for a large project, such as *Duke Nukem*, the game company will purchase the rights for that voice characterization to ensure that other games don't hit the market using their specific character. They will pay quite a bit more to retain ownership and the rights to exclusively use the character.

Licenses

Licensing is when the owner of a copyrighted piece of work grants exclusive or nonexclusive use of the work for a negotiated fee. When a song is composed and recorded onto a particular medium, the composition is protected under copyright laws. If you file an application with the U.S. Copyright Office for the piece of work, you own the copyright in a more official and legal sense. As we mentioned before, if you sell that song to a game company to use in their game, you've transferred the copyright to them and they are free to use it in every game, every commercial, and every soundtrack they produce until the copyright expires and the music enters the public domain. Licensing comes into play when you let another entity, such as a game company, borrow your song for their project—but you retain all rights to it.

Smaller developers would be more likely to seek out licenses to use your work in their game because it is more affordable for them. Because they are not buying the rights to the work, they will instead pay a smaller fee for the privilege of using it. You will grant them limited use of the work to be used *only* in their game and nowhere else. Depending on the agreement, they may negotiate that you cannot sell the music to another game company for a reasonable length of time—so that they may retain some semblance of originality. It doesn't mean you can't turn around and sell the music to a film or TV project; you can indeed if it's part of the agreement.

Music and sound effect libraries use this concept in their daily business practices. Audio is usually released in CD/DVD format—some offered as downloads from the Internet. When a purchase is made, it may be implied mistakenly that the buyer owns the music and sound effects. You've got a physical piece of matter in your hand which was paid for; it can be naturally assumed it belongs to you. In the case of library titles, this is a wrong assumption. The company is only granting the license to use the included materials as stated in their purchase agreement. You don't have an exclusive right to the sounds. Any other party who pays the users fee can use it in their projects.

Licensing is possible in the gaming world, although developers usually strive to own the original compositions in their projects outright. But a cost-conscious one might consider the option of licensing instead.

Platforms

Game platforms are considered to be any console, computer system, or game system a computer or video game can be played on. The PC, Mac, Wii, Xbox 360, PlayStation 3, Nintendo DS, Sony PSP, and video arcade consoles are all examples of separate game platforms. You will often hear a developer say a game will be "ported" to another platform, meaning that conversions will be made to the game in order to work on another game platform. Your ears should perk up a little when you hear that word because it could mean some extra income for you. I'll give more details in the section "Negotiable Contract Points" shortly.

SKUs

A SKU (pronounced "skyoo"), or stock-keeping unit, is another way of saying "game release" or "game platform." It's actually a unique code assigned to merchandise for inventory purposes. When making video games and porting them from one platform to another, a new SKU will be generated for the new version of the game to be sold to the public. These numbers can be found in the product's bar code, enabling stores with computerized inventory and point-of-sale systems to keep track of merchandise. Practically every item you find for sale in a store will have its own unique SKU—whether it's the grocery store or the record store.

For us in gaming, it can mean additional income to the savvy content provider who has foresight. Not only could a game be released on a different platform as another SKU, but say the same PC game is translated to another language for sale overseas, the game could be identical in every respect except for the language—and this SKU could earn you income if your music and sound effects are used in it. While technically it won't be issued a distinctive code for sale in the United States, it's considered a different product and could earn you additional monies.

Ancillary Rights

Ancillary rights pertain to the usage of content outside the project it was originally intended. Music and sound effects for games occasionally stray into other domains, such as TV, film, and CD soundtrack releases—far from the original purpose of their creation. When working under an agreement to compose music or create sound effects, the intention is to conceive these original pieces for the video game only. This is as far as they ever go most of time. But the billion-dollar video game industry is far-reaching and there will be instances when music you've composed or sounds you've designed will appear outside the boundaries of the game.

"Earthworm Jim" is an example of a video game character turned Saturday morning cartoon star. Tommy Tallarico had done the music for the game series and because of his negotiation prowess, he was also paid when the music was used in the cartoon series. The game company owned the music rights in the game, but Tommy had included an ancillary rights clause to split any net profits earned by his music outside that game. Bobby Prince of *Doom* fame had also negotiated ancillary rights to his audio work in the game and was compensated after a few sound effects appeared in several movies. This type of agreement allows the composer and sound designer to continue to reap the benefits and rewards of their efforts when their work appears outside the games realm. While it isn't quite the standard in the industry, enough game composers and sound designers are including it in their agreements that it is becoming more and more commonplace.

Bonuses and Royalties

Being part of a blockbuster game project is like winning the lottery. It's never anything we plan on. After months of putting our blood and sweat into the music and sound obligation, we normally part with a nice paycheck and thanks for our efforts. Occasionally, a game does so well that it breaks sales records around the world. In cases like this, it isn't enough to just be part of the winning team; it has to be in your contract for you to receive a bonus or royalty payments.

Bonuses are usually more palatable for a game company. For example, if their break-even point on a game is 60,000 units, a bonus after 100,000 units sold is a comfortable margin and the game company shouldn't have a problem with sending additional money your way. They can be set up in various stages, say a $10,000 bonus after 100,000 units, a $25,000 bonus after 250,000 units, and so on. It's completely up to you and the company during contract negotiations. Bonuses are easy to calculate and audit because they are based solely on the number of units sold.

Royalties are payments of a percentage of sales, usually made in quarterly installments. Unlike the music industry, the games industry usually turns its nose up at this type of arrangement. Calculating payments demands too much bookkeeping and time. It's not unheard of—just not a pleasant experience for the game company. If they scoff at the idea, consider the next option.

A more "planned" form of royalties, similar to bonuses, are straight percentages. These payments are calculated from net profit, after the game company has recouped its costs and has had a reasonable return on the investment. Like bonuses, payments can also be structured in stages based on the number of units sold or amount of money earned in increasing levels. The percentage could also be established at a comfortable number past their break-even point. An acceptable figure in the industry for established game composers is 1% to 1.5% of the net profits.

Normally, bonuses and royalties are negotiated by game composers who do music or both music and sound for a project. It is less common for a sound designer to negotiate bonuses and royalties for sound effects only, but not far fetched. I, as a sound designer, wouldn't consider asking for a bonus on smaller games where I only do a couple dozen sounds. For major game releases and hundreds of effects, that would be a different story. It is entirely dependent on the situation. But, it never hurts to ask. The worst that could happen is they say "no."

Deals with publishers will be more lucrative because they've got the bigger pie. That pie, in turn, gets divvied up among the developer and everyone else associated with the project. If you were to make the deal directly with a developer, unless they are self-publishing the title, you would be negotiating for a piece of their smaller slice of pie. Most of the time, the developer has to consult with the publisher when royalties and bonuses are brought to the table anyway, so why not just deal with them directly on the matter?

Property Rights

To further complicate matters, we can sell music to a game company but keep the property rights to release it as a soundtrack. It is similar in theory to negotiating ancillary rights, but this endeavor won't be split with the game company. "How can that be?" you ask. A game company is not a record company; they aren't set up that way and they don't understand the intricacies associated with it. They sell games. They distribute games. They do not sell music. There are record companies set up to duplicate, market, distribute, and sell game music and its success can be attributed to their years of experience. If I were to release music I'd worked hard on and was proud to share apart from the game experience, then I would want to go with the outlet with the most potential.

Still, the music will be associated with the game it was created for—and having the game company's support will make the experience much easier for both parties. While they may be reluctant at first, once they see the excitement your efforts bring to their product, they should be thrilled. You will shoulder the risks entirely—covering all the costs of the soundtrack release, handling all of the details, and never involving their time or resources in the process. They take no risk whatsoever and reap the advertising benefits and hype your efforts create. They'd be blind to miss the potential rewards of this type of plan.

But, if for some reason the developer still has issues with releasing the property rights, consider a compromise and offer them a 50/50 split of the revenue as an enticement. In return for their shared commitment in the up-front costs associated with a soundtrack release, they can share in the benefits of any sales without expending any effort. What business wouldn't be interested in making money from someone else's work? And, you'll have the possibility of increasing your earnings on the same music. Whether your costs of production, duplication, and packaging can in fact be recouped for putting a soundtrack together, by maintaining the property rights, you'll at least have the option if the opportunity presents itself.

Talent Releases

Whenever guest musicians and voice-over talent are involved on a project, it is always a good idea to have them sign a talent release. This legal document releases all of the

interests and legal rights of their performances to you, the contractor, and/or the game company. By doing so, the developer can be assured their interests are protected and that someone who may have played a small role in the overall production doesn't come back years later, after the game is a hit and sue for more money. In most cases, these documents are a requirement and will be a part of your contract to ensure no one else has any interest in a piece of work but you.

These documents also serve as a mini-contract for your guest talent, outlining the services required of them, how much they will be paid, and any other specific points unique to the project. Professionals expect to sign such paperwork and they understand the need. Others, not as accustomed to the particulars, might not be as willing to part with their signature and may need some gentle persuasion. Be careful to not get into a situation where your hired talent doesn't sign the release. If you use it in the project, it could lead to more trouble than you are willing to deal with when the developer comes looking for you down the road. Make the agreement plain and simple; either they sign the release or they don't get paid. Period.

Composer at Work

Mike Brassell

Mike Brassell—composer and voice-over artist.

Do you have any specific thought process when scoring for a game?

I try to immerse myself fully into the storyline and the characters as much as I can before and during writing. One thing I have found crazy helpful is to create my

(Continued)

orchestral palette before-hand. That way, as I view cinematics or game footage I can start synth-estrating earlier in the process—actually working out cues instead of just coming up with a piano melody. I really appreciate the visual imagery I receive and ask for as much as I can get to help stimulate the creative process. Doing a lot of reference listening really helps out, too. I mean, everyone wants to end up writing something as great as *Halo* or *God of War,* and maybe that'll happen, but the thing to focus on is to write your best for the game that's in front of you—each and every time.

Are there any secrets to your creativity?

I find that inspiration hits me more often when I'm not trying to write anything specific—when I'm doing chores around the house, for example. I've learned that to be the secret to unlock better ideas. It's funny how I'll be taking out the trash or doing the dishes when, *blam!* this great melody or action cue will become so vivid in my mind that I go running off to capture that brilliant flash of inspiration—leaving the trash where it dropped and the sink full of dishes until I work out the idea. Eventually I'll return to finish the chores. Eventually.

When do you find that you are most creative?

After lunch, mostly, when all of the morning activity has dissolved and the day is well underway. That's a great idea time, but the real "grind it out" time comes after nine p.m. until about two a.m. Oh, and of course right before a project's deadlines. Isn't that always the case? It's good practice to pick a time and stick with it. Tell your family and loved ones that you have to go and write but you'll take them out to dinner and then go write (but don't forget about taking them to dinner, because then you'll come out having something written but will be staring at angry, hungry people...not good).

How did you find your way into the games industry?

Being an avid fan of gaming from way back, it wasn't hard for me to put my two loves together: music and video games. That being said, I really started to get serious in 2003—when I starting talking with developers, developing key relationships, submitting demos, going to seminars and, of course, following through with lots of the advice in Aaron's first book.

Be sure to check out the sample agreements and contracts in this chapter and on the companion DVD.

Negotiable Contract Points

When negotiating contracts, the sky can be the limit. The process generally hinges directly on the personalities involved on the two sides—what their interests are and how creative they want to be when solving issues. Simple and reasonable requests can be taken care of

easily, but difficult issues can take weeks before reaching some type of consensus—leaving behind tension and ill will.

During contract negotiations, your general concerns will be how much work you need to do, how much time you have to do it in, and when and how much you get paid for doing it. In most simple gaming projects, there won't be much more than that. We are gearing up for the larger projects—where you work hard, get paid well, and can receive additional rewards for your efforts. There is much at stake for game companies and for you, which is why we need to be smart when dealing with these types of situations.

Part of being "smart" is knowing and understanding what contract points are acceptable in this particular business. The items discussed next are by no means all-inclusive. We will cover some serious ground, but in order to get it all, I'd need to write another book. For those of us who are imaginative with contract negotiations, there will be many "one-time" opportunities that present themselves and it will be up to you to take advantage of them. It will simply become another natural part of doing business.

Money

The primary negotiable contract point is money—mainly how much you will get paid and by what method. Much time can be spent dancing diplomatically around this particular issue. You know your costs and what you would want to make on the project. This is the leeway you have to play with during negotiations. Assuming the game company had you bid on the project first, they also have a good starting number with which to work from, too. You heard right: "starting" point. Don't feel compelled to stay with your original figure to avoid looking greedy. The parameters of the project might have changed several times since your original bid submission. You will need to adjust your price accordingly. They need to understand that it is due to their changes, not yours. Be ready for it.

Once a game company brings you in as part of the team, they tend to begin coming to you for everything: advice, favors, and other trivial audio matters. They may think it would be cool to have audio for their company logo. They may need a sound effect for another project and will ask you to do it. They will call on you for almost everything, and while it's certainly okay to do these kind of favors, you need to be aware it will be taking time away from other valuable money-making endeavors. Keep this in the back of your mind during negotiations and bring it to the table to justify your request for more money if they challenge your figure. Remember, they are a business attempting to keep as much money in their pockets as possible—and since their bottom line is the most visible to management and investors, their need to justify expenditures is tremendous. These "favors" can tip the scale in your favor.

If the amount of money you request for the project becomes an excuse for them to find someone else, concede this "deal ender" and consider making up losses in other areas. If the amount of initial cash outlay is the problem, change the amounts of milestone payments to their liking—with the later payments being the highest. Or negotiate your payments, bonuses, or royalties from their incoming receipts instead of from their operating capital—or negotiate equivocal services; perhaps artwork for your web site, programming a simple interactive demo for your promotion package, web site hosting, or maybe even a trade for some computer or recording gear they have lying around. If there is a

problem, work together to solve it instead of facing each other unblinking from opposing ends of the table. By being flexible, you will gain points to use during other issues of the negotiation.

Licensing

As mentioned earlier, most game companies insist on owning the music and sound effects created for their project. Under a work-for-hire agreement, this is clearly stipulated and will give you the impression there is nothing left to negotiate. Again, we could not be further from the truth. Everything is still completely negotiable! There are many types of licenses in this type of work—more than we could ever cover sufficiently. Whatever you do, during discussions about licensing, be sure to keep your options open and ready for anything.

If a game company complains your prices are too high for the buyout option, suggest they license your music and sound at a lower cost instead. You'll recall that by licensing your music, they don't have ownership—just a license to use it in their work. You would still retain full copyrights and could sell or re-license the work to others at your discretion. Smaller game companies who end up licensing work will negotiate an *exclusivity agreement* that states that the music won't appear in any other video game application or does so only after a predetermined length of time has expired (usually a year or two, depending on the life expectancy of the product). You can be very creative here.

Another licensing issue could be your right to self-promotion; that is, to use works you created for demonstration purposes. If a company opts for the full buyout, they own the copyrights—leaving you begging permission to use your own music. Seems silly, I know, but that's the way it is in the big world. Under normal circumstances, they have no qualms letting you promote your work and will license the music back to you for this purpose. They will never volunteer it though. It will be something you have to ask for because it is serving your interests and not theirs. Here's an example of wording you might use for this application:

Right to Self-promotion. Contractor has the right to self-promotion and is allowed to use, as creator of said works, any works created under this contract, to demonstrate the capabilities of contractor either in demo reel or computer file format at any time after acceptance of the work as final, without any further permissions required from Company.

Platforms

You sold your sonic masterpiece to a game company for a CD-ROM project and you assume that is that. Wrong again. What if they port it to the Xbox 360, PlayStation 3, or the Wii or make an arcade game out of the darn thing? Would you get compensated for your music and sound effects ported to these new versions? Unless you had it in the contract, the answer is a heartbreaking "No!"

Did you know there are people whose sole job in life is to take another composer's music, re-perform, re-record, and convert it to a format compatible with another gaming

platform? Why are they paying someone else to do it when they could be paying you instead? Why wouldn't they want the original composer to redo their own music in all its glory? Who knows. In order to protect this future income, have it as a contract point—stating you will do any conversions needed to port the music to any other game platform they request for an agreed-upon sum. Assuming the music was great in the first place, you are assuring them that the same quality and feel will be accomplished in the new format—maintaining the high standards originally set forth. Another person's interpretation of your music is an unknown; you risk ruining the entire audio mood of the game. What would game developers rather have: the original composer recreating his heartfelt masterpiece or someone else coldly regurgitating musical notes for a paycheck? Remind them of your value and get it in the contract.

SKUs

Almost hand in hand with the platform issue is the SKU. Don't walk away knowing they plan to release the project on other game platforms and in other languages to be sold internationally. Are you crazy? The company intends to make fistfuls of cash by releasing the game in several different versions using artwork, programming, and sound already paid for. Except for the cost to port and repackage, their profit margin is huge. What do the original creators receive for their hard work and dedication? Nothing, unless they negotiated this point in the contract. Get it in your contract!

SKUs, next to royalties and bonuses, allow the greatest income potential you can realize.

In order to take advantage of this potential moneymaker, you'll have to negotiate that the music and sound effects you create and sell to them are for the *primary SKU only*. If they use it in another, they have to pay you for that right. Big games, with average budgets in the millions of dollars, will cost a publisher roughly $200,000 to port to another platform. After much market research, they know this SKU will make a hefty profit for them or they wouldn't have wasted their time doing it in the first place. Do you think they would really care if you asked them for an additional $10,000 for every SKU your audio appeared in?

With large budgets, this is just a drop in the bucket and won't affect their bottom line whatsoever. But they will probably resist, saying they've paid you for the audio, it's their property, and they can use it however they like. Until you sign the contract, it's not their music—so you would really be arguing about nothing. If they intend to make other versions of a game, using your audio and making a handsome profit for themselves, why couldn't they reward the hardworking creators who made it happen for them with a measly 10,000 bucks? As an enticement, you can offer to make any necessary conversions for that fee, saving them the cost of having someone else do it. It then becomes an "extra service" you perform and they can justify it to the bean counters. If $10,000 is still too steep, after you've exhausted every argument, consider dropping it a couple thousand—but don't ever give it away for free.

Ancillary Rights

Occasionally, other moneymaking opportunities present themselves outside of gaming. If the popularity of the game spawns a TV show, cartoon, or movie, chances are your music and sound will be licensed as part of this new undertaking as well. Who gets paid for it? It depends on what's in the contract.

As mentioned previously, ancillary rights are not standard in the industry yet. For the big composers, however, it is more so and the practice will eventually trickle down to everyone else. One of the ways to achieve this is to make it a standard request for each contract. Eventually, when a game company pulls out their contract for signature, this clause will already be there. After every composer they've dealt with brings it to the table, they'll catch on and save some time by just doing it up front. That will be a nice change.

For those who regularly negotiate this point, the usual agreement is to split the net profits derived from the reuse of your music and sounds 50/50. Because they will be spending money to make these new endeavors a reality (hiring lawyers, additional marketing, and administrative chores), it is appropriate to split the money *after* they've recouped their costs (i.e., the net, not the gross income). Divvy up the profits more in their favor if need be; say, 60/40. If you are open to some give and take in the process, you can still walk away with a tidy sum. Or you could hold fast and lose the deal completely. It's a fine art indeed.

The same goes if they decide to release your music on a soundtrack CD. You can either negotiate to split the profits from this type of product or try another tactic: negotiating the property rights to release the music on your own, which we'll talk about shortly. The direction and the mood of the proceedings depend on the personalities at the bargaining table, which points they hold fast to, and what your needs are to secure fair compensation for your work. If they don't like splitting their profits with you for a soundtrack release, consider doubling your fee to make up for the lost income potential. An example: If the CD of your music sells 100,000 copies, your potential income could be $250,000! Doubling your rate from $50,000 to $100,000 for complete buyout on the project might seem like a lot to them, but it won't come close to the possibilities of what your hit game soundtrack could do in Japan or Europe. Consider what worldwide sales of your music could bring to the publisher and it seems ludicrous not to share in the fortune.

Bonuses and Royalties

There are many ways to proceed when dealing with these types of contract points. Generally, the easier you can make it for them, the more willing they will be to agree to your terms. They shouldn't have a problem spreading the wealth to the people who helped make the game a success, and as a composer and sound designer, you are responsible for a third of the total game experience. Good businesses appreciate the contributions from the creative team and will reward them accordingly. Others, more concerned with squeezing every bit of profit they can from a game, will be less likely to. If you have the misfortune of running across the latter type, you will have to work much harder to convince them you are deserving of more compensation. If it becomes a heated contest, then consider walking away from the deal—because at this point, it has all the signs of a rocky relationship and no money in the world would be worth it.

Royalties are not common, so the path of least resistance would be to request structured bonus payments as the alternative. Instead of requesting a percentage of their income from the game, which becomes complicated back in their accounting department, suggest bonuses based on the number of units sold. All you have to keep track of is how many of the darn games they've sold and if it has passed one of your negotiated milestones. Simple enough. And because this money is from incoming receipts and purely based on sales figures, they are assuming no risk and will lose nothing if a game doesn't sell well.

To establish your bonus structure, you need to know their break-even point and then set your first installment at a comfortable level above it; say, 75% to 100% more. As an example, if a game's break-even point is 60,000 units it would be acceptable to ask for a $10,000 bonus after 100,000 units had sold, $20,000 after 200,000 units, and so on.

Because these negotiations are happening prior to any work being done, this incentive can have a direct impact on how well you do your job. If they've set a generous payment schedule in front of you and correlate your creative efforts with the success of the game, you will be highly motivated to do the best work you've ever done. With that kind of backing and trust, you will naturally step up to the plate and hit a home run! Psychologically, it is an incredible boost to your creative powers and you will strive to make this game a hit. Remind them of this, as part of your presentation. Let them know what you can do if properly stimulated. Or, explain what the opposite effect will have. While you are a professional and can provide high-quality music and sound effects regardless, the lack of inspiration and the sense that the company is just a sweatshop will have a dramatic negative effect.

Property Rights for Soundtrack Release

As a composer, it is essential for our success and business well-being that a music soundtrack CD is released. It is the type of national exposure and moneymaking potential that may have enticed you into the music business in the first place, except that we are accomplishing it now in the games industry. If the sales potential exists, you or the publisher will want to do it. Either way, your music has to be able to reach the masses and this is the perfect method. If acquiring the ancillary rights and splitting the gross profits for the soundtrack doesn't appeal to the game company in question, perhaps they would be willing to let you try your hand at releasing one instead. It won't cost them a cent and they will take absolutely none of the risk while gaining the marketing and exposure advantages. Unless they have plans to release a soundtrack in the works already, there is absolutely no reason they couldn't let you give it a try.

Name Credits, Logos, and Splash Screens

Naturally, after all of this effort, money is not the only thing you want to negotiate. There are many other points to take advantage of which will increase your business and name recognition. There is no better advertising for your services than the music and sound effects you've proudly created presented within a game. For vanity's sake, millions of people living the experience your audio creates is an uplifting event. For marketing sake,

having other game developers researching and playing these games, hearing your efforts, is the best "demo" you can offer. When game companies decide to do a project, they generally examine every other game in the genre. Wouldn't it be great to have them discover the perfect composer for their new production in one of these games? Of course it would!

Now, in order for future clients and fans to know who did the brilliant audio, it has to be seen somewhere. Don't take this point for granted, thinking they will automatically give you space on their credits page. Most companies do attempt to give credit where credit is due, but just to make sure, have it in your contract that they will, at a minimum, include your name in any printed or on-screen credit sections. Take it a step further and have them include your contact information or web address, too.

You can also request to have your name and logo on the box cover and as one of the opening splash screens while the game is loading. You can't beat the value of your audience anxiously awaiting the game to start and seeing an entire screen with your name on it, something like: "Music and sound effects by award-winning composer...." It also builds excitement just before the curtain is opened. Psychologically, it will even make their perception of the sound better because, obviously, this sound guy must be good if they have his logo everywhere! TV and film always give a full screen to the key players so the public is accustomed to this method of presentation. For the rest of the game, the player will be listening a little bit closer to see who this notable personality is. That's what you want—to be noticed!

At this point in time, there are not many composers and sound designers requesting their name or logo on the box cover or on the splash screen. And, to tell you the truth, I believe it's just because they haven't thought of it yet. Here's a chance to get a leg up in the marketing department if you're in the mood. Game companies don't mind flashing a small picture file or sparing some pixels for your name on a splash screen, but logos on box covers may be another story. PC game boxes have generous real estate to accommodate 1/4-inch by 1/4-inch logos. They are seldom denied. Xbox, PlayStation, and Nintendo boxes, CDs, and game cartridges are much smaller and it's usually not possible to squeeze them on even if they wanted to. What little space there is they keep and it will be fought over ferociously in-house between their marketing, art, and sales departments. In cases like this, push a little harder for that splash screen because it will probably be all you can get.

Final Authority

It is extremely important to have the person who has final approval of your work identified and that person's name put in the contract. Why, you say? Because you want to get paid, that's why. Otherwise, decisions will be put off, waiting for someone else's opinion, and it will go around and around in the company until the game is published. No one wants to take sole responsibility. There are many creative people with varied opinions involved during development and it is impossible to please everyone. Have one named individual who can give "thumbs up" to your submissions, going on their own gut instinct or after taking a poll, allowing you to meet milestones and get paid according to the schedule in the contract.

Here's another war story for you. I've had a couple of companies whom I've done sound for call me up in a bind and need some sounds done within a couple of days. I jump on it, fire them off, and then never hear a thing back. After a couple of weeks, I start to wonder and grab the phone to find out they are beta testing or waiting for the company president or something else to happen before they make the decision on which sounds

they will keep. Weeks turn into a couple of months and still nothing. Finally, after about three months, now that the game has been released, I find out what I need to know and send an invoice. A lot of work to be paid for a dozen sound effects and by the time the check arrives, I've forgotten what project it was for. If we'd agreed upon the final authority at the beginning and in this case, changed my billing method from "per sound effect" to an hourly rate and billed them immediately, we both could have saved the extra effort.

I work best knowing who it is I'm trying to please. Ultimately, it is the game player, of course, but in this business, it will normally be the executive producer or creative director or someone high up on the project's design team. You'll have to work closely with this individual and it will be important to know their thought processes, what they need to make the decisions, and how best to keep them happy. There is a bit of "schmoozing" involved, but the definitive test will be the quality of sounds you submit. If they get the sense you are working hard, they'll feel they are getting their money's worth and are more apt to use sounds and music you've submitted instead of having you redo them.

Tools of the Trade

Aaron Marks

Aaron Marks is a composer, sound designer, voice-over artist, and president of On Your Mark Music Productions.

I previously considered myself a mid-level game composer and sound designer, having found my niche with mid-sized developers and online companies, but lately I've been moving toward the triple-A projects. Always open to catching the big fish, I gear my mindset and equipment list toward that goal. Previously, I had a collection of gadgets—impressive to studio visitors but basically just taking up rack space—which eventually was streamlined to only what was in constant use. If it hadn't been used it in a year, out it went.

Computers: (1) Pentium IV, 2.4 GHz, 1 GB RAM, 160 GB RAID array (two piggy-backed 80 GB hard drives), DVD-R, SoundBlaster LIVE Platinum 5.1 sound card,

(Continued)

Emu 1616 interface, cable modem, dual-head video card with 17- and 19-inch monitors. (2) Pentium IV, 2.8 GHz, 1 GB RAM, 120 GB hard drive, DVD-R, SoundBlaster Audacity sound card, MidiMan 2 x 2 MIDI card, cable modem. (3) Compaq Presario laptop with a Celeron, 1.8 gHz CPU and 512 MB RAM connected to an Emu 1616 card bus and USB MIDI adapter—plus several external hard drives for backup and easy sound effect library access.

Software: Sound Forge, Adobe Audition, Nuendo, Vegas Pro, Cakewalk Sonar, ACID Pro, CD Architect, Cool Edit, Goldwave, and numerous plug-ins.

Multi-track system: Nuendo, Cakewalk Sonar, Vegas Pro, and two ADATs synced to PC.

Mixing board and monitor system: Tascam M2600 24 x 8 x 2, Alesis Monitor Ones, Alesis M1 active monitors, Event PS8 active monitors and subwoofer, Orb center channel speaker.

Outboard: Numerous effects processors and compressors.

Keyboards and sound modules: Alesis QS8 with various Q-cards, Akai S5000 sampler and extensive sample library (yes, I still have use for an external sampler!), Roland Juno 106, Kawai K-1, Kurzweil MicroPiano, Akai AX-80.

Instruments: Electric, acoustic, and bass guitars, Roland TDK-7 E electronic drum set, standard acoustic drum set, numerous hand percussions, coronet, saxophone, flute, kazoo.

Remote recording: Tascam DA-P1, M-Audio Microtrack, laptop, and occasionally a really long microphone cord.

Sound effects libraries: Sound Ideas, Hanna-Barbera, Warner Bros., LucasFilm, BBC, my own extensive collection.

Navigating Negotiations

Musicians and sound designers are not generally taken to be serious businessmen. The free and easy lifestyles we supposedly live make us a little too "wild" for the business world and we are quickly pigeonholed into this category. One of the unique traits that set game composers apart from the rest of the musician world is that we do have a fairly good nose for business, which we have to have in order to run a successful company. But the stereotype is so well entrenched, you'll have to try much harder to prove yourself.

The demo package is the game company's first look into what we are about. The bidding process is their first chance to see whether we have some brains to go along with our creative genius. The contract negotiations will set the tone of your business relationship, whether you are the whiny prima donna artiste they originally feared or a professional service provider with a good sense for business and honest concern about the product's success.

Normal contract negotiations start by the person who brought you on board (usually the game producer) faxing or e-mailing you their contract. You spend a few days looking it over—talking with your legal advisor, adding your points, countering with your version, or simply signing. If you did have something to add, they'll mull it over, talk to their legal people, hem and haw among themselves, and counter with their new version. At this point, you will find it much easier to just pick up the phone and talk directly to the producer. E-mails can cloud the process, becoming too time consuming or harmless comments can be taken out of context, unintentionally offending someone. You can safely discuss the points which are most important, reach some sort of agreement, then wait for their legal department to give the final okay. Once they've finalized the contract, you'll sign it and then get down to what you've been hungry for: making music and sounds. Simple enough.

The more complicated negotiations may require you to fly to their office with your team and meet face to face with a boardroom full of their people. It doesn't actually happen as much as you'd think, though, so don't get nervous. Be prepared for this possibility only when you start dealing with large companies with large budgets and large global interests.

A Real-world Negotiation

Out of the dozens of contracts I've negotiated, there was only one which didn't go very well. Most of the time, it's a simple business affair with the two parties calmly and professionally discussing the needs of both companies. We resolved them amicably and moved on with our lives. This particular example was definitely a case of big egos on their part and concrete stubbornness on my part and in the end, we both walked away—they without sound for their game and me without a contract. I mention it here as a real-world case of what can happen when the two sides can't see eye to eye. Maybe we can both learn something.

I was called to a game developer's office to discuss a work-for-hire contract with the company's president and executive producer. The game was funded by a big name in Hollywood and, on the outside, looked to be a promising title. It was to be released for the PC and PlayStation simultaneously, with later plans for a Nintendo version. We were still one year away from the expected release and it appeared I could accommodate the project in my schedule. It looked like the kind of game I wanted to be associated with and I was anxious to get to work.

The speculative demo I had submitted was good enough to beat out three other composers and I was excited to be their man. I showed up 10 minutes early and was ushered into the boardroom to wait until the company's key players could attend. After a half an hour sitting alone, the president walked in, apologized for the delay, said it would be just a couple more minutes and disappeared. Forty-five minutes later, three of them walked in, apologized, and we settled in. At this point, I'm forcing a smile. I'm on their home turf, outnumbered, my butt is getting sore, and I have the sudden urge to use the restroom. Instead of giving them the chance to disappear and get involved with something else, I shuffle in my seat and decide to hold it instead. We've got work to do and I have another commitment to attend to later that day.

"Aaron, thanks for coming. We're looking forward to having you on board as an integral part of the team and can't wait to get things rolling. We've got high hopes for the game and we'll probably be working you hard," the president said, firmly in charge of the meeting. I nodded my head, smiled, and continued to listen. They moved into the history of the

company, how the game came to be, and mentioned Mr. Hollywood's name about a dozen times. I continued to nod and smile, trying to hold in my excitement as things were building towards a good offer. I was waiting for someone to slide a copy of a contract in front of me, but soon realized they didn't have one. Instead, they verbally covered the high points—all the standard contract stuff, nondisclosures, ownership of the rights, my duties, blah, blah, blah. I kept copious notes during the process, noting that they required that I be on-site three days out of the week. I put a star by it. I'd have to find out what they meant by that. I feverishly continued, trying to digest what they were saying and preparing my rebuttal speech—the opportunity I knew had to be coming soon.

"All right, Aaron. That's it. Thanks for coming."

"Uh, but I've got a few questions and a couple of items I'd like to discuss," I stuttered, slightly stunned by the speed of my dismissal.

"Sorry. We're out of time," he said, looking at his watch. "We've got something pressing to attend to. We'll fax you the contract shortly. Just sign it and fax it back. In the meantime, you can start working on some other ideas, and if you could have them to us by the end of next week that would be great. Thanks again," and they were gone.

I sat alone in silence for a moment wondering what the hell just happened. Did I say something wrong? No, couldn't have been that. I never got to open my mouth. Oh, well. These guys are obviously busy, I shouldn't worry. I'll give them a call tomorrow instead.

On the trip home, I couldn't avoid the uneasy feeling I was getting about this job. I couldn't put my finger on it, but something wasn't quite right here. Different game companies have different styles, but these guys were downright odd. Why did they keep name-dropping? Why did they call me all the way to their office for that? Why do I need to be on-site? A lot of questions; much to answer. Maybe I shouldn't start any work on this until we have a signed contract.

The next day, I called Mr. President, he seemed to be in a good mood and more receptive to two-way conversation. He talked a lot about the project and what kind of audio feel they wanted, sticking to a safe subject. I heard him mention they would be doing their own "sound design" in-house, using one of their programmers. They had just bought a sound library they would be using exclusively. "Do you think we bought a good sound library? By the way, what's a good audio editing program? Do you think I can get a good one under a hundred bucks?" he asked. I reminded him I was also a sound designer and could take care of the sound effects instead of leaving it to their guy, who would surely be busy doing other duties. I also explained that the sound library he bought had been available for many years and the sounds were already overused. I could make fresh, original sounds for the game, giving it its own audio identity, so to speak. Without even talking price or considering my idea, he said "no," and that was that. I attempted to shift the conversation toward the contract and was suddenly placed on hold. He had another call. Two minutes later he was back on, saying I should be there tomorrow morning at 10:00 a.m. to discuss the contract. Okay, I'll be there. Here we go again.

Ten a.m., and I'm steered into the president's office. He's on the phone. I get a nod to be seated and take up position directly across from him. He's not smiling. The phone conversation ends, and without as much as a hello, he rolls in right where we left off two days ago.

"Here's the deal. We need sixty to seventy-five minutes of music for the game and would like it completed within sixty days," he opened.

"What kind of budget are you proposing?" I asked, trying to get a feel for the overall picture.

"The entire audio budget is ten thousand dollars—sound effects and music," he countered.

As I scrape my jaw off the floor, trying not to look offended by the apparent slap in the face, I do a quick calculation in my head. *Hmmm, my usual fee is a thousand per finished minute. That would be sixty to seventy-five thousand dollars. I could discount the entire project to roughly seven hundred dollars a minute. That would be forty-two to fifty-two thousand five hundred, and maybe go as low as an even forty thousand. But he's proposing sixty to seventy-five minutes at ten thousand. I would have to drop my price to about a hundred and sixty-six or a hundred and thirty-three per finished minute.*

"How much is left for the music if you guys are doing the sound effects in-house?" I ask.

"About nine thousand," he says. Then seeing a sign that I'm having some trouble with that particular figure (which I thought was hidden behind my poker face), he continues. "Just think of the exposure you'd have as a composer on this game. This game is going to be big. We've already run the numbers and between the three platforms, we expect at least a quarter million units to be sold. This would be great for you. Just think of it. You could write your own ticket in the industry."

I silently doubt it and continue to grind the appropriate gears in my head. "Nine thousand would be for one platform only?"

"Nope, for all three. We need to have full ownership of the music and ten thousand is a firm number."

"If I do the music for that price, would you consider a bonus; say, after a hundred thousand units or perhaps royalties on each unit sold?"

"Nope."

"How about if I keep the rights to release the soundtrack on my own?"

"No can do. We require full ownership."

"Well, since I'd be practically giving away the music, what if I just sold you the rights for the video game? But if the music ever appeared in a TV show or movie or if you released a soundtrack, I could expect some income from that?"

"Aaron, I don't think you quite understand. We are offering you an opportunity to be a part of a very big project. Mr. Hollywood is backing us all the way and we know this will be big. With your name on this project, think of the other games that will practically fall into your lap. To have your name on a huge project is the best advertising you can get. I don't know what industry you are working in, but frankly your rates are a little high. Ten thousand is a very generous offer and we think you would be stupid to pass up this opportunity."

At this point, a hundred comebacks are running through my head—none of which I could actually say out loud. I know what rates are standard in the industry and I'm on the lower end of that. I know having my name on a big project will have a positive impact on my career. I know he makes a good case, but I'd be losing money and spending a lot of time on this. I have to make a living somehow. "You mentioned earlier that you required me to be on-site three days a week. What is that about, specifically?"

"Ah, yes. We will need your help to implement the sound effects and the music for the cinematics and gameplay. We'd need you here two, maybe three, days a week for that. That isn't a problem, is it?"

"Will you pay my hourly wage for those days?"

"No, we were hoping you would include that in your fee," he said.

"Well, if I'm going to be spending time here, I won't be able to work on any other projects and I'd need to make something for my time," I countered.

"We'd like to, but it's not in our budget. We just can't do it. Sorry."

At this point, I think we'd hit rock bottom. They were asking me to score roughly 60 minutes of music, plus they wanted me on-site to help implement (translation: help the programmer put the sounds in the game) three days a week for I don't know how long and pay me $10,000 for my efforts. No bonuses, no royalties, no soundtrack, no ancillary rights, no chance to make another dime off this project. I may have considered it for $50,000 to $60,000 and negotiated it down to one day every couple of weeks to be on-site. After all, I had to actually be in my studio to do the composing. I could tell this was going to be the veritable project from hell, and these guys were unbending. If it was such a big game with the backing of Mr. Hollywood, why wasn't there money to match? There were too many unanswered questions and I was still a little steamed at his comment asking me what industry I was working in. Somewhere in there I think he called me stupid, too.

I didn't know what to do. We'd reached a sort of impasse and my spider senses were all tingly. It's hard to walk away from what could lead to fame and fortune, but I wasn't about to be a prostitute either—grumbling every day about working for this obviously uncaring company who placed no value on the creative people. It was pretty clear the only ones who would benefit from this "big" game was the management and Mr. Hollywood. I wouldn't be able to convince them of their arrogance without making a scene, so I had nothing else to say.

"Well, I appreciate your consideration for this project. It looks like it would be fun, but I'm going to have to pass on it," I said at last.

"What? Are you sure? You're giving up quite an opportunity here. Sure you won't reconsider? Why don't you think about it and call me in a couple days?"

"No, it's pretty clear. I can't do it. I would lose too much money doing this project. You aren't offering me any other chances to break even and I can't take the risk the game will be as big as you say. Unless you could bend on some of the points I mentioned, I just couldn't do it."

"No, unfortunately, we can't. We have everything laid out, budget wise, and it just couldn't be done on our end."

I sat there, unthinking, staring out the window behind his head.

"Well, Aaron, good luck to you then. Sorry we couldn't work together," he said, gesturing toward the door as he got up from behind his desk.

We shook hands and I departed. After a couple of months, I finally let it go. Yeah, I blew a perfectly legitimate chance to score a "big" game title, but what I ultimately saved on headache and lost revenue is what convinced me—without a doubt—I'd done the right thing. There will be other fish to fry, I'm certain of that. But, it's funny how things work out. If this deal had been offered to me just a couple of years ago, I would have jumped at it with both feet and learned many valuable lessons the hard way.

You don't have to live it to learn the lesson. Make sure you never get yourself in a losing position. Always look at your bottom line and the interests of your "company."

The unscrupulous developers won't. They know creative people are a dime a dozen and if they dig down far enough, they'll eventually find someone who would beg to pay them to do the project. We don't want to cheapen the industry, so fight the good fight and get paid what you are worth. Sleep with one eye open if you have to.

Follow-up: Flash forward a year and a half later as I'm strolling the corridors of GDC. It's been a great trip and I'm in a fantastic mood, enjoying the conference and a chance to see colleagues and friends I haven't seen since the last visit. I'm all smiles as I happen upon a circle of fellow composers and stop dead in my tracks as I hear that infamous game title mentioned. Funny thing, the game had been out for about a month to a very mediocre reception (and consequently all but disappeared from existence a few months later) but I had never heard who was finally hired to do the music. Overhearing the discussion, I suddenly realized who the focus was on—and without a conscious thought, hurriedly corralled the individual to a nearby corner. "Excuse me, folks. He'll be right back."

"You did the music for *that* game?" I said as quietly as I could in the noisy space.

"Uh, hey, Aaron. Uh, yeah, I did but they ended up not using it," he said, suspicious of my inquiry and wondering why his back was up against the wall.

"Were they still only paying ten thousand for the audio?"

"Er, yeah. Hey, how'd you know that?"

"Did their programmer do the sound effects?"

"Yeah."

"Did you have to help them implement?"

He starts to smile, realizing I must have been that "other" composer the developer had talked about. "Uh huh."

"Tell me you didn't do the sixty minutes of music for only ten thousand!"

"Okay, I won't," he paused. "I only did ten!" A big grin began widening on his face.

Several seconds of silence went by as I digested what I'd just heard.

"Why, you son-of-a-gun!" I said finally, incredibly relieved that he hadn't let them take advantage of him—shaking his hand vigorously in congratulations! "I'm so glad to hear that." I was also secretly wondering why I hadn't thought of that.

"You know something, I believe I have you to thank," he whispered in my ear. "If you hadn't given them that little dose of reality, I think they'd still be trying to find someone to do the music for that. They didn't seem too shocked when I told them my rates were a thousand a minute. Guess they'd heard it before, eh?"

"Uh, yeah," I said, still in disbelief and making a mental note to put this in my bag of tricks for next time.

"But, the weird part about all of this is even after we went through all of that, I did the music and they paid me and everyone was supposedly happy. When the game came out, it didn't have any of my stuff in it. I called them up to see what happened and it turns out Mr. Hollywood changed his mind, said the feel was all wrong and ended up hiring somebody else to do the music!" He took a breath and looked around. "So, after all of this talk about getting my name on this big title and getting into Mr. Hollywood's inner circle, I'm a little disappointed."

"But, you did get paid for the music and you can still put it on your resume"—reminding him that he hadn't been taken advantage of or cheapened our talents. "And that's always a good thing."

"I guess you're right."

Composer at Work

Ron Jones

Ron Jones is a composer and owner of Ron Jones Productions.

Describe your process for composing and scoring.

I try to know the story and the characters completely. So I read the script, watch the film or gameplay, and really learn everything I can. After this, I ask myself questions that gradually narrow down the direction of my musical response to the project. I call it an informed approach because it is founded upon the knowledge of the story. Next, you ask yourself questions about the music. You ask what sort of melody, harmony, rhythm, and orchestration would support the story and characters best. This usually yields a basic group of themes and musical idioms. Then, as I score each scene that material becomes the building blocks of the individual cues. One can always choose to do something different when you want to. This approach, I find, helps you get things in a good workable zone from which a coherent score can come from.

Are there any particular secrets to your creativity?

Modern neurological understandings of how the creative brain works has confirmed for me that there are several layers to that creative act. So much of what is required for scoring is not really creative, rather, it is more constructive productivity as the main engine. Creativity is easy—do something different! It helps to clearly distinguish between creative tasks and constructive tasks, since they are not the same.

I would guess that aside from a genetic endowment which has always given me a limitless well to pull ideas from, I would have to say it is my process that propels me and helps me sit and crack out an amazing amount of very musically demanding scores, all in wildly diverse styles and instrumentation.

When do you find you are most creative?

I can write and be creative anytime. Pressure and the stress of very little time just forces you to sit there and throw notes on the paper. So, there is no special time for me really.

Any specific "lessons learned" on a project that could be shared?

Every project should demand your best work. If the producers don't have a high standard, you should always frame the project as it is the greatest thing ever—even if it sucks. Score to please yourself first. Usually, this will more than satisfy most producers and this needs to just be the way you work.

Do you have any negotiation techniques others could learn from?

Composers make terrible negotiators. Get a third party, an agent, or a legal adviser to represent you. Otherwise, the composer will be taken advantage of. Get everything in writing.

Any good advice when beginning a project?

It's all about being a good listener. It is their pet project. First let them fully explain and express their ideas. Be totally interested in them and in their project.

Have you had any interesting music creation techniques that resulted in a notable piece of music?

As a result of scoring several episodes of the popular sci-fi series *Star Trek: The Next Generation*, I found myself scoring cues which subdivided the ensemble into smaller groups. These smaller groups would play music designed to incorporate many time signatures and tempi simultaneously in real time. This created a different sense of time and space—so it was a leap, but it came off very well!

How did you find your way into the games industry?

Actually, they found me!

Negotiation Pointers

The contract and negotiation process is almost everyone's least favorite. The creative process is held up until the contract is complete and signed, and most people are just not prepared for this type of confrontation and find it difficult to separate business from personal feelings. You'll find that a lot of people take every issue you present very personally

and never quite get past it. The rest of your working relationship suffers because you turned out to be a different person than what they may have originally perceived. It's not your fault—they just become mad at themselves for not being prepared for the business issues and your professional business charm. They are like you: creative people who just want to make video games and hate ever having to deal with contracts and legal documents. That's why the big companies have legal departments; they handle the details and the producer gets to make the games.

When you are presented with a contract and begin the process, keep it strictly business. Stay away from getting personal or taking things personally. When two companies get together to negotiate a contract for service, with teams of professionals sitting on opposite sides of a boardroom table, there is no doubt what they are accomplishing is business. Just because negotiations seem more intimate when it is just you and a producer, it is exactly the same.

Don't be intimidated if you are outnumbered at the meeting. Think of it as a summit between all of the team members, working together to solve certain issues. This mind-set will keep you away from looking at it as an adversarial confrontation and let you work together toward the common good of both parties. There will be occasions when a developer may try using this intimidation factor to keep you from asking for too much and digging into their bottom line. You'll have the upper hand instead with this way of thinking.

There will be times when carrots are dangled before you—certain enticements designed to get you to sign the contract without adding your points to it. Be on the lookout for these and never feel like you were pushed into "buying something" from an overly aggressive salesman type. If you feel pushed, back off with the ball in your court and slow the process down to a more comfortable level. One thing I will *not* do is sign something I haven't been able to fully review.

I once had a game developer's lawyer fax me a contract with the instructions to "Sign this and return to me ASAP." The red flag went up. I told him I needed a few days to review it with my legal department and we ended up arguing about his take on copyright laws. Turns out, he knew nothing about copyrights and was a real-estate lawyer who was helping out the developer and wanted me to sign a document which would give his company full ownership of sounds I had licensed from a sound effects library! He didn't understand the concept that I could use licensed sounds as part of my work and sell the final product to them. Don't be forced into something you aren't totally comfortable with. While it may be a big company, with huge financial backing, your company is your life's blood and everything you agree to has a direct effect on its well-being.

Here is another thought. Let's say I felt strongly about earning a bonus after the game sells 250,000 units and it was the only point I brought to the table. When they say "no" that one time, there will be no psychological effect you could use to springboard on to another point. The negotiations are over. If I brought *several* points to the table, it is nearly impossible for a decent human being to say "no" to every single one of them. Even if they tried, after awhile they would realize they were beginning to sound like parents—saying "no" without good reason.

Experienced salesmen use this trick every day. They know you will say "no" at least five times before you start to waiver and eventually begin to say "yes." That's when they swoop in for the kill and make the deal. There have been studies done on this very phenomenon and I have experienced it firsthand myself at car dealerships and in other high-pressure sales situations. Our "trick" is to turn this around and use it to our advantage.

If you bring every contract point mentioned earlier to the table, I guarantee you, you'll walk away with one—if not several.

There is no need to be "high pressure" in this instance, but this subtle technique can definitely win you some bonus points. Now, I don't recommend trying this at your first contract negotiation with a small developer. Save it for the big boys and you'll have good results. The smaller fish may get intimidated and assume you are too high caliber for their needs.

Strike a delicate balance between what you ask for and what you know is a reasonable request. I wouldn't fight and claw my way into having a small developer, who is self-publishing a title, give me a $10,000 bonus after the game sells 100,000 copies. An instance such as that would be lucky to sell 20,000—plus a $10,000 bonus seems like a lot of money to developers on shoestring budgets. I would rather get my logo on the box and a splash screen in the game. I know they could do that.

Only *you* know what your business needs to survive, income-wise and marketing-wise. That's what a game project ultimately represents. You alone will have to look out for those interests. Even if the developer works for the most benevolent organization out there, they won't know your needs unless you express them.

You may be sitting there thinking, *Man, this guy is a greedy son-of-a-gun*. I wouldn't say it that way. I just know what the industry will tolerate and I ask for it. I became a musician for many reasons and being able to actually make a decent living doing it is a dream I am finally living. Business is not a place for timidness. Greatness cannot be achieved without taking care of your survival needs first and then being able to have the equipment to make grand music. It costs money, and a lot of it. I'm telling you, this is a great way to make it all happen. Make a lot of money. Buy your gear. Make awe-inspiring music. Rise to greatness on your talents and achieve the type of recognition you deserve. Ask for the bonuses, royalties, ancillary rights, and property rights and be successful. If you just sign their contract to make a fast $10,000 and nothing else, you've made the quick buck but you've missed the point. You'll always struggle and will eventually be unable to continue in your pursuits. You have to take care of yourself by taking care of business first. That's what the negotiation process is really about.

Tools of the Trade

Keith Arem—composer and sound designer

The control room at Keith Arem's million dollar facility, PCB Productions.

(Continued)

When I purchase equipment, I look at gear as a long-term investment. I try to evaluate where the industry is going and what tools I will need over a period of years. Even when I first started off, rather than buying inexpensive gear that would be outmoded within six months, I would save and invest in better equipment that I could use as foundational elements of my studio. Software will inevitably become outdated quickly, but the hardware it uses should not. After several years in the business, some of my gear has become hopelessly outdated—but I still find use for some of my first keyboards, pre-amps, and microphones.

Computer: MAC G5, PC

Software: Pro Tools, Sound Forge, plug-ins galore

Multi-track system: Pro Tools

Monitor system: M&K 2510, Genelec

Mixdown: ProControl

Microphones: Microtek Gefell UMT70s

Remote recording gear: 744, Pro Tools

Sound libraries: Custom

Change Orders and Reworks

A *change order* happens when a developer decides the creative route they are taking is wrong and makes the decision to try another direction instead. These moments happen in every business, around the world, but the first time it happens to you, it will literally crush you. How would you feel after spending a couple of months living and breathing a project, composing a magnificent score, putting your heart and soul into it, days away from recording it with a full orchestra, and then having a producer tell you they've decided on a techno score instead? Or how about actually completing a sound effects project and getting the word at the last minute they need to be redone for a different "period in time"? Your first instinct will be to throw your hands in the air. Your second thought will be: how are these contingencies covered in the contract?

Change orders happen. They are a way of life in the winds of creativity and big business. Expect them, prepare for them, plan for them. But, unfortunately there is no correct formula to apply when putting it in writing. Just make sure you are not caught in a position where you are taken advantage of and start losing money on the deal.

In a case where you may be working toward milestones, have it put in the contract that if any major creative changes are requested, you will keep the payments already received and a new milestone schedule will be worked out. If you are working for a flat fee, make sure something is in the contract or separate agreement which covers any added expense and time on your part. Spoken agreements are easily forgotten.

Reworks are a close cousin of change orders and also something to watch for. While change orders are basically starting over, *reworks* are taking the same piece and redoing it until it is right. For music, it might mean replacing certain instrumentation that sonically interferes with something else or changing the length of the piece. Maybe that music needs a gradual fade in and fade out; maybe it needs to be louder. The same for sound effects. Many times the length of the sound corresponds with a character action and has to be matched exactly, or perhaps a certain part of the sound is very grating if heard repeatedly. Maybe it's too loud. Whatever the requirement, you will redo the audio until it works perfectly.

I personally don't have a problem with reworks. They are a completely acceptable part of the job. What does bother me, and most other audio folks as well, is taking it to the extreme where it becomes a change order in disguise. The problems begin after receiving guidance from the producer for the music and sound effects, sharing the work while it's in progress, getting the appropriate nod that you are heading in the right direction, and then having to spend an unacceptable amount of time redoing everything. Communication must be the number one priority and if you are having trouble with it, you are bound to spend much time with reworks as a consequence.

Therefore, there has to be an agreement regarding reworks. When guidelines are established at the beginning of the relationship, a plan will be clear and no one will be taken advantage of. The developer won't have to settle for audio they aren't happy with and the contractor doesn't have to waste time redoing things. With open communication among the players, it should be fairly obvious when the contractor has reworked something to death and is starting to lose all feelings for the piece. At that point, whatever contingency was established should come into play. The bottom line is: you should never lose money on a contract, ever. You may feel slightly taken advantage of at times, and it's always a good business practice to go the extra mile for the client without complaint, but there is a limit. To protect your interests, it needs to be spelled out in the contract.

Sample Agreements and Contracts

The first time I saw a game contract, I nearly fell over backwards. Now, after dealing with them enough, I'm fairly comfortable with them—and more importantly, I am able to pick up on the portions that affect my interests directly. The more you see, the better you will understand—such as how they are worded and what others are using in the business. One of the goals of this book is to get you primed and ready for these very things. This section includes actual examples to examine closely, and as a bonus, they are included on the companion DVD for your use as well.

Contracts and agreements can come in many forms, from simple to the ridiculously complicated. It is entirely up to you which ones you use. I recommend, however, when dealing with smaller companies, to keep it as simple as possible and not to scare them away by presenting a demanding 10-page contract. They are more than likely in the same boat as you when it comes to experience in these matters and will appreciate your conscious efforts to not cloud the already complicated game production process. As you work up to the big companies, longer contracts with many points will be accepted as the norm.

Sample Nondisclosure Agreement

The following example is a complete NDA—the type of document you will normally be signing prior to obtaining any detailed information on a project. It has been written by a contract lawyer to cover every detail. This is a standard form in the industry and you will sign many in your career. Most are primarily concerned with guarding company secrets, but occasionally you may find wording which requires you to destroy or return materials used to create a project when the relationship is terminated. Use care when dealing with those types of contracts. Make sure, if they deal with your work product directly they do not override any other prior agreements and ensure the project contract specifically states it overrides the pertinent paragraphs in the NDA regarding your interests. You don't want to be faced with contractual conflictions like this in court, where a good lawyer could distort facts to say you were the one breaching the agreements.

Nondisclosure Agreement

THIS AGREEMENT is by and between Company X, Inc., a California corporation ("Company X") and the party or business signing below ("Receiving Party").

WHEREAS, Company X wishes to discuss and evaluate a potential business relationship with Receiving Party relating to video game hardware and software (hereinafter "Subject Matter"); and

WHEREAS, the progression of the aforesaid discussions will necessitate the passing of confidential information from Company X to Receiving Party.

NOW, THEREFORE, in consideration of these premises and the mutual covenants herein, the parties, in order to safeguard the disclosed confidential information, agree as follows:

1. "Confidential Information" for the purposes of this Agreement shall mean any and all information (1) disclosed in written materials, or (2) obtained visually by viewing premises, equipment, or facilities, or (3) disclosed by oral communication relating to the Subject Matter. Confidential Information shall include, but not be limited to, future market and product plans, marketing and financial data, engineering information, know-how, trade secrets, ideas, service and manufacturing processes, product designs, software data and information, and other information of a technical or economic nature related to the Subject Matter. Confidential Information submitted in a written or graphic form shall be clearly marked as "Confidential."

Any information that is transmitted orally or visually, in order to be Confidential Information subject to this Agreement, shall be identified as such at the time of disclosure and identified in writing to the Receiving Party as Confidential Information within thirty (30) days after such oral or visual disclosure. Confidential Information shall reference this Agreement.

2. Company X shall disclose such Confidential Information as it deems necessary for it to fully evaluate its interest in establishing a business relationship relating to the Subject Matter.

3. The Receiving Party agrees to (1) receive and maintain the Company X Confidential Information in strict confidence, (2) use the disclosed Confidential Information solely for the purpose of evaluating the business proposals under discussion, and (3) prevent unauthorized use or reproduction of the Confidential Information, including by limiting access to Confidential Information to employees, agents, or affiliates who are necessary to perform or facilitate the purposes of this Agreement and who are bound to hold such Confidential Information in confidence pursuant to the terms of this Agreement. (As used herein, the term "Affiliate" shall mean a corporation or business entity that, directly or indirectly, is controlled by, controls, or is under common control with the Receiving Party). This obligation of confidentiality and limited use shall not apply to (a) Confidential Information that at the time of the disclosure is in the public domain; or (b) Confidential Information that, after disclosure, becomes part of the public domain by publication or otherwise, except by breach of this Agreement by the Receiving Party, or (c) Confidential Information that the Receiving Party can establish by reasonable proof was in its possession at the time of disclosure by Company X or is subsequently developed by that Receiving Party's employees who have no knowledge of or access to the Company X Confidential Information; or Company X Confidential Information that a Receiving Party receives from a third party, who has a right to disclose it to that Receiving Party.

4. Either party may terminate the discussions without prior notice, for any reason, at any time, and without liability or restriction, other than the obligations of confidentiality and nonuse and the obligation to return the disclosed Confidential Information as provided for herein.

5. Upon conclusion of the discussions contemplated hereunder, unless otherwise agreed by the parties in writing, all written or graphic Confidential Information together with all copies thereof shall be returned to Company X, provided, however, that one copy may be retained in the Receiving Party's legal counsel files for archival purposes as a means of determining any continuing obligation under this Agreement.

6. The Effective Date of this Agreement is defined to be the latest date below written. The obligations of confidentiality and nonuse under this Agreement shall expire five (5) years from the Effective Date.

7. Nothing contained in this Agreement shall be construed, by implication or otherwise, as an obligation for any party hereto to enter into any further agreement with the other, or as a grant of a license by Company X hereto to Receiving Party to use any Confidential Information disclosed other than for discussions or evaluations relevant to the purposes of this Agreement.

(Continued)

8. This written Agreement embodies the entire understanding between the parties and supersedes and replaces any and all prior understandings, arrangements, and/or agreements, whether written or oral, relating to the Subject Matter.

9. This Agreement shall be construed in accordance with the laws of the State of California.

10. This Agreement is divisible and separable so that if any provision or provisions hereof shall be held to be invalid, such holding shall not impair the remaining provisions hereof. If any provision hereof is held to be too broad to be enforced, such provision shall be construed to create an obligation to the full extent allowable by law.

11. Each party represents and warrants to the other that it has the right to enter into this Agreement without breaching or violating any fiduciary, contractual, or statutory obligations owed to another.

IN WITNESS WHEREOF, the parties hereto caused this Agreement to be duly executed by their duly authorized representatives.

COMPANY X, INC. Receiving Party

By: By:

Title: Title:

Date: Date:

Distribution of Originals

One (1) to Company X, Inc.

One (1) to Receiving Party

Sample Talent Release

This example of a talent release is about as simple as they get and as complicated as they need to be. Because the purpose is for you to obtain the rights to their performance, there isn't much more to discuss or negotiate. You may run across professional voice talent who have been around the industry long enough to see the potential of their contribution—say, in film or other non-game releases—and might persuade you to pay him or her more. They may even attempt to secure ancillary rights for the same reason. I would never deny someone running their business and negotiating use of their "product" this way, but as the sound recordist in this case, I am not in the position to negotiate this type of request.

When games use high-caliber or name-brand voice talent for a lead character in the story, it is usually the game company who will handle the deal making with the individual. All you may need to do is just record them, edit their narration, and convert it for

the company. In cases where you've hired voice talent on your own, for a smaller contribution such as in a sound effect, it would be easier to hire and pay for their performance outright. If it goes beyond that, you'll spend more time than you could imagine being the intermediary between the game company and the talent—the unwilling go-between. My advice: Find someone who will perform their part, sign the release, and accept a lump payment as a fair trade.

Authorization of Release

For value received in the sum of _____, I, the undersigned, give and grant Composer/Sound Designer/Company X, its affiliates, successors, and assigns the unqualified right, privilege, and permission to reproduce in every manner or form, publish and circulate video games, compact discs, videotapes, audiocassettes, or films of recordings of my voice and/or my musical contribution arising from the production titled _____ and hereby grant, assign, and transfer all my rights and interest therein.

I specifically authorize and empower Composer/ Sound Designer/Company X to cause any such video games, compact discs, videotapes, audiocassettes, films, and recordings of my voice and/or musical performance, to be copyrighted or in any other manner to be legally registered in the name of Composer/Sound Designer/Company X.

Nondisclosure

It is understood by the below signed individual that all information obtained while providing service will remain confidential and that he/she will not directly or indirectly disclose to any third party or use for its own benefit, or use for any purpose other than the above mentioned project.

I am of lawful age and sound mind, and have read and understand this Authorization of Release.

Signed this _____ day of _____, 20_____.

_____ (Signature)

_____ (Print name)

Sample Contracts

Contracts can be particularly difficult to comprehend and their impact, dramatic. What you agree to by signing on the dotted line may return as a surprise, having not fully understood the convoluted legalese. To understand these potential nightmares, learn to read them, become familiar with them, and spend some time with them prior to having to negotiate your first one.

Contract A

Our first contract example is simple by contract standards but just as legally binding. It is designed with new or small developers in mind—the idea being to keep it simple for them as well and not to scare them off by making it more complicated than it has to be. New game companies are learning right along with you. Many have never dealt with sound contractors before. If you present them with a contract like the last one in this section, they'll end up thinking they can't afford you and will go find someone else. Later, after you've done several games and start approaching the big fish, they'll end up scaring you with their contracts and lawyers instead.

Work Made For Hire Agreement

This Work For Hire Agreement (the "Agreement") is effective as of _____, 20___ ("Effective Date") by and between Company X, Inc. (hereinafter referred to as the "Company"), a California corporation located at _____, and Composer Y (hereinafter referred to as "Contractor"), an individual residing at _____ _____.

In consideration of the mutual covenants herein contained, the parties hereby agree as follows:

1. Services

 (a) Contractor shall create audio content as determined by Company from time to time in a manner consistent with the outlines, explanations, and designs established by the Company (hereinafter "Services").

 (b) The Contractor agrees that any work he submits to Company under this contract, when accepted and payment is honored, becomes the property of Company and Contractor further agrees and acknowledges he has no proprietary interest in any of these works. Ownership rights to any work not paid for shall be returned to the Contractor immediately.

2. Term and Termination. This Agreement shall continue until terminated by either party upon 10 days' written notice, provided that termination by Contractor shall not be effective until completion of any work requested by the Company.

3. Payment For Services. The Company shall pay Contractor in a manner mutually agreed upon by each party for each project contemplated. ("Payment") for Services.

4. Independent Contractor. It is understood and agreed that Contractor shall perform the Services as an independent contractor. Contractor shall not be deemed to be an employee of the Company. Contractor shall not be entitled to any benefits provided by the Company to its employees, and the Company will make no deductions from any of the payments due to Contractor hereunder for state or federal tax purposes. Contractor agrees that he shall be personally responsible for any and all taxes and other payments due on payments received by him from the Company hereunder.

5. Warranties

 (a) Original Development. Contractor represents and warrants that all work performed by him for or on behalf of the Company, and all work products produced thereby, will not knowingly infringe upon or violate any patent, copyright, trade secret, or other property right of any former employer, client, or other third party.

 (b) Warranty of Expertise. Contractor represents and warrants that he is highly skilled and experienced in providing the Services required. Contractor acknowledges that the Company is relying on his skill and expertise in the foregoing for the performance of this Agreement, and agrees to notify the Company whenever he does not have the necessary skill and experience to fully perform hereunder.

 (c) Other Agreements. Contractor represents and warrants that his signing of this Agreement and the performance of his consulting Services hereunder is not and will not be in violation of any other contract, agreement, or understanding to which he is a party.

6. Indemnification. Contractor shall indemnify the Company from all claims, losses and damages that may arise from the breach of any of his obligations under this Agreement.

7. Protection of Confidential Information

 (a) Confidential Information. For purposes of this Agreement, the term "Confidential Information" means all information that is not generally known and that: (i) is obtained by Contractor from The Company, or that is learned, discovered, developed, conceived, originated, or prepared by Contractor during the process of providing Services to the Company, and (ii) relates directly to the business or assets of the Company. The term "Confidential Information" shall include, but shall not be limited to: inventions, discoveries, trade secrets, and know-how; computer software code, designs, routines, algorithms, and structures; product information; research and development information; lists of clients and other information relating thereto; financial data and information; business plans and processes; and any other information of the Company that the Company informs Contractor, or that Contractor should know by virtue of his position, is to be kept confidential.

 (b) Obligation of Confidentiality. During the term of this Agreement with the Company, and at all times thereafter, Contractor agrees that he will not disclose to others, use for his own benefit or for the benefit of anyone other than the Company, or otherwise appropriate or copy, any Confidential Information, whether or not developed by Contractor, except as required in the lawful performance of his obligations to the Company hereunder. The obligations of Contractor under this paragraph shall not apply to any information that becomes public knowledge through no fault of Contractor.

(Continued)

8. Ownership and Assignment of Rights. All Work Product created by Contractor shall belong exclusively to the Company and shall, to the extent possible, be considered a work made for hire for the Company within the meaning of Title 17 of the U.S. Code. To the extent the Company does not own such Work Product as a work made for hire, Contractor hereby assigns to the Company all rights to such Work Products, including but not limited to all other patent rights, copyrights, and trade secret rights. Contractor agrees to execute all documents reasonably requested by the Company to further evidence the foregoing assignment and to provide all reasonable assistance to the Company in perfecting or protecting the Company's rights in such Work Product.

9. Duty Upon Termination of Services. Contractor shall immediately deliver to Company all Work Product created under the Agreement. Contractor shall not delete any Work Product for six (6) months after expiration or earlier termination of the Agreement unless such deletion is requested by Company.

10. Subcontracting and Assignment. The Agreement and the rights and obligations of Contractor hereunder may not be subcontracted, assigned, or transferred by Contractor, in whole or in part, without the written consent of the Company. The Company may at its sole discretion assign or transfer the rights of the Agreement.

11. Governing Law. This contract will be governed by and construed in accordance with the laws of the State of California.

12. Consent to Breach Not Waiver. No term or provision hereof shall be deemed waived and no breach excused, unless such waiver or consent be in writing and signed by the party claimed to have waived or consented. No consent by any party to, or waiver of, a breach by the other party shall constitute consent to, waiver of, or excuse of any other different or subsequent breach.

13. Gender. Whenever the content of this Agreement requires, the masculine gender shall be deemed to include the feminine.

14. Right to Self-Promotion. Contractor has the right to self-promotion and allowed to use, as creator of said works, any works created under this contract, to demonstrate the capabilities of contractor either in demo reel or computer file format at any time after acceptance of the work as final, without any further permissions required from Company.

15. Sound Credits. Credit for creation of any sounds produced under this contract will be included in the appropriate "credits" section of any software product and its corresponding print media in which the sounds appear, as created by Composer Y.

16. Entire Agreement. This Agreement constitutes the complete and exclusive statement of the agreement between the parties with regard to the matters set forth herein, and it supersedes all other agreements, proposals, and representations, oral or written, express or implied, with regard thereto.

IN WITNESS WHEREOF, the parties have executed this Agreement as of the Effective Date.

CONTRACTOR	COMPANY
By:_____	By:_____
Its:_____	Its:_____
Date:_____	Date:_____

Contract B

This next contract example is the one our mutual friend, Tommy Tallarico, has been kind enough to share. Skewed rightfully in the game composer's favor, it is full of all of the appropriate paragraphs which cover the interests of composers who wish to retain ancillary rights and obtain bonuses or royalties for the success of the game. The majority of the time, large game companies have their own agreements drawn up and seldom entertain a composer's contract—again, because they want their interests protected.

The work-around is to use like paragraphs and wording when introducing your points to their contract. By all means, present this kind of contract to them first. It will show your professionalism, business prowess and the fact that you know what you are doing. They may not make full use of it, but you've at least put them at ease in regard to the job you can do. Conversely, you might raise their guard—introducing points they are not familiar with which will lead them to gather their legal forces. Negotiations are a game of wits and their lawyers give them a sense of security. All the more reason to have your ducks in a row and stay one step ahead.

Audio Development Agreement

This Audio Development Agreement (the "Agreement") is made and entered into by _____ ("Composer") and _____("Company").

WHEREAS, Company desires to retain Composer to develop and deliver to Company the audio known as _____musical score (the "Composition") for _____ (the "Game"); and

WHEREAS, Composer desires to develop the Composition on the terms and conditions set forth herein.

NOW THEREFORE, The parties hereto do hereby mutually agree as follows:

1. COMPLETION DATE; DEVELOPMENT: Composer shall develop the Composition according to the schedule attached hereto as Schedule 1. Composer agrees to

(Continued)

use diligent good faith efforts to develop the Composition according to the dates specified on Schedule 1. Composer acknowledges that time is of the essence of this Agreement and that Composer's best efforts must be utilized to complete the development of Company's Game. Composer agrees to be readily available for all reasonably requested revisions to the Composition. Composer shall develop the Composition in accordance with the information, materials, or other instructions provided by Company. Company acknowledges that Composer can only achieve timely performance of the matters required of Composer if Company timely delivers to Composer appropriate information and guidance. Company shall not attempt to declare Composer to be in default of this Agreement for delays caused by Company's inability to deliver information/guidance to Composer in a timely manner.

2. COMPENSATION: As compensation for the Composition, Company shall pay Composer the fees specified on Schedule 1. Composer acknowledges that this payment by Company represents the complete and entire obligation owed to Composer or any other party, either by Company or any other third party, for the Composition to be provided by Composer under this Agreement. If Composer uses any third parties in providing the Composition not specifically authorized and required by Company, Composer shall be responsible for the additional costs. If this Agreement is terminated without cause by Company, Composer shall be entitled to receive the next unpaid milestone within a reasonable time deemed appropriate by Company not to exceed six (6) months. All milestone payments will be invoiced by Composer and due within thirty (30) days upon completion and acceptance of milestone by Company.

3. RIGHTS: All results and the proceeds of Composer's work hereunder including without limitation, the Composition and any revisions, amendments, modifications, translations, alterations and enhancements, and sequels thereto, and derivative works therefrom, whether produced by Composer, or a third party and regardless of form, including without limitation, mechanical, code or written, and all materials produced by Composer in fulfillment of its obligations hereunder, including but not limited to reports, memoranda, drawings, documentation, and models, shall be deemed to be a work made for hire for Company within the meaning of the copyright laws of the United States or any similar analogous law or statute of any other jurisdiction and accordingly, Company shall be the owner throughout the world. However, where sounds or "demo" songs are rejected by Company and not made a part of the Composition, such rejected sounds or demo songs shall remain the property of Composer.

Without limiting the foregoing, Composer hereby assigns all right, title, and interest in and to the Composition and all of the foregoing furnished to Company hereunder, whether copyrighted or not. Composer shall assist Company and it's nominees in every proper way to secure, maintain, and defend for Company's own benefit copyrights, extensions, and renewals thereof on any and all such materials. The Composition shall be used in connection with all video game systems including

CD-ROM, all personal computer and home multi-player systems and or consoles and all distribution of such games through other entertainment systems or media presently known or unknown, now in existence or hereafter created or developed (collectively the "Uses"). In the event that the Composition is published for purposes other than or not related to the Uses such as cassettes, CDs, or albums, TV broadcasts, etc. that are not published in conjunction with the Game as samplers (collectively the "Additional Uses"), fifty percent (50%) (the "Percentage") of the Net Profits ("Net Profits") will be compensated to each party. Net Profits shall be defined as money which is actually received with respect only to its direct sales related to exploitation of the Composition for the Additional Uses less any monies that have been spent or are required to spend with respect to negotiating, developing, producing, or in any way preparing the Composition for the Additional Uses.

4. CONFIDENTIALITY: Composer acknowledges and agrees that any information which it may receive from Company, will be proprietary information of Company (the "Proprietary Information"). Composer agrees, both during and after the term of this Agreement, to hold in confidence all Proprietary Information of Company and to prevent the unauthorized copying, use, and/or disclosure of Company's Proprietary Information. Composer will place or cause to be placed on the Composition or any portion thereof any intellectual property right notices as requested by Company.

5. CREDIT: Company shall request that Composer receive credits within manual documentation, print ads, and on screen, it being understood that the publisher shall have the absolute discretion in such credit determination. The form, style, size, placement, and nature of any screen credit provided for herein shall be determined by Company (or its assignee, publisher, or licensee) in its sole discretion. Any unintentional and/or inadvertent failure to give screen credit as above provided, whether because of lack of broadcast time or otherwise, shall not be a breach of this agreement.

6. NAME AND LIKENESS: Subject to Composer's approval, which will not be unreasonably withheld, Company shall have the right and may grant to others the right to use, disseminate, reproduce, print, and publish Composer's name, likeness, voice, and biographical material concerning Composer as news or informative matter and in connection with advertising and for purposes of trade in connection with any motion picture or television program in which the Composition is used, and/or in connection with any other uses of the Composition.

Composer hereby pre-approves the use of his name, likeness, voice, and biographical material in and on packaging for the Game and within the body of the Game, as well as in printed materials concerning the Game. The rights granted herein shall not include the right to use or to grant to others the right to use Composer's name, voice, likeness, and biographical material in any direct endorsement of any product or service without Composer's written consent.

(Continued)

7. TRAVEL: In the event Company requests Composer to travel on behalf of Company, Company shall reimburse Composer for business class airfare, lodging in a first-class hotel, meals and local transportation, both to and from the airport, and at the place at which Composer is required to travel on behalf of Company. All reimbursements shall be made only after Company receives itemized bills for all expenses incurred by Composer pursuant to this paragraph and on a form approved by Company.

8. AWARDS: Company shall retain all awards won by the Composition. Company will use its best efforts to obtain a duplicate of any award won by the Composition to furnish the Composer.

9. COMPOSER'S WARRANTIES AND INDEMNIFICATIONS:

(a) Composer represents and warrants to Company that:

 (i) Composer possesses full power and authority to enter into this Agreement and to carry out its obligations hereunder;

 (ii) with respect to the Composition which Composer will deliver to Company in performance of this Agreement, Composer warrants that it has the right to make and disclose thereof without liability to any third party;

 (iii) Composer has not sold, assigned, leased, licensed, or in any other way disposed of or encumbered the Composition in whole or in part to any party other than Company;

 (iv) the Composition is new and original and capable of copyright:

 (v) neither the Composition, nor any portion thereof, shall infringe upon or violate any right of privacy or publicity or any patent, copyright, trademark, trade secret, or other proprietary right of any third party;

 (vi) the performance of the terms of this Agreement and the performance of Composer's duties hereunder will not breach any separate agreement by which Composer is bound, or violate or infringe any rights of any third party, and so long as this Agreement remains in effect, Composer shall not commit any act or enter into any agreement or understanding with any third party which is inconsistent or in conflict with this Agreement;

 (vii) there are no, and there will not be, any liens, claims, or encumbrances against the Composition which would derogate from or be inconsistent with any of Company's proprietary rights with respect thereto;

 (viii) Composer represents and warrants that it is, and at all times during the term of this Agreement will be the holder of all consents necessary for it to perform its obligations hereunder; and

 (ix) there is presently no litigation or other claim, pending or threatening, nor a fact which may be the basis of any claim against the

Composition, and Composer has not taken any action or failed to take any action which would interfere with the rights of Company under this Agreement.

(b) The representations, warranties, and indemnification rights set forth in the Agreement shall survive execution of this Agreement, the performance of the obligation of Composer hereunder, and cancellation or termination of this Agreement.

10. TERMINATION: Company shall have the right to terminate Composer for cause, provided Company compensates Composer in full for all Compositions completed and accepted as of the date of termination. Composer shall have the right to terminate this Agreement for cause. For purposes of this Agreement, cause shall mean a material misrepresentation or a material breach of this Agreement.

11. ATTORNEY'S FEES: Should any arbitration, litigation, or other proceedings (including proceedings in bankruptcy) be commenced arising out of, concerning or related to any provision of this Agreement, or the rights and duties of any person or entity hereunder, the prevailing party (solely as between Company and Composer) in such litigation or proceeding will be entitled, in addition to such other relief as may be granted, to recover its reasonable attorney's fees and expenses incurred by reason of such proceedings.

12. GENERAL:

(a) This Agreement shall be governed and interpreted in accordance with the substantive laws of the State of California.

(b) Composer shall be deemed to have the status of an independent contractor, and nothing in this Agreement shall be deemed to place the parties in the relationship of employer-employee, principal-agent, partners, or joint venturers. Composer shall be responsible for any withholding taxes, payroll taxes, disability insurance payments, unemployment taxes, and other similar taxes or charges on the payments received by Composer hereunder. Company shall have no responsibility or liability of any kind to any subcontractors providing services to or for the benefit of Composer.

(c) This Agreement and the rights it creates may be assigned by Company, but not by Composer, except that, with the prior written consent of Company, Composer may assign this Agreement, in whole or in part, and the rights it creates to Composer or any corporation in which Composer is the sole shareholder. This agreement shall be binding on the parties and their respective successors and assignees, and all subsequent owners or licensees of the corporation.

(d) Should any provision of this Agreement be held to be void, invalid, or inoperative, the remaining provisions hereof shall not be affected and shall continue in effect as though such unenforceable provisions have been deleted herefrom.

(Continued)

(e) This Agreement, including the Exhibits hereto, sets forth the entire agreement between the parties with respect to the subject matter hereof and supersedes all prior negotiations, understandings, and agreements between the parties hereto concerning the subject matter hereof.

(f) This Agreement may be executed in counterparts, but shall not be binding upon the parties until it has been signed by both parties.

IN WITNESS WHEREOF, each of the undersigned has executed this Agreement as of the date set forth below.

"COMPOSER"

By:_____Dated as of _____

Title:_____

"COMPANY"

By:_____Dated as of _____

Title:_____

SCHEDULE 1

Milestone 1: Upon signing of Agreement Date $15,000

Milestone 2: Complete audio for levels 1–3 Date $10,000

Milestone 3: Complete audio for levels 4–6 Date $10,000

Milestone 4: Complete audio for levels 7–9 Date $10,000

Milestone 5: Upon completion & approval of composition Date $25,000

TOTAL: $70,000

Any additional new music needed by Company from Composer will be charged at $1,000 per minute per Company's approval.

Royalty or bonus terminology goes here. For example:

Provided that Company actually incorporates the Music, or a substantial portion thereof, into the Game, if sales of the Game, not including promotional or complimentary copies, exceed Two Hundred Thousand (200,000) copies, Composer shall be entitled to receive an additional Twenty-Five Thousand Dollars ($25,000).

or

In addition to the above payment, Company will also compensate Composer five (.05) cents for every unit & SKU sold throughout the world.

or

In addition to the above Milestones, Composer shall receive a ten (10) cent royalty on each SKU sold after 125,000 units.

or

Composer shall receive a profit participation of One Percent (1%) of Net Receipts from any product for which Composer is entitled to receive any compensation hereunder after Company has sold 125,000 units of such product. For purposes of this Agreement, the term Net Receipts shall be defined as all monies actually received by Publisher from the sale of a product in excess of 125,000 units less deductions for the direct cost of manufacturing the product, royalties payable to third party hardware manufacturers such as Nintendo and Sony, returns or refunds, and all forms of taxes.

Contract C

The final contract example is from one of the big boys in the game development and publishing arena. Being much larger and much wiser than us common folk, they've assembled an army of officials and lawyers to cover every possibility and have used more big words than I've ever had the pleasure of seeing at once. This is the type of contract you will want to spend much time with, understanding each sentence and what impact it will have on your interests *before* you ever put your pen to the paper.

It will be blatantly missing any points referencing SKUs, ancillary rights, soundtrack rights, logos, splash screens, and credits. This should be no surprise. Knowing this in advance, you can look to adapting it to make it agreeable to your interests. Keep your eyes open.

Professional Services Agreement

Beginning on the _____ day of _____20___, _____, a _____ ("Contractor"), agrees to perform services for Company X, Inc., and its direct and indirect subsidiaries ("COMPANY X") pursuant to the following terms and conditions:

1. Acting as an independent contractor, Contractor will render the services as stated in Exhibit A ("Services"). Contractor will take direction from and report to Producer X or Creative Director X. Contractor acknowledges that time is of the essence regarding its performance of the Services.

(Continued)

2. In consideration for performance of the Services and upon Company X's acceptance of completion of same, Contractor will receive from Company X a fee which is payable in accordance with Exhibit A.

3. Contractor understands that he/she is not authorized to incur any expenses on behalf of Company X without prior written consent, and all statements for the Services and expenses shall be in the form prescribed by Company X and shall be approved by _____, or his/her supervisor.

4. Company X has the right, in its sole discretion, to terminate this Agreement for any reason with seven (7) days prior written notice. In the event of such a termination, Company X's sole obligation will be to pay Contractor, pro rata, for the fees with respect to all milestones achieved or Services performed, as applicable, which shall have been accepted as of that date by Company X. Company X will have no further obligation, whether financial or otherwise, to Contractor after such cancellation. Company X may terminate this Agreement immediately upon Contractor's refusal or inability to perform under, or Contractor's breach of, any provision of this Agreement.

5. Contractor will not, either during or subsequent to the term of this Agreement, directly or indirectly disclose any information designated as confidential by Company X, including but not limited to proposed products, product plans, product features, specifications, and human-readable source code; nor will Contractor disclose to anyone other than a Company X employee or use in any way other than in the course of the performance of this Agreement any information regarding Company X, including but not limited to Company X's product, market, financial, or other plans, product designs and any other information not known to the general public whether acquired or developed by Contractor during performance of this Agreement or obtained from Company X employees; nor will Contractor, either during or subsequent to the term of this Agreement, directly or indirectly disclose or publish any such information without prior written authorization from Company X to do so. Unless otherwise specifically agreed to in writing, all information about and relating to projects under development by Company X and/or parties doing work under contract to Company X including the Services rendered hereunder by Contractor shall be considered confidential information. Contractor acknowledges and agrees that all of the foregoing information is proprietary to Company X, that such information is a valuable and unique asset of Company X, and that disclosure of such information to third parties or unauthorized use of such information would cause substantial and irreparable injury to Company X's ongoing business for which there would be no adequate remedy at law.

Accordingly, in the event of any breach or attempted or threatened breach of any of the terms of this Paragraph 5, Contractor agrees that Company X shall be entitled to seek injunctive and other equitable relief, without limiting the applicability of any other remedies.

6. Contractor will return to Company X any Company X property that has come into his/her possession during the term of this Agreement, when and as requested to

do so by Company X and in all events upon termination of Contractor's engagement hereunder, unless Contractor receives written authorization from Company X to keep such property. Contractor will not remove any Company X property from Company X premises without written authorization from Company X.

7. As part of this Agreement, and without additional compensation, Contractor acknowledges and agrees that any and all tangible and intangible property and work products, ideas, inventions, discoveries, and improvements, whether or not patentable, which are conceived/developed/created/obtained or first reduced to practice by Contractor for Company X in connection with the performance of the Services (collectively referred to as the "Work Product"), including, without limitation, all technical notes, schematics, software source and object code, prototypes, breadboards, computer models, artwork, sketches, designs, drawings, paintings, illustrations, computer generated artwork, animations, video, film, artistic materials, photographs and any film from which the photographs were made, literature, methods, processes, voice recordings, vocal performances, narrations, spoken word recordings and unique character voices, shall be considered "works made for hire" and therefore all right, title and interest therein (including, without limitation, patents and copyrights) shall vest exclusively in Company X. To the extent that all or any part of such Work Product does not qualify as a "work made for hire" under applicable law, Contractor without further compensation therefore does hereby irrevocably assign, transfer, and convey in perpetuity to Company X and its successors and assigns the entire world-wide right, title, and interest in and to the Work Product including, without limitation, all patent rights, copyrights, mask work rights, trade secret rights, and other proprietary rights therein. Such assignment includes the transfer and assignment to Company X and its successors and assigns any and all moral rights which Contractor may have in the Work Product. Contractor acknowledges and understands that moral rights include the right of an author: to be known as the author of a work; to prevent others from being named as the author of the works; to prevent others from falsely attributing to an author the authorship of a work which he/she has not in fact created; to prevent others from making deforming changes in an author's work; to withdraw a published work from distribution if it no longer represents the views of the author; and to prevent others from using the work or the author's name in such a way as to reflect on his/her professional standing.

8. None of the Work Product is to be used by Contractor on any other project or with any other client except with Company X's written consent. If any part of such Work Product is the work of a subcontractor employed by Contractor, then Contractor will require such subcontractors to execute an assignment document in the form attached hereto as Exhibit B so as to secure for Company X exclusive ownership in such Work Product. In the event Contractor is unable to obtain exclusive ownership from such subcontractors, Exhibit C must be signed to obtain a license for the benefit of Company X. Contractor shall promptly thereafter deliver such originally executed assignment or license documents to Company X.

(Continued)

9. With respect to all subject matter including ideas, processes, designs, and methods which Contractor discloses or uses in the performance of the Services: (a) Contractor warrants that Contractor has the right to make disclosure and use thereof without liability or compensation to others; (b) to the extent that Contractor has patent applications, patents, copyrights, or other rights in the subject matter which is set forth in writing in Section 5 of Exhibit A, if any, Contractor hereby grants Company X, its parent, subsidiaries, affiliates, and assigns, a royalty-free, perpetual, irrevocable, world-wide, non-exclusive license to use, modify, make, have made, sell and disclose, and distribute such subject matter in any form now or hereafter known; and (c) Contractor agrees to defend indemnify and hold Company X harmless from any claims, litigations, actions, damages, or fees of any kind (including reasonable attorney's fees) arising from Company X's or Contractor's use or disclosure of subject matter which Contractor knows or reasonably should know others have rights in, except, however, for subject matter and the identity of others having rights therein that Contractor discloses to Company X in writing before Company X uses the subject matter.

10. It is understood and agreed that in performing the Services for Company X hereunder, Contractor shall act in the capacity of an independent contractor and not as an employee or agent of Company X. Contractor agrees that it shall not represent itself as the agent or legal representative of Company X for any purpose whatsoever. When Contractor is working on the premises of Company X, Contractor shall observe the working hours, working rules, and security procedures established by Company X. No right or interest in this Agreement shall be assigned by Contractor without the prior written permission of Company X, and no delegation of the performance of the Services or other obligations owed by Contractor to Company X shall be made without the prior written consent of Company X. This Agreement shall be deemed to have been made and executed in the State of California and any dispute arising hereunder shall be resolved in accordance with the law of California. This Agreement may be amended, altered, or modified only by an instrument in writing, specifying such amendment, alteration, or modification, executed by both parties. This Agreement constitutes and contains the entire agreement between the parties with respect to the subject matter hereof and supersedes any prior oral or written agreements. Nothing herein contained shall be binding upon the parties until this Agreement has been executed by an officer or agent of each and has been delivered to the parties.

Agreed to and Accepted:

Company X, Inc. Contractor

By: _____ Signature: _____

Title: _____ Social Security #/Fed. ID #: _____

Date: _____ Date: _____

Exhibit A

1. Services

The expected completion date is _____.

Date	Milestones	Payments*
__-__20__		$
__-__20__		
__-__20__		
__-__20__		
__-__20__		
__-__20__		
__-__20__		
__-__20__	Final Delivery	

* Payment shall always be contingent upon timely delivery and acceptance of each milestone.

2. Payment

Contractor shall be paid for the Services in increments as set forth above after acceptance at each stage of the work performed. Anything to the contrary notwithstanding, the compensation for the Services performed hereunder shall not exceed $_____ without the express, written consent of _____.

3. Expenses

The following authorized expenditures are the maximum that Contractor shall be eligible to receive as a reimbursement. Contractor must produce receipts for all pre-approved expenses for which Company X will reimburse Contractor within thirty (30) business days of receiving such receipts and expense reports. All expenses incurred by Contractor not specifically approved herein shall be the sole responsibility of Contractor.

Amount	Approved Expenses
None	None

4. Payment Schedule

Subject to Company X's prior acceptance of the milestone as provided herein, Company X will remit the fees associated with a delivered milestone to Contractor

within thirty (30) business days following Company X's receipt of Contractor's invoice. All invoices must be sent to the designated representative set forth in Section 1 above.

5. Work for Hire Exclusions

The following includes all subject matter that is excluded from the assignment of rights granted in Section 7 and the non-use provisions of Section 8, but which is licensed in accordance with Section 9(b):

1. NONE

Exhibit B

SUBCONTRACTOR COPYRIGHT ASSIGNMENT

For valuable consideration separately and previously agreed to between the undersigned and Company X, Inc., a California corporation, having a principal place of business at _____, the undersigned hereby assigns all rights, title and interest in and to the materials described below, including the copyright thereof, in the United States and throughout the world, together with any rights of action which may have accrued under said copyrights, which are owned by the undersigned, for One Dollar ($1.00) and other good and valuable consideration, the receipt of which is hereby acknowledged, to Company X, Inc.

Work: Materials relate to "_____."

Dated: _____

By: _____

Print Name:_____

Company Name:_____

Address:_____

Phone: _____

Conclusion

Hopefully the information shared in this chapter will help you handle the challenge of deal-making with confidence. There is a huge advantage to being knowledgeable about what goes on in this industry and knowing what types of deals are out there can increase your earnings potential exponentially. I'm certain I've given up a good deal of money in my first couple of years at bat because of my inexperience. But because game composers and sound designers have created their own behind-the-scenes network and support groups and have seen the advantage of sharing their experiences, it has paved the way for the rest of us to profit.

We talk to one another and discuss our deals quite openly. Because I know what the next guy is making, I know I can ask for the same and actually get it. Once our way of thinking becomes standard in the industry, we won't have to expend so much of our business energy because everything *we* want will already be in *their* contract. Then we can get on with why we joined the industry in the first place: making music and sound effects.

Composer at Work

Kristopher Larson

Kristopher Larson is a composer, sound designer, and owner of Tension Studios.

Describe your thought process for scoring and creating sound effects.

I first go with my gut instinct and make silly sounds with my mouth and voice. This gives me an idea of the initial shape and general texture that most immediately comes to mind. Then I try and wrap some words or descriptions around what I'm hearing in my head and write it down. This is essential for me since I'm too easily distracted by the infinite variety of sounds that one can create and frequently find myself on too exploratory of a tangent.

Are there any particular secrets to your creativity?

If there are, I wish someone would tell me because it would make my life *so* much easier! If I go down the rabbit hole too far, I need to just get away from the studio for

(Continued)

a bit. I take walks around the block just long enough to get my head cleared a little so I can attack the sound from a different angle.

When do you find you are most creative?

Usually in the afternoon and evening. While I might get a lot done when I stay up late into the night, it tends to need a lot of refinement the next day—to the point where it makes more sense to just do it once when I'm in a more focused state of mind. I try to shift my experimental noodling to late night, after I've made some headway in the day. This sort of exploration is absolutely essential, but it's always hit-or-miss—so if I do it late at night I don't feel like I've wasted my time if nothing good comes out of it. Of course, the *best* time is as I'm lying in bed drifting off to sleep. The music starts to unfurl in my head, but only because it knows it's safe to run free and never be captured by tools or consciousness.

Do you have any techniques when dealing with clients?

I like giving clients carefully crafted options so that they can feel like they have more control, but I never give them any choices that I'm not happy to provide.

Any interesting sound design creation stories?

One weekend I went on a short road trip with my girlfriend to Eastern Washington to go camping and record some ambiances. Driving down the road in the middle of nowhere, I spotted a bit of rusted metal off to the side in a little valley. So, I stopped the car to do a little exploring and we found an old dump filled with tons of metal junk—fridges, cars, vending machines, old scientific instruments, bottles, oil drums, and chunks of concrete by an abandoned road. This was a sound designer's dream come true. We smashed, mashed, crushed, threw, and toppled to our heart's content. It was such a great location we went back there again with my co-worker and we recorded a library's worth of destruction.

How did you find your way into the games industry?

Knowing the right people, right place, right time. But that just got me in the door. I had to back it up with skill, discipline, and hard work for many years.

CHAPTER SEVEN

Setting the Stage

For the most part, this is where the creative process begins for us sound guys and gals. Occasionally, game developers will have you on as part of the team from the beginning—this being the best situation, of course. But more often than not, they'll have a good amount of the work on the game already completed. Before they even call you, the developer will have been at work for many months planning, creating, and methodically carrying out production phases. Entering midstream is more the norm and you can help minimize the anguish by planning ahead and knowing what to do. Getting the information you need at the right time and understanding your exact role and what is expected of you can save you enormous grief and creative setbacks. This is the basic thrust of this chapter.

Company Liaisons

During the contract process, you will have identified who has final authority over your work. This person will be where the proverbial buck stops—the person who will approve your submissions so you can get paid. But, you will also need to know who your primary point of contact is as well. It may be the same person, and usually is, but at large development conglomerations, there may be several people to work with. Find the main one and get to know them.

Your contact will have a working style all their own and it will behoove you to find the best way to work with that person. Communicate through every step of the process, keep the lines open, and keep them informed. It will take some time to fully understand their creative guidance and to know what they mean by it. Every human being is different, their life experiences making them so. What means one thing to one person could mean something completely different to another, even if the exact same description was given.

For example, if I were to tell you to write a song and the only direction I gave was "Make it red!" what kind of music would you compose? I envision a searing bright red color—an upbeat, fiery, heavy metal piece with blazing guitar solos and impassioned vocals. But maybe you see a dark, scarlet red—a sexy, slow jazz number with hot saxophone licks and piano that would tear your heart to pieces. See what I mean? By learning what makes this person tick, you'll have a better chance of knowing what they really mean. Use all of your senses and ensure the translation is pure. In this case, don't be afraid to ask as many questions as possible to ensure you pinpoint what the client wants. Asking questions is far better than to assume you know what someone is thinking.

Is your company liaison hands on or hands off? Some will want to be a part of every step of the creative process, which means you'll need to get their okay for everything. You'll create many musical "sketches," letting them choose which ones are closest to their vision. Once they've approved them, you'll flesh them out to their final versions—submitting them again for their okay on instrumentation, arrangement, length, volume, EQ, and loop points, if needed. You'll rework them until they are perfect. Many versions of sound effects will be offered and they'll pick those that are closest and you'll rework those until they are perfect as well. The "hands on" types are usually a little bit high strung—highly passionate individuals who live and breath a project, taking their role very seriously. Some meddle to the point of almost interfering with your creativity; others genuinely care about the project and have their fingers in every aspect of it. Their name is on the product and their future in gaming is the true motivator.

"Hands off" individuals work differently. Because of their need to be in a hundred places at once, they are more comfortable delegating and letting content providers "do their thing" without much interference. They will set the scene for you, give you all of the proper adjectives and then let you create audio using the expertise they are paying you for. These types of individuals understand—either through years of experience or from their lack of it—they are incapable of doing a great job at everything. Instead, they go with their strength in leadership and put faith in you. It puts a lot of pressure on you to perform brilliantly, but don't worry. They will be there every step of the way to help keep you on track. The "hands off" type appears to be laid back, but underneath they are just as passionate about the success of the project as the next guy—they just go about it differently. They will keep the atmosphere fairly relaxed and will let you set your own hours and working methods, as long as milestones are met as promised.

Most of your company contacts will be somewhere in the middle of the previous extremes. Which one is the best to work for? It will depend on your personality type and what you need to prepare an inspired atmosphere. The "hands on" folks keep you on your toes, pushing you to do the best work you've ever done. They demand a lot, but the rewards gained by your astonishing audio will make it worth it. "Hands off" people will give you all the room and support you need to fulfill your vision of the project. They will protect you from the outside world, placing you in a cocoon—enabling you to give 110% and to take advantage of inspiration as it strikes. This person may have let you create on your own, letting you work your brand of miracle untouched, but they are just as responsible for the final masterpiece.

Executive Producers

The executive producer is generally the project lead. They have grasped the total creative vision and ensure each department is fulfilling their appropriate missions, on time and within standards. At most game companies, this individual has the final say on everything from artwork, game play, sound effects, music, narrations, cinematics, and so forth. They are normally encumbered with many tasks at once, but have the ability to know what each hand is doing. This ensures the audio you are doing will mesh precisely with audio from any other sources, such as narrations or sound effects, and will fit in perfectly with the game.

Executive producers may also be in charge of multiple game projects, especially at large developers or active Internet game companies. In cases like this, other help is needed in the form of a producer.

Producers

Game company structures are designed for the most efficient use of time, money, and personnel. The producer steps in to fill a more focused role in a game project, either overseeing a single game project in a company producing multiple game titles or managing a single department for one project. Normally, there is no "audio department producer" to report to per se, as an in-house composer, you *are* the audio department. They wouldn't be calling you in as a contractor if they have a true audio department. So, there would be someone else assigned to direct your efforts in this case. There is the occasional huge game company which does have an in-house audio department with an audio producer and even as a contractor, you may get a call to assist on projects in rare instances. Don't be too surprised if companies like Lucas Arts or Electronic Arts give you a call. Their guys have to take a vacation sometime.

A producer's role is essentially the same as the executive producer except they are a step down in the chain of command, so to speak, and report directly to the executive producer. If the two work well together, there will be little change of direction—and what the producer tells you is the same word passed down from the boss. In situations where the word isn't clear and you feel confliction, ask the producer before you go over their heads to get clarification. You have to work closely with these people, so be conscious of egos and the need to be in control of their assignments.

Creative Directors

The creative directors are individuals who manage the design elements of a game, unlike an executive producer or producer—who is also concerned with non production elements like the budget and schedule. Their job is similar, acting as the central contact point for the elements of game production—except these guys are what gives a game its "fun factor." This job is commonly filled within the online gaming communities or multimedia production houses where this fast-paced environment requires a common thread throughout the many simultaneous projects. In expanding companies, you may work with a creative director instead of a producer—who is typically close by, looking over her or his shoulder.

Meetings With the Game Development Team

It is essential to the success of a project that the many different contractors and in-house employees all work together as a cohesive team. Each player should know a little something about what each other member is doing and how it will all fit together in the final product. The one way to do this is to be present at the many meetings and discussion groups along the way. As a contractor working off-site, this may present more of a problem if there are many miles separating you. Teleconferences are a great alternative—or, better yet, have a speaker phone available at a meeting for you to participate.

Head of Audio at Work

Will Davis

Will Davis is head of Audio at Codemasters Software.

From your perspective as the head of Audio at a large game publisher, what advice can you give to composers and sound designers working in games?

As head of Audio, it's my job to ensure that any audio released meets the quality allowed by the budget and timescales. Needless to say, I spend a lot of time fighting for larger budgets and more time. As well as internally developed titles, like the award-winning *DIRT*, there are also externally developed titles to keep an eye on—not to mention trailers, presentations, and web sites! It's a busy place to be. The current team consists of eight sound designers, four game audio programmers, and three audio tools/technology programmers.

Part of my job is the hiring of composers, sound designers, and other audio specialists for various projects. The biggest tip I can pass on is make your information easy to access and avoid waffle—be professional and to the point. For show reels, include context. Explain why the sound design or music is the way it is. Everything is about context. Is the audio doing what it needs to do? This is especially true for music. All music has a place and great music isn't really about how good the tune is, it's about how well it's used and how well it fits. Good audio used badly is just ugly audio.

The other questions I have to ask myself are: Can someone deliver on time? Can they really do what they say they will? How easy are they to work with? And for someone new, that's a hard thing to get across.

Audio design documents are crucial at your level. What sort of things do you expect to see in them?

I try myself or have the developer to get as much detail in the audio design docs as possible. A few things to think about:

- Overview of the entire game.
- Good understanding of a typical gameplay situation.
- How the game flows from one section to another.
- How music is used within the game.
- Is licensed music required?
- How much of each asset type is required? How many music tracks? How much speech? How many engines? How many surfaces? How many different types of weather? How many different guns?
- A good understanding of the subject matter. What further research is required?
- How speech is used within the game. Is concatenation required? How many voice roles are there in the game?
- Are famous voice actors required?
- Is the game to be localized; and if so, to what languages?
- A good idea of the entire budget requirements for audio. To include external studio costs, localization, music composition, off-site recording, equipment needed for project.
- Is any other licensed material required?
- When are the important milestones, demos, previews, et cetera required?
- What aspects of the audio need to be prototyped?
- What tools are required to deliver what the audio technical design dictates?

Staying organized is important, especially if you are working on multiple projects—which is part of your daily routine. How do you keep up with it?

I'm a big fan of checklists and have a long list for each project. Things like:

- List of reference material required.
- List of research data required.
- Specifications for audio assets.
- Audio section for game design documentation.
- Audio design document.
- Audio asset list.
- Audio task list.
- Audio schedule.

(Continued)

- Audio non-game schedule (marketing/brand needs, check with products marketing and brand managers).
- DVD footage of location recording? Interviews? Do we have to produce them?
- Marketing movies (trailers)?
- Cover mount demos.
- Preview code.
- Review code.
- Other marketing deliverables in marketing plan.

When you do get to act as a composer? Describe your thought process for scoring.

The primary goal is to simply create audio the client wants. The trick is to work within the parameters of the project and create audio that has the desired effect on the player and also fits in with the vision of the designers. At the end of the day, the audio is just part of a greater whole. It has to feel right. Everything I create for a game is easily changeable, which allows the audio to adapt to modifications to the project with a minimum of fuss. There is little point in wasting time or money.

Are there any particular secrets to your creativity?

Not really. It's pretty simple, really. Music is just a note, a bit of a gap, another note, and so on until it's finished. Coming up with ideas and themes is the easy bit. It's the tidying up and getting the production to sound and feel right that takes the time.

When do you find you are most creative?

Any time except early in the morning. I'm a night person at heart. Which is fine, as it fits in with the American companies' office hours anyway.

Is there a typical workday for you?

Hmmm, I get up when I wake up—which is much better than trying to get up before I'm awake, which I've tried on occasion but I then spend several hours blindly fumbling around the kitchen desperately trying to make coffee. If I'm doing a handheld project, I'll just grab the laptop and find somewhere nice to sit and work—which in the summer is normally the beach. If it's a full-blown CD score, then it's into the studio and work away until I run out of coffee.

If that isn't possible, have someone attend the meetings who will fill you in on all pertinent details. Either way, make sure you are in the loop and get information in a timely manner. This will save a lot of "Didn't I tell you?" and "I thought you knew" comments. If you run into the phenomenon known as "information blackout" and feel the data you are missing is essential, talk to your point of contact, find out why, remind them you are under an NDA, are fully committed as part of the team, and need the facts to make informed, creative decisions. Do what you can to stay "in the know," especially when it can affect your part of the job.

Details to Discuss

If you were hired as the result of a bid competition, you will already have a solid idea about the parameters of the game. Don't be satisfied that all of the information has been presented and don't make any creative decisions until you have more data. Now that you are on board as part of the team and have signed the contract, the key players will be more willing to share their thoughts about where things should go sonically. As the outsider coming into a project already in production, you will have to ask many questions to satisfy your requirements prior to starting work. Obtaining a solid overall view for the entire project will give you exactly what you need. Start with broad questions and work on the finer details as you learn more about the production. The first question will set the tone for the rest of your investigation and for the eventual audio you'll be creating.

What is the general theme of the game?

Music and sound effects can make or break the immersive effect a game is designed to have. The most important question you can ask is "What is the theme of the game?" in order to have the style of audio accurate for the genre. Examples of themes are space, medieval, sports, racing, children's, religious, horror—all of which conjure up specific images and sounds. Even if the developer wants to attempt a new approach with the audio, there will still need to be basic elements of the genre to provide that certain familiarity for the players. If a game company tried to produce a medieval racing game, you can guarantee there will be orchestral instruments playing medieval melodies all backed by a fast-paced rhythm section.

Find out their *interpretation* of the "theme," even if you know what it is. What may look "horror" to you may instead be artwork of a tunnel you'll be driving your Ferrari through or some other small inconsequential scene which has no bearing on the rest of the game. I'd hate to see this "horror" scene, decide it was the "look" of the game, and run full steam off on a tangent. Not only will this false start be costly in wasted time, but it will harm your creativity. Ask lots of questions and see every bit of artwork you can. Have no doubt in your mind what the game is all about.

A case in point: I had been contracted to do, what I thought from the bid information, was a space game. The milestones were fairly aggressive and since I felt I already had a good idea of the theme, I ran head first into the opening, menus and level victory themes. Two weeks of nonstop work later, and just in time for the first milestone submission, I smiled as I sent in the music—knowing for certain I'd hit the nail on the proverbial head. The developers reply was polite but, reading between the lines, I could tell they weren't as happy with the music as I was. Something was amiss.

I pressed for specific information, attempting to understand how I could have been so far off. They were gracious and gave many thoughts for improvements. A sleepless week later, I submitted new music ideas which incorporated their suggestions—and again, I thought I was submitting very appropriate music. They didn't think so and were now growing less confident in my abilities to fulfill their vision. I too was disappointed, since I've always been pretty good at translating visuals to sound, and called for a last-ditch meeting to salvage the project.

As we got settled at a conference table, the flat screen on the wall was showing the menu screen from the game but the scene playing behind the menu wasn't a space environment like on my working version, it was a nice green park-like setting, with trees and flowers and birds flying by. I pointed with my mouth hanging open, obviously in a slight

state of shock. "The menu music I did would never work for that!" And that's when they explained that the game was planned to have several different levels, including space, a park, and a dozen other themes—but the space level was the only one completed and the only artwork I'd seen. They felt the opening, menus, and victory cues should be something which would set the tone of the game and be able to lead into any of the environments—basically a neutral feel but open to the many different possibilities the game would reveal.

I was as surprised as they were that I'd totally misread the theme of the game, but with this new information I was able to compose new music they absolutely loved and we were able to get back on track and head into the next milestones. The obvious lesson I learned from this was, despite what you may think you know about the theme of the game and despite what the developer thinks they told you about it, double and triple check to make sure all of the appropriate information is revealed.

What genre of music will set the mood?

Discuss their interpretation of the music they feel would enhance the game. It may seem rather odd, you being the composer and all, but asking them will only clarify your musical direction. Remember, they've been living with this game for several months and I'm sure the subject has already come up among themselves. Listen to what they have to say and don't be judgmental at this point. Any idea is a good idea when brainstorming. What may sound silly might give someone else the winning idea. Better yet, you might be the one with the idea and look like a hero!

Examples of genres of music to consider are many—orchestral, techno, industrial, rock, country, spiritual, and so on—but only a few will fit the bill for a game project. Much is dependent on the targeted age group, the theme of the game, and the taste of its creators. Your job is to blend these elements to remain true to what the game, is about and who it will be sold to. Discuss the demographics with them, identify the intended audience, and add that to your growing list of parameters.

What examples of reference music will fit the game?

Remember our earlier "red" example? Even after you've narrowed down the discussions about what kind of music is suitable for the game, it doesn't mean everyone's *perception* of that music is the same. What I believe to be "techno," for example, may not be what the next guy thinks is "techno." That's why you need examples to listen to together. Play tracks from the various suggestions and work on a consensus. Now everyone will be in agreement on the style and know what to expect.

Take this a step further. Find out the elements of this style which appeal to everyone. Is it the beat? Is it the instrumentation? Is there something in particular which stands out that would be perfect for the game? Sometimes you'll find it isn't even the genre of music they like but a specific sound used in a song or by a band. Give them chances to present their ideas clearly and to put their finger on all the sonic tidbits that will give the game its final personality. Your job is to listen.

The idea isn't to have someone else do your job but to make the game better and help your mental processing. It will be enough of a challenge composing, recording, and mixing the music but having no idea where to start can make it that much more difficult. It's been said, "Good composers borrow, great composers steal!" In this day of highly enforced copyright laws, I don't recommend stealing, of course, but by utilizing key elements of a band or style, you will be more able to get it right the first time. There isn't much of a chance you could recreate someone else's work even if you used the exact

same instrumentation and sounds, so don't sweat it. You could take five composers, give them the same five loops to use, and I guarantee you'd get five very different musical presentations.

Getting your team to listen to and review prerecorded music may be the best way to start off on the right foot, but unfortunately isn't always possible to accomplish. In the beehive of activity within the game developer's lair, time is always of the essence—and this step may get left by the wayside in favor of more important developer issues. After all, they hired you as the audio expert and are paying you to do a job—so it may be necessary to use the information you do have and your gut instincts. Try your best to schedule a meeting where you can discuss this particular issue.

What are the sound effect needs?

If you are contracted to do the sound effects, you will want to know as much as you can about any preconceived ideas the development crew has been working under. Just like the music, they may already have some ideas about what sounds would work best. The creators of certain characters may have a close, personal relationship with their work and would love to share their ideas of what makes this particular character special. You can translate their thoughts into some fitting sound effects and have an impact just by paying attention and asking the right questions.

If you aren't doing the sound effects portion of the game, it is still a good idea to find out what other audio your music will be competing with. If there are to be heavy background sounds during gameplay, it will have an impact on the complexity of the music you can offer. As the audio expert, you may have to point out to the developer that background sounds, music, and narrative playing simultaneously will cause confusion in the soundscape. Instead of the player having to turn the volume down, suggest the music you create be less dense—enhancing the experience, not highlighting a battle between all of the sonic elements.

More often than not, when there is more than one sound contractor on a project, no one knows if all of these separate elements will blend together or destroy the audio atmosphere until they are pieced together near the end of the project. To prevent this possible setback, it is extremely important to understand what other sounds might be competing and work on the problem from the beginning. Also consider staying in close contact with the other audio contractors to share information and prevent massive reworks for you both.

What are the dialog needs?

Are you recording and editing the dialog, too? If you are, your tasks are getting more complex—and at these initial meetings, it's a great idea to find out so you can schedule your time appropriately. Since the contract negotiations, parameters may have changed, maybe you originally weren't going to have anything to do with the narration but now that your skills are evident and since you're on their team, why not? Be sure to renegotiate in this case and find out the details.

- Are you expected to audition and select the voice talent or have they already taken care of that?

- Do the narratives simply need to be edited or do you need to bring the talent in and record them?

- Are you expected to write the scripts yourself?

These are just a few thoughts. Such questions will ultimately decide how much extra work you'll have in store—and if you are doing the music and sound effects, too, you'd best get busy.

If you aren't touching the narratives, character voices, or voice-overs, it is still appropriate to find out what they will consist of. Does the main character have a voice like James Earl Jones, low and intense, or is it something on the other end of the range? Instead of having to turn down the volume of the music as an answer, how about building a hole in the frequency spectrum? What the characters and other voices are saying are more important than the background music and a little pre-planning will save you having to redo that slamming bass line competing with Darth Vader's orders to squash the universe. Normally, the most understandable part of vocal work, especially on tinny multimedia speakers, is in the upper-mid to high-frequency ranges. By determining the needs of the game project first, you can ensure the soundscape is equitably managed and every facet is heard.

These first creative meetings are important. The details may seem inconsequential to the game developer, but it is imperative you discover as much of this "trivial" information as possible before you even sit down to compose. You will be very anxious to start creating, like a thoroughbred waiting for the race to begin, but exercising some patience is the way to go. Gather all of the pieces of the puzzle, sort them out, build the border frame, and then you can begin.

Tools of the Trade

Fernando Arce

Fernando Arce is a composer and owner of DamselFly Music.

My goal is to create sounds that are just a tad different. Really give myself in musical form to the people that are counting on me to give them sounds. Equipment-wise I've really kept it as basic as I can get it, only searching a particular sound or instrument when needed but always learning about new gear and new software when the right time comes.

Multi-track system: Cubase, baby!

Monitor system: A pair of cute M-Audio BX-5s.

Sound modules/VST instruments: GPO, Sampletank XL, a million plug-ins found about the Web.

Other instruments: Hollow body guitar, bass, a variety of small wind and percussion instruments, my voice.

Remote recording gear: My trusty and battle-scarred hp-120 iriver.

Sound libraries: My own.

By sorting out the fine points first, your creative energies will be spent producing music and sound effects which have a better chance of fitting perfectly the first time, instead of dealing with the creativity-sucking frustrations of false starts and redos. Set the stage for your best work and then blow them all away with it!

Pre-Compositional Considerations

Somewhere within the many initial meetings, someone is going to have to make an important decision: How much physical memory will be allotted to audio? The answer will have a direct impact on you—the final output quality of your audio and how you will be able to achieve the best balance of file size and sound quality. Each platform hard drive, game disc, and game cartridge will ultimately determine the memory available for all that makes up a game: programming code, engines, drivers, artificial intelligence, artwork, animations, and sound. For example:

CD-ROMs	700 MB
DVD-ROMs:	
Single layer	4.7 GB
Dual layer	8.5 GB
PlayStation 2 and 3 using single-layer DVD	4.7 GB
PlayStation 3 using dual-layer DVD	8.54 GB
PlayStation 3 using Blu-ray:	
Single layer	25 GB
Dual layer	50 GB
Xbox and Xbox 360 using single-layer DVD	4.7 GB
Xbox 360 using dual-layer DVD	8.54 GB
Nintendo Wii (using Wii optical disc)	4.7 GB
Nintendo GameCube (optical disc)	1.5 GB
Sony PSP (universal media disc, UMD):	
Single layer	900 MB
Dual layer	1.8 GB
Nintendo DS game card	Typically 64 or 128 MB 256 MB maximum capability

There is a hard limit to the amount of data competing for space in each game. Sound, fortunately for us, has moved from being the bastard child to an important aspect of gaming. Instead of getting what scraps of memory are left over after the others have their fill, audio is actually getting planned for ahead of time to share the real estate equitably—based on the needs of the game. If a game is touted as a graphical masterpiece, artwork will take up the majority. If surround sound is the big selling point, audio will have the space.

The Big Trade-off

One must evaluate:

- How much space is available
- What method of audio playback to use
- The processor speed which will be doing it
- How much audio there is
- What quality of sound for all of this is acceptable

Cartridge-type games actually don't require much space for sound. Because they use small files that tell the unit's internal sound device what notes to play and when, their actual file size is tiny compared to the rest of the information. Games which utilize "sound fonts" use more cartridge memory because the triggered sounds are actually stored in the cartridge. Most hard drive–, CD-ROM–, or DVD-ROM–based games play recordings stored on the discs. If the game you are working on is one of these, the sample rate, resolution, and whether or not mono, stereo, or surround are required will determine your best methods of creation.

Game developers actually use many different considerations before deciding on the final sound format and parameters. I mentioned physical memory first because it is the easiest concept to grasp: there is only so much space and you can't fill past the limit. The first and foremost factor a developer will consider is "speed." Is the game we are developing going to run smoothly on our target platform? Not only is a game's content competing for physical read-only memory (ROM) but when the game is in play and all that data is moving through the computer's insides, the pipeline through the processor has to be able to handle all of the information.

Complicated AI (artificial intelligence) and graphic-intensive scenery will chew through the available assets in a hurry, leaving little room for anything else. A way for programmers to make it all work is to cut down on the size of the data, including the audio and graphic files. Programming code is basically text files and not much can be done to squeeze the file size any smaller. Graphics and audio are different in the sense that using less "detail" will free up more room while still presenting the visuals or audio in one form or another. You will see the same picture or hear the same sound, only the quality will be less as the file size becomes smaller. You can see why complicated games of the past weren't much to look at or listen to.

A way around overloading the processor in a PC is to use Red Book audio which is played directly from a disc—bypassing the motherboard altogether via a cable connected from your DVD-ROM drive to the sound card. This gives you great sound that never gets near the processor and frees it up to do other chores. Other games use streaming audio and heavy compression to save on both space and processor performance. As music is needed, it is loaded from the disc a little at a time, decompressed, buffered into random access memory (RAM), and played back.

All of these methods of processing and playback will have some impact on your job as the sound person. By discussing these details with the developer at the beginning of the job, you'll be working from the same page, have an understanding of the entire production process and could possibly present alternative ways to accomplish certain goals. Plus, you'll be able to achieve the greatest possible quality on your end—which will make the project sound good. And isn't that what we are all about?

Memory Storage Requirements for 1 Minute of Sound

Type:	Mono	Mono	Stereo	Stereo	Encoded Dolby Surround	Encoded Dolby Surround
Resolution:	8-bit	16-bit	8-bit	16-bit	8-bit	16-bit
Sample Rate (K):						
96 kHz	5,626	11,251	11,251	22,501	11,251	22,501
48 kHz	2,813	5,626	5,626	11,253	5,626	11,253
44.1 kHz	2,646	5,292	5,292	10,584	5,292	10,584
22.05 kHz	1,323	2,646	2,646	5,292	2,646	5,292
11.025 kHz	661.5	1,323	1,323	2,646	1,323	2,646
8 kHz	480	960	960	1,920	960	1,920

Sound Quality versus File Size

Sample Rates

We've all heard the term *CD quality* and equate it to outstanding-sounding audio. The magic number associated with CD quality, 44,100 kilohertz (or 44.1 kHz), is actually the number of "snapshots" taken of a sound within 1 second. Comparing this to standard movie film which uses 24 frames per second, like the eye, your ear perceives 44,100 samples to be lifelike and is fooled into thinking so. Use of sample rates below this value will cause a loss of detail and dynamic range and is something we must consider as game audio providers. What are we willing to give up in quality to have the quantity needed for the game?

In the first chapter, we discussed an audio standard of 44.1 kHz. As storage space increases, all audio, music, and sound effects will use this particular sample rate in games. For now, though, samples rates of 22.05 kHz are still in use in some instances and sound pretty good—much like an FM radio broadcast. Sample rates of 11 and 8 kHz are widely in use in Java and Flash games. These generally sound horrendous but are designed with small file size and quick loading in mind. All of the previous concerns will ultimately determine what sample rate you end up with.

As musicians, you may already be working with sample rates as high as 192 kHz. It is doubtful we will see anything that high in games for quite some time, the argument being the gain of sound quality is imperceptible to the average listener and the space it would consume too valuable. It would also be some years before hardware that could accurately play back this quality of sound would be affordable to the masses. Would the player even be able to hear and comprehend this extra effort while engaged in an all-encompassing gaming experience? When will "good" be "good enough?" Of course, I subscribe to the school of thought that says you can never have too much of a good

thing, the more the merrier, the bigger the better—well, you get the idea. It will happen someday. That we *do* know.

Resolution

Another consideration in computer games which will have a direct impact on sound quality is *resolution* or bit size. CD quality not only uses a sample rate of 44.1 kHz to obtain its high quality, but also a resolution of 16 bits. Professional recording equipment today generally utilizes resolutions of 16 and 24 bits and while higher numbers make the end audio product better, it can confuse the issue when talking about games. Generally, games use 16-bit resolution—but on rare occasion use 8- or even 4-bit. The Wii Remote, as an example, utilizes 4-bit. This resolution facilitates the uploading of the sound data by keeping the file size small and any reduction of sound quality is inconsequential since the tiny speaker is incapable of any real fidelity.

So what is resolution? You could think of it like you do sample rates. While sample rates refer to the accuracy with which a sound is sampled within a period of time, resolution is the accuracy with which that sound is stored. Eight bits can store 256 different values, while 16 bits can store 65,536. To put that in over-simplified terms, say I have two colors, black and white, that I need to store. If I was able to store only two values of colors, everything would be perfect. I have one box for black and one box for white. But the world is not "black and white." There is a lot of gray and I want to store as many shades of gray as possible. With 8-bit, I can store 254 shades of gray between the two extremes (black would be on one end, white on the other) for a total of 256. Using 16-bit, there would be storage for even more precise values of gray—giving a smoother transition between each shade, not such a noticeable jump as with 8-bit. I could store a better representation of our little world. Does that make sense?

Another way to describe it uses musical metaphors. If I wanted to store a sample of every musical instrument in the world on my keyboard for some grand performance, I would need almost an infinite amount of banks to store them. If I were using 8-bit, I could only store 256 instruments. If I needed an instrument I didn't have stored, I would use one which sounded close to the one I wanted instead. If I were using 16-bit, I would have a better chance of finding the exact one I needed or a close cousin with 65,536 banks to chose from. What this is saying, in a roundabout sort of way is, 16-bit resolution gives you more precise storage capabilities—allowing fairly accurate playback of what was initially recorded. The higher the resolution, the better.

The game's resolution depends on the programming side and the sound driver used. You need to find out what resolution the final audio files will be presented in to plan your quality control accordingly. It is good practice to start your process with the highest sample rate and resolution available to you, knowing the final parameters will help make up your mind about how you may approach certain bits of audio. For example, an 8-bit resolution game will give you a lot of headache with "quiet" sounds or musical passages. A residual effect of converting down to 8-bit is quantization noise, which has a very prevalent hissy, static-like quality if the sound doesn't mask it. You'll end up compensating by making the sound as loud as possible. We'll go over this in greater detail in the next chapter, but I wanted to get you thinking early. Maybe you'll think about staying away from quiet sounds if 8-bit resolution is in the cards. You'll quickly discover, too, that sometimes it is not just about making killer tunes and sound effects. It's also the science that goes into making them sound their best.

Mono, Stereo, or Surround?

Probably the most important aspect of the sound issue is whether or not the end audio product will be in single-channel (mono), two-channel (stereo), or multi-channel 3D audio. The amount of memory available for audio will more than likely be the determining factor. Stereo files take up twice as much space as mono; surround can be encoded into two channels or delivered as six separate stems for 5.1 or eight stems for 7.1. Narratives and voice-overs will normally be mono, unless there is some special effect requirement added to give the voice a specific sonic character. There may be audio processing available either through the game engine or through the game's platform which would add some depth to the aural experience—and in these cases, most sounds would be in mono. There are some instances where dialog and sound effects are delivered in mono but an effect within the audio engine, such as reverb, will process them into stereo or surround outputs.

It is important from an artistic point of view to know ahead of time which kind of audio the music and sound effects will require. On a very basic level, music is always done in stereo; sound effects in mono. That's what we have been trained as consumers to believe and accept. Music on the radio or on CDs is always presented in stereo and as musicians we create music in stereo. Now, would you ever have an occasion to do it in mono? Yes, you would. How about surround? You bet. We need to start thinking outside the norm and be able to adapt our craft accordingly.

For good sound design, it is important to know how many channels to create for from the start. When I first started officially doing sound design, I approached it from a very flat, one-dimensional perspective. Only after visiting with someone with dozens of games under their belt, watching them create sound effects in Pro Tools, did I realize I'd been missing much of the equation. I watched this master create effects using the full stereo spectrum, swinging sounds from side to side, skillfully pulling you into the whole experience. It was like a slap in the face! I ran out the next day and bought a multi-track editor and haven't looked back since.

If you are creating for a game in mono, you'll work hard to get the most out of the sound. If the sounds are done for stereo, you'll have an extra channel to work with and be able to add much more dimension to your work. Even though I create almost every sound effect in stereo, if I know it will be converted to mono later, I don't waste any time having sounds fly around from the left to the right channel. Instead, after I convert to mono, I'll spend a little extra time making the sound interesting—adding some effects processing or creative EQ. The amount of work you put into the task is dependent on how many channels of audio you are creating for.

File Types

What file format will the audio be delivered in and what format will be used in the game? Most of the time these will be the same but occasionally you'll deliver it in one and find out it will be converted to another later. Knowing the file type, such as *.wav* or *.aiff* or *.au*, is important for final quality considerations. Because each type of file uses its own unique brand of compression and sound quality, there will be different things you can or cannot do.

Generally, the standard formats are *.wav* for PC and *.aiff* for the Mac—both regarded as the best way to store sound in the digital domain. The trade-off, though (because these are

uncompressed), is large file sizes. One minute of 44.1 kHz, 16-bit, stereo audio stored as a .*wav* file will take up 10.6 MB of space. A game using 60 minutes of total audio in this format would leave little for the rest of the game. Solutions to this type of problem include:

- Reducing the file size by using a lower sample rate, lower resolution, or fewer channels
- Using a different file type

Previously, developers would keep audio file sizes in check by lowering sound quality—but as new formats are born, developers are willing to try them in favor of giving the player decent sound. MP3 (.*mp3* or MPEG Layer III) is an audio format which has seen quite an increase in games. Its sound quality is comparable to FM radio, but uses far less space. You'll remember an earlier comparison of a 22 kHz sample rate being equivalent to a radio broadcast. But .*mp3* can sound better and take up less physical memory than reducing the sample rate. (See the following chart.)

1 minute of 22 kHz	16-bit, stereo	= 5.3 MB
1 minute of 44.1 kHz	16-bit, stereo converted to .*mp3* at 256 kbits/sec	= 1.87 MB (and sounds better!)

By this little comparison, you can see it may be better for the game experience to use a different file type to squeeze a slightly better sound quality from the proverbial stone. As the sound expert, recommend this option if it hasn't already been considered. Or simply be ready to make whatever audio format they've chosen sound its best. As an example, let's compare different file formats with their size and sound quality.

1 minute of 44.1 kHz	16-bit, stereo	.*wav* (Microsoft Wave PCM)	= 10.34 MB
		.*aiff* (Macintosh PCM)	= 10.34 MB
		.*smp* (Sample Vision)	= 10.34 MB
		.*au* (Java G.177 u-law)	= 5.17 MB
		.*dig* (Sound Designer)	= 5.17 MB
		.*vox* (Dialogic VOX ADPSM)	= 1.29 MB
		.*wma* (Windows Media Audio) at 128 kbit/sec	= 951 kb
		.*mp3* file at 128 kbit/sec	= 939 kb
		.*ogg* (Vorbis) at 128 kbit/sec	= 186 kb
		.*ra* (Real Audio)	= 113 kb

All of these were converted from the same original file using each format's standard compression. A different format alone can change the amount of storage space needed in a game.

By looking at format sizes, you may wonder why we don't use Real Audio, a *.vox* file, or any other similar configuration as standard. The easiest way to understand this is to conduct your own personal experiment. I recommend sitting down at your computer, opening your audio editor of choice, and simply practicing converting file types. Once you've done several, do a side-by-side comparison. I guarantee you will choose the original *.wav* or *.aiff* file for the best quality. You'll be better able to share your audio knowledge with developers because you've converted them, heard them, and developed your own opinions.

Go ahead; it'll be good for you. Sound quality is a subjective thing, of course, but most who are "in the know" would never consider formats just because of their small size. The programming language initially determines what type of format is used, but occasionally, there are options where other choices can be made. There are also licensing issues, which will cost the developer money—such as licensing use of the MP3 format in their audio engine—that will also have a say in what is ultimately used.

Setting Up Shop

The final pre-compositional consideration rests squarely on your shoulders. You've soaked up vast amounts of information and now the time has come to finally make some music and prove to the developer that they chose wisely when they called upon your expertise. So, how are you going to hold up your end of the bargain?

Plan ahead. From now through the end of the project cycle, plan your production schedule, write it down, and make sure it looks reasonable. I don't recommend madly composing and recording and hoping you complete everything by each milestone. More often than not, it will never happen and you'll fall short. Plot out how many pieces of music, sound effects, and narrative recordings are needed for each block of the production, decide how much time you'll need for each task, and then map out your schedule. Based on your working model, you can see fairly rapidly if you have a snowball's chance in hell of completing everything on time. If not, approach the developer and let them know you may not have enough time—instead of dropping a bomb on them the day before your work is due.

As part of your production schedule, be sure to set aside time for mental breaks, whether it is a half day, whole day, weekend, whatever—just do it. Living with a piece of music every day can quickly zap a musician of any objectivity. By letting a day or two pass between listens, you'll be able to pick up on parts which don't work and have other fresh ideas ready to go. Get out of the studio, get out of the house, change your scenery every so often. While it is tempting to immerse yourself in work, and tight project cycles have a way of pushing you to that limit, understand what even a couple of hours can do for your mental well-being and plan for them. Also ensure you get plenty of sleep and eat right. I know I probably sound like your mother, but in the heat of battle, it is easy to forget physical necessities. You can't expect to produce your best work if your basic survival needs aren't met. You may laugh now, but wait until that first contract when you've been in the studio a week straight before even realizing it. You don't want to burn out in this business. Pace yourself for the long haul.

Allot a day or two of prep time. Make sure you have plenty of storage medium—DVD-Rs, CD-Rs, and any other equipment you'll need for the endeavor. Make sure any

maintenance you've been meaning to do is done—all construction and admin projects hanging over your head are either done or out of the way. Try to prevent distractions from arising when you are on a creative roll. A couple of days at the beginning to clear all of this out of the way will help ensure a smooth production.

Get in the Mood

Have the developer send you pictures, artwork, storyboards—anything visual for you to look at—and then plaster your creative space with them. If it's a "dark" game, turn off the lights, set out some candles, cover the windows, and be ready to create within the virtual environment you are composing for. Conversely, for a "happy" children's game, open up all of the shades and turn on all the lights, let sunshine in, and watch lots of comedy. For adrenaline-packed games, do jumping jacks, run, listen to pumping music at full volume, and get the blood flowing every time you sit down to create.

Put yourself in the center of the game. Live and breathe every creative moment visualizing the virtual world. By doing so, you will instinctively compose inspiring music and sound effects without having to force it. Prepare your room within the first couple of days and you will reap the dividends throughout the production. Remember to take frequent breaks from your make-believe world to keep the stimuli strong and effective. Working in the same room for weeks on end, staring at the same walls, tends to drive one a little crazy.

High Quality From the Start

From the word "go," make sure every recording, every sound source, every sample, and every piece of audio you use to construct instrumentation, music, and sound effects are of the highest quality you can afford and obtain. *Why on earth would that matter?* you wonder. Take sound effects creation, for example. Most of the time, it is a blend of several different sounds pieced together to form a desired effect. By starting with the best quality at the onset, you can build from a strong foundation and make the sound do what you want it to do and not have to be stuck with something you get from a bad source.

Normally, sounds will be re-sampled to a lower sample rate or resolution—not the other way around. Initial sounds taken from 11 kHz, 8-bit, mono are going to have a lot of noise and other artifacts present. Trying to produce a quality effect from sounds like these is going to be difficult no matter what you do. It's kind of like recording an AM radio broadcast from 500 miles away in the middle of a thunderstorm then burning it to a CD for playback on your studio equipment. Just because it is on a CD doesn't mean the quality will be good. It is still going to sound like that scratchy noise-ridden broadcast you originally heard.

When collecting sound libraries—either buying them from professional outlets, borrowing them from your buddy's web page, scavenging them from various sources over the years, or producing them yourself—obtain and keep only the best. Over the years, I had amassed quite a collection of sound effects as a personal hobby. When it came time to create sound effects professionally, I first gave a close listen to the sounds in my inventory. Because most had been created and saved with a low sample rate and resolution to save precious storage space, none were even close to sounding acceptable—full of noise and a definite embarrassment if I ever considered selling them for money. I refused to put my name on anything that didn't pass my quality standards, so out they all went.

As I look back on the entire affair, I would have saved a great deal of my time had I started from day 1 collecting only superior sounds.

Initially, you may have some budget studio equipment and instruments in your possession. Because we are talking about quality, ensure you know how to get the best sounds out of them until you can afford better gear. I started out with junk. The little four-track cassette deck was noisy, the old spring reverb had its own definitive personality, the drum machine was tired and mechanical—but because I'd lived with these things for more than 10 years, I actually got some pretty decent recordings from them. If an initial cash outlay is a problem, take what you have and make it shine. Squeeze everything you can from your gear. There will be small developers who won't know the difference anyway and will hire you despite the equipment you have. As the income starts rolling in, start thinking about what you can replace to make yourself sound better, give you a competitive edge, and make more money. After a few years, you will have accumulated an envious collection of high-quality gear that facilitates the superior job you are now known for. In the end, though, developers don't really care what you have, as long as your audio sounds good and works with the game.

Composer at Work

Darryl Duncan

Darryl Duncan is a composer, sound designer, and president of GameBeat Studios.

(Continued)

Describe your thought process for scoring a game project.

Well, I would describe my thought process as meticulous in terms of giving the project the ideal audio atmosphere to make it shine. First and foremost, we let the cinematic or game's visual style dictate the mood the music will be. Whether it is drama, suspense, comedy, or whatever, we let the characters and the situation determine what the music does. If the mood is ominous or suspenseful, then classical orchestral instrumentation almost always works with minor-scale melodies. If we are working with a fast-paced or action scene, then often electronic instrumentation with quick riffs and heavy drums will be a good starting point for our compositions. The main thing is we let the visuals determine what the audio will need to be. I feel a good composer can simply look at a scene or a cinematic and will feel exactly where to go musically because only one direction will truly feel right.

Are there any particular secrets to your creativity?

I admit I am a strange beast creatively. I believe that one of my secrets is not allowing my mental musical palette to be an influence in any way. So, I don't listen to the radio—nor do I buy music. I think this is one of the only ways to ensure that your creative approach is truly fresh. I don't think we realize how much we are influenced, even subconsciously, by the things we listen to daily. So, I think this helps me to remain truly original and creatively fresh at all times.

When do you find you are most creative?

I am most definitely more creative in the evening hours and late into the night. But a great idea can hit me at anytime day or night, so that is when I use my digital recorder to quickly record my raw ideas—but it is the evening when I much prefer to hash out those ideas.

Can you share any advice when working with a developer to help the project go smoothly?

Always try to make sure you and your client are on the same page creatively. What one person may feel works for a particular piece of music or sound effect may not even be close to what someone else might feel works. So, make sure all of your creative conversations are detailed and thorough. The more you and your client are in tune creatively, the more smoothly your project will go.

Do you have any negotiation techniques or stories others could learn from?

Have confidence in your abilities and charge accordingly. All too often composers sell themselves short because of a variety of reasons. Know what the going rates are and don't be afraid to charge for the time you will spend on a particular project. Know that these game budgets allow for audio development. Too often I have seen even established composers or sound designers settle for far less than they should because work is often scarce or because they simply have no idea what the going

rates are. Do your research, know your value, and don't be afraid to stand firm. If you are good at what you do, your client knows it and will be glad to pay a fair, and most importantly, an industry standard price for your services.

Do you have any development stories that served as a good lesson learned or something which can be avoidable in future projects?

Just make sure that all expectations of services, compensation schedules, deadlines, delivery milestones, delivery formats, agreed-upon bonuses, and royalty schedules (if any) are completely documented in writing before a musical note or sound effect is recorded. This is clearly the headache part of it all, but trust me, you will be glad it is all clear if any confusion or discrepancies arise in the future.

Do you have any interesting sound design creation techniques which resulted in a notable sound effect?

Well, this is a somewhat old story—but a true one that is pretty funny and worth mentioning here since I've never shared this story with the public before. When I was the lead composer and sound designer for John Madden Football (*Madden 98, 99, 2000*), we often did live sound shoots to get the many "on the field" sound effects needed for the game. One afternoon, I conducted a sound shoot at a local community college. We used some of the school's football equipment because this day we were trying to capture the sounds of football pads impacting each other along with the human grunts and groans one might hear at the line of scrimmage immediately after the snap.

There were about eight of us out there and one of my co-workers had a somewhat cruel but halfway good idea of how to capture a truly organic natural impact hit with the human vocal hit impact sound. I won't mention any names here, but basically we decided to ask one of the guys on the field to hold a pair of shoulder pads while we got ourselves organized. Now this guy happened to be a quite thin guy weighing all of ninety pounds soaking wet. He thought he was just being helpful holding onto the gear for us, but unbeknown to him he was actually the target of another one of the much heavier guys who was planning to barrel into him at full speed, shoulder pad to shoulder pad, to capture the audio of not only the pads smashing into each other but also the poor guy's unsuspecting yelp cry as he was hit at full speed.

I tried to convince myself for years that I had nothing to do with this devious plan, but when I saw the big guy barreling for his target at full stride with the shoulder pad leading him like a knight in a medieval jousting event I must admit that I had my recorder rolling and quickly extended the boom arm of my microphone into the perfect position and captured the impact. What was the result? All I will say is if you had *Madden 98* or *99*, and if you listened to the hard impact hits in the game, one of them is the most blood curdling scream with pad clanks. Our poor victim was forever immortalized in the game and it is truly one of the most devastating hit impacts you will ever hear. Sorry, Ben, it wasn't my idea.

(Continued)

How did you find your way into the games industry?

I originally came from the mainstream music industry side. For me, the music industry became very strange in the late eighties and early nineties when it seemed that artists were being signed and selling records based on their looks or how much flesh they showed in music videos—instead of their true vocal talent. So, a lot of artists had deals who were no more talented than a brick—and even more unfair, tons of artists with amazing talent were being overlooked because they didn't fit a certain physical description. In my opinion, this trend was the beginning of the end for the industry and I very much wanted to change to something that was more rewarding and balanced in terms of my contributions as a songwriter and producer. So, I made a conscious decision to leave the mainstream music industry and to pursue other things.

I decided to enter the then newly booming video gaming industry. So, I created a strong demo reel and immediately began to market myself as a sound designer and game composer. After receiving multiple job offers in the game industry, I decided to accept the offer from Electronic Arts to start and manage their audio department in their Florida division—then named Tiburon.

"GOTCHAS" and Other Things to Watch out for

The art and science of developing video games is now more than 30 years old and we are slowly approaching normalcy in an industry involved in continuous change. With this comes a standard, a tried-and-true method of creating audio for games. Different teams, however, do things just a bit differently to meet that same end result. The road occasionally becomes fraught with unseen perils and unwanted frustrations inhibit our creativity at a time when it needs to flow. These are what you need to be on the lookout for.

Placeholders

Building and piecing together a video game is a huge undertaking and developers take some shortcuts to create their virtual worlds before bringing in the professionals like us. To test the audio drivers and spice up the silent game tests, they may put in "placeholder" music tracks and sound effects. They usually borrow something close to what they have in mind from other games or from commercial music. This can be a good thing in some cases. Now all you have to do is replicate something similar and you're all set. Most of the time, though, this can be bad for you and bad for the game.

As the game is produced, tested, and played among the development team, these place-holders will be heard hundreds of times. By the time they bring you in, everyone will be used to hearing them and will more than likely be attached to them. Anything you come up with runs the chance of being sub-par—new sounds and music of yours not quite living up to the developer's expectations. It can be nerve-racking, to say the least. Instead of the

developer letting the audio expert lend their particular brand of artistry to the mix, they will hurt the potential of the game by not giving you the opportunity to try something fresh.

Be cautious when approaching a game using placeholders and be ready to sell your ideas a little harder. It isn't impossible to get your ideas across, but as the new guy on the team, you might not be listened to as closely as you would hope. You do have one advantage in this type of situation, though. As the new guy, you are able to take an unbiased look at the game and provide the unclouded perspective of someone who hasn't been living and breathing this thing for the last year. As you see more of the game, you will notice things everyone else may have missed—from simple word misspellings to artwork of characters missing body parts. Use this to your advantage to quickly build credibility and to show your commitment to the project. Once you've shown that you are only looking out for the game's best interests and not your own "personal" inclinations, you've got it licked.

A Developer's Listening Preference

You wouldn't think in the professional video game industry a publisher or developer's personal tastes in music would be a big factor, now would you? Don't be so sure. Imagine trying to present music to someone who hates a particular style. Even if the music is perfect for a project, a decision maker up the line may dislike your submission just because they don't like that genre. There are the occasional few who lose sight of the big picture, failing to understand who the game is designed for and the make-believe world they are trying to immerse the player in. Those are the guys you need to watch out for.

I've never heard of a fishing game using techno; country would definitely be the better choice. But don't think somebody won't try to get you to do it. If they hate country music with enough passion, they may try to influence you and those you deal with. In times like this, you need to remind the producers that, while you can appreciate their personal tastes in music, the project definitely calls for a particular style. Help steer them back on the path of what is best for the project. Can't get your point across? Then do the style of music they want you to do, but make sure you don't end up redoing the work for free. This brings us to the next point.

Endless Reworks and Change Orders

Reworks and change orders were covered in Chapter 6, but I want to reiterate their potential impact on you. They are definitely something to watch out for in our business and one of the more standard "gotchas." There is an acceptable amount of reworks—the exact number being as many as you can tolerate. When it goes overboard, you need to stand up and say something. Perhaps you have already negotiated something in your contract about reworks and change orders and you've opened the lines of communication for a free-flowing exchange of ideas. You've done all the right things and still you seem to be working hard on several reworks. What gives?

Some good investigative work on your part may be in order. The producer you are reporting to reports to someone else and maybe they are the ones who are throwing a wrench in the machinery. The producer is trying to look good, too—making you work

extra hard in order for him to be able to present several options to his boss. This is fine to a point. But when you are wasting your creative energies taking new approaches, these little moments quietly disguised as "reworks" appear to have become "change orders" instead. You might want to subtly remind the producer about the particular clause in the contract which requires new milestones for change orders and see what happens. I'm not trying to say you shouldn't work hard to make a game the best it can be sonically, I just don't want you to be taken advantage of without appropriate compensation.

I had a situation once where I seemed to be working harder than normal on sound effects. I couldn't understand why the sounds I'd already sent weren't working and was getting no feedback from the producer. I just kept getting requests for different approaches to the same effects. My gut feeling was telling me to quit, but my head was saying to go that extra mile for this new client and so I continued to march. A month went by and I'd submitted five separate approaches. Creatively, there was nowhere else to go and I secretly prayed there wouldn't be anymore requests. When the list of sounds they picked for the game finally arrived in my e-mail, every sound was from the *first* batch I'd sent! Turns out it wasn't even the producer making the decisions but his boss, who had the final say. I promptly renegotiated an hourly wage for the next project and made a point to include the executive producer in my little network the next time.

When working as a new composer and sound designer on your first couple of projects, it is important not to let your inexperience appear obvious. Be easy to work with, but maintain that air of professionalism to ensure you are taken seriously when raising valid points such as those previously mentioned. Most of the time, developers don't know or don't care about the impact they may have on you with what seems to be "simple" requests. They are in the business of getting the game to the marketplace and everyone on the team is expected to work hard toward that goal, including contractors. Don't be afraid to express your concern over events which may interfere with your creative activities. The producer is managing an entire team and needs to know when nothing is happening on your end. Maybe they can help. The times I've called producers in this situation, I've ended up getting either an extension of a milestone (to ease the pressure and give me a day or two to regroup), or I've gotten brilliant ideas that pointed me immediately toward a solution. They are a valuable resource and their experience should be used wisely.

Communication Breakdown

From the very first meetings with a developer, do what you have to do to be included in the creative process and to stay there. As discussed previously, creative ideas have a tendency to change rapidly—and as a contractor, you'll end up being the last to know about important issues unless you are on the distribution list. Changes that seem "inconsequential" to the developer can have a great impact on your musical perspective and cause grief on your end.

An experience I had with an out-of-state developer illustrates this point clearly. At our initial creative meetings, we had discussed the personality of a particular character and all seemed to be in agreement. I received the scripts for the rather long narratives, hired the voice talent, and spent two days in the studio recording and editing the sequences. I was very happy with our work and sent it off to the developer. I received a phone call after the producer had heard the recordings saying they had changed this dark, evil character

to a more mystical, less intimidating one instead. "I thought you knew," was the chilling statement I received. "Uh, mmm, ah…" was about all I could come up with as a response. We ended up throwing out that version and went back into the studio with new talent for another round. I was lucky the developer was understanding and that the breakdown in communication was not considered my fault. I didn't have to eat the cost of the first voice talent. It could have easily come out of my budget.

Another example: I got the parameters for a slot machine game and it looked cut and dried. I had done more than 40 similar games for this developer and lately, they had been giving me carte blanche; that is, accepting my own sonic interpretation of each game. I didn't receive any advanced artwork but was given a link to the game sponsor's web site from which to glean some ideas. Unfortunately, the site was void of any artwork, except for one little icon in the top corner, and that didn't provide much help. I fired off an e-mail to the new producer I was working with, explained my predicament, and got the go-ahead for a "fun ship" theme for this ocean liner–themed slot machine game. I spent a few days working up the sound effects, even spending money for a new sample library—determined to outdo my previous game submissions. I sent off the sound files, feeling pretty good about my efforts and went on to other business.

I usually got confirmation within a day or two that the sounds were received and which ones they wanted to use for the game. I heard nothing for a week. After two weeks, while conversing with the company's executive producer on another matter, I found out the producer I was working with wanted to chat with me—something about needing different sounds for the game. So, I picked up the phone to find out what's up. The artwork came back and the new artist had interpreted their take on the game as the "golden age" of ocean liners instead of "fun ship." Now that there were two ideas in the barrel, the sponsor decided on "golden age" and since then, the producer was trying to figure out how to tell me. It seems somewhere in there, I got nudged out of the loop and missed out on important creative direction. I went back to work and created some "golden age" sounds, having to push the rest of my schedule back by a couple of days. As a contractor charging per sound effect and not by the hour, I lost money on the deal. Lesson learned: staying in the loop saves both time and money.

Conclusion

The stage has been properly set for our mesmerizing performance. We've discussed and planned our strategy, opened the lines of communication, and are poised to bravely leap into the fray. There isn't anything left to do but press the little red button and start recording the music and sound effects which will launch our meteoric rise. As long as we jump into this wisely, we will be able to get our best efforts accepted on the first try and save some serious headache. I strongly recommend using the points talked about here—not because I'm cloning an army to take over the gaming world, but because the lessons previous game composers and sound designers have learned will save you tremendous grief and make this entire experience something worthwhile. After all, satisfaction in our chosen career is the reason most often given for staying with it—not the monetary rewards.

Sound Designer at Work

Kurt Kellenberger

Kurt Kellenberger is a sound designer for Sony Computer Entertainment of America.

Describe your thought process for creating sound effects.

I suppose there are a number of things, beginning with just a gut feeling about what an effect should sound like—based on whatever information I might have, visual or descriptive. I consider how a sound fits with other sounds and ideas in the game. I also usually immediately think about the interactive implementation: how is this sound affected dynamically by information from the game, not just 3D location and volume, but layers of elements that combine for varying layers of intensity, for example. I think about what I want the listener to feel as well as what I'd want to feel as a listener—things like satisfaction, anticipation, tension. Then I think about how to obtain the elements to make the sound as I've imagined it to this point. And that's just the beginning, as actually finding and creating those elements usually ends up taking me in all sorts of further directions!

Are there any particular secrets to your creativity?

More cowbell! Seriously, I don't necessarily know how other people approach their creative tasks—so I can't really say if anything I do is especially unique. I do generally begin with just a strong initial gut impression of what I think I want to make, but getting there usually ends up providing many interesting alternatives and happy accidents.

When do you find you are most creative?

Usually early in the morning or late at night, but hardly ever during the day. There's usually just too much other stuff going on during the day, so I'll tend to let ideas brew in the background—and then something usually kicks in in the middle of the night. A big deadline or milestone approaching usually helps to stir the pot, as well!

Any specific "lessons learned" you've learned over the years?

There are definitely some ongoing themes I've discovered. Be proactive: the earlier you can request support or introduce audio features, the more likely those things will happen. I've learned that no matter how great your idea might be, if it comes toward the end of the development cycle, the chances of it making it into the game get pretty grim, and then you just have to save it for the next project. Be visible: stay connected with the team, and you'll figure out who to talk to when you're looking for information or for a way to implement something you want to do.

Do you have any suggestions when working with a developer that can directly affect your efforts?

Well, it's more of a general thing but it's a simple fact that audio is cheap, comparatively, and yet can add immense value to a gaming experience. Use this fact to find or develop an advocate—a producer or lead, maybe, who understands the value of good audio for the game. Having an ally can help make it so much easier to get difficult things accomplished.

Also, remember that game development is an evolutionary process. There are things inherent in every project to watch out for—things like the usual changes in direction, feature creep, and aborted plans. The more you can plan ahead the better, but with the caveat that things will inevitably change.

Do you have any sound design creation techniques which have led to interesting results?

I've experimented with things like contact mics on hockey skates and mic'ing up players in a variety of ways for a variety of effects. I've also gotten lots of cool stuff by using PZMs in a number of ways, either mounted on the glass for a hockey shoot or spaced out for recording crowds at NBA games—or you can take the plates off of them and use them almost like contact mics.

I also like to do stealth field recording, especially crowd ambience—which I've recorded in a variety of places: sports events, shopping malls, bars, amusement parks. And like any proud dad (who also works in sound) I've got all sorts of recordings of my son—and yes, he is in a game! For that matter, so is our cat!

We are doing a lot more Foley these days, both to-picture for cinematics and wild for effects creation. We are also doing a lot of dialog capture during motion capture

(Continued)

shoots, using the same talent and performances for both motion and dialog—so that's been very much like working on a film shoot.

Any horrible endings to a project?

I've had a few projects cancelled, which is always disappointing—especially after you've already planned interesting features. But, you take those ideas with you to the next project.

How did you find your way into the games industry?

Heh, through reading this book, actually! Or at least in part, as I found it to be an invaluable resource in familiarizing myself with the industry.

To make a long story short, I already had a career in sound for theater but decided to seek out new opportunities in audio—when I came across this very book and became intrigued by the idea of interactive game audio. Next, I did some research and just sent out a ton of letters and e-mails—not looking for jobs so much as looking for information. This resulted in a few opportunities to correspond with people in the industry who could actually give me some insight and advice—including Aaron, who was even kind enough to meet with me and later took me with him to a G.A.N.G meeting. Meanwhile, a few opportunities popped up, a little contract work here and there, and one thing led to another (friend of a friend of a friend kind of thing) and I got an interview to work as a contractor at SCEA. Well, I guess they liked me or my work and asked me to stay—and here I am.

Now, in my case I'll be the first to admit that there was some amount of luck involved—some "being at the right place at the right time"—but I'd say my message to others is that you have to work very hard to build that network and to create those opportunities to put yourself in a position to seize the moment when it occurs. Once you've got your foot in the door, then all you can do is back it up with some good ol' hard work!

CHAPTER EIGHT

Creating Music for Games

Music is a powerful force in the modern world. The right music coupled with the right visuals is pure magic. Film and television have much to do with our perceptions, as does the music we choose for our own life's soundtrack. When we are emotionally "up" or psyching ourselves to be that way, we listen to music that is upbeat, has a positive rhythm, and makes us feel alive. Conversely, when we feel down or making an effort to relax, we feel better listening to slower, less complex music. Music affects us at a purely emotional level. Great composers know how to capitalize on this and by design, make you feel how they want you to feel.

Movies are a great way to learn methods of emotional manipulation. These complex screen dramas use music as the force to portray what pure visuals cannot—enhancing them appropriately to express what a character is feeling. There is a problem with comparing movies to video games, though. Movies are linear. They start, they play, they end. Each scene is perfectly planned and the composer knows exactly what to compose and where to take you emotionally because it is all scripted. Most video games are not presented in linear fashion; each time a game is played, something different happens. It would be extremely difficult to score a game as you would a film, so different methods are used.

The future has moved more toward interactive music—music which follows each twist and turn in the plot, matching your every move. It is possible to create the right atmosphere for what is to come, causing tension or giving a sense that something is about to happen—as is popular in film scores. Not all games require this type of adaptive music and rely on music instead to set the mood and provide a certain "pulse" to the accompanying scenery. The two mediums require different skill sets, obviously, and some of us are better suited for one over the other.

Writing music for games is not necessarily a difficult thing. It does require a different mindset to deal with the number of intricacies the games business has to offer. Because you are proficient at composing music for yourself or your band, or for commercials and film, it doesn't mean you will automatically enjoy something like this. In games, you wear all hats: the composer, arranger, copyist, engineer, producer, musician, mastering engineer, CD manufacturer, and so on. The pressure and challenge of dealing with all facets can be incredible. One of the objectives of this book is to present you with details which allow you to make an educated decision about this line of work.

Composer at Work

Richard Jacques

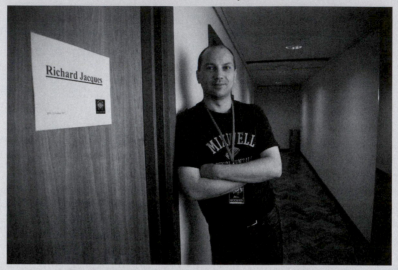

Richard Jacques, composer. (Photography by Matt Eaton.)

Describe your thought process to scoring a game.

I treat each game completely differently, and therefore have a unique approach to each project I score. In general, I would begin the process by discussing the music requirements with the developer of the game. Many people create a music list or brief at the beginning of the project, and the first thing I do is usually change this, sometimes beyond recognition, as I find that sometimes music is just not needed in a particular section or the developers may have missed a musical moment which I feel is essential in the game. I try to think about the shape of the score and how it fits into the game. Where are the highs and lows? Do they follow the emotional map of the gameplay? What is the function of the music in a specific piece of gameplay? Are we going to use themes? What is the overall stylistic setting? Is the score going to be tonal or atonal or a mixture? Is it going to be organic and earthly sounding or synthetic and edgy? These are the kinds of questions I ask myself and discuss with the developers before I compose a note of music.

Once we agree on the creative brief, and discuss any technical requirements such as the interactivity of the score and how it plays within the game setting, I then start to compose. I may work on some of the key themes or melodies in the game first (if it is going to contain any, that is) and then look at the parts that need more of an underscore. I like to have as many assets in front of me as possible, from game design documents, reference movie files, and hopefully the work-in-progress

version of the game that I can play. I am a very big gamer so always like to play what I am scoring, since a game will instantly speak to me with regard to aspects such as tempo, dense versus sparse orchestration, instrumentation, and the like.

I usually score any cut scenes last, before recording and producing the score with live instruments where applicable, and then mixing and implementing the cues into the game itself. I always get involved with implementation, it is key to delivering a working interactive score in my opinion.

Are there any particular secrets to your creativity?

Of course, and too many to list in this book! But seriously, it is hard to put onto paper exactly how and why I do what I do. Basically, we are still composing music to picture here, even though the picture is not a locked linear picture (with the exception of some cut scenes), so it is still what is happening on screen that rules how I compose creatively. Music can provide the emotional backdrop to a game, or we can make the player feel something quite unique and unexpected when he or she is playing. I use a lot of improvisation when forming ideas, across many instruments. I may sit at the piano (not at my sequencer) with an old-fashion pencil and paper and just work on melodies or harmonic ideas, or I may work on the guitar, or sometimes when creating rhythmic ideas I just improvise on a drum kit, or a single snare drum or other percussion instruments. I like to be free from technology at the very beginning and just run with the ideas I have in my mind.

When do you find you are most creative?

I think I have the best ideas in the morning, or when I'm out walking, or just away from the studio. It's amazing what music you can hear in your head when you are just out and about. The main theme for *Headhunter* (Jack's Theme) was written in 10 minutes on the train, and as Tommy Tallarico said, "That is one of the greatest video game themes of all time." Go figure! I do work very late into the evening and early mornings on a regular basis, and although I don't consider myself a "morning" person I know that my best creative input happens between about six a.m. and two p.m. Once a cue is sketched out, I can work on the orchestration, arrangement, and production.

Any specific "lessons learned" on a project you could share?

When creating interactive scores—for example, using multiple layering techniques— it is important to have a very clear brief from the client, since scheduling this type of work can be hard with many unknowns. For example, if the client requests one specific change in a specific cue, this may affect three or more associated cues that play underneath of or on top of the cue in question, so this has obvious ramifications. In this case, spreadsheets and project scheduling programs are our friends!

(Continued)

Here's another one. In the games industry, there are often lots of games based around licensed intellectual properties—including film, TV, and other properties. It is always important to be sure who has sign-off on the work that you are producing, because when a license holder becomes involved, it is more often the case that they will have creative sign-off on all aspects of the game—which would often include your music or sound design. Make sure you find out from the publisher exactly the process and personnel involved. I learned this on a recent project which was a licensed movie IP, where I was led to believe the producer and associate producer at the game publisher had total sign-off. It turned out that this was not the case!

Any good business advice to offer?

It is important to have good business skills as well as creative music or sound design chops. Believe in what you are doing, believe in yourself and charge a fair price for the work involved. There will always be someone who will do it cheaper, but that does not mean it will be as good quality. Like the saying goes, you get what you pay for. That is especially true for game audio.

There are many pitfalls when working in the game industry. Have you had any bad experiences?

One of the most common ones is a project getting shelved. This is unfortunately part of the games business, because a project of developer may get into financial difficulty or the game may be canned for other reasons. It can be tough on a creative person when you've put your heart and soul (not to mention blood, sweat, and tears) into a project for months on end only to have a game cancelled, and the stress of wondering if the developer or publisher will keep going long enough to pay you.

How did you find your way into the games industry?

I followed a traditional classical music education in the UK, studying piano, trombone, percussion, and guitar and completing an Honors Degree in Music. I had been a gamer since a very young age and had grown up with technology, doing small bits of programming along the way, as well as building up a basic studio setup throughout my teenage years. During the final year of my music degree at university, Sega Europe was looking for an in-house composer. After several interview rounds and a few demo tracks later, I was hired. I finished my degree on a Friday, moved to London on the Saturday, and started in the games industry with Sega on the Monday—it was literally that quick! Right place, right time, you could say. I spent eight wonderful years at Sega as Composer and Audio Director, working on big franchises such as *Sonic, Daytona, Jet Set Radio, Headhunter, Outrun 2*, and then formed my own company in 2000. Now I have the luxury of working with the biggest names in the business all over the globe.

Game Music Varieties

One of the beauties of game music is that you rarely get bored working on a project. Within video games, there are several musical specialties that guarantee to keep the perspective fresh and your skills employed. You'll get to compose scores for cinematics, background gameplay ambience, and in-your-face title themes, all for the same project. It's a great testing ground to prove your compositional skills, but it can also tax your creative stamina. It's definitely an exciting prospect—one worthy of the paycheck you receive for your talents.

Let's turn to an overview of the various types of music required in games. This is by no means a complete listing because there are no specific rules for when and where music should be applied. But certain similarities exist where game players expect to hear music and these are the ones we'll discuss.

Intro, Closing, and Credit Sequences

The first piece of music the player will encounter is the opening (or introduction) sequence. This is presented either as a "main title theme" or a score accompanying opening cinematics. The music will help build the momentum and excitement of the game, set the mood, and establish the main storyline. This first moment capitalizes on the player's exhilaration for purchasing the game and reassures them they have spent their money wisely. This music plays an important role in establishing the quality of the game—the crucial first impression that will last until other opinions are formed. If the music sounds cheesy, it cheapens the purchase immediately—regardless of the quality of the graphics. If a compelling orchestral score greets them, the player has a sense that they are in for a first-rate experience.

Closing and credit sequences are normally where the final musical cues occur. This late in the game, they might not enhance the player's opinions, but they still serve an important purpose in the overall scheme. The closing cue will accompany a final cinematic sequence, a slide show, or the end credit sequence. It is designed to give the player a sense of closure after the effort of playing the game. Normally, it's a big accomplishment to actually finish a game and this final fanfare will reinforce the moment. The music will set whatever final mood the developer wishes to leave the player with, whether it is triumphant and happy, or calm and serene. Someone has spent $50 and possibly weeks of their time playing your game, and we want to congratulate them and give them every reason to believe all of our games are worth playing.

The credit sequence is the chance for the development team to have their name in the spotlight and get a little public recognition. The slide show or scrolling display is either triggered by the player from a game menu or will automatically play after the objectives of the game are accomplished. If it plays at game's end, the sequence will also serve as the closing sequence. If the sequence is activated at the player's whim, the music accompanying it will generally be designed as background music. Because a player might be exploring the menu features or taking a break from gameplay, the music should still somehow connect with the rest of the game—keeping the pace and remaining on theme. This particular music is sometimes considered "throwaway" music. A player will only hear it once or twice in the course of playing the game and is normally considered unimportant to the rest of the project. But you, as the composer, could also look at it in a different light. For pure vanity's sake, or as brilliant marketing, a composer could create their best music cue to attract prospective clients (who also play these games) or to gain some extra name recognition.

Cinematic Sequences

Cinematics are merely mini, in-game movies. They are used as part of opening sequences, transitions between game levels, advances in the storyline, and a multitude of other functions that require moving pictures. From a scoring point of view, it is exactly like composing for film, that is, a linear presentation that flows from start to finish in a pre-scripted fashion. The music will serve the very same purpose: creating a mood, setting the pace, highlighting plot shifts, and adding tension and excitement to all of the appropriate spots. This type of composing work requires a certain skill level and is often quite difficult to do properly. Those experienced in this type of music composition generally thrive in games that rely heavily on cinematics and can also dabble successfully scoring for film.

This type of animation sequence is often paired with a full and very expensive-sounding orchestral score—usually a multilayered synthesizer and sampler arrangement. More often, though, live orchestras are being used to fill this role for total and complete realism. A lush audio soundscape can put a small-screen cinematic sequence on par with a full-scale movie production and smart developers will capitalize on this. It's not to say that other types of music won't work; a myriad of musical styles will deliver the same affect. But a good game composer will practice their orchestral proficiency despite their love of rock or techno in order to stay marketable in the industry. It can definitely take your appreciation for music to an entirely new level. Be sure to check out the examples on the companion DVD.

Menu Screen Music

Menu screens come in all shapes and sizes, but all act as the user's interface for gameplay selections and parameter adjustments. The player can push buttons or select various objects to set video, controller, audio, and other basic functions to personalize their encounter. Music for these screens can perform an assortment of objectives, dependent on *when* they are experienced in a game.

Initial menus are the "calm before the storm," or where the sense of excitement is built. They may require a more complex tie-in from preceding cinematics or other opening sequences and tend to be busier than a standard menu—generally opting to keep the energy level high. Menus accessed during the game can give a moment of rest from the onslaught of gaming over stimulation. Both types require music within the theme of the game, but "mid-game" menus are usually less dense than standalone music. The player isn't particularly interested in hearing an in-your-face soundtrack during these moments. They are making needed adjustments that require some concentration. The music here should keep the player immersed in the virtual world, but not annoy them. Because there is no way to predict how long the screen will remain active, music which loops continuously is normally used to maintain a seamless rhythm.

Gameplay Music

Music which occurs during gameplay can have various purposes, dependent on the type of game. The music for driving games, for example, is usually dense, upbeat, and very loud. The player doesn't need to think about much besides where the road is and what obstacles they are trying to miss. These games rely on constant movement in both the screen and audio track to keep the player's adrenaline high. This type of music is very different in contrast to low-key background music.

Driving games are good examples of games which use "soundtracks," that is, individual songs that can usually stand up well on their own. They could easily be popped into a CD player to enjoy while out on the "real" open road with the same effect. Other games, such as strategy games that require more brain power and less distraction, use more of incidental music. This music sits subtly in the background creating the mood and remaining unobtrusive. It generally flows smoothly underneath the surface to anchor a player to the virtual world while they interact in a concentrated effort on the task at hand.

Plot Advancement, Cut Scenes, and Tie-ins

As a game progresses to the next level or drastically changes direction during play, visual and audio cues assist in the transition. As mentioned previously, cinematics are often used and are scored per usual from a musical perspective. These changes are significant, requiring a dramatic score to grab a player's attention and motivate them to make it through the next level to see the next movie. These offerings often serve as a reward to the player, where they are able to watch the on-screen action and inwardly pride themselves for making it happen—translating to satisfaction for the game purchase.

For shifts that don't use cinematics (for example, a character entering a room to meet the level's big bad guy), the music will act as the setup for the upcoming confrontation—subtly warning or encouraging the player. The visuals don't typically change until the bad guy actually shows himself. The audio becomes all-important in this instance. Without it, the player doesn't have any foreshadowing and won't know to take out his or her weapon or to get out of the room until it is too late. While this can lead to a learning experience for a player, repeatedly dying and having to start a level over can be frustrating enough to stop playing the game. Audio cues, in this case, will play to their intelligence and allow them to use more senses than just their sight—keeping them in the fight longer and preserving their happiness.

"Win" and "Lose" Finale Cues

We've all heard these types of music cues. Since the dawn of the video game era, this particular musical feature has become a standard. When you win, an optimistic flourish of sound rewards your efforts. When you happen to be less successful, the music is either demeaning or mildly encouraging—prodding you to try again. It is almost unnatural to *not* hear something at the end of a game level. These types of cues provide proper closure to the player's experience.

Musically, these cues will remain within the game's genre and will normally utilize the same sound palette and instrumentation. Winning cues will tend to be upbeat, composed in a major scale and with a lot of pomp and circumstance. After all, the player just won! They deserve a glorious finish and a boost to their ego. It is human nature to want to win and good games will capitalize on the basic need for recognition.

A loss can be presented to the player as a major defeat or a minor setback. Some games go all out with the losing cue and really put it to the player, making a spectacle and giving them a good razzing. These will be heavy on the minor scale and occasionally make use of childish musical putdowns to make their point. Other games are more sensitive to the player and choose not to go to that extreme. Losing isn't always a bad thing, especially in children's games. If you were to slam younger players for their "failure," it would eventually discourage them enough to give up on a game. Leaving them with the sense they were

still successful and can do better next time will ultimately prove to be a better approach. Music should set the tone and not be condescending in cases like this. These cues can be difficult—the perfect blend of defeat and encouragement. You can often get by simply using a toned-down win cue—still positive but just not as enthusiastic.

Interactive Music

Developers have turned toward interactive music as the next major improvement in gaming. The chances are pretty good you will run across this type of project in your career as the appropriate enhancements are made and its popularity increases. This activity will require a good working knowledge of many musical styles and how they can be implemented into the game. It won't be enough just to know how to compose good music. You will need to know how to ensure compatibility between the many musical pieces which could play at any time.

By design, interactive game music will adapt to the mood of the player and the game setting. Music will be slow and surreal as a player is exploring a new environment. If the game character moves from a walk to a run, the music will also keep pace by increasing in tempo. As danger approaches, the music will shift to increased tension, then to an all-out feeling of dread as the bad guy appears out of the shadows. The player chooses a weapon and begins the attack as the music shifts again to a battle theme to fire the player up. As the player gets hacked to pieces by the bad guy, the music will turn dark—conveying that the end is near. But, as the hero gets his second wind and begins a determined counter-attack, the music will morph into a triumphant flurry as he imposes death and destruction upon the evil villain. This is a good example of interactive audio—music that swings with each turn of events and provides an adaptive soundtrack, giving the feel of participating in an interactive movie. If you were to watch a recording of another person playing the game, a good interactive soundtrack would seem as if it was specifically scored to the scene—similar to a linear movie. When it works right, the feeling is indescribable. That's where we step in.

The basic rule to composing interactive game music: Any change in the soundtrack must blend with any other music cue at any time.

Game players are not predictable. We don't know when they will walk, run, hide, enter a new room, meet the bad guy, draw their weapon, or do any of the other hundred possible actions that can happen during a game. But, truly adaptive music is prepared for any possibility. Ensuring the music can transition naturally is what makes it work.

Obviously, the first key to interactive music is to use the same sound bank and same instrumentation. This provides an inherent similarity working in our favor. Another recommendation is to base all of the music around the same key. This provides a solid foundation to make key changes within the same scale and enables the music to return to a familiar root. These changes will have greater impact, while blending perfectly with the rest of the soundtrack. This is used in film scoring, and there is no reason it can't be applied here. Fade-in and fade-out music cues work very well and are used liberally to make adaptive audio applications succeed. Music that begins with a sharp attack is also beneficial, especially when the game mood swings quickly from peaceful exploration to combat mode or when the bad guy jumps out of the bushes. A quick, loud beginning to a musical piece has emotional impact—and if done right, will take the player's breath away, catching him or her completely off guard.

Loops

When physical storage space, processor speed, or RAM is a factor, efforts will be made to save space wherever possible. For audio applications, one of the best ways to achieve this goal is the liberal use of music *loops*. A music loop can quickly load into RAM and play repeatedly without placing further demands on the processing pipeline. Gameplay, menu screens, and finale screens are perfect places for this type of music. Because it is difficult to predict how long a particular screen will be active, music with the capability of continuous repetition works great. Developers may also ask for "loopable" cues as a cost-saving method. Less music equals less money to pay out and cost-conscious businesses are always looking at the bottom line.

As a composer, loopable cues are not difficult. The only real secret is finding the perfect spot after a bar or measure to abruptly cut off the music, enabling it to seamlessly begin again. A little trial and error and quick, imperceptible fades are effective in the audio editing environment. Various loop software programs are also available if you end up doing this type of work often.

Any type of music can be looped, from orchestral to techno, with agreeable results. Longer loops are best, especially during gameplay—where the same 15-second loop would get stale after listening to it for an hour. In these cases, 3- to 4-minute loops would be preferred—basically, full-length songs which can be repeated without a noticeable breakpoint. Menu and finale screens work best with 30- to 60-second loops and inconsequential low-level menu screens work best with 15- to 20-second loops.

Ambient Tracks

In an effort to battle unwanted silence, ambient music can be used to maintain continuous audio activity within the game environment. This type of background music is purposefully designed as light, uncomplicated, mood-setting pieces set to linger almost unnoticed in the soundscape. Of course, if it weren't there it would be noticed and other non-game sounds would have a chance to disturb the player.

Ambient music still remains within the style of the main theme, just a less dense version of it. These lighter cues utilize long, sustained notes and occasional percussion to break any monotony. An orchestral score would make use of string sections and the occasional timpani thrown in. Modern music could use various synth pads or simple ambient keyboard samples. Regardless of the style you are composing in, there is always a unique instrument to be used. Just be sure to keep it simple and keep the volume low.

Normally, ambient music is perfect in long gameplay scenarios where a player may need to concentrate. Think of the last time you drove somewhere unfamiliar. While you are on the highway or in familiar territory, the music is usually up pretty loud. But as soon as you turn off the freeway and need to start concentrating, the volume comes down or gets turned off altogether. It's the same in gameplay, except we don't want them to turn it off. Instead, we make it simpler for them.

More and more these days, I'm noticing ambient music in places I'd never heard it before. Sports games and flight simulators are typically devoid of gameplay music. They tend to let the stadium crowd or the roar of the jet engine provide the realistic effect. But, if you listen closely you may hear a slight bit of music playing way in the background—subtle proof that developers are continuously working to improve the overall game experience.

Stingers

Used in conjunction with other gameplay music which may already be playing, stingers are bits of music which are triggered to call attention to a sudden change in the storyline or other significant events. These pieces of music are generally very short in length, beginning and ending within a few seconds; and while noticeable over the other music, they are created to remain within the theme using similar characteristics such as instrumentation and production. In addition to punctuating a moment during gameplay and introducing, ending, or linking various sections, stingers can also be used for splash screens, logos, or other non gameplay moments. Sound effects can also be created for the same purposes, and often are, but there are occasions where a musical stinger will fit even better.

Tools of the Trade

Tom Salta—composer and producer

As a composer, I enjoy the challenge and intensity of working on triple-A game titles, but I also enjoy the variety of working on all types of games, big and small. I got into the game industry because I love games, and creating music is what I do best. Some of the games of which I'm proud to have been involved in are Tom Clancy's *HAWX* (Fall '08), Tom Clancy's *GRAW 1 & 2, Red Steel, Need for Speed Underground 2, Cold Fear, Crackdown, Project Gotham Racing 3, Fast and the Furious: Tokyo Rush*, and *MLB 2006*.

My studio has evolved over the years to depend more and more on software rather than hardware. I mix in the box and don't use a control surface. This allows me to work very quickly, with no patching and full recall.

Computer: Mac Pro 8-Core Intel Xeon, Logic 8, Blue Sky Monitors, Apogee Rosetta 800 w/Symphony card

Favorite soft samplers: EXS-24 and Kontakt

Virtual instruments: All Spectrasonics and most of the NI VIs

Microphones: Custom tube mic made by Roy Hendrickson, AKG C 460b

Pre-amp: API 512c

Sound libraries: Combination of custom and commercial, including SAM, East West, Sonic Implants, and VSL

Exercises to Create Fitting Game Music

A question I often hear from prospective game composers is, "What can I do to create music that fits?" It's not enough to write good music; you have to be able to make it work perfectly within the environment. There is a little bit of human psychology involved in game composing, whether you believe it or not. You don't want the game player to turn down the volume and it will take some effort on your part so nothing annoys them enough to do it. You will definitely need to get your point across without being obtrusive.

There are game developers out there who don't consider this, who ask for slamming music tracks and put them into the games without contemplating what the player will feel as they play the game. They take music they themselves are absorbed with and expect everyone else to like it, too. Turns out, the 6- to 12-year-old female who would play the game is completely repelled by the sound. The developer just didn't get it and wonders why they aren't around to make another game. Developers: please don't use just any music; make sure it fits the project. Composers: don't compose garbage because the developer tells you to; make sure it will work in the project—and if it doesn't, let them know. If the music doesn't fit the game, no one who sees it will ever consider hiring you for their project.

So, how does one get good at composing game music? Let's take a look at what other game composers have done to boost their success in this industry.

Watch and Listen

The one most effective technique to gain insight into the craft is simply exercising your ability to listen. Listen to the musical world around you. Listen to music while you drive, to the music in the grocery store, to the background music at a party—whatever music is playing during another activity. Think about what the music does for the happenings around you at the time. Analyze what makes the music work or not work. Is it your mood, how you feel, the action, the drama? What element is present that enhances the experience?

For me, driving down Interstate 5 with heavy metal blaring works great! Sitting in a Texas Barbeque eating ribs and listening to old country music is heaven. Hearing a children's lullaby as I put my daughter to bed at night is fitting as well. A romantic dinner

with the wife and some light jazz makes for a fine evening. Whatever music enhances the experience I am living at the time works on an incredibly emotional level and is what I strive for when composing. It's a great exercise for you to try. Would speed metal work at my daughter's bedtime? What about opera at a BBQ? Get the picture? This is an easy way to get it straight in your mind before doing it to picture.

Speaking of scoring to picture, you can learn a great deal from our cousins in Hollywood. They've been making music fit to picture for a few years and are pretty good at it. Watch a lot of movies. After you've watched the movie, go back again to *listen* to it. Listen to the ebb and flow of the melodies—to the techniques used to increase tension, build suspense, and create an atmosphere unique to the film. Listen for the music you don't hear, as well. This is the music that fits the visuals so well, it doesn't even register in your mind. This is the type of music you want to do for games, especially for the background gameplay segments. Learn from the masters. They don't get paid a million dollars per movie for nothing.

Another great way to discover scoring techniques is to analyze movie trailers. These 2- to 3-minute mini-movies can display the entire range of a movie in a short span of time. Not all trailers are done by the original film composer; most of the time, other composers who specialize in trailers perform the task. Many times, the music in the trailer has nothing to do with the film score. It's focused on building excitement to draw you into the theater. This kind of musical stimulation is perfect for learning the art of cinematic scoring. Game cinematics are normally three to five minutes long, with rapid changes of scenes and characters—packing enough information to carry the story to the next level with little wasted motion. Listen and learn how movie trailers get the blood pumping and build the mood for the experience to come.

After analyzing the real world, you can also learn the subtleties of composing for games by actually playing them. Play them and pay close attention to the music, not getting the bad guy. I want you to start forming opinions about the musical soundscape, that is, what music is really good and what music, stinks. You can learn valuable lessons from both. Pay close attention to how they match the theme of the game, what instrumentation was used, the density and complexity of the music, and how the score affects the mood of the game. Can you do it better? What other directions would work? What other instruments could be used effectively? I want you to get to the point that you *know* you could have done as well, if not better. This confidence will land you jobs and knowing exactly what has worked (or not worked) in the past is experience you can advertise. Being familiar with your craft is a whole lot easier than learning as you go. Dig in now, have a little fun in the process, and reap the rewards later.

Create in Different Styles

This particular idea was touched on in Chapter 3, when I talked about putting together a solid demo reel. Put various musical styles on separate pieces of paper, put them in a bowl, and every day, take one out and compose a 1-minute piece in that style. Try rock, country, hip-hop, dance, techno, orchestral, ethnic, bluegrass, R&B—whatever you can think of to hone your skills. You don't need to be elaborate or spend more than an hour on the piece; just do a rough sketch and then decide whether you portrayed the style believably. If you didn't, determine what elements were missing and try again another time. If you nailed it, put this in your "stronger styles" category and push it hard to prospective clients. You can listen and talk theory all day long, but it won't make any sense until you actually sit down and do it. Prove to yourself and prospective clients that your capabilities match what comes out of your mouth.

While you are performing this little exercise, take a look at the methods you use to compose each style. Did you try something different each time? Was that method conducive to the creative process? Should you have tried something different? Loop-based production is great for techno and dance, but not so good for orchestral or bluegrass. MIDI- and sampler-based production is perfect for orchestral and ethnic creations. Live recording methods are good for rock. You get the message. The method is just as important as the style you are creating in. Work out all the kinks before clients are putting the pressure on you to deliver the goods—and get some great practice in the process.

Try Something New

Keeping compositional chops fresh can be a chore when working on video games. You can get pigeonholed into the same style very easily, either for a large game project or for a series of them, and your other skills will rust. It's not a problem until you get the call for an orchestral score after you've spent two months doing an industrial soundtrack. It will probably take almost a week to get spooled up, get organized, and get comfortable with the style before you even begin to roll tape. When time is money, a week of downtime won't help your bottom line very well. Stay ready and stay practiced to keep life easier.

Keep pushing yourself into new directions. Try styles you dislike, combinations of styles, and made-up ideas such as "Venetian techno" to prod yourself into new territory. Continuously push yourself and your abilities to new levels of competence. Music in entertainment is all about creating a mood while using unique approaches. If you gain the reputation of being "distinctive," it will do a lot to help your career and the money you can demand.

Composing with the help of a studio full of talented musicians can also keep your musical perspectives wide open. Even though most game composers work alone, this approach can bring fresh air to your creativity and it can even be fun!

Personally, whenever I spend too much time on a particular cue, the different versions I try all end up sounding blah. It's not that they won't work. It's more that I'm not happy with them because none break any new ground. A certain stale quality can snowball and every subsequent effort continues downhill. I lose the excitement for the cue and it shows in my work. When this happens, I find taking a step backward and approaching from a different angle yields better results. Try a different rhythm track, different instrumentation, or a different frame of mind. Get out of the studio, watch a movie, go for a jog, listen to some of your favorite music—change your latitude, as they say. But, over time—as I get deeper into the game world—this happens less and less because I have other musical experience to fall back on.

By rounding out your compositional experience, your creativity and production of other styles of music (and even your specialties) will benefit tremendously. Adding elements from other styles into your music brings an entirely new feel to your work—something exclusive, something your own. Game composer Jon Holland has many musical "side projects" to keep him busy. My favorite is his "Orphan Sister" project. This jazz offering is characteristic of the light jazz genre but with a distinctive "electronica" quality to it. The melding of two very independent musical styles has resulted in an interesting sound completely identifiable with Jon. That's the kind of distinction I'm talking about. The way to achieve this is through experimentation and experience.

Practice Makes Perfect

Here is another great exercise: take existing game cinematic scores and replace them with your own music. Do the same with company logo animations, stock film footage, or the mass–e-mailed video clips everyone keeps sending—whatever you can find. Most DVD-ROM games have *.mpg*, *.mov*, or *.avi* video files in them somewhere. Make a copy and get to work. Practicing with real cinematics is a perfect way to learn the art of scoring. You can even use them as examples of your abilities. Just be sure to make it clear you didn't perform the work in its original release. You don't want to misrepresent yourself.

Most of today's audio editing programs have the capability of replacing audio in video files. Find out what yours does and look for those types of files to practice on. It's a relatively simple process. Open the file in the editor. The video will be in one block, the audio in another. Erase the audio and resave in the video file format. Use the new audio-less video to apply your brand of music. Don't just replace the music with a similar style. Try different ideas, see what works and what doesn't. Practice timing, build, and fade as the on-screen action dictates. Shift the music as new scenes cut in, paying close attention to what each is about and how the music can provide enhancements. Remain true to the overall presentation and ensure all of the music fits together as one cohesive piece. This type of valuable practice will pay off when the time comes to do it for real. Take advantage of any downtime to practice and stay on top of your game.

Some Technical Considerations

Before sitting down to write a game score, there are a few points that should be defined first. These pre-compositional technical considerations will identify the direction you will

take to compose, whether it's a full DVD-ROM, surround, orchestral score, or a simple melody for a cell-phone title. As touched upon in Chapter 7, knowing all of the details in advance, before you even write a note, will help prepare you for the challenge ahead and save any false starts.

I've made many references to the importance of communication, especially when working as a contractor. By asking the right questions, it will be clearer in your mind, you'll be able to hit the mark the first time and it will make you look that much better in the developer's eyes. After all, you don't want them looking anywhere else for their music and sound needs.

Many of these concerns may already have been addressed through the bidding process and previous discussions with the developer. Don't ever assume all is constant. Double-check to make sure that none of the parameters of the game has changed and then keep a close eye out for further modifications as the production continues. I've worked on a game where the final cue was changed from MIDI to digital audio at the last minute. It wasn't a terrible change, but it would have drastically changed the way I had approached the piece if I'd known about it earlier.

Which Platform Is the Game Being Developed for?

Secrecy is a huge issue in the billion-dollar games industry. There have been times when I didn't find out what platform a game was being developed for until the last minute. Developers are wary of outsiders and are rightfully afraid to give any hints of future game releases. Sometimes, even after signing the NDA, they will remain tight-lipped until they feel comfortable releasing information. I guess it just goes with the territory.

It is important that you, the composer, know what system the game will play on as far in advance as possible—for many obvious reasons. A Nintendo is not a PlayStation is not a DVD-ROM game. They are all completely different systems with different constraints and different methods of addressing audio issues. If I were doing a cell-phone title, I wouldn't go out and hire musicians or a full orchestra. That would be insane! I might, though, for a PlayStation 3 or DVD-ROM game because the chances of using direct or streaming audio are good.

What Is the Playback and Delivery Format?

You cannot compose a masterful score without knowing the delivery and playback formats. The platform a game is developed for will give a good indication of what type of playback system will be used. Console games will be played through a TV or home entertainment system. DVD-ROM or Internet games will be played through either a desktop or laptop speaker system. Arcade games will use a customized system.

Developers study their demographics. They like to know in advance if the people who buy their games also own a home theater and surround system or if their PCs are equipped with upgraded or surround speakers. Find out what their research indicates and cater to that particular type of playback system. Ultimately, you want your mixes to sound great on any system—but you can pull out all the stops for those earth-shattering effects for systems with subwoofers.

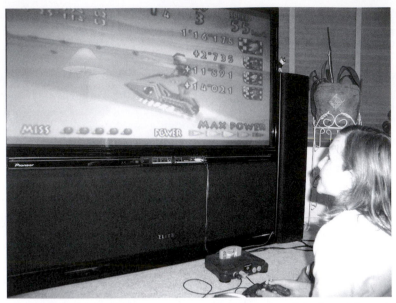

Ensure you know what type of playback system your audio will eventually be heard through and gear your production toward making it sound great!

For coin-op games, find out what the developer has in mind for their customized cabinet. Larger systems have subwoofers and several different speaker pairs. Some utilize discrete playback channels for narration, music, and sound effects that keep the audio separated and provide for clearer presentation. If you are lucky enough to be creating music for this type of game, you know the music, will be receiving the attention it deserves and will take a prominent place in the overall gaming experience. Make it shine.

If a developer requires delivery in MIDI format, you won't waste time with live instrumentation, vocals, or audio loops. Instead, you will break out your keyboard chops and spend extra time tweaking that MIDI guitar solo to perfection. While use of MIDI greatly reduces the actual musicianship of some instruments, its characteristically small file size will far outweigh this disadvantage. As the composer, you'll have to use a different skill set to make the music dynamic and exciting. It's an entirely different frame of mind from the process of bringing in a live band and composing with traditional methods—but who ever said composing for games had anything to do with tradition? Find out what formats the developer needs as soon as practical.

Delivery and final playback formats can be the same; other times they are far different. Sometimes you will deliver a MIDI score and sound bank and they will convert it using a development system. Sometimes you will make delivery in 44 kHz, 16-bit, stereo *.wav* format and they will convert it to 8 kHz, 8-bit, mono *.au* format. Ultimately, you want the music to sound great in its final format, no matter what it may be. If the delivery and final formats are the same, you stand a pretty good chance. If it changes, fate will more than likely take over instead. Perhaps you can work out a deal where you can deliver music in its final format. That way, you retain control over the outcome of your hard work. Most game composer will throw the service in for free as a purely selfish way for them to

ensure their work sounds good. With their names in the credits, they want to make certain their work is represented accurately. If you don't have a particular platform's development system handy, that may be difficult—but not totally disastrous.

Is a Preset Sound Bank Available?

Some game platforms make use of an internal *sound bank*—either in the system hardware itself or on detachable game cartridges and discs triggered to play by a MIDI file or some other proprietary format. Some sound banks (or *sound fonts* as they were called in the not so distant past) are preset into the hardware. Others are changed as a new game cartridge or disc is placed into the machine. It is important to find out if you will have to compose using a preset sound bank or not. A predetermined set of sounds will greatly limit the tools in a composer's arsenal and may force you into unfamiliar territory. If orchestral music is your specialty, a game platform with only a drum/percussion, piano, bass, and synth patch will limit your abilities to do a piece the way you want—the same way a sound bank with only strings, brass, and timpani will prevent you from composing anything techno or rockish.

Most preset sound banks have a decent variety to accommodate several of the most popular styles of music. But, they still force the composer into using sounds which may be uninspiring and ones which weren't chosen specifically for the piece. Look at it this way: this can be a challenge which will only make you better musically. You may have to try a little harder to make this limitation work for you, but I guarantee the results will be worth it. You can't get around a predetermined bank, so make the best of it.

Attempt to get a hold of the actual sounds first, either as samples or sound fonts—or at the very least, listen to the sounds and match them with ones you already have. By doing so, you will be able to compose using similar characteristics and dynamics and allow your mix to be close to the final game version. Don't assume that because the developer says they have a piano in the collection that it is what you think it is. Their little "toy" piano will be a surprise if you understood it to be a grand piano instead. That teary grand piano ballad will take on a different meaning when you hear it in the game played on a toy. The tears you'll be crying won't be from joy.

What Memory Parameters Will You Have to Work Within?

All of the music you compose has to fit on the game cartridge, CD, DVD, console, ROM, or RAM. Find out ahead of time what physical memory restrictions your audio will face and plan accordingly. If 60 minutes of direct audio has to squeeze into 10 MB, you'll probably have to down-sample, adjust the resolution, reduce to a single channel, and save them in a compressed format. This is an ugly example, but it gives an extreme idea of what you should be thinking about.

What instruments will be lost with the lack of high-frequency sounds? As you down-sample, the high-frequency range shrinks and instruments like hi-hats, cymbals, and acoustic guitar begin to disappear. What noise floor will you have to stay above? As the resolution is dropped, quieter passages of music won't cover up the quantization noise introduced by lower-resolution values. If the music will only play back as mono, there won't be any need to spend time with stereo sounds or effects. In addition, extra care should be taken to ensure that the final mixes don't have any phase cancellation when the original stereo tracks are paired.

Technical Wrap-up

The short list of nonmusical considerations we just discussed will ultimately define the restrictions your compositions must remain within. I choose to have these technical issues clear before I ever begin to compose. Writing music is an intense experience, with no place for distractions. Understand the environment and it will almost subliminally guide the process of creating appropriate audio.

Composer at Work

Lennie Moore—composer

Describe your thought process when scoring for a game.

I'm someone who gravitates towards themes. I spend a lot of preproduction time thinking about things like, "What is this game about?" I'll then create a central theme that reflects these ideas. For *Lord of the Rings: War of the Ring* I had a hope-versus-despair theme that I wove into the fabric of the entire score. This was based on my extensive reading of the Tolkien books (since junior high school!) and my understanding of the characters and the story. For *Outcast*, I used a central theme and tonality (or harmonic structure)—as there was a component where you could eventually travel between all five regions in the game and I wanted the player to feel that all these regions were connected by a common thread.

Are there any particular secrets to your creativity?

I pretend I'm eight years old, playing with my toys and making up my own sound-track—like a lot of kids do naturally. I also make it a point to not answer the phone, check e-mails, or in general be distracted during my composing time. I do my best to eat well and go to bed at a reasonable hour so I can keep my creative energy consistent from day to day, especially on larger projects where I have to sustain the same high level of creative energy over several months.

When do you find you are most creative?

I'm the most creative in the early morning, from six a.m. until about two p.m.

Any specific "lessons learned" on a project you could share?

I worked on one project where all I had were screenshots to compose to. There was no way for me to see how the game *moved* and that was a challenge in figuring out how fast the battle music tempos should be. As the game was about zombie killing, I figured zombies move slow, so I could actually do a slower tempo (like sixty-four beats per minute) but 1/32 notes for a lot of intensity and it would work well. The end result was great and the client was happy, but I really prefer as much detail as the developer will allow in order to really nail it.

Do you have any negotiation techniques or contract stories others could learn from?

When negotiating a contract, I always ask myself what clauses, or points, do I absolutely *have to have*, what are ones I'd *like to have*, and which ones are *not an issue at all*. This helps me determine what I want my agent to really fight for. I think it's also very important to understand the other side of the negotiating table. What do they have the rights to give or not give? Are their hands somewhat tied? Finally, I think it's important to remember that you are not negotiating with an adversary— you are negotiating with a friend. They want to hire you and that's a great thing in itself.

What advice can you give as a composer when working with a developer?

In general, I find it's all about great communication. Anytime there has been an issue in the past, the resolution has been to talk it out and find a workable solution together with your client.

The other lesson, which I think is a very important one, is that there are absolutely no guarantees that the music you write will end up in a game that actually makes it to market. Having an emotional attachment to a particular score can be devastating. I've had two projects where I delivered completed scores (both of which I'm very proud of the work I did) ended up on the proverbial shelf, where they weren't released. Where I'm emotionally involved is composing and delivering a great score

(Continued)

for every project. Once I hand it off to my clients I have to let go of it because it's completely not up to me what happens after that. It's almost like I'm a surrogate mother carrying a baby for someone else! The key to finding peace in this type of situation is to realize that my life doesn't end with one project and to move forward to the next cool endeavor.

Do you have any interesting creation techniques which resulted in a notable piece of music?

Here's a cool orchestration puzzle I enjoyed solving. In bar 45 of the Lumina region in *Outcast* I was trying to figure out how to create a very shimmering effect in the strings, where the violins and violas moved up and down through different chord inversions (you'll need some music theory to get this!) by doing a technique called fingered tremolo—similar to a trill but actually trilling between different notes of a given chord rather than the normal whole- or half-step trill. Then I had to figure out how to divide up the fingered tremolo so it could be easy to read and very playable. In the end, I chose to divide the rhythms on each 1/8 note—plus I voiced

it in a five-part divisi, which gave it a beautifully rich color. This took me a half a day to figure out but was totally worth it!

Have you ever had any horrible endings to a project?

No, not really. I've been lucky in having great experiences with all my clients. I think part of this is due to my commitment in creating consistently great music, meeting all deadlines, and being a good guy to work with. Doing this is not always easy! I have my moments when I'm stressed, challenged, or just angry about something, but I always go back to telling myself, "This is exactly what I want to be doing with my life and I love it."

How did you find your way into the games industry?

The *Outcast* developers posted on a newsgroup that they were looking for a Hollywood film composer to score orchestral music for their video game. I sent them an e-mail saying "Hey, I'm your guy!" and after submitting some music I did with a live orchestra and choir for an atom bomb documentary (*Trinity & Beyond*) they saw what I could do and hired me. I'll be forever grateful to them, as they introduced me to an industry that I love with all my heart and soul. I've found my people and they are geeky programmers and technology freaks!

Musical Details to Reconsider

These particular "musical" questions need to be asked, just like the previous "technical" ones, before the composing process begins. Some of them may have been answered during the bidding and contract phases as well, but they may have also changed since then. The answers may not give you the information you need to actually do the music. Previously, you needed to know how much music was needed, what formats, what platform, and so on to determine how you were expected to create and deliver your "product" and to give the developer a dollar figure for your services. The following list is specific to creating the magic which is music, without the business distractions.

What are the specific intentions of the music in the game?
Is the music to serve as the main title theme, subtle background ambience, or other music cues designed to create tension or announce victory—or all of the above? The music's purpose should be clear prior to a first note being composed.

What is the genre of the game?
Is it a sports, horror, children's, strategy, board, puzzle, shooter, racing, flight sim, adventure, role playing, action, or arcade game? Find out, if you don't already know, the overall theme of the game project and your musical choices will narrow themselves

automatically. Knowing the era and the locale of the game ahead of time will also help dictate the direction the music will take.

What similar music styles can be used as examples?

If a developer tells you the score should be "industrial, not too gritty, but with an edge," what does that mean to you? They seem to know, so ask them for specific examples of music from a band, movie, or commercial. Then, find it and figure out what they are talking about. After listening several times and becoming familiar with the music, ask them specifically what it is about the music they like. Is it the beat, the guitar, or that great synthesizer patch? Is it the reverb tail on the end of each snare hit or is it the swirling effect on the electric guitar? Is it the melody or the rhythm that catches their ear? Have them put their finger exactly on the elements they would like to hear in their game. Discuss it with them until you are positive. But, even then, there are no guarantees.

An example: the developer sent along an audio example with their request for music. I listened to it several times, got a good feel for it, and decided to jump in without discussing it first. I used the same instrumentation, almost the same beat and tempo, and thought I'd matched their idea fairly well. Turns out, it wasn't any of those elements they were looking for. They liked the distortion patch on the electric guitar and wanted me to focus on that! Aaahh!!! Funny, there was absolutely no discussion about it.

Is there a preference for instrumentation?

Here we go again. You're supposed to be the audio expert, why can't you choose the instrumentation? Ultimately, you can and will most of the time. I prefer to throw out this question for ideas on what the developer is thinking—yet another chance for communication to be concise and allow the music to match their vision the first time. Find out if there is anything special they would like to hear. It makes them part of the music creation, lets them in on the decision process, and gives you something to fall back on if they try to change their minds late in the game. I'd rather not waste time just because someone forgot to mention they didn't want a crunchy-sounding guitar in that racing game. Find out at the same time which ones they are definitely against.

Is the sound bank predetermined or will you be creating it?

The answer to the earlier question will have made it clear whether or not a sound bank will be used. The question here is: will you have to create the sounds yourself or is it preordained? Established sound banks will limit your use of instrumentation and effects, forcing use of sounds chosen by someone else. If the sound bank is left up to you to create, find out some details. How much space is allowed? What format is needed: .wav files, .aiff files, .mp3? What parameters are required? What sample rate, what resolution, and will the sounds be stereo or mono? In a sense, these sounds will be played back as the sounds in a sampler would—so it's up to you to find out what it takes to make them work.

A PlayStation 2 game I worked on a couple of years back allowed for a sound bank of 2 MB. The final samples were delivered in .wav files, but the instruments and parameters were left totally up to me. All I had to do was ensure the sounds were delivered under the 2 MB limit. Using various drums and percussions, piano, bass, organ, and synth samples, in 44.1 kHz, 16-bit stereo, the total size came to over 5 MB for my

original sound bank. I composed the music in the highest fidelity possible, mainly as inspiration and because I had to listen to them throughout the entire two-month project. When the final delivery was made, I down-sampled to 22 kHz, 16-bit mono, did a final remix of the music without a noticeable difference in quality, and made my budget of 2 MB. The best part of the experience was being able to pick and choose sounds which were inspiring to my style of composing and not being stuck with someone else's idea of instrumentation.

Today's game platforms aren't quite as limiting as the PS2, except for maybe the current generation of handheld or cell-phone systems—but it's always a good idea to know if a sound bank is to be used and what resources have been allocated to it.

What is the length of each cue?

The bidding process may have revealed estimates for the lengths of needed audio. Now that the recording and implementation phases are quickly approaching, for various reasons ideas may have been amended and levels may have been added or may have disappeared altogether. It is important to have the final length set in concrete for the pieces you are creating. If you don't and the length changes, you'll be starting over or spending some extra time with complicated editing.

Obviously, cues for cinematics will be more manageable—but splash screens, menus, and finale and background cues will need to be defined. There's no sense creating a minute of music when 10 seconds was all that was needed.

Will the music transition fade or loop?

Find out what the developers will be doing to your music as it is implemented in the game. What happens to the music when a player clicks out of a menu screen, for example? Will the music end suddenly or will it fade out for a couple of seconds? Then, will the music behind the next screen slowly fade in? Will these transitions overlap or will one fade out completely before the next fades in? What will your music sound like as these two cues crossfade? This type of situation has the potential to sound like fingernails across a chalkboard as the two cues overlap. If you know ahead of time, perhaps it's possible to use the same key for each piece—something to tie them together successfully.

If the music is expected to repeat itself, will it be as a seamless loop or will the cue fade out then fade in from the beginning? Most of game music that repeats continuously is composed as a loop arrangement, but that doesn't mean it can't repeat using fades and a little bit of silence in between as a contrast. Learn what the developer has in mind and be wary of changes as new ideas are implemented.

Cues that will seamlessly loop are generally more difficult to compose. The challenge is to have enough going on—enough layers of audio events to hold the player's interest through several passes. Loops tend to become predictable, especially the shorter ones. Experimenting with different musical structures, where beats fall randomly or where the rhythm is more free-flowing, is a good way to hide the fact the player is listening to a loop. If you do it right, it will take several passes before they even realize the music is repeating. Making the loop longer is another great way to fool the player. The less a piece repeats, the better. Of course, the reason loops are used in the first place is to save space—and longer ones are not always the answer. But definitely do what you can to keep the repeats less noticeable and musical.

Tools of the Trade

Nathan Madsen

Nathan Madsen is a composer, sound designer, and owner of Madsen Studios.

For the first few years of my career, I worked as a freelance composer/sound designer on small- to mid-sized projects. In the last two years I've been able to work as an in-house composer/sound designer for triple-A-rated titles. It has been my goal to have the capability to work with all types of teams, from small independents of five people to major companies with crews of more than one hundred—through being familiar with multiple software platforms. Staying up-to-date on the most recent software releases and the newest techniques has helped me become more marketable.

Computer: Home: ADK custom-built computer, Intel 2.67 GHz dual core, 3 GB RAM, three hard drives (totaling 800 gigs); Office: Intel Mac Dual Core 5 gigs RAM, three hard drives (totaling 700 gigs), Dell XPS PC, Intel MacBook Pro 2.4 GHz Intel Core Duo, 4 GB RAM

Software: Home: Windows XP (32-bit), Sound Forge 8, Cakewalk Sonar Producer 6, Reason 4, Finale 2006, Acid Pro 4; Office: Mac OSX Tiger, Pro Tools 7.3, Logic 8, Digital Performer 5, Sound Forge 8

Monitor system: Home: JBL ES20; Office: Mackie HR824

Audio Interface: Home: Cakewalk SPS 660; Office: Mbox 2 Pro

Sound modules/VST instruments: Home: 8 East West Quantum Leap sample libraries; Office: 7 East West Quantum Leap sample libraries, VSL sample library

Keyboards: Home: Fantom X8 Workstation; Office: Fatar Studiologic 88-key workstation

Other instruments: Selmer Series 3 saxophone (alto and tenor), Buescher curved soprano (made in 1922), Yamaha acoustic guitar (with pickup), Takamine classical guitar

Microphones: Home: Shure PG-58; Office: Mojave MA-200 vacuum tube capacitor

Remote recording gear: Edirol R-09

Sound libraries: Home: The SFX Kit, Just Birds and Animals (vols. 1–4), Madsen SFX collection; Office: The SFX Kit, Universal Sound Effect library, The General Series 6000, The Big Whoosh, The Sci-Fi Combo DVD, Cartoon Trax (vols. 1–5), Animation FX (vols. 1–5), Acid Sound FX collection (vols. 1–10)

Compositional Methods

Composing and recording music today can be a blend of traditional methods using tape recorders and what some consider "old-fashioned" studio recording techniques and new, highly specialized and integrated audio production systems. The good news is you really don't need to buy all of the latest and greatest software to make impressive music. The bad news is you will need it if you plan to get it into the computer and in a format the developer can use. The good news is if you already have the latest and greatest, you don't need the old, traditional ways. The bad news is you'd better learn those complicated programs inside and out if you expect to be able to use them to their full potential.

Music is music, no matter how it is composed or recorded. As long as the final output is of a professional quality in both composition and how it sounds, your audio product will stand alongside other authorities in the industry. The key is to develop a process you are comfortable with which allows maximum output with minimal effort. Never work any harder than you have to. You'll have plenty of sleepless nights—nights where that next cue comes to you at 3:00 a.m. or when you're far away from your studio. There will be plenty of aggravation that only us creative types are familiar with, so why make the process any more difficult than it already is?

Get your system organized, stay focused, and be ready to turn on that creativity with the flip of a switch. Don't think about that looming deadline. Concentrate on the music and it will literally happen by itself.

Determine Your Best Personal Methods

If you don't know already, find out when you are most creative. You want to love your job and forcing it when you don't have to will quickly turn a lifelong dream sour. Settle

on a daily working model where you compose at your creative best and take care of the logistical and business tasks when you are not. This will work wonders on the quality of your creations and the longevity of your career.

If it's a peaceful, ambient piece I'm working on, my mood will match before I begin composing. If it's a hyper, energetic piece, I'll run a mile, drink a case of Mountain Dew, and intake a lot of sugar before the record button is pressed. Put yourself in the appropriate mood and the music will naturally follow. It won't always happen that way, though. Professionals can and do create impressive music without ever reaching that plane. It may drain you physically and emotionally doing it this way, so be sure to compensate with some downtime to recover.

Choosing the Best Palette of Sounds

Many years ago, a veteran composer offered me the advice of collecting as many different musical sounds as possible. The idea was to "stockpile" an assortment of samples, keyboard patches, and noise makers and draw upon them to keep my sound fresh. The only problem with having a great quantity of choices is resisting the urge to use all of them in each project. This is where the idea of choosing a "sound palette" comes into play.

Before composing for a new project, sort through the collection of samples and patches. Develop a list of sounds and instruments which initially seem to fit the theme of the game. Slowly narrow this list down to roughly a dozen or so sounds which will serve as your main "palette" and begin the composing process. By doing this first, you will make a conscious effort to determine which particular sounds will work well together instead of having to search during a hot streak and ruin your concentration. Other sounds can still be used, nothing is preventing additions to the palette, but the main instrumentation will be set. This, in turn, provides an audio personality to the game—leading every piece of music to fit automatically. A neat little trick.

Stay Within the Theme

When the clock is ticking and milestones are waiting to be met, resist any temptation to be distracted or follow other paths. How do you stay on theme? The best way is to surround yourself with it. A couple of years ago, I did a heavy metal score. I like metal but I don't normally listen to it 24 hours a day. During this project, though, it was a completely different story. I played every metal band I could get my hands on—in the car, in the studio, making breakfast, and eating dinner. I did the same thing with an orchestral project recently. By listening to and *living* with the type of music you are composing, you will be able to pick up on the subtle nuances of the style. This focus will help keep things on track and on theme.

When composing for cinematics, another trick is to watch a lot of movies and movie trailers (as mentioned previously). My least creative time is between 2:00 p.m. and 5:00 p.m., when I often feel a bit sluggish and unmotivated after the busy morning. Whenever I am doing cinematics or a film-like score, I'll break for lunch and then watch a movie during this "off-peak" moment of my day. By the time it's over, I'm fed, digested, and ready to roll after watching a multi-million-dollar Hollywood production!

Immersion

Many game composers choose to fully immerse themselves in a game's "virtual" world. I don't mean playing the game for 10 minutes then writing a score for it, I'm talking *full* immersion. Get your hands on as much artwork, storyboards, full-size cutouts, and other game design paraphernalia as you can from the developer, and surround yourself with it. Cover your walls from floor to ceiling with everything related to the game. Study the storyline; live and breathe this new environment. Spend some time playing whatever versions of the game you can get a hold of.

As discussed under "Get in the Mood" in Chapter 7, you'll also want to prepare your writing/composing/recording space. If it's a dark game, compose at night, turn the lights off, light some candles, and be totally consumed by the atmosphere. A happy kid's game will require sunshine and should be worked on during the day. Keep the mood light and smile a lot.

Much of what happens when writing inspired music takes place on the subconscious level. Music created while immersing yourself in a game's environment will affect other listeners subliminally. You won't be able to compose like this every time, but important scores will benefit greatly from this approach.

Compose While Recording

Composing does not necessarily have to be a separate step apart from recording, although it can be. When writing for games with a tight deadline, consider recording while you compose. Typical music creation phases consist of an idea-gathering segment, a writing stage, an incubation period (where the music begins to germinate), and then the recording phase. When working on an everyday music project (say, for your band), this method allows for the music to develop into something over time through experimentation. Other ideas have an opportunity to surface. When making music for games, there is usually little time for this particular approach and shortcuts are needed to stay on schedule. That's where recording while composing can be a valuable tool.

A recent project proved to me how beneficial this technique can be. With five days to compose a 4-minute orchestral score, there wasn't much time to reinvent the wheel. Instead of using the standard songwriting method, the situation dictated a more rapid output of music which wasn't going to happen unless I made critical changes. I made the decision to create the piece with three movements, to prevent it from getting stale, and established the tempo. The music was to accompany gameplay as background music but also as a display piece for the developer to use in previews of the release. The tempo was consciously set to match the game character's walking pace, since this loveable guy seemed to have a good rhythm. I fired up a sound bank, specifically created for orchestral pieces (no time to design a specialized sound palette on this one), started the sequencing program, and went to work. But, instead of working out ideas first, I chose to go straight into recording and compose as I went.

The piece began with percussions, a little bit of timpani and snare and bass drums—which laid the foundation. The opening flourish was the next step and other instrumentation was layered from there until the piece began to sound like something. I wish I could say I had a plan. Instead, I was relying heavily on instincts and a cliché or two in the process. But, by the end of the third day, the piece had a melody, counter-melody,

rhythm, bass, and plenty of percussion. I spent the next day cleaning up the various bits and pieces and fixed flubs and missed notes. At the close of the fourth day, the music was finally tight, cohesive, and ready for the last step. The final day was spent mixing, EQing, adding effects processing, and rendering the final mix with time to spare.

While I could have spent a couple of days toiling over the perfect note to play where, I opted for the adventure of just letting it happen. As each layer is recorded, your musical mind starts to hear other ideas and those are the leads you go with. It's like writing an essay in a testing situation: start with the first sentence and the rest will follow. When taking the plunge like this, it is important to listen to that little voice and run with it. There's no time to pine over that approaching deadline; you have music to make.

Using Loops as a Tool

For a one-man band with a lot of work and little time to do it in, music loops are a lifesaver. Where else can you pop in a CD; load up a prerecorded and fully mixed beat, bass line, rhythm section, and various other band members in your own mix; and lay a melody line over the top? These little gems are perfect for composing, generating other ideas, or as final production elements themselves.

Whenever you happen to be devoid of ideas or need something with an interesting flair or outside your musical abilities, reach for a loop library and see what happens. I don't know how many times I stared blank-faced at my drums begging them for a good groove. When they don't answer me, out come the loops and usually within a few minutes, new life is injected into the creation process. Purists may argue they aren't original musical creations—that your recordings contain elements anyone can license or even that you've stolen someone else's work! Music in the games industry is a different animal and nobody really cares unless it detracts from the experience. As long as you've properly licensed any material used in the final work, everything is all nice and legal-like and there is nothing to fear.

Experimentation

The one thing I love about music is there are no rules except one: If it works, it works! Creating new music day after day will eventually leave you without any new fresh ideas. You'll hit that plateau where frustration grabs hold and your musical future will be in doubt. So, we must fight the phenomenon with experimentation.

For those multi-instrumentalists who have got gadgets and nifty toys strewn about, start mixing and matching. It took many years for me to consider running keyboards through the guitar effects, especially distortion. Wow! What a revelation! How about playing your instruments in unconventional ways? Banging on your electric guitar strings with a drumstick can bring interesting results. How about using effects processing in ways that aren't expected? Most people mix reverb onto drum tracks, but what about using a flange or chorus instead? I'm sure you've got plenty of ideas and have tried many already. When the going gets rough and the music starts to sound lifeless, stand on your head for awhile and look at the musical world in another way. The ideas you glean from experimenting might bring the excitement back into the creation. Don't be shy.

Compose While Playing the Game

One of the most obvious but often overlooked methods of creating perfect music is to compose while actually playing the game. I'm not talking about playing the game with one hand and a piano with the other (although, that could be a marketable skill to put on your list of unique talents). I'm talking about having a working copy of the game up and running, either through a dev kit or on your computer, while you work through your compositional process. Assuming the game is in a semi-decent state and there is some pertinent artwork to look at, you'll be able to get right into the game, let the musical ideas bounce around while you play it a bit, and then with a live imagination, compose. In addition to immediately translating the experience, you will be able to tell very quickly whether the music is going to work or not.

Composer at Work

Chance Thomas

Chance Thomas is a composer and owner of HUGEsound.

(Continued)

When scoring for a project, how do you focus in on the central elements?

Years ago some of my friends were involved in a recording session for a national commercial jingle. The client was Kraft Foods and the product was Velveeta Shells and Cheese. The session wasn't going very well, and the young producer—desperate to bring the right vibe to the singers' performance—in exasperation finally blurted out, "*Be* the cheese!"

The comment was ridiculous, of course, and we have all laughed about it for years. But the concept is pretty close to the mark when applied to scoring for film, games, and other entertainment media. Get as deeply into a project as possible. Almost like method actors, you really need to lose yourself in the role. To help with this, I like to get lots of concept art sketches, video footage, designer's documents, desktop wall paper, et cetera so that I can immerse myself in the world. Read everything about it you can get your hands on. Think it. Dream it. Feel it. Or in the words of our young and exasperated producer friend, "*Be* the project!"

I like to interview the director, writer, designer, artist, et cetera frequently and try to ferret out as much of the psychology and emotion underscoring their creations as possible. After all, that's the job of the composer—to convey the deeper under-currents of a story, a quest, or a conflict so that the end user feels those things internally.

Think about San Francisco sitting on the surface of the earth. Big trucks rumble along I-80, jumbo jets rise from and fall to the runways of the airport, cars, bicycles and pedestrians scurry around the town. All of this commotion on the surface is frenetic, but creates relatively little impact on the city structure itself. Now think far beneath the surface to the subterranean tectonic plates upon which the city rests. Movement in these plates (otherwise known as an earthquake) causes a *huge* impact on the city and everything in it.

Like traffic in the city, there are lots of little busy things going on in a film, game, or other media presentation. But all that frenetic energy has little real impact on an audience. Something in that presentation must resonate beneath the surface, must "rumble" deep in the human heart or psyche if it is to have real impact. Music is a language that speaks to those places when used skillfully. Understanding the emotional subcontext is a foundational step for any composer who hopes to speak in the language of music to the deeper understandings of the audience. "*Be* the project!"

When are you most creative?

Nothing inspires like a deadline and a big paycheck. A tight production schedule and ample compensation are wonderful tools for focusing creativity and heightening motivation.

What skills should composers have to succeed in the games industry?

A great understanding of the language of music. At the end of the day, great game music is still about great music. I chair the Music and Sound Review committees for the Academy of Interactive Arts and Sciences. We review the submissions in the Music and Sound categories for the Interactive Academy Awards, narrowing the field from twenty or thirty nominations to four finalists. We play the games, listen to the games, and decide what we feel represents outstanding achievement in our industry. The committee members come from a variety of technically and/or musically oriented backgrounds. Guess what? Great music always rises to the top. Implementation can be clever, even brilliant and that always impresses us. But we all respond most profoundly to the music that moves us. Understand the language of music. It all begins there.

Recording Methods

Recording music for video games is no different than standard music production. There is no mysterious underground system. There is no top-secret decoding ring you'll be handed after you join the club. Nothing like that. Music recording is music recording no matter how it is done. The only element which differs from audio CD production is the conversion to the final in-game format completed at the end of the cycle.

I'll continue to assume that most, if not all of you, are familiar with getting sound to tape or disc. When it comes time to record your game score, carry on with what works for you. This section explores alternatives which may or may not have been previously considered. For those of you who are musicians and have never had the pleasure of pressing that big red button, this will give you options to pursue as you get settled in. When working on game music, especially as a one-man show, it is essential your engineering and recording chops are solid.

Whether you're an experienced artisan or taking your passion to a new level, it is definitely good to be familiar with other methods. After all, different forms of music are easier to work with using different recording techniques. In a business where several styles could be recorded in a short time, it helps to have something extra in your bag of tricks.

Traditional Recording

Traditional recording methods refer to those that have been around for many years and are the essential foundation for all other techniques of recording. It's a predictable scheme near and dear to many. After the initial composing phase, musicians are brought in and their performances are tracked to tape—whether it's an analog or a digital medium. They can be recorded all at once or one at a time, whatever happens to work best for the music. Multi-track tape decks provide for separate controllable layers and the ability to overdub without affecting previously recorded music.

The mixdown process follows the completion of the "tracking" phase, where a mixing engineer and producer toil for hours over a mixing board. They adjust volume levels, equalization, and placement of instruments in the stereo field. They add effects processing, compression, and noise gates to control or enhance each track—and finally record the multi-track efforts down to two channels for a stereo mix. After all of the music for that particular project is completed, each song is "mastered." This step takes each separate tune; adjusts its overall equalization, volume and "sound"; and matches their sonic characteristics. The overall effect is a cohesive assemblage of songs which sound like they belong together.

This type of recording is perfect for the one-man band with a need to record live instrumentation, such as guitars, horns, or vocals. Despite the use of a MIDI rig, which triggers notes from samplers and keyboards, multi-track tape decks can supplement computer playback with a human feel. It also works well for orchestras or music groups who might play off each other during a performance. The number of tracks can be limited by your hardware, but when synchronized with a sequencer, additional "virtual" tracks can be added that are almost unlimited.

These Alesis ADATs, while a bit dated now, still perform traditional tape-based multi-track recording very well.

Progressive Recording Methods

As technically savvy musicians and engineers pursue the elusive better mousetrap, new and improved ideas begin to take shape alongside traditional music recording. At first, these techniques merely assisted in the process—making certain aspects easier. These new processes evolved as complete and separate entities capable of incredible things. Today, we have a solid marriage between ideas and technology—and eventually, the traditional methods will fall by the wayside.

As luck would have it, many of these improved processes are perfect for recording music for video games. Gaming has a tendency to influence and drive computer technology. Coincidentally, music production has become almost completely computer based—including sequencing programs, multi-track recording, audio editing, effects processing, and sound generation. It is completely impossible to produce music for games without one.

As the recording scene evolved over the last 25 or so years, one of its greatest contributions was the invention of the musical instrument digital interface (MIDI). This standard allows for computer-based electronic instruments and effects to interact, to allow one person to perform using multiple electronic instruments at once, or to program them all to playback prerecorded routines at the touch of a button.

Initially, dedicated hardware sequencers were designed to record a performance and allow others to be layered on adjoining tracks until a piece was complete. All you had to do was press Play and your electronics came to life, each playing a dedicated instrument through its own discrete data channel. This allowed for huge productions to be composed and performed by a single person, something unheard of only a few years earlier. The greatest advantage during final mixdown was the ability to skip a generation of tape and record the actual performance, instead of a tape recording of one. In the analog domain, this meant one less chance for unwanted noise—the constant quest.

The sequencer then moved inside the computer, with loads of added features to assist in the creation. Today, we see these types of programs paired with multi-track audio recording capabilities—more powerful than anything we've seen before. Composers have the capacity to sequence triggered sound patches and samples, and record synchronized live tracks via MIDI right alongside them with ease.

This production technique has incredible advantages, making traditional ways pale by comparison. Where else can you change instrumentation on a whim? Don't like the bass? Reset the patch until you find the one you like, all without having to rerecord. That darn snare hit was late. No problem: grab your editing tool and move it where it should be, right on the beat. Piece of cake. The 1-minute piece is too long by 2 seconds? Adjust the tempo a couple of beats faster, now it's exactly 1 minute long, just like the client wanted. See what I'm talking about? This MIDI stuff is sweet!

Some developers want their music done as a MIDI file. These files are tiny, simply containing the data that tells notes when and how long to play. The developer, in turn, takes that file and pairs it with a sound bank and has instant game music. There is no way to do something like that with the traditional tape-based music recording process. The format is incompatible.

Multi-track Computer-based Recording

Multi-track still has its place in music production—a fact which will most likely not change for many years. Like any system that works, it has been improved upon and has discarded many of its weaknesses in the process. Gone is magnetic tape—replaced by the reliable hard drive. With affordable drives available with more than a terabyte of capacity, storage is no longer a problem. Gone are the hardware-limited recording channels, now replaced with a virtually unlimited number of tracks.

With processor speeds over the 3 gigahertz range and affordable RAM, this far surpasses the need for a room full of mechanical tape decks. Gone is the need for huge mixing consoles and racks of outboard effects processors. All of these are included inside the machine,

accessible with the click of a mouse. Can't afford one of those high-priced automated mixing desks? Don't worry, most multi-track programs have their own form of automation which can handle everything from volume and panning adjustments to effects processing.

In addition to the huge operating advantages to computer-based multi-track systems, recording on a computer allows for easy editing, limitless "undos," and file sharing previously impossible on tape-based recordings. Computer-based multi-tracking also allows importing into an audio editor, either one track at a time or to manipulate the final mixdown prior to delivery. And if you are using the *.wav* format, it is only one step away from becoming Red Book audio, the music CD standard.

Cakewalk's SONAR fulfills the roll of both computer-based multi-track audio and MIDI production.

Only a few years ago, the weak link in this formula was the sound card. Computers are full of noisy components, generating electronic artifacts that are detrimental to clean recordings. Today, most of those issues have been successfully dealt with and computer-based recording has nearly reached the sonic level of professional recording studio equipment. This allows us all to attain high quality at a reasonable price in the comfort of our homes. With the addition of a stable of high-priced microphones, pre-amps, effects, and other equipment, we just might give the big boys a run for their money.

Loop-based Production

As music production advanced, so did the methods to create unique compositions. Instead of instrument samples only being sold to musicians, some smart entrepreneur discovered a market for entire beats, rhythms, and instrument riffs. These performances were organized into tempos and packaged as music "loops"—bars and measures of repeatable patterns—that became an entire musical piece when layered together. Initially, only a

small subculture of musicians took to this new form of music—but others quickly joined the movement, discovering the advantages were too great to miss.

Along with the advent of MIDI, loop-based production has become another great milestone in music. With literally thousands of loop libraries available today, almost every conceivable instrumental combination has been presented—making this an indispensable tool for any game musician.

No matter how good you are at composing, there is no way to think of every musical idea. Loops can be a tremendous conduit for new ideas. With a strong groove played by a professional musician as your backing track, the music you compose on top of it will sound that much better.

Playing with talent, whether they are in the room with you physically or as a recording, has a way of bringing out your best. Want to add a live drum track to your mix but you're afraid your neighbors may not approve? Piece together a few loops of prerecorded live drums and, voilà!—instant drums without all the trouble. Need a smoking guitar solo but are strictly a keyboard player? Grab a loop CD and take your pick. There are hundreds to choose from. What if you need to do a 30-second looping menu cue in a hurry? Loops are already designed to seamlessly repeat. Just time them out to 30 seconds, layer the instrumentation over the top, and you've saved the day.

Loop-production and music software has also made great strides in the past few years. Like sequencing programs, loop-based production tools, such as Sony's ACID Pro, have integrated live multi-track recording into their lineup. After building solid backing tracks with loops, it is possible to record your own flavor of live instrumentation right alongside them. Do the final mix and export the new stereo tracks to whatever format you need for mastering or conversions. This is an incredibly powerful music production system all on your computer screen.

Other Music Making Methods

New programs and methods of music making are introduced to the masses almost monthly (some good, some not so good). It's up to you whether you pursue new methods as they appear or not. I prefer not to. I take a more "wait and see" approach, letting other people try them out and write reviews in magazines about them first. I'll show an interest after the cream floats to the top. Programs such as Reason, ReCycle, Reaktor, and Tracktion, for example, have introduced new concepts in music production by integrating software synthesis, sample triggering, loop production, and MIDI sequencing into intuitive products.

The trend seems to be leaning towards combining past music production methods into one integrated system. For a game composer, this is a good thing. In order to drive the entertainment value of our audio to the next level, we must be able to stay with the times and consistently push into new areas of music creation. Most game composers use every one of the music production methods previously discussed. It's not a "keep up with the Joneses" kind of thing—it's a matter of survival in the highly competitive music trade. Keep your ears open and be ready.

Streamline to the Final Format

If the music will be delivered to the developer in a pre-specified format, it is possible to streamline the recording process and save some time on your end. For example, if MIDI files are requested, why compose an audio score on a multi-track tape deck? Some composers

prefer, in order to be enveloped by their creation, to write and record their score as audio to make sure it works first. Then, when they are happy, they transpose manually, note by note, instrument by instrument, to the MIDI format. What a grand waste of time! The music will change as a MIDI file and will sound nothing like the original. So, why not compose in MIDI from the start—always knowing what it will sound like?

Conversely, why compose in MIDI if audio files are the final format? Let's say you plan to bring in a few musician friends to help record the music. Instead of relaying your ideas to them directly, you decide to let them hear a rough sketch of the intended music. So, you beat out each drum hit, each bass note, each psuedo-guitar part on a keyboard and record on a sequencer. It takes you a week, but darn it, you want to have something for the boys to listen to first. Well, you're wasting your time. Bring the guys in, sit them down, vocalize your ideas, and let them play. It may take a day at the most to practice and get their parts down, and at most, maybe another day to record. Streamline the process; don't waste time. Go straight to the final format.

Game composers don't often have the luxury of waiting for a muse to strike or to record under perfect conditions. Audio is usually the final content implemented in a game and we can't hold up the Christmas release because we need an extra week. Keep things simple and cut corners in the production, *not* in the quality. Set yourself up to do 25 games a year and this business will indeed be kind.

Editing Music

After the music score has been recorded, unless it is intended for a surround application, it will be mixed down into a two-channel stereo version. Whether this process is completed using more traditional tape-based methods (such as mixing to DAT) or rendered utilizing the feature on a multi-track program as a *.wav* file, this process will allow further editing and conversion as needed. Your personal working methods will dictate how you accomplish this stage, ultimately ensuring the final version of the music will sound its best. However it is done, keep in mind that further work will need to be done to these new files before delivery to the developer.

Audio Editing Software

The next step is to import the music mix into an audio editing program for any cleanup and maximizing. If the music was recorded to hard drive, make a copy and save it in your normal working format, usually as a *.wav* or *.aiff* file. If the recording was on any other medium, such as DAT, transfer it into the computer using an audio editing program like Sound Forge or Adobe Audition. Depending on the sound card, it is possible to input via standard analog (either RCA or 1/8-inch stereo jacks), Firewire, digital coaxial, or digital fiber optic (also referred to as Lightpipe) inputs. If at all possible, utilize digital inputs and outputs. These provide for the purest audio.

When recording into an audio editor, always record the music at the highest possible sample rate and resolution. I recommend 44 kHz, 16-bit stereo as the absolute minimum. Later, when making any conversions, this will be important. You can always sample down without any grief; sampling up is a problem. Once the computer recordings are made, save the file and prepare for editing.

Sound File Cleanup

From your audio editing program of choice, open the music file to be edited. It's a good idea to save the file you are about to work on under another file name, like *music_file_ new* or *music_file_2*. That way, the original file is left untouched in case something goes wrong and you need to revert to the beginning.

The first plan of attack is the dead air on the front and back of the file. Give it a listen. Do you hear any background noise? If it is prevalent, highlight the space and let your noise reduction plug-in analyze it and process the rest of the file. If you don't have this feature, fear not. If you recorded the sound at a good level, and if it isn't a quiet piece, most of any noise floor should be masked anyway. Trim off the dead space from both ends, being careful not to cut any of the sound wave. Use the zoom feature to see exactly where the sound begins and ends if you need to. This process will ensure the file is as small as possible and that the music plays immediately after it is triggered, without silence first. Save the file.

Visual File Inspection

The predominant feature of audio editing software is the ability to "look" at the music. By visually inspecting the file, you are able to actually see noise, peaks, and clipping and get a good idea of the overall quality of the sound. What should you look for specifically?

Is the sound centered on the zero baseline?

The line that runs through the middle of each channel is known as the zero baseline. If there are electrical mismatches between the sound card and input device, it can cause the entire sample to be centered somewhere above or below it. This can cause unwanted audible artifacts you'll need to get rid of. The DC Offset function (or something similar depending on your software) will analyze the file and recenter it to zero, keeping the file as clean as possible.

This example shows a horn sample which sits slightly above the zero baseline. Although this is normal for horns, it illustrates something to be on the lookout for when dealing with other sounds.

Does the wave file look "healthy"?

Does it fill much of the screen or is it a bunch of puny little lines barely perceptible until you zoom in? It is important that the actual sound is louder than any noise floor in the recording and louder than the noise on any playback system. If the volume is at least medium intensity or thereabouts, you can beef it up by either increasing the overall volume manually or using a normalization function. Normalization will scan the file and increase its overall gain, set by you, without clipping. This will maximize the volume proportionally, leaving a strong and solid sound.

Does the sound look too intense?

Has the waveform saturated the screen completely? If the sound file shows a solid wall from the zero baseline to infinity, with the edges of the sound cut off, chances are this file will be distorted and lack any dynamics. Depending on the effect you are trying for, this may be alright—but the majority of the time you'll need to give something else a try. First attempt to reduce the overall volume or apply a moderate amount of compression. If the peaks are severed, peak restoration plug-ins are available to repair this type of damage. Listen to the results and decide if it sounds any better or if you just simply reduced the volume and applied "band-aids" to a distorted sound. In that case, re-recording the sound will be your only option—just be sure to do it at a level a few notches below the previous attempt.

This is a normal, healthy-looking music file. It's not too weak or too strong and is what most of yours should look like when working in an audio editor.

Are there any points in the file where the volume peaks or causes clipping?

Nothing sounds worse than a digital file passing 0 dB on a level meter. These prominent peaks cause unwanted clicking and distorted screeches in sound files and need to be dealt with. One option is to reduce the overall volume of the file enough to bring any peaks below the point of clipping. Another is to apply a slight amount of compression (such as a 2:1 ratio), which in effect will squash the peaks and raise the quieter levels proportionally.

If your music looks like this, chances are it will sound like a distorted mess! Keep the overall levels under control for audio the way you intended.

My personal favorite is to use a peak limiter set to −0.01 dB, which allows for the highest possible levels without reaching 0 dB. Depending on the playback system, you may have to adjust the peak limiter to a lower setting to compensate for poor speakers. Keep an eye on the peak levels, especially after adding EQ or other processing and be prepared to repeat this step if necessary.

Peaks, such as the one noted here, will cause digital distortion and ruin a perfectly good take if not properly controlled.

The previous items have been addressed by simply looking at the sound file. Audio editing programs are unique in providing visual input to creating sound. But what the file actually sounds like is obviously as important. Give the music a listen. Does it sound good? Is there any distortion or clipping? Is it a good representation of what you were trying to accomplish? Answer these questions truthfully and take care of any repairs prior to the next step.

Conversions

The music file is almost complete and ready for delivery. If the developer requires a 44 kHz, 16-bit stereo uncompressed audio file, we're done because that's what we should (at least) be working in. If you happen to be working in anything higher, follow the next steps to accomplish the conversions in the same manner.

The developer in this example requested a 22 kHz, 8-bit, mono file, so we'll need to do a couple of things. Using a copy of the last saved version of the music file, resample it to 22 kHz using the editor's resample function. Ensure the anti-alias filter setting is used to prevent any of the lost high frequencies from becoming low-frequency distortion. This will keep the sound file as pure as possible. Keep in mind the higher frequency ranges are not represented at lower sample rates and the sound will change. Listen to the file again after down-sampling and EQ to boost the sounds as necessary. Remember that the higher frequencies will not be available.

The next step is to convert from 16-bit to 8-bit resolution. Selecting this feature on your editor should give choices such as *truncate, round,* and *dither.* Try each choice and listen to the results. You should be most concerned with any introduction of quantization noise, which sounds similar to high-frequency static. In this example, you will notice it most where the music loses intensity and any ending fade-out. This is one of the reasons why we maximized the sound earlier either using normalization or volume increase; it masks this particular phenomenon. The noise you hear after the conversion depends on which setting you use, of course. My personal experience dictates I use either the *round* feature or *dither* with a value between 0.5 and 1.0 bits. Dithering adds what is known as *Gaussian noise,* which is designed to mask the more obtrusive quantization noise. Your opinion and the sound effect's application will determine which is best.

The final step is to save the file in the required format. If you happened to be using *.aiff* or anything else, simply save the file as a *.wav,* give it one last listen, and you are done. For those who edit in this format anyway, there is nothing left to do but move on to the next project.

Now, imagine you have thousands of audio files to do this to. Have no fear, there is a better way. Batch converters, such as the ones found in Sound Forge and Audition, are a lifesaver for those who deal with large amounts of audio files on a regular basis. These little gems allow you to script the entire process, instructing the application what processing to execute and in what order—and to save in the desired format. All you have to do is load in the files, tell the application where and how to save them and run the script. But, if you insist, you can still do all of this manually and claim all of the glory for yourself.

Tools of the Trade

Ron Jones

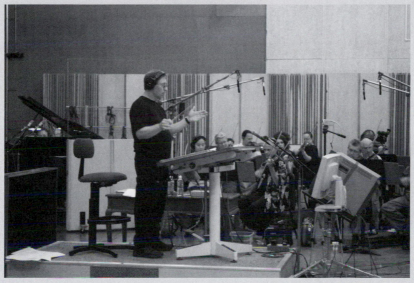

Ron Jones is a composer and owner of Ron Jones Productions.

I like to think of music technology as a means to an end, not the end itself. I design the flow of work to utilize the best of current music tools, but to keep them as transparent as possible. It is the music itself that I think is of greatest importance. Gear today is really good. Use all you can, but remember to create music and to make music for the human receptor. I have a huge catalog of music which I have created. After all these years it is still fun and very compelling.

I value most the people who perform the music and those involved in the full process of recording and mixing the music. The projects are great, but I love the people and the process of creating most of all. I have everything but use very little of it. The stuff is there when I need it. Pencil, paper, a piano plus a metronome—for me, this is my core. My vote for greatest software is probably QuickTime.

I have two separate computer systems: one primarily for sequencing and recording music, the other is involved in aspects of digital picture and all other nonmusical things. I compose at an upright grand piano. I have a graphite mechanical pen full of graphite leads. I have many good erasers, a writing table, several good lights, a metronome and stopwatch, and score and sketch papers at hand. Once I have composed and completely orchestrated the cue, it is scanned on a big Keocera scanner copier and turned into PDFs. Those PDFs are then sent out to my eight assistants, who then realize the music I composed with midi, samples, and live parts. When they finish the "midi mockup mix," they upload it to a site I have. We then lay those cues to picture in Final Cut Pro so the producers can see and hear how each cue works dramatically. With those notes or with their approval the scores are sent to copyists to be copied for the live players at a recording session to perform and record.

Creating Sound Effects for Games

Sound effects are an integral part of any game—equal in importance to artwork, music, and gameplay. Good sound effects create an impact which rounds out the entire gaming experience and without them, that experience would suffer. They are designed to completely absorb the player into a virtual world, making it believable, entertaining, and satisfying all at the same time. Continuous ambient sounds keep the player from being distracted by the "real" world, ensuring game silence doesn't ruin the immersive effect of a game. Foley sounds ensure believability. Action effects provide guttural satisfaction.

In this chapter, I won't pursue the psychological aspects of sound and its effect on the human psyche. For those who are serious about this particular aspect of audio, I do highly recommend pursuing the subject to complete your skill set and increase your design effectiveness. For now, we'll focus on the creation process for games: how particular sounds are chosen, how they are made, and how to make the process less grueling for both the development team and sound designer. I've asked fellow sound designers and game producers in the industry to share their experiences, their sound design creation and selection process, and how they came up with particular sounds. We'll also delve into how to create professional sound effects and prepare them to drop into a game.

The Creative Aspects of Sound Design

Anyone can do sound design but not everyone can do it well. The difference between the average sound "hobbyist" and the professional sound designer is not just that the professional gets paid. It is an intangible quality running through their veins which allows them to create audio magic out of thin air. If you are a musician, you already know what I mean. We share the same passion for excellence with the expert sound designer, having spent thousands of dollars on our "hobby" just for the sheer joy of making our own brand of genuine noise. Musicians, and anyone who has the desire, can put this same enthusiasm into making great sound effects for games.

Tools of the Trade

Rodney Gates

Rodney Gates is a lead sound designer at High Moon Studios.

As a lead sound designer at High Moon Studios, it is my goal to not only deliver the best audio experience possible for our projects, but also keep our audio team happy and do what I can to make it fun and exciting to work here, in a relaxed, creative environment. The team did a fantastic job with *The Bourne Conspiracy* and I look forward to working on future projects with them as we continue to hone our skills and set even higher goals the next time around.

Computers: Apple Mac Pros and dual-core AMD PCs.

Software: Pro Tools HD/LE systems, Nuendo 4, and Sound Forge 6, 8, and 9 applications.

Multi-track system: Digidesign Pro Tools HD/LE and corresponding interfaces (we are about to switch to Nuendo with RME/Apogee interfaces).

Monitor system: Mackie 5.1 system, THX certified and calibrated.

Outboard gear/plug-in effects: Avalon 737 and 2022 pre-amps, a PreSonus ADL 600 pre-amp, a True Systems P2Analog pre-amp, a Manley electro-optical limiter, plus other outboard hardware from Eventide, Lexicon, and T.C. Electronics. DM and/or native plug-in suites and bundles for our DAW systems from Waves, McDSP, Sound Toys, Massey, Serato, Audioease, TL Space, and several others.

Keyboards: Access Virus, various MIDI controllers.

Microphones: Neumann M 149, Neumann KM-184 (pair), Rode NT4, Sennheiser MKH-416, Sanken CSS-5, Shure SM-57, AKG 414, and others.

Remote recording gear: Fostex FR-2 and several M-Audio MicroTracks. I personally use a Rode NT4 stereo mic through a Sound Devices MixPre into a MicroTrack, which works really well (awesome limiters on the Mixpre). We're also looking forward to trying the Edirol R-44.

Sound libraries: Too many to list. We also have a huge 96k Hz, 24-bit custom library that we have been recording over the years.

Creativity, a microphone, the ability to listen to the world around you, and some way to edit sounds are the basics you need to jump into this occupation. To take it to the next level and beyond, you'll need:

- Remote recording gear
- Collection of sound effects libraries
- Computer
- Multi-track recording software
- High-end audio editing program
- Experience

The best part about sound design for the gaming industry is that there are plenty of new developers out there who are willing to let you cut your teeth, gain the experience, and have the cash to propel you to that next level. There are many composers and sound designers today who started out with the bare-bones minimum and have amassed quite a collection of studio equipment from their gaming contributions. It may take a couple of years, but it is possible for those who are patient and smart.

Chapter 2 discussed the equipment and software recommended for this type of work. Refer to the section "Tools for Your Business" to refresh your memory. It's about time we uncover the mysteries of what it's all used for and a quick review might help if this is new to you.

Types of Sound Design

In Hollywood, the art of making sound for picture is highly specialized and compartmentalized. There are experts who spend years sharpening their skills in this one particular area, a fairly constant profession. Careers as a sound recordist, Foley artist, sound editor, and sound designer can easily consume a lifetime of work. For games, the term *sound designer* encompasses all of these activities into one package. Are you ready to take all of them on? As a musician, you are already a composer, arranger, copyist, engineer, and producer. What's a few more titles to add, especially when they can earn you some extra income and sustain you through the dry music-less times? Interestingly enough, while I got into games to do music, I probably earn about 70% of my income from sound design—so if you don't think you're interested, you might not want to write it off just yet.

Foley

In film work, *Foley* is the art form which adds believable sound garnishment to on-screen character movements. Imagine a character running on wet pavement, slipping, then tumbling into some metal trash cans. Foley artists would perform this sequence in a sound studio while viewing the dry footage, matching each movement precisely using various props and a team of artisans. Someone would jog in place on a wet, gravelly surface with similar footwear as the on-screen character. Someone else would create a slipping sound by quickly scraping a couple of shoes on a matching surface.

Over in another corner, someone would perform a "bodyfall" by throwing themselves or a weighted dummy on some appropriate facade and it would all be wrapped up with yet another artist tossing a couple of metal garbage cans full of empty "trash" around in another area. After a couple rounds of practice and a sound check, it's recorded and sent out to be dubbed into the project. It's always entertaining to watch these guys at work—shuffling around, manipulating various objects, and tossing things around in concert. They seem to have a lot of fun themselves.

Doing Foley work for video games is slightly different. The advent of digital audio editing software and synchronizing capabilities make "performances" such as the activity described previously less likely. I can't equivocally state it would never happen (and somebody would do it just to prove me wrong), but the chances of it happening are slight. Doing this kind of sound work for an animation file would utilize the same concept, but with a different delivery method.

If you were to add sound to the same scene from the previous example, most game sound designers would record the sounds separately or grab them from stock sound libraries, then sync them to the actions. With every instance of the character's foot hitting the ground, they would lay an appropriate sound at the same spot—repeating the sequence until the slip. A slipping sound is added, followed by a body falling into the garbage cans, to complete the scene. In the simplest form, you would only need three sound effects to make it believable: a footfall, slide, and spill sound.

To soup it up a bit, you could use a left and right footfall (because each step in real life never really sounds the same), some hard breathing (because the character is supposed to be running), a sliding sound, a gasp (because the character is surprised), a bodyfall, a mixture of several clanking and spilling sounds which dissipate slowly as objects come to rest and the trash can lid stops spinning, and punctuate it all with an annoyed cat screech. It seems like a lot of work for this short scene, and most of the time someone watching it will only hear the sounds subconsciously. But if the sounds were inappropriate, out of sync, or missing altogether, they would stick out like a sore thumb.

There are plenty of sound effects libraries with many different versions of the sounds you'd need for our example. You'll eventually have a good supply of them to reach for, but in order to keep the sounds you produce fresh and original, you'll do your own version of Foley. This won't be as complicated as how it's done on the Hollywood scene. There won't be any pressure of performing an entire scene on the fly. Instead, you'll produce individual sounds to edit and sync later.

Continuing with the same example, let's say we have chosen to create the sounds ourselves. You can create off-site using remote recording gear such as a portable flash, hard disc, or DAT recorder and a quality microphone or bring the props into your studio to create in a noise-controlled environment. Let's take a look at the remote method first.

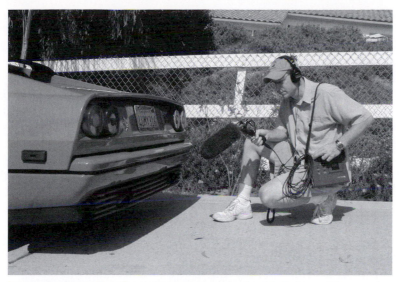

Remote recording not only requires the right equipment for the job, but conditions such as weather and background noise can be a factor.

Remote Recording

Noise is always a factor, whether you are recording inside the studio or out in the field. Always be conscious of it and whether it has the potential to destroy your recordings. Loud, obtrusive, off-subject sounds will ruin your efforts every time. Recording between landing jets overhead or cars whizzing by on the street is a must in the worst-case scenarios. The only things you can control when doing remote work is when and where it takes place. Either find some place which has negligible background noise or pick a time, such as at night, when the chance of silence is improved.

For times when you absolutely can't prevent extraneous noises, there are still ways to repair or salvage a good take. Background ambience is made up of two types of sounds: continuous and random. In the office building I'm sitting in at the moment, I can hear a ventilation fan (continuous), the hum of my hard drive (continuous), footsteps (random), distant voices (random), a door opening and closing (random), and fingers typing on a keyboard (random, although it's beginning to feel like it's continuous). Recording sounds within this atmosphere, I would have a fairly good chance at success—timing my efforts between the random sounds and blocking them out when I could. The only sounds which pose a serious problem are the continuous noises, but they too can be dealt with appropriately.

Noise reduction software and plug-ins these days are fairly good at neutralizing continuous background noise. It is highly recommended at some point you beef up your arsenal with this type of application. While you can get away with creative use of equalization, it has a way of negatively affecting your sound while eliminating all noise in the respective frequency ranges. If you tried to remove a noise (say, in the upper frequency range, like tape hiss), as you pull down the EQ faders you lose all other sounds in that range. You get rid of the hiss, but it also makes your sound dull. Noise reduction software analyzes the continuous sounds and totally eradicates them using complex algorithms. To take advantage of this,

be sure to record a few seconds of the atmosphere you are recording in—all of the background sounds from the mic position where you plan to do your Foley work. The software requires this to examine the sound you wish to remove and then applies what it learned to the rest of the sound file. Of course, the best way is to make sure you get a clean recording.

Another way to rid yourself of the evil background noise is to edit around the sounds you are recording. If I were recording footfalls, I would have the choice of making a sound file for each footstep or one of the entire running sequence. Doing it singularly, you would copy the single footfalls to their own individual files—ensuring there is no blank space on the front or back end of the sound wave. There may be some background noise in the actual sound, but because it happens so fast, it would barely be noticeable except to the expert ear. EQ adjustments would suffice if needed. Doing it with the entire sequence, you would mute all space between each footfall, manually or by using a noise gate, yielding a clean sequence which could be edited in later. Other layers of sound you add to the soundscape would mask the unnatural sound of a footstep, then silence, then footstep, then silence. Or, you could add a touch of reverb (after you've cleaned up the file) to simulate the environment the character is running in. Either way, experiment to see which works best for you and the sequence you are working on.

A good rule of thumb when recording sounds in the field: Record at the level you plan to play them back in the game.

If you are creating footfalls from the player's perspective, they will be louder than if a bystander were watching them run by. Street ambience shouldn't be loud in-your-face sounds unless your character is a mouse scurrying along a gutter. You want to ensure the sound you are capturing is based on the perspective used within the game. You can adjust volume levels to suit, but your quality and realism won't quite be the same. If you record garbage cans tumbling from 50 feet away, increasing the volume to make it sound like your character is falling into them will also increase the background noise as well. You'll end up with a very noisy effect that sounds amateurish. Always consider the context of the sound before hitting that Record button.

In-studio Recording

Most of the considerations discussed for remote recording apply to your in-studio Foley work as well. While the environment may be a bit more controlled and the potential of unwanted noise less, there are still some things to watch out for. Listen closely to the room or studio where you plan to record. Computer fan noise, fluorescent lighting hum, dogs barking, street noises, and so on can have the same effect as your on-location recordings unless you have a soundproof room. Using the same techniques for recording and editing will prove successful as well as the potential for higher quality because of your enclosed location.

The best place to record would be in a soundproof studio or perhaps a soundproof booth, that is, if you like those telephone-booth-looking things in your creative space. Imaginative uses of modular sound-absorbing dividers and gobos can help. Even creating a tent made of blankets will work miracles. Close your doors, close the windows, push towels into the cracks, tack blankets up on the walls, and you've got a pretty good spot to

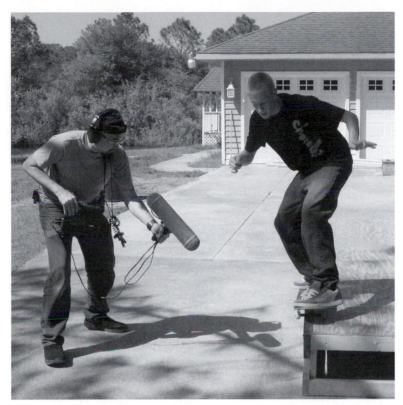

Always pay close attention to background noises when outside. Weather, aircraft, traffic, wildlife, and bystanders can sometimes ruin a great take which are often not noticed until you are back in the studio. Watson Wu is seen here recording the skateboarding moves of Charlie Canham.

do your Foley work. A walk-in closet is also a fantastic spot. Stay flexible and creative and be ready to do what it takes. After all, these sounds will have your name on them.

One of the perils of recording in-studio is the mess and destruction of valuable studio components while caught up in the performance. For those who are resourceful enough to have their own separate control rooms apart from their main recording room, the dust and debris might not be too difficult to clean up after a session. Trying it within your control room may prove an expensive endeavor if some flying object manages to smash into your new monitors. Keep mindful of the sounds you are creating and the consequences of the performance. If you plan to smash cement blocks with a sledgehammer for a cool sound, consider dragging a microphone outside via a long cord instead. You laugh, but I'm telling you, it's going to happen and you're going to live with the inevitable "I told you so!"

Doing Foley sounds in your studio is really no worse than allowing an entire band of musicians and groupies trash your sanctuary. Even though I know the consequences, I still stand back after each session to survey the damage and shake my head. When I'm in the creating mode, I work furiously, maneuvering all sorts of debris and carnage around—focused intently on that one little sound effect I'm giving birth to. When it's complete, I'm routinely surprised at my now cluttered surroundings—left wondering how all this garbage got there. Next time, I promise myself I'll take it outside.

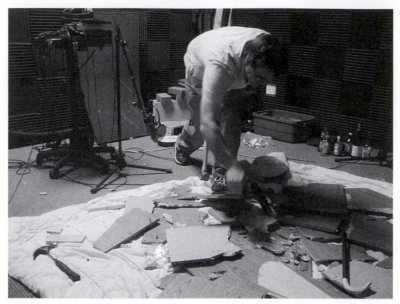

Recording sounds under controlled conditions is preferred, but the mess can sometimes be extensive. Robert Burns is in-studio, creating sounds for one of High Moon Studios' recent games.

The Acquired Skills of Listening and Manipulating

Developing a good ear for the sound design business takes some time. We are relied upon by the game makers to conceive the perfect sounds to establish the atmosphere and believability of the virtual world they are presenting. We gaze at dry pictures and animations, letting our aural imagination take control—hopeful we can translate what we hear in our heads into great sound effects.

Turn on your TV and mute the volume. What do you hear in your head when you watch the picture without sound? An experienced sound designer will have a multitude of sounds firing off, adding their own brand of personality to the picture. This is the first step in doing sound design. If you are staring at the screen and hear nothing in your head, try this instead: pretend a new client just gave you this cinematic to put sound to and your career depends on hitting the nail on the head. Do you hear anything now?

As another exercise, turn on a movie or something with a lot of action in it. Don't look at the screen. Instead, listen to what is happening aurally in the scene. Listen to each sound, how it is placed in the soundscape, what effect it has on your perception of what is going on. Pick a few and figure out how they were made. Which ones are Foley sounds? Which ones are actual recordings of the action? Which ones are manufactured from other sounds? Sometimes it's difficult to tell.

It is surprising to learn that what you thought were actual sounds are something else altogether, used in a context which makes you believe they are the real sound. Take gunshots, for instance. In the real world, most small-caliber firearms are a rather boring "pop." Hollywood sound designers—always looking for something bigger than life—add small explosions notched up in pitch, the crack of a whip, a snare drum, or any sharp sound that makes a big impact on the audience when the weapon is fired on-screen. Is what you

hear the actual sound of a gun firing? Probably not, but your perception makes you believe you are hearing one—so much so that if you ever hear a gunshot for real, you won't be impressed. It will assist you in this line of work if you leave behind the preconceptions built over a lifetime and move from the audience's to the artist's perspective.

Listen to the world around you. Every sound you hear is a reality-based phenomenon corresponding to an action. Many of these sounds, in a different context, could work for something else. If you were shown an animation sequence of a raging storm, how would you create thunder? You could wait for a storm to blow by and record it, hoping to get some usable thunder, you could reach for a sound library or you could grab a sheet of metal (such as aluminum or copper) and shake it. Foley artists have been doing this for years and you know why? Because it works!

What if you needed a crackling fire? Are you going to light a fire in your studio? I'm not sure I'd subject a microphone to the heat. Instead, try slowly crushing some dry paper and plastic wrap. By itself, it might sound like paper being crushed, but presented along with a picture of a campfire, it will work great. That same sound could even be used as radio static. Need a hatching egg sound? You could buy a dozen eggs to crush or slowly peel some Velcro apart. That same Velcro sound done right could pass as radio static, too. See what I'm getting at? You can creatively use commonplace objects to produce some believable Foley sounds without all the mess or anguish of destroying perfectly good (and expensive) objects.

Sound Libraries

A close cousin to the art of Foley are sound libraries. These initially started in Hollywood years ago as a way to save some time on the Foley stage by recording a vast array of everyday sounds which are then licensed to the user. Instead of running off to have footsteps and background sounds created, a sound editor could just grab one of these libraries and have them instantly. Car door slams to cracks of baseball bats to a crying baby to explosions are all within your reach. They were pretty good then and have only gotten better in quality and quantity over time.

Now, crisp, clean digital recordings are available from several different sources as all-inclusive CD and DVD libraries. Not only can you find everyday sounds but some sound designers have even licensed their original creations. Larger-than-life and make-believe sounds are also available to us mere mortals for licensed use. Entire game projects have been done using nothing but library sounds, and while I don't recommend using them exclusively, they can save the day for those last-minute changes the night before going gold.

To most sound designers, sound libraries are a good stepping-off point. Everyone I've ever run across uses them, but few use them as is. The one major problem with licensed sound libraries is that anyone can have them and some sounds have a tendency to be overused. Originality is important and when one of those overused sounds breaks the immersive effect of the game, it becomes obvious. The way around this is to creatively manipulate or use small pieces of the original sound to make something new and fresh.

At the very least, a sound designer will take a stock library effect and change its pitch either up or down. It still has the same basic presentation except the tone has changed, and while it may be recognizable, it won't be the same old tired sound. Other basic tricks would be to apply some severe EQ, either by dramatically sharpening or dulling the sound, or utilizing effects processing (like reverb or flange) to give it new character. Combining stock

library sound is also another great way to create something new. For example, a bullet ricochet layered with an explosion gives you an entirely fresh explosion. Manipulation and creative layering of sounds will breathe some new life into those stock samples.

Using sound libraries for long, background ambience, such as a city street scene behind a skateboarding game, can also benefit from some subtle manipulation. Changing the pitch up or down a couple of notches can provide enough of a change to get away with using the same sound within the same game. You could also cut the scene into several pieces and rearrange the order to keep people guessing.

Sound designers use sound libraries as one of the many tools in their arsenal to piece together good sound effects. By taking bits and pieces of an existing library sound, they can produce the exact sound effect they were after. This saves valuable time by relieving them of starting from scratch or having to run out with a microphone just to grab a simple engine noise.

In a space game I had worked on, the design team discussed ways of making use of some new gizmos easier for the player to recognize by having them sound like what they were. If it's a power pack, have it sound like one. If it's a type of communications gear, have it sound like one. But because none of us live in space and have never heard these things (and partly because they don't really exist), we decided to base them on earth-bound objects so you recognize them immediately. For instance, one of the vehicles has a massive power plant and one of the options for its sound is to have a mixture of a revving Indy race car and a jet turbine. I couldn't easily record either of those objects at the time, so I turned to a sound library instead. The power pack and shield will have elements of "electrical" sounds in them. The communications gear will have some static and transmission sounds, as well as a few computer bleeps. I'll get most of these sounds from an effects library, and edit and layer them to make my new sounds.

Original Development

Our third and final stop in the trilogy of sound design methodology is original development. Game sound designers masterfully use all three techniques to achieve their magic—grabbing a mic and recording a sound, picking up a sound effects library, or pulling one out of thin air. By using combinations of tone generators, software, synthesizers, and everyday objects in unusual ways, inventive sound effects emerge at the hands of the artisan. The beauty of this approach is there are no rules and no limits except one: the sound effect must enhance the corresponding action by providing the player with suitable aural feedback.

Sound designers have their own style, whether it's "over the top," "bigger than life," "cartoony," or "believable." It is dependent on their way of thinking and creating, their mindset, their personality, and what motivates them. Secondary factors that also help create a "sound" are sound effects libraries, equipment, recording methods, software, and even the microphones they use.

As mentioned, original creation can come from practically anywhere. Look around you. Everything makes a noise if you drop it, hit it, scrape it, or move it around. Pick up objects and smack them with something. Fill them with water and hit them again. Dig through your drawers, the dumpster behind the mall, the junk yard; there are plenty of sounds to be had. While you are on the hunt for individuality, don't be unique for unique's sake. Listen to how these sounds can be used for your purposes when brought back to the studio.

Another appealing source for sound is a synthesizer or sampler. Manipulating a preset sound using LFOs, filters, modulation, varied attack, sustain, decay, and so on can create some interesting effects. It can be done manually or through a sequencing program which allows management of these parameters. Sequencers are great for tweaking your performance prior to recording the final version, especially when multiple sounds are triggered. Some audio editing programs also come with built-in synthesis to create simple tones, FM, and DTMF (dual-tone multifunction, the sounds you hear when you push numbers on a touch-tone phone). These tones are particularly useful when doing games with cartoon or computer-type sounds. By manipulating them with linear pitch shifting, they make some neat beep-like effects. Experiment and see what you can come up with. Try a flange, reverb, and chorus. Try distortion, amplitude modulation, and EQ. Try a vocoder, Doppler, or reverse. Try every on-board effects processor you have and listen to what they can do. Understand what each one does and you will be able to skillfully apply them to other complex sounds.

Original development is definitely a state of mind. As you become immersed in the virtual game world, it will be easier to create within this atmosphere. By placing yourself in the game, you can better imagine what something will sound like than by standing outside, looking in.

Sound Designer at Work

Matt Piersall

Matt Piersall is a sound designer and composer for GL33k.

(*Continued*)

Describe your thought process for creating sound effects.

I start raw with the first thing that pops into my head. A lot of times, based on what it is, I usually know where to start looking and I go from there. Sometimes, though, it's completely unrelated. If I'm totally stumped, I'll go through my recordings and at least get the cadence and movement of something, or bust out Absynth. I feel complete with a sound when I've added an unrelated element to it or something that wouldn't be the obvious source.

Are there any particular secrets to your creativity?

Creativity is not really a secret. Everyone has it. Some people learn to exercise it and tap in to it more than others. Regardless, though, creativity takes effort and if you don't exercise your creativity it becomes harder and harder to accomplish what it is you want to accomplish. I make something seven days a week and it's paid off. The technology aspect has become transparent and the act of making a sound isn't daunting anymore. It's what I love to do.

When do you find you are most creative?

Probably the morning.

Any specific "lessons learned" on a project that you could share?

Simplicity is king. I worked on *Metroid Prime 2* and *Metroid Prime 3*. "Prime 2" was huge for me and I wanted so desperately to impress Scott Peterson, Clark Wen, and fans of the *Metroid* series. I overdid it, though. I over-thought sounds, I added too many elements, and I forgot that my sounds are not the focus—the experience is the focus. It took me a *very* long time to truly realize that at the end of the day you might hear a sound only once and if it calls too much attention to itself, regardless of technically how good it is, it's not appropriate.

Scott Peterson took me under his wing during "Prime 3" and really showed me the ropes of good game audio. He's worked on a number of titles and has a massive amount of experience, and to this day I feel very lucky to have learned so much of the inner workings of game audio without ever being in-house.

Do you have any negotiation techniques or stories others could learn from?

Wow, that's a great question. In the beginning, I handled the salesmanship aspect of my company with too much intensity. When starting your own business, it's human nature to feel quite vulnerable and in those moments you act in desperation. I wanted to send demos to every company and put an advertisement in *Game Developer* magazine, but it would have been pointless. I don't like getting random stuff I have to listen to in the mail and neither does anyone else.

At the end of the day, negotiations should be treated as if you were dating. The more desperate you come off, the less interested a fine young honey will be in you.

The same is true of game developers. They want to hire somebody that they get along with and someone who will do a good job. Trust in your ability, and the ability of your team, and *always* try and understand things from the developer's perspective. Why do they want to hire you? What are they trying to accomplish? And what can you provide them that will help them accomplish that goal?

The money aspect shouldn't be the final straw. If you are going to learn something, be a part of something cool, or get more creative control, you should do it. The first five years of your career are spent establishing yourself and who you are and what you do within the industry. I've been involved in plenty of bad negotiations—and good ones, too—but its all led up to now having consistent work for a team of people.

Do you have any development stories that serve as a good "lesson learned" or something that can be avoidable in future projects?

On my first project, I was given the ability to do whatever needed to be done. I was completely green and was seeking approval from anyone who would give it to me. I spent most of my time revising sounds and creating sounds based on peoples' opinions who didn't even listen to the game. Programmers and level designers who could care less when I opened the floor to them were giving me horrible advice on how sounds should change or how a sound should play within the game. At the end of the day, I should have trusted my instincts and taken true ownership of the audio.

Do you have any sound design creation techniques that resulted in something interesting?

I keep a mic hooked up in my room at all times. I could care less about machine noise or ambient noises in the background, but I always have this mic hooked up. Sometimes, whenever I'm having a hard time finalizing a sound I vocalize in a mic what it should sound like. After I vocalize it, I tweak it and a lot of times it ends up in my sounds. A lot of world sounds that I've done for various games are me humming into a mic.

The mic is also great in the room as well for recording cloth or hitting something to get that right tone. I've done this since the beginning. People tend to not record stuff because it takes a lot of effort to either go get the sound or build a perfectly quiet room in which to record. I was the same way. Then I bought a good shotgun Sennheiser 418 and it works like a charm. Mixed in with all the other sounds, you really can't tell that it was recorded next to my computer. I'm ghetto like that.

Any good or horrible endings to a project others could learn from?

Every project ends perfectly for me. Okay, not really. At the end of every project I'm tired, I think it all sucks and half of my vision never made it into the game.

(Continued)

I go home, cry for about three months, and then get the game. I'm usually surprised that while *never* perfect, being so close to something distorts your vision. There have been times when I haven't been happy about the final product, but I just try to stay positive.

How did you find your way into the games industry?

In 1999, I started dating this girl, who's now my wife. I was constantly broke and she asked me what I was going to do to make money. I was a bit offended because obviously I was going to be a superstar DJ! While we were out I ran into this gal. She did voices for the cartoon show *Dragon Ball Z*. The director of *Dragon Ball Z* happened to be a guy I was in a band with a few years before, Chris Sabat. I put it together and got a job at FUNimation. I started as an engineer and did sound design on the sly using their gear. My sound design background came from writing electronic tracks for years, so it all made sense. At that time, no one really did sound design for cartoon trailers but I started doing it and was told not to waste too much time. But, the first or second trailer I did sounds for was really well received and that became my job—but unfortunately no pay increase.

I had always wanted to do games and after a year of doing trailers I hooked up with Kyle Richards, who is the audio director at TRI. He liked my demo and gave me a shot. From there I began to do more and more games through connections I had met during my days of playing electronic shows. After the game work became steady-ish, I left my job and started doing nothing but games. As the work continued to come in, I got together with some of my talented friends—Bob Arlauskas, James Barker, Matt Chaney—and started a company.

Editing Methods

In Chapter 2, I listed some audio editing and multi-track software programs you could use when doing sound for games. I also discussed editing techniques for music creation in Chapter 8. I recommend having a good audio editing program like Sound Forge, Audition, or Cool Edit at the very minimum. Multi-track software like Sonar, Nuendo, Pro Tools, and Vegas are also fantastic tools you should consider as your resources allow. These tools are key to what sound designers do and are indispensable in their everyday creative activities.

I've learned a lot from other composers and sound designers over the years by watching them in action. I've walked away from every session with another trick in my bag, usually scratching my head at how obvious it was. The tools sound designers use and the way they use them is pure magic, except the magicians in the games industry are eager to share their secrets. This particular section will communicate techniques and tricks I, and others, use in professional game sound design as if you were standing behind us watching it all happen. The intent is to start you with a strong, solid foundation, then let you loose on the gaming world.

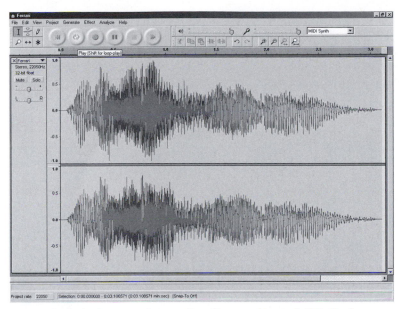

Audacity is an excellent audio editor—and best of all, its free!

Most audio editing and multi-track programs are capable of performing the same types of edits and processing. I won't get into the specifics of the dozens of programs out there, but I can present generalities and features common to them all. Let's take a look at the three most common types of programs and their use in sound design.

Using Audio Editing Software

The cornerstone of game sound design is audio editing software. As you'll recall from Chapter 8, these versatile programs can record, edit, and convert sound files in a multitude of ways. The best way to explain how they are used is to put you into the action, creating a couple of sounds. We'll try something easy and move into a complex sequence.

A Simple Sound Design Example

A developer has asked you for a sound of a kitchen pot clank for a children's game to be delivered in 22 kHz, 8-bit resolution, mono, *.wav* format. Grab a pot, something to smack it with, a microphone, and some method to record it. For this example, let's assume you'll be recording direct to your hard drive—saving us the step of getting it into the computer from a portable rig.

The first order of business is to open a new file in your editor and determine the parameters of the recording. Always start with the highest sample rate and resolution; in this case, it will be 44.1 kHz and 16-bit resolution. Unless you're using a stereo microphone, we'll record this in mono for simplicity's sake. If for some reason you need this sound in stereo later, it is an easy step to open a new stereo file, paste the mono sound to both sides, and apply a pseudo-stereo effect to it.

Now, set your recording levels as high as possible without clipping—and press Record. Bang on the pot in different spots at various strengths to provide plenty of takes. Your ear may perceive things differently than the microphone, a take which you thought sounded bad might actually be the one you go with. Each take should be about one second apart, being careful to let the ring completely fade each time. After six to eight of these, stop recording.

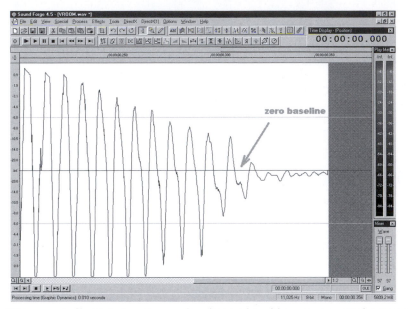

The tail of this sound effect is below the zero baseline and could cause unwanted noise in the file.

A waveform will appear on your screen. It will have blank space and the obvious waveforms of each clank. Most sound editors have an automatic backup of the file stored in case your computer crashes, but to be on the safe side, store this file and name it something like *pot_clank_roughs_01.wav*. Before doing any editing, listen to the entire file and choose the best take. As you are listening, it may be helpful to place file markers near the ones with potential—saving yourself having to re-listen to the entire file over and just concentrating on your favorites.

Once you've found the one you want to go with, highlight the take (leaving a second or so of blank space on each end if possible), and then drag it to the program's desktop or copy it. The programs that allow files to be dragged will automatically open a new file set to the parameters previously specified, ensuring it is set at the same sample rate and resolution as your rough file. For those without that capability, open a new file manually and paste the clank sound into it. Save this new file as *pot_clank_01.wav*.

You're probably wondering about that dead air on the front and back of the file. Give it a listen. Do you hear any background noise? If it is prevalent and noticeable on the level meters, highlight the space and let your noise-reduction plug-in analyze it then process the rest of the file with this setting. If you don't have this feature, it will still be fine. The pot clank sound is much louder than the background noise anyway and won't be noticeable with such a quick sound. Trim off the dead space from both ends, being careful not to cut

any of the sound wave. Use the Zoom feature to see exactly where the sound begins and ends. This process will ensure the file is as small as possible and that the sound will play immediately after it is triggered, instead of playing any silence first. Save the file. This will be the basic file you'll be working from.

This sound effect looks good. It has all of the properties of a "healthy" file.

By visually inspecting the file, you should be able to tell a couple of things. (If you've read the section "Visual File Inspection" for game music in chapter 8, the following outline will be a bit of déjà vu. Move on to the next section, "Making Your Effect Unique."

Is the sound centered on the zero baseline?

The line that runs through the middle of your sample is known as the zero baseline. Occasionally, when there are electrical mismatches between your soundcard and microphone, it can cause the entire sample to be centered somewhere above or below it. This can cause some unwanted audible artifacts you'll need to get rid of. The DC Offset function, or a similarly named feature, will analyze the file and recenter it to zero—keeping the file as clean as possible.

Does the wave file look "healthy"?

Does it fill much of the screen or is it a bunch of puny little lines barely perceptible until you zoom in? It is important that the actual sound is louder than any noise floor in the recording and louder than the noise on any playback system. If the volume is at least medium intensity or thereabouts, you can beef it up by either increasing the overall volume manually or using a normalization function. Normalization will scan the file and increase its overall gain, set by you, without clipping. This will maximize the volume proportionally, leaving a strong, solid sound.

Does the sound look too intense?

Has the waveform saturated the screen completely? If the sound file shows a solid wall from the zero baseline to infinity, with the edges of the sound cut off, chances are this file will be distorted and totally lack any dynamics. Depending on the effect you are trying for, this may be alright, but the majority of the time, you'll need to give something else a try. First, attempt to reduce the overall volume or apply a moderate amount of compression. If the peaks are severed, peak restoration plug-ins are available to repair this type of damage. Listen to the results and decide if it sounds any better or if you just simply reduced the volume and applied "band-aids" to a distorted sound. In that case, re-recording the sound will be your only option—just be sure to do it at a level a few notches below the previous attempt.

This is the previous "healthy" sound file example turned up a few notches too many. The meter to the right doesn't begin to describe the pain this sound effect is feeling.

Are there any points in the file where the volume peaks or causes clipping?

Nothing sounds worse than a digital file passing 0 dB (decibels) on a level meter. These prominent peaks cause unwanted clicking and distorted screeches in sound files and need to be dealt with. One option is to reduce the overall volume of the file enough to bring any peaks below the point of clipping. Another is to apply a slight amount of compression, such as a 2:1 ratio—which in effect, will squash the peaks and raise the quieter levels proportionally. My personal favorite is to use a peak limiter set to –0.01 dB, which allows for the highest possible levels without reaching 0 dB. Depending on the playback system, you may have to adjust the peak limiter to a lower setting to compensate for poor speakers. Keep an eye on the peak levels, especially after adding EQ or other processing and be prepared to repeat this step if necessary.

Making Your Effect Unique

Because the file will be down-sampled and left as a mono signal, we don't need to spend any time creating a stereo or surround effect. We can apply effects processing such as reverb, chorus, flange, pitch shift, and so on in mono with good results to add a bit of "seasoning." The clank is a short sound, so the chorus or flange will make it "meatier." The reverb will sustain the ring portion of the sound. Equalization can alter certain frequency ranges, adjustable to your taste and the playback device. Depending on the type of microphone (and proximity), it will have its own coloration. Different mics are better at capturing certain frequencies than others. Use your ears and make adjustments accordingly. Save the file.

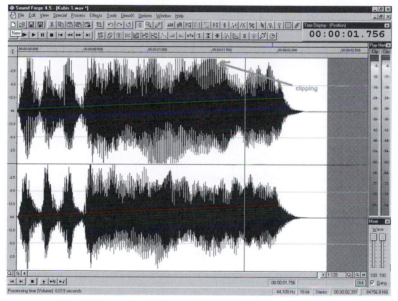

These peaks are caused by high levels and can be tamed by simply decreasing the volume, adding compression, or applying a peak limiter.

For our example, I would use a slight touch of reverb, using a bright, small room setting. You'll notice the end of the sound does not decay naturally and is cut off before it fades. We can fix this. Highlighting the tail and using a linear fade-out will force the sound to gradually disappear before the end of the file. For our short sound, this will suffice because we never intended for it to echo for very long. But, if for some reason you wanted the sound to appear with a normal-sounding fade, add 0.5 to 1.0 seconds of silence to the end of the file, add your reverb, and then delete any remaining dead space after the fade. This will allow more room for the effect to decay naturally, making it more realistic.

After processing the file, you should save it as its own file—keeping the original file untouched in case you decide later you didn't need the adjustments. With some types of editors, you will be unable to undo additions selectively, the last edit is layered over

the previous changes. In order to undo something you did three edits back, it would be necessary to undo the last two as well. Saving your file in various stages will give you something to go back to in case an idea changes or an effect doesn't work out as planned. Be sure to label them accordingly or use the summary or notes to describe the sound. Staying organized is essential when dealing with a large number of files. There are some more advanced audio editors which allow for selective undos, even after the file has been saved, so there are ways around having to save different files at every adjustment. If this is important to you, expect to spend a little extra money on a high-powered program, or we'll talk about creating sound effects in a multi-track environment in the next section, which will definitely solve this issue.

The sound effect is almost complete. The developer requested the file format of 22 kHz, 8-bit, mono and because we built the file as 44 kHz, 16-bit we'll need to do a couple more things. Using the final version of the file, resample it to 22 kHz using your editor's resample function. Ensure the anti-alias filter setting is used to prevent any of the lost high frequencies from becoming low-frequency distortion. This will keep the sound file as pure as possible. Keep in mind the higher frequency ranges are not represented at lower sample rates and the sound will change. I once recorded brass shell casings landing on cement for a game project. The best part of the sound was the ring they produced, which became totally lost when I down-sampled to 11 kHz. They ended up sounding like dropped pebbles and were barely usable. Listen to the file again after down-sampling and EQ to boost the sounds as necessary. Remember that the higher frequencies will not be available.

The next step is to convert from 16-bit to 8-bit resolution. Selecting this feature on your editor should give choices such as Truncate, Round, and Dither, as you'll recall from Chapter 8. I could go on all day about which one is best for each situation, but I will defer to experimentation instead. Try each choice and listen to the results. You are mainly concerned with the introduction of quantization noise, which sounds roughly like high-frequency static. In this example, you will notice it most where the sound loses intensity and fades out. This is one of the reasons why we maximized the sound earlier either using normalization or volume increase; it masks this particular phenomenon. The noise you hear after the conversion depends on which setting you use, of course. My personal experience dictates I use either the Round or Dither feature with a value between 0.5 and 1.0 bits. Dithering adds Gaussian noise, which is designed to mask the more obtrusive quantization noise.

The final step for this simple sound effect is to save it in the required format. I normally work in the *.wav* format and in this case, no further action is necessary. If the client wanted an *.au* format, this particular popular Java format creates its own change to the sound and additional EQ may be necessary to compensate for the loss of high frequencies. But, if you were using *.aiff* or anything else, save the file as a *.wav*, give it one last listen, and get ready for the next sound effect.

A Complex Sound Design Example

Building a sound effect using an audio editor is normally a simple affair. It gets wildly more complicated when you have to string together or layer other effects in order to compose an involved sound effect such as a full audio sequence for a cinematic or animation. In our next example, the developer has requested a realistic multipart sound effect of a

low-flying aircraft getting shot down by an angry shotgun-toting farmer. The file is to be no more than 6 seconds in length, delivered as a 44 kHz, 16-bit, stereo *.wav* file. Let's put this together using just our two-channel audio editor of choice.

This sequence will be made up from several layered sounds to form the final version. The first step is to gather all of the individual sound files and manipulate them accordingly. Using our first example as a guide, record and save the following stereo sound effects.

- Airplane flyby
- Single gunshot
- Short explosion
- Small crash with metal fallout

Develop an idea in your mind of the "scene" you plan to create and where the listener will be during this. The farmer's perspective seems like the logical choice, so we'll start from there. I picture him miffed, watching his cows being pestered by the low-flying aircraft and rushing out to the field with his shotgun. The aircraft enters from the far left, the farmer takes a potshot at it when it gets to the center, and as it moves to the right side, it explodes and crashes in a burning heap.

Luckily for us, the developer wants this in stereo—so we'll get to show our stuff. Unlike our previous mono example, the manipulations and processing will have an effect on the stereo spectrum. Depending on what sound file you acquired, the aircraft flyby could pose the greatest challenge. Using the panning feature, adjust the effect so the aircraft sound begins in the left channel, moves to the center at about 2.5 to 3.0 seconds, and ends on the right. The explosion effect will happen to our right. Using the panning feature again, adjust the explosion so that 60% to 75% of the volume of this is to the right side. The crash sound will happen far to the right, so manipulate this to 85% to 90% of the sound to the right. You don't want to put 100% of the sound of the crash to the right because in real life your left ear would still pick up some of the sound. This will keep it sounding natural. If you are using the other suggested sounds, also consider them in the stereo spectrum and run them through the pan feature. We plan for the gunshot at center stage, so no adjustment is necessary on this file. Save all of the new files.

For effective realism, also consider using a *Doppler effect*. Apply it to sound effects which are in motion either to or from the listener's point of view. In this example, the explosion and crash could probably stand a touch of this because their sound sources start close to the listener but move away at the speed the aircraft was flying. Be careful not to overdo the effect; a slight touch is all that is needed. If the airplane engine sound you started with was from a static perspective, you could apply this particular effect to its maximum extent and get a believable flyby.

Now let's piece this baby together. Open a new file as 44 kHz, 16-bit, stereo and make it 6 seconds long or insert 6 seconds of silence if the first feature is unavailable. Starting in a logical order, grab or paste the flyby pan effect to this new file. If it's longer than 6 seconds, don't worry. At the 4-second mark, mute the remainder of the sound. Because airplane engines don't make engine sounds after they've exploded, you won't need the rest of that noise. Save the file as *version 1*. Next, add the gunshot file and place the beginning of the file at about the 2.5- to 3.0-second mark. The important part here is to ensure the

volume of the gunshot is consistent with the rest of the sequence. It will be louder than the flyby, but not overwhelm the scene. Mix the volume without fades and give the entire sequence a listen. More than likely, the gunshot will have caused the wave to peak and possibly distort somewhat—so pay attention to what it sounds like. Apply compression or a peak limiter to control it and save the file as *version 2*.

Next, we add the explosion. Find a logical spot after the gunshot where you feel the airplane might explode. It should be somewhere between the 3.5- and 4.0-second mark—definitely not past the point where you performed the mute. Unfortunately, 6 seconds isn't a lot of room to get an explosion and crash to decay naturally—so we have to keep an eye on the rapidly approaching finale. I chose to have the explosion happen quickly after the gunshot in order to save room on the end for the other sounds. Paste the sound over the existing file in the same fashion as the gunshot. The explosion will indeed be a big moment in the scene, so make it as loud as you can in the context of the rest of the sequence. Don't sweat having the sound decay past the 6-second mark; we'll take care of that when we add the crash sound. Check for distortion and apply the peak limiter or compression if needed. Give the entire sequence another listen. If you like what you hear, save this as *version 3*. If you don't, undo your edits to the point where it went astray and try it again.

For the final addition, we'll add the crash element. If the explosion sound took us past our 6-second max, this is the time to make a decision. For me, it depends on what qualities the crash effect has and how much it will add or detract from the explosion. In this case, I have chosen to cut off the existing explosion sound right at the 6-second mark and use a linear fade-out for the last second of the explosion. This will fade the explosion sound so it doesn't cut out noticeably and give some room for the metal fallout. Since my crash sound has a nice impact, using it within the explosion sound will add an interesting overall effect. So, as I add the crash sound I carefully align the sounds so the point of the explosion and crash impact coincide. Adjust the volume and mix them appropriately. Because the explosion and impact sounds are both loud, be careful not to mix so that it becomes overly distorted. Once you've mixed the new sound, listen to the entire sequence again. Adding sounds with high transients guarantees some out-of-control peaks, so you will definitely have to keep them restrained. Pay close attention to the levels and adjust any peaks with a limiter if needed. Also listen to the structure of the sequence. It should flow believably from the left channel to the right without being obvious. Save the file as *version 4*.

Before we can stick a fork in this and call it done, critically listen to the overall sequence one last time. The sounds should all blend and give the impression they were recorded as the action was played out for a microphone in the farmer's field. A touch of EQ and light reverb might help bring them together if needed. If worse comes to worse, you might need to go back to a specific sound, EQ it, and then start the process over from there. Because we saved several versions along the way, we can go back to any step and not have to redo acceptable work. It takes a bit of work using an audio editor alone, but it can be done.

If you are satisfied with the sequence at this point, cut off any excess sound past our 6-second max and fade the last 0.5 to 1.0 seconds of the file. This will keep the file within specifications and prevent it from cutting off unexpectedly. Save the complete sound effect using an obvious file name, such as *farmer_flyby.wav*, and you are done.

I chose the previous two examples to introduce you to concepts you will encounter making sound effects using an audio editing program. With a little patience and practice,

you can produce single sounds or complex layered effects. Once you get the basics down, they become second nature and you'll soon find yourself whizzing through the entire creation process without much trouble. There is much more audio editors can do and I encourage you to become familiar with yours. The tools are available for serious sound manipulation, but it takes a little bit of digging to find out everything your editor can do. Spend time experimenting before you get busy with work. That way, your creativity won't have to fight with technology when making professional sound effects.

Using Multi-track Software for Sound Design

The day I discovered the use of multi-track software for sound design creation was a professional rebirth for me. I remember exactly where I was, who the sound designer was, and the color of the massive brick that struck my thick skull. Ah, the years of headaches I could have prevented! If you plan on making sound design a part of your audio production services, I implore (no, I beg) you to acquire a good multi-track audio program. Your creative life will become infinitely easier with this powerful tool at your disposal. If this is the first time you've been introduced to this concept, I guarantee you are five years ahead of where I was at this point.

A good multi-track program, however, cannot stand on its own. Your audio editing software is still required for final sound effects editing, so don't make the mistake of only buying a multi-track program. If you have to make a choice, buy the audio editing program first and make upgrades later. Or, consider a program like Adobe's Audition—which actually does both very well.

You'll soon discover the extreme joy of creating sound effects in multi-track. If you tried the previous complex sound design example on your standard audio editor, you will immediately realize the simplicity and flexibility you have doing it this new way. Imagine having the ability to add effects and EQ and to control panning and volume in real time to each individual track, and then to instantly hear the results. You won't have to save every step or suffer through numerous undos and redos as you craft a sound. It will be great.

Let's take the farmer flyby example and create it here again as a comparison. The delivery parameters shall remain the same: no more than 6 seconds in length and delivered as a 44 kHz, 16-bit, stereo .wav file. Gathering individual sounds will be performed and created the same way using the audio editor. Nothing changes here except there isn't any need to cut to length or add effects processing to prepare for the mix process. Collect your sounds: some cow pasture ambience, an airplane flyby, a mumbling farmer voice, a shotgun-loading sound, a single gunshot, a sputtering engine, a Mayday transmission, a short explosion, a scream, and a small crash with metal fallout. Let's use them all! We can mix this longer list of sounds without even batting an eye.

Again, before slapping sounds together, start with a picture in your mind of how the scene will play out. This time, though, we will be adding additional sounds plus an ambient track of the cow pasture—so the overall soundscape will be a bit more dense. Pay close attention to what sounds are "action" sounds and which ones are purely "window dressing" to add additional realism. This much layering can get busy and may work against us unless we keep a close eye on it.

Sony's Vegas Video allows for nondestructive complex audio editing guaranteed to take your sound design to another level.

A good rule of thumb is to keep background sounds in the rear and those sounds which tell the story in front.

Resist the urge to have mooing cows and chirping birds hogging your scene. Use them sparingly, as a chef does with seasonings.

On your multi-track program of choice, open a new window with at least 10 available tracks. It is possible to create the sequence in one track, using cross-fading and mixing, but because you paid extra for the convenience of multiple tracks, we'll put one sound on each track and use its full potential. If the number of tracks does become an issue for you because of hardware resources, it is possible to place multiple sounds on each track. By placing nonoverlapping sounds on the same track, it is still possible to adjust individual volumes, durations, and fades while cutting down on the number of tracks your processor has to deal with. Any effects processing or EQ inserted in a track, though, will affect every other sound. For our purposes, we'll assume that one sound will go on one track and that all processing will be done separately.

Track number 1 will start out with 6 seconds of cow pasture ambience. If you have a longer piece, shorten it to fit or mute the track after the 6-second end mark. How you do this depends on the features of your program. Some will even allow you to size a file by moving either end to fit. If your ambient file is only 3 seconds, consider simply repeating it twice or overlapping them with cross-fades to allow smooth transitions between the pieces and to keep them from sounding like a loop. Play the track, listening for any unnatural sounds such as clicks or pops. Don't worry too much if the overall sound isn't 100% perfect, because this is the background sound. The volume will be low and other sounds playing will cover up most of the discrepancies. With the background in place, save the project file and begin adding the rest of the sounds.

On the next track, let's add the flyby—starting at about 0.5 seconds. We want the background ambience to be heard first. This way, the listener's subconscious will hear it even though it will be buried. If the airplane noise started simultaneously, the listener would pay attention to the airplane and probably never even hear the cow pasture. Human nature will lead you to key in on the "action" and disregard any background distracters. This form of selective listening can sometimes work against our efforts, causing us to compensate appropriately.

Depending on the flyby sample you are using, you may have to shorten it to about 4 seconds to fit the scene. If it already works well as a stereo effect with the aircraft coming from stage left to the center at about 3.5 seconds, set the volume and save the file. If you are using a mono sample, exercise the panning feature to get the desired movement. Set your index points for the panning controls to simulate the flyby and ensure the sound moves past center stage about halfway through the sequence. Adjust the volume and save the file.

For the rest of the individual sounds, place them on their own track with start points in roughly the order you would expect to hear them. Have the farmer mutter, load his gun, and fire it. Then have the engine sputter, a short Mayday from the pilot, an explosion and scream, and then cap it off with the fallout ending at 6 seconds into the sequence. Adjust the pan for the final sounds to have them play further and further to the right to keep a fluidity over the entire scene, from the sputtering engine to the fallout sounds. Adjust any sounds which are longer than the sequence length, fading before 6 seconds. Once that is complete, save the file and then proceed to adjust volume levels.

As in our previous example, make sure the levels all blend from the listener's perspective (i.e., the farmer). Make the gunshot and explosion the louder of the sounds. You may also want to add compression to these particular sounds which have a sharp attack for an extra boost without suffering from clipping. For sounds that might get buried, such as the muttering farmer and Mayday, consider using a touch of EQ to increase the higher frequencies—just enough to be able to understand what's going on. For the pilot's emergency transmission, EQ out the lower and mid frequencies to give it that tinny radio quality. You might even have a preset for this very effect. The artist has the discretion to use any other effects processing—some slight reverb perhaps or a hard flange for the tail end of the explosion just for fun. This example doesn't really require much. Again, save the file. Yeah, I know; I keep harping on this but the first time your system crashes and you lose 2 hours of hard work, you'll become a believer. Save early and save often.

Building a complex sound effect in the multi-track environment is fairly simple. Once the sequence is tweaked to perfection, save the work as a "mixed" or "rendered" file for further processing. This process assembles the multi-track sequence into a single sound file which will then be further manipulated. From the audio editor, open this mixed file and run through the checklist we were introduced to in the first sound effect example.

- Is the sound centered on the zero baseline? Utilize the DC Offset function.
- Does the sound file look "healthy"? Increase the volume level or use the Normalize function.
- Is it too intense? Apply compression or decrease the volume.
- Are there any major volume peaks or clipping? A peak limiter or slight compression will take care of these.

How does the sequence sound now? There is definitely a lot going on in our soundscape—everything from very subtle sounds to in-your-face explosions. If you can make this sound great, you are on your way to making some professional high-quality sound effects.

Comparing the two processes now, you might feel this method is far superior to the time-consuming and almost archaic way of doing business using a straight audio editing program. Multi-track affords many options to layer complex sounds without having to save and resave multiple files. Nondestructive editing is a godsend and I often beat myself up for waiting so long to incorporate it into my creative practices. If you intend to be in this business for any length of time, this will be an investment that will pay for itself every day.

Sequencing Software and Samplers

The final stop on our sound design creation tour is the use of samplers and sequencing software as production tools. This method goes back many years to the Hollywood scene—sound designers in film having paved the way for the invention of audio editing software while pioneering this particular technique. This routine is still in use by some as their system of choice using hardware- or software-based elements. Whether you physically load a hardware sampler full of basic sounds and then manipulate them via keyboard or sequencer or trigger samples stored on your computer with an internal software sequencing program, the end results are the same.

It is still necessary to have an audio editor in your arsenal even if you use a sampler and sequencer setup. Editing basic sound elements before loading into a sampler has to be done somewhere, as well as editing and formatting of the final product. It is impossible to create audio for games without one, so again, a sampler and sequencer will only supplement the creative process. It all comes down to what works for you, what drives your creativity, and what method serves the means.

The simplest form of sampler-based creation is its use as a basic pitch shifter over the chromatic scale. My personal favorite is to record party guests at their uninhibited best, load it into the sampler, and listen to their uproarious laughter accompany the playback. Middle C becomes the unprocessed recording. Everything up or down the scale from there becomes cheap party fun. The lower the notes triggered on the keyboard, the lower the pitch of the original recording. The opposite is true for the higher notes. This is an easy way to instantly find out what pitch of sample works best for your application. It can also be used to layer the same samples—adding a note lower or higher to the original to fatten it up or to add some interesting artifacts. This doesn't work the further you stray from the root. As pitch is dropped, the sample playback becomes longer. As the pitch is increased, it becomes shorter—making it difficult to seamlessly overlap. If you triggered three notes of the same sample to simultaneously playback, the higher-pitched one will finish first and the lowest pitch will be last.

The best creative use for sampler-based rigs is to layer multiple elements for one large effect or sequence in a real-time atmosphere. In this manner, it is perfect for performing to a cinematic (much like a Foley artist would do with their props)—except all of your "props" are pre-loaded into a sampler. Some artists prefer to perform this task manually, matching keys visually to the actions or sequence—relying on their own timing skills. Others utilize a sequencer to create complex effects, layering triggered sounds using MIDI data synchronized to specific visual cues. Both methods require an understanding of your particular sampling device and how to set up sounds across a keyboard for optimum use.

Our previous sound effects sequence of the farmer flyby can be done using this sampler-based technique, although a couple of extra steps are needed to prepare. Preproduction now includes loading the various sound effect elements into the sampling device and assigning each sample to a key or group of keys.

To make this already complicated process less demanding, let's build the sequence using the four basic sound effects: flyby, gunshot, explosion, and crash samples. You could simply load these four sounds and have each triggered by one key and get away with it, but where would the fun be in that? To illustrate the potential of this setup, let's load them chromatically so they have an octave "key group" from which to be triggered. This way, we can pick and choose which pitch we like and layer multiple explosions and crash effects as the feeling strikes us.

It is possible to perform this sequence while recording to any medium, but you'll be bypassing important features of the sequencer. By recording MIDI data to sequencing software, we can take advantage of automated panning and fader controls—not to mention some limited effects processing and the ability to tweak the multiple triggered sounds to perfection.

Open a new file in your sequencer and set up four tracks to the same MIDI channel, preferably the one your sampler is also set to accept commands from. Either from a master keyboard controller or by using a mouse on the piano roll screen, trigger the flyby sample to start on track 1 at the 0:00 mark. Save the file. On track 2, trigger the gunshot sample to play at 0:03 seconds. The explosion can start at 0:035 seconds on track 3 and the crash at about 0:04 to 0:045 seconds on track 4. Save the file. This will be the basic sequence.

Start by adjusting the pan of each track. Different software accomplishes this in different manners. Some merely establish what percentage of left, right, and center the track will play for the entire playback sequence. You set a number value and it never changes. More advanced programs will allow linear changes to this feature that serve as a sort of software automation. If your software will only let you "set and forget," pan the flyby sample between full left and center. Since the gunshot, explosion, and crash will fill the soundscape, it will be difficult to distinguish the location of the initial engine noise—totally masking the fact that it isn't moving. Also, by panning the other sounds appropriately, it will give the sequence the desired movement—even though we are only using static settings. No adjustments need to be done with the gunshot because it is fired from the center position anyway. The explosion can be set at about the "one o'clock" position, just right of center, and the crash sound almost to full right. This will give the stereo field plenty of action and give a believable feeling of movement. But we can go one step better.

If the program allows for automated panning, movement can happen in real time. Start the flyby sample from the full left position and set the automation to adjust the pan position until the aircraft comes dead center at 3 seconds. The gunshot can be left where it is (in the center) because our listening position is with the farmer. The explosion can start at the center and pan further right as the sequence progresses, the crash starting further to the right to also end full right at 6 seconds. This type of automation will create the desired movement for the sequence on its own, leaving the dirty details to the program instead of having to deal with it manually in an audio editor. Save the file.

We can also set the individual track volume levels in the same manner as was done for the panning process, either "set and forget" or automated. Usually, fixed volume levels will work fine in a short sequence like this—but depending on the original samples, a little manipulation may be in order to make it sound good. It is a good idea to use linear fades on each of the samples, especially the explosion and crashing sounds, in order to stay within our 6-second limit. All sounds should fall to zero by the end. If not, later work within the audio editor will need to be done.

As further tweaks are made to tighten up the sequence, consider adjusting equalization for each track or adding compression or other subtle effects. If the sampler outputs are split to run through a mixing board, use any built-in features on the board and any outboard gear to add that perfect final stroke to the piece. It is also possible to run this into a multi-track program as individual tracks to take advantage of its features as well. If worse comes to worst, record it as a mixed file into an audio editor and make adjustments from there. Keep in mind, though, anything you do will affect the *entire* sound file—not just the one sound you may have been trying to deal with. Regardless of how the piece is mixed and brought together, utilize an audio editor to complete the final checklist in the previous examples and save to the desired file format.

The same sound effect sequence has been built using yet another array of tools, all with a similar result. For quite some time, this last method was considered the only way to do post-production sound design work and still has a place with some of the more established creation teams. The method you use is dependent on the tools you currently have, your personal sound effects "thought process," and above all what gives you the best results for the effort. My personal recommendation is to use multi-track and audio editing software paired together as the ultimate sound effects creation tool. Don't discount the sampler-based setup entirely. You never know when a developer may call asking for a MIDI-triggered bank of sound effects.

We've spent a considerable amount of time discussing the mechanics of sound design creation. Let's turn our attention back to how this fits with video game production.

Tools of the Trade

Tim Larkin

Tim Larkin is a composer, sound designer, and is Audio Director at Cyan Worlds.

I've been doing game sound and music for fifteen years now. I've shipped over fifty titles, most of which have been triple-A. As a result, I've tailored my setup to not only be compatible with most other studios in the industry but I try to maintain the highest-quality studio setup in order to continue to deliver high-quality audio. I currently have two complete Pro Tools studio setups in two separate locations: one at home and another a few miles away at Cyan Worlds.

Computers: Several PowerMacs (Dual G5 and Dual G4, quadcore on the way), four PCs for running games and Gigastudio

Software: Pro Tools, Digital Performer, Bias Peak

Multi-track system: Pro Tools HD Accel 3, Pro Tools Mix Cubed

Monitor system: M-Audio BX8a's, M-Audio BX10s sub, Mackie HR824s, Genelec 1030a's, Cambridge Soundworks THX game surround system

Mixdown: Mackie Control Universal Pro, Pro Tools

Sound modules/VST instruments: Atmosphere, Stylus RMX, Sonic Implants String Library, RA, too many more to remember

Outboard gear/plug in effects: Lexicon PCM 80 and PCM 90 reverb units, Waves plug-ins, Izotrope Spectron, Trash, and Ozone

Keyboards: Kurzweil K-2000, Korg Triton Extreme, Roland D-70

Other instruments: Selmer Trumpet, Couesnon Fluglehorn

Microphones: Neumann U-87, AKG 414, AT 835

Remote recording gear: MicroTrack, MicroTrack II

Sound libraries: Many

Sound Design in the Production Cycle

Sound design creation can begin at any point in the development. Experience, however, dictates that it not be done too hastily. Initial artistic concepts and storyboards can provide a decent advanced look at the intended genre and what sort of sounds may be needed, whether general Foley sounds or imaginative "far-out" sounds are required. But because early concepts of art and gameplay have a tendency to evolve continuously, actual sound design this early is a waste of time.

Joey Kuras, while sound designer for Tommy Tallarico Studios (currently at Epic Games)—with personal credits of more than 120 games—was given a list of effects needed for the James Bond game *Tomorrow Never Dies* very early in the project. He designed and

delivered more than 200 sounds per the developer's request only to have almost 90% of them discarded as the production matured, redoing them later in the project. On another project, he received a list of unspecific and vague sounds. For instance, a request for a "splash" sound had little meaning. Was it a rock, a 400-pound person, a cannonball, or a building? Is it in a bathtub, a pond, or an ocean? No one could be specific and they ended up waiting until later in the project.

This is an easy lesson for all of us. Sound design at the outset of a project is usually not wise. Producers have the difficult task of determining audio needs of a game early in the development cycle, and if a contracted sound designer is used, the producer must find and negotiate with an individual whose skills and credits match those of the game being developed. When a game company is spending $30,000 for sound effects alone, they want to get their money's worth. If the game will have a wide range of settings and characters, trying to imagine and pinpoint a large bank of effects can be tricky.

It's important to bring the development team together to begin thinking conceptually about the game audio as early as possible. Planning is key. If they've decided on a sound designer, that person should be brought in on discussions and given an opportunity to share her or his experience. Developers shouldn't wait on the audio implementation details until later. But starting work on the actual creation of game sound effects too early often leads to major headaches down the line.

If money isn't a terrible concern, the developer can choose to add rough sound effects to help inspire the team. Putting in placeholder sounds can give life to soundless artwork and open the floodgates of creativity. As the sound designer, don't do this for free, of course, negotiate fair compensation for your work. And be careful—these "temporary" sounds have a way of becoming final sounds and unless your payment plan is spelled out ahead of time, you may be out money. As an example, say you get a call to do 10 placeholder sound effects.

Your normal rate may be $100 per sound effect; therefore, $1,000 in your pocket. But because the developer needs them today, you knock out these rough ideas in eight hours and charge them an hourly fee for your services. As the project progresses, the team gets used to hearing your rough sounds and decides they should stay in the final version. When it comes time for payment, you discover these 10 sounds have been left off the final invoice. The developer reminds you that you have already been paid at an hourly rate for the effects. So, now these 10 sounds bring in only $400 (working at $50 an hour). Don't naively think a developer doesn't have some money-saving tricks up their sleeve. Suddenly working on a "per sound effect" rate makes some sense.

Most of the time, a game is far enough along that characters, movements, and a defined gameplay model are present before a sound designer ever enters the picture. Being able to meet with the development team, view some rough game levels, and perhaps see some animation is crucial to churning out applicable sound ideas.

Specific Sound Design Questions to Answer

Once the final contract negotiations have taken place and documents are signed, the other details regarding the project are normally released to the sound designer. This is the point where "clear and concise" means the difference between complete audio bliss or a sound disaster. Ask for the specifics in order to make things crystal clear.

What genre of game is this intended to be?

It is important for the music and sound effects to keep within the spirit of the game—whether it's space, driving, fishing, or sports. Get a good overall "feel" for the game. Find out which current games are similar in tone and investigate them. (This is where buying video games becomes a tax write-off, by the way!) See movies that fall in the genre to look for ideas and set the stage for your creative juices.

Sample rate, resolution, and stereo versus mono?

At some point, the development team will have done all of their homework to determine how much space will be allotted for graphics and sound. This will help decide how high the sound quality can be and what parameters the sounds will be created within. While you should always create sound effects in the highest sample rate and resolution possible, conversion to lower ones will affect sound quality and destroy any subtle nuances you may have added.

Will the sound effects be treated through any in-game software or hardware processors?

Driving games are an example where reverb is used quite frequently. Most of the sounds will have an "echoey" quality as the player drives through a tunnel. This is the kind of information you need to know as the sound designer. Additional processing by a game engine will determine to what extent certain sounds are processed beforehand. You could have a problem if the developer plans on applying reverb to an already processed sound. The developer should decide and communicate as soon as possible if there are plans for this type of processing. That way, you can be sure to not over-process any files on your end.

Are any ambient sounds needed?

Remember, we don't want the player distracted by silence. While this is more of a content-type question, the creation process is complicated and many details fall through the cracks. By asking this question, you may jog memories or present ideas the developer may not have thought about previously. The sound designer wouldn't know if they intend to play music instead unless he or she were also the composer. This alleviates a phone call to you late in the production for forgotten ambient sounds or music. If these types of sounds are required, determine if they need to be loopable or will playback as random background sounds. Looping sound effects get monotonous and delicate surgery may be necessary to make them less so.

Will certain effects have priority during playback?

There can be instances during gameplay—such as when a player unlocks a hidden door, stumbles into a trap, or is attacked by a villain—when one single sound punctuates the moment. These are the ones you want to represent the biggest bang for the buck. Because other sounds won't be drowning them out or playing over them, you won't have to make considerations for other effects being heard at the same time. These are the types of sounds you want to take the player's breath away. Have a developer point to them so you'll know which ones to pull out all the stops for.

Will there be any voice-overs or speech commands that need to be heard?

As the sound designer, you may be involved with voice recordings and can process them via EQ or volume to ensure they can be heard and understood. This process is similar to

having the vocals stand out in a song mix. If you're not involved directly, you can add that particular service to your list and offer it to the developer.

Is any dialog needed? Background sounds to accompany the narration?

Dialog fits into the sound recording category and generally, anyone capable of sound design can also record narration. If narratives are prerecorded, you can usually provide the service of transferring to digital files, maximizing the sound, cutting them to length, and adding any additional background or Foley sounds. If narratives are to be recorded, you need to know if you will be providing voice talent and budget accordingly. Developers may ask if you have experience directing narrative sessions, if not, the producer may fill that role. Maybe you will be the voice talent. If so, make sure there is appropriate compensation for your efforts.

Any special sound considerations?

Is the game intended to playback in Dolby Surround Sound or DTS, with studio-quality speakers or subwoofers? Are they planning to advertise the game's cinema-quality sound? Ensure your longevity in the business and seek out this tidbit of information so you can pull out all the stops. These higher-quality systems demand even better sounds since they have the tendency to reveal every nuance. Conversely, if the sound is being played back through something like the Wii Remote speaker, you won't need to waste time with subtleties that won't even be heard.

What platform are the sounds being created for?

This will suggest what type of playback system the consumer will use and the confines of the final sound effects. I mix to several playback systems, from "el cheapo" grocery store multimedia speakers to high-end studio monitors. The sound effects should work well with them all, but the main focus should be the system the majority will be using.

What type of music, if any, will play as the sounds are triggered?

This will give you an indication of other sonic activity happening during gameplay. If the music is a softer, orchestral score, the sound effects can be geared toward that mood and not sound obtrusive. If a rock soundtrack is to play, harsher sounds and careful manipulation of effects in the higher and lower frequencies will ensure they stand out. The sounds should all work together to enhance gameplay, not aggressively compete. The last thing we want to do is cause the player to turn the sound off.

Are any sound resources available to the sound designer for licensed materials?

The Simpsons, *Alien vs. Predator*, *Star Trek*, and *South Park* games, for example, are based on film or television properties produced under licensing agreements. If the publisher or developer has secured use of the actual sounds from these works, do you have them at your disposal to manipulate for the game or are you expected to recreate them from scratch? While you may not have an actual hand at creating them, you are equipped to edit and convert them to the proper formats and need to know if this will be part of your tasking.

Are any special file-naming conventions required for final delivery of sounds?

If the development team is overly organized or if they waited until late in production to bring you on board, they may already have file names programmed into the code. While renaming files is not a big deal, it may help cut down on confusion when delivery is made if they are already named appropriately. The developer should make this need clear or define an acceptable method. Large game projects demand organization and this will help keep everyone on the same page, especially when a sound the developer renamed needs to be tweaked. You definitely don't want to spend hours searching through your differently named files for the right one.

When can I expect a build of the game?

The sound designer needs to actually play the game they are creating sounds for, not just so they can have a little fun but to ensure the sound effects are a good match. Detailed descriptions, artwork, and graphics can really only go so far and it isn't until that moment you first see and hear everything working together do you know if it's right or not. For PC games, this is a relatively easy request. Console games are a little tougher unless you have a dev kit. In cases like this, consider obtaining one through official channels or as a loan from someone. The best-case scenario is having the ability to audition sounds within the game, either by simply replacing sounds in the games audio directory or creating your own build—such as you can using XACT and the Xbox 360 dev kit. Sending the sounds off to the developer and waiting for them to make a new build is the other alternative, which may take a little extra time but eventually accomplishes the same thing.

Determining Necessary Sounds

The process of determining which sound effects are needed can take on many forms. There are times when the sound designer will be presented with a long grocery list of sound effects to create. Other times the developer will present a prerelease copy of the game and let your experience decide. Either way, it's not a cut-and-dried process and will require much patience, flexibility, and teamwork. Tommy Tallarico describes his experience.

> I've been in the industry long enough to know you can have a sound effects list, on average of 200 to 250 sound effects per game—which will end up changing at least 400 times. Sound effects are most definitely postproduction. The developer will insist they need a series of sounds; let's say, of magic appearing, a loop, the magic sound traveling, and then one sound hitting a person and one hitting a wall. In reality, it's going to be one sound of the magic releasing and one generic hitting sound. So, where they've listed 12 sounds you'll do two.

Initially, a developer will want a sound effect for every action in the game—from simple button clicks on a menu screen to intricate character movements, weapons, environments, background ambience, and so on. Providing this type of feedback to a player is, in essence, the magic that draws them into the virtual world. They interact with the game and are rewarded with aural and visual cues adding to the feeling of being *inside* the game making

Composer at Work

Henning Nugel

Henning Nugel is a composer, sound designer, and owner of Nugel Bros. Music.

Describe your thought process for scoring/creating sound effects.

Before starting the scoring of a game, I usually sift again and again through the information—mainly concept material, sketches, plot summaries, et cetera—anything the developer gave me beforehand. It's important for me to get a basic idea and feel of the game and some kind of emotional picture. This is where I think about what style of music would fit the game best. Should it be purely orchestral or more contemporary with electronic and rock elements or a mixture of it all? Of course, quite often the developer has already decided upon a certain kind of music style he wants incorporated in his game and has perhaps already sent some demo cues taken from the various film scores which feature that particular style. So, in this case I usually skip thinking about the music style and turn towards the deeper analysis of the game structure, events, and characters—of course always depending on the amount of info material given by the developer.

If there are specific characters, locations, or objects the game centers around, I usually like to create motifs which are going to recur—often in modified or altered

versions—all through the game. I also like to create a specific main theme for the game's title screen, which might also feature some of the aforementioned motifs which are going to appear later on in the game. In some cases I might compose a specific "global" main theme which might pop up at certain key moments in the game. I've always found the concept of using themes and motifs very helpful to create a balanced and organic soundtrack.

After having decided on the preliminaries, I usually sit down at the piano—which is the instrument I use mainly to sketch out ideas and chord progressions. In some cases—let's say for a game with a more folk music sounding style—I might take the guitar, flute, or violin to develop ideas and motifs. There are also times that I come up with a nice percussion rhythm first from which I build the rest of the track.

I then normally start producing the main theme which will also serve as a first demo for the producer. In due course, the rest of the tracks will be finished and sometimes rewritten. In between there will be discussions with producers and developers about sound engines, formats, and other stuff that can have a certain influence on how the music will be integrated into the game.

Are there any particular secrets to your creativity?

No secrets, really. Creativity is based a lot on learning and experience, at least judging from my own situation. I grew up in a musical family, as my parents are and my grandparents were very good players on their particular instruments—mostly piano or violin. At an early age I began playing the recorder for a short time, followed by a classical piano education. After that, I played keyboards and guitars in several different bands with styles ranging from wave rock, gothic metal to electronic pop music. I now have an arsenal of instruments in my studio which I like to play and record for different projects; lots of them flutes and whistles, an Irish bouzouki, my grandfather's violin, and percussion stuff.

So when I compose music, it's all of these things together that are part of my creativity. The lessons I have learned by playing these instruments and listening to so much music, the bits of theory here and there, the experience in writing music and always comparing the creations with the stuff of my peers and masters, the failures and successes. This particular and personal combination of experience and intuition is the backbone of my creativity.

When do you find you are most creative?

I often get some good ideas when being outside the studio, mostly while doing my daily jogging laps. I also find myself "listening" to music in my head and shifting scraps of melodies back and forth while doing something completely different like gardening or house work. Yet most of the time I have to be creative while being in the studio and as there are certain time limitations to a project these are often the

(Continued)

times when I have to be productive regardless of the muses kissing me or not. Still, I'm happy to say that there are not many days where my creativity has let me down.

How did you find your way into the games industry?

Having received a classical piano education as well, it was my brother Ingo's greatest ambition to compose music for games. He sent out practically hundreds of demo CDs to game development companies. Eventually, in 1999, when he got his first commission he asked me as his brother to team up with him. Of course, being an enthusiastic gamer myself it took no time to convince me. We had found out before that we could work together very harmoniously and that the music did profit from our mutual contributions. We soon agreed on the company name Nugel Bros. Music.

things happen. Sound effects play a grand part in this design and at the onset, the developer will want to cover every possibility. As reality slowly creeps in, they will discover there isn't the need or the want of every sound effect on their list. The soundscape would become grossly overloaded, random access memory and processors would be jammed, and new programming issues would arise from the chaotic use of sound—not to mention the sanity of the game player as his or her ears are bombarded with too much information. It should become clear which sounds have priority and which ones aren't really needed. Unfortunately for you, this won't happen until late in the game. Try to have it narrowed down as soon as is practical.

Sound Effects Lists

If you stick with game sound design business long enough, you'll end up seeing practically every form of sound effects lists imaginable. I sometimes refer to these as "wish lists" because they often never get totally fulfilled. Most will look like the following.

Game: *Video Poker*	
Sound effects needed:	Intro sequence
	Background ambience
	Card shuffle
	Card turnover
	Card select
	Button push
	Win 1
	Win 2
	Jackpot

This example of a small video poker game isn't much on detail. It leaves a lot of questions to ask prior to beginning work. Without artwork accompanying this request, it's pretty much open to interpretation. I'd guess it would be a standard Vegas-style video poker machine with all the bells and whistles, a fairly straightforward project. But what if the producer had taken time to fill in some details? A better sound effects list would look like the following.

The game is *Jungle Adventure Video Poker*. This game will have the look and feel of a jungle with ancient ruins covered in overgrowth. The game screen will consist of an ancient temple with the five cards appearing in the entryway. These cards will be made of old stone tablets with early inhabitants on the face cards. Two large waterfalls will sit on either side of the temple, creating a relaxing cascade of water. This game should have a tranquil atmosphere, with an occasional tribal drum beat heard far in the background—nothing dangerous-sounding, just enough to add to the ambience.

Sound effects needed:		
Intro sequence	Plays as the opening screen appears. This will set the mood for the game. Play heavily on establishing the jungle theme while giving the flavor the player has stumbled across an ancient game.	4 seconds maximum
Background ambience	Starts after the intro sound effect stops. This looping effect should be of gentle cascading water to simulate the waterfalls, adding to the relaxed atmosphere.	2–3 seconds maximum
Random ambient sounds	(4) different effects. These sounds will be triggered at random as background ambience. Ideas such as bird calls, tribal drums, jungle noises, etc. would work well here.	No more than 2 seconds maximum for each
Card shuffle	This sound will indicate gameplay is ready to begin. Because we are not using conventional cards, some sort of primitive sound (perhaps wood hits or a short drum beat) would work well.	3 seconds maximum
Card turnover	This sound will play as cards are turned over. The sound of a heavy stone being moved or dropped may work nicely.	1.5 seconds in length
Card select	This sound will be heard as the player touches the card to indicate which ones they will hold. This should be a firm but neutral sort of sound because the player will hear it many times during the course of play.	1 second maximum
Button push	As the player presses any button on the game console, this sound will play. Similar to the card select sound, it should be neutral—but slightly more "fun" in nature.	1 second maximum

Win 1	This sound will be triggered for a small win. It should stay true to the jungle theme, giving positive reinforcement to the accomplishment without going overboard. A mixture of animal noises and jungle sounds might work well as an example.	3 seconds maximum
Win 2	Another notch in intensity up from Win 1. The player will have achieved a substantial win when this sound is triggered. Stay within the theme and make it positive.	3 seconds maximum
Jackpot	This sound will be heard after a royal flush. It should be loud, triumphant and attract a crowd when the player achieves this rare reward. Pull out all the stops and make this one really shine!	5 seconds maximum
Delivery format:	44 kHz, 16-bit, mono .*wav* files	
Delivery date:	1 week from the date of this request	

This is a good example of the type of sound effects list you would like to receive every time; the developer has put some time and thought into the game. Their vision is clear and concise and there is no doubt concerning the atmosphere they are trying to create. They have given you precise ideas yet have left enough room for your interpretation as a sound artist. If artwork is available, now would be the best time to ask for it. The visuals will give you extra ammunition to do your work.

More detailed lists may accompany a developer's request for sound effects, especially when animation and artwork are unavailable. Using the previous example, intricate timing may need to be matched.

Card turnover	This sound will play as cards are turned over. There should be a 0.5-second delay for the card select sound to fade before this one begins. Once the card is selected, the stone will rise slightly and then proceed to turn for 1.5 seconds before settling back down with a small cloud of dust. Key timing points to hit: 0.5 delay from trigger of sound before the sound plays; at 00:00.5 the stone rises; at 00:01.0 the tablet begins to turn over (lasting 1.5 seconds); at 00:02.0 the stone settles with a thump and a small cloud of dust appears from the edges.

This one small animation sequence is very intricate and the developer is trying hard to provide you with every detail. But, until the animation is complete it will be impossible to know for sure if all of this planning will pay off. More than likely, you'll have to redo this sound later—after the animation is finalized. The more details the better when doing sound effects, but effective sound design is best when completed postproduction.

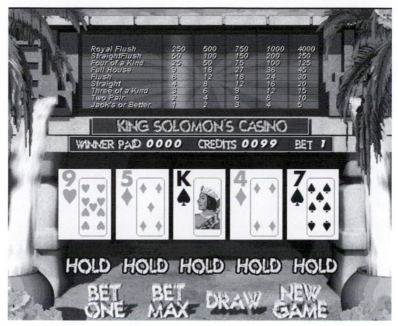

Royal Flush	250	500	750	1000	4000
StraightFlush	50	100	150	200	250
Four of a Kind	25	50	75	100	125
Full House	9	18	27	36	45
Flush	6	12	18	24	30
Straight	4	8	12	16	20
Three of a Kind	3	6	9	12	15
Two Pair	2	4	6	8	10
Jack's or Better	1	2	3	4	5

A picture of the game describes much more than words alone. This graphic shows us exactly what the game is about.

When receiving any type of list, I recommend going over it line by line with the producer in person or at least over the phone. Get as many details as possible for each item, discuss every possibility, and narrow down the field to a couple of solid ideas. I once had a ridiculously simple request for the sound of a small stone game piece being placed on a wooden game board. Without even talking to the developer about it, I proceeded to record a marble hitting several types of wood at varied intensities and sent back a dozen sounds. None of them were accepted. I tried again. Another dozen, another rejection. I asked which ones sounded close and received an answer. Another dozen, another rejection.

As you can imagine, this was starting to get a little bit frustrating and I picked up the phone. We talked. He performed the correct sound of a stone hitting his personal game board over the phone and within 10 minutes, I had the sound and pitch he wanted. After submitting more than 50 sounds, we were finally done. A simple task had become an ordeal because I didn't think it was important to talk to the producer. Now, it is another item on the checklist before I begin any work. Again, there is something to be said for actually communicating with other human beings on the team.

Alpha Game Versions and Other Visuals

In addition to receiving a list of requested sound effects, it is likely the developer will forward a rough version (or build) of the game. This isn't always possible, obviously, for

console or arcade games unless you have access to a development system—but it's a good option for a PC or web-based game if one is available. It's a perfect way for you to interact with the game, as a player would, and determine the best use of sound effects. These rough versions will be lacking many of the game options, levels, and artwork but will give a rudimentary idea of what the title is about.

While you may be tempted to have a little fun, pay close attention to the details and what you can do to improve upon the visuals. Your job is to enhance the work of the rest of the team, adding that perfect audio touch. If the developer is thinking ahead, they will even have made it easy for you to add your sound effects and test them in the game during your design phase. By having a separate sound folder under the game's root directory, it becomes a simple task of replacing and renaming files. All you have to do is fire up the game to get instant feedback.

For non DVD-ROM games, developers may provide movie files of various parts of the game, character movements, animations, menu screen shots, and so on. Some even go as far as to record someone playing—stopping at every menu screen, flipping to each option, meticulously going through every action currently in place. For sports games, I've even received tapes recorded at an actual game—not of the players but of the crowd reactions and various other happenings on the sidelines they wanted recreated. Their research gave me exactly what I needed without having to attend a game myself. Organized development teams will also provide a *track sheet*, which specifies times and events to pay close attention to as you watch. If you can't be there on-site, this is a great way to share information.

Whether you receive your visuals in the form of a video file or an alpha version of the game, it is also possible the developer will rely entirely on your ideas and experience to provide sound effects for the project. Basically, they will say, "Here's the game. Make some noise." The perception of free reign doesn't mean the developer won't have anything to say about the sounds. Far from it. They will provide specific guidance and will always be close by to share opinions. The company climate may be one where artists are given space to work without overbearing management types constantly peeking over their shoulder. This lack of micromanagement will be appreciated and let you create freely.

As you play the rough game, keep meticulous notes. Gather ideas for every place a sound effect should appear and any initial thoughts of what they should sound like. Develop your own comprehensive list. After some quality time, present these ideas to the developer for approval before starting any work. Some selling may be involved, explaining your reasoning for including some sounds and not others. This is basically the same process they would have followed in-house had they developed their own list, except they are choosing to have the "expert" make the determination.

There are no hard and fast rules governing the choice of sound effects. Understand how a particular sound will impact the game, the player, and the soundscape. A pinball game should have sounds happening almost constantly, even when the ball is at rest. This game is designed as a fast-action stress-relieving game. An intellectually stimulating game requiring concentration, such as chess, would require fewer sounds—maintaining a serene atmosphere instead. The overall theme of the game, level, or section will guide the final choices. At this point, there is no problem going overboard with suggestions.

It will make for some extra work on your part having to create sound effects that may end up getting dumped anyway, but for the sake of the game, it's worth the effort to go all out.

The other school of thought says that because you don't get paid any more or less (depending on the negotiated deal) why should you do more work? There is a fine line between doing enough work to "get by" and going beyond what is expected. Your judgment and experience will ultimately dictate your decisions, but personally, I like to leave a developer feeling I did my best and insist on always working hard and going the extra mile. If that means creating more sound effects than the game will use, then so be it. Working hard will pay off in the longevity of your career.

There will be times when no matter how hard you work, a developer will never be satisfied. You may think a sound effect is perfect, but they continually request reworks or new sounds altogether. Your best approach may be to pull out your best diplomatic skills and talk to them. Eventually, a sound will be good enough. Eventually, you'll have a case where any of a couple of dozen different sounds will work fine. Remember, though, if *none* of your efforts seems to satisfy them, it may be they are just plain difficult to work for. It happens.

Beta Testing

Another important practice of determining sound effects for a game project is the process of *play testing*, also referred to as *beta testing*. Game companies have different methods, depending on their resources. Larger ones have an in-house staff whose job it is to play the game, look for bugs, and suggest improvements or they farm out this type of work to outside firms that provide this specific service. Small game developers use themselves as the guinea pigs. The end result is the same: a list of needed sound effects from different people and personalities. The variety of opinions gives a good cross section. Typically, the developer will stick with the majority and put this plan into action.

Play testing is also a good test bed for valuable outside opinions of sounds that may already be in place. If sounds have been created earlier in production, it becomes difficult for the developer and sound designer to fairly judge what they've heard every day—their familiarity clouding the ability to gauge a sound's effectiveness. By letting play-testers express their unbiased thoughts, the game can only benefit. They aren't there to bolster anyone's ego, just lend their opinion. This final form of checks and balances will help get it one step closer to the marketplace. Ultimately, the game player will have the final say about your work—but it's too late then for any changes. This process is the next best thing.

As the sound designer, you can get involved in this step a little deeper by providing the quality assurance team with a checklist to consider—with questions such as "Does this sound fade correctly?" or "Do any of the sounds cut off abruptly?" or "Is more than one sound triggered for the same event?" These are usually things you look for when conducting your own run-through, but fresh ears will be able to pick up on things you may have grown deaf to after months of listening. Everyone working together will most definitely create a higher-quality product.

Tools of the Trade

Christos Panayides

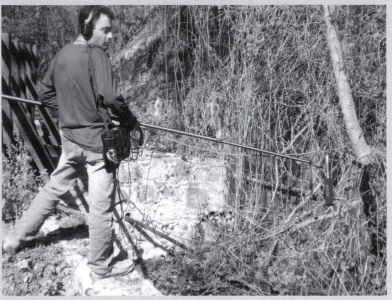

Christos Panayides is a sound designer, voice-over artist, and president of CP Audio Services.

Computer: PC Dual Core, 2024 MB RAM , 2 x 700 GB external disks 1 x 350 GB internal drive.

Software: Adobe Audition 1.5, Sound Forge 8.

Multi-track system: Tascam DP 01FX.

Monitors system: Sony, Tannoy, NS10.

Mixdown: PC Tascam DP 01FX.

Sound modules/VST instruments: Creative X-FI Platinum, M-Audio sound cards.

Microphones: Rode NTG2, Neumann TLM 103, Neumann U87, AT 2020, MXL 990, MXLV67I dual capsule, Behringer B-2, Shure 58.

Remote recording gear: HD Portable Tascam HD-P2, Sony Mini Disk with digital stereo mic.

Sound libraries: Sound Ideas Series 6000, 6000 ext 1, XV Series, Mix 4, Mix 8, Ear Candy (2, 4, 7, 10), Tommy Tallarico's SFX kit, Sound Ideas EFX (1 and 2), Digital Juice SFX (1-3), my own SFX library of more than 120,000 SFX. (You can listen to my new libraries online at www.shockwave-sound.com. Search by music or *sfx* box: Christos Panayides, and all of my libraries will be displayed.)

Creating Original Sound Effects That Fit

It's been said that those of us who create sound in the video games industry should take a lesson from Hollywood. Bobby Prince, of *DOOM* fame, presented the paper "Tricks and Techniques for Effective Sound Design" in 1996 at the Game Developers Conference. The paper listed common attributes of movies that had won Academy Awards for best sound effects. The listed commonalities offered a good jumping-off place when thinking about game sound design. These sounds:

- Focused the viewer's attention
- Were bigger than life
- Didn't get in the way of each other
- Placed the listener into another "reality"
- Always had some sort of background ambience in place as well

These basic ideas will work just as well in games.

Getting Organized

It's time to start making some noise! You've been hired, your list of questions has been answered, and we are off to a good start. If it hasn't happened already, the developer should assign one or two individuals to act as the liaison to the sound designer. Rather than getting mixed signals from numerous artists, programmers, and so on, the company can assign the producer, creative director, audio director, or audio lead the task of communicating the specs and signing off on the work. This ensures clear and effective communications, which I believe is *the* key to obtaining sounds which match the developer's vision.

If you are a locally based contractor, stop by the developer's work site, meet the rest of the creation team, and discuss the game's intention. It's a good fact-finding mission, become a mental sponge and absorb everything related to the project. If you are unavailable for a visit, be sure to obtain copies of artwork, storyboards, and any story text as has been mentioned. Now is not the time to have secrets. You are part of the team and on their side.

An alpha version of the game can be delivered with placeholder sound effects already in place. Library sounds or effects taken from other games can be inserted as a way of giving life to soundless artwork and to show you where new effects are needed. Placeholders can be words instead of sounds. In a game I worked on, the producer inserted words such as *click*, *bonk*, *explode*, and *shot*. As I played the game, every time I heard his voice, I created a sound to match the action. This worked out very well for me and the producer maintains an interesting psychological advantage—his booming voice having a subconscious effect on my psyche.

Creating a Sound Palette

The first order of business is to choose a sound "palette" and organize your computer or sampler files so they are easily called upon (as discussed in Chapter 8). I generally grab

sounds I've developed or recorded within the genre I will be creating, put them into their own directory, and draw upon them as the work progresses.

Create new directories and start throwing in any sound that might sound like it belongs in the game. If it's a cartoon-type game, grab your "cartoon" sounds. If it's a war game, grab all the gunshots and explosions you have lying around. You won't necessarily be using them all, or any of them. You are establishing a theme and a good starting point. You'll look to this folder for the bits and pieces to form the core of your game sounds.

Why bother with a palette? I too was resistant at first. Why spend extra time preparing to create when I could just jump right in? On a couple of larger games I tried just that, but found I was spending administrative time away from the actual design process looking for ideas anyway. By spending a couple of days at the beginning, I only had to break my creative spell a few times now that all of the sounds were handy. You would drive yourself crazy choosing from millions of possible sounds. By narrowing the possibilities down, you:

- Naturally build an aural theme based on the couple hundred or so sounds you've chosen
- Ensure that the game sounds have similar qualities because most are made from elements from your palette
- Will design better, more original sounds by limiting your choices and forcing yourself to be more creative

Try it both ways and I guarantee you'll always start the process by forming a sound palette, be it computer or sampler based. Jamey Scott, former sound designer and composer for the now defunct Presto Studios (developers of *Myst III*, *The Journeyman Project* series, *Gundam 0078*, and others), believes putting together the initial palette is the most important step—finding sounds that will mix well. He uses a sampler in his sound design process and for each game, develops an entirely new sound palette to keep them original. He finds using a sampler has many advantages over straight computer files and sound editors.

> Layering sounds internally in the sampler works very well for me, more so than doing it on a computer. That way, I can save my banks as a palette rather than having sources in various folders all over the computer. They are all looped, EQed, and noise filtered to my specifications. Plus returning to them to make any changes is a simpler task.

Effective Creation

Most sound guys believe video games are on the level of interactive movies and strive to grab the player's attention with their sounds. Nothing is more satisfying that having a player remark that the sounds are cool. Realistic Foley or "over-the-top" sounds can have that impact and we certainly aim to please.

Most sound designers are never satisfied with stock library sound effects. If they use them, they are manipulated several ways—pitch-shifted, filtered, layered, textured, reorganized, reversed, inverted, compressed, expanded, or cut into smaller elements—anything to give them a new life and make them less recognizable. Nothing is more annoying than hearing the same sound effect used on television, radio, and in other games. It happens more frequently than you probably notice.

I used to have a large German rottwieler who ran around the backyard barking at the sky whenever he heard a certain hawk screech sound. I have a Hollywood Edge sample disk I used to enjoy playing for the neighbors and friends and we would all laugh at the silly dog and his antics. The exact sound is in dozens of TV shows, commercials, and video games and, unfortunately, the poor dog ran barking into the backyard several times a week without my help. This experience opened my eyes to how incredibly over-used some library sounds really are. Our job is to change that.

As an example, let's talk about the creation of a different sound effect—using one from a current project. It is a real time strategy game within the "space" genre where units are maneuvered in formation to battle against other players. It is a PC game with final sounds to be delivered as 22 kHz, 16-bit *.wav* files. This particular sound is a "shield" sound which activates when the unit is fired upon.

I wanted the shield to have an electric quality to it—a controlled surge of energy that might sound as if it was absorbing or deflecting a shot from a laser weapon. I wanted it to be original so I stayed away from the stock library effects and turned instead toward one of my synthesizers for inspiration.

I ultimately settled on a patch (similar to the keyboard sound in Van Halen's "Jump") and recorded about 4 seconds of a three-note chord. I saved it into my audio editing program, Sound Forge, as 44.1 kHz, 16-bit, stereo. Experimenting with a few different effects processors, I opted for a nice Doppler effect in another program (Goldwave). I edited an existing effects patch to give it a quick 1-second Doppler increase with about 3 seconds of Doppler decrease. Back in Sound Forge, I pulled up a radio static sound file, ran it through a 1-Hz stereo flange effect, and equalized it to increase the high-frequency range. I then cut that file to 4 seconds to match the manipulated keyboard sound and mixed the two sounds, keeping the static barely perceptible. I gave the new mixed file about a 1-second fade-in and faded out the last 2 seconds with a linear fade. Now it was beginning to sound like something. I normalized the file to maximize the sound, adjusted for any abnormal level peaks, and finally saved the new file as *shield.wav.*

Later, the producer wanted a dull, metallic clank mixed in to give the player some distinction between a shield hit and a hit to the unit's space suit. I pulled up a nice clank sound, EQed out most of the highs, and mixed to the shield file. All is well; producer happy.

To convert down to 22 kHz is a simple task. The resample feature in Sound Forge does the trick. Because some of the higher-frequency band gets lost in the conversion, I usually add some EQ to compensate—just a slight amount gives it the right touch. Another check on the levels and now the effect is ready for the game. Total amount of work on this one sound effect: 2 hours, 15 minutes. A lot of manipulation? You bet! You could do this same edit using a multi-track editor.

Creative Forces

Jon Holland, a former game sound designer turned full-time composer with many game credits, reflects upon a past project.

> Combining unexpected sound sources with recognizable sounds or timbres will yield truly original sound effects. I remember a few years ago, on *Vectorman*, I combined the sound of detuned dinosaur steps with the crack of a bullwhip. Then I layered that

with a regular thunder sound to get a lashing thunderstorm feel. Even though it was a Sega Genesis game, the sound was very effective and had definition that cut right through. You have to be creative and try things even if you can't see an obvious correlation immediately. Experimentation should be paramount if you want sounds that are difficult to duplicate.

Jamey Scott has many tricks up his sleeve, too. For a previous Presto project, the game had many machines that required their own personality and uniqueness. He normally starts with stock engine or mechanical sounds but runs them through a fast LFO filter, warbling the pitch and then mixing in what he calls "clunketty-clunk" sounds. For machines that are primitive, he ensures they sound rickety and unpolished on purpose. He will also start completely from scratch on some, preferring to mix low-frequency rumbling sounds, mid-range mechanical noises and on top some high-frequency whining. He tends to shoot for a full-frequency spectrum sound—massive and very full.

For odd creature sounds, Jamey creates something like an exaggerated insect noise—a high-pitched screech but with a very low-frequency sound to make it memorable. He's been known to use his own mouth noises, or to grab someone walking by in the hall, as interesting touches. After tweaking and layering, you would never know their origin.

Joey Kuras makes good use of the world around him for his sounds. Sometimes there just isn't a particular sound in any of the libraries he uses, so he ventures out with his portable rig and microphone. A previous "Beavis and Butthead" game required the sound of large gymnasium bleachers opening. So, he went to a local school and had the maintenance crew open them while he recorded. Instant sound effect.

The boxing game *Knockout* used a lot of embellished punching sounds, occasionally punctuated by the sounds of a breaking jawbone. Joey made use of many stalks of celery to add just the right touch of crunching and snapping.

Test Drive 5 and *6* required over-the-top engine and car sounds. His trek led him and his microphone to southern California's Marconi Auto Museum to record some track-ready muscle cars firsthand. Play these games and you'll agree that the effort was worth it.

Several games' need for sounds of grenades bouncing led him to a military surplus store for dummy grenades. A quiet afternoon of grenade tossing produced some nice effects.

Assaf Gavron and Oosh Adar, sound designers in Israel who worked on Electronic Art's (EA) flight sim, *USAF*, relayed this interesting method of effects creation. Oosh describes this particular session.

In flight simulations, there is a lot of mid-frequency activity in the cockpit. Most of those sounds are being processed by filters and a bit of distortion. I had to create a "G" effect (heavy breathing in an "over G" situation) that needed to sound like you were hearing yourself over the headphones—the sound being in the same mid-range area. I didn't want to repeat the same software treatment as in the radio connection because it's a bit different and it's better to avoid a crunchy mid-range overload. I decided to record it live.

I made a heavy-breathing session and listened to it. It sounded oddly like phone sex. Every detail of the breathing was so clear and it was not even sexy, it was dirty, full of "aahhcchhs" and "fifs." Staying away from the mic and the other usual tricks didn't work either, it was too dynamic no matter what I tried. So, I closed the mic in the closet to imitate claustrophobic air pressure ambience and I brought a long plastic

tube (one and a half meters) and connected it to the mic. The plastic tube acts as a natural band pass that creates the illusion of distance. Now, if someone was looking through the window it looked dirty but sounded perfect. The breathing was far away but still close and it sounded filtered but not software generated. The "resample" to 22.5, plus some fine-tuning tricks, made it sound right.

Experimentation, experience, and the willingness to leave the studio once in awhile can lead to some fantastic sound creations. These guys are at the top and only climbing higher. I can't wait to hear what they have coming up next.

Presenting the Final Work

Now that you've spent a great deal of time creating these fantastical sound effects, it's time to make delivery to the client. It is not just a simple matter of sending a CD or e-mailing the sounds and saying, "Here they are!" It can be done that way, but usually there is a little more to it. You are making a presentation and selling them to the client.

When presenting finished effects to the producers, I usually send more sounds than needed. I work up several effects, letting them in on the process and giving them the chance to choose the ones that match their vision. Some have minor subtle differences, changes in length, layering, or effects processor settings. Others use completely different angles to get the same point across. Some are "happy accidents" I'll throw in that might work from a completely different angle. These serve two purposes: to give an idea so far out that it might just work or to make the others sound that much more right for the game.

The producer will more likely be happiest with their choice, believing in it enough to sell it to the rest of the team. If you had made the choice for them, it would be like swimming upstream against a strong current. The psychological trick is for them to make the choice, take the responsibility, and do the rest of the legwork. I usually have my favorite, and if I believe in it enough, I'll say so to help slant the decision. But, most often it's their choice entirely.

Also occasionally included (if it isn't already obvious by the file names) is some sort of documentation that describes what each sound effect is for. It will highlight which sounds are for specific actions and which less critical ones could be mixed and matched, such as button presses. This key will save some headache for everyone involved and score points for the organized sound designer.

Other sound designers have their own unique delivery methods that help them stand out from the crowd. Darryl Duncan, of GameBeat Studios, has a fresh idea that works for him.

Aside from delivering good work, we feel that our package and delivery method must give attention to detail. We find that it truly is the little things that the clients appreciate. A small example of that is this: when we deliver music or sound effects, we create a detailed Excel spreadsheet that allows the client to listen to all of the delivered assets right from the Excel document. They simply click on the music/ sfx title and the music or sfx plays right from within that document, as they read a detailed description of the version they are hearing, what it is meant for in the game, etc. We have found that this is one of the simple things that our clients really appreciate and has even led to other projects from word of mouth about this simple service feature we offer.

Conclusion

Have you ever watched a B movie and actually liked the sound effects? Occasionally, the amateurish production has some charm to it, but for the most part they are not that great. Would you buy a B video game or even set out to make one? Of course not! With all of the competition for shelf space, we set out from day 1 to make a product that will be profitable and perhaps even win us a few accolades from our colleagues in the process.

There are no hard and fast rules, no secret formulas and no prescribed methods for creating the consummate assemblage of sound effects for a game. It takes fluid communication and a firm vision from the development team coupled with a sound designer who shows no bounds to their creativity and patience. The tips and tricks discussed in this book should give a solid foundation for you to build upon and thrive in this gratifying industry. Knock 'em dead.

For further reading on game sound design, see *Tricks and Techniques for Sound Effects Design* by Bobby Prince, *http://www.gamasutra.com/features/sound_and_music/081997/ sound_effect.htm*.

Sound Designer at Work

David Chan

David Chan is a sound designer, audio producer, and owner of Giant Sandbox Productions.

Describe your thought process for creating sound effects.

Here is a breakdown of the overall process I usually go through.

- Read the story and look at the art for the game.

- Make lists of all the things you know will need sound effects.

- Solicit information from designers and artists about what they want for sounds.

- Capture animations from creatures, spells, et cetera onto video to be used in a sound editor for the creation and synching of sound effects.

- Start creating content, usually on an as-needed basis. For instance, you might want to make the sound for all the creatures that are fully modeled, textured, and animated first so they can be put into the game and tested as soon as possible.

- Make a few more passes to see what might have been missed or added, as this happens sometimes.

- Take the remaining time you have, which is usually about half of what you'd like, and do a final polishing.

As for the creation of each individual sound, it really depends on what is needed. I look through the libraries I have put together over the years, which are a combination of commercial products and my own source material that I have gathered over time. Some sounds will require new source material that you don't have in your library. For that, I have my own mics and space to record whatever I need. I also try to carry around my portable Zoom H4 recorder to capture "found sounds" that I run across day to day. You never know what might come in handy down the road.

I also try to think of sounds in terms of layers or elements. I can often arrive at a sound that is made of parts that have nothing to do with the object you are designing for. For example, in the game *Prey* the designers wanted a very organic sound for the weapons. One of the rifle sounds I made combined clicks from an antique camera with squishy gelatin sounds and a modern servo motor. On the surface that comes across as kind of bizarre, but in combination it just worked. So, never be afraid to think of grabbing bits of sounds from all over the place and mixing them together. Like a good recipe, every part works to enhance all the others.

I usually try not to use material straight out of a commercial library. If I find that an element from a commercial suits my needs I like to tweak it and make the sound mine. Sometimes you may not have a choice if the designer wants a very specific sound or if there is something that you know you most likely would not be able to capture on your own, like World War II artillery or an extremely exotic animal. Overall, in the end it's not the source that matters in my opinion, it's how the final sound turns out.

Are there any particular secrets to your creativity?

Don't force creativity. If you are stumped on something, move on to the next task and come back with a fresh perspective. I learned the hard way after spending hours hitting my head against the wall trying to make certain sounds that creativity often

(Continued)

comes to you when you least expect it. In fact I have on many occasions stopped working on a sound, moved on to another, only to find that in the middle of working on the next sound I find exactly what I needed previously. Try not to put up road-blocks for yourself by adding stress to what can sometimes be a stressful process to begin with.

When do you find you are most creative?

Usually, I start later in the day. It takes me awhile to get my mental motor running and I tend to fire on all cylinders later in the evening. That being said, I also find it's important to keep your creative batteries charged by being rested and making sure you balance your activities throughout the day. Taking fifteen- to thirty-minute breaks as you are working to stretch your legs and do something unrelated to work really helps, too.

Any specific "lessons learned" on a project that could be shared?

Pace yourself. Ear fatigue can set in after a few hours, even if you take breaks. When sounds all start to be noise or you can't seem to judge if something is working, there is a good chance you are experiencing ear fatigue. Take a break and come back later. The other important lesson I have learned is to talk to as many people on a project as possible. Learn the language that people use to describe sounds. Audio is so visceral that many people talk about it on a very primitive level and not in technical audio terms. Find out what they mean when they say they want a "whoosh," because it may not be what you think a "whoosh" is. Don't be afraid to make funny sounds in front of people when discussing sound design because this might encourage them to do the same and in the end it could help you get to the sound they want quicker.

Do you have any negotiation techniques or stories others could learn from?

I think it's important to never undervalue your work. Don't be afraid to walk away from a project if you think it's not worth your while. It's a hard thing to do if you are a contractor, but it's important for your own well-being and your reputation. It's no fun to work on a project where every day you feel like you compromised too much.

Do you have any development stories that served as a good "lesson learned" or something that can be avoidable in future projects?

Close to the end of *Neverwinter Nights* I finally had an additional person in the audio department to help out. Up to that point, I had been the only audio person at BioWare. I *was* the audio department. Having another person turned out to be a good thing because the number of products in various stages had increased from two to three. At one point, the audio department was working on *Neverwinter Nights*, *Shadows of Undrentide*, *Hordes of the Underdark*, *Knights of the Old Republic*, and *Jade Empire*. That's not to say that all projects were demanding full-time audio resources. They were all in various stages of production and therefore each project had different needs.

When the demands from NWN and the first expansion died down, I jumped straight into *KotOR*. It was the first time I was put in the position of audio producer—in an official sense, anyway. I had been performing audio production tasks all along to varying degrees over the years. It's not uncommon for companies to expect audio folk to be "jack of all trades"–types of people. In fact, a few people at BioWare over the years gave me odd looks when I told them I wasn't a musician. I dabble in music but have always felt more comfortable on the side of the recording console with all the flashing lights and buttons.

Putting sound into a game is done differently at every company. At BioWare, the sound department was responsible for everything sound except programming. With programming, we worked together with coders to put in the functions we needed to make sure the game sounded as good as possible on both platforms with as little extra work down the road as possible. All these diverse tasks require a lot of juggling and the ability to shift from a production mindset to a creative frame of mind and on to technical thinking as the tasks present themselves.

KotOR was an intimidating project, to say the least. Not only did I feel the pressure to live up to the expectations of *Star Wars* fans but also the quality bar set by the awesome audio staff at Lucas Arts. Fortunately, we had a secret weapon and that was Bay Area Sound. It's a company made up of former Lucas Arts employees, so they knew the drill when it came to *Star Wars*. The amount of dialog in that game is staggering. I think the unique dialog line count was around twelve thousand lines. That doesn't include the combat sounds and all of the alien dialog. I tip my hat to Lucas Arts sound department for all the work they did.

If you have played *KotOR* and notice how cool the Selkath sound then you are noticing Duff Studio's outstanding work. In my opinion, they do some of the best VO processing in the business—and were called in to help out with *KotOR*. Unfortunately, the audio department at BioWare had stayed at two people (it had briefly been bumped up to three, but it didn't quite work out). It was to expand to three, but as many in the industry know, it's difficult to find game audio people that are good at technical and creative tasks and don't have a problem with coming to live in the upper, upper tundra known as Edmonton. So, it was up to Steve Sim and me to get to the finish line with *Hordes* and *Jade Empire* nipping at our heels.

The shear amount of files for a game like *KotOR* can be overwhelming. In film work, you have production sound if you want to use it. If someone walks down a hallway, opens a door, and starts talking to a person, it just happens. Not saying that sound effects aren't added after the fact in motion pictures, but there is always production sound to use as a base or as a complete audio track. In video games, and animation as well, you are dealing with a completely artificial world. Everything that should make noise has to be placed by someone. In fact, it's often the case that people don't even notice the sound unless it's left out. Footsteps are a perfect example. If characters don't make footstep sounds people will notice something is wrong even if they can't put their finger on what it is.

(Continued)

The ultimate irony with *KotOR* was when most reviewers talked about the sound they assumed that it was all stock from the "Skywalker" libraries. Now don't get me wrong, to have someone mistake something I did for something out of Skywalker Sound is a compliment of the highest order. Still, it's a bit disheartening that people automatically assumed all the sound effects were just copied from a library. When, in actuality, a lot of people had put many months into making a unique slice of the *Star Wars* universe. All said, there was actually very little content from the movies in *KotOR*—but it sure fooled a lot of people.

In the end, we were able to put together a soundscape that seemed to make most people happy and got reviewed well. You never know how people are going to react to work that you've done. When you have spent two years on a project, you can lose your objectivity. You can no longer tell if it is the best work you have ever done or the worst. So, when the game goes gold, hits the shelves, and comes back with good reviews the most you can do is smile and think that it all worked out in the end.

The important lessons that I took away from that experience was firstly you need to have an audio advocate at any game company—someone that keeps the audio agenda on an equal footing with other parts of the project, someone that makes sure staffing is adequate and that the lines of communication stay open all through the process because change can happen literally overnight in this business.

Do you have any interesting sound design creation techniques that resulted in a notable sound effect?

Well, I have a little mutt dog that my wife and I love very much. Unfortunately for her she got a bit of a throat infection a few years back. After some antibiotics she was good as new, but her bark changed to this weird gravely growl. I've since used it in creature sounds because I have never heard another dog sound like that and it works well for small, snarly creatures.

Any funny stories?

One night on *MDK2* we were at work at three a.m. Everyone was tired, burnt, and getting a little grumpy. Now, if you have ever played the game you know that the Dr. Hawkins character works by combining found objects into tools or weapons. There was a line that said something like, "Well, I have the fishbowl and the blow dryer, now where's that monkey." I had an outtake from the voice actor that said, "Well, I have the blow dryer and the KY Jelly, now where's that monkey?" I knew that there was one more build to be done before we all went home for the night, so I slipped the outtake into the games resources. My office was a few doors down from the main area where we all gathered, so I just waited because I knew they were testing the area where that dialog would be triggered. Sure enough, about fifteen minutes later I heard a roar of laughter coming from the common area. Apparently, everyone really needed a good laugh to blow off some of the stress and I was glad to provide it.

Why did you leave BioWare?

A lot of people have asked me about that and what it was like working there. After nearly six years and six projects, I decided it was time for a change of venue. It's not that I didn't enjoy my time spent at BioWare; it's just that it's difficult to sustain a workload that triple-A titles require for such a long period with long hours and not experience some burnout—which is precisely what I felt coming down the road for me. So, I decided to venture out on my own. I am still quite involved with game audio and intend to keep it that way. It's a passion of mine and I don't see that changing anytime soon.

How did you find your way into the games industry?

I have always had an interest in computers and audio. One of the first major purchases I made as a teenager was a Roland synthesizer so that I could experiment with sound and music. After high school and some university, I decided to take an audio production course to further my interests. Using that knowledge, I created a job for myself at a local computer store by convincing the store owner to partner with a local music shop. After many years working and finally managing that computer store, I decided to expand my horizons and obtain my Microsoft certification.

At the same time I was taking my certification I helped start a LAN event known as Fragapalooza. I invited the owners of BioWare (then a relative unknown) to demonstrate *Baldur's Gate* at the event. Ray Muzyka was impressed with the job I had done for Fragapalooza, so when I finally got my Microsoft certification I ended up working at BioWare in the systems department. The owners were aware of my audio background and offered me a chance to make placeholder sounds for *MDK2*. They liked the sounds so much, they wanted me to do the whole game. The rest, as they say, is history. Since then, I have been an active member in the Game Audio Network Guild since its launch in 2002 and am on the Advisory Board as well. At the Game Developers Conference I was the lead speaker of a panel on "Audio Asset Management for Large Projects."

CHAPTER TEN

Blending the Total Soundscape

An assault of unorganized game is nothing but noise, pure and simple. With an onslaught of voice-overs, music, and sound effects, a game can quickly become a chaotic nightmare—forcing the player to run away screaming or to simply turn off the racket with a flip of a switch, neither of which are good for the games business. The development team has the difficult task of finding the perfect balance, relying heavily upon the audio content providers. Sometimes this cohesive blend materializes entirely by accident; other times, after months of planning and perfecting. I've heard people say they would take luck over skill any day, but in the billion-dollar games industry, success rides squarely on abilities—not chance.

Have you ever walked into an arcade and been blasted by sound as the door was opened? The same racket happens on a tradeshow floor, where each booth has a noise-making machine determined to attract attention. That is what a really bad game sounds like—the kind of mess where so much is happening at once you have no idea of what's going on. And, believe it or not, there are games out there where sound overpowers the experience instead of enhancing it.

Some games attempt to combat this lack of foresight and experience by giving the player the "power" to adjust all of the audio elements, making them responsible for their own experience. If it doesn't work, the blame can be placed on the consumer—not the developer. Of course, there are some advantages to this feature—but the point is, we *can* make a difference and can affect the success of the soundscape *ourselves*. By simplifying the game experience and mixing the sound elements ahead of time, the player can spend their time playing and enjoying a game instead of adjusting parameters.

Can music, sound effects, and narratives exist simultaneously in the soundscape without negatively impacting the game experience? Yes, they can, but a certain amount of care needs to be taken to ensure they do. When working on a new piece, a composer's initial mindset should be to create music able to stand on its own. The majority will add several layers of melodies, counter-melodies, and percussion tracks to keep the music interesting and alive. After all, this is what musicians and composers do.

There are times when this type of music works well in games—in intro sequences, cinematics, menu screens, and other standalone cues where no real thought from the player is required. Music intended as background music, though, has to be just that—in the background. Layers tend to interfere with other audio in this type of situation. I know you want to make some great music to showcase your talent and sell lots of soundtrack albums, but busy, complex scores do nothing for the overall soundscape

of the game. If music is the only audio playing at a particular time, you are home free; knock yourself out, make the best music you can. But if your music will be sharing real estate with other sounds, lay back a little and make some room for the rest of the audio. Save your elaborate performances for the soundtrack remix release and let your professionalism shine through for the sake of the product.

Sound effects require a bit of finesse. During gameplay, they must take priority over the music to ensure the player receives the needed feedback. A driving game may be the exception, where music creates the pulse and rhythm. For something as simple as a menu screen, a jamming techno cue could be playing—pumping up the player for the experience they are about to receive. The player clicks on a button, and except for the visual cue of seeing the button depress and the screen changing, gets no other feedback. There may have been a sound effect associated with the button depress but it was either too low in volume or lost in the music.

Some choices need to be made. Do you turn down the volume of the music? Do you increase the volume of the sound effect? Do you dump the sound effect? Another alternative, and probably a better solution, is to create a sound which will actually stand out from the music or to create a hole in the frequency spectrum of the music. Either way, this will enable the sound effect, whether subtle or not, to be heard. By utilizing opposing frequencies, or ones that are not overloaded by other audio, the game can be experienced as the developer intended—not sacrificed to chance.

As an example, a bass-heavy rock track will definitely not leave room for any other low-frequency activity in the soundscape. Sound effects, such as hits or explosions, may barely be heard or could overload an audio playback system—causing distortion. Instead, consider keeping those sound effects in the mid to upper ranges or remix the music with less bass. Look for the hole in the frequency spectrum and jump into it. Music with a lot of high-frequency percussive activity won't leave much room for small effects that go "click." Consider making them "thumps" instead. By maintaining awareness of other audio in the game, you can create practical sound effects which work the first time.

Voice-overs, narratives, and speech require the same considerations as the other sonic activity. Rules that apply to FM radio jocks won't work in this business. They get away with full-bodied vocalizations that saturate the entire frequency spectrum because they can. They want you to pay attention—they want that booming voice to grab hold or else they would be looking for another line of work. If other audio is present when they speak, a technique called *ducking* is used to decrease its volume and keep the voice on top. This type of speech unrealistically becomes what producers expect of their narrative recordings as well. They want them full, with lots of low and high end—making them bigger than life. But they do not realize the impact it can have on the rest of the audio. When an overly full narrative is mixed with music and sound effects, it becomes mud. By narrowing the spectrum the voice uses and developing a good mix with EQ, the words will be easily heard and understood—and the rest of the audio can be heard clearly, too.

A common mistake inexperienced musicians and music producers make when doing final mixes of a song is to solo each instrument and individually tweak them to perfection. When all of the instruments are brought together later, the resulting competition for space creates a mix which is generally muddy and blurred. Another few hours of adjustments will follow to persuade them all to sound good together. Most of the time, if you were to solo one of the instruments, like a piano or guitar, it will sound thin and unimpressive—nothing like what you would expect it to. But what ultimately matters, for the good of the song's overall production and when doing *any* audio for video games, is that everything

blends. By allowing each instrument to work within a narrowed spectrum of the frequency band, they can all be heard clearly and as intended in the compilation. The misconception that all of the elements must sound perfect on their own needs to be overcome and we sound guys and gals must ensure that developers understand this concept and stick to it.

Consider a wailing sax, hammering piano, or guitar riff competing with a narrative as an example. All of these elements have primary occupation in the middle range of human hearing. If they just happen to all be playing at once, you wouldn't be able to understand a word a character is saying. To put it more musically, you never hear a vocalist singing during an instrument solo—right? Same idea. Saturated soundscapes mean degraded effectiveness, with the only options being to turn it down or turn it off. We can prevent either from ever happening.

Audio Director at Work

Alexander Brandon

Alexander Brandon is Audio Director at Obsidian Entertainment.

Describe your thought process for scoring and creating sound effects.

When scoring I try to equate an emotional state to music. How does a particular scene make me feel? This then leads to a lot: instrumentation, tempo, and, of course, composition. Sometimes I will go in another direction, sometimes even in an opposite direction. For example, one of the themes in the sci-fi strategy game *Vasteel* is cocktail jazz. Pretty contrary to what people traditionally think. Imagination plays an important role, as well as experimentation. Often just playing around will yield great results that can be applied to a game I've never seen.

For sound design, similar principles are involved. You take what people are used to hearing in reality and you want to enhance that. For example, Ben Burtt used many different unusual recordings to achieve very impressive sounds in *Star Wars*. His imagination really is what set the stage for that. Who would've thought to use edited elephant screams for a TIE fighter?

(Continued)

I'll throw in VO here, too. Voice-over is markedly different. It really relies on a person's natural speaking voice as a base, and in that way people are your instruments—your sound asset palette, so to speak. In that way, you need to build a library of samples—and when you have the right sample for the job you pick up the phone and call them or their agent rather than dialing in a patch on your keyboard. There are *many* factors that go into VO that are important that don't apply to sound or music. And they're harder to tweak. In this way, voice may be the toughest of all the audio disciplines to do effectively in a game.

Are there any particular secrets to your creativity?

Imagination, but having a good system you can use to create sounds and music quickly is very important. Avoid picking up a magazine and drooling every month (with apologies to my favorite magazines like *Keyboard*, *EM*, and *Mix*). Reading about what other people do can yield very cool new ways to work, but it can also overwhelm. These days there's so much gear and technique that you never actually produce anything! You just worry about perfecting one thing or end up just twiddling knobs. Try to avoid getting stuck in this rut.

When do you find you are most creative?

At night, without question. The later it is, the more effective I am. Weird, but I always even drew pictures to look more realistic and cooler later at night than earlier in the day. I'm sure there's some sort of phenomenon associated with that. Being inspired also helps my creativity, also. If a piece of music blows me away, sometimes I get the urge to sit down and damn well do something better. It rarely happens, but when it does—well, it's a pretty great feeling.

Any specific "lessons learned" on a project you could share?

Talk to people. Ask questions. Be polite. Don't be afraid to sound dumb, just be nice and if the person who is talking to you is an asshole, just leave them and talk to someone else. Life's too short to be worried about what other people think. Do what you need to do. If what you're doing is wrong and you know it, admit to it. Don't defend a mistake.

Do you have any contract stories others could learn from?

Well, it's funny. I was on the phone with Tim Sweeney and James Schmalz, who were both working on *Unreal* at the time. I was set to do the music and sound effects. My royalty was the third or fourth highest of any individual on the rest of the team, and James and Tim wanted to lower it a bit by taking sound effects off my plate and giving them to David Ewing—who was working with James in Canada. In hindsight, I should have held on and provided a few hundred sound effects the next day—which I could have done with some blood and sweat—but I acquiesced. After talking a bit more, the notion of a salary came up. "Well, I'm not actually making money now, so I need at least this royalty to keep working," I told them. James instantly sealed his own doom by saying, "We will *gladly* give you a salary right

now! Name your price!" It was clear that no salary would have matched the royalty I had. I made the right decision. Royalties are better.

Times have changed, though. I take a salary and all of my colleagues at Obsidian do as well. Then, union folk doing voice-over want royalties. So do musicians. Sorry, chaps. I don't disagree royalties are worthwhile, but until we *all* have them, none of us do. We're a team.

Do you have any advice to help lay a solid groundwork for the audio content creator?

Don't ever let someone tell you it "isn't the right time" for you to be involved with a project, especially if it is already in production. The only reason someone says that is because they just don't feel like dealing with it, or that they don't want to pay you right away. You need to start communicating with folks as soon as possible about audio, any aspect of it, as much as you can. The more you know, the better you'll do at creating high-quality assets.

Do you have any interesting music or sound design creation techniques that resulted in a notable piece of music or sound effect?

Predator inspired me to create a pretty complex chain gun sound for the *Unreal Level Pack*. I layered and layered and layered numerous rifle sounds, and hand tweaked that sound until it was perfect. Cliff Blezskinski told me to add the whine pitch to the chain gun (another *Predator* rip), and I did that, too. I played the level pack for the first time not too long ago. That sound still kicks ass.

Another Cliff story is that he wanted a song that sounded like a combination of Carmina Burana and White Zombie for *Unreal*. To this day I have no idea how I would have written a song like that, or what he heard in his twisted skull. However, a potential project came along where Cliff wanted a piece of music that sounded like the trailer to the movie *Dark City*, which utterly rocks. I wish I still had that song.

Any horrible endings to a project others could learn from?

Some projects ended by being cut short because they had to make a deadline. In a publicly traded company, a lot of games may get shoved out the door because some executives might have a board and stockholders to answer to. But the problem with this is that your games suffer greatly. Not one game I worked on at a company was ever any good for this very reason and it was because a project had to be shoved out too early. I'm all for saving money. But, if a project doesn't look like it will do well, call it a failure, cancel it, and write it off. Make layoffs, get called names. Just don't push a bad product out the door. Ever.

A company did lay me off because of budget and personality issues once. But I learned it wasn't so much my personality as the other person's. Can't name names really. But it happens.

(Continued)

> *How did you find your way into the games industry?*
>
> I took a demo a friend of mine did and submitted it to Epic Megagames (now Epic Games) and Apogee (now 3D Realms). Apogee didn't take it. Epic did, and published it. The game was *Tyrian*. For all the smack talk I'll give people about Cliff, he's the one who convinced Epic that our game reminded him of *Zanac* and that they should publish it. I'll be forever grateful for his wisdom.

Maintaining Consistency in Production With Audio Elements

Fitting together audio elements like puzzle pieces is just one of the many tricks to effectively master game sound. Maintaining consistency is another issue an audio content provider must apply. All audio requires the same character; that is, the element which cements it to this, and only this, particular game experience. Having an effect distract the player during gameplay because it sounds out of place or like it's from another game breaks the magic. Even that one innocent little sound effect thrown in the game as an afterthought has the ability to screw up an entire production. A little melodramatic, I know, but you know what I mean.

The easiest way for a developer to ensure consistency is to use the same composer, the same sound designer, and the same voice actors for every aspect of the game. This will provide the same basic flavor by using the same recipe ingredients, thus providing overall uniformity. Each artist has his or her own style and equipment which contribute to his or her "sound," and by utilizing the same providers, this will keep a game's audio sounding cohesive.

In the event last-minute audio is needed and the original content provider isn't available, extreme care should be taken by the developer. Ensure the stand-in audio provider has other music or sound effects from the game to measure their new offerings against. If possible, find out what programs, settings, and effects processing were used during the production—to at least increase the chance of similarities or maybe even get the audio folks in touch with each other so they can talk about it and share ideas. It's no secret that if I ran all of my sound effects through some acoustic processor to add ambiance, you would be able to hear it. The setting I used is the unknown, and unless it's a company secret, I shouldn't have a problem sharing it with someone else involved in the project. All they have to do is ask.

Another way for an audio content provider to ensure consistency is to devote time to only one game for the duration of the project. If a developer is particularly concerned about this, they will more than likely ask prospective composers and sound designers up front whether they can commit solely to one project at a time. Often, this focus alone will obtain the desired consistency.

Another good rule of thumb is to not separate working sessions with considerable gaps of time. For instance, Joey Kuras had to revisit sounds he created for *Tomorrow Never Dies* many months after he had completed the initial sound list. After designing new sounds, the old ones didn't quite sound like they belonged. He ended up spending extra time EQing and adjusting the volume of the previous sounds to bring them up to speed. Although he used the same equipment as the first time around, his mixing board and equipment settings had changed enough in the interim to make the new effects sound different. By making adjustments during the same timeframe, the chance of this level of edit is remote and better consistency results.

Consistency in Music

There are some specific steps we can take when composing, recording, and implementing a game score to help maintain its uniformity. Recording artists in the mainstream music scene work hard to ensure their CD releases measure up to other music on the market and that all of the songs on that CD sound like they belong together. We can take a lesson from this.

I recently worked on a project that could have benefited from this type of consideration. By the time I became involved in the project, the opening title sequence and main title screen music had already been done. These had been licensed from the mother company and were done by two different composers. They had similar qualities, with similar style, but were obviously recorded in different studios with different musicians and instruments. They sounded very different. The plan was to implement these into the game as direct audio. I was tasked to write several cues—one as direct audio and the rest as MIDI files to trigger the sound bank, chosen with the guidance of the audio director. So, now we had three different direct audio tunes composed by three different composers—recorded in three different studios by different musicians and instrumentation *and* several other pieces of music done in a completely different format and style using a sound bank with only average quality samples. Yikes!

Musically, the game didn't show any consistency and sounded uneven—but somehow most of it worked. The intro sequence was designed to tie the game into its real-life counterpart that used the same theme song and because it would probably only be watched a few times during the course of ownership, it didn't become that much of an issue. The direct audio music used for the credit sequence would probably only be seen a couple of times at the most, so that became a non-issue as well. The only real difficult connection was between the main menu direct audio cue and the rest of the game music, MIDI files triggering an internal sound bank. These were heard every time the game was played, and because they were of different musical styles, there was noticeable contrast. The developer made a conscious choice to do this, creating a different rhythm for each part of the game, but it still sounded incongruous.

What could we have done to develop some consistency? The first thought would be to develop the sound bank using similar instrumentation as the original direct audio piece and to compose all of the music in the same style. Another idea would be to have a single composer redo all of the direct audio cues utilizing the same instrumentation. Yet another option would be to use MIDI cues and the same sound bank for all of the music. Plenty of ideas, any of which would help.

This example helps illustrate many points. Music is a highly personalized experience and composers will always create with their particular "sound." As mentioned in an earlier chapter, every element a composer uses—from their instruments, samples, and talent, to the microphones, signal processors, and recording mediums—contributes to this sound. As you become familiar with an artist, you can recognize their work. I remember hearing a new song on the radio the other day. I had never heard it before and by the first measure I had guessed who the artist was without them even singing a note. Their style and sound was obvious. This concept plays out the same with video game composers. Different composers on the same project are obvious. Not that it can't work—it just has a different sound and may distract the player enough to remind them they are just playing a video game.

If all of the music is within the same genre, using the same main instrumentation will tie the experience together. If direct audio will be used, ensure the recording method is the same. If the songs are recorded live, make sure all of the songs are recorded live. If the instruments are all plugged directly into a mixing board and triggered via MIDI in the recording studio, make sure all of the music is done that way. Finally, when the music is implemented into the game, use consistent playback methods. Have all of the music streamed from a CD or have it all trigger a sound bank. The type of music occupying the majority of airtime should set the tone. If there are several cinematic tie-ins, make sure the rest of the music has those same elements. By doing so, the entire production will have a constant audio personality. This is a good thing.

Tools of the Trade

Chris Rickwood

Chris Rickwood's Music for Interactive Media.

The projects I get range from cutting-edge MMOs to mobile phones with stylistic requests from full orchestral madness to me beating on my surprisingly resonant belly (seriously, that's in an online game out there). My main goal is to always try to impress my client no matter how many times I have worked with them. With that in mind, I try to keep up with the latest and greatest gear out there. But at the same time I try to get the most out of the gear I have without falling into the vast gear lust abyss. So, I made a decision to cut back on the tools I use and really focus on a couple of great-sounding and useful tools.

Computers: Mac Pro Quad 2.66 GHz with 5 GB of memory and 3 x 500 GB Seagate hard drives as my main sequencer; Custom PC, 3 GHz with 3 GB of memory and

2 x 200 GB Seagate hard drives for those PC-only VSTs and Sound Forge; Sager 9262 Quad Core laptop with 3 GB of memory for running game engines, dev kits and playing games. This thing is huge! Macbook for e-mail/Internet/office.

Software: Logic Studio 8, Sound Forge 8, Adobe Audition 2, Soundtrack Pro 2, Iced Audio AudioFinder, MidiOverLan, Audio Kinetic Wwise, Google Docs, Transmit Quicksilver. (All Mac users need this right now. Go get it.)

Multi-track system: Logic Studio 8, Pro Tools 7.2 LE sometimes.

Monitor system: Event 20/20 bas.

Mixdown: It's all in the box—unless it's live; then I get to hire someone else to do this.

Sound modules/VST instruments: East West Quantum Leap Symphony Orchestra, East West Quantum Leap RA, East West Quantum Leap Voices of Passion, East West Quantum Leap Symphonic Choirs, East West Quantum Leap Stormdrum, East West Quantum Leap Ministry of Rock, Spectrasonics Stylus RMX with expansions, Spectrasonics Atmosphere, Native Instruments Kontakt 2, Native Instruments Battery 3, Native Instruments FM8, Native Instruments Absynth 4, Native Instruments Reaktor 5, Native Instruments Pro 53, Project SAM Trumpets, Project SAM Horns, Prominy LPC Guitars, Logic's ES2, Logic's Sculpture—and there's a lot more, but these are my "go-to" instruments.

Outboard gear/plug-in effects: Camel Audio CamelSpace, Zibba Stutter, Smart Electronix Live Cut, Michael Norris's Spectral Effects, Native Instruments' Spektral Delay, Native Instruments' Guitar Rig 2, Native Instruments' Vokator, Logic Space Designer, Logic Delay Designer.

Keyboards: M-Audio Axiom 61, vintage Yamaha KX-88 controller.

Other instruments: Takamine acoustic guitar, Ibanez electric guitar.

Microphones: Shure SM57, Rode NTG-2.

Additional relevant hardware/software: Kensington Expert mouse trackball, Logitech G5 gaming mouse, Wacom Bamboo tablet, my ears.

Music Mastering

A game score can take another important lesson from the record industry. Before any CD release is made, the music is taken to the next level with what is known as the *mastering* process. This is where subtle EQ, volume, and compression are used to even out the rough edges and to blend the music into one cohesive work. Often, 10 different songs recorded for an album will end up with 10 slightly different mixes. Some will have more bass, others more high end, and others will have volume mismatches.

When a listener plays an entire album, they might have to continuously adjust the volume for each song or turn down the bass—which may be perfect in the first nine songs, but blows out the speakers on the last one. Mastering takes all of these differences into account and ensures the listener can relax during the playback experience and not have to re-engineer songs on the fly. During this process, all aspects are matched from song to song so that the EQ and volume knobs never have to be touched. It's a process which often gets forgotten in the rush to meet a deadline.

For game music, various pieces are submitted at milestones during game development. Over the course of the month or two a composer is working, the last music cue submitted will have changed in volume and EQ from the first one and will be noticeably different in the game if they were to be played side by side. Some composers get around this by comparing each submission to the first piece they've done, but to do it right, a couple of days at the end of the final cycle should be set aside for the mastering process. This helps guarantee a consistent collection of music. Unfortunately, it won't be appreciated much by the player when done right—but you can bet it will have the opposite effect when done wrong.

Consistency in Sound Effects

Sound designers can naturally benefit from lessons learned in the music world to take their craft up another notch, to bring commonality to the player's experience and increase the chance for audio success in a game. More so than composing, it is important for sound designers to be able to commit to one project at a time to achieve consistency. I can't remember how many times I've tried to work on several sound effects projects at once and ended up losing perspective on all of them.

What ended up happening is I began treating it as one big project, even though none were related—using the same sound palette, trying to take shortcuts. At the time, it seemed logical—but when I sat back to listen to the four games side by side they sounded the same and none had its own personality. It's a pretty straightforward idea, but difficult when you are busy.

Another step to ensure uniformity across the entire lineup of effects is to process all of the game sounds using the same sound processor settings. Using the same EQ, volume, reverb settings, and so on will furnish them with a similar *feel*. Jamey Scott uses this trick with much success in his projects. This type of final mastering gives the sounds an overall homogeny.

Sound Effects Mastering

Mastering can also be accomplished on purpose, planned in advance as the final step before delivery. Running all of your sound effects through mastering software to adjust compression, limiting, volume, and equalization is a great idea that many non-musicians don't ever consider. They associate the process with music, but it can be equally valuable with sound effects. A final "mastering" session sees to their overall uniformity and ensures consistent playback quality, giving the final mixed audio a certain characteristic which ties it to the game. Good software can add a pleasant analog warmth, clarity, and presence; allow hard digital clipping; or add a smooth, tape-like saturation to the mixed sounds for a feel that is truly unique. Some sound designers use this process as their secret weapon to give the final polish to their work.

The final step, before submitting finished sound effects, is to listen to them in their entirety back to back—one after another. Listen specifically to their volume or perceived loudness with respect to the other effects and make adjustments to those that seem out of place. Be sure this comparison is conducted aurally and not visually. Some sounds can "look" softer than others but will actually be louder when played. Your ears have to be trusted on this one. There will be some sounds which need to be softer or louder by design, such as soft button clicks or thundering explosions, and you can ignore those. The rest will require some consistency, and by listening to them as a whole, there won't be any surprises later on. With the myriad of details needed to complete a game project, it is easy to let a sound slip through the cracks. This process will ensure it isn't your fault and will keep the game sounding smooth.

Early in my sound design career, I worked on a Bingo game project—initially delivering about 85 sound files for the number/letter calls. I had edited the best takes from the voice talent recordings and just sent them in. It was pretty cut and dried and I didn't think much of it. The calls seemed fairly consistent and I was in a hurry to meet the deadline. It wasn't until the following week, when they were placed in the game, that I noticed the conspicuous volume differences between them. That's when I discovered the little trick of listening to them all back to back, as well as randomly, to ensure they were even in volume. Looking at the sound files and using the same normalization and limiter settings didn't work as I had expected, but the time spent listening sure did. The middle frequency range is generally better reproduced by most multimedia playback systems and this all-voice sound effects project required some extra care.

Consistency in Voice-overs and Speech

After discussing the considerations for music and sound effects, voice-overs, speech and other narrative sound files would need to show consistency as well. Everything previously mentioned, from using the same equipment and signal processors to the mastering process, should be utilized in this pursuit. Additional factors can also help maintain uniformity when working with voices.

This might sound obvious, but always use the same voice talent for a specific character. There are exceptions, for instance, an alien creature who has the vocal range from the growling lows of James Earl Jones to the high screech of a five-year-old girl, where you might need at least two voice actors to accommodate the requirements. (Unless you can find someone who has that range, of course.) And there are always the times when you need a line at the last minute and you are the only one around to perform the substitution. But, as a whole, using the same voice makes sense. People who play these games aren't dumb and they will notice anything out of place, cheapening their gaming experience. If there is a female voice announcing warnings and malfunctions aboard your spaceship, make sure it's the same voice. Make sure your little gremlin characters start with the same voice, even if it is processed beyond recognition.

Another consistency trick is to record all of the narratives in one session, using the same recording technique, the same microphone, and the same settings. By doing so, there won't be any concerns about the voice actor's tone sounding different either. Human voice qualities can change depending on the time of day, how tired they are, how humid or dry the air is, or whether or not they just drank battery acid. If they have to return later, you

may suffer the possibility of them having a cold, for example—which could affect their sound and ruin your efforts. Equipment properties may have changed, and unless you have instant recall available on every piece of gear you use, they too will sound different. It will all add up to the same person sounding conspicuously dissimilar in the game.

Consistent audio quality is an important issue for everyone on the development team to concern themselves with. Much effort and thought goes into not only the creative aspects of audio production but how it all fits into the game. By utilizing the aforementioned ideas and techniques, it is possible to produce a game with sounds that are enhancements and not distractions.

Composer at Work

Mark Scholl

Mark Scholl is a composer and sound designer for International Game Technology (IGT) and Screaming Tigers Music, Inc.

Describe your thought process for creating sound effects.

I like to do a lot of layering, especially for big-events sounds. Layering gives you more textures and depth as well as helping to create a unique signature sound with a stronger impact. There are also many small subtle button/select sounds in a game. Those sounds

will be heard over and over again and as a result I like to make those sounds reasonably subtle and as pleasant to the ear as possible—because if they are too harsh, they can get very annoying very quickly. Sometimes there are sounds that accompany dynamic gameplay movement, like footsteps or weapon hits, for example, and in order to give them a more natural dynamic feel, I will create several versions of the sound and then have the engineer either randomly trigger or cycle through a series of the sounds.

Sound effects that are intended to go with animation must have an accurately timed representation of that action to get a clear sense of what will be in the game, as the timing of the sound is as crucial as the actual sound itself. The animations are usually created long before the sound work begins and I will request those video files before I start. After I have created my sound effects package, I will go through and assess the volume and EQ balance from one sound to the next—as that is also important within the context of the game. I will usually have the effects package implemented into the game build itself to get a real sense of how the sounds are working both individually and interacting as a group.

Are there any particular secrets to your creativity?

As with most creativity, I think it is a bit of a mystery—but I do find that visuals from the game are very helpful to stimulate ideas. I like to get a cinematic or some representation of game play with screen shots or maybe a preliminary build of the game. A lot of times that will help to give me a direction.

When do you find you are most creative?

For the past several projects, where I have been a full-time composer, I have to write on a consistent weekly daytime schedule. As a result, I will simply have to sit down and start creating—but of course I don't always feel inspired to write. I have found that once I can get past the blank slate stage and have struck upon a nice idea that feels like it is working, my creativity always seems to flow much more smoothly and quickly at that point in my writing process. Sometimes I will have more creativity the next day. If I get to a point in the composition that I am getting stuck or I am starting to not like the idea, I have learned to let it go until tomorrow. When I come back in the next day I will hear things more clearly and will often have a flow of ideas that is inspired by the previous day's initial thoughts. And occasionally the next day has inspired a totally new direction.

Any specific "lessons learned" on a project you feel are important?

Organization and backup files are both very important! I also find it to be quite helpful if I write out a score (or at least a melody/chord chart) for most pieces that are fairly involved musically, even if I am not planning on adding any live players. There seems to be many times when you need to revisit a project long after it is complete. Being able to just re-open a file and start working is ideal. I had a hard drive crash several years ago and lost a bunch of files for a few projects that were already completed. Most times that may not have been a problem, but sure enough one of the projects wanted to make some new additions based on the original idea.

(Continued)

Well, I did have the score parts in another location—which made it easier to reference melodies and adapt them for the new outlet, but I had to rebuild my entire Digital Performer template from scratch.

Do you have any negotiation techniques or stories others could learn from?

As my wife Robbin constantly reinforces with me, ask for what you are worth. For most people, it is very easy to feel insecure when you are putting a fair-size number on the table because as we all know, there is always someone else who is willing to do the project for next to nothing. However, you are doing yourself a disservice if you don't account for the amount of time it will actually take for you to complete a project. Music composition, sound design, and everything that goes with those two jobs (such as performing, arranging, orchestrating, recording, mixing, mastering, writing charts, hiring additional musicians, et cetera) are all very high-skilled jobs that take a lot of time to complete.

It is always good to come to the table with a high/low number in mind. One side or the other has to throw out a number first and it is good to know what to counter with in the event that they throw you a lower number than yours and you need to work up from there. Also, if you have a number in mind that you really feel you need to make on a specific project don't be afraid to put it out there first and let them counter. Sometimes the biggest challenge is that you may be dealing with people that don't really know how much work is involved to write and produce a lot of music. A very good friend of mine has a humorous insightful observation in these situations: *How long does it take to write three minutes of music? Well, three minutes!* One final thought that I have learned about negotiations is that the person who is willing or able to walk away from the table is the person with the most negotiating power.

What sort of things do you feel are important during the development process?

Communication with your team is really important, as this is ultimately a joining of creative forces. All games involve a lot of people from start to finish. Even though most of the work is done by individuals working in their own studios, there is always a need to discuss direction and come together for update meetings along the way. Once I have written a main theme (or two) and have produced them enough in a direction that conveys the right feeling, I like to invite people to my studio (or send MP3s via e-mail or upload to *ftp* if they aren't in the same city)—usually before I add some live instruments. It helps to confer like this to make sure that all of the team leads are happy with the direction. I think that it is also a good way for your team to gain a little insight into how involved the composition process is. I have had very favorable results come from these interactions and it creates a nice sense of camaraderie.

Do you have any interesting creation techniques which resulted in a notable piece of music?

I come from a very extensive live performance background, including lots of work with symphony orchestras and big bands. All of my live performance experiences

have been very insightful exercises in how all kinds of instruments are performed and how challenging it is to actually get a sample to simulate the real thing. As a result, I have always preferred using at least a couple of live instruments if possible—because even though the samples can sound great they will usually lack the emotional depth that a real well-performed instrument brings to a piece. I mostly bring in guitar and/or some live horns to add on top of the samples. The mixture of these elements will often create some really exciting results that you may not get from just one or the other. Not that I haven't used just samples for a piece but if there is a budget to account for the additional players then I will write out a couple of charts and set up a session.

Like many composers, keyboards are my writing instrument—but unlike many composers, drums are my first and strongest instrument. I have a ton of both modern and vintage drums in my studio. Another technique that I use fairly often is that I have written orchestral score pieces that lend themselves to a massive drum-ensemble-type march somewhere in the composition. I will use some samples to set the foundation (like Taiko drums, which I don't have) and then I will play numerous tracks of huge toms and/or various snare drums over top. It creates this thunderous dynamic effect that samples wouldn't be able to achieve on their own. Another technique that I use is that I will also play live drum kit or hand percussion over top of samples and/or loops for more modern edgy pieces (maybe a hard-rock-type vibe) to create a live energy with a very modern sound.

What advice would you give when looking for and possibly getting involved with certain game projects?

There are tons of people out there trying to do games and many upstart companies that are seeking funding. These can be great places to start, but the downside is that they usually don't have any resources to fund until they shop for a publisher or some kind of venture capital backing. I have had both good and less than good experiences with these types of situations. I have discovered that it is best to only get involved in a project if I truly like the game concept and believe in the idea. If the game doesn't end up selling or getting funded, you can always use your music elsewhere—but hopefully the experience was a good one and you were able to learn something along the way. You do have to be careful to not get taken advantage of in these kind of situations, though.

As a side note, at a composition seminar that I attended years ago, I remember one of the composer panelists saying that he felt that there is no wasted writing. If you do take on a project that doesn't end up going anywhere, you can always keep your music and possibly find another use for it in the future.

How did you find your way into the games industry?

I think the same way that most everybody in the entertainment business finds their way in: drive, determination, lots of research, going to the occasional conference, and the most important of all—connections.

Quality Control

Video games, though nothing but coded strings of 1s and 0s, are like any other product and require some form of quality control. As the sound person, there is much to do from your end to ensure the audio portion of the product is up to par. Creating a third of the game experience is a heavy responsibility and it behooves you to not leave this step to the developer entirely. You are the audio expert, you know the intentions behind every piece of music and sound, your name is on the box, and this final product is what might attract your next big money-making project. There is a lot riding on your sounds and you can't just leave it to fate or some low-level code programmer who doesn't understand audio.

If the audio was built using top-notch professional studio equipment, those standards are usually acceptable and odds are it will also sound professional. Using experienced and talented craftsmen along with great gear will increase this chance of success. Starting out with quality will boost you past mediocrity, giving less need for a separate quality control phase. But, regardless of how good you and your sounds are, it is always a good idea to keep track of their progress once they've left your hands.

Check Mixes on Several Systems

Before any final music or sound effects are delivered to the developer, it is a good idea to listen to them on different systems and different speakers. This will check the integrity of the audio across a wide range of possible playback systems, whether it's a cheap set of multimedia speakers bought from a swap meet to a full-on $10,000 home theater surround sound system. The options are infinite and you want to have the confidence your audio sounds good on all of them. Play back at different volumes, from very soft to as loud as the neighbors can stand. Listen for an even mix in each cue or effect. Make sure the low-end frequencies don't distort and the high end is present and not overpowering at any setting. If all of the audio sounds good on the various systems and settings, they've passed the test. If not, fix them.

Check Your Sounds in the Actual Game

This sounds obvious, but more often than not the sound person gets left out of this final step. If you're able, listen to the audio in the game. If not, make sure a trusted member of the development team, with audio experience, is there to perform this crucial assessment. Some actually believe this process to be the most vital phase of the production cycle. Most composers, sound designers and producers insist the audio guru listen to their sounds in the actual game—typically happening around time the game goes into beta. At this point, the effects and music should be in place and the sound team should sit down and study their audio intently. It's not uncommon for the audio to sound great in the studio but not so hot (too loud, too soft, too long, or too short, as examples) once they're in the actual game.

While analyzing the audio in the beta version of a game he was working on, Joey Kuras discovered a programmer on the project had taken one of the sound effects (footsteps) and

cranked up the volume so they could be heard at the same level as the rest of the sounds. What were intended to be subtle, barely discernable Foley effects turned into a loud series of crunches which sounded seriously out of place. Thankfully, Joey's screening session caught the problem and it was corrected in time.

Remember, you are the person getting paid for your particular audio expertise. Your opinion and experience is a valued asset in the production process. Often, the developer will be in such a hurry that they attempt to cut corners to make a deadline and your opinions will be left unsolicited instead.

You must insist, prior to releasing your sounds, that you are permitted to test them in the game.

The example with Joey is just one of many stories I've heard where your intentions to make quality audio are thwarted by someone on the team who doesn't have a clue. They don't do it deliberately; it's just they don't know any better. Your job is to stay on it to the very end and make sure your hard work is presented to the game player as intended. Tenacity is a good quality to have.

Teamwork With the Developer

As an audio contractor, it is sometimes quite tough to build a relationship with a development team who's been together for a year or more. You are the new kid on the block, entering the picture late in the game. And, with your part completed within a couple months or so, you won't be around for long either. Not having every member of the team present as one cohesive unit can be a serious stumbling block. As the outsider, you must fight this phenomenon and work a little bit harder to show them you are part of the team and are as passionate about the project as they are. Enthusiasm is infectious and if you display a steady stream, you'll score points quickly.

This bond with the team will strengthen the overall quality of a project. When they see you working hard toward making the game better than anything else that's ever been done, they won't resist your ideas and opinions as much. Nobody likes a snooty, self-centered boob concerned only with making the game a showcase for their work. Games, films, and television shows that only seem to serve one actor, artist, or director are often doomed to failure. The public picks up on these things quickly and demands the total experience. They want good artwork, good gameplay, and good audio with the total package. Working with a unified development team will naturally lead to good quality control, where everyone is interested in the overall picture and not just their own agenda.

Conclusion

Exercising good quality control is as integral to the process as hiring the best team money can buy. As all of these incredible pieces of the game project come crashing together, this is the time for attention to every little detail to get them to mesh perfectly. It doesn't matter if every component is a masterpiece on its own. What does matter is how all of the

individual masterpieces fit together to form the big picture. By maintaining tight control of every aspect, the developers can ensure a great game. By maintaining good control of your audio submissions, the developer will benefit from your valuable knowledge, experience and talent and have one less issue to concern themselves with at crunch time. Now you can continue on your path to game audio superstardom!

Tools of the Trade

Watson Wu

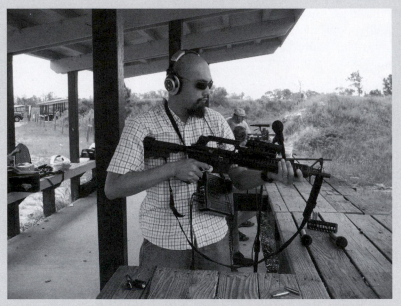

Watson Wu is a composer, sound designer, and president of WooTones, LLC.

I think of my company as an audio content provider. We often solve problems with our numerous resources and contacts. Moreover, we are driven to complete all projects on time and within the agreed-upon budget. Middle- and large-size companies are both challenging and fulfilling to work with. Did I mention we are all gamers?

Computer: Six customized PC workstations, one Mac Pro, one Mac G5, two Macbook Pros, two Powerbooks, and one Dell laptop.

Software: Ableton Live, Adobe Audition, Cakewalk, DigiDesign, Encore, Final Cut Pro, GigaStudio, and Sibelius.

Multi-track system: Mainly through multi-track software such as Pro Tools, Sonar, Vegas. Sometimes we use the M-Audio Project Mix.

Monitor System: Alesis, M-Audio, Mackie monitors, Stanton, and Sennheiser Pro Headphones. Final mixes are listened through consumer speakers such as Logitech and other generic brands.

Mixdown: M-Audio Project Mix and outsourced mixing/mastering studios.

Sound Modules: Korg, Roland, Yamaha, and various software programs such as BFD, Cakewalk, GigaStudio, Native Instruments, Reason, and Spectrasonics.

Outboard gear/plug-in effects: MOTU 8-Pre Firewire interface, Antares, Cakewalk, Hyperprism, Lexicon, Sony Media, TC Native, Timeworks, Waves plug-ins.

Keyboards: Edirol, Novation controllers, Korg, Roland, Yamaha synths.

Other Instruments: Fender, Yamaha guitars and bass guitars, and voices.

Microphones: Audix, Neumann, EV, OKM, Rode, and Sennheiser.

Additional relevant hardware/software: Hardware samplers from handheld field recorders and synthesizers are helpful to create fresh and original sounds.

Remote recording gear: Fostex FR-2, M-Audio Microtrack, Sony Mini-disc recorders, Rycote windshields, shotgun mics.

Sound Libraries: None. I use my own!

CHAPTER ELEVEN

Game Platforms and Their Audio Development Issues

Fortunately, for composers and sound designers today, providing audio content for the myriad of gaming consoles and platforms isn't as difficult as in the recent past. With the relatively simultaneous launch of three game consoles—the Sony PlayStation 2, Nintendo GameCube, and Microsoft Xbox—an era of audio development opened to allow audio creators to utilize familiar tools instead of dealing with often laborious development systems. And with the introduction of the next-generation (next-gen) systems—Sony PlayStation 3, Nintendo Wii, and Microsoft Xbox 360—it's even easier to create sound, although implementation considerations have become exponentially more complicated. Previously, a game composer would have to acquire and license a development system and spend time learning it before they could even begin composing. Thankfully, those days have gone the way of the dinosaur and content creators have far less restrictions and far more freedom.

It's not to say that there aren't any development systems involved. Each new console has its own proprietary kit that allows developers to create a game title. Audio you create will have to pass through it at some point. The big advantage for us is that we can deliver our music and sound effects as *.wav* or *.aiff* files (as we normally save and edit to anyway) or as *.mid* files—all of which are converted to useable formats after delivery. As an in-house audio specialist, you may be more directly involved with this conversion; outside third-party contractors have less of a chance. Currently, the new console development systems are closely guarded, except to licensed developers and qualified content providers.

So, the good news is that we can make great audio in a fashion we are accustomed to. The bad news is, there are still many different game platforms and system standards we must conform to. Despite the massive improvements of the new offering of consoles, we are still restricted to some fairly solid boundaries. The game consoles themselves have built-in limitations. The developer's choice of implementation will introduce others, depending on how they use the available resources. I plan to address the current known quantity of the hardware limitations. Any further developer restrictions will have to be investigated separately prior to a project, of course. Just be aware they will exist beyond what I've discussed here.

Currently, there are several consoles and platforms games are being developed for. But as new ones are launched, games for the older generation are obviously no longer produced. Simple economics dictates that once the gold mine is played out, it's time to move on to the next. When this edition was published, the Nintendo 64, Sega Dreamcast, and Sony PlayStation 1 were long gone and it's doubtful you would ever do music for one of these platforms. (Although, that's not entirely true either. Just a couple of years ago I did some music for a Dreamcast project.) With that said, I won't waste your time discussing historical audio details of how it used to be done. Instead, I shall concentrate on the consoles and platforms you *will* provide content for: PlayStation (2 and 3) and PSP, GameCube, Wii, Game Boy Advanced and Nintendo DS, Xbox and Xbox 360, CD/DVD-ROM, Java, Flash, and coin-op. Even though the next-gen consoles are a major part of the market force, there is still enough of an interest in recent platforms and their games—and for those just starting out, there is a good chance you may run across solid projects for them. Plus, it never hurts to be familiar with them so you can really appreciate the latest console offerings and their features.

Tools of the Trade

Jon Holland

Jon Holland, composer *(www.jonholland.com)*.

I have really enjoyed the proliferation of affordable professional mobile recording tools. This has truly changed my life when it comes to inspiration turning into workflow. It seems I'm always traveling somewhere. I can't stand still. Hotels. Deserts. Mountains. Beaches. Other studios. I love the new world of global communication and high-tech toys. I'm able to complete most, if not all, of my projects on the road. I can receive and send works in progress and have direct feedback from clients and game producers within minutes via wireless web.

We've had the Web for awhile now, but the quality of music tools now available (such has DAWs and software instruments, including wonderful orchestral sample libraries) has truly matured. For example, in a matter of minutes I'm able to construct the foundation of an entire piece of music with software such as Propellerhead Reason, Ableton Live, Pro Tools, Logic, Nuendo, et cetera using nothing more than a few pieces of gear. If I want to improve on the quality of sound and have the time, I can utilize the portable pre-amps, compressors, and converters to add character to the sounds—all while sitting lakeside somewhere in the middle of nowhere.

The fact that I can now fit much of my toolkit in a briefcase and go anywhere is for me liberating beyond words. In the end, the quality of the music will be all that matters to the listener. That will never change, but for an artist, freedom to create in an environment conducive to the way you live and work—it's truly unprecedented. Having said that, I'm not out to replace my home studio—just to take advantage of other work methods so that I can be as efficient as possible. My gear is in the constant state of flux. It's not about more gear or less gear, just the right gear for the time and place. My road rig is a way of experimenting and creating at the drop of a hat.

Home studio: Pro Tools 5.2 Mix System with multiple MixFarm Cards running on a Mac G4/733 (hopefully to be replaced by a native DAW system that will give me hundreds of pristine audio tracks and plug-ins, zero latency, killer mix bus headroom, and money left over to buy the system that supercedes it in 12 months), Propellerhead Reason (amazingly useful), pre-amps, and compressors

Monitors: Yamaha NS10 monitors

Synths and sound modules: Roland Juno-106, Roland JD800, Sequential Pro One, Bass Station, Voce Electric Piano module

Other Instruments: Electric and acoustic guitars

Road rig studio: Laptop running Pro Tools LE, M-Audio Audio Interface Box (usually external ADC via S/PDIF input)

Next-Generation Consoles

The seventh-generation consoles, referred to as "next-gen" (short for "next-generation"), officially began with the release of the Xbox 360 at the end of 2005—and the subsequent introduction of the PlayStation 3 and the Wii. Each offered its own breakthrough technology utilizing the latest hardware and software contributions, ultimately designed to entice the game-playing public to invest in these "better" products. The obvious enhancements were with their graphics and the focus on high-definition visuals, found on the 360 and the PS3. Nintendo chose a different route, offering an entirely unique game controller instead.

Regardless of the advertised upgrades, the playback of audio and the ability to implement audio content for these new next-gen consoles had also made significant strides as well. Each platform offers a larger selection of onboard digital signal processing (DSP) effects, more audio channels, better control of them, and a myriad of audio playback and implementation options not previously offered. This not only translates into an incredible game experience for the player but a more flexible creation and implementation process for the content provider.

The availability of audio middleware tools such as Firelight Technologies FMOD, Audiokinetic's Wwise, Microsoft's Xbox Audio Creation Tool (XACT), and RAD Game Tools Miles Sound System, as examples, are blurring the lines and finally enabling true cross-platform audio development. There are still some very specific issues with each separate platform, of course, but we are well on our way to finally being able to create and implement audio for multiple-platform releases using a single, more familiar tool, instead of the learning curve and issues involved with having to be proficient with many. These middleware tools, combined with the power and capabilities of the next-gen consoles, have allowed the creative talents of all of those involved with the audio side to literally explode.

Microsoft Xbox 360

The first of the next-gen consoles was released with much anticipation in late 2005. The successor to the Xbox, dubbed the Xbox 360, sold more than 18 million units by mid 2008 and has proven to be a popular console—especially among fans of the *Halo* game series. With major improvements under the hood—including a 3.2 GHz triple-core Xenon processor, a 500 MHz ATI Xenos graphics processing unit, and a hard drive up to 200 GB—the console provides the hardware for a great game experience. This increase in benefits not only provides the same advantages as those found on the original Xbox (discussed in more detail later in the chapter) but takes them to the next obvious level. Be sure to review that section as well for a full understanding. Audio advancements were also significant, both in hardware and implementation options available to the developer and open up incredible choices for audio presentation.

- 256 audio channels
- 320 independent decompression channels using 32-bit processing
- Support for 48 Hz, 16-bit sound
- Playback in Dolby Digital, DTS, and multi-channel WMA Pro

All sound files are encoded and compressed in the XMA audio format through the use of the Xbox Audio Creation Tool (XACT), enabling a significant increase of possible audio content. The Xbox 360, for our purposes, is a very friendly platform. The most significant difference between the original Xbox, which had physical audio processors, and the 360 is that audio is handled mostly within software. Instead of dealing with the restrictions of a built-in audio processing unit, software updates will allow the console's audio capabilities to improve as needed.

Composers and sound designers can enjoy making assets utilizing their familiar tools (as *.wav* or *.aiff* files), so there are no compromises to worry about during the creation

phase. If you're only required to deliver these final audio files to the developer, then your job is basically done there. But, if you're to be a little more closely involved, then expect to get intimate with XACT. Luckily for us, XACT is provided free to registered Microsoft game developers and content providers as part of both the Xbox Development Kit (XDK) and the DirectX SDK—which can be found under the "Developers" section at *www.xbox.com*.

XACT supports both the Xbox and Xbox 360, along with the PC. Its primary purpose is to prepare audio files for implementation, such as compressing and converting *.wav* and *.aiff* to *.xma*, assembling and encoding audio stems into 5.1 surround format and creating wave and sound banks for streamlined audio management. It also organizes sound groups for ducking, fading, and other purposes; establishes the compression presets; and handles the assignment and parameters of internal DSP effects. The best advantage of XACT for the composer and sound designer is, along with the development kit (which in this case is a slightly modified version of the consumer console), it allows the content creator to make their own audio builds and test the sounds in the game, assuming the developer has made this capability available. I don't know how many times I created a sound I thought was fantastic only to hear it in the game months later and realize it didn't quite match. Having a way to immediately test your sounds in the game will definitely prevent this from ever happening again.

Creating and implementing audio can be as simple or as complex as the developer's overall audio vision. Games such as *Halo 3* are an incredible maze of intricate audio files, triggers, effects processing, and mixing painstakingly interweaved to bring you the final mind-blowing experience. Every bit of the lengthy development cycle is used to do it. Typically for games of this type, the entire audio team is working together to ensure its success. But, that doesn't mean a single composer/sound designer couldn't do great audio for the 360. They definitely can!

After completing my first Xbox 360 project, I realized that, while there is a lot to do and to think about, with proper management of time and assets, it really wasn't that bad—and actually far easier than some of my previous endeavors. Using my standard audio production tools and techniques, XACT and access to a 360 dev kit, the developer and I were able to work together to create an audio-rich game experience far beyond what I expected was even possible. We set our milestones early on, both stayed on track and with each new game build, I was able to review the music and sounds I created. As part of the next milestone, I tweaked any audio that needed adjustment and repeated the process until three months later we had a pretty good-sounding game.

The final step came when I sat down with the programmer for the mixing process, basically playing each level and adjusting properties (such as volume and panning) in code. He'd create a new build after each pass through the game and we'd repeat the process until the entire game was mixed to our liking. During the process, we discovered a few sounds which needed minor adjustments in EQ or timing—and for that, I had brought my computer and external drive with all of the files and programs I used for the game. While we could have done some of this in the code using the power of the 360, we preferred at this final stage of the development, not to break anything because the code and assets were stable and working correctly.

As a third-party contractor on this project, and because it was within commuting distance, I insisted on being a part of the mixing phase so I could take a little of the pressure off the developer and because I was hired as the audio expert and this final, absolutely critical stage, could make or break the overall quality of the audio. Yes, I could have just sent the files to the developer and walked away—and sometimes for various reasons you

have to do it that way—but because my name is on the project and reputation is on the line, it was an easy choice. The worst-case scenario would be to have someone on the team who has a good ear or other audio experience to be present, especially if the composer or sound designer can't be there.

Overall, though, creating audio for the Xbox 360 was a pleasure—and instead of having to concentrate so much on technical issues, I was able to stay on the creative side of my brain more often and really focus on the quality of the music and sound effects.

Sony PlayStation 3

Considered one of the next-gen consoles, the PlayStation 3 (PS3) is a considerable improvement over its predecessor the PS2. Released in late 2006, it has sold a respectable nine million copies by the summer of 2008 but is seriously lagging behind the other next-gen platforms. Despite this fact, it's still a pretty amazing machine. It houses a powerful 3.2 GHz cell broadband engine CPU, an NVIDIA RSX Reality Synthesizer graphics processing unit, and up to a 80 GB hard drive. While it might not be at the top of the sales heap, audio-wise it is a strong contender for the first spot. Playback of standard and Blu-ray DVDs and standard and Super Audio CD formats is a definite plus but it also offers other consumer- and developer-friendly audio features.

- Dedicated audio processor
- 512 audio and voice channels
- 44.1 or 48 kHz sample rate
- Playback in stereo, DTS, 7.1 Dolby Digital and Dolby TrueHD
- Access to a 256 MB shared memory system

Like the Xbox 360, the PS3 has also moved toward software-based audio with an audio system created from the ground up. This move allows for virtually unlimited power and content free from the limitations of the previous generation. Some of the key audio features include easier integration and testing of audio, cross-platform capabilities, and the ability to author custom DSP effects or utilize those already on-board.

The real advantage to having available effects processing (such as reverb, EQ, filters, pitch shifting, distortion, and vocoder) is the ability to have the audio deliverables dry and allow for any final processing to match the environment or situation, as well as the ability to change it if needed due to new artwork or environment. It is also great for localizing dialog into different languages, allowing the same processor effect for each version without having to apply it separately. With less need for preprocessing audio assets, it streamlines the creative process, gives more control to the developer and ensures the effect always matches what the player expects.

Music can be handled in a variety of ways. As expected, it can stream directly from the disc or loaded into RAM as needed using compressed or non-compressed formats. Unlike the PS2, which required all audio in the VAG format, developers can mix and match depending on their needs. But, similar to the PS2 (which often used a variation of the *.mid* format in conjunction with a sound bank) the PS3 can use actual *.mid* files—triggering a soft synth or samples to create the soundtrack. The advantages to this are fast loading times, flexibility, and a small footprint—which are perfect for networked Internet games.

Sony is quickly moving away from anything proprietary, and for us audio folks, this is a great thing. They are now using open-file formats, common-feature tool sets and allowing the audio team to use Sony tools or other more accommodating and robust tools such as FMOD. This gives the developer the flexibility to use the best features of the PS3 and to use data they have already created (perhaps for an Xbox 360 version of the game) without having to re-author it. SCREAM, which was used for the PS2, has been adapted for use on the PS3 as well—but the current version doesn't address many of the next-gen issues. Sony has promised that it will evolve over time to be more open and extensive, with a more "sound design" looking interface.

Creating audio for the PlayStation has never been easier now that Sony has instituted a new line of thinking. Composers and sound designers can work with familiar creation tools, delivering their assets as digital audio or MIDI files as needs dictate. The ability to use audio middleware applications such as FMOD now gives the audio team even more familiar territory in which to work and create an entertaining audio experience. Content providers who are also deeply involved with integration of their audio can do so without a huge learning curve, especially if they have used these middleware applications in other non-PS3 projects.

Composer at Work

George "The Fatman" Sanger

George "The Fatman" Sanger, game audio legend, philosopher, and author of *The Fatman on Game Audio: Tasty Morsels of Sonic Goodness.*

Describe your thought process for scoring/creating sound effects.

My mom gave me one art lesson: picture the thing on the page, then trace what you see. Do that—only with your ears.

(Continued)

Are there any particular secrets to your creativity?

Yep, and I'm just as curious as you are.

When do you find you are most creative?

When I'm being sassy during interviews, and other times I feel that belly-laugh thing in my gut. Like many actual artists, I have tried to nurture that state. That is what makes us kind of retarded. Real artists laugh coffee out their noses. Crap artists tell you how much money you're going to make on this project and they talk about the music they are working on more than they work on it.

Any specific "lessons learned" on a project that could be shared?

Too many to count.

Do you have any negotiation techniques or stories others could learn from?

It is hard to be sure a musician knows that you respect his value and his time. When I am paying a musician, here is my MO.

> I can never pay you what you are worth, which is infinite. All I can pay you is this much, which is all I can pay you and still convince my money sense that hiring you is a good idea. When you get here, the check will be written out and on my desk. The session will go until 4:00. If 4:00 comes around and we're still working, I want you to put your horn in the case, push me out of the way, grab your check off the desk, and leave.

Likewise, it is hard to name a price that will fit a client's budget, and the haggling process can erode the sense that there is respect between the two negotiating parties. I have been known to say, "Make me an offer that you feel has dignity. If I can do the job for that amount without feeling that I'll be losing money or wasting time, then I will happily take the job."

Do you have any development stories that serve as a good "lesson learned" or something which can be avoidable in future projects?

Happiness in working life depends very much on the people you pick to work with. If you can help it, don't work for anybody who mistakes being a fussy consumer for being a good producer. You will know them by phrases like this: "This is going to be a great game because we actually play games and we know what sucks."

Corporate butt-heads can ruin your day, too. Watch out for anybody who uses the phrase "responsible to the shareholders." His goal is to make a creative product that's sure to sell. That's impossible, so he will either try to crush the creativity out of the project to make it just like something else that has sold before or he'll make you do and redo your work out of frustration with his own double-bind goals—trying to find something that draws no negative comments from anybody in the company who hears it.

Similarly, try not to work for young cocky guys with money who haven't had a nice big failure yet—especially if they are funded by money they got from a parent. Guys without money who just can't stop coding—that's a different story. And the more that being with these people feels like you're in a cool movie about a cool band, or feels like you've finally come home, then that's where to hang out—*even if it's not game music that they're doing.*

Any great stories you want to share?

http://www.fatman.com/stories.htm.

How did you find your way into the games industry?

The thing that I do sought me out like it was a stalker and I was a delicious presidential movie starlet leading a peace march. But I'm not sure I'd call it "being in the games industry." I like making noises for people who could use to have some noises. Many of the people I love and dig working with are in the games business. Many things that we think of when we hear "games industry" have nothing whatsoever to do with me or what I like or what I do.

Nintendo Wii

Nintendo's follow-up to their GameCube platform was released in late 2006 and has proven to be the most popular of the next-gen consoles. By the summer of 2008, the Wii had sold more than 21 million units to not only their loyal fans but to a large number of non-gamers as well. Of course, the main selling feature was their wireless game controller and unique motion-intensive gameplay element which got people off the couch and into the game.

Technical specifications of the Wii aren't well advertised, but at the time of publication there were some details available. The CPU is a PowerPC-based Broadway processor reportedly clocked at 729 MHz and its GPU is an ATI Hollywood chip clocked at 243 MHz—neither of which have been officially confirmed. Memory consists of 88 MB, 24 MB as part of the graphics package and 64 MB of SDRAM. There is also an additional 3 MB of memory embedded in the GPU for other purposes. There is no hard drive on the unit, but saved game and other info can be stored on the 512 MB of built-in flash memory, which is expandable by up to 2 GB with an SD card.

Audio-wise, the console feels like a step back from the GameCube's capabilities with the reduction of the digital surround sound feature. But, what it does have is sufficient for what it is designed to do.

- 64 voice capability
- 44.1 kHz and 48 kHz sample rates at 16-bit resolution
- Playback in stereo and Dolby ProLogic II embedded in the analog audio
- Mono playback on the controller at 6.3 kHz sample rate, 4-bit resolution
- Access to a 512 MB shared memory system

While not as sophisticated as the 360 or PS3, it does house features such as reverb, chorus, and delay effects processing (plus a wavetable synthesizer using DLS)—giving a wide variety of sound options to the composer and developer. Creating and implementing audio on the Wii is fairly straightforward, and where the composer or sound designer is concerned, you can again create using familiar tools and deliver your audio content as digital audio and *.mid* files. There are specific tools the developer will use for implementation, and as part of the team you'll become familiar with them.

There is a little bit of a learning curve, as there is on most applications, but it is learnable and will give you a good end result. Unfortunately, because there is little information on the Wii or its available tools in the public domain and the inconvenient fact that I am bound by NDAs I can't go into much more detail. But trust me, you'll be fine when it comes to creating audio for this platform.

On a recent Wii project, I was tasked to create music, sound effects, and dialog. Producing the assets was straightforward—all created using my standard tool set and delivered as *.wav* files. The developer integrated the audio assets and invited me over for the final mix. We played the game, often having to remind ourselves of the purpose of my visit, and I'd call out volume levels to the programmer sitting nearby. Using the interface connected to the dev kit, he'd make adjustments, I'd reload and play the game, and we would repeat the process until we were confident it sounded great. For any sounds that needed further adjustment or just didn't fit with what we were seeing, I'd create alternative sounds or make minor timing tweaks and that was that. In the end, there were absolutely no surprises on my end and the audio was great.

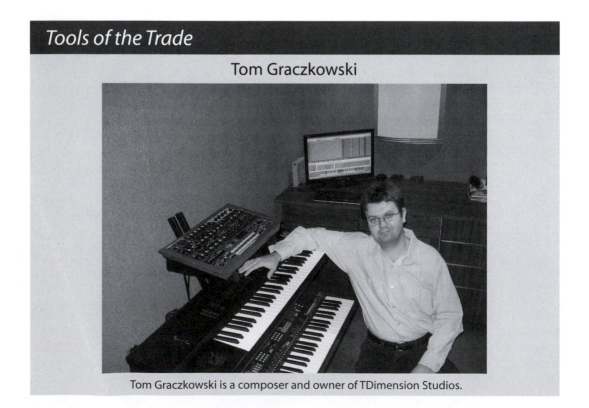

Tools of the Trade

Tom Graczkowski

Tom Graczkowski is a composer and owner of TDimension Studios.

I always considered myself a versatile composer, with great passion for game audio—but I also don't mind working on other projects which may include an independent film, a music library, a web site. Bottom line, I love writing great and inspiring music and if it can be used to enhance somebody's project then that's even better. Due to a variety of projects I could be working on, my gear list (or more accurately, arsenal) of VST instruments is always increasing. I actually still have my first keyboard, which is barely more than a toy, but certain sounds are quite decent and have been useful on more than one occasion. I'm a strong believer in "Just when I throw it out I'll need it." Hence, I don't throw out my gear. With many abandoning their old equipment, suddenly that old and forgotten sound can become new or at the very least a basis for something new and unique.

Computer: One AMD Athlon 64 X2 Dual Core Processor 6000+ 3 Ghz, 3 GB of RAM, NVIDIA GeForce 6150SE, Realtek high-definition audio; two SATA hard drives, 500 GB and 160 GB; two AMD Athlon XP Processor 1800+ 1.6 Ghz, 1 GB of RAM, NVIDIA GeForce 6800GT, Creative Labs Sound Blaster X-Fi Fatality Edition; hard drives, 160 GB and 40 GB.

Monitor system: BlueSky System Sky One 2.1. I also use consumer Panasonic satellite speakers for my B comparison.

Mixdown: Steinberg Nuendo 2.01 Surround Edition.

Sound modules/VST instruments: Steinberg Strings Edition Vol. 1, Hypersonic, The Grand, Spectrasonics Atmosphere and Trilogy, and various other software and plug-ins.

Keyboards: Yamaha PSR-500, Korg M1, and Roland JP-8080 (rack).

Other instruments: Shakers, bongos, castanets, and whatever makes a noise.

Microphones: AKG Perception 200 condenser.

Additional relevant hardware/software: Motu 828 MK II Firewire interface, Lacie Firewire 120 GB and Western Digital USB 2 250 GB external hard drives, Tascam GS3 Orchestra, and FX teleport (for MIDI over LAN).

Remote recording gear: Digital video camera (What? It's great for recording ambiences, et cetera).

Sound libraries: Vienna Symphonic Library, Prosonus (The Orchestral Collection), Bela D Media (Classical Soloists), Voices of the Apocalypse, and others.

Other Gaming Platforms

Just outside the next-gen realm are other popular gaming platforms you can expect to create audio content for. While those consoles and their home theater playback systems offer a tremendous gameplay experience, there are other ways to have a good time—if not better. Typically, games created on the new consoles will be ported to at least the PC—but

may also see a new life on handheld or coin-op systems. But, obviously, not all games are specifically targeted for the 360, PS3, or Wii. A large proportion are actually created exclusively for the devices which fall within this category.

First-person shooters thrive on the PC because of the very precise control offered with a keyboard and mouse. Real-time strategy games have better luck on a PC as well because of the multitude of menu controls and the easily accessed interface. Other games do well because of the age group of the players and the portability of the device, such as the PlayStation Portable (PSP) and Nintendo Dual Screen (DS). Rarely do any games created for handheld platforms get considered for anything else, so there will be plenty of opportunities as a composer or sound designer to work on exclusive games on exclusive platforms. Working on so many platforms may seem a bit overwhelming and has a tendency to cloud the process, but throughout the differences of technology and integration options the creative mindset will pretty much stay the same.

CD/DVD-ROM Games

CD and DVD-ROM games, for the PC or the Mac, rely on several variables in the scheme of development. Unlike consoles (which have standard and predictable hardware), home computers can have a wide range of processors, graphics cards, sound cards, memory, and peripheral devices that add complexity to the task. Developers must target specific minimum system requirements and hardware standards for their game to work as advertised, but always run the risk of surprises and conflicts. They must decide whether or not to take advantage of any new features, such as surround sound or on-board effects processing. It's a jungle—one fraught with many twists and turns. But for those who work on this platform a high-end PC will always be light-years ahead of any next-gen console.

There are many different ways for a CD/DVD-ROM game title to deliver sound. Many current titles still make use of standard linear music and sound effects—basically those that are turned on and play from start to finish. Some games are blazing the trail with use of interactive audio tailored specifically to what a player may be experiencing at the time. How this is actually accomplished is left to the developer's imagination.

When a game is first installed on a player's machine, several things will happen that affect the sound and how it is used. Considerations such as file size and processor speed will first determine what format the audio will be stored in. Other data elements, such as graphics or program data, will decide what has to be crammed through those skinny little pipes and how it will be done successfully.

CD/DVD-ROM games can make use of PCM (*.wav* and *.aiff*) or compressed formats (*.wma*, *.mp3*, *.ogg*, and so on), Red Book audio, sequenced data files (*.mid*), or any other proprietary format deemed appropriate by a developer. These sounds can be implemented in many ways, with varied results, dependent on the hardware inside a player's computer.

Most game sounds are delivered as an audio data file such as *.wav* or *.aiff*. These are then stored on a game CD/DVD or loaded to the hard drive during installation. Most sound effects will further be stored in the system's RAM as a game is launched for immediate triggering. Those less critical remain on the hard drive. Direct audio such as music (because it is considered a lower priority and because of storage considerations) usually remains on the disc. Music playback will depend on the system resources—whether it is streamed directly from the CD/DVD, bypassing the processor altogether, or buffered onto

the hard drive or RAM. It could also be played as Red Book audio, as you would do it if you put the disc into an audio CD player. It is essential the large file sizes of linear background music not interfere with any other elements of a game. Red Book audio bypasses everything by going from the CD, down a separate wire to the sound card and directly to the speakers. Unfortunately, this type of audio also takes up a lot of storage space and isn't always the right option. With today's effective compression schemes, 256 kbit/sec MP3s (for example) will easily rival uncompressed *.wav* files—and as long as you have a decent sized buffer you're good to go. But, it is a delicate balance indeed.

Once all of the audio is set to play, CD/DVD-ROM games will normally use a licensed audio development tool or library of pre-written code—often referred to as an API (application programming interface) or SDK (software development kit), such as the Miles Sound System as an example—to make an efficient use of it all. If not, they will budget extra time into their development cycle to reinvent the wheel. But for a relatively cheap licensing fee, the time and energy saved is well worth the expenditure. Embedded audio tools can handle most of a developer's needs. A developer has many different ways to present audio, with the following available in a pre-packaged drop-in application.

- Multiple channel mixing
- On-the-fly format conversion
- Volume and panning control
- EQ and effects processing
- Interactive MIDI music with downloadable samples
- 3D surround sound support

You can see why it becomes important that the sound designer and composer know what content is needed, what format, and an idea of how it will be implemented. Overall, doing work for CD/DVD-ROM titles is fairly similar to other game platforms. Music and sound effects will be created in a linear one-shot format or as several pieces for interactive or random use. These will typically be delivered as *.wav* or *.aiff* files, but compressed formats such as *.mp3* and *.wma* are rapidly becoming more appealing for their small file sizes and good audio quality.

Music can be a bit more complicated, with several variables. Linear music can be performed and delivered much the same as sound effects, but obviously as larger files. In addition, it can be burned as Red Book audio (the standard audio CD format)—something you don't normally do with sound effects. They can also be delivered as a sequenced data file, such as *.mid*, to include customized sound fonts which can be very beneficial for sound effects that repeat often. By storing them in the sound card, they won't take up RAM resources and will make room for other applications. Customized sound fonts can change from level to level or scene to scene, providing fresh sounds for both the music and sound effects.

You may also have an opportunity to work with the various formats of 3D audio, interactive music, and many of the latest hardware features of the home computer market. Be sure to keep up with what is happening and you won't be surprised when a developer starts talking about something new. Console game platforms vary little in technology until the next one is developed a few years down the road. Home computers are in a constant state of flux. This type of new technology has a way of subtly creeping into the game market and it behooves you to stay informed.

Composer at Work

Tim Rideout

Tim Rideout, recording artist and music producer.

Are there any particular secrets to your success?

People always want to know the "secrets" of success, of creativity, of how to be a rock star and get chicks. The secret is this: It's not about the music. Potential employers all know you have your act together musically. If you're in the game and in the running for consideration, your music isn't even an issue. It's about everything that goes on *around* the music: your demeanor, your attitude, your deliverables. Were you unpleasant on the phone? Did you use umpteen exclamation marks in your e-mail and write in L33t? Were you disorganized, aggressive, late? If so, you'll come to see that even though your music sounds great people will hesitate to hire you. Because, at the end of the day (when the board is shut off and Windows has crashed), it's all about the people. It's about relationships, networking, and doing something we love. Like being a rock star. And don't forget the chicks.

Do you have a specific ideology that drives your way of doing business?

I don't believe in competition. I think there is enough work for those of us who stick it out, and anyway a producer is going to hire me for me. Plain and simple, there's no one else who does the music that I do—so if you can find your own personal voice and make your art unique you'll never have to worry about so-and-so stealing your job. This will change your whole outlook on the business, too—making you a cooperative player, a team player, a neighbor. If you're always on the lookout to screw or be screwed then I think you should seriously question what you're so afraid of. And perhaps consider therapy. Or at least moving away from L.A.

Any worthwhile creative advice you'd like to share?

I'm so *not* a gear head. I used to record CDs for clients on a Sound Blaster Live. And it sounded great. Why? Because I knew my gear and how to use it. People are all concerned about bits and bytes and such. Kiss my Nyquist. Grab a frakkin' mike, plug it in and bang some crap together. Have fun. Forget about Pro Tools for God's sake. Nobody cares anyway when there are machine guns and aliens ripping your head off! We play the audiophile card because it's fun, yes, I agree. And we love to impress ourselves as to how great or cool it can sound. But when the technology gets in the way of the creativity it's time to get back to the basics: grab the drumsticks.

Nintendo Dual Screen and Nintendo Dual Screen Lite

The Nintendo Dual Screen (commonly referred to as the DS) and the DS Lite are highly portable handheld game consoles released in 2004 and 2006, respectively. As the name implies, the main point of interest is the two 3-inch LCD screens—one of which is a touch screen, which introduced a new dimension to gameplay and more visual space. Under 10 ounces in weight, it carries two ARM CPUs running at 67 MHz and 33 MHz, 4 MB of RAM, and a serial flash memory storage of 256 kB. It supports game cards up to 256 MB, but the drawback for these is their slower data transfer rate compared to smaller 64 MB cards.

Considering the limited processing and storage capacity, audio features are not the highest priority. It does feature stereo speakers, which have the ability to project a form of virtual surround sound using 16 simultaneous channels and a built-in microphone for unique applications. Some games incorporate speech recognition, online chat, or the use of voice as part of the game experience—requiring players to blow or shout. There is also an optional MP3 player variation which plays files stored on a removable SD card.

Creating audio for the DS is typical of older game projects, where memory is a scarce commodity and some finesse is involved to make the music sound good. Audio can be delivered as digital audio, MOD, or MIDI files, depending on the developer and the tools they are using for implementation. Various sound development kits are available for the DS and the available capabilities are dependent on the needs of the game—which will obviously affect the available audio resources in these nonstandard SDKs. In an effort to maintain a small audio footprint, all the tricks of the trade come into play. Digital audio files will be down-sampled and often delivered as mono files. Sound samples triggered by MIDI messages will be massaged to include the smallest amount of notes and instruments needed. The only saving grace is the speakers and headphones are forgiving and high fidelity doesn't make or break the experience.

For a recent DS project, Jamie Lendino created a custom sound bank and the MIDI files to trigger them appropriately and found the composition phase to be the only normal part of the operation. Creating a sound bank within the memory constraints proved a bit of a challenge, juggling sound quality for size, but it was doable and his results were good. The SDK being used had the capability of pitch-shifting the samples within the sound bank to the appropriate notes, and this neat little feature allowed him to use fewer samples and save some room.

The interesting challenge was to not only create a workable sound bank and music which was engaging, but to help keep the implementation process easy and enable the developer to hear the audio as it was intended. Jamie found that unless he was duplicating the Windows Media Player sound set, which the developer could play on their Windows PC, he would either have to record them as digital audio files for the preview, or spend a little time with the programmer to get the DS audio engine set correctly. He found that by helping the developer adjust the sound set, setting specific instrument volumes and fine-tuning everything they could then "freeze" the sound bank so that the entire team could be on the same page and hear the MIDI files as they were meant to be heard. The side benefit was that when the final audio files were delivered all they had to do was drop them into the game and the music was done, without having to do a final mix.

To create commercial games for the DS, developers are required to be accepted into Nintendo's official developer support program. They must be an established "company" with a development team experienced in certain areas to qualify.

Additional information on this aspect is available at the Nintendo Software Development Support Group web site at *www.marioworld.com*.

There is also an enthusiastic "home-brew" network for the DS which is quite robust. Several online resources, which at the time of publication where active, discuss various methods and techniques for creating and handling audio—and while not Nintendo sanctioned, are still a great way for audio folks to learn and confidently work on DS titles. Many thanks to Jamie Lendino for sharing them with us.

- *http://patater.com/files/projects/manual/manual.html#id2537262*
- *http://www.double.co.nz/nintendo_ds/nds_develop4.html*
- *http://osdl.sourceforge.net/main/documentation/misc/nintendo-DS/homebrew-guide/ HomebrewForDS.html#sound*
- *http://www.palib.info/wiki/doku.php?id = day7*

Sony PlayStation Portable

The PlayStation Portable, officially known as the PSP, is Sony's handheld game console—which was first released in North America in the spring of 2005. Competing specifically with the Nintendo DS, the PSP and a remodeled version referred to as the "Slim and Lite" have better overall features than the DS but haven't enjoyed quite the same success. It is the first handheld to utilize an optical disc format, has a larger 4.3-inch LCD screen, and can connect to the Internet, to the PlayStation 3, and to other PSPs. It also doubles as an MP3 and movie player, which makes it much more than just a game console.

The PSP weighs in at only 9.8 ounces, but don't let that fool you. Its CPU runs at 333 MHz (as compared to only 67 MHz on the DS), and its GPU runs at 166 MHz, with 2 MB of VRAM on-board. It also has 32 MB of RAM and 4 MB of embedded DRAM. It is incredibly powerful for its size and game developers can use these features to create some incredibly intense games.

Sound-wise, we're looking at minimal focus by the manufacturer—with only two small speakers and a headphone jack, although 5.1 is possible with the right headphones. But,

considering the purpose and portability of this handheld, it is sufficient. Internally, we aren't faced with anything too unexpected for the handheld market—and creating audio for it is predictable. Digital audio or MIDI files triggering an internal sound set, as we've seen on most other consoles, will get the job done. Space is always an issue, so expect considerable compression, down-sampling, and conversion to mono files to ensure all of the needed assets will fit.

Once you sign a deal with a Sony-supported PSP developer, expect to sign an NDA which will then enable you to get brought up to speed in both the use of the audio engine and the types of files needed on your part. Each development house and game will utilize the available tools a little differently, so what may have worked on a previous PSP project may not necessarily work on this one. But, if you are prepared for a little change of technique, you won't be caught by surprise.

There is also a considerable "home-brew" niche within the PSP community. The good thing for us is the information which is made available with no specific strings attached. Do a little search on the Internet for "homebrew PSP development" and you'll see what I mean. The following are a few sites I thought were worth taking a look at. You'll find many more!

- *http://www.psp-programming.com/tutorials/c/lesson06.htm*
- *http://www.psp-homebrew.eu/*
- *http://deniska.dcemu.co.uk/*
- *http://www.pspslimhomebrew.com/*

Web- and Cell-phone–based Games: Java and Flash

Doing music and sound effects for games can also mean providing content for the web-based or cell-phone–based genres as well. The scale is not quite as grand as other types of games, but they do have their advantages. Where else can you knock out a game a day? Where else could you work on games with various themes every week instead of the same large project that spans several months? The pay is the same (except you're doing fewer sounds so the paycheck *is* smaller, but the fee per sound effect can be billed at your same big game price!) and the variety keeps things fun. I spent many years contracting for an online game company that put out a new game every couple of weeks and eventually amassed more than 60 of them. I had a blast and always looked forward to that next project.

Online web and cell-phone games are typically produced as Java or Flash applications that can be played directly on a web browser or on a phone. They are generally novelty or casino games, with many recently moving toward multiplayer action. They are extremely popular with web enthusiasts and cell-phone users, as well as those who don't like the over-complexity of today's brand of video game entertainment. One popular online game site's demographics found that 85% of their clientele were actually middle-aged women!

The one huge difference between online/cell-phone games and other console games is the need to produce decent quality with very small file sizes. Because developers must take into account the unpredictable bandwidth of the Internet and how users may connect to it, as well as the limited phone hardware capabilities and work within those constraints, content size becomes the main issue. Generally, sound effects are very short in nature—to keep content size to a minimum. Music is a low priority and normally not considered for these types of games but short loops can be used with acceptable results if sound effects are sparse.

In a world where composers and sound designers strive for high fidelity, this type of work may be considerably frustrating. Web/cell-phone–based games must use every trick in the book to keep file sizes to a minimum, which means cutting a lot of corners. Where 44.1 kHz was the norm, it now becomes 8 kHz. Where 16-bit resolution once ruled, 8-bit takes over. There is no such thing as stereo, all files are done in mono. Expect to deliver content as 8 kHz, 8-bit, mono, and like it.

Flash content is converted in its own process with its own compression and can be delivered as *.wav* or *.aiff* files. Some developers will even take *.mp3* files. Java requires the *.au* format using µ-Law (pronounced "mu-Law") compression. This type of compression is a specific algorithm for voice signals as identified by the Geneva Recommendations (G.711), which defined this method of encoding 16-bit PCM signals into a nonlinear 8-bit format commonly used in telecommunications and Java applications. You'll need to become very intimate with this format's idiosyncrasies if you expect to work in this particular world.

Creating audio for these types of games takes a little more finesse than other full-resolution sound projects. I recommend initially creating all content at the highest possible sample rate and resolution, then converting down to what is needed. The big problem when resampling to a low rate such as 8 kHz is that most of the higher-frequency activity is lost, causing severe loss of definition. Listen to a really bad AM radio broadcast and you'll know what I mean. It is essential to keep the end conversion in mind and construct audio that works effectively. Subtle sounds such as "clinking" brass shell casings hitting the ground will sound like small pebbles and that expensive cymbal crash will sound like a cheap child's toy. None of those high-frequency sounds will make it, so don't be shocked. But, on the other hand, you *can* create sounds with predominantly low end all the way down to 4 kHz with great clarity. Do your best to work within the given parameters and make the files as clean and healthy as possible.

Coin-op Games

I've focused mainly on the home market of video games thus far, but there are other systems that we can provide audio for—such as the wonderful world of "coin-op." The highly proprietary games in the big cabinets cover a broad scope and variety of possibilities. Besides the standard coin-op games we all know and love, where the player stands in front of the machine mashing a shelf of buttons, the new generation of games takes on many shapes and forms—from consoles you sit in or ride on to those you stand on and gyrate. The array of audio needed is as diverse as the game platforms available on the market today.

As far as system specs are concerned, coin-op machines are generally designed from the ground up—depending on their mission. The developer/manufacturer will piece together each component for an explicit purpose—its audio parts being no different. Audio subsystems, playback amplification, multi-speaker placement, and other proprietary hardware and software are all designed to meet the needs of the game—and almost no two are alike. There are some coin-op units that use an existing console, such as the Sega games running on their Dreamcast system and Sony's PS2. These units are essentially a home game console with custom peripherals stuck in a cabinet that requires quarters.

There is no one standard for audio generation and playback in coin-op machines, it's all over the map. Composer and sound designer Michael Henry (while at Atari Games/ Midway Games West) did the music and sound effects for the coin-op game *San Francisco Rush 2049*. The cabinet featured a five-speaker fully discreet surround sound system running on proprietary hardware designed in-house for that particular game. There were two main speakers above the video monitor, two speakers located in the molded seat behind the player's head, and a subwoofer in the seat which thumps the player's bottom end. In addition to the use of a five-channel surround music mix, Michael was able to pass real-time sound effects to any of the five speakers. If the car hit a curb, a big THUMP from the subwoofer would rattle the seat. If a car approached from behind during a race, you'd hear it in the rear speakers and the sound would pan to the front speakers as the car passed. Sounds in the environment were also fully positional. If the car passed a giant lava lamp in the Haight–Ashbury track, the bubbling sound passed from front to back and left to right—depending on where the car traveled.

For the coin-op sequel to *Rush 2049, Hot Rod Rebels*, Michael designed a patent-pending audio delivery system that involved actual chrome car exhaust pipes mounted on the cabinet below the seat. Big rumbly dragster and funny-car engine sounds were directed to the pipes to enhance the realism of the driving experience. If you put your hand down near the opening, you could even feel air blowing out of the exhaust pipes. There have also been shooting games where speakers were mounted in the gun, so when the gun was fired, the sound actually came from the weapon. There are motorcycle games where you sit on a realistic-looking molded plastic motorcycle that has a subwoofer and other speakers in the bike for engine sounds.

While many coin-op games may not require such sophisticated audio implementations, it all depends on what the game needs to convince the player they are really "in the game." Therefore, audio systems can often be built from scratch for just one game and then you'd start all over again on the next one.

The original *San Francisco Rush* and *Rush the Rock* (Alcatraz edition) had an interactive audio component. The composer who did the music for these, Gunnar Madsen, came up with a clever implementation for the music. When the player sees the screen where he or she register his or her name, a tune plays with a vocal that says, "What's your name?" When the player finishes entering her or his name and selects End the music seamlessly goes on to a tag that says, "That's your name!" Just one example of crafty implementation. The interactive music component required a custom-designed audio system that involved custom hardware, audio programming resources, and some of the lead game programmer's time.

In the case of *San Francisco Rush 2049*, the developer had a proprietary system to deliver five channels of discreet sound. Michael would make a surround mix of music tracks using Pro Tools and then save out and convert individual tracks. These were then interleaved or multiplexed using a proprietary tool. After he converted the music tracks to this format, a game programmer would add them to the game—and then Michael would go back and audition it in the actual game cabinet and make changes if necessary. In the end, if you want to implement anything in a coin-op situation it will mean working closely with a game or audio programmer. This applies whether it is music or sound effects or any in-game real-time effects processing such as panning, reverb, Doppler, volume adjustments, and so on.

Composing and creating sound effects for coin-op games is like everything else in coin-op: it depends on the game. In the case of the interactive music for the original

"Rush," Gunnar needed to set up sample banks with instruments and score the music using these. At some point, the samples would be transferred to the coin-op, burned into ROM, and played back in the cabinet for testing—after which additional adjustments would be made.

For most coin-op titles, you'd approach composing just as you would for any other consumer platform. There are some differences, however. For example, play times for a level are usually shorter in coin-op than in a typical consumer game—so, long drawn-out compositions are usually unnecessary. The player will almost never hear the end of the music track because the game will be over. Remember, coin-op games are designed to suck the quarters from a player's pocket and several dollars is usually needed just to complete a level.

Unless the game has some specific requirements such as interactivity or another proprietary format, you will most likely deliver audio to the developer as 44.1 kHz, 16-bit, stereo—typically in an uncompressed audio format such as *.wav* or *.aiff*.

As far as a development kit, there are no commercially available audio tools specific to coin-op because most developers design their own. A developer may provide the composer or sound designer with a PC card or software that emulates their proprietary audio subsystem and sometimes with specific software tools to generate content as well. Generally, all you will need is the usual assortment of audio and music software. In the case of console-based arcade games (cabinets with a PS2, Dreamcast, or Xbox inside, for example), the developers will normally provide the audio tools, conversion utilities, and so forth. These are obtainable directly from the companies or through the licensed developer you are working with.

Coin-op is certainly unique. If you walk into any busy arcade and listen for a few minutes, you'll meet the biggest challenge when creating audio for these types of games: simply getting your sound effects, voice, and music heard intelligibly over the general din. Any subtlety in a music track or sound effect will be lost in a busy arcade. Most coin-op audio providers will make sure their audio sounds brighter, either through EQ or some sort of effects processing, to help the audio cut through the noise level in a typical arcade. If you happen to be involved in the cabinet design, clever speaker placement will also help solve this audio nightmare. You don't want speakers that are too far away from the player or amplifiers that are underpowered. Use your ears and listen from the player's perspective. Get out of the studio and into the field. Michael Henry often hits an arcade when one of his games is out on test to hear what it sounds like in the noisy real-life situation.

Previous-Generation Consoles

Gone, but not forgotten, are the previous sixth-generation game consoles still entertaining gamers around the globe. While the commercial gaming world has moved on to the newest money-making consoles to showcase their games, there is still quite an extensive community which creates games for this market. Obviously, these consoles are not as viable as the latest and greatest editions—but with millions of them still in circulation, there is a good chance you could still be asked to create audio for any one of them.

Official manufacturer-sanctioned ventures have given way to an immense community of home-brew, hobbyists, and student game projects which capitalize on the wide array of tools and available information to learn how or to satisfy their need to create. If you're

Tools of the Trade

Kristopher Larson

Kristopher Larson is a composer and sound designer for Tension Studios.

Tension Studios is geared towards multi-channel sound design and composition. I know the strengths and weaknesses of my studio and the scope of my contracts, so I prefer to keep a small but refined tool set in-house that caters to my skills.

Computer: Macs.

Software: Cubase/Nuendo, Logic Pro, Live.

Monitor system: Genelec 5.1 1029a and 7050a, JBL 4408A studio monitors, 5.1 M and K S5000, crappy TV.

Mixdown: RME Fireface 800, Digidesign Digi 002, Tascam DM-24, Tascam DSM 7.1, Dolby DP563 PLII encoder, Dolby 564 reference decoder.

Sound modules/VST instruments: Native Instruments' Komplete.

Outboard gear/plug-in effects: Smart Electronix, Ohmforce, iZotope.

Keyboards: Kurzweil K2000 KS and R, Octave Plateau CAT, Akai AX-60, Sequential Circuits Prophet 2000.

Other instruments: Roland Pad-80 MIDI drum unit.

Microphones: I rent what I need/ I only have a few in-house: Sennheiser e835, 2 x Rode NT-1a, contact microphone, phono cartridge mic, Sound Professionals binaural microphones.

Remote recording gear: Zoom H2, Shure FP-24 field pre-amp.

first starting out in the games industry, finding a project for one of these consoles will teach you far more by doing than you ever could just reading about it. So, if you find yourself with an opportunity like this, it would be well worth the investment in time to take in all you can about the process.

In this section, we discuss the major sixth-generation consoles: the PlayStation 2, GameCube, Xbox, and GameBoy Advanced. Because this is "old news," there is plenty of information available and we know more about them than we do with the next-gen consoles. This makes creating audio for this previous generation a bit easier and definitely negates the need for approval by the manufacturer just to gather information.

So, while you peruse this section consider the differences between their next-gen cousins—what was improved upon and what processes were abandoned. Doing so will help you appreciate the improvements of the latest generation of game consoles and how manufacturers are finally making it easier on the developer and, ultimately, on the composers and sound designers who create audio for them.

Sony PlayStation 2

The Sony PlayStation 2 was the first of the sixth-generation game consoles to hit the streets in North America in October of 2000. While not radically different from the original PlayStation regarding the way sounds are prepared and used, there were still improvements in quality and storage. Most of the effort, it seems, went toward processor speed and graphics support—bowing to public demand for "better-looking" games. The use of the DVD storage medium and streaming capabilities did allow for higher-quality audio than in previous years but it ultimately came down to how the developer utilized the console resources and what elements took priority.

The main processing unit on the PS2 is known as the Emotion Engine (EE), a CPU capable of 128 bits and a clock speed of 295 MHz—supported by 32 MB of RAM. Graphics capabilities are enhanced by a separate CPU, a "graphics synthesizer," and 4 MB of embedded cache VRAM. Sound processing for this console exists on its own, on a processor known as the IOP (input/output processor), to keep from having to share other resources. The IOP has a complement of two SPU2 chips, allowing for a combined local sound memory of 2 MB.

The SPU2 chip allows for high-quality sounds, up to 48 kHz sample rates, although original source files are not required at this high sample rate. Creative decisions still need to be made regarding file size and quality in order to conserve space. For those files that do use a lower sample rate, they will be up-sampled to 48 kHz at the time of output. Generally, most audio will be stored and implemented at a lower sample rate.

As audio is completed, the PS2 requires conversion of audio files to a Sony proprietary format known as VAG (like the original PlayStation). This particular format applies data compression of 3.5:1, which can change the resolution of the sound during output—but overall, it is consistent. Event-based and streamed audio is mixed in the SPU2 using 48 total voices and routed to either analog stereo or digital optical outputs for playback. If the player is using a Pro Logic decoder, they can experience the audio in Dolby Surround instead of standard stereo—a nice feature.

The 2 MB of sound RAM can be utilized many ways, at the developer's discretion. Sound effects can be stored for instantaneous playback, music or background ambience loops can be streamed using RAM as a buffer from the DVD, and sound bank samples can be stored for triggering from MIDI files—or a combination of all three.

This increase in RAM brings many advantages over the original PlayStation. Higher-quality audio and longer loops can be stored on disc, and streamed and better-quality sound bank samples and sound effects can be stored directly in RAM. It is also possible to stream continuous music and background ambiance at the same time, both in stereo or surround.

Direct audio falls into two categories on the PS2: PCM and ADPCM. PCM (pulse code modulation) is uncompressed audio (like the *.wav* or *.aiff* format) used for music and ambience, voice-overs, and complex sound sources. This format encourages a higher-quality sound that uses software-based effects and is easy to implement programming-wise. The downside is its need for high storage space on a disc and its limit of only two channels. ADPCM (adaptive delta pulse code modulation) is a compressed format used specifically for simple sound effects, MIDI triggering, and streaming. This smaller-size file doesn't require as much disc space or processing power but is lower in quality.

If you are an in-house composer or sound designer for a Sony developer, you may be involved in the audio conversion to VAG. These developers are licensed to use the development kit, which includes various tools for conversion. Outside audio contractors will more than likely be required to deliver their music and sounds as uncompressed digital audio files such as *.wav* or *.aiff*. Different developers may request different formats based on their needs, so be sure to check with your project lead to be certain.

Overall, the PS2 console does not limit the process of composing music and designing sound effects. The only real limitation comes when final conversions are made and smaller file sizes are needed, but it won't change your creation process. The exception is if the developer requires a sound bank or instructs you to use one they provide. This will limit you to a 2 MB bank of samples and may change your way of musical thinking. Instead of delivering music in a PCM format, a mutually acceptable sequenced format like *.mid* will suffice. Both methods are workable and you can still provide excellent work.

On one of my PS2 projects, I ended up delivering music cues for direct audio use as *.wav* files, a 2 MB sound bank of my choosing as *.wav* files, the key groups and mapping specific to our mutual sampling equipment and the remainder of music as *.mid* files. The sound bank and direct audio were converted directly to VAG, the *.mid* files and sampler-specific details were pieced together into a platform-workable format—all done by the developer. As the composer, the direct audio cues were a no-brainer. I was able to create music using standard audio production methods and could go all-out using whatever sounds I wanted. The challenge came designing a 2 MB sound bank and composing acceptable cues. In the end, overdubbed percussion and counter-melodies helped keep the music interesting and dynamic despite only having drums, bass, piano, organ, and synth to work with. A PlayStation 2 game project can certainly test your compositional abilities.

Nintendo GameCube

Nintendo's next offering after their N64 console was the GameCube. The physical console size is smaller, but substantial improvements under the hood promised a quality gaming experience. There were improvements in every feature across the board, including a proprietary 1.5 GB optical game disc (instead of the previous game cartridge) that allowed for larger file sizes and more audio.

The GameCube's main controlling unit is a 405 MHz, IBM Power PC, 3D-enhanced microprocessor unit known as "Gekko." Twenty-four MB of 1T-SRAM, considered the fastest RAM available at the time, acts as the main system memory—with 16 MB of auxiliary RAM (A-RAM) as the main source for elements such as sample audio data. Associated with the MPU is the system LSI referred to as "Flipper," where graphics, the AI, and audio processing are accomplished. Despite other elements sharing the pipeline, audio is processed as a separate entity on a special audio digital sound processor (DSP) mounted to Flipper without compromise. This chip is a proprietary DSP with an attached "accelerator" hardware that organizes data flow, decodes PCM samples, and flows audio to the audio interface. The audio interface is a two-channel analog or digital connection capable of 48 kHz, 16-bit, stereo or surround encoded audio.

The basic path of audio begins with data being loaded into A-RAM, where it is moved as needed to the audio DSP for processing. The DSP manages the information; adds any chorus, reverb, or delay effects; and sends the audio through the interface to the playback system. Audio from the optical game disc can be streamed directly to the audio interface without expense to the rest of the program, completely independent of the DSP, or can be routed through the DSP for additional processing if needed. It is completely the developer's call.

Audio can be produced as 16- or 8-bit PCM (uncompressed audio such as *.wav* or *.aiff*) for two-channel playback or as ADPCM (compressed audio) for a maximum of 64 simultaneous-channel playback—all of which is capable of 3D and can be encoded for surround. The Nintendo 64 console used ADPCM exclusively. PCM audio's introduction on the GameCube is a noteworthy enhancement.

The beauty of this platform, at least from a composer or sound designer's perspective, is that no development kit is needed for audio creation. Music and sound effects can be produced as you are accustomed to and delivered to the developer for implementation. There is an audio tool available from Nintendo developer support called MusyX (pronounced "musics") that simplifies implementation, so all the audio creator has to do is deliver the files to the programmer—who then simply inserts them into the game. The advantage is that the final audio mix can be performed by the person with the ears and not by the one who is deep into the code.

The MusyX tool emulates the GameCube audio system and can handle all of the audio needs for a game title. Sound effects, sequenced interactive music, and streamed audio are its main function—but it can also provide dynamic voice allocation and programmable audio macros. All 3D surround functions such as panning, volume and effects processing, and multiple sequencer instances (including cross-fades) can be created using this tool as well.

Sound effects can be randomized and panned easily, without actual loop points. A programmer would only have to make a call to one sound event, which would trigger the sound designer's bank of sounds established using the macro tool. Where there may be several sounds involved triggered at random moments, the programmer only sees it as one instance. The sound designer becomes completely responsible for when, where, and how loud a sound plays.

The macro function is a powerful part of the MusyX tool, designed to free the programmer from having to make creative decisions. When a game company hires a composer and sound designer, they are paying for their skill in audio and now no longer have to be concerned with involving the programmer. This tool can design macros, using provided

templates or by building your own, to be as simple as "start sound, stop sound" or as complex as managing the complete soundscape in an entire level. These macros can even be used in place of MIDI files, with better results due to smaller data transfer.

The GameCube console can play streamed audio direct from the game disc or trigger a sound bank via MIDI or programmed macro files. Interestingly, the system has the capability of using different sets of sound samples—much like sound fonts that can be loaded and used for different occasions. Instead of having to trigger from the same set of sounds for an entire game, this offers the potential of replacing them for different levels or situations—keeping the audio fresh and the player entertained.

As the composer or sound designer, you can expect to perform many different functions for the GameCube platform. Ultimately, you could provide music and sound effects as .wav files, or other PCM audio formats, and either stream them from the disc or trigger them from MIDI files and macros. Music can be delivered either as direct audio or as sequenced data files, which in turn would require one or more sound banks to be created as well. Macro programming may be required using the MusyX tool. However, this tool is not available to content providers unless they are a licensed GameCube developer. Programming your own macros is said to be relatively easy linear programming, so don't concern yourself too much having to learn something complex.

Sound effects creation will be slightly more complex. Instead of delivering single one-shot effects, sounds that can be layered will need to be produced for more options and interactivity. If you are creating a sound effect for a big machine, for example, instead of layering several other sounds into a single file and then looping it over and over, GameCube audio lets you apply components of the sound (such as individual hums, whirrs, and clanks) separately and have them play back randomly without an actual loop point. Be prepared to work with a different mindset. This idea seems to be here to stay.

Microsoft Xbox

The Xbox was Microsoft's first entry into the game console business and was well received. Looking past the initial hype, the capabilities of this machine far exceeded any previous company's attempt at a home game console. With a Pentium III–class 733 MHz CPU, 64 MB RAM, 250 MHz custom GPU, DVD and 8 GB hard drive (a first in console gaming history), this platform was set up to be a powerhouse. Initially, you got the sense that the Xbox was a beefy PC without all of the artery-clogging administrative functions running continuously in the background. Basically, you'd be right—except for the added features designed to move enormous amounts of graphic and audio data.

The main processing unit for audio data is the Xbox Media Communications Processor (MCP), which includes four independent audio processors: the setup engine, Voice Processor (VP), Global Processor (GP), and Encode Processor (EP). Audio data flows from the setup engine to the VP, to the GP, and finally to the EP for connection to the outside world that will give analog or digital outputs in stereo or 3D positional audio.

The setup engine's main function is the setup of data transfer for multiple output streams and to expand 16-bit data out to the Xbox format. By doing this in hardware, it relieves the programmers of having to deal with various software issues to achieve the Xbox format. The setup engine will also accomplish parameter ramping and other housekeeping functions if needed.

The Xbox Voice Processor (VP) is a hardcoded fixed-function DSP. It has a 256-voice synthesizer running at 48 kHz, either mono or stereo—and all running concurrently. Of those 256, 64 can be 3D encoded for surround applications. A single band of EQ, essentially a filter block, is available for specific obstruction/occlusion effects—such as a voice being heard from another room through a wall. A hardware submixer also lies on the VP, allowing any number of the 256 voices to be grouped into different submixes and rerouted back through to make further use of different filters and EQ settings a second time. The 256 voices use the DLS 2 (downloadable sound) standard and allow for an incredible array of possible game sounds and instrumentation.

The Global Processor (GP) is a fully programmable DSP designed specifically for effects processing, but can be used for other things as deemed necessary by a developer. Since the goal is to make sound effects and music more interesting and dynamic, the unit ships as an effects processor with preprogrammed settings. Sound processing using modulation, chorus, compression, flanger, reverb, and distortion is possible out of the box—and a developer can also add capabilities of its own.

The Encode Processor (EP) receives all of the audio data from the GP and creates the final audio output. This EP is capable of real-time multi-speaker encoding and automatic multi-channel mixdown to stereo. It has been designed to handle all aspects of multi-channel data internally, including multi-channel .*wav* files.

The 8 GB hard drive, new to console gaming with this platform, has some very distinct advantages. Because it has a lower seek time and throughput than the DVD drive, the hard drive is used primarily to augment the system RAM. It can serve as a temporary cache or as an audio buffer to reduce hits to the DVD, which will allow other information to be accessed unencumbered. How the hard drive is ultimately used is left to the developer. An average audio budget for an FPS- or RPG-style game was about 6 MB, which works out to about 10% of the shared budget—which wasn't bad for these consoles.

The software used to create and implement audio for the Xbox is based on DirectX 8 and Windows Media software. The basic application programming interface (API), DirectSound, is designed specifically for the Xbox and accomplishes programming direct to the hardware. The DirectMusic API is a complex tool that takes care of most of the audio content design and implementation on a content-driven basis and is created with a program called DirectMusic Producer. With these tools and DirectX audio scripting, the programmer only has to give high-level cues—such as "entered hallway," "fired gun" and "enemy died"—and the sound designer decides what audio events will happen. The composer can react to other cues and design various levels of the same music. For example, if a programmer cues two bad guys in a room as the player enters, the composer would dictate music of low intensity to play as opposed to if the room had 20 bad guys waiting in ambush. In that case, the music would more than likely be at its highest level of intensity as decided by the content provider. The programmer sets up the cues, the composer and sound designers decide what audio plays during them.

Creating audio for the Xbox is essentially the same as anything else. Composers and sound designers can utilize their existing audio editors and sequencers and deliver sounds as .*wav*, .*wma*, or any sequenced data format such as .*mid*. There is no need to learn any new tools just to create audio. DirectMusic Producer is a tool Microsoft provides if you want to do any DirectMusic content, DirectX audio scripting, DLS collections, audio path configuration, or wavetable synthesis. Any work done on the PC is compatible and can

be cross-platformed to the Xbox. However, DirectMusic Producer is not necessary if the developer intends to use strictly linear audio, such as a single music cue playing in the background or standard one-shot sound effects.

The greatest challenge a composer may have when creating music for the Xbox is the need for various levels of intensity for the same music. Film composers may be more practiced at this and perhaps we can take a few lessons from them. The ability to take the same music theme and use it in quiet moments as a soft, minimal piece and then turn the intensity up to 10 during the action sequences makes them perfect for this type of work. Check out any James Bond flick to see what I mean. The familiar theme is *everywhere*.

Music is always in various layers, so it won't be as difficult as it may seem. The lowest level of a piece could be a piano playing the simple melody. The next level up would add percussion. The next would add bass, then a counter-melody, then strings playing in harmony, then full-on drums and electric guitar. It may be as simple as building the massive score at the start and then working backward, taking tracks out one at a time until you reach the simplest form.

Sound designers will have greater responsibility and creative license when producing sound effects. A programmer will set the cue and the audio provider will simply decide which sound effects to play and when. Various sound effects for the same action will have to be created—a lot of extra work. Creating sound effects in different layers and triggering them as needed will keep you on your toes.

Microsoft has taken a new approach to providing support to game creators. Besides standard developer support they are also providing "artist support," where content providers (such as composers and sound designers) can contact them directly for answers.

If you are an artist working on an Xbox title (or even an Xbox 360 project for that matter) with questions or ideas, you may contact them at *content@xbox.com*.

Nintendo GameBoy Advanced

One of the most popular game platforms in our short video game history is the Nintendo GameBoy. This compact handheld device is tremendously popular with our mobile society—where adults and children alike take their fun on the road. Millions of systems and games have been sold over the years, with millions more after the introduction of the GameBoy Advanced (GBA).

Technical specifications for the GBA are impressive, considering it was released in 2001. The 16.8 MHz CPU is capable of 32-bit ARM with embedded memory—versus the previous 8-bit for the GameBoy Color. Memory consists of 32 kb plus 96 kb of VRAM (internal to the CPU) and 256 kb WRAM (external to the CPU). The 2.9-inch TFT color LCD screen is capable of 240 x 160 resolution and 32,768 possible colors (512 of those simultaneously). The audio hardware is basically the same as a normal GameBoy, with the addition of two dedicated hardware sample channels and an improved redefinable channel. The upgraded audio capabilities include:

- Two pulse-wave channels capable of variable-width pulse wave with four settings
- One variable-frequency white noise channel

- One redefinable channel switchable between 16 and 32 bytes, with four volume settings
- Two 8-bit sample channels

It is additionally capable of 32 sampled voices and believe it or not, is also certified for Dolby Surround Sound! Music is implemented on the GBA through a dedicated program code known as the *audio driver*. Audio drivers come in several forms; a basic driver ships with the system's development tools. They are normally workable but require extra finesse to operate correctly. Dedicated drivers are available from a few companies, and while often powerful, they are limited in that they are made to suit as many scenarios as possible and often have excessively high processor times.

The final option, recommended by GameBoy audio creator extraordinaire Will Davis, is the best way to get the most out of a limited chip: get your hands dirty and code your own drivers, customizing them to fit your client's requirements. Very few people these days actually have both the technical and creative know-how to take this route, so an alternative would be to hire a competent audio programmer to work with you.

The limitations of the GBA system will ultimately define the music. If you're composing music in a certain style, you are limited to certain sounds, rhythmic patterns, and other factors that govern why certain pieces of music fall into that genre. The key is to find a palette of sounds that fits the style and fits within the constraints of the project. These confines can actually help composition. If you're composing a piece of music to be played by a pianist on a single piano, for example, you wouldn't waste time composing parts for guitar, bass, and strings.

Some composers who specialize in GameBoy audio will compose straight to the target platform through a dedicated editor and driver. Their composing rig connects to the GameBoy circuitry to trigger internal sounds, so what they compose is what they hear. Final files delivered to a developer will be as *.bin* files for inclusion in the product's code. Another method is to utilize custom audio tools such as the GameBoy version of MusyX, which is much the same as the GameCube version. This program offers macro-based programmable MIDI and sound effects playback to include a Dolby Surround Sound encoder and 32 mixed sample voices that fully support programmable sound generation (PSG) voices adopted directly from the original GameBoy system. Because this program doesn't offer its own sequencing program, musicians can utilize their current software and save the music as *.mid* files for implementation.

The pitfall to avoid when composing for the GBA console is not knowing the limitations of the machine. Even knowing the limitations, experienced GameBoy composers might go a step further to try to beat the machine—to get it to do things it's not designed to do—even if no one else notices. Getting wrapped up in this endeavor, though, often leads to being surprised by a deadline. Running out of memory or running out of processor time can be another problem. Customized drivers generally use only 1% to 2% of the CPU resources compared with the 15% to 30% for ready-to-buy drivers.

The GBA console will certainly challenge any composer. It may even be the last true game composer's machine, at least from an "old-school" perspective. The latest handhelds are powerful enough to stream MP3s. But with this one, you'll really need to concentrate and work within the box to make a melody shine. Keep the tunes simple, clean, and tidy—and remember that spaces or silence between sounds are still part of the music.

Conclusion

Without going into too much technical detail and losing the audio production issues, this is the basic state of today's game consoles. Researching these platforms simultaneously is enough to cause the lines to blur, but I can assure you, once you get into a project on a specific console, it will make better sense. The beauty of music and sound production in this day and age is that most audio can be created using techniques and programs familiar to you without the arduous task of having to adapt to a whole new process. It can get quite involved when the various audio tools (such as MusyX, DirectMusic Producer, and XACT) come into play, but at least these run on the PC or Mac and don't require new and expensive hardware.

Game sound is more involved with many 3D surround options, interactivity and an increase in overall quality. These advances are what will drive audio production for the next generation and it behooves you to become familiar with (if not an expert on) the properties of the latest incarnation.

Composer at Work

Eric Doggett

Eric Doggett is a composer, sound designer, and co-owner of MoonDog Media.

Describe your thought process to scoring a game.

For myself and my partner Raymond Muniz, the process really starts when we discuss the project with the client. We encourage them to talk to us in terms of "feelings" that they want to convey rather than technical requirements. Of course, if they want to get into particular instrumentation we're happy to oblige! But usually, describing the atmosphere as they see it tells us more.

(Continued)

Are there any particular secrets to your creativity?

Sometimes I am reminded about musical approaches that I've heard in pop or film music, and I try something similar with a project I am working on. It also helps to have templates set up and ready to go, so that you aren't wasting time getting ready. I like to have all of my favorite instruments loaded, plus a few open slots for creating something brand new on the fly.

When do you find you are most creative?

I can work in the mornings or the evenings and having two children sometimes requires that. The secret I have found is that I am not usually the most creative when I sit down, but rather after I've been working for a while. Also, I usually get a creativity bump while I am away from the project but still have the melody running through my head. It's important for me to write down these new ideas as they appear.

Any specific "lessons learned" on a project that could be shared?

For us, trying to determine the "quality of the client" is very important. I don't mean in terms of how much money they have to spend, although that's nice too, but rather how they value the music and our contribution. Sometimes we've had clients that view the audio as just another box that needs to be checked, and we try to avoid those projects. We'd rather have a project that pays a little less where the client is excited about working with us. This doesn't always work and there are times when we take a project because of the money, but we always try to understand the value of our work to the client beforehand.

Do you have any negotiation techniques or stories others could learn from?

We try to get an idea of the client's budget first before talking expenses. Sometimes, you get wrapped up in the particulars of a project only to find out that the client can't afford it. We also offer alternatives at different price points to get something close to what they want.

Do you have any development stories that serve as a "good lesson" learned or something that can be avoidable in future projects?

Be sure to take ownership of your part of the project early. Let the team know that you are there to help them and do your best to facilitate their work process so that they can think of you as someone that is really looking out for the project.

Do you have any sound design creation techniques that resulted in something interesting?

For the intro animation of our web site, I recorded my dog Queso running across the hallway tile. I must have recorded that ten times to get something usable. Poor Queso— he didn't understand why he had to run back and forth so many times!

How did you find your way into the games industry?

My wife and I left Washington, D.C., in search of a more fun, creative city, and landed in Austin, Texas, where I met Raymond. Since that move several years ago, I've been very fortunate to work on fun, exciting game and film projects in the Austin area. I don't think we'll ever move!

For the Developer

If you are a game developer, or happen to play one on TV, this chapter is specifically designed with you in mind. There are many aspects of "all things sound" that musicians and sound designers have gathered over years in the trenches, most of which are never fully understood by the nonmusical artisans. The intention of this chapter is to shed some light on these invisible subtleties and to talk about audio issues in general.

As a developer, audio often tends to be the misunderstood entity in creating a game. There is a certain psychology that can be applied to enhance the gaming experience in regard to audio content providers. It's not merely adding music, sound effects, and narration and hoping it works. There has to be a definitive plan to make it work right. More times than I care to remember, I've heard game players complain about a game—not about the graphics, not about the game play, but about the sound. Why is that? Were their expectations too high? Was there too much audio bombarding their senses? Was the audio just bad? There are other audio issues to deal with in conjunction with making the content pieces fit.

- What if you need to hire a game composer, a sound designer, or some voice talent for your project? How would you go about finding them and the one that fits perfectly? Game composers don't normally advertise in the local phone book, that's for sure.

- What actually goes on with a composer/sound designer after you've made the order for audio content? Music and sound effects don't magically appear. There is some serious work involved. By having a general idea about what goes on behind the scenes, your expectations will more closely match your requests.

- What can you do as a developer to make dealing with an audio contractor a fruitful experience? Certain guidance and motivation is needed. A developer can certainly influence the quality of the audio content by their interactions with the contractor.

These are all valid concerns—ones which, in my conversations with many developers, appear to be the "questions of the day." Answering and understanding them will help make the process of game creation easier for all of us.

Understanding Sound

Video games are pure entertainment that stimulate many of our senses. The ability to provide quality sound happens to be one of the most recent technological advancements to game evolution. We've had graphics drawn with millions of colors and worthy artificial intelligence for many years, but decent audio implementation and playback systems have

Tools of the Trade

Kurt Kellenberger

Kurt Kellenberger is a sound designer for Sony Computer Entertainment of America.

I feel somewhat blessed to be an in-house sound designer working on triple-A console titles and spoiled by the generous resources available to me. It is a lot to live up to! I love the technical and artistic challenges presented by working on interactive audio. I am thrilled to be a part of teams that are consistently striving to innovate and appreciate the contribution of audio to that end.

Computer: Mac: Dual G5, PC: Dual P4, MacBook Pro (home)

Software: Proprietary implementation tools, Sound Forge, Pro Tools, NetMix, Peak, Max MSP, Pluggo, Audiofile Engineering (Sample Manager, Wave Editor, Loop Editor, Spectre)

Multi-track system: Pro Tools HD

Monitor system: Custom Chris Pelonis Signature Series speakers and amps (5.1), Genelecs (5.1), Dynaudio (2.0), Blue Sky (2.1, home)

Mixdown: Yamaha DM1000, Pro Tools

Sound modules/VST instruments: NI Komplete (Reactor, Absynth, Battery, Kontakt, Massive, Vokator), Reason, Atmosphere

Outboard gear/plug-in effects: Waves Diamond bundle, Altiverb, TL Space, Pitch 'nTime, Speakerphone, SoundToys, GRMTools, SurrCode

Keyboards: Novation ReMOTE SL25

Other instruments: Martin D-15 acoustic

Microphones: Sennheiser MKH416, MKH70; Neumann KMR81i, RSM191, KM184, TLM103; Sanken CSS-5; DPA 4007; Shure SM58, Crown PZM; AT 825; various binaural mics

Additional relevant hardware/software: PS2, PSP, PS3 reference tools and debugger stations

Remote recording gear: Fostex FR2, Tascam HDP2, Sound Devices 722, PCMD1, Zoom H2

Sound libraries: Hollywood Edge, Sound Ideas, proprietary SFX library

not caught up with our expectations until recently. With these new advancements, we are discovering the need to be skillful and in control of what the player hears and feels on an emotional level.

The games industry is experiencing what the film industry encountered when sound was first introduced into movies. Technology has advanced to the point where those simple "bleeps and bloops" have given way to 8-channel surround sound, full orchestral scores, Hollywood sound effects for every tiny thing, narration, celebrity character voices, and now multi-player voice interaction—all competing for a player's attention. The aural experience has gotten literally insane!

Our goal is to use the music and sound to enhance the player's gaming encounter, not distract them. We want the players to enjoy the audio, not turn it off. We want them to become totally consumed by the sights and sounds of our creation. We want them to tell their friends! Before that can happen, though, we must understand what sound can and cannot do for us.

The Psychology of Sound

There is a certain psychology associated with what we hear and what we experience. Throughout our lifetimes, on an individual basis, we have each encountered sound. Our reactions to it vary depending on the events associated with those sounds and the context in which those sounds are presented.

For instance, the sound of tires squealing can have a wide range of emotions attached to it. If I'm sitting at a stoplight and hear a tire screech close by, my first reaction is fear, an accelerated heart rate and a quick look around to make sure I'm not about to be hit. Once I see it's a car of teenagers peeling out around a corner, my emotion turns to anger at their recklessness. But, as the light turns green and all alone at the intersection, I mash my foot on the accelerator and smile as the tires fight to grip the pavement, I feel exalted as I return to my younger years. The same sound, three different emotions.

Sound effects in games serve many functions. Primarily, they are a method of aural feedback that simulates what you would hear if you were actually in the game. If I shoot my weapon and it's not empty, it goes "bang" instead of "click." If I hit something with it, it goes "thwack-oomph-thud." If I depress a button and it opens a door, it goes "whoosh." Every direct action has a corresponding sound reaction.

Sound effects can lend believability to an otherwise unbelievable place. Ambience and general Foley sounds bring a scene to life and lend an air of realism. For example, a good driving game will use sounds of city life, wind, scenery ambience, and even animals—all of which we have heard ourselves in our travels. We expect to hear them and are satisfied when we do, even on a subconscious level. These sounds don't have to be "in your face" to do the job, they just need to be there somewhere in the background.

Guttural satisfaction cannot be discounted either. Sound effects are also designed to entertain and wow the player. Hollywood goes with bigger-than-life sounds and games can, too. After spending 5 minutes in a battle with the big bad guy, you want to hear something to make the effort worthwhile. This little sonic reward can bring a smile to the player's face and keep her or him coming back for more.

Music has an equal effect on us as well. A fast tempo raises our heart rate, a slow tempo makes us relax. The choice of instrumentation, whether soothing or obnoxious will have an effect. Events associated with certain music can trigger flashbacks whether they are pleasant or not. Music can set the stage and place us in a different world, a different country, or a different time. Music can make you laugh, make you cry, make you aggressive, make you docile, make you feel love, or make you hate. It is a powerful force that when used properly, can bring an entirely new dimension to a gamer's experience.

Music is primarily designed to create a certain atmosphere or feeling for the player while in the game world. It can create a dark and mysterious world, adding tension and desperation to reinforce the seriousness of a situation. It can be silly and fun, clowning around to keep the mood light and upbeat. Music, like sound effects, can also add a sense of realism. Whether the scene takes the players to the Wild West or to India, the musical accompaniment helps put them within that setting. If it is done correctly, it will not only provide a hint to their location but serve another purpose: to give the game experience a pulse. Driving games usually have tracks throughout the world players can test their skill on. Most of these types of games will have an emotionally upbeat and fast tempo which keeps the game moving. Techno or rock serves this purpose well and by adding an instrument native to that particular locale, it provides an obvious personality to the scene. Creating a rhythm, whether slow and thought-provoking or fast and out of control, can be done through the use of appropriate music.

By understanding the effect and exploiting the deep-rooted psychological aspects of music and sound, video games can be taken to the next level of believability and entertainment. It's not a difficult prospect, just one that requires some thought and proper planning. Remember the power, then be sure to turn it on.

Soundscapes

Chapter 10 discussed the concept of a soundscape in detail, but I want to reiterate the importance of this useful philosophy just in case this is the only chapter you dive into. Basically, the game soundscape is every element that makes sound: the music, the sound effects, and the narratives. It is the purposeful blend of these elements that form an organized presentation known as a "soundscape." Without this type of order, there is audio chaos.

As a developer, you must concern yourself with the overall balance of graphics, gameplay, and audio. Before you can do that in earnest, though, you must treat the audio features as a single entity—as the soundscape. Some developers have dedicated audio directors or producers whose sole function is the coordination of the project's sound. Others utilize a single person or audio company for the music and sound effects and rely on their expertise

to harmonize the efforts. Both are steps in the right direction and I applaud those who are serious enough to pursue these routes.

The complexity and density of any music will first be determined by its purpose. If it serves as an opening sequence, a cinematic score, or menu screen music, it can be busier. If it is to play as background ambience, extra care should be taken to make the music simple—using less counter-melodies and percussive elements. If the music serves its purpose, it won't compete with other audio.

Sound effects should normally take priority in the soundscape and not be buried in the music. Music with a lot of mid-frequency activity will encourage the design of sound effects that stick more to the high- or low-frequency ranges. If sounds are created with the music in mind, they can be designed to complement the sonic activity already in progress.

Narratives, or voice-overs, are primarily located in the middle of the frequency spectrum. Instruments such as piano, organ, guitar, and saxophone have dominance here, too. A concerted effort must be made to prevent a blazing guitar solo to play over important narration, a game-winning clue could be lost in the melee.

When the final audio pieces are assembled, take some time to ensure an equitable mix. The first instinct is to reduce volume levels of offending audio in order to hear those with priority. If there is time before the project deadline, resist that urge and look for other solutions instead. All it might take is an equalization adjustment to make the one stand out or to produce a hole in the spectrum. You want all of the audio to be heard clearly. Pulling a sound out of the mix is like casting it aside. Why was it created in the first place? All of the audio serves a purpose and it is extremely important that it be heard as intended.

Composer at Work

Adam DiTroia

Adam DiTroia is a composer and sound designer.

(Continued)

Describe your thought process for scoring/creating sound effects.

My process usually starts with collecting as much information as possible about the project. I love to do research and learn as much as I can about the subject matter, storyline, characters, et cetera. I also tend to be very inspired by visuals. Anything from rough concept art to finished cinematics help me get "fired up" and in the right mindset. From there I try and put together a sound palette (a wise author of game audio books once suggested that!).

Are there any particular secrets to your creativity?

Clinical insanity. Seriously, though, I'm not sure—to be honest! Again, I think it comes back to surrounding myself with the subject matter in whatever way I can. And although it's been said before, a deadline definitely juices up the creativity!

When do you find you are most creative?

I tend to be more creative at night. That seems to be a pretty common thing among composers, actually. My theory is that it stems from all the years I spent playing in bands— late nights and all that. I actually still play in a weekend thing for fun and I love it. And again, if something is needed right away I can usually "turn it on" when I need to.

Any specific "lessons learned" on a project that could be shared?

Honestly, I've been very fortunate to work with extremely professional and talented developers so far. I think one of the most important lessons I've learned is to trust my instincts. For instance, there have been times when I've passed on a project because I just didn't feel I could give it a hundred percent. It could be because of too many other commitments, not my strongest style, or a number of other reasons. Don't be afraid to do that. It will come back to bite you if you take on more than you can handle. And passing a gig on to another talented composer/sound designer is always appreciated!

Do you have any negotiation techniques or stories others could learn from?

I think it's important to remember you're ultimately on the same team. They want great audio for their game and you want to provide it. Don't bring a rock-star or cocky attitude to the table. And do your research on what's acceptable and typical on a deal. That being said, never be afraid to stretch the boundaries and try and help the industry grow and progress. Game audio has come very far but we still need to constantly stay educated and help educate developers and publishers.

Do you have any development stories that serve as a good "lesson learned" or something that can be avoidable in future projects?

I think one of my biggest learning experiences was working on the Nintendo DS. I've created music and sound effects for several DS titles, but in the beginning it was a very new experience. I made the mistake of not doing enough research and just

jumping in. One way to deliver DS audio is a combination of MIDI files and triggered instrument samples. I ended up spending extra time revising MIDI files to make sure they included things like patch change messages, bank change messages, et cetera. If I took some time in the beginning and made sure that was all done before I delivered the audio, it would have been much more efficient and just plain easier on the developer and myself. But, fortunately I've since learned my lesson and now DS titles are always looked forward to and a lot of fun.

Do you have any sound design creation techniques that resulted in something interesting?

One thing that comes to mind as far as sound effects: I filled one of those big metal salad bowls up with varying amounts of water and struck the side with a metal spoon. It produces the coolest natural flange/phaser sound. That raw material turned into sound effects for several projects including *Looney Tunes: Duck Amuck* (Warner Bros. Interactive/Wayforward Technologies) and *Dino Hunters* (Kuma Reality Games).

How did you find your way into the games industry?

I started out scoring mods for games like *Unreal Tournament* and others. There are some very talented groups out there creating not only modifications but full "total conversion" games. *Red Orchestra*, for instance, started out as a total conversion. I wasn't involved with the audio for that game, it just comes to mind. From there I did my first game, *Taxi 3: Extreme Rush*. It was my work on that game that got the attention of my agent, Bob Rice of Four Bars Intertainment. It helps to have at least one commercial title under your belt when looking for representation. Getting projects to work on is constant work.

It takes a tremendous amount of patience and perseverance on your part to get the attention of developers. I'm still chasing the "big break" but I am extremely passionate about what I do and wouldn't change it for anything. I would like to say that you have to remember that this is an industry full of people who love games. Relationships are vitally important. Once you have an "in," be professional, humble, creative, and a team player! Honestly, the first edition of this book helped me tremendously. It was an extremely valuable resource for me and to many others! Thank you, Aaron.

Size versus Quality

Composers and sound designers normally create their audio product with excellence in mind. Music and sound effects are saved to digital files that can be quite large in order to preserve their sonic integrity and high quality. The typical standard is:

- 44 kHz sample rate
- 16-bit resolution
- Two-channel stereo

Each minute of this format produces a file size of roughly 11 MB and an hour of this audio can almost completely consume the space on a CD—leaving little room for anything else. As a developer, the amount of storage space and processing speed available is of great concern. For all elements of a title to fit into a nice, tidy package, priorities are made and file sizes are economized.

In the end, only two aspects of a game have the ability to be resized to conserve valuable storage: graphics and audio. Smaller graphic files with fewer colors and pixels equal a grainy, unrealistic visual presentation. Graphic artists can balance their artistic vision and file sizes by adjusting parameters to an acceptable conclusion. Sound artists face similar considerations.

To make a smaller sound file, the sound quality must be degraded in such a way that less information will be stored. We can do this by lowering the sample rate, the resolution or the number of channels to a size which is more palatable. While compression schemes such as *.mp3* and *.ogg* are available which solve this dilemma somewhat, understanding what the reduction in file size does to the quality will help convey that neither compression nor sample rate/resolution reductions are without a cost.

The following table (from Chapter 7) has been reprinted here for reference. When asked to reduce a file's size, I will first decide how important the stereo or surround image is. If converting to mono doesn't make an appreciable difference, I do this first—cutting the file size in half. Or, for slightly less audio quality but maintaining the stereo field I could reduce the sample rate to 22 kHz. Either way, the quality of the sound is less affected by a higher sample rate. Frequency degradation becomes obvious as sample rates are lowered and the sound quality starts to collapse. The very last choice I would consider would be a change in resolution. Sixteen-bit audio resolution is better than 8-bit, but it is also twice as large in size. Eight-bit resolution is prone to excess noise and care should be taken to ensure the audio volume level is louder than any noise by-product associated with the loss of resolution.

Memory Storage Requirements for 1 Minute of Sound						
Type:	Mono	Mono	Stereo	Stereo	Encoded Dolby Surround	Encoded Dolby Surround
	8-bit	16-bit	8-bit	16-bit	8-bit	16-bit
Sample rate (k):						
96 kHz	5,626	11,251	11,251	22,501	11,251	22,501
48 kHz	2,813	5,626	5,626	11,253	5,626	11,253
44.1 kHz	2,646	5,292	5,292	10,584	5,292	10,584
22.05 kHz	1,323	2,646	2,646	5,292	2,646	5,292
11.025 kHz	661.5	1,323	1,323	2,646	1,323	2,646
8 kHz	480	960	960	1,920	960	1,920

Each year, the quality of video game music and sound effects gets closer and closer to that of movies. As the sound quality increases, so does its file size and the trade-off between size and quality must be debated.

Always specify that you want your sound effects originally created in the highest quality possible.

Because new technology is now becoming more mainstream, some development teams may soon opt to go even higher—to 96 kHz, 24-bit audio. Why? Because you want to develop the sounds in the highest fidelity and then convert down to what is needed for the game. If a game needs 22 kHz, 16-bit, stereo audio and it is discovered later that it can fit 44.1 kHz, 16-bit, stereo, it may already be too late for the content provider. Attempting to convert up almost always adds unacceptable noise to a recording. You can't do it. You usually have to start the entire recording process again from scratch.

One company decided to do a television commercial for its game and wanted to use original effects. They contacted the sound designer who worked on the project and requested their sounds in 44 kHz, 16-bit, stereo. Unfortunately, he didn't have them at that sample rate and proceeded to spend a few sleepless nights recreating them. It would have been just a few minutes of work had they already been available. These days, computer storage space is inexpensive and larger file sizes aren't a burden. Encourage your contractor to use the highest quality, for the game's sake *and* for future possibilities.

This quality-versus-size issue basically comes down to a final trade-off: what quality of sound is acceptable for its affected file size. Be sure to discuss with your sound people what they recommend, if there is a choice involved. Their expertise and quest for high standards are a perfect source for advice. Sometimes (especially with Java and Flash games), 8 kHz, 8-bit, mono files are about all you are going to get—and you'll just have to make the most of them. There won't be any options. But, overall, the higher the sample rate and resolution, the better the sound quality—and this is what we should all be pushing for.

Working With Contractors

The process of determining the appropriate audio content, creating it, and then implementing it isn't always a painless experience. Game producers and contractors alike need to understand each other's professional needs and responsibilities so the audio creation process becomes less grueling for both. This section describes the process of determining what you will need from a third-party audio expert and what that person will need from you.

Early concepts of art and gameplay have a tendency to change and continuously evolve, so music and sound design at the outset of a project is usually a grand waste of time. Producers have the difficult task of trying to determine the audio needs of the game early in the development cycle, and if a contracted sound person is used, the producer must find someone whose skills and credits match those of the game being developed and negotiate a contract. When you are spending $30,000 for sound effects or $75,000 for music, for example, you want to get your money's worth.

Take a long-range look at what sort of sounds the game may need, such as general Foley sounds, imaginative or "far-out" sound effects, music, and narratives. Specify whether or not your game will have a wide range of settings and characters. It's important to bring the development team together to begin thinking at least conceptually about the game audio as early as possible. If you've decided on a composer and/or sound designer, bring them in on the discussions and listen to what their experience has to say. Much time

can be saved and the process will have more grease for a smooth ride. Don't be tempted to wait on the audio implementation details until later. However, as mentioned in Chapter 9, starting work on the actual game audio too early in the process often leads to major headaches down the line.

When a game is far enough along (for example, at the point when characters, movements, and a defined gameplay model are present), the composer and sound designer should enter the picture. By allowing them to meet with the development team, view some rough game levels and perhaps see some animation sketches. Their idea machine will begin to churn out possible routes to take. A few specific questions will bring direction and needed information together to start off smartly.

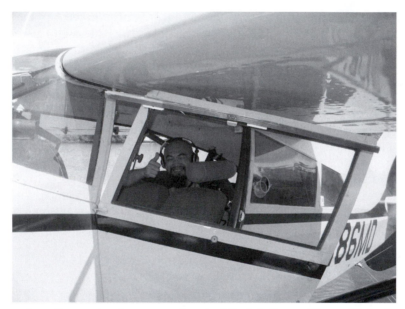

Original sound creation can involve some serious logistical challenges. Watson Wu had to procure a seaplane for a recent recording session in southern Florida.

Reconnaissance and Homework

The actual task of finding a third-party contractor can be as arduous as creating the game itself. Unless you've worked with a particular audio team in the past and are comfortable using them again, you'll need to take care of some advance work. This type of investigation can be done painlessly if done during downtime or between projects and not at the last minute.

Even before the project is put out for bid, the media buyer can do his homework. Investigating various audio companies and individuals beforehand is a good idea to help stay ahead of the game. Web search engines can help, developer resource web sites are prevalent, and the numerous unsolicited e-mails, inquiries, and resumes can be (finally) taken advantage of. Because everybody knows everyone in the games business, you could also touch base with your counterparts at other game companies and find out who they use. Word of mouth and networking are powerful resources, so be sure to use them to their fullest. I've gotten most of my jobs that way. Request a current demo reel, references, and past work examples and retain on file until the time comes.

As of publication, the web sites that follow in the table "Selected Web Links to Investigate for Gaming Project Help" were available for industry-wide talent (not just sound artists but programmers and graphic artists)—many also serving as general development resources.

Selected Web Links to Investigate for Gaming Project Help	
Gamasutra.com	*www.gamasutra.com*
Music 4 Games	*www.music4games.net/directory.html*
Game Audio Forum	*www.gameaudioforum.com* (specifically, the job-posting section)
Game Audio Network Guild	www.audiogang.org
Google	*www.google.com/Top/Games/Video_Games/ Music/Composers/*
GameDev.Net	*www.gamedev.net/gamejobs/*
Nextcat	*www.nextcat.com* (go to the Gaming tab and from the left menu select "audio designer" or "music composer" for listings)
LinkedIn	*www.LinkedIn.com* (do a search for composers or sound designers)

When that time does come, the producer alone (or with several of the team members) should sit down to evaluate the submissions. Generally, you are looking for:

- Great work
- Creativity
- A shared vision
- Reliability
- Experience
- Someone who you feel can work with the team for the length of the project

After the field has been narrowed to a couple of choices, pick up the phone or invite them over. It's a good idea to actually *talk* to the candidates. Check their production schedules (some busier sound guys are booked two to three months in advance), ensure they will be available, see which one you feel is best at communicating and receiving ideas, and who you can get along with. A gut feeling will tell you the one who is right for the job.

So, now we've moved from the courting stage of our business relationship to engagement and the possible commitment of marriage. Both parties bring their interests (and sometimes lawyers) to the table and work out an agreement both feel comfortable with. Overall, negotiations for sound design are fairly simple. More complicated negotiations come up when music creation is involved, such as hashing out ancillary rights, payment for different SKUs, bonuses, property rights for soundtrack

releases, and so on. Spend a little time working out an equitable agreement. That is, get the business out of the way so you can focus on the creative aspects of making a great game.

The key contract point is the cost the developer will incur for the audio services. Price varies per contractor, each has a different overhead to meet and costs that need to be covered. Some, with more experience, can demand more—which will definitely be worth the price for the maturity, experience, and hassle-free production. Other factors can increase the price too, such as:

- Rush jobs
- Special requests
- Processing prerecorded narration
- Auditioning, hiring, and producing voice talent
- Abnormal amounts of revisions or change orders

So, do your best to plan ahead. When it comes to the bottom line, the final costs are, of course, negotiable—but don't expect the contractor to work for free or below their expenses. It costs money to be in business and we want to support those who work hard for our cause.

Tools of the Trade

Matt Piersall

Matt Piersall is a sound designer and composer for GL33k.

Okratron5000/GL33k is a small sound design house *strictly* dedicated to game audio asset creation and implementation. All of our designers have very similar setups, which at the end of the day are pretty simplistic. While our gear is very good and capable, it's not overly fancy. It does its job and we know our rigs very well.

Perfectly tuned rooms and 40-k Pro Tools rigs are overrated and unnecessary. We moved our entire studio to Austin in one UHaul and I'd like to keep it like that. It's the talent, not the tools (but sweet hot gear is still sweet and we've got some of that).

Computer: Design computer, Mac G5s; implementation computer, Windows Machine 3 GHz; 8800 video card, gangs of RAM.

Software: Sound Forge, Pro Tools, Ableton, Logic, XAct, Unreal 3.

Multi-track system: Pro Tools LE.

Monitor system: Monitors A, Blue Sky Media Desk (pretty cheap, pretty sweet); Monitors B, Mackie 824s (way more expensive and less representative of a gamer's rig but still good to have around).

Mixdown: Mix using IK Multimedia's ARC in Pro Tools.

Sound modules/VST instruments: Native Instruments' Komplete, StormDrums, Symphonic Choirs, Microtonic.

Outboard gear/plug-in effects: Native Instruments' Komplete, Sound Toys Native, Waves SSL, Waves Gold, GRM Tools ST, GRM Tools Classic, Pluggo, Audio Damage Destrukto, KymaX, FabFilter Timeless, FabFilter Volcano.

Microphones: Rode NT4, Shure SM57, Sennheiser 418, Sennheiser 421.

Remote recording gear: Fostex FR2 LE *2, OctePre (when remote recording with Pro Tools LE), M-Audio Microtrack, Apogee Mini Me.

Sound libraries: A *lot* of stuff, recorded and purchased. Too many to list.

Questions Composers and Sound Designers Will Ask

When a developer has made the final contract negotiations and the documents are signed, the other details regarding the project are released to the audio provider. This is the point where "clear and concise" means the difference between complete audio bliss or a sound disaster. Words have a way of meaning different things to different people and the sound guy will ask for the specifics in order to make it crystal clear. (For more information, see "Asking the Right Questions" in Chapter 5 and "Meetings with the Game Development Team" in Chapter 7.)

What is the intended genre for the game?

You want the music and sound effects to follow the spirit of the game. Make sure you give your sound contractor a feel of what the game is about, what genre it falls into, and what similar games are available.

What sample rate, resolution, number of channels, and file format is desired?

The development team will have done all of its math to determine how much space and processing power will be allotted for graphics and sound. This will help decide how high the sound quality can be and what parameters the audio will be created within.

Will sound effects be altered by any software or hardware processors?

Driving games are one example where the reverb effect is used quite frequently. This is the kind of information the sound designer needs to know. Additional processing by a game engine will determine to what extent certain sounds are processed beforehand by the sound designer. (If a sound designer applies reverb to a sound the developer had planned on applying reverb to in the game, that could be a problem.) Decide as soon as possible if there are plans for this type of processing and communicate them. That way, the sound designer is sure to not over-process any files. Music is normally left untreated, but be sure to let the composer know if her or his music will change in any way.

Are any ambient sounds or music tracks needed?

We don't want to have the player distracted by silence. This question may jog memories or give you ideas not thought of previously. If you intend for music to play instead of ambient sounds, communicate it. This will prevent a phone call late in the production cycle for forgotten pieces.

Will certain audio have priority during playback?

There can be instances during gameplay when one single sound or musical cue punctuates the moment. All other sounds become irrelevant and this one bit of audio takes priority. Because other sounds won't be drowning them out or playing over them, you won't have to make considerations for other effects or music being heard at the same time. By pointing to them, the sound designer or composer will know which ones to make shine.

Will there be any voice-overs or speech commands that need to be heard?

A composer or sound designer can also be involved with processing speech via EQ or volume to ensure they can be heard and understood. This is a similar process to having the vocals stand out in a song mix. It will also give the audio contractor indications if room is needed in the soundscape for speech and they can leave frequency holes for them to be better heard.

Are any narratives needed? Will there be background sounds or music to accompany narration?

Narratives fit into the sound recording category and generally anyone capable of music and sound design can also record narration. If you already have narratives recorded, the sound artist can often provide the service of transferring to digital file, maximizing the sound, cutting them to length, and adding any additional background or Foley sounds. If narratives are to be recorded, they would need to know if they will be providing the

Many audio contractors can also handle dialog needs including auditioning, hiring, and recording actors—even celebrities. Ian McNeice (*The Black Dahlia, The Hitchhiker's Guide to the Galaxy, White Noise, Bridget Jones' Diary*, and *Around the World in 80 Days*, to list a few) is one of the many Hollywood actors available for voice work. Ian is seen here recording for the game *I, of the Enemy*.

voice talent and budget accordingly. A good question to ask your prospective sound artist is if they have any experience directing narrative sessions. Or make it clear the games producer or another designee will fill that role.

Any special sound considerations?

Is the game intended to be a trendsetter with Dolby Surround Sound, DTS, and studio-quality speakers or subwoofers? Are you planning to advertise the game's cinema-quality sound?

What platform are they creating audio for?

This information will suggest what type of playback system the consumer will likely use. This indicates the confines for the final music and sound effects. As sound people, our interest is to make submissions work well with all audio systems—from dime-store speakers to high-end studio monitors—but the main focus is on the system the majority of players will be using.

What type of music, if any, will play as the sounds are triggered?

This would give the sound designer an indication of what other sonic activity will be happening during gameplay. If the music intends to be a soft orchestral score, the sound effects can be geared to that mood and not sound obtrusive. If a rock soundtrack is to play, harsher sounds and careful manipulation of an effect's higher and lower frequencies will ensure these stand out. The sounds should all work together to enhance gameplay and not fight for attention. The composer could also leave room in the frequency spectrum for certain sound effects if they know about them ahead of time.

Are any sound resources available to the composer or sound designer for licensed materials?

Some games are based on film or television properties produced under licensing agreements. If you have secured use of the *actual* sounds or music from these works, does the composer and sound designer have them at their disposal to manipulate for the game or are they expected to recreate them? While the sound designers may not have an actual hand in creating any sound effects originally, they are equipped to convert them to the proper formats and sample rates and need to know if this service is desired, too.

Are any special file-naming conventions required for final delivery of audio?

If the development team is organized, or if they waited until late in production to bring an audio provider on board, they may already have file names embedded into the code. While renaming files is not a big deal, it may help cut down on any confusion when delivery is made if they are already named appropriately.

Getting to Work

The contractor has been hired, the previous questions have all been answered, and we are off to a good start. This is a good point for you to assign the one or two individuals to act as the liaison to the composer and/or sound designer—someone responsible for communicating specs, signing off on the work, and so on. This will prevent mixed signals, ensuring clear and effective communication—*the* key to obtaining sounds that match your vision.

This is the point where the audio creation process begins in earnest. If it is a locally based contractor, have them stop by, meet the rest of the creation team, and discuss the game's intention. If they are unavailable for a visit, consider sending copies of artwork, storyboards, and any story text that may have been written. If there are any animation ideas, movie promos, or even a rough version of the game available, send those along, too. Now is not the time to keep secrets. The contractor has signed an NDA, so there should be no fear. They are part of the team and on your side.

Working With Sound Designers

There are several ways sound effects needs are conveyed to the sound designer. A sound list could be delivered, specifying a description of the sound, what it is used for in the game, and the requested duration. I refer to this as a "wish list" because often enough it never gets totally fulfilled. Numerous changes in the game see to that and what initially seems like a good idea at the time becomes something different later on. For more information, see "Sound Effects Lists" in Chapter 9.

An alpha or beta version of the game can be delivered with placeholder sound effects already in place. General library sounds or effects taken from other games can be inserted, giving life to soundless artwork and to show the sound designer where new effects are needed. Other placeholders can be words instead of sounds, such as *click, explode,* and *shot.* As the designer plays the game, they create a sound to match the action.

For a better idea of what it takes for a sound designer to craft audio, see the example in the section "Effective Creation" of Chapter 9.

Providing the audio provider with a working copy of the game will allow them to not only get a feel for the experience but be able to create better audio for it! Mark Temple, president of Enemy Technology, insists on providing his contractors with as much information about the project as possible. His game, *I, of the Enemy*, is shown here.

Working With Composers

A developer can convey music needs to a composer in a manner much like you do for a sound designer. A list of requested music can be made, highlighting specific details such as the length of each cue, whether it needs to loop continuously, and in what format it should be delivered. Or you can forward a beta copy or video file of the game and leave it up to the composer completely. A list is generally the best approach, but be sure to leave the door open to other suggestions from the music professional just in case.

A composer will need to have plenty of details and care should be taken that your vision is conveyed. I don't recommend telling them exactly what to play and how to play it. Unless your musical background is substantial, this will not guarantee their best work. But, if you point them in the right direction and trust their expertise and musical judgment, the results will be dramatic.

Timelines and milestones in a development project can be critical. Resist the temptation to procrastinate and don't wait until the last minute to bring a composer on scene. For truly inspired performances, musicians and composers need time to let ideas surface. If your game is something special and can benefit from a brilliant score, use your time wisely and share schedules and expectations with the artisan. Professional music people are not prima donnas—they just need room to let the music grow. Capitalize on this phenomenon and make your game great.

To learn more about the game composer's world, also see Chapter 8.

Music Creation Example

When a composer receives the call for music, the developer, without even knowing it, has set a massive creative wheel in motion. Music in our culture is taken for granted and most do not understand the often monumental effort it takes to create something out of thin air. When all you hear is the end result, it is easy to discount the behind-the-scenes effort.

This example will illustrate what a composer goes through when creating a short musical piece for a game. This particular one is a music cue from a previous PlayStation 2 project. The developer requested a 30-second loopable cue to be delivered as a *.mid* file and a 2 MB sound bank of instrumentation which would be triggered by the *.mid* file. The game was of the sports genre and this music was for the main menu screen.

Before any music was composed, time was spent viewing videotapes of actual gameplay, the menu screen itself, and a tape of the actual live event which the game was emulating. I took copious notes of initial thoughts, ideas for instrumentation and direction of the piece. I listened to audio examples of licensed music that would also appear in the game and additional ideas the audio director had in mind. After a few hours of concentration, I put everything aside until the next day. The intention was to let my mind process the information and to form ideas that I could pursue later, during the composition phase.

The next morning, I began the arduous task of assembling instrumentation and other sounds which would form my basic "sound palette." We had decided on a dance theme with piano and organ as the primary instruments—and I started with those, along with a bass sound, a synthesizer, a pad, and percussions. After spending hours sifting through sample and keyboard libraries, I narrowed the choices to 10 patches and 2 to 3 possibilities for each drum sound. I initially started with 7- to 8-note samples of each instrument, enough to cover most of the keyboard range, with the further intent of discarding those that didn't get used. I didn't want to limit myself and this gave plenty of options if I decided to play an instrument higher or lower than its normal range. I also chose drum and percussion sounds that would blend well with the musical style and the other instruments. At the end of this process, I felt confident there were plenty of sounds to work with and began the next step.

With only 2 MB of space available for the sound bank, I had to make tough decisions early on that would affect the musical output. Composers don't normally work well within tiny restraints and I was attempting to make it as painless as possible. How long should the percussion sounds ring? How much sustain should the keyboard instruments have? The idea was to make the sounds as short as possible without using loop points, but long enough so the instrument wouldn't fade too quickly. I chose to work with each sample and estimate the music needs, making each sample slightly longer than I would probably need. After composing, I planned to come back and re-edit the samples to save space and figured it easier to shorten them later rather than to make them longer.

Each sample was imported into an audio editing program; in this case, Sound Forge. One by one, I adjusted each sample to maximize the file. Samples from the same instrument were sized similarly and all were saved as separate *.wav* files. These files were then imported into a dedicated hardware sampler; that is, a piece of musical equipment that allows playback as notes are triggered from a keyboard or other MIDI device.

Inside the sampler, each individual sample was assigned an instrument patch and a range of notes to be played over (technical terms such as *key grouping* and *key mapping* describe this process more accurately). Discrete MIDI channels are assigned to each

instrument group, organizing separate patches for easy sequencing and manipulation. Much time is spent testing these sounds to ensure there are no dead spots and that all of the notes blend naturally. Simple adjustments and tweaks are made to make the digital files sound musical. Once everything is set, the samples and key groups are uploaded back into the computer, burned to CDR and tested a final time in the sampler. Sample selection, editing, and the loading process ended up taking the better part of the day, and after two days, a note has yet to be composed. We'll remedy that shortly.

A lesson developers can learn from this is that technically a lot of work has to be accomplished before actual music creation can begin. In this case, we are creating a sound bank for a PlayStation 2 game—but similar processes are involved for "standard" music creation as well. The composer must choose, from their array of sounds, the ones that fit together and belong in a specific game. They must set up keyboard rigs, samplers, and other instruments. Some composers will try to leave their studio setups plugged in and ready to go, but because different types of music require different processes, preparation time is always a necessity.

After the technical aspects are dealt with, the composition phase can begin. I started early the next morning by firing up the keyboard rig, loading samples and key groups, and opening a sequencing program on the PC. The software would become the canvas, where separate layered performances would trigger sampled instrumentation to be saved in the final requested *.mid* format.

There is no one way music composition begins. Composers have their own methods that can even change from project to project, depending on their resources. In this case, the dance style dictated a solid groove as the foundation, so I began with drums. The electronic drum kit was maneuvered center stage and I spent about a half an hour beating out ideas. Another 15 minutes and a drum take I could live with was recorded to the sequencer. In the sequencing program, I spent some time cleaning and tightening up the performance and setting a good loop point as close to the 30-second mark as practical. The beauty of a sequencer is the ability to move drum hits around and to add parts that a human couldn't possibly play. Next, a half hour was spent creating percussions (bongos, woodblocks, tambourine, and such) to complement the drum pattern and give inspiration for the performances to come. These were also cleaned up in the sequencer and saved to the working file.

With a solid groove established, I tried a couple of different approaches in search of the music. I started with the bass then moved to the piano to see how these ideas were fitting together. After about an hour, a legitimate idea was forming and I pushed to flesh it out. Another half hour later, the main piano and bass line were recorded with acceptable results and it was into the sequencer again to clean them up.

Next came the organ, with some arpeggio riffs and spark of a melody, another hour had these recorded. Some synth counterpoints and exclamations came to mind and these were recorded next. This was a good point to step back and listen to the piece as a whole because most of the elements were in place.

After some lunch and fresh air, I came back to the studio for a clean look at what I'd been up to. A few minor tweaks were made here and there, adding chords instead of single notes and making volume adjustments. Just for fun, I threw in some subtle bongo rolls and other punctuations and spent the remainder of the day fine-tuning the piece. It was sounding great and I was thoroughly convinced it would fit the bill. Now that I was happy, it was time to get the opinion that really mattered. An audio *.mp3* version was made and sent off to the producer and I shut down for the night, waiting for the thumbs up.

The next day, I received the blissful word that all content providers long to hear. The client accepted the cue! And off I went to work on the next in the series of contracted cues. After the music was completed, the final step was to whittle the sound bank from the 5 MB I was using to the 2 MB required for the PS2 console. The sounds were all recorded as 44 kHz, 16-bit, mono audio and the goal was to keep the quality as high as possible. I first threw out sounds that didn't get used and then shortened long sounds that weren't sustained. This narrowed the collective size down to 4 MB. I looked at what instruments could possibly be combined, desperate for any space at all. Even after dumping one instrument, the savings were inconsequential and I decided to resample instead. In the audio editor, the sound files were re-sampled to 22 kHz, leaving them at 16-bit resolution and burned to CD.

The final phase was to test them in the sampler and in the cues. Some very minor adjustments needed to be made, mostly volume parameters, but overall, the music remained as intended. I shipped out the new sound bank disc and the updated *.mid* files and that was that.

The total amount of effort for this one 30-second music cue came to four days. Two days were spent in preparation, getting organized and readying the sounds. The last two days were spent composing, tweaking, and delivering the final sound bank. It was a lot of work—basically, 96 hours for a 30-second return on the investment. This is a great example of the "behind the scenes" efforts most developers never see, so be sure to keep this in the back of your mind when asking for music with a short deadline.

Composer at Work

Nathan Madsen

Nathan Madsen is a composer, sound designer, and owner of Madsen Studios.

Describe your thought process for composing.

The first and most vital step is to have a clear vision of what the game or project needs. Without this, you may waste valuable time heading off in the wrong direction! This is why I try to get as much information as possible from my clients—from screen

shots, animation files, and concept art to plot and game play documents. I also like to ask for any inspirational media references that the creators used while working. From there, I play around with ideas (either melodic or harmonic) until I land on something that strikes me. This can take as little as five minutes or as long as a few days. The key is to keep experimenting with ideas and letting your creative mind wander. If I find myself getting bogged down or tired, I take a break.

Sometimes I watch a movie that follows the vibe of the project I'm working on and other times I try to get as far away as possible. This way, when I do come back my mind and ears are fresh. The important thing for anyone to realize is that this process is somewhat out of your control. Being creative day in and out can be tiring, so you must find ways to recharge yourself. For me, I take my iPod and go running. This always seems to clear my head, give me new ideas musically, and relieve any frustration that might have built up.

Are there any particular secrets to your creativity?

Orchestration is one of the most important elements of any piece. A mediocre piece can be enhanced by a superior orchestration and an incredible melody can be tarnished by a poor arrangement. Orchestration for a video game composer goes deeper than simply deciding which instrument section gets what line. Now that a majority of video game scores are created with VST plug-ins and not live recordings, it is very important that a composer have a superior knowledge of the VST samples and how to use them.

When do you find you are most creative?

Early morning is my best time. I naturally wake up early and I'm always ready to write some more music. There is the occasional night session as well, but I often work on other things in the evening.

Any specific "lessons learned" on a project that could be shared?

Always work under a contract and try your best to keep the business agreement steady. Don't allow the agreement to be altered too many times, because it might be a sign that the client is either struggling financially or is unprofessional. I had one company offer me a freelance job complete with a contract and monthly pay, so I began to work. This company was a start-up, so we agreed that they could defer my payments for three months then pay in full. Once it came time to pay, they claimed that they didn't have the finances.

Foolishly, I tried to work with them, but the company tried to change our agreement several times or simply ignored the contract altogether. The last straw was when the company claimed that I had not fulfilled my portion of the contract and wanted to settle for one-quarter of my earnings. Luckily, I had had enough foresight to save every conversation and piece of paperwork that they had sent me. Now I'm taking them to court for breach of contract and nonpayment. Keep it steady, keep it simple. If a company tries to change the agreement, simply stop work and demand what you're owed.

(Continued)

How do you approach negotiations with a new client?

I try to keep my negotiations as simple as possible. I always present my rates as formulas so the client can decide if this is something they can afford or not. I also always explain where my rates fall in relation to the industry standard. If they cannot afford my rates, I might adjust my prices if it is a project that I'm particularly interested in. However, this is rare.

Do you have any good advice when working with a developer?

Try to establish who has final authority before you begin work, so you don't get conflicting opinions and requests from various team members. Not only can this be confusing it can really halt the creative process because the team doesn't have a clear direction. I worked with a team where I would get conflicting tasks and also contradicting reviews of my work. The team members couldn't agree on anything, so I told them I would halt production and wait until the team had a better idea of what was needed for the game audio. After a few weeks, we resumed production with a clear direction and a more established hierarchy in the production management. From that point on, it was smooth sailing.

Have you had any interesting sound creation experiences?

While at FUNimation I was working on a new show called *School Rumble*. It is a very odd, funny, quirky show and the trailer wanted kid voices yelling "No! Wait! It's not what you think!" I had the brilliant idea of trying to record elementary school kids where I used to teach. So I head down there and get my gear all set up. I tried to pump up the kids saying this will be on TV and the Internet and they got really excited. We were using seven kids and we did several takes. I thought it turned out decent. However, when I got back to the work studio I realized that it wasn't going to work at all. The other sound guy and I just gathered up eight guys in our office and had them scream the line. Then we pitched it up. Worked great. I never had the heart to tell the kids it wasn't them in the trailer. Hopefully they're not reading this!

In my current position with NetDevil, we commonly use office members to record various voice assets for our games. The other day I got to play a space pirate with a deep, gravely voice. It was a blast but my throat hurt for the rest of the day!

Any horror stories that have impacted how you do business?

Avoid working on an MMO project by a small, amateur team unless they can provide a solid track record of completed titles, a sound business plan, and proof of funding. Instead, I would shoot for smaller, more attainable, projects (which can be just as creative, rewarding, and fun).

The first project I took on was an MMO by an amateur team that was already one year into development. I was promised twelve thousand five hundred once the game was completed and published. I was ecstatic, and very naive. Against my wishes the leader of the project wanted to work without contracts, which still doesn't make any sense to me today. However, I was young and thought that if it worked out, then great, and if not, at least I get some experience.

Two years later, the project had wasted all of its funding and missed ten consecutive deadlines. It was at this time I left the project and took all of my assets with me. The leader of the project tried to claim he owned the assets I created but without a contract or any payments made he was forced to let me walk. It was a shame, really, because I had written a complete soundtrack that I was very proud of and spent two years of my life working for this project and didn't get paid anything for my time and work. To this day the project is still stalled but at least I still own all of the audio assets.

How did you find your way into the games industry?

I started by reading this book back in 2005! I was a graduate student and knew I wanted to do music for games—I just didn't know anything about the business side. I took the advice I learned from this book, and other sources, and began to make a solid demo reel. I created a web site where I could feature my work and then began to network anywhere and everywhere I could. I was lucky enough to land several great gigs in about two months, including a third-party Nintendo DS project. At the time, I was a full-time schoolteacher—so all of my freelance work was done after hours.

My first real big break in the industry was working for FUNimation Entertainment. There, I learned many more vital skills and worked on some major properties. The entire time with FUNimation, I continued to freelance and network with other professionals. I attended professional workshops and conferences like Austin GDC and forums presented by IGDA. I got to work on another Nintendo DS project as well as one for the Sony PSP. Most recently, I was hired by NetDevil to act as their lead composer and sound designer. I am currently working on *LEGO Universe* and assisting with *JumpGate Evolution*. Throughout this entire journey, I've been fortunate enough to meet and work with some truly amazingly talented and creative people. I've never had so much fun in my entire life!

Any other advice you'd like to share?

I'd like to stress the importance of keeping an up-to-date portfolio. I've seen several people try to cram together a last-minute portfolio for a job opening and the end result is never that impressive. Not only is it more stressful, it gives very little time to consider the flow, balance, and variety of the portfolio. These jobs get posted without much notice (usually) and are filled quickly. Make things easier on yourself and have a portfolio ready to rock and roll at a moment's notice. It's always worked out well for me!

Soapbox Time

Pardon me for a moment while I get up on my soapbox, but this is worthwhile. Producers and developers who know nothing about how music creation and sound design is accomplished tend to place undo demands on the composer and sound designer and/or ask for the impossible, and in the process kill any inspiration. It is tremendously frustrating to negotiate and work with those who don't know the basic concepts of our processes. One original sound can take 2 hours on up to create; it is not just taking something from an effects library disc and converting it to the needed format. One minute of original music can take 8 hours or more to compose and record, depending on the style. A lot of hard work, creativity, and several days' preparation can go into creation. An entire game can be done in two weeks, with much pressure on the audio content provider, but it can take a month or two easily.

The art of music and sound design is just that: art. Composers and sound designers are artists complete with egos, emotions, and insecurities. Great music and sounds cannot be regurgitated on command. Please keep this is mind when making requests.

Thanks. I'll get down now.

The Next Step

After the music and sound effects are created, other matters should be focused on to guarantee the audio will fit the game like a glove. Maintaining consistency is the first issue a sound designer and composer must apply. All sounds need the same character; that is, the element that cements it to this (and only this) game. Having a sound distract the player during gameplay because it sounds out of place breaks that spell.

The best way to ensure consistent game audio is to have the audio provider devote time to *only* your game for the duration of the project. Ask prospective contractors up front whether they can commit solely to one project at a time. Often this focus alone will obtain the consistency you are pursuing. For instance, Joey Kuras had to revisit the sounds he created for *Tomorrow Never Dies* many months after he had completed the initial sound list. After designing the new sounds, the old ones didn't sound right. He ended up spending extra time EQing and adjusting the volume of the other sounds to bring them up to the new level. Although he used the same equipment as the first time around, his mixing board and equipment settings had changed enough in the interim to make the new effects sound different. By adjusting all of the effects at once, the chance of this is more remote—and greater consistency results.

An additional step to ensure consistency across your audio is to process all game sounds using the same sound processor settings. Using the same EQ, volume, reverb settings, and so on will furnish them with a similar feel. Jamey Scott uses this trick with much success in his projects.

Another concern to address with your composer and sound designer is that of quality assurance. Some believe this process does the most to guarantee the sounds work perfectly in a game. Every composer, sound designer, and many producers I've talked with insist the audio experts listen to their sounds in the *actual* game. Typically, this happens around the time the game goes into beta. The music and effects should be in place. The sound team

should sit down and study their audio intently. It's not uncommon for audio to sound great in the studio but not so hot (too loud, too soft, too long, or too short, for example) once it is synchronized with the action in the game. As related in a previous chapter, while analyzing the audio in the beta version of a game he was working on Joey Kuras discovered that a programmer on the project had taken one of the effects (the sound of footsteps) and bumped up the volume. What was intended to be subtle, barely discernable Foley effects turned into a loud series of crunches. Thankfully, Joey's screening session caught the problem and it was corrected in time.

Production Nightmares

In a perfect world, the audio creation process would go off without a hitch. The audio would come in on time, on budget and would be precisely what your game needs to make it a hit. But we all know there is no such place. We strive, instead, to keep the pain of the process at a tolerant level and just deal with it.

Many variables can come into play as the laws of Mr. Murphy blossom exponentially. The producers may not choose the proper adjectives to describe the game and in turn, the description may not mean the same to the content provider. The production could go through so many changes the composer or sound designer loses interest. The audio guy could suddenly become a monk. We've all had our own experiences to share. Many, I'm sure, we'd rather forget altogether. But, I'd rather we all learn from them and not be doomed to repeat history.

I once ended up replacing a sound designer late in the production of a fantasy game because the producer was becoming ever dissatisfied with him. It seemed the milestone work was being submitted later and later and the overall creative quality was rapidly declining. He became unpredictable to the point where weeks would go by without ever hearing from him and then the work he did submit stunk. An example was some magical spells used by various wizards in the game. It seems he was recording profanity and simply playing it backwards. While it wasn't recognizable, someone with audio editing software could reverse it and a possible lawsuit could develop.

That was something this small developer couldn't afford. I was able to step in late in the game and help out. The other guy? He was never heard from again.

Lee Moyer, founder and Executive Producer of the former Digital Addiction (now head of Lee Moyer Design and Illustration), related this story.

As we were working solely in on-line games, we needed only the shortest of sound effects so as not to blow our "bit budget." We had two spells in our game *Sanctum* that provide the only noise as effects: Elven Piper and Organ Grinder. These spells were given only to beta testers and were therefore valuable due to their scarcity. Some players went months before first encountering the drone of Elven Pipes.

Since we desired short, almost existential, sound bites to score some of the 375 spells in *Sanctum* there was a need for sound help. The first sounds we got back were created by a contractor. They all sounded okay, but did not seem to match the actual effect within the game. Our contractor's taste did not match our own understanding of the virtual world we'd created. Conveying our needs to an outsider was almost impossible, and so we turned inward. We had a musically talented staff and the sound libraries we needed. Company founder and lead programmer Ethan Ham and QA lead Matt Hulan did the lion's share of sampling, playing, and editing.

Mark Temple, owner and Executive Producer of Enemy Technology, has many games to his individual credit and is currently at work on the company's third game title. One of his biggest pet peeves is trying to work with composers and sound designers who are not computer literate. Yes, believe it or not, even in this day and age there are still some out there who don't know much beyond their immediate sound applications. He has made several treks during hectic schedules to visit a contractor just to get a copy of the game running. He's also had to instruct them how to zip and unzip files, attach sound files to e-mail, or to connect to the company FTP site. It gets a little frustrating when your efforts should to be focused on producing the game, not troubleshooting someone else's lack of knowledge. He makes it a point when hiring anyone that they know their way around a computer.

Mark offered other situations he has faced and ideas we discussed to avoid them. While in the middle of a contract, his sound designer left the project with half of the milestones complete and half of the sound effects budget. A new sound artist was quickly brought in, but the effects had a different quality and it became difficult to match the previous work—not to mention the time spent to "spool up" the new guy. Reluctantly, they opted to start from scratch, thus going over the sound budget and past their time schedule. People leave in the middle of projects all the time—sometimes for creative differences, sometimes because they don't get along with the development team, or sometimes because a bigger carrot has been dangled in front of them elsewhere. There are as many different ways to prevent this as there are reasons to leave. Honest communication and understanding of the creative processes involved is a good start. Contract points, that give the proper incentive (such as increasing the milestone payments with the largest at the completion of all work), are another option, but overly aggressive ones will spoil the relationship early. Find the balance.

A potential contract sound designer whose work was outstanding, wanted to do the job but didn't have the right equipment or money to buy it. He didn't get the job in this case because neither party had the resources to make it happen. Developers in the past have been known to either loan or buy equipment for the contractor. It depends heavily on the need for the contractor and the cash flow of the developer. In this case, though, it was seen as a lack of commitment from the sound designer. Talk about it together and see what solutions are available before passing on the deal.

Attempting to "one-stop shop," Mark found few sound designers who could also compose and produce music. The idea was to bring one less member onto the team to save time and money. Looking in the right place may have helped this situation. If they had done previous research, they could have had a list of names and demos at their disposal—but that didn't appear to be the case. There are plenty of on-line sites that cater to this very thing. (See the web site resources listed in this chapter.)

Conclusion

There tends to be a stigma attached to hiring any outside third-party contractor. It seems a highly unnatural act to search beyond the company walls after you've spent a tremendous amount of time and effort collecting and nurturing your own talent. But, even these companies need to look elsewhere on occasion—when a flood of work drowns your staff or when everybody goes on vacation at the same time.

Many arguments can be made regarding in-house audio talent and contractors. If you have the financial resources to pay someone to staff your audio department, despite not having enough work to keep them busy, these particular bragging rights might become expensive. Hiring outside help only when there is work to be done can actually make good sense. Some very large game developers have recently let their in-house staff go for this very reason. It is often cheaper to hire a contractor as they are needed rather than have someone collecting a paycheck with no work on his or her plate.

Artists are more creative in the worlds they have designed for themselves. Avoiding a rigid nine-to-five schedule lets them budget their own time and work when they are at their best. Their happiness and security can be heard in their much inspired work.

Working with these types of people is no different than coaxing excellence from your other team members. Graphic artists, programmers, composers, sound designers, actors, and voice talent are all looking to you for the proper motivation and mothering—and although the audio contractor is not immediately within the corporate view they respond to the same positive stimulus as well.

Triple-A titles can be an expensive endeavor and the audio budget alone can be very large. $750,000 isn't uncommon for a larger game, with at least two full-time in-house employees focusing just on audio, this makes the cost of audio an easy $1,000,000 and up! That's not to say that great audio can't be created and implemented for less, but also consider that film composers can demand a minimum of $2,000,000 for a triple-A film—and that's just for the music. Games are serious business and if the publisher wants serious talent working on it, the budget, man hours, and schedule definitely need to reflect it.

Even though there are no hard and fast rules, no secret formulas, and no prescribed methods for creating the consummate assemblage of audio for a game, it can happen. It takes fluid communication and a firm vision from the development team, coupled with audio contractors who shows no bounds to their creativity and patience. Together, we can take on the gaming world and keep them lining up at the stores. I'll see you there.

Tools of the Trade

Brian Tuey—sound designer and audio programmer for Treyarch

Since my focus is on in-game sound effects and in-game technology, I put far more importance on what the game engine can do versus how perfect an individual sound is. The truth is that when you get individual sounds game-ready you'll find that alone it may not sound very good on its own. Because of this, I do a lot of spectral analysis and think about the big picture—such as how many sounds are going to be going off in this area and what frequency ranges are prominent here? The tools that you use aren't nearly as important as figuring out how to use them effectively, in order to get the results you're looking for.

Because of this, I don't spend too much time worrying about using compressors and maximizers. I like to let my sounds breathe. Dynamic range is a good thing; over-processing is not. So my setup is very simple, quick to use, and has great monitoring capability.

(Continued)

Computers: Intel XENON X5355 at 2.66 GHz, 3.0 GB RAM; Mac Pro with 4.0 GB RAM.

Software: Pro Tools 7.3, proprietary tools.

Multi-track system: Pro Tools HD 96.

Monitor system: (5) Blue Sky SAT 6.5 plus matched sub and bass management system.

Mixdown: Pro Tools, Command 8 USB mixer.

Sound modules/VST instruments: EMU Proteus 2000, ORBIT v2, BOSS 770, KORG Electribe.

Outboard gear/plug-in effects: Waves Native, IZOTOPE Ozone 3.

Additional relevant hardware/software: Avalon pre-amp, Adobe Audition, Sound Miner.

Remote recording gear: Lots, but my personal favorite right now is M-Audio's MicroTrack 24/96. Not fancy, but works great!

Sound libraries: More than you can imagine!

POSTSCRIPT: GAME OVER? NOT HARDLY.

Audio for the video game industry is a continuous pursuit. For the composer, musician, and sound designer, it's a quest to be heard, to create noteworthy compositions, to sell them, to make a living, and maybe to gain a little notoriety in the process. For the developer, it is the aspiration to take their game to the next level with the ideal audio enhancement, to create a truly entertaining experience, and entice consumers to spend money on their product. It's by no means a simple proposition for anyone, but when it does work, it is a beautiful thing!

Getting into the game industry will be easy for some and very difficult for others, but whichever way it happens for you, don't take it at face value. You need to also be able to sustain yourself. Some will get a job with the first phone call they make, others will get 100 "no's" before they ever get a nibble. The ultimate trick now is to use that momentum to get the next job and the next and the next. Be sure to look in the right places, make yourself known, and use every bit of talent and skill you were born with. You will need all of it every day of your new career to establish a solid foothold in the industry. It can be done, and you can do it!

Once you do become involved in the games industry and begin pumping out massive quantities of incredible audio, be sure to also take care of yourself, your family, and your industry. Always do your best work and what's best for the project. The optimal way to attract new clients is to offer superior workmanship on every project. This keeps you in demand and the standards high throughout the industry. Never give your music or sound effects away for free or below cost. This only cheapens your work and other game audio creators' worth. By charging rates similar to everyone else, the people who make a living at this endeavor won't have to lower prices to match those who are giving it away. Don't let yourself be taken advantage of. While most game developers are part of honest, hard-working companies, there are a few without scruples who will sway you into poor decisions that will cost you money. Always protect your interests and remember that you are in business to make a profit—definitely not to take it in the shorts.

You've read all about the ins and outs of game audio, from the composer and sound designer's side to everything the developer has to consider. You know what tools you need, how to get organized for business, where to look for work, how to make the deals, and that ever important skill of actually doing audio for the various game platforms. It's been an enlightening tour—one that I hope has given you the insight to fulfill your personal and professional goals. Many game composers and sound designers are incredibly happy in the games industry, there's no other place they'd rather be. There is so much to offer the skilled artisan and anyone of you with the ambition can be quite successful at it.

But, don't let it stop there. This book was originally conceived by the surprising feedback I received from my early articles in *Game Developer Magazine* and on *Gamasutra. com*—by the many people who typed in my e-mail address (the current one, by the way, can be found on my web site *www.onyourmarkmusic.com*) and told me what they thought. Their questions and concerns are what became the basis of this project and I've incorporated every one of them here.

So, let me know what you think. Did this book help you? Did you learn the skills to thrive in the games industry? Did I accomplish my goal? Let me know how you used this information and what it did for you, and most of all, please share your successes and the experiences you have in the business. I'd really like to hear them. And if you ever see me wandering the aisles of GDC, SIGGRAPH, ComicCon, or any of those other glorious trade shows, be sure to come over and say "hi." I'd really enjoy meeting you.

Take care, work hard, and make us proud!

Appendix A

Game Audio: Getting the Help You Need to Succeed

Todd M. Fay

Todd M. Fay speaking at the Game Developers Choice Awards.

I'm glad you read this book. Aaron's done great work over the years for the benefit of the game industry. His leadership keeps us well informed, encouraged, and on a path for success. Without Aaron (and others like him), it'd be much more difficult for us to find and keep our bearings in the ever-evolving video game audio industry. Hence, the foundation for this essay: Getting the help you need to succeed in game audio.

You're Serious About Game Audio

Since you're reading *The Complete Guide to Game Audio*, it tells me you're serious about game audio. I can't say that I blame you. Game audio is exciting. It's on the cutting edge of the music and pro-audio industries.

I believe you have this book in your hands because you see some possibility for your future. The pull you feel now may be faint—a subtle curiosity—or it may be a burning desire to define yourself as a game audio pro. Either way, I want to make sure you know what you're getting yourself into. People enter game audio professionally for all sorts of reasons, including:

- Creative inspiration
- Obtaining a steady job working with sound design, music, and voice-overs
- Gaining industry acclaim
- Financial reward
- Their love of games!

Speaking for myself, I dreamt of becoming a big star in video game audio. As such, I was *very* focused on breaking into the business. I integrated game music into my college studies before it was offered as an official course at any school. After graduating, I refused to let anything get between me and my career goals. I sold most everything I owned and moved 3,000 miles away from my family to go where the action was in Southern California. I worked two industry jobs, one for free and one for just above minimum wage (while getting 3 hours of sleep a night) and attended every networking event I could talk my way into.

I knocked on (and sometimes knocked *down*) doors until, eventually, I began achieving the kinds of successes I was after. And I did it while competing with many others who were in my observation, smarter and more talented. What I lacked in those departments I made up for in inspiration, passion, and determination. Some might call it heart. Whatever you call it, if you've got it and run with it, nothing can get in your way. That's what those who helped me get into the industry told me and I've come to believe them. It's your inner powers—that drive to achieve—that distinguishes you as *one who does* from those who try to do.

My definitions of personal and professional success continue to evolve and my goals and roles shift in kind. My desires to grow, achieve, and win remain constant. I believe your same desire for personal and professional growth has you reading this book right now. Chances are you're either looking to break in or you're in and you're looking to move to the next stage. It takes passion to get from here to there (whatever "there" is for you). Passion is so critical, that one might say to proceed without *knowing it inside yourself* is frivolous.

Yeah, I know, that's pretty deep stuff. *But wouldn't you agree it's much better to love what you do for a living than to not?*

Let's tap into your inspiration right now. Take a few seconds to breathe deep and look around your surroundings. Just look around and take in what's around you. Good. Now close your eyes and picture yourself being, doing, and having whatever it is that inspired you to pick up this book. Imagine that gig you want, that piece of gear you want to own, that smile on your face from a job well done. Do you feel a certain sense of excitement? Satisfaction? *Inspiration?* Focus on that. Deepen it. Bring it to the forefront of your mind. Excellent! It's that essence, that spark, that's going to fuel your success—not only in game audio, but in all you do.

Of course there's the matter of how to channel that raw passion into practical steps to help you win. No problem. We're going to look briefly at that together in the material following. But first I want you to get that *you can make an impact in game audio*. For one person making an impact in game audio can mean composing the first Grammy-award-winning game score or it can mean creating a state-of-the-art interactive sound design. However you want your career to go, it's in your power to make it happen. And I know if you're truly serious about game audio you will do just that.

Five Keys to Success in Game Audio

In case you missed it on the cover, this is the second edition of this book. I have a copy of the first. I've owned it since it came out. It proved an invaluable tool. As Director of Development for the Game Audio Network Guild (G.A.N.G.), I recommended this book to many people. It was part of my standard response, what might be called *the five keys to success in game audio*, to the question "How do I break into/succeed in the game audio business?"

Key to Success	Example
Networking	Go to trade shows and industry events such as GDC (*www.gdconf.com*).
Mastery	Read Aaron Marks' book *The Complete Guide to Game Audio*, Second Edition.
Reputation	Build a killer demo reel.
Community	Join G.A.N.G. (*www.audiogang.org*).
Guidance	Get a mentor.

NETWORKING

Building a network of friends and business associates who help you meet your personal career goals is critical. An excellent first step to accomplishing this, as mentioned previously, is attending the major trade shows (GDC, DICE, E3, and so on). There are other opportunities, too, once you've got your foot in the door. For example, take colleagues out to lunch and get to know them. Ask them about themselves (people love that), give them an opportunity to open up and come to know you. If you listen with honest interest, it's almost certain they'll come to respect you. This is important, especially down the road. You never know how the relationship you build today may help you tomorrow.

MASTERY

Understanding and mastering your craft is crucial. It doesn't really matter who you know if you can't get the job done when it comes time to deliver. There are plenty of resources upon which to draw and to learn from. These include schools, workshops, web sites, books, podcasts—you get the idea. If you want to get hired you've got to be good. Learning the tricks and technology, practicing with the tools, taking risks and being willing to make mistakes are at the foundation of success in game audio.

REPUTATION

You can be good at what you do and know the right people, but if you can't show it off in a way that works for decision makers, you're bound to come up short when casting the net for gigs. This means having a professional-quality demo reel. This is so critical that I've teamed up with a number of top talents in the industry to start DemoNinja (*www.demoninja.com*), where creative people—including sound designers, voice professionals and composers—can submit their work for honest practical feedback for perfecting their demo reel. (Yes, that was shameless self-promotion, which by the way you might want to consider the secret/bonus/sixth key to success in game audio!)

COMMUNITY

Every successful person understands it's not just about them, it's also about the group they belong to as well. As a member of the game audio industry, you're in league with hundreds of other professionals who are very talented and passionate about the industry. They gather in various groups to promote the industry and to learn from one another. The preeminent game audio group is the Game Audio Network Guild (*www.audiogang.org*). Belonging to G.A.N.G. can be a useful way to make contacts in the business. More importantly, support for G.A.N.G. is support for:

- Game audio scholarship programs
- Industry outreach to other organizations, such as the National Academy of Recording Arts and Sciences (NARAS), Game Developers Conference (GDC), and the American Federation of Musicians (AFM)
- The Annual Game Audio Network Guild Awards

Supporting the industry at large increases the stature and credibility of game audio as art and as a critical component of the game experience. In the end, it helps you out because it raises the ceiling for what's possible in the field professionally.

GUIDANCE

My strongest recommendation is aligning with someone who can show you the ropes of the industry and motivate you. *A good mentor is indispensable.* This could be a senior team member at the office or a trusted advisor you've befriended along the way.

One of my personal priorities is seeking opportunities to learn experientially from experts. I believe what I pick up from lectures, books, and articles is best applied under the tutelage of a master tradesman. Building skill requires action, it requires experience. In doing this I receive the benefit of having positive-minded, focused, successful, and experienced professionals in my life.

At one time, apprentice/mentor relationships were commonplace. When success demanded membership in professional trade guilds, newcomers would find a master of their trade and work as understudies to learn the craft—developing into an adept or "journeyman" and eventually becoming masters themselves. The relationship, when respected, worked in favor of both parties.

Many people I met went out of their way to help me because I was willing to ask. Aaron Marks, for instance, was one of the first names I learned about in the game audio industry when I began researching who was who. I searched for masters of the trade to connect and form relationships with. I read his articles on *Gamasutra.com* and respected his perspective on the business and craft of game audio. I wanted to know more from him so I e-mailed him one day and initiated what is now coming up on a decade-long relationship.

Aaron taught and motivated me, helping me with the questions, projects, and curiosities I had about game audio. If it weren't for Aaron Marks I wouldn't be where I am today. He took professional and personal risks on me that I'd like to think he'd say paid off. And it's come round full circle for him. I'm now pleased to be one of his advisors in his business and personal development endeavors.

I've come to believe that in general, people want to see you succeed. So don't be afraid to ask for help. Speak up and put yourself out there. I recommend being both persistent and respectful. Remember, even though people will help you, they're not likely to do so at the detriment of their livelihood or reputation. Appreciate that they've got limitations, their personal interests and commitments (families, bills, hobbies, and so on) come first. This probably seems like a no-brainer on paper but you'd be surprised how often people push boundaries in professional relationships. When desire becomes desperation, stupidity can take over, and stupidity hurts. I also believe pain is the best teacher, so put yourself out there. It's better to make an effort, to make an error and learn from mistakes, than to never make an effort at all!

It's worth noting, my single biggest regret from my years with G.A.N.G. as Director of Development is that I never got an apprentice/mentor program off the ground before I left my post. I believe so deeply in the importance of these types of relationships that I now find myself working to solve a growing leadership gap we're experiencing today. Let's take a closer look at what this leadership gap is and how you can cross it effectively.

Your Peers Compete With You for Access to Experts in Your Field

The video game business is highly competitive and game audio perhaps more so, given the limited number of standard jobs/gigs available. And there are more people trying to get into the game audio industry than ever before. When I first set out to get into the video game business, everyone else seemed to be fighting over animation and programming jobs—so much so that game audio looked like the path of least resistance. Now, it's anything but. Your peers compete with you for jobs, for face time with decision makers and, problematically, access to experienced experts for guidance.

As the game audio industry became increasingly crowded, I found more and more people coming to me looking for help on how to get in or move ahead in their career. I also heard stories from the industry brass about their in-boxes filling up more rapidly with people looking for advice and help. Their time, as their careers and businesses grew, became proportionally scarce—whereas the demand for it seemed to be growing exponentially. The demand for leadership grew while the supply of leadership dwindled. There was a time when a thoughtfully crafted e-mail to the industry bigwigs all but guaranteed a prompt, friendly response chock full of useful tips specific to your situation. Those days, it seems, are behind us. The willingness to help remains. It's the availability that's changed.

Don't Go It Alone

I launched a coaching practice in the autumn of 2007 to meet the rising demand for (and limited supply of) practical and principled guidance in the game industry. I've since become a sounding board, a brainstorming partner, a devil's advocate, a one-man cheering squad and someone who challenges my clients by getting them to step outside what they know and try new approaches to the problems they face.

Ultimately, my clients understand the responsibility lies with them to produce results. I simply help clear a path for their success. They feel good knowing there's someone they can turn to for honest, objective advice and feedback on their goals and plans. You might say I'm their reality check. I wasn't sure how such an unorthodox venture would be received. I've since assisted a number of people achieve the success they desire. I've also (gratefully and humbly) received praise by those who mentored me, as their desire to see others succeed persists even while the demands on their time preclude them from providing the same leadership they did years ago.

Aaron and me poolside with our respective books at Tommy Tallarico's BBQ (2003). Watson Wu displays "The Fatman's" book.

Having a dedicated member of your team there to help you overcome personal and professional challenges is, for many people, both ideal and practical. Consider that while there are a lot of people out there with similar dreams, there is only one you. A good coach helps you distinguish and focus on what's purely unique about you—how to be true to yourself and succeed in ways other people would never try. If coaching sounds right for you, I strongly encourage you to seek one out and build on that relationship today.

Get the Help You Deserve

In summary, there is help out there for people looking to break into the game audio industry and for current professionals looking to take the next step in their career. Specifically, there are people throughout the industry interested in seeing you succeed. Putting yourself out there, creating relationships, and asking for help can open doors for you. However, what personal guidance and advice used to be readily available is now scarce because of increased competition for access to industry experts' time. The good news is you can hire a dedicated coach to help you cross the chasm between where you are today and where you envision yourself tomorrow. However you decide to proceed, please do it with heart, passion, and deep personal knowledge that what you desire is yours for the taking. Your time is now!

Todd M. Fay (*www.toddmfay.com*) is an entrepreneur, consultant, and professional/personal coach.

Todd M. Fay (*www.toddmfay.com*) holds a Bachelors of Music degree in Sound Recording Technology from the University of Massachusetts, Lowell. He is an entrepreneur, consultant, and professional/personal coach. Todd has worked with companies such as GameInvestors.com, Blizzard Entertainment, CMP Media, Creative Labs, G4 Media, Ubisoft Entertainment, 1 C Company, Tommy Tallarico Studios, Threewave Software, and Video Games Live. His writing is published by *Game Developer Magazine*, *Gamasutra .com*, *Music4Games.net*, Wordware Publishing, and Charles River Media. Todd has been a featured speaker for Los Angeles Music Productions, the IGDA, the Art Institute of California, the University of Colorado, The Game Developer's Conference, and Thompson's Xtreme Game Developers Xpo. He proudly stands for the Philosophy of Liberty (*http:// www.isil.org/resources/introduction.swf*).

Appendix B

The Grammy Awards and Other Game Audio Awards

So, fame, fortune, and the satisfaction of a job well done isn't quite enough motivation for you, huh? Well then, how would you like a Grammy Award for your troubles? Beginning with the 42nd Grammy Award Ceremony in 2000, game scores were at last able to compete for one of those enviable golden gramophones. The National Academy of Recording Arts and Sciences (NARAS) Board of Trustees approved three categories to include music written for video games:

- Best Soundtrack Album for Motion Picture, Television, or Other Visual Media
- Best Song for a Motion Picture, Television, or Other Visual Media
- Best Instrumental Composition for Motion Picture, Television, or Other Visual Media

Other visual media is the term designed to encompass video and computer games, multimedia, and the future possibilities of the Internet into one tidy little package. Although no game music has yet to be nominated, the ball has begun its roll. Our very own game industry music notables—led by powerhouse Chance Thomas (*Quest for Glory V*, *Middle Earth*, *Lord of the Rings: Shadows of Angmar*, *Peter Jackson's King Kong*) and supporting cast (Tommy Tallarico, Mark Miller, Ron Hubbard, Brian Schmidt, George Sanger, Bobby Prince, Tom White, Michael Land, Alexander Brandon, Murray Allen, Greg Rahn, and others)—presented a persuasive case to the Awards Committee.

And to think this all started by accident. Chance Thomas had met one of the key leaders of the Academy and during a conversation, mentioned composing for video games. This man of great stature and influence scoffed, wrinkled his nose, and said, "You mean, like *Pac Man* and *Donkey Kong*?" If only outwardly unaffected by the situation, Chance explained he had just completed a game soundtrack using a live orchestra and other high-brow instrumentation such as classical guitars and layered voices. The nose became unwrinkled and eyebrows raised in pleasant surprise. Now that he had the Academy member's attention, he casually asked if there could ever be a Grammy category for game scores. The answer even surprised Chance, who was to write up a formal proposal and send it to the address on the business card being thrust into his hand.

Thus began a two-year journey into what Chance has described as "like getting a bill passed through Congress." Endless letters, e-mails, phone calls, faxes, meetings, and an ever-growing number of allies on the inside led the Awards and Nominations Committee to eventually review the proposal. Their interest became evident when they scheduled a Game Music Summit in December of 1998 with a dozen of the game industry's top music professionals. This Working Group on Game Music Awards and Membership opened the eyes of the committee, giving them clear insight into the quality of game music. On 6 May 1999, NARAS made the announcement many had eagerly anticipated: game scores would be allowed to compete for Grammy Awards beginning with the year's 42nd awards ceremony.

This new attention can only be positive to gaming and to the music makers within the industry. There is no better advertisement than putting "Musical Score by Grammy Award Winner…" on the box cover.

Who's Eligible?

Because the Grammy's are awarded to honor excellence in recorded music and the music is judged on its own merits, not just any game soundtrack is eligible. Many past and current games have an outstanding score, but unless the music is available in its own standalone format it won't be considered.

To meet the eligibility requirements, a game score has to be commercially available as either its own separate music CD or stored in Red Book audio format on the game CD-ROM or "enhanced" CD (able to play on a standard CD player). NARAS has the exact definition of a commercial release, but for our purposes it must be a serious commercial distribution and not from our own "vanity" label (i.e., not burned on our CD-R and available only through our personal web site).

This is where it all began for game scores—the 42nd Annual Grammy Awards. While no game scores were nominated for a Grammy, the long road to eligibility had finally come to fruition.

NARAS Details

Are you interested? Let's talk about how to become a part of it all, shall we? There are three categories an individual may join for the Recording Academy.

VOTING MEMBER

This is where everyone wants to be—an actual voting member of the Academy. You and your peers determine who will be nominated and who will win a Grammy by two separate rounds of voting. Professionals with creative or technical credits on six commercially released tracks (or their equivalents) and those who have had credits as a vocalist, producer, songwriter, composer, engineer, instrumentalist, arranger, conductor, art director, album notes writer, narrator, music video artist, or technician are eligible in this category. Proof, such as photocopies of album jackets or liner notes, is required.

 As game composers, most of us will be eligible in several categories—everything from songwriter, arranger, and engineer to musician and producer. And if you have at least six tracks on a single game, or on a combination of others, you are eligible for this category.

ASSOCIATE MEMBER

This nonvoting membership is open to creative and technical professionals with fewer than six credits and to other recording industry professionals such as writers, publishers, attorneys, label staff, and artist managers who are directly involved on a professional basis in the music business. By joining this category, you are getting involved and showing your support for the process. And after you have your six credits it's an easy transition to Voting Membership status.

STUDENT MEMBER

This category of supporting members is made up of college students pursuing a career in the music industry. This level allows students access to networking, educational programs, and performance opportunities and prepares them for their future in music.

Applying

The applications process is fairly easy.

- Go to *www.grammy.com/Recording_Academy/Member_Services/Join/Default.aspx* and download the latest Adobe Acrobat file.
- E-mail *memservices@grammy.com*.
- Call (310) 392–3777 for an application.

There is also an application in Adobe Acrobat format on the companion DVD. Fill it out and mail or even fax it back, along with any proof of participation and membership fee and you are set. After the Academy's membership committee reviews your application and verifies your eligibility, you will receive notification of their decision.

If applying for Voting Membership, you must list your credits and show proof by way of a copy of the album jacket or liner notes. Associate membership also requires proof of credits (if you have fewer than the six credits for voting status). Alternatively, send a business card and detailed description on your company letterhead outlining any professional affiliation to the music industry for consideration.

Other Game Music Awards

While NARAS is the most prestigious organization to recognize musical achievement, they are not the only ones who acknowledge excellence in our work. The Game Audio Network Guild (G.A.N.G.), a nonprofit organization focusing on the advancement of interactive audio, recognizes excellence in game audio at their yearly awards ceremony. The G.A.N.G. Awards identify the highest quality and achievement of individuals, projects, and products which offer a significant and positive impact on the art and craft of producing interactive audio, its community and the interactive industry as a whole. They recognize music, sound design, and voice acting as three distinct disciplines and judge them on production value, quality, innovation, and impact on the community. G.A.N.G. can be found on the Web at *www.audiogang.org*.

The Academy of Interactive Arts and Sciences (AIAS) offers the Interactive Achievement Award in the Best Sound Design and Best Original Score categories at their yearly presentation. This previously combined category was split after a proposal, considerable lobbying, and follow-up by a now familiar name, Chance Thomas. Awards are usually presented at GDC or other major game-related conventions. This is also a superb way to show your support for continued industry excellence. "If we will support and nurture this, our own Academy," Chance Thomas adds, "it will become meaningful to our careers in offering education, networking opportunities, legislative support and of course an award that means something to our peers." An application, for those of you who are interested, can also be found on the companion DVD. More information and membership information on this growing organization is available on their web site at *www.interactive.org*.

In addition, there are also several industry and other events which hold their own yearly awards competitions. The Game Developers Conference (GDC), Independent Games Festival (IGF), *PC Gamer* Magazine, Spike TV, and the British Academy of Film and Television Arts (BAFTA) are among some that recognize achievement in various video game categories—including music and sound design.

And you thought nobody would care about all your hard work. Granted, it wasn't always this way—but thanks to many of our long-established colleagues in the games business, we can now have something to show for it besides a paycheck.

INDEX

Page references followed by "f" denote figures; those followed by "t" denote tables

A

WHAT'S ON THE DVD

Root directory

Introduction to the DVD readme.txt

Audio samples – audio samples readme.txt

 Myst – game trailer examples

 uWink – gameplay examples

Audio demos – audio demos readme.txt and DemoNinja.doc

Fernando Arce, DamselFly Music

Keith Arem, PCB Productions

Alexander Brandon, Celadon Studios

Mike Brassell, composer

David Chan, sound designer – *Star Wars: Knights of the Old Republic* and *Neverwinter Nights* gameplay examples and .xls DVD track list with descriptions

Will Davis, composer

Eric Doggett, Moon Dog Media

Darryl Duncan, GameBeat Studios

The Fatman, George Sanger

Rodney Gates, High Moon Studios – stems for surround demonstration

Tom Graczkowski, TDimension Studios

Richard Jacques, composer

 Headhunter

 Mass Effect

 The Club

Jon Jones, voice-over demo

Jamie Lendino, composer

Nathan Madsen, Madsen Studios

Aaron Marks, On Your Mark Music Productions

Lennie Moore, composer

Henning Nugel, Nugel Bros. Music

Christos Panayides, CP Audio Services

Matt Piersall, GL33k

Chris Rickwood, Rickwood Music for Media

Tim Rideout, composer

Mark Scholl, Screaming Tigers Music

Tommy Tallarico, Tommy Tallarico Studios

Watson Wu, WooTones

Docs – documents readme.txt

Applications – NARAS and AIAS

Contracts – book examples of contracts and talent release in .doc format

Dolby – Dolby readme.txt

Booklet – surround for games booklet in .pdf format

SDK – Dolby Sound Development Kit

Interviews – interviews readme.txt and additional composer/sound designer interviews in .doc format.